Black and White in Colour
African History on Screen

edited by Vivian Bickford-Smith
and Richard Mendelsohn

JAMES CURREY
Oxford

OHIO UNIVERSITY PRESS
Athens

DOUBLE STOREY
Cape Town

Published 2007
in the UK by
James Currey Ltd
73 Botley Road
Oxford OX2 0BS
www.jamescurrey.co.uk

and in North and South America
and the Pacific Rim by
Ohio University Press
The Ridges
Building 19
Athens
Ohio 45701

and in southern Africa by
Double Storey Books
a division of Juta & Co. Ltd
Mercury Crescent
Wetton, Cape Town

British Library Cataloguing in Publication Data available on request
Library of Congress Cataloging in Publication data is available on request

ISBN 10: 1-84701-522-0 (James Currey paper)
ISBN 13: 978-1-84701-522-8 (James Currey paper)

ISBN 10: 0-8214-1747-9 (Ohio University Press)
ISBN 13: 978-0-8214-1747-8 (Ohio University Press)

ISBN 10: 1-77013-057-8 (Double Storey)
ISBN 13: 978-1-77013-111-9 (Double Storey)

Printed by Paarl Print, Paarl, South Africa

Black and White in Colour

Contents

Contributors

Mohamed Adhikari is an Associate Professor in the Historical Studies Department at the University of Cape Town and author of *Not White Enough, Not Black Enough: Racial Identity in the South African Coloured Community*. His current interests include the history of genocide in Africa.

Ralph A. Austen is Professor of African History and co-chair of the Committee on African and African American Studies at the University of Chicago. He is the editor of *In Search of Sunjata: The Mande Epic as History, Literature and Performance* and author (with Jonathan Derrick) of *Middlemen of the Cameroon Rivers: The Duala and their Hinterland*. His many publications include *African Economic History: Internal Development and External Dependency*.

Teresa Barnes, an Associate Professor of History at the University of the Western Cape in Cape Town, has published widely on gender and labour history in colonial Zimbabwe. Her current research interests include nationalism and education in Zimbabwe, and gendered intellectual trajectories and institutional histories of universities in Africa.

Robert M. Baum is an Associate Professor in the Department of Religious Studies and co-ordinator of the African Studies Initiative at the University of Missouri, Columbia. He is author of *Shrines of the Slave Trade: Diola Religion and Society in Precolonial Senegambia*, which won a prize in 2000 from the American Academy of Religion for the best first book in the history of religions.

Professor Vivian Bickford-Smith works in the Historical Studies Department at the University of Cape Town. He has published extensively on South African history, including several books on the history of Cape Town. Together with Richard Mendelsohn, he has pioneered teaching and research in film and history at the University of Cape Town.

Professor Carolyn Hamilton, an historical anthropologist, leads the Constitution of Public Intellectual Life Research Project at the University of the Witwatersrand in Johannesburg. She has published widely on the production of history, and on archives, historiography and Zulu history.

Robert Harms is Professor of African History at Yale University. He is the author of two books on the slave trade: *River of Wealth, River of Sorrow: The Central Zaire Basin in the Era of the Slave and Ivory Trade*, and *The Diligent: A Voyage through the Worlds of the Slave Trade*. He is currently working on a book about early colonialism in the Congo River Basin.

Patrick Harries is Professor of African History at the University of Basel, Switzerland. He is the author of *Work, Culture and Identity: Migrant Labourers in Mozambique and South Africa, c.1860–1910*. His new book on Swiss missionaries and systems of knowledge in southeast Africa, *Butterflies, Barbarians and Swiss Missionaries*, is in press.

Shamil Jeppie, a graduate of Princeton University, teaches African and Middle East history in the Department of Historical Studies at the University of Cape Town. He has worked on both South African social history and on the history of Sudanic Africa.

Richard Mendelsohn is currently the head of the Department of Historical Studies at the University of Cape Town. He has published extensively on South African Jewish history, and together with Vivian Bickford-Smith has pioneered teaching and research in film and history in South Africa.

Litheko Modisane is a doctoral fellow at the University of the Witwatersrand in the Constitution of Public Intellectual Life Project. He is an accomplished actor, director and scriptwriter. His research interests span three major areas: black intellectual history, South African film and literature.

David Moore teaches economic history, development studies and politics at the University of KwaZulu-Natal in Durban. He writes on Zimbabwean politics and history, development theory and on the Democratic Republic of the Congo. His edited book *The World Bank: Poverty, Development and Global Hegemony* has recently been published.

Bill Nasson is currently Professor of History at the University of Cape Town and is a former editor of the *Journal of African History*. His publications include *Abraham Esau's War*, *The South African War 1899–1902*, and *Britannia's Empire*.

Nigel Penn was born in Kenya. He is an Associate Professor in the Historical Studies Department at the University of Cape Town and the author of *Rogues, Rebels and Runaways: Eighteenth Century Cape Characters* and *The Forgotten Frontier: Colonists and Khoisan on the Cape's Northern Frontier in the 18th Century*.

David Philips teaches in the Department of History at the University of Melbourne where he has run a course on South Africa under apartheid. He has researched and published on crime, law and punishment in 19th-century Britain and Australia, and on comparative colonial indigenous political rights. His current project is on the South African Truth and Reconciliation Commission.

Mahir Saul is a Professor at the University of Illinois, Urbana-Champaign. He has published (with Patrick Royer) *West African Challenge to Empire: Culture and History in the Volta-Bani Anticolonial War* and many articles and book chapters on West African domestic and community organisation, agriculture and ecological change, regional trade, gender roles, colonial and pre-colonial economic and political organisation.

Ruth Watson is a lecturer in African history at the University of Cambridge. She is the author of '*Civil Disorder Is the Disease of Ibadan': Chieftaincy and Civic Culture in a Yoruba City* and is currently completing a project on literary cultures and colonial citizenship in interwar Yorubaland. Her interest in African colonial history stems from her childhood, which she spent in Nigeria during the 1980s.

Nigel Worden is Professor of History at the University of Cape Town. He specialises in the history of the VOC (Dutch East India Company) period at the Cape and in the western Indian Ocean, and in particular works on slavery and forced labour. Publications include *Slavery in Dutch South Africa, Cape Town: The Making of a City* (with Vivian Bickford-Smith and Elizabeth van Heyningen), and *Trials of Slavery* (with Gerald Groenewald).

Introduction

~

VIVIAN BICKFORD-SMITH & RICHARD MENDELSOHN

B *lack and White in Colour* represents a convergence of two historiographical streams: African history and 'film and history', the former long established, the latter of more recent origin. The academic study of African history first emerged in the last decades of European colonial rule but accelerated with the coming of independence to the former colonies as the new states sought a 'usable past'. By the 1970s it was a well-established area of historical study, deeply embedded in the academy, with prestigious journals and well-attended conferences.

The study of 'film and history' got off to a slower start. Though historians occasionally used film as a teaching aid in the classroom, there was a collective scepticism about the value of film as a means of engaging with the past. Pioneering attempts in the 1970s to grapple with film's possibilities focused primarily on its uses as evidence.[1] How might film footage surviving from the past supplement other more traditional forms of evidence – the written word in particular – in broadening historical understanding? How might newsreel film, for example, complement the written record?[2] This focus on film as evidence expanded to include fiction films. What might these reveal about the values and preoccupations, the mentalités, of the societies and times in which they were produced?[3] What might they tell us of the ideologies that shaped their production? What could we learn, for example, about Nazism from the popular cinema of the Third Reich? What did Hollywood's science fiction films of the 1950s reveal about Cold War angst?

This growing interest in film as evidence emerged against a backdrop of continuing scepticism on the part of historians at large about film, particularly fiction film, as a reliable vehicle for representing the past. Feature film was seen as inherently flawed as a means of 'doing history'; when historians condescended to discuss these 'historical' films, they were summarily dismissed for their many inaccuracies and errors large and small.[4]

The turning point came in the late 1980s, with a debate in the pages of the

1

esteemed – and mainstream – *American Historical Journal* about film's value or otherwise as a means of understanding and representing the past.[5] (One of the participants would later joke about the editor's efforts to turn his article into a more acceptable form that 'may well have kept readers from being even more upset than they were at the invasion of the journal by discussions of this new medium'.)[6] The contributors to the forum included the philosopher of history Hayden White, who counterposed the notion of historiophoty, 'the representation of history and our thought about it in visual images and filmic discourse', to historiography with its 'representation of history in verbal images and written discourse'.[7]

The other key participants were Robert Brent Toplin and Robert A. Rosenstone, who in subsequent years were both to make major contributions to the theory and practice of history on film. Rosenstone's article was republished in an influential collection of essays he authored in the mid-1990s, titled *Visions of the Past: The Challenge of Film to Our Idea of History*. In one of these Rosenstone provided a valuable yardstick – widely employed in the current volume – for measuring the historical merits of history films. While insisting that invention was an inherent and acceptable element of the historical feature film, he distinguished between 'true invention' and 'false invention', invention engaging with the 'discourse of history' as opposed to invention ignoring or violating the 'discourse of history'. 'To be considered "historical"…,' he wrote, 'a film must engage, directly or obliquely, the issues, ideas, data, and arguments of the ongoing discourse of history. Like the book, the historical film cannot exist in a state of historical innocence, cannot indulge in capricious invention, and cannot ignore the findings and assertions and arguments of what we already know from other sources. Like any work of history, a film must be judged in terms of the knowledge of the past we already possess.'[8]

In this and subsequent writing, Rosenstone mounted an energetic defence of the 'dramatic feature' as history. Accuracy (as in 'facts alone') was not the sole criterion, he argued, for good history, whether written or filmic. Instead, what we demand from history, in whatever medium, is to be told what to think about 'the facts'. Historical filmic dramas, he insists, can, just as well as written histories, 'recount, explain, interpret and make meaning out of people and events in the past'.[9]

While Robert Rosenstone has elaborated the theoretical underpinnings of history on film, Peter C. Rollins and Robert Toplin have contributed significantly to its practice, the former as the editor of *Film and History*, its leading journal, the latter through his work on Hollywood's 'use and abuse of the American past'.[10] Through *Film and History* and the writings of Toplin and others, Hollywood's enduring fascination with history – dating back to the days of silent film – has

been thoroughly canvassed. Most recently Toplin has offered a sturdy defence of Hollywood history. While conceding that feature films are inferior to books 'as a source of detailed information and abstract analysis', he maintains that they '*can* communicate important ideas about the past ... the two-hour movie can arouse emotions, stir curiosity, and prompt viewers to consider significant questions.'[11]

What of the study of filmic history beyond the Hollywood version,[12] in particular what of 'film and history' in Africa? Inevitably this is at a more pioneering stage than its American counterpart. While African film in general has attracted considerable scholarly attention,[13] the study of 'film and history' in Africa is in its infancy.[14] The editors of this volume convened the First International African Film and History Conference in Cape Town in July 2002.[15] Among the papers delivered was a 'critical survey' by the film scholar Mbye Cham of 'current trends and tendencies' in 'film and history in Africa'.[16] Cham argues that there has been a significant 'turn towards the subject of history' among African filmmakers in the past few decades. Since the 1970s many have drawn on the African past for their film narratives, often as a means of engaging with and 'historicizing' the pressing issues of contemporary Africa. These history films set out to contest older, European versions of the continent where 'Europe is presented as the bringer of history and civilization to an ahistorical Africa'. Instead these films 'present versions of the African past from African perspectives', revisioning its major themes, including slavery, imperialism, colonialism and post-colonialism, in 'more complex and balanced' ways and, crucially, reaffirming African agency.

Cham's brief survey (which discusses some of the films covered in this volume) coincided with a more extended treatment of the topic by the American-based sociologist Josef Gugler in his *African Film: Re-imagining a Continent*, published in 2003.[17] Pursuing his theme of the ways in which film has provided a 'window on Africa', Gugler selected fifteen 'key films' – three of these are in the present volume – by African filmmakers and contrasted them with two highly popular but less authentic cinematic visions of Africa, Hollywood director Sydney Pollack's glossy *Out of Africa* (also discussed in this book) and the South African director Jamie Uys's *The Gods Must Be Crazy*, dismissed by Gugler as 'the world according to apartheid'. Like Cham, Gugler stresses that the African filmmakers he discusses present an image of Africa altogether different from the stereotypical Western view of the continent. They 're-imagine' Africa and its people; in their cinematic vision, 'Africans inevitably hold centre stage'.

While Josef Gugler's selection of films deals with both contemporary and historical topics, the films chosen for this volume on 'film and history' in Africa focus squarely on the historical and include films both African and non-African in provenance. The editors, historians themselves (with a specialist interest in

film and history), have recruited a team of fellow historians to consider how a selection of 'historical films' – all 'fictional' as opposed to non-fictional or documentary – chosen both for their geographical and chronological coverage of the continent's history and for their intrinsic interest as attempts at filmic history, has represented (or misrepresented) the African past. The contributors (all scholars engaged with the African past) have been asked to take into account the theorising of film and history, particularly by Rosenstone. This, inevitably (and productively), has yielded a wide range of approaches which (as the term 'film and history' suggests) should be of interest not only to historians, but also to those engaged in film studies.

It is not the intention of this introduction to summarise each of the seventeen essays that follow. Rather, we hope to give a sense of why particular films were selected for inclusion, the range of historical topics they address, and the ways in which the authors have analysed them for what they contribute to historical understanding. Thus the particular African history films in this collection were chosen partly for their subject matter, the history they relate, and partly to provide examples of very different kinds of ways in which such history can be conveyed in dramatic (rather than documentary) form in this medium.

We wished to provide considerable geographical, chronological and thematic coverage of the African past. The films included duly range from reconstructions of pre-colonial West African societies located in an indistinct (perhaps far distant) period, to representations of genocide in Rwanda, and South Africans struggling with questions of truth and reconciliation in the near present. However, we also wanted to include examples of different kinds of history films. Rosenstone's latest schema suggests that many of our films could be put within one of two major categories in this respect: 'mainstream' (Hollywood, or imitative of Hollywood) dramas and 'innovative' ('oppositional', compared to Hollywood) dramas.[18] Both are represented here, most obviously the former by *Out of Africa* or *Cry Freedom*, and the latter by *Proteus* (about a same-sex relationship in the 18th-century Dutch Cape Colony). Most West African history films (for example) are 'innovative' compared to Hollywood-style dramas. And within Rosenstone's broad headings there are numerous gradations of difference in terms (for instance) of narrative strategies or casting policies. Almost all – *The Battle of Algiers* is a notable exception, but even here director Pontecorvo initially wanted to cast Paul Newman in the leading role of an American journalist – tell their stories through the perspective of (one or more) individual protagonists. But some of the innovative dramas are played by 'stars' (who may carry with them the 'baggage' of former roles) and others by relative or complete unknowns. Equally, protagonists vary according to gender, ethnicity, race or nation – and differing 'identity' perspectives are likely to have consequences for the history

conveyed. Protagonists in these African history films include males and (less commonly) females, 'whites' and 'blacks' – if rarely the latter in 'mainstream' dramas about Africa – 'African' insiders and 'non-African' outsiders. Yet how, in this last respect, might we categorise the white protagonists of films set in apartheid South Africa or its aftermath, such as *Cry Freedom*, *A Dry White Season*, *Red Dust* or *Country of My Skull*? This is a question beyond mere academic debate in contemporary South Africa.

Almost all the films we have included deal with issues that have received extensive attention in written histories of Africa: the nature of pre-colonial African societies, the nature and effects of the slave trade, of imperialism and colonialism, of racism, of the two world wars, of anti-colonial resistance, of gross human rights abuses during apartheid, and of genocide in Rwanda. Different ways in which these issues are represented on film are not, of course, simply a reflection of different or similar subject matters, or indeed budget, though both are certainly important factors. Portraying radically different topics – romance on a 'farm in Africa' (*Out of Africa*) rather than a bitter and vicious civil war in Algiers (*The Battle of Algiers*) – might well suggest the need for radically different styles and story-telling strategies. Clearly West African directors like Kaboré (*Wend Kuuni*, *Buud Yam*), Cissé (*Yeelen*) and Kouyaté (*Keïta!*), or activist filmmakers like Greyson and Lewis (*Proteus*), do not have the same financial resources at their disposal as a Spielberg (*Amistad*) or Attenborough (*Cry Freedom*), and this has in some instances affected the nature of their reconstructions (for instance, in terms of casting or extent of 'spectacle'). Yet just as important in explaining the contrasting nature of 'historiophoty' are the diverse motivations behind the making of particular history films, themselves intimately connected to when and where each was made – in our collection, ranging chronologically from 1964 (*Zulu*) to 2004 (*Hotel Rwanda*, *Country of My Skull*, *Forgiveness* and *Red Dust*), and geographically from Africa to Australia (*Breaker Morant*), Europe and North America – as well as by whom, and with what audience and effects in mind.

So understanding and explaining these often highly varied visions of the past requires knowing not only something of the histories they ostensibly discuss, but also of the individuals who made them and (film industry, historical and social) contexts in which this happened, as contributors to this collection demonstrate. For example, the motivations for making films and the aesthetic preferences of the directors of these historiophoties range from those of an Ousmane Sembène (*Ceddo*, *Emitai*, *Le Camp de Thiaroye*) – someone whom Rosenstone has accorded the accolade of 'filmic historian' – continually concerned with understanding and explaining what the past has meant to the present, to 'industry professionals' like Basil Dearden (*Khartoum*) and Sydney Pollack (*Out of Africa*), primarily con-

cerned with producing films that succeed commercially in Europe and the United States.[19] Using this scale, the likes of Richard Attenborough (*Cry Freedom*) and Steven Spielberg (*Amistad*) arguably lie somewhere in-between.

Contributors demonstrate that many directors were avowedly politically motivated, are on record as stating that they wished to make 'issue' films or to bear witness to past or ongoing injustices – with varying levels of enthusiasm or auterist ability to determine the final product – and apportion blame. Beyond those mentioned thus far (leaving Dearden and Pollack aside), these would include Alex Haley (*Roots*), Haile Gerima (*Sankofa*) and Roger Gnoan M'Bala (*Adanggaman*), all of whom deal with the slave trade. They would also include John Greyson and Jack Lewis (*Proteus*), Raoul Peck (*Lumumba*), Gillo Pontecorvo (*The Battle of Algiers*), Ingrid Sinclair (*Flame* – about the experience of women in the Zimbabwean freedom struggle), Euzhan Palcy (*A Dry White Season*), and Terry George (*Hotel Rwanda* – about the 1994 genocide). Less obviously from their subject matter, we might also include Gaston Kaboré and Dani Kouyaté. Mahir Saul demonstrates that Kaboré (*Wend Kuuni, Buud Yam* – about pre-colonial Burkina Faso) wanted to counteract what he believed to be Western stereotypes of an Africa without any tradition worth remembering. Ralph Austen persuasively argues that Kouyaté (*Keïta!* – about modern ignorance of oral epics of Sunjata, the founder of the Mali empire) wished to critique a Burkina Faso education system that (whether under the French or after independence) supposedly neglected Mande history, and specifically the existence of powerful states in the pre-colonial past.

Werner Herzog (*Cobra Verde* – another film ostensibly about the slave trade), a leading figure in New German Cinema, would appear to be primarily interested in film as an art form rather than in history, let alone African history, *per se*. Of course many of the directors we have already mentioned (most famously, Sembène and Pontecorvo) are interested in both. For some, their interest in the African past was at least partially a result of personal childhood experience. Beyond West African directors, Ruth Watson suggests that this is true of Claire Denis (*Chocolat* – about colonial life in post-Second World War Cameroon). Likewise David Moore tells us that Raoul Peck's interest in Lumumba stems from his childhood in Leopoldville, and led to him making not only the eponymous feature film but also a documentary, *Death of the Prophet*, eight years earlier.

The films have been analysed by the contributors in one or more of the ways that have interested historians in the medium: as attempted filmic histories that can, while employing greater and lesser use of 'true' and 'false' invention, be compared with existing historiography on the topics they deal with; as 'texts' that contain evidence about the ideologies of the people, places and periods that produced them; for their role '*in* history', in shaping opinion about the past and

present (and debates about the connections between the two); and for the ways in which they either directly raise questions about the nature and purpose of history or, not least through comparing them, indirectly prompt us to think about such matters.

Some of the films offer more serious engagements than others with 'the discourses of history'. This is not simply a matter of the degree to which they deal with 'real' rather than 'fictitious' people and events in the past. Arguably both *Cry Freedom* ('real' people like Steve Biko) and *A Dry White Season* ('fictitious' people) are equally serious engagements with the nature of apartheid South Africa in the mid-1970s and both, according to Bickford-Smith, are largely 'true inventions' of a record that 'itself consists in large part of opinion about people, reports of speech and events'. Robert Harms goes as far as to argue that in making a 'fiction' film about the slave trade, Roger Gnoan M'Bala (*Adanggaman*) is able 'to reflect on the relationship between Africa and slavery without being accountable to historians'. Certainly he may feel less burdened by the need for 'factual accuracy', compared to those making films about 'real' people and events in the recent past. But Harms adds that accountability is also connected to whether filmmakers are claiming to be producing 'history through art [as Debbie Allen, the producer of *Amistad*, claimed] rather than making art out of history'.

Many contributors have demonstrated the ways in which their particular history films relate to contemporary, and subsequent, written accounts of their topics. Some examples must suffice to suggest disparate conclusions. Thus Austen reveals how Souleymane Cissé's depiction of the Mande past in *Yeelen* both attempts to challenge and may yet replicate elements of European ethnography. Worden suggests that *Proteus* was made by filmmakers 'well aware' of recent social and cultural histories of the Dutch Cape Colony. *Proteus*, like some of these written histories, employs a 'micro-narrative' technique to explore the 'hidden histories' of the socially marginalised. This technique entails, *inter alia*, the analysis 'of a specific episode in great detail ... to illuminate the kinds of social and mental processes that could exist at a particular time and place': in this instance, questions of sexuality, gender and power. Hamilton and Modisane assert that 'on most issues of substance' *Zulu* and *Zulu Dawn* 'were faithful to or, perhaps in certain aspects, in advance of the written history of their respective times', although they also warn that, as historiography develops, 'the evaluation of the historical accuracy of the films shifts' accordingly. Nasson guides us adroitly through general histories of the two world wars as well as of Africa in the 20th century, and the particular historiography surrounding African conscripts, to point out the nature, achievements (and limitations) of the history on offer in *Black and White in Colour* and *Le Camp de Thiaroye*. This includes their common 'harsh' construction of French colonial administration and the unmuffling of the 'identities and

voices of France's colonial African soldiers'. Barnes argues that *Flame* reinforced the work of Norma Kriger by offering a revisionist view of the Zimbabwean liberation struggle, one that challenged the triumphalist and androcentric narrative that dominated since independence: 'when Flame [the nom-de-guerre of the female guerrilla fighter] is raped by Che, you can almost hear thirty-odd years of mainstream nationalist historiography crashing to the floor'.

In contrast, others are more critical. Baum argues that although Sembène (in *Ceddo* and *Emitai*) portrays 'a dynamic strength in African cultures ... he sees little constructive role for organised religion. Therefore, he writes it out of the historical record or oversimplifies its complex role in the historical events that he portrays.' Mendelsohn doubts the seriousness of *Breaker Morant*'s engagement with the discourses of history. He explores what has been written about the eponymous hero of this film, an Australian soldier executed for killing Boer prisoners in the South African War, to suggest that director Beresford's portrayal is more concerned with reinforcing heroic Australian legend and Australian identity than replicating the evidence of the historical record. Equally, David Moore suggests that *Lumumba* is also hagiography, not least for omitting its hero's earlier career as a 'liberal and an embezzler'. Adhikari argues that *Hotel Rwanda* largely ignores the insights of existing historiography on the underlying causes of the genocide, particularly those that reveal the reinforcement of Hutu and Tutsi ethnicity in the colonial period and the removal of 'flexibility and safety valves that had blunted social conflict' before European conquest. Consequently, the film may suggest to Western audiences that the 1994 genocide was just another (if extreme) result of 'savage' African 'tribalism'. For his part, Philips contends that *In My Country* is guilty of too many 'false inventions' about the Truth and Reconciliation (TRC) process in South Africa.

The fact that Philips argues that *Red Dust* provides a far better sense of 'the drama of the amnesty process', and that *Forgiveness* 'offers a good sense of the working-out of issues of reconciliation ... in the post-TRC environment' reminds us of the rewarding possibility of comparing filmic histories on the same, or similar, topics. Indeed, if there are seldom alternative visions or internal debates about how to interpret the past within a single film, these are implicitly there if several are analysed. So such an exercise was a deliberate element of this collection, and exists within many individual chapters, with (for instance) Harms surveying as many as seven history films that deal with the slave trade. Equally, by including two films on very different topics by the same filmmaker, Baum demonstrates some of the enduring characteristics of Sembène's engagement with the past.

Most of our history films try to achieve a sense of authenticity in terms of the 'look' of the past, even while attempting to convince the viewer that South

Australia (*Breaker Morant*) or Zimbabwe (*Cry Freedom, A Dry White Season*) is in fact South Africa. Some go to considerable lengths to do so, and thereby lend authority to their historical arguments: Attenborough, for instance, carefully copies the framing of Sam Nzima's iconic photograph of the dead Hector Pieterson during *Cry Freedom*'s reconstruction of events of 16 June 1976 in Soweto. Others, particularly filmmakers reconstructing the more distant West African past, are less concerned with authenticity than with making a more general statement about history and its significance to the present: Kaboré is seemingly not worried about offering us imprecise geography and material culture in his rendition of an idealised Burkina Faso past in *Wend Kuuni* and *Buud Yam*. And in *Proteus*, as Worden demonstrates, Greyson and Lewis intentionally introduce anachronisms as part of an attempt to draw parallels between Robben Island in the 18th century and the anti-apartheid struggle in the 1960s and the ongoing fight for gay rights.

Whether or not a particular history film is seriously engaged with the discourses of African history, contributors have demonstrated that it can also be a rich resource of historical evidence about contemporary ideologies of the place or period that produced it: surrounding, say, appropriate gender roles, imperialism or the nature of war. The films gathered here may collectively, for instance, bear witness to what Natalie Zemon Davis (in discussing films about slavery) sees as a growing concern in the course of the late 20th century for the horrors of large-scale persecution 'under the shadow of the Holocaust'.[20] But ideologies also include, of course, attitudes towards particular people, places and events they portray. Such attitudes are often most apparent in stereotypical depictions of people: evil Afrikaner security police (*Cry Freedom, A Dry White Season*); amoral and libidinous white Kenyans (*White Mischief*); or, perhaps most noticeably of all, what Hamilton and Modisane call the 'massed collectivity' of black Africans, in other words black Africans rendered as hordes largely devoid of individual identity and, implicitly, individual agency, in films like *Zulu*, *Zulu Dawn* and *Khartoum*. But both Watson and Penn, in their chapters on settler experience in Cameroon and Kenya respectively, focus on one way in which Africa itself has been stereotyped (in *Chocolat* and *Out of Africa*), as hyper-aestheticised, a people-light (but perhaps exotic animal-full) landscape devoid of black politics, poverty or protest.[21] Indeed, Penn persuasively argues that it is largely thanks to Blixen's book and Pollack's film that pre-Mau Mau colonial Kenya has endured in Western popular consciousness as the epitome of this romanticised view of Africa. Yet sometimes, of course, depictions of people, places or events can be more ambivalent: Hamilton and Modisane detect both pro- and anti-imperial ideology in *Zulu*; and *The Battle of Algiers*, as Harries puts it, 'is not a propaganda film glorifying one side at the cost of another' (unlike the way that black nationalist causes are depicted, say, in *Lumumba*, *Cry Freedom* or *A Dry White Season*).

9

Discussing ideologies of filmic histories begins to suggest ways in which these films have been analysed by contributors for their roles *in* history: for shaping attitudes about Africa or Africans, or about national, ethnic or racial identities (both African and non-African), or about specific processes or events (such as slavery, apartheid or the genocide in Rwanda). Some may have achieved intended or unintended political results, though this is not always certain: perhaps *Cry Freedom* played a part in promoting world-wide revulsion that helped end apartheid; more certainly the South African government feared the consequences of its release and intervened to ban its exhibition. In any event, contributors give attention to how their history films were received. Patrick Harries goes further than most by making this a major way in which he analyses the historical significance – 'as an icon of memory for the left and as a source of division for the right' – of *The Battle of Algiers*.

Finally, many history films use the past to raise questions about the present – a point made by Marcia Landy and reiterated by Hamilton and Modisane.[22] Thus, as Saul asserts, Kaboré's depiction of an idealised Burkina Faso past was partly meant to lead to comparisons in Burkinabe minds with a considerably less-than-ideal present; or, as Baum argues, Sembène intentionally draws parallels between the role of Islam and Muslim leadership in Senegal's past and present; and, as Adhikari acknowledges as one 'well-accomplished' theme in *Hotel Rwanda*, Terry George's emphasis on the inaction of the international community has ongoing and recent relevance (most obviously in Darfur). Yet an 'experimental' history film like *Proteus* goes further, as Worden demonstrates, and raises questions about the very nature of historical knowledge itself: be it the 'untrustworthiness' or 'instability' of the historical record or the fact that all history (written and filmic) is merely 'a construction'. This is a single film that 'forces us to face the central question of the practice of history: can we ever really know the past?' Such 'philosophy of history' questions are of necessity also raised by the very process of analysing and comparing the often very different approaches to representing the past on film that we have deliberately gathered together in this collection. Most obviously, they include the matter of how and why 'history' has been used in the way that it has in each film, and what the films are saying about what the past means or should mean to us.

1

History as cultural redemption in Gaston Kaboré's precolonial-era films

~

MAHIR SAUL

Two films produced by Burkinabe director Gaston Kaboré, *Wend Kuuni* (1982) and its sequel fourteen years later, *Buud Yam* (1996), are set in precolonial times. They were a major success with West African audiences, won international prizes, and (especially *Wend Kuuni*) had an impact on other filmmakers in the region. This chapter explores the personal and social factors that shaped Kaboré's filmic representation of the West African cultural past. In order to explore these issues, the films are necessarily situated within the context of the history of West African cinema.

Wend Kuuni opens with a scene where we see a young woman resist her in-laws' pressure to engage in a leviratic second marriage because they presume her lost husband is now dead. Other villagers accuse her of being a witch and drive her out of the village with her sick child on her back. During the flight she dies of exhaustion, leaving her traumatised child alone in the wild. This section lasts a few minutes and consists mostly of obscure interior shots in the narrow confines of the woman's room, which help convey her solitude and desperation. Their impact on the viewer is limited, however, because titles and credits separate this sequence from the main body of the film. After the credits we begin anew in a different location. On a bright sunny day a peddler travels on his donkey amidst the luxurious vegetation of open country. He encounters a boy who is unable to speak and takes him to the next village. The villagers make efforts to find the boy's parents, but they fail. A family adopts the boy and they name him Wend Kuuni ('God's Gift'). The viewer is able to establish the connection between this main story and the scene that came before the credits only at the end of the film when the boy recovers his speech. A second trauma towards the end of the film precipitates this revelation. A noisy row between an elderly man and his rebel-

lious young wife (seemingly surprised in a tryst with another man) causes scandal in the village. At twilight, Wend Kuuni runs into the hanging body of the old man, who in his humiliation has committed suicide, and this shock brings back the boy's speech.

In between these events, village life is depicted in an idealised fashion: as harmonious relationships between relatives, spouses and friends; in the extension of kindnesses to outsiders; and in agreeable scenes of harvesting, herding, weaving and sociability in the marketplace. Wend Kuuni's sister (by adoption) is depicted as yearning for gender equality, but her fantasies lack bitterness, and the viewer is impressed mostly with the mutual love between the two children. The film ends with an endearing dialogue between the boy and the girl in an open pasture, and a return to the village where one imagines that calm reigns once again after the ripple of drama.

Throughout the film we see no objects that would locate this story obviously in the present or in remembered colonial times, or that would indicate any contact with European civilisation. The viewers in Burkina Faso identify instead a bevy of objects that are no longer in common use, which point therefore to a more remote past. A voice-over narrator, who is heard a few times during the film and whose comments move the story from one section to the next, announces near the beginning of the film that the story takes place before the White Man arrived, when food was abundant. In this sense, the film is clearly 'historical', an impression confirmed by the promotional literature (which was particularly aimed at non-African viewers).

Buud Yam revolves around the two main protagonists of *Wend Kuuni*, the boy and the girl, now grown up (Wend Kuuni is interpreted by the same actor as in the first film, Serge Yanogo). Yet it is a very different kind of film. Wend Kuuni is shunned by his age-mates and the villagers hold him responsible for the many misfortunes that strike his family. He is tormented for not knowing the identity of his birth parents – the name of the film could be translated, accurately if clumsily, as 'the spirit of the descent group' – and is haunted by scenes from his early childhood (portrayed through shots of his pensive childhood self taken from *Wend Kuuni*). His adoptive sister succumbs to a mysterious affliction, and he is commissioned to travel to find a special medicine that will restore her health, made by a renowned but elusive healer. The feat will also vindicate him from the suspicion hanging over him. A further detail complicates this part of the plot. Before falling ill, the sister has visions of being bitten by a snake. It is possible to believe that she has brought infirmity upon herself in order to give her brother the opportunity to cast off his destiny. Throughout his quest she continues to communicate with him by extrasensory means, guiding and protecting him.

Wend Kuuni sets out from the village riding a chestnut horse, has wondrous

encounters in foreign lands, and manages to bring the healer to his dying sister who is cured by the potion. Thus the plot is a quest, and Wend Kuuni's monologue at the end of the film tells us that successfully completing the quest enabled him to find himself and clear away his self-doubts. The journey is also a way of chronicling – for protagonist and viewer – the eco-cultural diversity of the lands that constitute present-day Burkina Faso.

These summaries of the two films make clear that neither is historical in the conventional sense of depicting 'real' characters from the past or important events known from historical records. In fact they are not listed in a recent survey of African 'history' films by Cham, nor indeed are the other francophone films that are mentioned in this chapter.[1] However, the element of history can be present in a film in other ways: in the sense it might give of past styles, tastes and custom, of 'what it was like to be alive in [those] times and places';[2] or because the film possesses what Toplin called the 'capacity to pull audiences into the historical environment, to show the distinctiveness of the past'.[3]

We can start unravelling the presence of these historical elements in our two films by noting that Diawara placed *Wend Kuuni* (along with some films of fellow Burkinabe filmmaker Idrissa Ouédraogo and the Malian Souleymane Cissé) under the rubric 'return to the source' films. Diawara explains that such films display 'the existence of a dynamic African history and culture before European colonization'.[4] By doing this, they participate in an important undercurrent of public discourse.

The perspective and choices of Gaston Kaboré anchor these stories in the ethos of his place and era, which is of as much interest as the degree of historical accuracy in the films. The director of a film that is set in the past may not be overtly attempting to do 'history' in the academic sense, but he or she is nonetheless expressing an attitude about the past. The explicit and implicit intentions behind the making of a film give us insights of a different nature from the quality of the history lesson we get from it. And of course, as time passes by, the film becomes historical in further senses: it attains the status of a primary document and a force that moulds what comes after it.

Compared to the examples that existed before in West African filmmaking, the framing of historical time in *Wend Kuuni* was novel. From a strictly film genre perspective, *Wend Kuuni* presents too vague a 'durée' to qualify as a true period film. Kaboré himself recognised this. '*Wend Kuuni* takes place in precolonial times ... [but] its exact time frame is not important. It could be 1420 or 1850 because the sociocultural reality which I depict remained unchanged for years.'[5] Some promotional literature is equally imprecise in saying that events take place during 'the climax of the Mossi Empire'.[6] This imprecision exposed the filmmaker to the criticism that he reproduced the stereotype of timeless Africa.

Perhaps in response, when *Buud Yam* was released it was promoted as taking place 'in the beginning of the nineteenth century', but visual information in the film – especially about material culture – does not peg it to a precise period any more clearly than is the case with *Wend Kuuni*.

We may consider first a factor that may partly explain this situation, although in my opinion it is not the most important one. Representing the remote West African rural past on film presents particular difficulties if a director wishes to attain the same accuracy of detail (especially in respect of costumes, furniture and architecture) evident in many European or American history films. Historical and archaeological research on Burkina Faso or Mali does not yet offer readily available resources for this kind of undertaking. Still, this cannot be the only reason for entirely ignoring specificity of period because (for the nineteenth century at least) a director could consult both oral history and the literature of European explorers.

So what we may deduce is that Kaboré is not concerned with historical faithfulness in the sense of accuracy of material detail. If he were, some of the minor incongruities could have been avoided, assuming that the period is meant to be the 19th century, without much specialised knowledge of history. Let us take the landscape for example. We see in *Buud Yam* a lake with dead trees standing in the middle of it. This slightly surreal feature is almost a signature of the present, because it results from the recent damming of a small river and the permanent flooding of its valley to constitute a shallow reservoir lake, dozens of which have been built in the country since the 1970s in small projects funded by international organisations. Occasionally we make out in the background a mango tree, which people of Kaboré's generation know, as somebody of a younger generation might not, is an introduction of the colonial period. We even see the cherished round Moose houses in versions built with rectangular mud bricks and mortar, a very recent development. Older Moose walls were built (as they still might be albeit more rarely) with layers made of fresh lumps of clay smoothed into one block before drying, to give the buildings the very different look of superposed horizontal bands, and interior spaces with an expressionist-like, off-plumb quality. In the lovingly depicted market scene we see a woman negotiate the price of a piece of cloth, and once the agreement has been reached – in one of the rare close-ups in the film – pay the seller by counting cowries one by one into his palm. The cowries are used here as icons of an exalted past, but the scene appears reasonable only to the uninformed. The haggling over the price is questionable, because it is not part of the trading etiquette in villages and more traditional markets, where prices fixed in the morning by sellers' cartels are maintained at least for the day. More importantly, the cowries were a low-value currency. In the middle of the 19th century the explorer Heinrich Barth reported that at Moose

markets, 700 to 800 shells was a fairly low price for a small shirt and 2 500 to 3 000 shells was reasonable for a simple robe.[7] The price equivalent for the large quantity of cloth that the boy is selling would be a heap of cowrie shells, not a few, and these would have to be counted on the ground by pulling the shells with the fingers of the two hands – a time-consuming activity that was frequently left to a professional – and handed to the seller in a calabash or basket.

This much established, we can start probing what drives Kaboré to situate his stories in pre-colonial times and why the past represented in his films looks the way that it does. Understanding the context of West African filmmaking and the innovations in this respect in *Wend Kuuni* will be of help. Filmmaking in West African countries that were previously colonies of France began shortly after independence (from 1960). But it became a truly sustained artistic activity only in the 1970s when it came to world attention by having a few of its products win international film prizes in Europe.[8] The 1960s pioneers had come to filmmaking by various idiosyncratic ways, but in the following decade limited subsidies provided by the French Ministry of Co-operation became critical in getting this fledgling cultural activity off the ground. Technical and financial support from various North African and European Union institutions remains important in keeping it alive.

In the earlier West African films both village life and history were brought to the screen, but not in the style and with the thematic content that we find in *Wend Kuuni*. The Senegalese pioneer Ousmane Sembène recreated in his epic *Emitai* (1971) an episode of colonial resistance during the years of World War Two in a Jola village in the Casamance area. A tense conflict between the army and the villagers later divides the villagers; rituals in the sacred grove and around the body of the dead warrior become expressions of the disposition of the characters and their disagreements, very successfully so even though their ethnographic faithfulness has been questioned.

In *Ceddo* (1976) Sembène took a bolder leap in historical re-creation, presenting a political confrontation between a group of local Muslims and pagan warriors led by a fearless princess, a story that seems to be an amalgam of various episodes that took place in the Senegal basin during the 17th and 18th centuries.[9] Some symbolic gestures stand out and give the film the quality of a parable: the more sympathetic treatment of the pagan warriors compared to the Muslims and the princess Dior, played by the very dark and beautiful Tabara N'diaye, who in some of Sembène's most arresting images lounges and moves against a sun-drenched savannah backdrop almost naked. She is simultaneously an assertion of the mythical pagan culture and an affront to the bourgeois sensibilities of the Senegalese elite, skin-lightness (often enhanced with beauty creams), fashion consciousness and clothing modesty.[10]

In *Si les cavaliers ...* (1981) the Nigerian director Mahamane Bakabe told the story of an actual anti-colonial uprising of 1905, using as physical setting the old buildings that survived from that time, and as props the very weapons and articles of clothing that belonged to the historical characters represented in the film. These had been preserved by their descendants (although the director recognised that his obligations to these people induced him to change some plot details that were politically compromising to the characters).[11] In *Sarraounia* (1986), a film of great stage effects that is better known and internationally acclaimed, Mauritanian director Med Hondo also presents an anti-colonial resistance organised around a beautiful pagan princess, this time against occupation forces led by the infamous captains Paul Voulet and Julien Chanoine, based on a novel by Abdoulaye Mamani.[12]

Another pioneer from Senegal, the woman director Safi Faye, is somewhat closer in style to Kaboré's two films. Faye's *Kaddu Beykat* ('Lettre paysanne', 1975) is made up of reportage-like village scenes. But that film, too, depicts disillusion in the ill-fated love of its protagonists, the juxtaposition of city and village and the foregrounding of economic exploitation, which marks Faye as belonging to the anti-colonialist first-generation filmmakers.

Kaboré's films under review in this chapter are different from these mostly earlier examples in that they do not touch upon the problems of the colonial period, or on political problems among Africans in pre-colonial times. They do not mention even the pre-colonial history of the Moose chiefdoms, which is a well-researched scholarly topic and, for those who identify as Moose, a source of pride and a central political symbol.[13] These two films primarily make comments about the cultural order. Importantly, Kaboré was not averse to making a political statement elsewhere; the second major feature film that he made, *Zan Boko* (1988), has as subject matter class conflict in the post-colonial state, and the expropriation of villages through urban zoning that goes along with the expansion of the cities, a serious issue that colours all aspects of municipal government in Burkina Faso at present. But his historical village films are devoid of similar political sensibility.

The main novelty of *Wend Kuuni* was presenting a village life of great serenity. In this film, West African village lifestyle was visualised for the first time as chief protagonist, as the essence of cultural identity. Kaboré's African past is made up of myriad details of daily interaction. By the end of the film these details remain in the viewer's mind to become the real subject of the film. Daily greetings constitute a good portion of the dialogue in *Wend Kuuni*; domestic chores, the gender division of labour, the small gifts and thoughts that sustain kinship and friendship, are all shown at a leisurely pace, without being necessary for the understanding of the simple plot. He is especially fond of depicting scenes of weaving industry, the setting up of the warp, the operation of the loom and

the product of these activities, the beautiful handwoven cloth that everyone in the two films wears as clothing or wraps themselves in as blankets (he does not show the seeding of the cotton and the spinning of thread, which were by far the most time-consuming tasks performed by women and, where they existed, by slaves). The camera focuses on the new calabashes, the goatskin bags, the clay pots, basketry and the mats. The compounds made up of cylindrical clay houses with conical thatched roofs are very prominent, as these are the centrepieces of Moose identity, which gain in strength with nostalgia at the rate at which cement block buildings with corrugated metal roofs replace them in city and village. Very central elements of these two films are the panning shots of spectacular vistas of the red-brown West African savannah.

What drives, selects and shapes this new content is to be found in Kaboré's personal trajectory; and history, or rather training in history, was decisive in it. He brings up this training in almost every published interview he gives, and it is duly recorded even in the shortest biographical sketches about him. After finishing secondary education in a Catholic boarding school, Kaboré earned a two-year college degree in history from the University of Ouagadougou. In 1972 he went to Paris, where in a few more years he earned a master's (D.E.A.) degree, also in history.[14] As he was poised to continue for a doctorate in the same field, he changed his course by turning to visual studies, and eventually to cinema. This is how he explains this development:

> During the fourth year of my studies, I became interested in Western representations of Africa and how these representations stereotyped Africans and reflected prejudices against them. I was intrigued by the depiction of Africa in the French press during the period of the late nineteenth century when the European colonial powers re-partitioned Africa; and especially, in the drawings of the French newspaper *Le Petit Journal illustré* from 1885 to 1900. I did research at the Bibliothèque d'Outre-mer in Paris where I studied and photographed the drawings, and became familiar with the colonial iconography of that period.
>
> After completing the research at the Bibliothèque, it appeared to me that in contemporary European television documentaries, Africa was still being misrepresented as an exotic and strange continent without traditions. It was apparent, at the time, that I had to learn the language of film to be able to critically analyze those documentaries. I also wanted to understand how television and film mediated ideologies of racial superiority and how Africa served as a laboratory for their articulation. And as a student of history, I wanted to understand how European representations of Africa affected and structured the mentality of Africans, especially since as Africans, we were unable to escape those stereotypes.

So I studied cinema at the Ecole Supérieur d'Etudes Cinématographiques (ESEC) in Paris to learn the language of images in order to better understand history, especially the colonial and postcolonial history of Africa. After a year of film studies, I realized I was more interested to tell stories through film than use film as a research tool to record and analyze history.[15]

A point worth noting is that Kaboré thinks Europeans misrepresent Africa as being 'without traditions', whereas it could also be maintained that they misrepresent it as having too much tradition, a promising start for a 'working misunderstanding'. In the same interview he also said: 'We are not inferior beings. We have a very rich culture ... We must continue to try to make people understand that Africans have contributed to world civilization and our universal patrimony. And through the medium of film and television we can communicate this fundamental truth to Africans and the rest of the world'.[16] Kaboré's historical references are evocative rather than scholarly, because his vision takes root in his desire to counter a stereotype.

The second element in Kaboré's development as a filmmaker is the play of mutual influences among West African filmmakers of the francophone zone. Kaboré obtained a cinema degree in Paris, but he explains that his cinematographic sensibility developed in the intra-African film milieu. In another interview he said: 'I refused to watch any of the major films that were recommended to us in school. I wanted to learn first how to speak with images before eventually learning to speak like the masters or the professionals do. That is very important. There are many films that most film students cannot even imagine not seeing but which I did not see at all ... I cannot cite a single film director who has had a conscious influence on the way I perceive cinema.'[17] In an earlier interview he conveyed, nonetheless, that he was impressed with African examples, even during his stay in France: 'One day, when I saw Sembène Ousmane's *Xala* at the Champollion movie theater, I realized that the camera could be used as a tool to express African culture.'[18]

This curiosity in the few but internationally noted early works of the pioneer West African filmmakers was nurtured by the exposure that the Panafrican Cinema and Television Festival of Ouagadougou (FESPACO) made possible, and the excitement surrounding this periodic event. FESPACO was regularised in 1971 under the sponsorship of the Upper Volta (after 1984, Burkina Faso) government and soon became one of the most significant cultural events in sub-Saharan Africa. Alternating in odd-numbered years with the Carthage Film Festival (JCC) in Tunis, it provided a forum where aspiring and established filmmakers of francophone Africa could see each other's work and learn of the reactions of foreign critics, festival organisers, film distributors and journalists. In

these intra-African venues the younger filmmakers compensated for their limited knowledge of the 'classics' of cinemathèque history, or of the acclaimed products of avant-garde movements (which the directors of the preceding decade, such as Ousmane Sembène and Souleymane Cissé, had acquired in the intellectual ambience of European cinema connoisseurship). Inspiration flowed particularly freely between the directors of Senegal, Mali and Burkina Faso (Niger had sporadic presence despite early on having produced Oumarou Ganda and Moustapha Alassane); other francophone countries, such as Côte d'Ivoire, Cameroon and Congo (Zaïre) were more peripheral to this exchange, while anglophone Ghana and Nigeria followed an altogether different development.[19]

The younger directors who started making films in the late 1970s also found openings in different kinds of settings, the newsrooms of national TV or educational video projects. In Burkina Faso, the latter were especially formative because the country was a frequent recipient of development aid and NGO projects. In lieu of experimental shorts of the film training school, the filmmakers of Kaboré's generation shot documentaries on rural development or education, commissioned by international organisations or government ministries. The early filmography of Kaboré indicates no graduation project completed during his two years in film school in Paris but several documentaries after he returned to Burkina, produced with the help of his students and with funding from various national and international agencies.[20] Idrissa Ouédraogo, now the best-known Burkinabe director in the world, who was trained in Ouagadougou in the now defunct film school INAFEC where Kaboré was teaching part-time, also started producing educational documentaries for the government. He explained that this experience set in him habits of image and setting that later characterised his fictional work.[21]

This entry to cinema through village documentaries provides the key to the way 'history' eventually acquired shape and plot in Kaboré's films. Parsimonious dialogue; slow pace; wide-angle landscape shots that dwarf solitary characters; the use of existing villages, buildings and nature as location; the casting of unschooled villagers, including very old people, as significant characters in the plot – all hallmarks of Kaboré's style of filmmaking – were worked out in these earlier projects. These elements do not exist in the Senegalese and Malian films that provided the first models.

Kaboré's particular way of imagining and giving filmic form to historical reality could be called ethnography purified of modern clutter. It is achieved by filming the villages of today, but creating the illusion that they represent the past by cleansing the area framed by the lens of the objects that saturate the present rural environment: bicycles and motorcycles, enamelled bowls and basins, transistor radios, two- and four-litre plastic oil containers, sundry articles of attire made

available by the international second-hand clothing trade, insecticide sprayers on an increasing scale, TV antennas, car batteries to power the TVs and cellphones, and so on. This manner of filming was not invented by Kaboré. The elimination of modern contamination is an old convention of ethnographic film (although these days it draws criticism as a betrayal of the promise to document the world as it is, in order to cater to the dream world of affluent audiences). For example, Trinh T. Minh-ha's *Naked Spaces: Living is Round* (1985), which was in part filmed in Burkina Faso, presents villages recognisable to anyone who has lived in them, but with an aestheticised exoticism achieved by removing all the objects that connect the place to our time. Kaboré used this technique not with the more common aim of beautifying ethnography, but to create an image that could stand as the past. This was original. Sembène's *Emitai*, on the contrary, had emphasised colonial presence. *Ceddo* created pre-colonial times as a quasi-fantastic world, partly, as Rosenstone remarked, by the theatrical nature of the staging and acting, which work upon the viewer like a Brechtian distancing effect, very different from the soft, earthy, pastoral realism of *Wend Kuuni*.

One wonders whether in the development of history film as rural ethnography there was an influence of Jean Rouch, the innovative French director who fathered the movement called *cinéma-verité*, a spontaneous style of filmmaking that blurred the boundaries between ethnographic, educational and fiction film. I would like to leave this question open. Rouch filmed in many West African countries, where he trained actors, directors, cameramen and technicians. He was, for example, one of Safi Faye's first mentors. The African filmmakers that Rouch promoted did not in the end become avant-garde *cinéma-vérité* directors, largely because they could not afford to take ten or twenty hours of rushes to produce a 45-minute feature, but he may have had an effect in other ways. When Rouch set out to produce history he adopted a version of ethnographic realism. In 1975 he filmed a story situated in the late 19th century, *Babatou, les trois conseils*, with a crew of technicians from Niger and on the basis of a script written by the historian Boubou Hama. Following his work habits, he developed only minimally the dialogue, which the actors fleshed out by improvisation on location. The team travelled around to find a suitable location. 'The problem was', Rouch explains, 'to find places that had not changed in a hundred years, without corrugated metal roofs or plastic containers.'[22] Without further safeguards this solution is illusory, because the sun-baked clay houses of the savannah rarely survive one hundred years and what appears old now may be an environment radically transformed during the colonial period. Rouch's search still reveals more concern for historical authenticity, compared to the shortcuts that Kaboré takes, but is inspired by the same supposition that in Africa the actual looks like the historical once you remove from it what is of ostensibly European origin.

Despite such parallels a major difference exists between Rouch's cinema and the style initiated by Kaboré, and that is the purpose of the final product. Rouch's aesthetic is guided by the effort to produce ethnographic estrangement; whereas Kaboré's ethnographic realism tries to create the opposite effect of attachment. Rouch's celebrated film *Les Maîtres fous* (1955), filmed in Ghana among migrant workers from Niger who undergo a possession ritual, is very much a display of radical difference, even if recorded with humour and respect. As such, it goes very much against the grain of how most West African intellectuals would like to see their cultural heritage presented to outsiders, the main reason, I think, why many of them do not like Rouch's films. West African films look different and show the culture in a different way. They are statelier in rhythm and style, and less adventurous in form; they present their characters as likeable, not wild.

Restricting our discussion to visual representation, we can contrast two attitudes toward history. One is to think of the past as radically different from the present and visualise it in such a way as to shake the viewer's sense that the habitual is natural. This inclination is unconnected to the different question of how faithful the representation may be to the knowable past. The past as 'other' can be created with meticulous attention to the remains of the period represented, but can also be imagined in total disregard for them. To illustrate the latter possibility Pier Paolo Pasolini comes readily to mind, a director whose historical imagination shares something with Rouch's 'ethno-fiction'. In Pasolini's *Medea* (1969) incongruous elements – a harsh nature, ethnographic titbits selected opportunistically for their effect rather than their historical appropriateness, a scene of human sacrifice invented with Frazerian imagination – are blended together to create a fictionally plausible but perplexing mythological Colchis that sharply stands against Jason's own classical Greece and, by extension, against modern Europe.

The opposite, the sense of the past as similar to the present, can also be created either by dismissing historical details or being faithful to them. Many Hollywood history dramas, for example (and even more so, programmes dramatising the Holy Family that appear on our TV screens on the eve of Easter), display an elaborate search for period realism when it comes to costumes and settings, but lack of imagination in staging cultural patterns and human relations not identical with the habits of American suburban life or college campus.

In this divide I think Kaboré, like most African intellectuals who reject the strange presentation of African history and ethnography, is situated closer to the second pole. The past is a different country, for some, but not for him. On the contrary it is the same country where he lives today, the very same village where his father came from, only cleaner, more presentable, with attractive people, abundant food and security from want. This past is primarily a rhetorical figure of the present, an argument hurled against the ghost of colonialism.

What guides this idealisation is a concern with European opinions, and we perceive this clearly in the matter of clothing. In Kaboré's films even children or poor villagers make a great display of it, somewhat exaggerated by historical (and ethnographic) standards. To take a few simple examples: in most places in the savannah, women's breasts are not subject to erotic curiosity and, in the absence of pressure from outsiders' judgement, are (or were, until recently) left exposed. Not in these films. The 'true past' and the 'idealised past' are two different things. In other words, although it might have been true that people traditionally wore very little clothing, it is not true of the idealised past, i.e. this 'true' past does not fit with a European audience's understanding of an 'idealised' past. Young men and women working in the fields also used to wear very little clothing. In some situations (e.g. unmarried girls in Moose villages) people may even express embarrassment at covering themselves. As missionaries and administrators have for decades berated village and city people for these practices, members of the younger generation developed an acute awareness of proper dress by assumed European standards and it is increasingly common to find that they will not let anyone photograph them if they do not feel as well dressed as the photographer. We find the same attitude in Kaboré's films. The Burkina people's idea of the negative attitude of Euro-American audiences toward nudity shapes what is presented in this self-proclaimed window on national culture.

Only the desire to display a world that meets European approval, however, would hardly have given Kaboré's cinema its emotional power. *Wend Kuuni's* success with the critics and audiences of Europe and America is also due to his skill as narrator, the lyricism of his film language, the compelling screen personality of its young actress Rosine Yanogo and, important for the present discussion, Kaboré's ability to satisfy foreign audiences' craving for the foreign and the uncommon. This last objective Kaboré accomplishes by bringing together carefully selected images of landscape, architecture, stylised cultural icons and, to some degree, by the use of the Moore language in the dialogue.

The use of African languages in West African films was pioneered by Sembène, with his Wolof version of *Mandabi* (1968). He explained, as is well known, that he took this step because he wanted to address the common people of his country, although we can imagine that cultural nationalism and anti-colonialism also played a role in this far-sighted decision. Later, the use of national languages became standard and a distinguishing mark of films made in Senegal, Mali and Burkina Faso, as opposed to those made in Central Africa or even in neighbouring Côte d'Ivoire and Ghana, which still rely on French or English dialogues for wider communicability (at the expense of verisimilitude). What the 1980s productive filmmaking in Africa revealed, which is not self-evident, is that the use of African languages can also give particular films an exotic appeal in the export

market, because the audience for these films in Europe is a self-selected group of cultural sophisticates. It is no coincidence that West African films are invariably promoted in Europe and the USA under their original foreign name (also true currently for some films made in the Middle East), and not under a translated title, which is the common procedure for foreign films made in European and Asian languages. One of Kaboré's achievements was developing a fluent visual language that does well with spare dialogue and overcomes the difficulties that might have resulted from using a national language with foreign audiences.

Outside some physical objects which are given synecdochic value, the language, and a few hints at quaint rituals that would not alienate any audience, genuine cultural elements have very limited presence in *Wend Kuuni*'s history. We encounter no elaborate ceremonies or dances, nothing in fact that could direct a foreign viewer to associations commonly made with Africa. The most glaring exclusion is magic. *Wend Kuuni* can be contrasted in this respect not only with what, say, the European gaze of Rouch sees, but also with the hyperimaginative craft of the booming film and video industry of Nigeria, which caters exclusively to a local audience. Magic is the master trope of European thinking about Africa, and Kaboré's earnest patriotism can find no room for it in any form – not in the form it takes in Sembène's *Emitai* (a staged kind of anti-colonial defiance), nor in that found in Djibril Diop-Mambety's superb *Touki-Bouki* (1973) (as unmarked reality in a humour that runs with equanimity) – and of course, least of all, as the commonplace currency of ethnographic realism/voyeurism.

A gentle form of magical realism enters Kaboré's world in *Buud Yam*, after Souleymane Cissé had shown how to do it in *Yeelen* (1987). Of a generation older than Kaboré, Cissé had become known in the 1970s with films depicting urban social problems and labour conflict. Simultaneous with the success of *Wend Kuuni*, Cissé discovered the Sahelian landscape and ethnographic historicity, including, when he turned to history, an approach to chronology as carefree as that of Kaboré's ('I chose to set my story ten centuries ago,' he said about *Yeelen*).[23] Cissé's innovation was to add the thaumaturgic element to village culture, which had a reciprocal influence on Kaboré. Férid Boughedir explains how Cissé turned to the esoteric.[24] Cissé's 1982 film *Finye* included a dialogue between an old initiated man and spirits living in a sacred tree. This scene had stunned European critics and many of them encouraged him to further develop his description of 'African spirituality'. *Yeelen* was the talented reply, but Boughedir observes that the supernatural that transpired was not simply an escapist journey offered to the European spectators, nor a nightmarish metaphor for an unlivable economic situation; Cissé makes the supernatural instead an essential component of African cultural identity and specificity.

Malian films seem to have inspired Kaboré's *Buud Yam* also with the theme of

quest and the episodic narrative structure that goes with it. The quest scheme is found, besides *Yeelen*, in Adama Drabo's *Ta Dona* (1991), which includes a long sequence of the hero searching for a magic pot that will heal a young woman. *Buud Yam* consists mostly of a long journey by the hero in search of the cure that will save his sister, whereas in *Wend Kuuni* most action was confined to one village. *Buud Yam*'s hero encounters contrasting climates, physical environments and groups recognisable as representative of some of the major ethnicities that make up the present population of Burkina Faso. The juxtaposition of cultural differences, the white cotton shirts and thatched houses of the Moose, the veiled and dark robed Tamashek, the multi-storey Bobo villages crowded with excitable inhabitants exhibiting their naked torsos, accompanied in each instance by bits of dialogue in the corresponding language, diversifies the visual and aural content of the film, and also projects the nation-state back into the past. This gallery of costumes and ethnic signifiers is intended for the enjoyment of local audiences who can recognise most readily and appreciate the distinctions. The message is also of political import because the hero's quest recapitulates the modern nation-state as cultural plurality (even if it takes account of only part of it; the eastern third of the country falls by the wayside in this reconstruction).

In the travel episodes *Buud Yam*'s laxity extends from history to geography. The journey's eco-cultural variety is achieved at the cost of common sense. The hero travels north first and reaches the driest part of the Sahel; then he continues his journey and arrives at a river flowing in a green valley. As everyone watching the film in Burkina Faso knows, if you continue in the same direction, after the Sahel you arrive not at a green valley but at the desert. What Wend Kuuni, in his search for the healer, has done is take a long curve to the west, and then to the south, extending his trip several times, instead of taking the most direct route to his destination, the active 19th-century caravan road connecting Moose country to Bobo-Dioulasso, rebuilt today as a major highway in the country. Audiences in Europe and the United States wouldn't mind (although I hope some students in my class do know the difference) but the problem is not only with historical accuracy. Thom Andersen says in his recent *Los Angeles Plays Itself* (a documentary on how over the decades films visualised Los Angeles) 'silly geography' makes for a less engaging film, even if that film is a thriller.

As we reach the end of this discussion I would like to consider briefly absences that are also relevant to what has been presented so far. *Wend Kuuni* and *Buud Yam* are silent on some broad social and historical themes, and I think this is because these themes may generate unease in national audiences and break the poetic charm of the films for international ones. Pfaff pointed out that political stratification and polygyny are left out of Kaboré's historical films.[25] Pre-colonial Moose chiefs remain invisible in them, unlike the corrupt politicians and their

businessmen acolytes, who occupy the centre stage in the post-colonial world of *Zan Boko*. For historians another notable silence is slavery. Would a boy abandoned in the wilderness be kindly collected and left in a village so that his parents could be searched for? In the 19th century the area where the film takes place, the Moose kingdom of Ouagadougou, was known as a purveyor not only of simple slaves, but also of eunuchs, who were ultimately conveyed to the Mediterranean market through Hausa trade networks. Would a trader venture alone on his donkey in unfamiliar territory, without connections to political authority and the relative safety of a caravan? For me one of the most fantastic features of both films is images of boys mounted on beautiful horses darting out of the village. In the past cavalry was the equivalent of heavy artillery and horses were strictly military gear. As for European knights, a horseman in the West African savannah might have had two or three servants just to care for his mount. In the last decades of the 19th century in the Volta basin, the exchange value of a horse varied between five and seven slaves. Taking account of such information would have necessitated selecting different images. They would have made these films more useful for some of my classes, but perhaps not as enjoyable to watch in the cinemas of Ouagadougou, or of Brussels and Paris.

Recapitulation

I suggested that Kaboré's two films under review respond to three major imperatives, and that knowing this helps understand why he chose to set his stories in the past and what he includes or leaves out when he visualises this past.

The first imperative is the desire to counter a view of Africa that is presumed to be common in Europe. This is a typically post-colonial urge linked to the injuries of the colonial past. Kaboré reconstructs his own transition to cinema in the light of this urge and it is no coincidence that his first feature film, *Wend Kuuni*, undertakes a restoration of pre-colonial history. It presents a society of ideal forms, universal human nature, innocent of political conflict and class rivalry. Any element that might lend support to commonly held but objectionable images of Africa has been eliminated from it. The attitude that rules in this respect – and that sharply contrasts with the impulses that gave us the early films of Sembène and Cissé – is similar to the characteristic Trey Ellis identified as the New Black Aesthetic in the United States, the concern over 'what white people will think'.[26]

The second imperative takes root in the material conditions of film production. Most West African countries have a very narrow market for film; the sale of

films abroad is the hope for recouping the outlay made for them, and for profitability. The way francophone West African cinema has developed since the 1970s means that filmmakers rely on European funding for capital, on international festivals for visibility and on European audiences to recover their production costs. This state of affairs affects the form and content of the films they make, as has long been recognised in Africa and among African film fans elsewhere.[27] *Wend Kuuni* in particular was successful in international venues because it blended a poetic realism with the display of a foreign way of life, which mostly consisted of outward appearances (architecture, clothing and language use), rather than the more inaccessible and difficult-to-appreciate aspects of the culture. The apprenticeship in making documentaries on contemporary rural life served Kaboré well in imagining a way to visualise African history responding to these constraints.

The third imperative is Kaboré's need to communicate a message about dignity and self-reliance to his own countrymen. The revelation of traditional culture in film affirms the sense of pride and the resolve to change things for the better. Kaboré expressed on many occasions the African artist's duty to edify fellow citizens with a positive lesson from the past: 'To me, cinema and television are tools that we can use to investigate our culture and history, in order to understand the past and the present, and to imagine a future in which we have a role … my principal audience is my community … You cannot renew the present without the experience of the past.'[28]

This vision met its right moment. First it resonated with a cultural reawakening that took hold of Burkina Faso in the wake of Captain Sankara's revolutionary government (1983–87). New fashions emerged celebrating traditional textiles, including indigo and *bogolan* dyes, and intellectuals started wearing embroidered 'bubu' gowns to formal parties. I saw young people with straw hats, or carrying knives forged by local blacksmiths, or dodging through city traffic on their mopeds with skin bags of the type shown in *Wend Kuuni* on their shoulders. On the music scene, songs with lyrics in Manding performed or inspired by famous singers from the Wasulu region of Mali started displacing the pop music of Congolese inspiration. It is remarkable that this trend spontaneously manifested itself across all strata of society. At the same time village senior men began purchasing shrouds made of handwoven local cloth for when they died, instead of the imported white percale, which had become the custom before.

Wend Kuuni slightly anticipated this trend, and became its emblem and one of its models. According to reports, when the film was first released it drew huge crowds to the cinemas. Subsequently it was shown numerous times in theatres and on the television channels of the country. In the cities especially, it is hard to find an adult of any age who has not seen it. It is the most watched domestic film in Burkina Faso.

But *Wend Kuuni* also became a signpost and the inspiration for a broader drift in the same direction in Africa. Kaboré is the wellspring of the 'return to the source' films, all situated in that vague terrain between ethnography and history. His impact on fellow Burkinabe director Idrissa Ouédraogo, who has made a larger number of films and was given the opportunity to make films outside of Burkina Faso, is well recognised (where these two directors differ from each other would provide insights complementing the present discussion). The mutual influences between Kaboré and Souleymane Cissé have already been mentioned.

More unsuspected is the mark that Kaboré left on the legendary Ousmane Sembène. Sembène's last film to date, *Molaadé* (2004), was produced in Burkina Faso, a serendipity that helps draw attention to the significant influence of Kaboré's style on it. Sembène combines in this film an aestheticised and personified ethnographic rural world, which is not characteristic of him, with the exploration of social issues and of women's worlds, which is.

Further proof of Kaboré's impact comes from far away: South African director Darrell Roodt's *Yesterday* (2004), nominated for Best Foreign Film Academy Award, is impregnated with Kaboré's filmic features. The way the characters are fashioned in this film, the slow pace, spare dialogue, the overriding of tragedy with a soft optimistic ending, the landscape photography and the uncommon use, for a South African film, of the African language Zulu, are all unexpected from the perspective of the various styles Roodt used in his previous films. They find an explanation in a comment from Roodt, that he wanted to give this film an African look.[29] African in this case means to a very large extent *Wend Kuuni*-like. Could there be a greater tribute to Kaboré? By inventing a particular vision of the African past, and combining several elements of drama and photography to communicate it to African and foreign audiences, he has defined what counts now as African style.

2

Beyond 'history':
two films of the deep Mande past

RALPH A. AUSTEN

The films

Keïta!: l'héritage du griot

Jeliba Kouyaté is summoned by a mysterious old hunter to leave his rural home for the big city residence of the Keita family; he is their hereditary *griot* (bard).[1] Jeliba then undertakes to teach the young (c. 11 years old) Mabo Keita the story of his great ancestor, Sunjata, founder of the Mali empire. A good part of the film depicts major episodes of this classic Mande epic and the narrative ends midway, with Sunjata's exile from his original and destined kingdom, due to the machinations of his mother's co-wife and her son, the rival heir to the throne. Mabo takes very much to Jeliba's teaching but at the cost of his modern, very Eurocentric, schooling. The teacher and the parents of two other children, also distracted from school by Mabo's retelling of the Sunjata story, complain to Mabo's parents. His mother agrees with this criticism and threatens to leave her husband if Mabo does not return to his studies. Jeliba, unwilling either to cause conflict or compromise by limiting his instruction to the schedule of school vacations, returns to the countryside. Mabo is left with a very incomplete narrative (the meaning of his own name has not yet been explained), his own glimpse of the mysterious hunter, and the overhead flight of a bird, said to be Jeliba's totem.

Yeelen

Nianankoro Diarra, a young Bambara man, and his mother have been in flight for ten years from Soma, Nianankoro's father, for initially unexplained reasons.[2] As the film begins, Nianankoro's mother sends him off on his own to deliver a precious stone to his uncle (the twin brother of his father), Djigui. We now learn

28

that Soma believes Nianankoro to have stolen precious secrets of the Komo ini-
tiation society. Soma uses the power of Komo and Kolonkalanni, a giant magic
pestle, to trace and intercept his son. Nianankoro passes from the country of the
Bambara to that of the Fulani cattle herders, where he impregnates the young
wife of a local king, but is allowed to take her away as his spouse. He finds his
uncle Djigui living as a blind sage in Dogon country and learns that the jewel
he has brought is the eye of the wing of Kore (another initiation society). At
last Somo and Nianankoro confront one another and the wing of Kore and the
Kolonkalanni post are both unveiled. A voice explains that the Diarra lineage
has long abused the power of Komo. Then the sunlight catches the eye of Kore
and a similar stone in Kolonkalanni, producing a cataclysmic flash of brightness
(*yeelen*), apparently immolating the universe. In the final scene Nianankoro's
widow and his very young son are alone in a desert, where they unearth two eggs
and she gives him the wing of Kore and his father's cloak.

~

Introduction

Neither of these films is historical in the sense that they represent specific
moments or epochs of an earlier time. They both, however, deal with beliefs
about the Mande past and their relationship to moral issues of the present.
These issues are clearer in *Keïta!*, since Sunjata, the subject of the story told by
the film's *griot*, is a 'real' historical figure. However, the film is less about Sunjata
than about the contemporary need to know his story. The elements of that story
that the film covers deal only with Sunjata's prophetic or magical origins and
troubled childhood, rather than his political career in the 13th-century Western
Sudan. *Yeelen* takes place entirely in an unspecified pre-colonial (and apparently
pre-Islamic) period.[3] The film does state that the sins of this time are the cause
of more recent Bambara catastrophes, such as slavery and colonialism, but no
details or time frame for such events are given.

A great deal has been written about both films (especially *Yeelen*) but little
of it is informed by historical concerns or, more significantly, by a critical sense
of the modern cultural prism through which the Mande past is represented. The
film critics are at least partially justified in reading both these productions as
personal literary, moral and visual statements whose value does not depend upon
either the auteurs' or the audience's concern for scholarly understanding of his-
tory, let alone historiography. Nonetheless, both make some claims to historicity.
They also represent the Mande past to audiences who may never otherwise con-
front this history in any medium and may have been shown it (by colleagues and

29

myself) in university and secondary school courses dealing with West African history. Thus the two films present an interesting double challenge for historians: first, to offer a hitherto absent historical analysis of their content and, secondly, to consider whether this is relevant to either film's main purpose.

My own approach will focus on two overlapping issues: firstly, the relationship between the historical and ethnographic assertions made in the films and the understanding of these same issues in contemporary scholarship; second, the nature of the concepts (largely stemming from French colonial-era discourse) upheld or attacked by the filmmakers themselves. Indeed the major critical emphasis will be on 'the French connection'. After all, cinema in this region – arguably the main centre of the entire African 'art film' industry – has relied heavily upon French sponsorship, as is revealed in the credits of the films themselves.[4] What I wish to emphasise is a less visible but in many respects deeper and more problematic link between the films and French thinking about Africa.

―

Background on the Mande world

In geographical terms, this region coincides with much of former French West Africa, as well as the small ex-British colonies of the Gambia and Sierra Leone. The southern half of Mali and the northern portion of Guinea are the historical core of Mande culture, although it extended far more widely through political conquests and migrations of merchant communities (*juula*[5]). The language of the core regions (designated by linguists as 'Manding') has two locally-named and mutually-intelligible dialects: Maninka (Malinke) and Bamana (Bambara), the language used in *Yeelen*. Jula, the language used in *Keïta!* and spoken in the merchant diaspora regions of Burkina Faso and Côte d'Ivoire, is another variant of Manding.

The region was the site of a series of pre-colonial empires. Around 1250 the Maninka ruler Sunjata founded the Mali empire, which flourished for another 150 years. The Bamana Kulibali and Jarra (Diarra) dynasties ruled Segu from about the 1710s until 1861. Islam has been present here since at least the 9th century CE and influenced Mande culture in many ways. However, efforts to reform society and political life along more strict Islamic lines have usually come from other groups in the region, particularly the Fulani, rather than the Mande themselves.

Mande society is perhaps best known for its craft castes, collectively called *nyamakalaw* because of their dangerous proximity to *nyama* (occult power). Most prominent among these are the *numuw* (blacksmiths) who, among other things, control the Komo society given such prominence in *Yeelen*. Perhaps bet-

ter known outside the region are the *jeliw* ('*griots*' or bards), who perform praise poetry for all lineages but who are particularly close to powerful patrons such as rulers. *Griots* are the performers of long narrative works like the Sunjata epic featured in *Keïta!* Men who join hunting societies (*danson ton*) are also recognised as having special access to the dangers and secrets of *nyama*.

The establishment of French rule over almost the whole Mande world (including Mali and Burkina Faso) was of major significance for the development of post-colonial cinema in this region. On the one hand colonialism, and especially the imposition of French culture, became an almost constant target of local filmmakers, even (perhaps especially) when no explicit references were made to a European presence.[6] On the other hand, the emergence of this region as the centre of African 'art film' production – signalled by the biannual Panafrican Cinema and Television Festival of Ouagadougou, or FESPACO – owes much to the French. It is France's concern (much greater than that of Britain) for maintaining influence over its former territories that accounts for the financial support which makes francophone West African cinema possible. Paris's highly developed cinema culture also helps to explain the intellectual and aesthetic seriousness that has distinguished film production in this sector of the continent.

~

Keïta! Mande versus French heritage
('Nos ancêtres les Gaulois')

Although *Yeelen* was the earlier of the two films, it is easier to start with *Keïta!* because it addresses issues of Mande history and culture in more direct and comprehensible terms. Even if *Keïta!*'s ending is somewhat inconclusive, the point of its story is abundantly clear. In order to be a fully realised African or Mande person, each individual must learn the oral tradition behind his *jamu* or lineage name; in other words he has to learn the history of his ancestors. This is especially true of the Keïta, who are descendants of the supreme Mande hero, Sunjata.

The vehicles for such knowledge are Jeliba, the *griot*, and the Sunjata epic he narrates to the young Mabo Keita. Jeliba is a figure of the present rather than the past, since *griots* (*jeliw*) still abound in contemporary Mande society. Dani Kouyaté, the filmmaker, is himself a member of the *jeli* lineage most closely linked, as the script states, to the Keita descendants of Sunjata. Sotigui Kouyaté, the actor playing Jeliba, is Dani Kouyaté's father. Sotigui is a genuine *griot* himself and provides the music for the soundtrack. Like a number of fellow *griots*, he has turned his talents to modern media: in his case not only films and the musical stage, but also Peter Brook's Paris-based theatre troupe.[7]

Does the fact that this film is produced (in various senses of the term) by two generations of *griots* mean that its technique and narrative style can be understood as a cinematic version of *jeliyya* (*griot* art)? I have not found any statements by Dani Kouyaté making such claims. Rather, Kouyaté's film is a contemplation of *jeliyya* in a modern context through a modern medium. Indeed, even though *Keïta!* belongs to the post-Kaboré era of African filmmaking, it has none of the slow pace characteristic of such cinema and is thus much more readily watched by my students.

The Jeliba whom we see in the film does not even perform in the classical poetic-musical manner but rather narrates in prose, even in conversational form, the history of Sunjata. This is something that many knowledgeable persons could do (part of the story is told to us by Mabo, who is relating it to his school friends), although *griots* do have a special responsibility for remembering such matters. A number of commentators have made a great deal of the contrast between Jeliba's Jula-language presentation of 'Sunjata' and the boyish French of Mabo's narration.[8] However, at no point is very much of the epic recited; most of it becomes a fully staged 'film within the film', with some dialogue which does derive from recorded oral performances.

The only fully performing *griot* we see in the film is a female who chants praise for the Keita lineage to Mabo's parents when they are at a wedding. The poetic and allusive words of the *griotte* (*jeli muso*) are not translated in subtitles, as is other Jula text, and she receives money from the father, Boicar Keita. Some critics perceive the point of this scene as an invidious comparison between the noble *griots* of the past, represented by Jeliba, and their degraded, market-based, present-day heirs.[9] This is an argument also made by D.T. Niane in the introduction to his 1960 translation of 'Sunjata', which is the source for much of Dani Kouyaté's version of the epic.[10] Subsequent research on *griots* does not, however, support such a claim. Praise poetry (*fasa*), not epic narrative, is their dominant genre; moreover, they always functioned in various capacities, depending upon age and prestige, and have most consistently sought patronage wherever they could find it, whether in the transitory encounters of public spaces or as established members of elite households.[11] *Keïta!* thus simultaneously reveres the 'heritage of the *griot*' and also reduces it to rather straightforward expository prose (somewhat elevated in vocabulary, and laced with proverbs and at least one riddle).

Jeliba is linked to the Mande past in another way by his origin in Wagadu. In the established oral traditions of the Western Sudan, Wagadu is associated with the Soninke – a Mande group distinct from the Bamana and Maninka – and the empire of Ghana, which preceded Mali and was located to its north and west. Wagadu is said to have been controlled by a snake divinity, Bida, who demanded the annual sacrifice of a virgin. When the lover of one such maiden slew Bida,

Wagadu became desiccated and the Soninke were forced to migrate elsewhere.[12] *Keïta!* begins with a voice-over narration that links the creation of the world, Wagadu, and Sunjata's father: 'From chaos a new world is born. The darkness and obscurity of pre-life had just been dissipated. Wagadu was the theater of the first reunion of all the creatures of the universe. In those days no one commanded men. A man Maghan Kon Fatta arose and spoke to all the others ...'

The version of the Sunjata epic presented in *Keïta!* draws a good deal from Niane's rendition, which is sometimes quoted verbatim, but also varies from it in important details: for instance, the means by which the crippled child-hero finally manages to rise on two legs. Niane's book is the most widely read account of Sunjata, but there are many other versions in print. There are even wider variations in the oral performances by *griots*, whether recorded in the past or in more recent times.[13] The variant used in *Keïta!*, with two Kouyaté *griots* involved, is certainly as 'authentic' as any others. Even the unusual opening link to Creation takes the place of more frequent references to early Islamic history at this point in the epic.

The story of Sunjata is presented in the film as 'history', but *griot* performances, like most oral epics, never make any claims to specifying the time period in which the events took place, or avoiding anachronisms.[14] The Jeliba of the film even admits that 'there are several sorts of truth' when discussing how long (eighteen months, seven years?) Sunjata's mother was pregnant with him. Jeliba's last words to Mabo also suggest a relativist attitude towards narratives of the past: 'Do you know why the hunter always beats the lion in stories? It's because it's the hunter who tells the stories. If the lion told the stories, he would occasionally win.'

The real historical issue in *Keïta!* concerns the relationship of the Sunjata story to the modern educational system of French-speaking West Africa. The film goes out of its way to contrast the two: Mabo speaks Jula with Jeliba but French at school, with his parents and even with their domestic servant (all of whom also use Jula with Jeliba). Oral tradition teaches about Creation and ancestry; the school teaches evolution, expressed as 'Our ancestors looked like gorillas, their intelligence was not developed. Nowadays man has evolved to become *Homo sapiens*, who is more intelligent.'

At the moment when Mabo is becoming distracted from school by his sessions with Jeliba, the class lesson starts with Columbus and the European discovery of America. But the question that Mabo cannot answer epitomises all the clichés about French colonial education: 'What were the inhabitants of France called in ancient times?' The answer, not given in the film, is obviously 'the Gauls': the implication is that African schoolchildren, like their metropolitan counterparts, are (and were) taught to recite 'nos ancêtres les Gaulois'.

The idea that this is what African children were taught was widely believed

in the colonial era, if less so by Africans than by Europeans trying to make sense of Africa through projections of their own national character stereotypes. But it was obviously not true even then. French authorities had, since the early 20th century, prepared special texts for teaching history and geography to African students, although the medium of education (in contrast to British Africa) did remain exclusively French.[15] Some of the earliest versions of 'Sunjata' were also published in the colonial era, two in a journal for and by African teachers.[16] Niane produced his widely circulated version of the epic in 1960, the date when French rule ended in West Africa. A middle school history textbook published in the year of Dani Kouyaté's birth (1961) has several pages dedicated to Sunjata and the Mali empire.[17] By the time Mabo, the 1990s child in *Keïta!* is attending school, we can reasonably consider the pedagogy to which we see him subjected, as well as his total ignorance of Sunjata, as quite implausible.

At the same time as this film creates a very straw-man version of French-language education, it draws on French Africanist motifs to create its contrasting image of 'tradition'. One of these is the very privileging of empires and rulers as the focus of an African past in which states played only a limited role in most people's lives.[18] Here limited financial resources defeated the conscious purpose of depicting imperial glory (for which Gugler again criticises Dani Kouyaté). But in compensation the film, probably inadvertently, succeeds in giving us a more realistic picture of small-scale village authorities who had little power.

The insertion of a Creation myth at the beginning of the Sunjata epic also appears to draw upon a somewhat notorious French ethnographic account of the 1956 septennial ceremonies at Kangaba, Mali. The epic was performed there by a respected *griot* lineage, the Diabates of neighbouring Kela. The first article on this event, by Germaine Dieterlen, is called (in its English translation) 'The Mande Creation Myth'. In both English and French versions, it implies that most of the Kangaba *griot* performance is dedicated to reciting a very locally based account of the beginning of the world. Later research, including a re-evaluation of what Dieterlen's informants actually recorded, indicates that there is no knowledge of such a 'genesis'[19] narrative among the Maninka.[20] However, this whole French understanding of Mande culture as a formal system of esoteric knowledge is much more central to *Yeelen* and will be pursued further in discussing that film.

The main problem that *Keïta!* poses for historians is its juxtaposition of tradition and modernity as starkly opposed approaches to the understanding of the past. This kind of strict duality is itself an aspect of the modern, but no longer acceptable as a tool for analysing either history or historiography. The filmmaker creates a facile posture for himself by claiming to assert an 'authentic' African heritage against the colonial or neo-colonial denigration of indigenous culture.[21] Such an image distorts the history of even the relatively assimilation-

ist French. In any case, as the example of apartheid education in South Africa dramatically indicates, the promotion of African culture could be just as much an instrument of colonialism as the teaching of European values. But 'négritude' and Afrocentrism are also elements of African historical consciousness and film-makers may be forgiven for sometimes acting them out uncritically.

Dani Kouyaté thus takes an historical, and perhaps even moral, shortcut in his images of French or modern education. But the centre of the film is ultimately Jeliba and the Sunjata story. These are convincing. They are even given a certain charm by their immediate incongruity with the urban world of Mabo. In particular, very effective use is made of the old hunter as a figure joining the various worlds of the story.

Hunters and the idiom of hunting play a major role in Mande accounts of how domestic village life is linked to the surrounding bush and the wider world beyond them, by providing knowledge of both occult *nyama* and distant settled places. Within the Sunjata epic, hunters appear as a source of prophecy concerning the as yet unconceived hero (this particularly in Niane's version), and as the means through which Sunjata's mother, Sogolon (the Buffalo Woman), comes to his father (in virtually all versions). Dani Kouyaté extends this figure both within his depiction of the epic – the prophetic old hunter returns at Sunjata's birth and when the crippled Sunjata finally stands up – and in the Jeliba–Mabo plot-line. The hunter summons Jeliba to the city in the opening scene and, at the end, comforts Mabo after Jeliba's departure: 'You will find other *griots* on your road. They can tell you the meaning of your name.' One implication of this last utterance is that Mabo's 'road' (his life in the contemporary world) need not, any more than that of Sotigui and Dani Kouyaté, be so sharply divided between 'tradition' and 'modernity'. I will thus continue to show *Keïta!* in my classes while also feeling compelled to deconstruct the more troubling aspects of its cultural-historical argument.

—

Yeelen: Sunjata meets Star Wars

The much-discussed *Yeelen* takes us far further into the 'deep' Mande past than *Keïta!* While Dani Kouyaté makes no references to Islam in his presentation of the Sunjata epic – in other versions of the epic these usually come after the point where Kouyaté's rendition ends – he does include regular Muslim prayer as part of the heritage maintained by Jeliba and abandoned by the urbanised Keita family. In contrast, *Yeelen* imagines a Mande world built entirely upon localised knowledge and rituals, particularly those of the Komo society.

It is possible to read the references to a 'Bambara' nation and the lineage name 'Diarra' (Jara) in *Yeelen* as references to the 18th–19th-century Segu empire. This was identified with the Bambara/Bamana – as opposed to the more southern Maninka/Malinke of Sunjata's Mali – and was ruled by a Diarra dynasty during the period depicted in its own epic traditions. However, there is no naming of Segu as such in the film or, to my knowledge, in any interviews with Souleymane Cissé.[22] But this state's notorious participation in slave trading forms part of the catastrophic Bambara future prophesied towards the end of the film.

Although it is older than *Keïta!*, *Yeelen* belongs to the slower-paced, visual and not-entirely linear school of African cinema which Mahir Saul identifies with the 'revolution' of Gaston Kaboré. Consequently, neither its narrative nor 'moral' is easy to follow.[23] However, its multiple motifs do ultimately come together as a coherent story: about the destruction of a corrupt world and its rebirth from 'point zero': a desert, an egg and a child. Most of the film, though, deals with the process of working out this cosmic tale through a more immediate struggle between father and son, a journey of initiation, and the understanding of the powers that lie in secret Mande knowledge.

Before I saw the film it was described to me as 'Sunjata meets Star Wars'. The Sunjata parallels in *Yeelen* – though there are no explicit references – are the themes of *fadenya* (father-sonness) and voyage into northern exile. The Mande term *fadenya* literally refers to a kin relationship – half-brothers of the same father but different mothers – but implies heroic yet anti-social behaviour emanating from the expected competition between such siblings. Classically, as in the Sunjata epic, the conflicts begin with rivalry between co-wives and then extend to their respective sons. However, there is also an implicit (and sometimes explicit) struggle between father and the mother–son unit, as in *Yeelen*. The issue is not Oedipal (assuming the Greek or Freudian meaning of this term), as many critics have stated, because sexual competition over the mother does not occur (and Nianankoro's mother is shown as very old). It is rather about the control of secret knowledge, which females are always suspected of stealing from their sexual partners or husbands (necessarily of other lineages), and of sharing either with their brothers or fathers – this is how Sunjata ultimately defeats his rival, the 'evil emperor' Soumaoro Kante – or their sons, the theme of *Yeelen*.

As Joseph Campbell and others have noted, there is a close affinity between the structures of initiation rituals and epic or heroic narratives.[24] The former are built around separation from society, confrontation with dangers in a liminal and seemingly chaotic world, and reintegration into society with elevated status. The second usually involve exile into 'the wilderness' and a triumphal return, in which not only the protagonist but also society itself is transformed.

Sunjata fits this pattern well, except that his exile takes him not from 'home/

culture' into the 'wild/nature', but rather north towards the Sahara into 'hyper-culture': an awareness of Islam and the Mediterranean world. Nianankoro, the hero of *Yeelen*, also goes more or less north across the Mali landscape, from the Mande savannah through the Sahel of the Fulani pastoralists and finally (as an egg or his son) into the Sahara Desert. However, this orientation is not linked to the Mediterranean or even strictly northward; after the Fulani encounter he ascends into the Dogon highlands, which can be thought of as south of the Fulani Sahel (on the desert's edge). The point being made here by Cissé is Nianankoro's desire to acquire not ecumenical but 'deep Mande' knowledge to defeat and then aid a Fulani chief. This quest is completed when he moves 'back' into the Dogon home of his uncle.

The 'Star Wars' element of '*Yeelen*' – apart from the narrative having affinities with the father–son conflict of Han Solo and Darth Vader – derives from the fact that secret Mande knowledge is akin to a 'force' that strongly resembles modern technology. Mande epic heroes learn secrets that can help them defeat their rivals and elevate themselves to fame and political power; but they do not normally destroy or re-create the universe. Souleymane Cissé is, of course, a late-20th-century filmmaker and not a hereditary *griot*, so he is more than entitled to link his understanding of Mande knowledge with contemporary forms of science. For the kind of critique I am attempting here, however, we have to juxtapose Cissé's stated intention in making this film against a French colonial ethnographic tradition to which he is also the (perhaps not fully conscious) heir.

In the case of *Keïta!* I have argued that at least one element of this 'heritage' – the linking of 'Sunjata' with Creation myths – seemed to derive more from problematic French ethnography than the documented practice of *griot* performances. In *Yeelen*, such influences appear to inform much more critical elements of the filmmaker's conception. These include the relationships between the Komo and Kore initiation societies, the figure of the blind Dogon seer as the repository of 'pure' Mande knowledge, and the more general notion of Mande 'secrecy' as the barrier between ordinary understanding and a formal system of occult knowledge.

The texts and graphic signs at the beginning of the film do echo classic, and much-disputed, French texts on these subjects. I have no clear evidence that Cissé drew his knowledge directly from these sources, nor is this important. French anthropologists have, as will be shown, influenced a range of modern Mande intellectuals and artists. More significant is whether, in presenting African culture the way he does, Cissé can still claim (in a similar vein to Dani Kouyaté's historiography) to be refuting 'those who call themselves Africa specialists who say they have the key to African cultures'.[25] Cissé's own methods of acquiring Mande knowledge are, in many ways, closer to those of the outside ethnogra-

pher than the 'native' inhabitant of such a culture, not to mention the initiated spokesman.

The closest resemblance in *Yeelen* to French scholarship is the representation of Kore (in the opening titles) as 'the seventh and final Bambara initiation society'. This concept of a universal Bambara initiation practice, arranged in a systemic hierarchy was formulated in the 1950s by the anthropologist Dominique Zahan.[26] More recent studies indicate a much more varied and changing set of such societies (called *jow*) across the Bamana landscape.[27] This is certainly how anyone actually initiated into such a group in a specific time and place would have experienced the process. However, this relationship between *jow* ultimately plays a small role in the film, which focuses mainly upon the Komo, whose rituals are depicted in one long and much-discussed (by Cissé himself and commentators) sequence.

Kore enters the story only when the hero, Nianankoro, finally reaches his uncle Djigui. The setting is never named but is easily recognisable as the Dogon escarpment of Bandiagara. Djigui is blind but very knowledgeable, and reveals to Nianankoro the function of the stone he has brought, the curse on their family, the fate awaiting the Bambara nation and his own duty to confront his father carrying the now-bejewelled 'wing of Kore'. Blind sages are a rather universal trope – there is another one, a blacksmith, in *Keïta!* – but the Bandiagara setting inevitably recalls Ogotemmêli, the central figure in the pivotal and most widely read text of French Africanist anthropology in this region.[28]

The Dogon are not, in linguistic terms, a Mande people, but like the Fulani they share much culture with the Mande. For Marcel Griaule and his disciples (including Germaine Dieterlen and Dominique Zahan) the Dogon provided a key to Sudanic culture because their highland base seemed to isolate them from the empires, trade routes and the Islamic influence which so pervaded the rest of this region. The Griaulians could thus claim to have discovered a pure African culture, living outside of history and responsible for developing an elaborate cosmology and astronomy completely on its own. This approach is now much criticised empirically because the Dogon have been in close contact with the wider Mande world and many are Muslim, and also for its 'essentialist' methodology, which seeks to define, in Cissé's own words, a fixed 'key to African cultures'.[29]

Is Cissé himself replicating what he claims to criticise? He does admit that, unlike the case of the two Kouyaté *griots* who produced *Keïta!*, he possesses no inherited access to the knowledge presented in his film. As his lineage name indicates, Cissé is ethnically Soninke rather than Bamana/Bambara, and he even spent a large part of his childhood outside Mali (in Dakar, Senegal), although Bambara is his principal African language. His previous films all dealt with contemporary social issues,[30] and he states that he knew nothing of Bambara

initiation cults before making *Yeelen*. This project 'was a discovery of a new thing that I knew existed but which I had not experienced in real life. And discovering the ritual scenes was *like taking part in the activities* [author's emphasis]; it was *like* an initiation for me.'[31]

Cissé's previous knowledge of Komo came from a song played on Mali radio twenty or thirty years ago and fraught (as Komo certainly is throughout the Mande world) with an aura of mysterious, even frightening, power. This same song is used in the film, and another concept very close to French ethnography is signalled when Cissé tells us that he was looking 'for the codic meanings of the song, which are most important because it contains the secrets of the universe … The sentences are codified and refer to other objects which obey the rules of specific knowledge. The rules of this knowledge can only be decoded by initiates of the Komo.'[32]

This notion of secrecy fits neatly into the basic paradigm of Western science and is the basis for the study of Mande culture by the entire Griaule school. Current scholars have sometimes gone to another extreme and characterised Mande secrecy (*gunduw*) as having no specifiable substance but rather expressing a way of addressing the unknown (and unknowable) or even the widely known: 'a grammar of public behavior … a system of what can and cannot be publicly stated'.[33] Clearly there is a belief among the Mande that forces such as *nyama* and the power of the Komo society actually exist. However, they do have to be understood within a world that does not spontaneously codify them in any systematic way. When such codification occurs, it results from the Mande world being engaged in historical dialogue with the very external forces (Islam, colonialism, a certain style of European ethnography) that both the Griaule school and a film like *Yeelen* want to excise from their vision of 'true' Mande culture.

If it is important to understand what informed Cissé's vision of Mande culture, this does not mean that it – or even Griaulian ethnography – needs to be rejected as a colonial 'invention of tradition'. An underlying premise of post-colonial studies is that all traditions are constantly invented; none are the (sole) 'authentic' version. It follows that authenticity should not be the benchmark for accepting or rejecting a particular self-representation. Souleymane Cissé is far from unique among Mande scholars and artists in incorporating Griaulian 'essentialism' into a view of his own culture.[34] Just as the pre-colonial Mande world cannot be abstracted from its millennium or of contact with Islam, so post-colonial Mande culture includes the one-century-plus confrontation with French (and, to a lesser extent, British) conceptions of Africa, both during and since the colonial era.

Yeelen is a powerful and rich statement of this hybrid Mande vision. It helps those who so desire – including many urbanised Africans like Cissé himself – to

incorporate 'the secrets of Komo' into their own cultural vocabulary. It inevitably performs this task in a mediated fashion, but there is no other way to use 'the media' for such ends. The role of the historian in analysing a film of this kind is not to present an alternative version of the past: *Yeelen* contains no falsifiable propositions like the account of French-language education in *Keïta!* Rather we are obliged to indicate the processes that help explain the nature of the 'history' presented in the film, both because this is an exercise in cultural history that is of interest in itself, but also because in carrying it out we qualify the claim that any visions of the past can fully transcend the conditions of their own construction.

3

Tradition and resistance in
Ousmane Sembène's films Emitai *and* Ceddo

~

ROBERT BAUM

C *eddo*,[1] a Wolof term for the warrior caste, is set in a small, Senegalese, coastal kingdom in the 17th century. It examines the struggles between an Islamic faction, led by a non-Wolof Islamic teacher, and an indigenous faction, led by traditional advisors to the Muslim king. It also examines the impact of the Atlantic slave trade on the political struggles between them. *Ceddo* opens with a peaceful scene of the royal capital of a small, Wolof coastal state in the late 17th or early 18th century. Suddenly, a group of men are led into the town, bound by the neck and attached to a wooden pole. They are sold to a white trader, who sells in turn cloth, muskets, and gunpowder. As Muslims perform the midday prayer, a messenger arrives with the news that Princess Dior Yacine has been seized by *ceddo* rebels. Several men offer to rescue her. The first receives a blessing from the Muslim Imam and sets out with his musket, only to be slain by a *ceddo* armed with bow and arrow. He receives a Muslim funeral. Then a *ceddo* loyal to the throne sets out, but he too is slain. The Muslims refuse to perform a funeral for him when they see his long-tressed hair, symbol of his identification with Wolof tradition. As the elders deliberate about what to do, it becomes clear that the Muslim faction does not respect the idea of kingship and insists on the acceptance of Islamic law. The *ceddo* advisors to the king decide to organise a rebellion, but the Muslims, armed by the sale of slaves to the French trader, are tipped off. They burn the church, kill the missionary, burn the royal court, kill the king, and arrest most of the *ceddo*. The *ceddo* flee or accept conversion and the Imam declares himself king. He sends out a Muslim warrior who frees the princess and brings her back to the court to marry the Imam. As she is brought before him, she seizes a musket from a soldier. As she advances on the Imam, she fires her musket and kills him, freeing her people from foreign domination.

Emitai[2] depicts a rebellion by the Diola (Jola) people of southern Senegal against the French, during the Second World War. The film is based on a series of Diola village rebellions in response to military conscription and taxation, in the form of requisitions for rice and cattle, which occurred in 1942 and 1943. Sembène combines a careful attention to the presentation of Diola material culture with the depiction of sustained resistance on a community-wide basis. The film portrays a village led by a group of elders of Diola traditional religion. It opens with Senegalese troops seizing men to serve in the French army, while the French commandant forces old people in the village to be placed in the blazing sun until their sons, who fled the military recruitment, have returned. The elders consult their spirit shrines and decide to use violent means to resist French requisitions of rice, which is their staple crop. They are defeated and the senior priest of the community is killed in battle. The French commander orders the women to be placed in the sun and forbids the burial of the slain village leader. These actions lead the men to abandon the revolt and bring in their rice. After a boy is slain by soldiers, the women carry his dead body and place it alongside the body of the slain priest. They then pick up the men's war spears, used in funeral dances, and begin the burial ritual. Hearing the women singing funeral songs, the men put down their baskets of rice and back away. The French commander orders the Senegalese troops to fire on them. The film ends with gunshots fired into the darkness.

Introduction

Ousmane Sembène is the most famous and most productive filmmaker in francophone Africa and in the West African region. He is also well known as a gifted writer of novels and short stories. While most of his work has focused on the corruption of post-colonial societies, he has also produced a number of films and written several novels focusing on West African history. Here I examine Ousmane Sembène's first two feature-length films that focus on the history of Senegal before independence. These films, produced in the 1970s, describe two communities' resistance to foreign domination. In both cases, Sembène seeks to illustrate the powerful values of African cultures as a source of resistance, while separating them from what he sees as fundamentally corrupt or impotent religious institutions.

These films depict two important events in African history, the spread of Islam in West Africa during the era of the Atlantic slave trade, and the sustained resistance of small, stateless societies to military conscription and taxation dur-

ing the colonial era. In *Emitai*, released in 1971, Sembène examines a Diola revolt against French military conscription and requisitions of rice and cattle during the harshest days of colonial rule, when administrators loyal to the German puppet regime in Vichy governed Senegal. While focusing on a single village and its struggles against a French commandant, the story is based on several revolts in a number of southern Diola villages at the time of the prophetic movement of a woman named Alinesitoué Diatta. This film, released before any historians had published scholarly work on Diola history, explores the personal recollections of Diola elders, which had previously been ignored in studies of Senegalese history.

In the far more controversial film, *Ceddo*, Sembène describes a similar type of resistance against a foreign presence in the 17th and 18th centuries. In this film, however, he portrays the external threat as coming not only from French slave traders and missionary Catholicism, but from an aggressive and often hypocritical Islamic movement, which allies itself informally with the European slave traders to advance its programme. The idea that Islam came to West Africa in a peaceful process, adapting itself to local cultures, and that Muslim leaders like Al-Haji Umar Tal and Ma Ba Diakhou led the resistance to French colonialism, is central to Senegalese popular history and oral traditions.[3] The portrayal of Islam as a foreign ideology in a nation where the director of its major research institute, the Institut Fondamental d'Afrique Noire, wrote a pamphlet arguing that Islam was the indigenous religion of Senegal is bound to generate considerable controversy.[4] This film's focus on Muslim–French collaboration is an extremely controversial topic in a nation that is 85 percent Muslim.

These films demonstrate Ousmane Sembène's profound ambivalence about African traditional cultures and the various religious systems that continue to influence African societies. While exhibiting a deep respect for the values of traditional African cultures as a source of the determination and sense of community solidarity necessary to resist foreign domination, Sembène expresses an equally intense disdain for religious authorities who set themselves above the general population or who rely too uncritically on the aid of spirits or gods. Sembène first articulated this ambivalence in his great historical novel, *Les Bouts de bois de Dieu*, published in English as *God's Bits of Wood*.[5] This novel, set during the labour strikes on the Dakar–Niger railway line after World War Two, contrasted the power of men and women who embraced the personal piety of Islam – with its emphasis on prayer, help to the poor, and community solidarity – with the false pretences of Muslim teachers or marabouts and imams who claimed a superiority over other Muslims, who exploited their faiths, and who betrayed them to the French.[6] In *Ceddo*, Sembène traces out what he sees as the origin of this problem, in an Islam that presented itself as opposing Christian, European

colonisation, while engaging in commerce with its least humane aspect: merchants of slaves eager to purchase Africans to work in far-flung European colonies. In *Emitai*, Sembène provides an admiring glance at the quiet power of Diola traditions of independence and solidarity, while portraying the elders of the spirit shrines (*ukine*) as paralysed by their dependence on spirits who cannot help them. Finally, in these two films, as he did in the novel *God's Bits of Wood*, Sembène emphasises the power of women in African cultures to challenge the oppressive force of an invasive Islam, a dehumanising slave trade, and the brutal force of the French colonial regime.

Before tracing these themes and the historically specific content of these two films, I will briefly provide some background on the writer, director and producer of these two films, Ousmane Sembène. Born in 1923, the son of a Lebou fisherman, in the regional capital of the Casamance at Ziguinchor, Sembène grew up in a multi-ethnic town, where he was exposed to a number of different Senegalese traditions. He attended a French school at Ziguinchor, but was expelled for slapping a French teacher who had struck him.[7] Moving to Dakar in his teenage years, he worked as a plumber, bricklayer and mechanic, before being drafted into the French army. He participated in the Allied invasion of Italy, then returned to Senegal and worked on the railway. Shortly after he participated in the Dakar–Niger railway strike of 1947, he returned to France to seek greater economic opportunities. He found work as a longshoreman in Marseilles and joined in labour union activities on the docks. It was during this time that he began to write and became interested in Marxist politics. In 1956, he published *Le Docker noir* (*The Black Docker*), which examined the situation of African workers in the metropole immediately after the war. Returning home to Senegal, he wrote *O pays, mon beau peuple* (*Oh Country, My Beautiful People*), about a returning World War Two veteran who has a French wife and a strong desire to participate in the liberation of his people. In 1960, Sembène published what many consider his greatest novel, *God's Bits of Wood*, which documented the history of the Dakar–Niger railway strike.

Frustrated by the inability of his novels and short stories to reach the vast majority of West Africans and aware of the popularity of film in urban areas, Sembène decided to shift his creative focus to film. Sembène saw a potential to use historical film to mobilise a far broader range of West Africans than he could ever reach through his novels.[8] In the early 1960s, he studied film-making in Moscow at the Gorki Institute. Shortly after his return in 1963, Sembène directed three short films, including one for the Malian government on the history of Songhai (*L'Empire Songhaï*). *Borom Sarret* and *Niayes* focus on the difficult lives of lower-class Senegalese in the capital city of Dakar, in the 1950s and 1960s. In his first feature film, *La Noire de …*, produced in 1966, Sembène examines the

plight of a young Senegalese maid who is taken to France to work and becomes so isolated that she commits suicide. Two years later, he directed *Mandabi* (The Money-Order) based on his novella about the corruption of urban life in Senegal immediately after independence. In 1971, he shot his first historical, full-length feature film, *Emitai*.

Senegal, the subject of most of Sembène's work, has been in contact with Islamic cultures since the 9th century, and with Europeans since the 15th. Its close proximity to Europe and to the Americas made it an important slave-trading source up until the 19th century. By that time Senegal had become the centre of France's West Africa territories. With its deep-water port, its position as the terminus of the Dakar–Niger railroad, and its role as the administrative capital of French West Africa, Dakar became an important economic centre, but it was sharply divided between Europeans and Africans. In the rural areas of central Senegal, an Islamic brotherhood known as the Mourides consolidated its control of the groundnut trade and worked closely with French commercial interests to successfully market Senegal's major cash crop. The Casamance, separated from the rest of the country by the British colony of The Gambia and more persistent in its resistance to the French occupation, received little administrative attention until the Second World War. At that time, Casamance was seen as a potential rice granary for the rest of the country, no longer able to feed itself because of its increasing reliance on groundnuts and its neglect of millet and sorghum, which had once been staple crops.

Since independence, the Senegalese government has actively encouraged the arts and sponsored a number of art festivals. For most of its post-colonial history, Senegal has maintained a relatively free press and tolerated outspoken writers like Sembène. During the 1970s, however, Senegal restricted political activity to a few recognised political parties and sought greater government control over cultural activities. This created increasing tension between the government and the local intelligentsia. It was during this time of conflict with the government that Sembène released his most controversial film, *Ceddo*.

It is clear from his interviews and writings that Sembène regards his films as important vehicles for the spread of knowledge about the Senegalese past and for mobilising the population against persistent injustice and exploitation. In an interview in 1978, he likened himself to the West African *griot*, an oral historian and bard. 'The African filmmaker is like the griot who is similar to the medieval minstrel: a man of learning and common sense who is the historian, the raconteur, the living memory and the conscience of his people. The filmmaker must live within his society and say what goes wrong with his society ... The filmmaker must not live secluded in an ivory tower; he has a definite social function to fulfil.'[9]

Since my primary concerns are *Emitai*'s and *Ceddo*'s views of history, I will describe them in the order of the time periods that they portray, rather than the order in which they were filmed. In both cases, I will analyse the films on three levels: their value as historical sources; their value for the teaching of African history; and their use as primary documents of an African intellectual and artistic history (a history of African perspectives on an African past). Finally, I will also examine the problem of film itself as attempted history and what Robert Rosenstone calls 'visual fictions'.[10]

Ceddo

Even before it was released, Ousmane Sembène's film *Ceddo* generated controversy. The Senegalese government refused to allow it to be released domestically, citing the refusal of the director to use the official spelling of the title's Wolof term, which government linguists had decided should be spelled 'cedo'. While one could imagine that President Léopold Sédar Senghor, a linguist himself, might delay the release of the film because of its violation of an official Wolof orthography,[11] the real reason was the politically explosive nature of the film's perspective on the period of the spread of Islam among the Wolof. This was a particularly sensitive subject for a Catholic president of an overwhelmingly Muslim country, whose political base included powerful Islamic brotherhoods who did not wish to see their religion denigrated. Popular and scholarly histories of Islam in Senegal had emphasised both the longevity of an Islamic presence and the peaceful nature of its growth in the region.[12] As Mbye Cham noted:

> In 'Ceddo,' the image of Islam that is portrayed is not a beautiful one at all. The Muslims are presented as scheming, violent fanatics, with little regard to the principles of self-determination and religious and cultural freedom. Their belief in the supremacy of Islam is translated into a series of highly studied moves, which systematically eliminates the rival Christian mission, the traditional secular power structure, and a significant number of *ceddo* and their belief systems. This project culminates in the establishment of a regime of rule based on principles of Islam, with the imam as head.[13]

Ceddo undermines the popular image of a peaceful Islam, which only embraced violence when threatened by French colonisation. The association of Islam and slave trading threatens Muslim Africans' claims to an 'authenticity' and a distance from the taint of collaboration with Europeans that had long given them special claims to legitimacy within Senegalese society. The film is still rarely shown in Senegal.

In a rapid series of opening scenes, Sembène portrays a peaceful village undisturbed by the horrors of enslavement occurring within its territory. Suddenly a messenger appears carrying the news that the king's only daughter, Princess Dior Yacine, has been kidnapped by a *ceddo*, determined to put a stop to the influence of Muslims at court. Most of the Muslims continue to pray, but a few head toward the royal court for a meeting of the king's principal advisors. This is one of Sembène's first indications of the Muslim group's greater allegiance to Islam than to the king who has welcomed them. The princess herself remains silent, elegantly attired and defiant. She retreats to a shelter to await what will occur. Only once does she try to escape.

The king summons all the people in town to attend a meeting, including the Muslims, the Catholic priest and the slave trader. The priest and slave trader, both Europeans, sit together and confer with one another, suggesting that they too are linked to the nefarious business of the slave trade. The king makes a grand entrance, sheltered by a large umbrella. This is something more typical of the lower Guinean states than of Senegambia, but it does draw attention to the king's claims of royal privilege. His Islamic advisor, identified as the Imam or head of the Islamic community, looks Peulh or Mauritanian, rather than Wolof, and is dressed differently than the others. He sits near the king, constantly fingering his prayer beads. The king speaks primarily to the *griot* or bard, Jaraf, who repeats the royal speech to the assembled community. Again, this is more typical of lower Guinea than Senegambia, where kings often employed a 'linguist' to speak outside his closest royal circles. Jaraf carries an elaborately carved staff, called a *samp*, which features an image of a female form that is rarely seen in Senegal. Here again, Sembène surrounds the king with the trappings of lower Guinea, rather than of Senegambia. Perhaps he finds such imagery more visually powerful for his narrative.

The meeting begins with the king seated under a shelter and his advisors seated around him in the shade of trees. Ordinary people sit out in the sun. One of the Muslim followers takes the umbrella, no longer being used by the king, and uses it to shelter the Imam, another hint of the aspirations of the Muslim leader. The leader of the *ceddo*, Diogo, reminds them that their first obligation is to rescue the princess. He says that 'no religion is worth a life', implying that they should negotiate the princess's release in exchange for some concessions about the growing Islamic influence. The Muslims are horrified and repeat over and over again the name of God, Allah. A young *ceddo* named Saxewar offers to go and rescue the princess if he is allowed to marry her, but this provokes the angry response of the Muslim Madiour Fall, who was already engaged to marry her, and once married would gain a place in the line of succession to the kingship. The Imam states forcefully that inheritance of such positions on the maternal side is

forbidden by Islamic law. The king supports him, leading Fall to renounce Islam and his kinship with his cousin, the king. The Imam promises a jihad against all those who reject Islam. When the king asks the Imam why he never addresses him as king, he replies that only Allah is king, again underscoring his opposition to a system of kingship which has its origins in a non-Islamic, Wolof tradition.

So the princess's Muslim brother sets out to rescue her. He receives the blessing of the Imam and sets out, armed with a musket. But the *ceddo* who holds his sister hostage kills him with a bow and arrow. His body is brought back by his servants and he receives a Muslim funeral. Then Saxewar, the *ceddo*, sets out to rescue the princess, but without the Imam's blessing. He too is fooled by the princess's captor and killed. The Muslims mourn him, until they notice his carefully tressed hair, a sign of adherence to a Wolof tradition. They refuse to bury him, a sign of the growing rift between Muslim and *ceddo*, even at court.

During these unsuccessful efforts to rescue the princess, there are brief but powerful scenes of slaves in neck and leg irons being branded with the French fleur-de-lis. An African-American spiritual, 'I'll Make It Home Some Day', plays as the slaves gasp in pain and shed tears of anguish. Meanwhile, the Catholic priest, aided by an altar boy, performs mass to an empty chapel. A young *ceddo* sits outside observing it and the priest comes out, looks up to the heavens and imagines an elaborate flash forward to the late 20th century with some Senegalese bishops and a racially mixed group of priests and nuns presiding over the Senegalese pilgrimage to Poponguine, one of the earliest Christian centres in Senegal. This has little to do, however, with the overall narrative, and provides an unnecessary distraction.

After the two unsuccessful attempts to rescue the princess, the king convenes another meeting of his advisors. This time the meeting begins with a prayer to Allah. They then discuss what they should do about a *ceddo* rebellion. The Imam insists on expelling the three non-Muslim advisors from the meeting, though Diogo cautions against this growing division of the community. The Imam insists that all of the *ceddo*, as non-Muslims, are going to hell. Again, the king supports the Imam over his long-time advisors. Gradually, the king begins to realise that the Imam, through his claim to represent true Islam, has placed himself above the king.

The *ceddo* gather in a secret meeting and plan the rebellion. They fear the growing dominance of the Islamic faction and have heard that the Imam intends to marry Princess Dior Yacine and assume the throne. Diogo likens the Muslims to slave traders; both are like ticks that live off the blood of other people. Before the *ceddo* can acquire guns, however, the Muslim faction sells slaves, buys guns, and routs the *ceddo* opposition. In the process, they kill the king and burn his compound, kill the missionary and destroy his church, and arrest all the *ceddo*

they can find. Some manage to escape, but most passively accept their forced conversion to Islam. As 'I'll Make It Home Some Day' plays in the background, every *ceddo* man and woman has to bow down before the Imam, receive his prayer beads on their heads and a new name, all suggesting a fealty to the Imam, not to Allah. The Imam also removes all the king's traditional advisors, even though they had accepted Islam, and replaces them with some of his core Islamic faction. It appears that Islamisation is complete.

As they are doing this, a Muslim aide to the Imam kills the captor of Princess Dior Yacine and brings her back to the courtyard. Through his marriage to her, the Imam hopes to gain legitimacy as ruler, a pattern of succession he had previously decried as non-Islamic in the case of Fall. When she is taken to the Imam's court, Dior Yacine grabs a musket from an unsuspecting Muslim soldier and walks towards the man who had assumed her father's throne. As she points the musket at him, the *ceddo* seize some of the Muslim guns. Princess Dior Yacine fires on the Imam and kills him. Once again, Sembène focuses on the ability of women to lead resistance.

This is not a film about a specific kingdom or a specific struggle between Muslim and traditionalist factions at a Wolof court. The size of the court and the royal capital is reduced to the size of a small village in which the viewer can identify the principal actors. Contrary to Sembène's depiction of the Imam's usurpation of the throne, I know of no such case in Wolof history. Muslim leaders who sought political power generally preferred to have a central place at court, to be the power behind the throne, rather than the kings themselves. That Muslims engaged in the enslavement of non-Muslim Africans in the Senegambia region is accurate. So is the idea that non-Muslims would convert in order to protect themselves against Muslim slave raiders. Thus, the linkage of the spread of Islam to the Senegalese slave trade, while controversial, is historical. Still, Sembène's portrayal of Muslims is highly suspect. Most Senegalese did not embrace Islam during the era of the Atlantic slave trade but in the aftermath of the French conquest and the consequent discrediting of royal and *ceddo* leadership.[14] Similarly, the view of Islamic prayer as an incessant repetition of the name of Allah is something that Sembène knows to be untrue.

As a source for pre-colonial Wolof history, the film is of limited use. It oversimplifies the long-term struggles between Muslim and traditionalist factions among the Wolof that began during the years of the Atlantic slave trade and persisted well into the 19th century. Its importation of court traditions of lower Guinea, its lack of attention to ethnographic detail, and the rather intrusive use of African-American gospel songs during the slavery scenes all lessen its ability to develop an empathetic understanding of historical events that films can be so effective at providing. For the teaching of West African history, however, it can

be useful for raising questions about the relationship between Islam and slavery and the divisiveness of Islamic expansion, even though the 'inventions' of the film often seem to be directed more by the director's disdain for institutional Islam than by a quest for verisimilitude. Equally important, however, is the inability of the *ceddo* faction to understand the nature of the Islamic threat to their institutions, a phenomenon not limited to Wolof society or to the threat of Islamic domination.

Its greatest value from the point of view of historians, however, is as a document of Senegalese or West African intellectual history. In *Ceddo*, we witness the reflection of one of West Africa's greatest writers and filmmakers on the history of Islamic expansion and its long-term influence on Senegalese life. The collusion of Islamic leaders with the raiding and sale of non-Muslim slaves and the divisive effects of struggles between Muslims and traditionalists both influence the role of Islam in modern Senegal. In this process of Islamisation, Sembène sees the roots of a comprador Islam in the colonial period. Sembène suggests that such collaboration by Islamic leaders with the French in exchange for economic privileges helped ensure the success of the colonial system. In most of his literary and cinematic work, Sembène has harshly criticised Senegalese Islamic leaders for making themselves of such invaluable service to French colonisers, their abuse of the resulting patronage to consolidate economic and spiritual power, and their opposition to any grassroots forms of resistance. In *Ceddo*, Sembène argues that it was in the 17th and 18th century that Islamic collaboration with an exploitative European presence began and that it continued throughout the colonial era, transforming Senegal into the overwhelmingly Muslim society that it is today.

Ceddo does not, however, glorify the traditionalist faction. With the exception of the captor of Princess Dior Yacine, the *ceddo* are portrayed as largely ineffectual, too wedded to their own statuses and privileges to recognise the dangers of an external threat. When they finally realise that the state is in danger, they are easily defeated. To Sembène, however, the strongest source of ongoing resistance rests on the shoulders of those whose power comes from a quiet strength, Senegalese women, who receive few privileges and whose invisibility itself gives them the power to resist. Princess Dior Yacine can readily seize a musket from an unsuspecting soldier and can approach the Imam and kill him, because he never expected it. This power of women, for Sembène, is an underutilised source of strength in African societies.

Emitai

Far less controversial was Ousmane Sembène's 1971 film, *Emitai*. For the first time, this film made northern Senegalese and foreign audiences aware that the Diola too had engaged in sustained resistance against the French, thus creating a place for the Diola in the list of heroic opponents to European expansion, including such figures as Lat Dior, Al Haji Umar Tal, Ma Ba Diakhou, and Sheikh Ahmadou Bamba. In fact, Sembène dedicated the film to all 'militants in the African cause'. In many ways, the film closely follows the newspaper reports and oral testimony about Diola resistance to military conscription and forced requisitions of rice and cattle during the early years of the Second World War. Governor-General Boisson controlled the administration of French West Africa during this period; he was eventually convicted of war crimes for his harsh rule on behalf of the Vichy French.

This is an unusual film, shot mostly in the Diola language, a language that Sembène does not speak.[15] For several years, Sembène worked closely with a group of rural Diola, mostly non-actors, to develop the outlines of the narrative and to recruit local participation in the film. Sembène wrote the broad outlines of the script, but allowed for considerable improvisation by older Diola men and women who remembered the difficult times of the Second World War and the demands of the French administration. Thus, the film presents extraordinarily accurate dialogue (in a southern Diola dialect known as Kasa) that is highly idiomatic and reflects knowledge of the styles of speech used in Diola ritual. It also incorporates many of the reflections of Diola elders who were eye-witnesses to the real-life events of thirty years earlier. There is a similar attention to the detail of Diola material culture – the ways in which men and women plant rice and maintain the rice paddies, the carrying of firewood, and the collection of oysters and palm wine. Clearly, Sembène admires the skill and determination that characterise Diola agricultural labour. Thus, this film provides an excellent introduction to Diola material culture. Unfortunately, this precision is not carried over into some of the material representations of Diola religious practice, where a number of masked spirits, of a type not associated with Diola religion, make their appearance and speak to the village elders, amidst sounds of thunder. The sanctuary of the village's major shrines features human skulls near the seat of each of the elders, something that is not practiced at any of the spirit shrines (*ukine*) that I have attended in over four years of field research in Diola communities. Perhaps Sembène added this for dramatic effect, but it reinforces stereotypes of African religions that seriously detract from the quality of the film.

Sembène opens the film with a group of Senegalese soldiers kidnapping a young Diola man returning from the rice paddies, so that he can become a 'volunteer' for the French military. Another man is seized while riding home on his bicycle from harvesting palm wine. In a Diola village, one of the elders is tied up and left in the blazing sun until his son, who fled the military recruiters, returns from hiding. The young man leaves his hiding place in the swamps, unties his father, and begrudgingly accepts his fate. A group of men taken from the village are brought to a French officer's post, who welcomes the 'volunteers' into the French army.

These scenes quite accurately reflect the practices of the French administration in the conduct of military recruitment and provide an emotionally powerful description of French war-time military recruitment.[16] Resistance was widespread and local officials were largely unsuccessful in gaining compliance. Several African local administrators (including Benjamin Diatta) lost their positions because of an inability to meet their recruitment quotas. In the southern Senegalese circle of Ziguinchor, which included the rebellious villages, local representatives of French authority, canton chiefs or province chiefs, would arrive in a village with a list of names of people who had to report to the local administrative centre for a physical examination. Upon hearing their names called, many young men hid in the swamps or ran away to the neighbouring colonies of Portuguese Guinea or The Gambia. French officials retaliated against draft resisters by holding their parents hostage in the sun, until they returned. As to the seizure of individuals on footpaths, this would have been far less common. The inclusion of Diola farm implements in this scene underscores the loss of manpower for labour-intensive rice farming that military recruitment imposed. Thus the opening sequences of *Emitai* provide an example of what the historian R.J. Raack describes as 'empathetic reconstruction' through which the viewer can be shown individuals in the colonial situation experiencing the harshness of colonial rule.[17]

The narrative resumes a year later, with a rich ethnography of Diola rice production. Women are shown carrying vast quantities of homemade fertiliser into the rice paddies. Men are then shown ploughing with *cadyendo* in flooded paddies and women transplanting rice. Finally, it shows the women carrying heavy baskets of rice from the rice paddies. The scene then shifts to the regional capital of Ziguinchor where a French colonel, presumably Colonel Sajous, instructs a French lieutenant that he should take a detachment of soldiers and seize rice from a village that had refused to pay its rice tax. News of the French column spreads by talking drums, large slit gongs, which are still used in Diola areas of the Casamance today. By the time the French detachment arrives, women in the village have hidden their rice in the forest areas.

Elders of the major spirit shrines sit in an enclosed space consulting the

spirit shrines. Each of the elders sits adjacent to a human skull, an image that may be a part of Hollywood Africa but is not a part of Diola religious practice. While drinking cups of palm wine, the elders discuss the problems of military recruitment, the seizures of local cattle and the requisitions of rice. They decide to consult the spirit shrines and offer palm wine at the shrine. One of the elders describes how the spirits are central to Diola culture. In sharp contrast to ordinary practice, the palm wine is poured silently on the shrine, rather than the normal practice of using the libations to accompany prayers offered to the spirits. They talk about the importance of rice, particularly for the women of the community. Meanwhile, young Diola warriors wait outside the enclosure for a decision by the shrine elders.

Suddenly, amidst thunder and mist, several masked figures speak to the elders. One of the elders addresses a spirit as Ayimpene, the name of a Diola woman prophet, by then deceased, from the area of the revolts who had been active in the early 20th century. It remains unclear if Sembène knew the reference to this prophetic figure. After hearing the advice of the spirits, the village chief decides to lead an attack on the French column. He leads the young men into the forest and they attack the advancing French force. They are armed only with bows and arrows and spears, which fall harmlessly to the ground. Several Diola are killed, including the chief priest, and the French column occupies the village.

This scene bears no resemblance to what really happened. Firstly, the village chief who would wear the type of red hat used by the group of shrine elders is known as an *oeyi* or priest king. He is forbidden by Diola tradition to participate in warfare of any kind and would not have led an attack.[18] Secondly, as a result of the slave trade, Diola people in the area where the rebellions occurred had access to old rifles and muskets. In the actual fighting, a French sergeant and several of his Senegalese troops were killed. Sembène presents an image of an impotent Diola resistance. He ignores the sustained fears of a widening Diola rebellion expressed on a number of occasions by Colonel Sajous, the local commandant.[19] It was these fears that led to the arrest of the Diola woman prophet Alinesitoué Diatta, early in 1943.

The French occupy a village that is apparently deserted. Gradually, a number of women who have been hiding in their homes or rice granaries are rounded up and brought to the central meeting place. The commandant detains all the women out in the sun until the rice tax is paid. A poster of Marshal Pétain, proclaiming the need for glory and sacrifice, looks over the assembled women. Finally, a number of men are captured and told that the women will be held until the tax is paid.

After their leader is killed, the elders gather in the spirit shrine enclosure and again consult the spirits, this time accompanied by the sacrifice of a red

rooster. The spirits appear, including one named Baliba, a title associated with the prophet Alinesitoué, who was quite influential in the area of the revolts. This is the only mention of this most famous of Diola female prophets. Prayer is also offered to Emitai, though Emitai is not identified either in this scene or anywhere else in the film. 'Emitai' is the Diola name for the supreme being and is the source of revelation for Alinesitoué or Baliba, as well as Ayimpene. One would have hoped that the use of this very important Diola term in the title of the film might be explained somewhere. The spirits respond to the prayers, insisting again that the Diola may not give away their rice, but must keep it in the community.

The elders begin the funeral for their leader, singing songs honouring the ancestors and asking the corpse why it chose to die at that time, an essential part of Diola funerals. The women being held hostage hear the songs associated with the funeral and they join in the singing. This unnerves the French officers who send troops to stop the funeral. The commandant tells the people that there will be no funerals until the rice tax is paid. The body of the priest-king is left in the hot sun, a violation of ordinary burial practice, especially forbidden by the fact that he was the ritual leader of the community. Only initiated men are allowed to participate in the funeral of the most senior priest among southern Diola.

The elders return to their ritual enclosure and confess to the shrine that they do not know what to do. They are ashamed of their inability to bury their leader, protect their youth and protect their rice. The elders decide to pay the tax and free the women. As they carry their rice requisitions for the French, a boy is killed carrying a message to the women. After waiting stoically in the sun for hours, the women rise up en masse, chase away the French soldiers and carry the boy to the place where the village chief lies on the ground. Then the women seize the spears used in the men's funeral dance. Assuming the male role, they dance and sing the songs of the ancestors. The men hear the women singing and are ashamed. They put down their baskets of rice and back away from them. In response to their renewed resistance, the commandant orders his troops to fire on them as the film ends.

In many ways, this is a powerful film. The choice of a southern Diola village as the location, and its reliance on local villagers as actors, provide a strong sense of authenticity. Its portrayals of military recruitment and the brutality accompanying the forced requisitions of rice are reasonably close reflections of the historical record. The Diola villages of Siganar, Karounate, Efok and Youtou openly resisted the rice requisitions. People were left in the sun or threatened in other ways in order to get them to pay. Shrine elders were arrested and held in prison until their villages met their rice and cattle requisitions. The villages of Efok and Youtou, where most of the casualties were inflicted on the French, were occupied by the colonial military for several years. Their people fled, with their rice, across the

border into Portuguese Guinea and were not allowed to return until almost a decade later. Their resistance was far more sustained, however, and more effective than Sembène allows.

Sembène's most serious omission, however, is his failure to recognise the influence of the famous Diola woman prophet, Alinesitoué Diatta. She had led a prophetic movement in the area which was seen as hostile to the French, particularly in their efforts to spread new agricultural practices. In 1941, she introduced a series of new religious rituals designed to ask Emitai, the supreme being, for rain (*emitai ehlahl*). French tax collectors were regularly greeted by villagers with the statement that before they would give their rice to the French, they would give it to Alinesitoué, who prayed on their behalf for rain, while the French did nothing to help them. While it is unclear whether Alinesitoué ever advocated tax resistance, Colonel Sajous reacted as if she had. In the midst of the armed revolts at Efok, Youtou, Siganar and Karounate, Sajous had Alinesitoué arrested. She was eventually tried, convicted of opposing colonial authority under the native law code, known as the Indigènat, and exiled to Timbuctou, where she died in captivity. It is curious that Sembène makes no mention of this prophetic movement, focused on revelations from Emitai, the supreme being. The actors mention her as Baliba and they mention another woman prophet, Ayimpene of Siganar, but there is no evidence that Sembène suggested them or even understood the reference.[20] Instead, he prefers to show old men sitting in an enclosure filled with human skulls, calling on masked spirits to appear to them and tell them what to do. There is no mention of Emitai apart from a single prayer offered by the elders, nor is Emitai's prophet, active at the time of the rebellion, ever openly acknowledged. In this case, Sembène's discomfort with religion in a formal sense leads him to banish it from the historical record, substituting a hollow mock-up of an African religious tradition that in itself inspired sustained resistance to colonial rule.

This is especially sad because *Emitai* incorporates the recollections of elders of these southern Diola villages about the events surrounding the Diola rebellions of 1942 and 1943. This is new historical data, even if it was gathered in connection with the making of a motion picture. Sembène worked closely with a group of village elders to create a text close to this historical record. He presents a reasonable description of colonial military recruitment and the forced requisitions of rice. The film's focus on the ability of women to resist the French accurately mirrors French perceptions of women's leadership roles in this respect. In colonial dispatches from the regional capital to Dakar, complaints were common that men were willing to pay taxes or engage in forced labour until the women showed up and shamed them into resisting. The women of Efok and Youtou carried their entire rice granaries over the border into Portuguese Guinea to avoid

French requisitions. Sembène provides us with a rare opportunity to see rural people improvising a film about their own tradition of resistance to colonial rule. If only he had included Emitai in *Emitai*.

In terms of teaching, this film must be used with caution. Its powerful portrayal of a rural Diola village is valuable, as are its portrayals of French oppression and the resistance of women. Despite these strengths, however, its portrayal of a Diola religious tradition that was intimately involved in the revolt panders to stereotypes widely held in the West and in some African circles. Its use of human skulls and tourist art masks are not useful portrayals of an African religious system that was intimately involved in the Diola rebellions of 1942 and 1943. These may well reinforce stereotypes of African religions for those viewers with little direct experience of such practices.

Finally, this too is a document in West African and Senegalese history, allowing for the first time a public acknowledgement of Diola resistance to colonial rule, something that had been omitted from the Senegalese historical record. As a document in the intellectual and artistic history of Senegal, this film shows Ousmane Sembène's profound ambivalence about the relationship between African traditional cultures and organised religion. In the case of the Diola revolts, these two form a seamless whole, but this does not conform to Sembène's vision of Africa's liberation, a liberation that draws on African values, wedded to a more pragmatic, materialist perspective.

<div align="center">⌒</div>

Conclusion

These two films examine the issue of resistance to foreign domination. *Ceddo* examines the complex relationship between the slave trade, the penetration of Islam, and the destabilisation of Wolof kingdoms. The mere fact that Sembène regards Islam as an external ideology on a par with Christianity and Western culture is highly controversial in modern Senegal. Indeed, it is this presentation of Islam as equally foreign and exploitative that generated much of the controversy about *Ceddo*. President Senghor's ban on its distribution within Senegal was never really about Sembène's spelling of this Wolof word, but about its critique of Sengal's relatively recent embracing of Islam. While Muslim traders did engage in the slave trade and some communities did convert to Islam to avoid enslavement, Sembène suggests that it was the norm. His ultimate target is those Muslim leaders who supported the colonial authorities and who continue to oppose efforts to bring greater economic justice to post-colonial Senegal.

Emitai generated far less controversy. In contrast, it was widely welcomed as

an exploration of (the then still relatively unexamined) history of anti-colonial resistance by the Diola, one of the more marginalised groups within Senegalese political and cultural life. *Emitai* helped Diola communities assume a well-deserved place in the history of resistance by various Senegalese ethnic groups to French rule. It examined Diola villagers' resistance to military conscription and the requisition of food by the French during the Second World War. While laudably chronicling, for the first time, the stoic heroism of rural Diola, it nevertheless presents a simplified view of their resistance, stripping away the religious component and reducing a complex religious system to a caricature. Simultaneously, it generated a new northern Senegalese respect for Diola traditions of independence, while denigrating a Diola religious system that had sustained their resistance.

In cases where the filmmaker gathers oral traditions or personal recollections of historical events, and when he or she allows those who witnessed them to improvise their roles, films can be an added source of information for the historical record. They must be used cautiously, but they can evoke a holistic sense of the events portrayed that goes beyond a written or oral source in isolation. Like such sources, however, filmic histories must be carefully scrutinised. In the case of Sembène, the historical viewer must keep in mind that the filmmaker is more than just a *griot*, a praise-singer and bard, displaying the heroic deeds of the past. He is an activist, who has come to see religious authorities as one of the primary problems confronting modern Senegal. He sees a dynamic strength in African cultures, particularly as understood by women, but he sees little constructive role for organised religion. Therefore, he writes it out of the historical record or oversimplifies its complex role in the historical events that he portrays in film. Sembène does not see a role for organised religion in inspiring the type of resistance movement that will liberate Africa, which is what he is searching for in his films and writings.

In an essay on the ability of film to portray historical events, Robert Rosenstone raises the spectre that film 'compresses the past to a closed world by telling a single, linear story with, essentially, a single interpretation'.[21] While this can be true of written texts as well, the reader can more readily assume a critical engagement when reading than when watching films, which tend to bring viewers to situate themselves within the film. The dangers of such an uncritical acceptance of the filmmaker's interpretation are partially offset by the empathetic understanding of historical experience that film can so effectively portray.[22]

While Rosenstone suggests that all historical texts are 'verbal fictions', those produced by historians are subject to certain rules of evidence and an ever-elusive quest for objectivity. Historical films can be subject to similar constraints but (whether 'fiction films' or 'documentary') do not have to be. A certain degree

of plausibility is all that they require. In the case of Ousmane Sembène, who makes films primarily to mobilise people for the liberation of their societies, he was not bound by historical rules of evidence. Instead, both *Ceddo* and *Emitai* reflect Sembène's understanding of Senegalese societies, throughout most of the 20th century, in which Muslim and Christian religious authorities have had far too intimate a relationship with government, whether colonial and post-colonial regimes. From this perspective, in *Ceddo* he traces the origins of Muslim collaboration, of a comprador Islam, through to the ways in which Islam was spread in the pre-colonial era, emphasising only its role in furthering the slave trade and undermining sovereign African states. This is only a partial view of the spread of Islam, and ignores any cases of a genuine Islamic resistance. In the film *Emitai*, Sembène cannot but admire the persistence of Diola resistance to colonial rule, but he ignores the meaning of the title of his film, the Diola name for the supreme being, and excises the important role of women prophets of Emitai during the period of Diola rebellion. He substitutes a view of African religions as a kind of 'mumbo-jumbo' replete with human skulls and masked deities that bears no resemblance to Diola realities. He carefully separates Diola values of independence and community solidarity from a broader cultural system that includes their own religious tradition. In doing so, Sembène creates films that illustrate his own view of where African liberation will come, from African values of justice and self-determination wedded to a new historical materialism. By reducing a more diverse Islam to its comprador manifestations and excising Emitai and its prophets from a film entitled *Emitai*, Sembène goes beyond mere 'verbal fiction' to the reworking of the historical past to inspire new types of liberation movements in the future.

4

The transatlantic slave trade in cinema

~

ROBERT HARMS

Nearly two centuries after it was outlawed by the major European powers, the transatlantic slave trade was finally declared a 'crime against humanity' at the 2001 United Nations Conference on Racism in Durban, South Africa. A group of African countries led by Namibia and Zimbabwe demanded that the West should make reparations by providing debt cancellation, more aid and special payments that were specifically acknowledged as being compensation for the slave trade. After a rancorous debate in which the United States withdrew from the conference and several European Union nations threatened to follow, the final declaration contained only a brief and vague statement on reparations.[1]

Then the declaration turned toward the issues of history and remembrance: 'We emphasize that remembering the crimes or wrongs of the past ... unequivocally condemning its racist tragedies and telling the truth about history are essential elements for international reconciliation and the creation of societies based on justice, equality, and solidarity.' The condemnation of the European and American slave-trading nations was well justified and long overdue, but the debate and the declaration contained a curious omission: nowhere was there any acknowledgement of the role of Africans in the transatlantic slave trade.

During four centuries from c. 1450 to c. 1850, the transatlantic slave trade carried between eleven and twelve million captive Africans from Africa. Between 15 and 20 per cent of them died during the middle passage; the rest spent their lives toiling as slaves in the New World.[2] Most of the captives were shipped out from ports between the Senegal River in West Africa and Benguela in southern Angola. During the 16th and 17th centuries, the captives came mainly from regions near the Atlantic coast, but by the beginning of the 19th century slave caravans were coming from as far as 700 to 800 miles inland. After the slave trade was declared illegal by most of the European slave-trading nations in the early 19th century

and the British Navy began to blockade Atlantic slaving ports, European slave ships travelled as far as the Indian Ocean ports of Madagascar and Mozambique to purchase African captives.

A large body of historical scholarship produced over the last fifty years has outlined in great detail the roles of African kings, chiefs, armies, merchants and bandits in enslaving Africans and delivering them to European slave ships on the coast. This body of scholarship was largely pioneered by African scholars such as K.O. Dike, I.A. Akinjogbin and K.Y. Daaku, and the Afro-Guyanese historian Walter Rodney.[3] Subsequent scholarship has reconstructed the operations of the slave trade within Africa in great detail. The bibliography for the second edition of Paul Lovejoy's *Transformations in Slavery: A History of Slavery in Africa* is 36 pages long indicating that a great deal of work has been done.[4]

As a result of this research, the general operations of the slave trade in Africa are well known. Africans became enslaved through local and regional wars, raiding by predatory states, kidnapping by local bandits, or judicial condemnation for a crime or a debt. The captives were either pressed into local service or sold to African merchants, who had the option of selling them to rich African slaveholders or taking them to the Atlantic coast to be sold to European and American slave traders. Many captives were bought and sold several times before reaching the Atlantic coast. Slave ships coming from Europe or the Americas carried cargoes of European, American and Asian trade goods that were exchanged for slaves at African slaving ports.

Much of this scholarship has not filtered out to the public at large. Most Americans still seem to believe that European slave ships simply landed on the African coast and rounded up Africans for transportation to the New World, even though such a view reinforces stereotyped images of 'primitive Africa'. From my own recent experiences as a consultant for a radio news story and a documentary film on the slave trade, I can attest that the media in the United States are extremely nervous about any mention of the role of Africans in the slave trade. Without minimising the central role of Europeans and Americans in the horrors of the transatlantic slave trade, it is important to understand the African segments of the slave route if we ever hope to explain how such a brutal and deadly institution could have operated on such a massive scale for such a long time.

Although historical research has revealed a great deal about the mechanics of the slave trade, it leaves unanswered many questions about the emotions that such a brutal traffic generated, the corrosive effect on societies, the psychological scars on individuals, the way it corrupted slavers and captives alike, and the sheer horror and brutality of the trade in human beings. Such issues can perhaps be explored more effectively in novels, poetry or film than in footnoted historical studies.

This chapter examines how the African segment of the transatlantic slave trade has been portrayed in cinema.[5] Given the rancour and the economic stakes that surround this topic, it is not surprising that directors have handled the topic in very different ways. In the first part of this chapter, I will look at how four films that concentrate on New World slavery – *Roots*,[6] *Tamango*,[7] *Amistad*,[8] and *Sankofa*[9] – have depicted the African segment of the slave route. In the second part, I will examine three films that focus on Africa itself: *Ceddo*,[10] *Cobra Verde*,[11] and *Adanggaman*.[12]

The analysis will focus on the relationship between the cinematic portrayals of the slave trade in Africa and what we know from the historical record. Robert Rosenstone has argued that fidelity to known facts is an inadequate criterion for judging historical films because the cinematic art requires a certain amount of invention for clarity or dramatic effect. He makes a distinction between 'true invention', which uses invented or altered characters or scenes to engage 'the issues, ideas, data, and arguments of the ongoing discourse of history', and 'false invention', which ignores the discourse of history.[13] Because most of the films discussed in this chapter tell fictional stories, the key issue is whether or not they engage the discourse of historical scholarship in an authentic way.

Roger Gnoan M'Bala, the director of *Adanggaman*, has stated that he made his fictional film about the slave trade in order to exhume a forgotten chapter of the past so that we can reflect upon it. He noted that historical facts are less important to him than ideological connections with the past. Fiction allows him to reflect on the relationship between Africa and slavery without being accountable to historians.[14] In a similar vein, the German director Werner Herzog remarked that in making *Cobra Verde*, he was seeking to produce 'a deeper truth through fabrication; a poetic truth, which differs from the truth of an accountant'.[15] In Herzog's case, the problem lies in identifying which deeper truth he is trying to express. Is it a deeper truth about the slave trade, or is he merely using a fictitious representation of the slave trade to express a deeper truth about the human condition?

For films such as *Roots* and *Amistad*, which claim to be based on actual historical events, the bar needs to be set somewhat higher. Such films should not only engage with the discourse of history, but they also need to tell their specific stories in ways that are consistent with the historical logic of the events within their larger context. Debbie Allen, the African-American producer of *Amistad*, fought for over a decade to make the film because she wanted to 'create a dialogue about the very nature of history'. She believed that the film was 'creating history through art'.[16] By claiming to create history through art rather than making art out of history, she invites the very scrutiny from historians that Roger Gnoan M'Bala tried to avoid.

—

Slave route films

Not all films that deal with New World slavery mention the transatlantic slave trade or Africa. Many of them tell New World stories and feature characters born in the New World who have no direct connections with Africa. Other slavery films, however, deal with first-generation slaves or the middle passage, and they are more likely to include scenes based in Africa. I refer to these as 'slave route films' because their stories typically begin in Africa, continue through the middle passage, and then move to the New World for the bulk of the narrative. My focus here is on the African segment of the slave route.

Tamango

The first film to depict captive Africans being loaded onto slave ships was John Berry's 1958 French film *Tamango*. Berry was a film director whose career in Hollywood came to an abrupt end when he was blacklisted for being a communist. He emigrated to France, where he directed a number of films during the 1950s and 1960s before returning to the United States in the 1970s.

Tamango is loosely based on a short story with the same title written by the French author Prosper Mérimée in 1829. The 1820s were a time of agitation against the slave trade by intellectuals in France. Even though France had officially outlawed the transatlantic slave trade in 1815, the illegal trade was still flourishing. In 1822 the Académie Française offered a prize for the best poem on the theme of abolishing the slave trade and, at the time, writers such as Victor Hugo were writing about slavery. In this agitated intellectual climate, Mérimée read an anti-slavery pamphlet written by the British abolitionist Thomas Clarkson, which contained detailed drawings of the slave ship *Brooks*, and he read a French translation of Mungo Park's *Travels in the Interior Districts of Africa*, in which the explorer described slave caravans travelling from the interior of West Africa toward the mouth of the Gambia River. He may have also been acquainted with the work of Léon Vignols, who wrote about the slave revolt aboard the French slave ship *Compte d'Estang*. Mérimée's short story *Tamango* was thus based upon the most accurate information about the operations of the slave trade that was available at the time.[17]

John Berry wrote the screenplay for *Tamango*, basing it loosely on Mérimée's story. The bulk of the film takes place during the middle passage of the slave ship *Esperanza*, which is travelling from the Guinea coast to Havana in 1820, a time when the transatlantic slave trade was illegal. The *Esperanza* is an outlaw slaver commanded by a Dutch captain.

The story focuses on Aiche, a slave from Cuba who was taken along on the voyage to be the captain's servant and mistress. The captain develops a fondness for her, and she stays faithful to him mainly because he treats her well and offers her a better life than any of her previous masters. On board she meets Tamango, a rebellious slave who spends his time trying to organise a shipboard revolt. She tries to convince him of the futility of rebellion, but Tamango spits in her face and calls her the 'white man's trash'. When the rebellion breaks out, Aiche tries to remain uninvolved, but eventually she is forced to choose between solidarity with the African slaves and a life with the captain, who has promised to free her. She sides with the slaves and joins them in a grisly death.

The African segment of the slave trade is depicted only in the first minutes of the film. As the opening credits roll, we see a caravan of slaves escorted by African slave traders wending its way toward the coast. As the captives are being loaded onto the ship, the captain negotiates the price to be paid in rifles and rum with the local chief. When the captain remarks that it is illegal to sell rifles to Africans, the chief replies that he uses them only for 'hunting'. By the wink of his eye, he makes it clear that his quarry is people. The film thus alludes to the gun–slave cycle that has been identified by some historians.[18]

The opening segment leaves a lot of questions unanswered. It doesn't tell us who the African slave traders were or explain how they operated. More importantly, it tells us nothing about the origins of the slaves, how they were captured and how long they had been travelling before reaching the coast. The film presents a white slave trader's view of the African segment of the slave trade. Slaving captains often knew nothing of the origins or experiences of the slaves in their hold. They just sailed to the African coast, purchased their human cargo and sailed off. In the film the captain tells the slaves, 'I didn't enslave you. I am just transporting you.' In the nasty and brutish business of the slave trade, the captain preferred to know as little about his captives as possible.

The film makes no pretensions to historical accuracy, and the emotional triangle of Aiche, Tamango and the captain is a screenwriter's fantasy. Yet it is clear that the mechanics of purchasing, loading and transporting slaves were well researched. The film is remarkable for the way it shows the captives plotting a revolt and debating the pros and cons of various strategies. It accurately highlights the key role of slave women in planning and carrying out shipboard rebellions.[19] When the film first appeared in 1958, it was banned in both the United States and the French colonies because it depicted an inter-racial relationship.

Roots
The best-known slave route film is Alex Haley's *Roots*. First shown in 1977 as a six-part television mini-series, it is nearly ten hours long. *Roots* was seen by

130 million viewers during the initial American telecasts. It won dozens of awards, including nine Emmys and a Golden Globe. *Roots* tells the story of three generations of Alex Haley's ancestors who endured slavery and triumphed in freedom. The family lives through key events in American history, including the Revolutionary War and the Civil War.

What made *Roots* so electrifying was that the story began in Africa with Alex Haley's ancestor whose name 'Kin-tay' had been handed down over seven generations and recounted to Haley by his grandmother. The well-known African historian Jan Vansina helped Haley trace the origins of that name to the Kinte clan living in the area of the Gambia River. Haley enlisted the aid of government officials in The Gambia, who located a *griot* of the Kinte clan in the village of Juffure. Accompanied by the music of a *kora* and a *balafon*, Keba Kanga Fofana recounted the history of the Kinte clan until he finally mentioned a certain young man named Kunta who 'went away from this village to chop wood to make a drum ... and he was never seen again'. This statement provided the missing piece that allowed Haley to begin his story in Africa along the banks of the Gambia River.

The problem was that Haley's research methods were highly suspect. He failed to realise that *griots* are known for tailoring their stories to fit the needs of their patrons. Haley had told Gambian officials every detail that he knew about his ancestor, and the officials put out the word throughout the Gambian countryside. Fofana thus knew in advance what Haley was hoping to hear. When the historian Donald Wright later visited the village of Juffure to conduct oral research on the history of the Mandinka state of Niumi, he was astonished to learn that Fofana was not a true *griot*, but a simple storyteller who was not considered by the village elders to be particularly knowledgeable about local history.[20] Fofana had apparently seized the moment by telling Alex Haley exactly what he was hoping to hear. Beyond the fact that Haley's ancestor 'Kin-tay' was quite possibly a member of the Gambian Kinte clan, there is no historically reliable evidence on how or when he became enslaved. The book, and later the film, presented a fictionalised version of the incident based in part on Fofana's statement. Haley has used the word 'faction' to describe his particular blend of fact and fiction.

Episode 1 of the television mini-series tells the African part of the story. The episode seeks to counter negative stereotypes of Africans by showing Kunta Kinte growing up in a Gambian village surrounded by a loving family and wise elders. There are no slaves in the village. The core of the episode takes place in 1765 when 15-year-old Kunta Kinte undergoes the circumcision rituals and the military training that will make him a man. He is taught to live by the code of the Mandinka warrior, and told that the 'way of the Mandinka is not easy, but it is best'. The boys are taught to be strong, fearless and honourable.

Scenes in the initiation camp are intercut with scenes showing the progress of the slave ship *Lord Ligonier*, which has left Annapolis, Maryland, bound for The Gambia. Its captain, who has never commanded a slaving vessel before, has misgivings about the morality of such a venture. His qualms are quickly dismissed by the first mate Slater, who is a veteran of 18 slaving voyages and sees the Africans as 'a special breed' who are 'well suited to be slaves'.

Lord Ligonier was the name of a real British slave ship that left London for The Gambia in the spring of 1767 and arrived at Annapolis, Maryland, with a load of 140 slaves on 29 September. Haley had located records of this ship through archival research in London, Washington and Annapolis, and he became convinced that it was the vessel that had carried Kunta Kinte.

Since *Roots* is an American story, the film makes the *Lord Ligonier* an American ship that leaves from Annapolis with a load of tobacco, which it takes to London to trade for chains, shackles, thumb screws and branding irons to be used on African captives. Then it heads for The Gambia to get slaves. While effectively making a point about the cruelty of the slave trade, the scenario distorts its actual operations. The ship arrives in The Gambia with no trade goods on board, except for a bit of rum, which is apparently used for the pleasure of the officers. The captain meets with a white slave trader named Gardiner on the beach who promises to go out and capture enough slaves to fill the ship. If he falls short, he tells the captain, he will have to purchase some slaves from local chiefs. Although the film suggests African collaboration in the slave trade, it depicts slave-hunting as a predominantly European activity.

Meanwhile, back at the initiation camp, Kunta Kinte is on a training exercise when he sees armed white men driving a group of bound African captives toward the coast. Barely avoiding capture, he runs back to the camp to tell the story. The camp commander gives the young men the following advice: 'Never be alone … never be out at night … keep away from high weeds or bushes. If ever you see much smoke away from any village, it is probably the white man's cooking fires because they are always too big. And remember, when you are close to where he has been, his scent remains in the air. It has a smell like a wet chicken.' He closes the scene with the dramatic declaration, 'The white man is here!'

After the initiation training is finished, Kunta Kinte fails to follow that advice and goes into the forest alone to look for a log to make a drum. He is captured by the white slave trader, who is working with four African assistants. In a makeshift slave prison on the beach, he meets his wrestling coach from the training camp and a young woman whom he knows. It is clear from their stories that the countryside has been devastated by the white slave hunters. By the time his village discovers him missing and mounts an armed operation to rescue him, it is too late. The ship has already left.

The film's attempt to paint a positive picture of strong, brave and honourable Mandinka warriors clashes with its attempt to picture slave-hunting as a predominantly European activity. When Kunta Kinte first reported the white slavers in the forest, why didn't the young warriors mount a commando operation to free the captives? Why did the initiation commander urge the young men to avoid the white slave hunters instead of confronting and killing them? Why were they so afraid of the whites, whom they outnumbered many thousands to one? The film does not attempt to reconcile this contradiction, which was noted by some critics.[21] The image of the brave Mandinka warrior was so appealing and the image of the white slave hunter so ingrained that many viewers apparently preferred to hold the two images simultaneously without reflecting upon their fundamental contradiction.

Historical research conducted by Donald Wright subsequent to Haley's visit to The Gambia has given us a clearer picture of the operations of the slave trade. In the 18th century, Kunta Kinte's village of Juffure was part of the Mandinka kingdom of Niumi. The king, known as the *mansa*, collected an annual tax from the British, who had a fort and trading outpost on an island in the Gambia River. In addition, his agents collected a variety of customs payments on individual slave ships. Vessels would anchor off the village of Juffure, where they would pay their customs and purchase their slaves. Villagers in Juffure were thus accustomed to seeing white people and slaves on an almost daily basis. The *mansa* also collected payments from African caravans that brought slaves from the upper Niger River region.

Most of the slaves sold at Juffure came from far inland via the caravan route, although there was some back-and-forth slave raiding carried out among the coastal kingdoms of the region. The kingdom of Niumi did this less than its neighbours, perhaps because it already had a steady source of revenue from customs payments. There is evidence to suggest that some Niumi warriors, acting outside the king's control, carried out occasional raids in the countryside, and this may explain how Kunta Kinte became enslaved.[22] The *griot* Fofana told Alex Haley that Kunta Kinte disappeared shortly after the '*mansa*'s soldiers came'. If we give any credence at all to Fofana's story, then it is most likely that rogue elements in the *mansa*'s army enslaved Kunta Kinte.

By portraying the slave hunters as white, the film not only departs from the historical record, but it projects a condescending view of Africans by showing the proud Mandinka warriors reduced to helplessness in the face of a few white slave hunters. By 1765 slave ships had been coming to The Gambia for over a hundred years, but the film gives no hint that Gambians had developed any effective strategies for defending themselves, or any institutions for dealing with slave traders. The film's laudable efforts to project a positive image of an African society are

undercut by its unwillingness to explore the roles of African merchants, rulers and soldiers in sustaining the operations of the transatlantic slave trade.

Amistad

Amistad, directed by Steven Spielberg, is based on the true story of a group of Africans who were taken on the slave ship *Tecora* from Sierra Leone to Havana in 1839, and who then successfully revolted while being transferred to a plantation in the north of Cuba on the coasting vessel *Amistad*. Attempting to sail the ship back to Sierra Leone, they ended up instead in New Haven, Connecticut, where they were put in prison on charges of mutiny and of being escaped slaves. Three successive court trials ensued, culminating in a victory for the captives in the United States Supreme Court. The trial transcripts and the accompanying publicity produced an abundance of documentation on the captives and their experiences. There are pencil drawings and biographical sketches of each of the individuals on the *Amistad*, and letters written in their own handwriting. The abundance of documentation makes it easy to judge the historical accuracy of almost every element of the film and places a heavy burden upon the director.

The film opens with a dramatic scene depicting the revolt aboard the *Amistad*, which was sailing from Havana to a plantation in the north of Cuba. The main character Cinque finds a loose nail and frees himself from his chains. The ensuing uprising, shown with almost no words spoken and a lot of grunts and screams, is depicted as a spontaneous eruption rather than a planned and co-ordinated event. This stands in stark contrast to the carefully planned revolt in *Tamango*. After the *Amistad* lands in the United States, the film concentrates on the courtroom dramas in Connecticut and Washington.

The African part of the story is told through flashbacks into the life of Cinque, played by Djimon Hounsou. In a brief scene that reflects Cinque's own account, he is captured in Sierra Leone by four Africans who ambush him along a road. The film skips over the fact that the historical Cinque was sold to a Vai chief, who kept him for a month then sold him to a Spanish slave trader named Pedro Blanco.[23] The next scene shows Cinque arriving at a towering and sinister slave fort on the coast of Sierra Leone. Pedro Blanco's actual slave fort was a miserable compound with mud walls and wooden palisades,[24] but that would not have made a dramatic visual impact, so Spielberg used Fort El Morro in Puerto Rico instead. There is a puzzling scene in which a British anti-slavery squadron (the slave trade was illegal in 1839) cruises the coast of Sierra Leone in a vain attempt to find Pedro Blanco's slave fort. Given the way the fort is pictured in the film, one wonders how they could possibly have missed it.

The most powerful scene in the movie takes place during the middle passage when Cinque and his comrades are headed for Havana on the slave ship *Tecora*.

With food supplies running low, the captain decides that the weaker slaves should be thrown overboard to leave more food for the stronger ones. There follows a gut-wrenching scene of horror as the captives are thrown overboard and sink into the ocean, weighted down by their chains. Critics were almost unanimous in praising Spielberg for capturing the horror and agony of the slave trade in that one powerful moment. *Newsweek*, for example, noted, 'the horrors of the slave trade have rarely been captured in such indelible, painful images'.[25] The scene allows viewers to make an emotional connection with the cruel brutality of the slave trade.

Given the power of that scene, it may seem like an academic quibble to point out that it did not happen. Nobody was thrown overboard during the middle passage on the *Tecora*, and the captives later testified that at mealtimes they were given generous quantities of rice and were whipped if they did not eat every grain. One of them testified that they were 'forced to eat so much as to vomit'.[26] The ship had clearly left Sierra Leone at a time of the year when rice was plentiful and cheap, and the captives were being fattened up for sale in Cuba. A scene showing the captives being force-fed, although historically accurate, would not have provided the emotional intensity of starving Africans being thrown overboard weighted down by their chains.

The drowning scene did have an historical antecedent, however. In 1781 the British slave ship *Zong* was badly off course and running low on water. The officers hatched a scheme to throw the weaker slaves overboard in hopes of collecting insurance payments. When they later filed their insurance claim in England, the truth of the grisly incident came to light. Substituting the *Zong* for the *Tecora* was Spielberg's attempt to condense the emotional horror of the slave trade into a dramatic cinematic moment.

If the scene in which slaves are thrown overboard in the movie *Amistad* is an example of what Rosenstone calls 'true innovation', then it is a problematic one. By using an invented scene to capture the larger horrors of the slave trade, Spielberg undercuts his ability to tell the story of the *Amistad* revolt in an authentic way. According to testimony by Cinque and his assistant in the revolt, Grabeau, they decided to revolt after the ship's cook told them that they would be eaten upon landing at the plantation.[27] This testimony also explains why the first person killed by the mutineers was the cook. In a letter written by the captive Kale on behalf of the entire group, he explained the revolt as follows: 'Cook say he kill, he eat Mendi people – we afraid – we kill cook.'[28] If the captives had arrived starving and emaciated, as depicted by the film, they would have had little fear of being eaten. The truth was that they arrived fat and overfed. This explains why, after weeks of being force-fed, the captives believed the ship's cook when he told them that they would be eaten.

Steven Spielberg once remarked, 'While making this film, I never felt I was telling someone else's story. I felt like I was telling *everyone's* story.'[29] By creating the drowning scene, Spielberg clearly moves from the story of the *Amistad* captives to the larger story of the slave trade itself. But by picturing the captives as starved and emaciated, he subverts the logic of the revolt itself. Instead, he presents it as a sustained primal scream. By trying to tell *everyone's* story, he fails to tell the story of the *Amistad* captives in an authentic way.

Perhaps the most innovative feature of *Amistad* is the way it portrays the captives retaining their African culture and identities even after they arrive in the New World. Most notable is the way the captives speak to each other on screen in the Mende language. Spielberg wanted to cast native speakers of Mende recruited from Sierra Leone and London to play the *Amistad* captives, but in the end only a minority of the African actors spoke Mende (Djimon Hounsou, who played Cinque, was from Benin), and so language instruction was provided. Unfortunately, much of the Mende dialogue is not translated by subtitles, and so it is lost to the audience.

The transplanting of African identities into the United States is further illustrated by a scene that takes place in the prison where the *Amistad* captives are being held. They are visited by their defence attorney, who wants to set up a table and chair in the courtyard. However, he finds that the courtyard has been divided up into separate territorial encampments for the Mende, Temne and Kissi tribes. He is at a loss as to where to put his table because the African captives are fighting over the territorial boundaries. The scene tries to make the point that African tribal animosities persisted even after the captives had arrived in the New World. The problem is that it rests on a stereotyped view of African ethnicity, and on a view that is not true to the historical record.

Professor Arthur Abraham, Sierra Leone's leading historian, was hired by Spielberg to serve as cultural adviser and Mende translator for the script. Abraham objected to the scene on the grounds that ethnic identities in Sierra Leone were not rigidly exclusive and ethnic relations were not based on mutual hostility. Wars were as likely to break out between rival Mende chiefs as between chiefs of different ethnicities. But somebody at the Sierra Leone embassy in Washington had told producer Debbie Allen that the Mende and Temne had been engaged in tribal wars throughout history, and so the scene remained.[30]

It is unfortunate that the Africanness of the *Amistad* captives is shown largely through untranslated utterances and stereotyped inter-tribal conflict. In a film that dwells mostly on the courtroom trials of imprisoned Africans, there is little room for African agency, and even the revolt itself is pictured as a spontaneous uprising instead of an event that required co-ordination and planning. A viewer in Djimon Hounsou's home country of Benin noted sadly that the scene of

Cinque's capture by his fellow Africans was the only Africanness that stood out in the film.[31]

Sankofa

Sankofa is not a typical slave route movie because it begins and ends at Cape Coast Castle in modern-day Ghana. The slave route is not travelled by a person on a slave ship, but by an ancestral spirit carried by a bird of passage. The production of *Sankofa* was sponsored in part by the Ghana National Commission on Culture and the cinema agency of Burkina Faso. The film was written and directed by Haile Gerima, a native of Ethiopia who teaches film at Howard University in Washington, where he founded a film distribution company, Mypheduh Films.

Sankofa concentrates on the spiritual links between Africans and the descendants of New World African slaves. It opens with a close-up shot of an old African man at Cape Coast Castle drumming and calling out: 'Spirits of the dead, rise up and possess your bird of passage. Rise up and tell your story.' Then the scene shifts to Mona, an African-American fashion model who is at the castle on a photo shoot. She is approached by the old man, Sankofa, who tells her:

> Go back to your past. Return to your source. Here is sacred ground covered with the blood of people who suffered. It is from here that our people were snatched and taken by the white man. The ground is holy ground. Blood was spilled here before. It was from here that we were bought and sold to America, to Trinidad, to Jamaica. The white man forcefully snatched away our people. It was genocide. They treated us with contempt. They disgraced us, put us to shame. Go back. It is special ground.

Cape Coast Castle was built in 1674 and served as the headquarters for the Royal African Company, which had a monopoly on the British slave trade along the Gold Coast. It had a notorious slave dungeon carved into the rock under the parade ground. Divided into several large rooms, the dungeon could easily hold one thousand slaves. Because of the filth, bad air and damp stone walls, slaves imprisoned in Cape Coast Castle died at extraordinarily high rates. In 1721 the Royal African Company made plans to abandon the dungeon and build a new slave prison outside the walls of the fort, but the plan was never carried out and the slaves continued to die.[32] Today, Cape Coast Castle is one of Ghana's major tourist sites.

During a break in the photo shoot, Mona wanders down into the old slave dungeon. Possessed by the spirits of the dead that still linger there, she suddenly finds herself surrounded by African captives in chains. Attempting to flee, she returns to the courtyard only to find that it has become the old slave trading fort. The white guards strip off her clothes and put her in chains with the others. Her bird of passage then carries her spirit to the Lafayette sugar plantation some-

where in Louisiana, where she is a second-generation house slave named Shola. She meets Nunu, an African-born Akan woman, who becomes her surrogate mother and introduces her to Akan spirits.

Shola is in love with the field slave named Shango, a rebellious troublemaker from the West Indies. She tries to persuade him to be more docile and co-operative, but soon she attempts to escape after being repeatedly raped by her master. After being severely punished for her attempted escape, she joins Shango and other slaves who are planning a rebellion with help from a nearby maroon (runaway slave) community. During the uprising, she kills a white overseer who is attempting to rape her. Fleeing the armed guards sent out by the plantation owner, she suddenly finds herself back in Cape Coast Castle in the present day. Walking out into the sunlight, Mona hears Sankofa drumming and chanting, and she sits down beside him to commune with the spirits of the dead as the film ends.

The bulk of the story takes place on the Lafayette sugar plantation, and so the African segment of the story is concentrated in the Cape Coast Castle scenes at the beginning and end of the film. Since the castle was a British enclave on the African coast, the film does not really deal with African societies in Ghana or their role in the slave trade. The only hint of African involvement in the slave trade comes from the Akan woman Nunu, who says, 'I was snatched away and sold from my birthplace by my own people.' Such a vague statement leaves us to wonder whether her 'own people' were members of her local community, other Akan, or simply other Africans. Since this is less a slave route film than a film that concentrates on spiritual connections across the Atlantic, the omission in no way detracts from the story that Haile Gerima is telling.

~

The slave trade in Africa

Films that focus on the slave trade in Africa itself are relatively rare.[33] Two of the films reviewed in this section were made by African directors, and the third is by a German director. It is the Africans, above all, who are interested in exploring the impact of the slave trade on Africa.

Ceddo
Ousmane Sembène's *Ceddo* is not primarily a film about the slave trade, but slaves and slave traders are ubiquitous throughout. Robert Baum has already given an analysis of 'tradition and resistance' in *Ceddo* in this volume, but a brief reminder of the plot is warranted. The film portrays an attempt by a group of Muslims to

gain power in a Wolof kingdom in Senegal and to force peasants to convert to Islam. The peasants resist by abducting the king's daughter, Princess Dior. When the king's attempts to rescue her end in failure, the local Imam usurps the throne and arms his disciples so that they can impose Islam on the peasants. Unable to resist, the peasants convert and the kidnappers set the princess free. As the movie ends, the princess confronts the Imam and kills him.

As Baum has already suggested, the precise historical setting of the film is uncertain. Sembène refused to put a date on the events he depicts.[34] They could refer either to 'The War of the Marabouts' of 1645–73 or to another marabout (Muslim holy man) insurrection in 1795.[35] As Baum also related, the film generated considerable controversy and was banned in Senegal until after President Senghor's death. Baum argued that this banning was probably because it offended the Muslim establishment in Senegal, not because of argument over the correct spelling of *ceddo*. However, the dispute remains. The Irish scholar Firenne ni Chreachain questioned hundreds of Senegalese, including leftist intellectuals, and was consistently told that the spelling of the title was indeed the issue.[36]

A second problem with the title is that the word *ceddo* is ambiguous and difficult to define. The literal meaning is 'outsiders', but just who are the outsiders in this film? One might expect that the followers of the Imam, who clearly looks like a foreigner in the Senegalese setting, would be the outsiders, but the *ceddo* in this film are the local peasants whose customs and traditions are being undermined by the Imam. Sembène has explained the term by saying that when Islam first came to Senegal, the people who refused to convert were called *ceddo* because they remained outside the spiritual circle of the Muslim faith.[37] There is a further layer of complexity and ambiguity because in the 18th and 19th centuries the word *ceddo* was used to refer to the armed slaves (hence, outsiders) who made up the military aristocracies of the Wolof states.[38] The *ceddo* soldiers rejected Islam, and they defied Muslim religious practice by drinking alcohol openly. Sembène has described these *ceddo* as spirited libertines who lived openly sinful lives and whose speech was littered with double entendres.[39] The downtrodden *ceddo* of Sembène's film are in some ways the social opposite of the historic *ceddo* warriors, but they nevertheless evoke the *ceddo* spirit by resisting Islam.

Despite the film's focus on religious conflict, the slave trade quickly emerges as a major theme. The film opens with a scene of two bound slaves being brought in by an armed African. They are taken to the compound of the white slave trader and traded for a rifle. The slave trader does not utter a word in the entire film, but he is always hovering in the background. When the king calls his subjects to a meeting, the slave trader sits on the fringes of the crowd. He is despised and mistreated by the Muslims, but that is because he sells alcohol, not because he buys slaves. Twice in the film, the camera cuts away from the main action to focus on

the captives held in the slave trader's compound. In the first scene they are being fed, and in the second they are being branded with a hot branding iron. Both scenes are accompanied by the music of an American gospel choir singing 'I'll Make It Home Some Day', suggesting a link between the slave trader's compound and the transatlantic slave trade.

References to the institution of slavery within the Wolof kingdom itself are scattered throughout the film. When Princess Dior's abductors try to tie her up, the defiant princess refuses, saying, 'Only slaves and animals can be tied up, and you are the only slave here.' When the king seeks a champion to rescue his daughter, he calls upon the great warrior Saxewar. When Saxewar arrives in the king's presence, a slave girl brings him a gourd of water to drink. He knocks the gourd and the girl to the ground and declares that he will not drink water until it is offered to him by Princess Dior. Gesturing toward the slave girl, the king's spokesman addresses the warrior: 'What is your desire? To sharpen your weapons? Sharpen them on her. Decide. She is a slave. Let your will be done. You have rights of life or death over her.' A few minutes later the girl is sold to the white slave trader in exchange for a gourd of wine. Later still, Saxewar is negotiating with the king's son for the privilege of rescuing the princess. He says, 'Let me go and free Dior. I will give you 100 pubescent slaves and as much in horned cattle.' Apparently both slaves and cattle could be tied up and traded.

The film makes it clear that the white slave trader is the sole source of guns and ammunition. In discussing his desire to marry the princess, Saxewar tells the king, 'I have accepted the terms of the dowry by exchanging them as slaves for weapons at the white man's shop.' When the king's nephew renounces Islam and defiantly drinks wine in front of the Imam, the king's son reproaches him, 'If it were not for your birth, I would trade you for powder to fill my guns.'

One of the most powerful scenes in the film arises after the Imam arms his disciples to force the peasants to convert to Islam. The Imam instructs his disciples to be tolerant toward those who agree to convert, but to sell those who refuse. The peasants want to defend themselves, but they lack guns, and they also lack slaves to exchange for guns. One of them suggests that if each family sold a child or other family member to the white slave trader, they could get arms to defeat the Muslims. There follows an agonising debate over whether it is better to accept forced conversion or to sell members of their own families. One man says, 'Sacrificing one's own children to save one's own life is a rude test for a father. Is it morally possible?' Another man counters this by saying, 'When the princes and nobles raped our daughters and traded our sons for rifles, we cursed them in a cowardly way. Harassment will stop only when we are willing to die. The white man, princes, nobles, and the Imam are all blood lice who feed on us.'

As the discussion continues, some peasants reject the plan. One man says, 'I

cannot sacrifice my family. I am going to convert.' Another says, 'Our family has never been slaves and we have never owned any. I prefer exile.' Those who remain determined to fight then agree to meet up later that night bringing with them family members to sell into slavery. While they are purchasing the guns from the white slave trader, the Imam sends his disciples to attack them. The Muslims kill the Catholic priest and capture the peasants, but they do not harm the slave trader.

Although *Ceddo* is not a film about the slave trade, it does a masterly job of showing the corrosive effects of slavery and the slave trade on an African society. It brilliantly illustrates how ordinary people in difficult circumstances could face agonising choices about whether to participate in the slave trade. By including slave trade scenes in a movie that is really about religious conflict, Sembène makes the powerful point that the slave trade had almost become a part of the landscape. No matter the issue that was commanding people's attention at the moment, the slave trade was always lurking in the background, ready to intrude when the opportunity presented itself.

Cobra Verde

German director Werner Herzog's *Cobra Verde* is based on Bruce Chatwin's novel *The Viceroy of Whydah*, which is loosely based on the career of the Brazilian-born slave trader Francisco Felix de Souza, who becomes Manoel da Silva in the movie. Herzog decided to make the film because he was intrigued by Bruce Chatwin's book, not because he wanted to make a slave trade film. The main setting for the story is a slave trade castle on the coast of the kingdom of Dahomey in the first half of the 19th century, although the actual filming was done at Elmina Castle in Ghana. Author Bruce Chatwin was on the set in Ghana for at least some of the filming. Although the movie seems to be mainly about the eternal restlessness of Manoel da Silva's soul, it also explores the complex relationship between a white slave trader and the local African rulers in carrying on the slave trade.

Cobra Verde is a kind of reverse slave route film because it opens in Brazil, where Manoel da Silva, an outlaw on the run, gets a job managing 600 slaves on a sugar plantation. After he impregnates all three of the owner's daughters, he is exiled to the West African kingdom of Dahomey, where he is supposed to re-establish slave trading links with the volatile and possibly insane king. The king had earlier withdrawn from the slave trade and stormed the Brazilian fort, killing all who were inside. The Brazilians think that the king will most likely kill Da Silva, but they have heard that Dahomey is at war with the neighbouring Egba, and they reason that the king might need to reopen the slave trade to get guns. After negotiating a relatively smooth resumption of the slave trade, Da Silva is abruptly arrested by the king and sentenced to death. That night the king's

brother rescues him and together they raise and train a female Amazon army to overthrow the king.

After a successful rebellion, the new king makes Da Silva the viceroy of the kingdom and gives him complete control over the slave trade. However, Da Silva's success does not satisfy him and he longs to return to Brazil. Things quickly fall apart as the Portuguese cheat him, the British anti-slavery squadron puts a price on his head, and he loses favour with the king of Dahomey. Da Silva tries to head out to sea in a small wooden boat, but it remains stuck in the sand on the beach. Exhausted, he lies down in the water as the waves wash over him. As the film ends, a text appears on the screen with the enigmatic statement 'The slaves will sell their masters and grow wings.'

Although fiction, the film intersects with the known history of Dahomey in several ways. The most striking is the use of women soldiers. Although women soldiers were not common in West Africa, they did become a standard feature of the army in the kingdom of Dahomey. Female soldiers were first reported by Europeans in 1729. In the mid-1840s the female troops of Dahomey were said to number between five and six thousand. The women were the best armed of the Dahomian soldiers, and they fired their rifles from the shoulder in the European fashion whereas most male troops continued to shoot from the hip.[40] In the film, Da Silva and the king's brother create their own Amazon army to fight against the king. There follows a rather preposterous scene in which Da Silva tries to teach the Amazons to drill like Prussian soldiers.

Another historical intersection is that the character of Da Silva is modelled very loosely on the historical person Francisco Felix de Souza. Born in Brazil to a Portuguese father and an Indian mother, he went to Dahomey in 1800 to work as a slave trader at the small port of Little Popo. With his commerce in decline, he got a job at the Portuguese fort at Ouidah, the major port of Dahomey, as secretary to the storekeeper. After two governors of the fort died in quick succession, he assumed command. Because of a breakdown in communications with Brazil, he abandoned the fort and established himself as a private slave trader, buying slaves from King Andandozan. When he travelled to the capital city of Abomey to collect a debt from the king, he was arrested and, according to legend, dunked in a vat of indigo dye to darken his skin. He escaped from prison and returned to the coast to resume his slave trading. De Souza supplied the king's brother with trade goods that he (the king's brother) distributed as political patronage to win support against the king.

After the brother staged a successful palace coup in 1818 and took the throne as King Gezo, he invited De Souza to serve as both his commercial agent and the governor of the Portuguese fort. De Souza also operated as an independent commercial agent, sending out slave ships even though the transatlantic slave

trade had been illegal since the Anglo-Portuguese treaty of 1815. His role as both the commercial agent of the king and governor of the Portuguese fort gave him limited protection from the British anti-slavery squadrons that patrolled the coastline. De Souza lived like an African potentate with numerous wives and concubines. Local legend has it that he sired eighty sons and an unknown number of daughters.[41]

There are a few similarities between the historical Francisco Felix de Souza and the character of Manoel da Silva in the film: both were involved in the slave trade; both were arrested by the Dahomian king and then helped the king's brother seize the throne; both became the king's agent in the illegal slave trade at Ouidah; and both served as governor of the Portuguese fort. Beyond that, almost everything else in the film is fiction.

Certain details in the film are based on historical sources. In one scene, Da Silva is wrapped in a cloth and tied up as a bundle to be delivered to the king in Abomey. Such an event actually happened in the 19th century, but it did not happen to the historical De Souza. It happened to a British botanist named Alfred Skertchly. Skertchly's 1874 book *Dahomey As It Is*, which recounted his eight months in Dahomey, was one of Bruce Chatwin's main historical sources for his novel.[42]

Another scene shows Da Silva's face being painted black on the eve of his execution because it was forbidden to execute a white man. This scene is loosely based on the Dahomian oral tradition about Francisco Felix de Souza being dipped in a vat of indigo dye by King Andandozan. I believe the purpose of the oral tradition is to highlight De Souza's transition from a European to an African. The scene in the film serves no such purpose.

The storyline about the king of Dahomey withdrawing from the slave trade and killing the white inhabitants of the fort, and then later reversing his policy when Da Silva arrives, is not historically accurate, and the film in no way explains the volatility and policy reversals of the Dahomian kings, except to portray them as mad. Historically, it was De Souza who abandoned the fort in order to pursue the slave trade by other means, and it was King Gezo who invited him to return to reclaim the governorship. However, the story makes the historical point that the slave trade could only function with the permission and support of the king.

Many of the scenes in the film are visually stunning. Scenes set in Abomey, the capital of Dahomey, were filmed in northern Ghana where a local king was engaged to reproduce his court ceremonies in front of the cameras.[43] A palace was constructed on the edge of an existing Ghanaian village and decorated with skulls and bloody heads on poles to reflect the practice of the kings of Dahomey. Otherwise, the film portrays the material and ceremonial culture of Ghana, not Dahomey. Visually, many scenes in the film are authentically African, but they

do not present a faithful portrait of the kingdom of Dahomey. To Western eyes, African kingdoms may be interchangeable, but the people of modern Benin, where the Dahomey kingdom was located, may see things differently.

Although not intended as a commentary on the slave trade, the film shows gruesome scenes of captives in chains being imprisoned in the fort and loaded onto slave ships, thus reminding viewers of the grim realities of the slave trade era. The film accurately depicts the kings of Dahomey as having a great deal of control over the forts and the slave trade in their territory. Despite their forbidding walls and their rows of cannons pointed out to sea, the forts could not carry out their trading functions unless they had the co-operation of the local kings and chiefs. But when the closing scene shows the phrase 'The slaves will sell their masters and grow wings', it is clear that the film is really about the impact of the slave trade on Manoel da Silva.

Adanggaman

Roger Gnoan M'Bala's 2000 film *Adanggaman* deals with the complexities of the slave trade within Africa. The opening scene displays the text 'Wandering procession, lost in a mirage on the route of the slave caravans, Mandinka, Allada, Bambara, Ibo, Ashanti, Fanti, Yoruba, moaning a song choked by iron collars', making it clear that this is intended to be a slave trade film. The Ivory Coast-born director describes the film as 'pure fiction', even though he acknowledges that the character of King Adanggaman in his film carries echoes of certain pre-colonial West African slave trader kings such as Samori and King Behanzin of Dahomey.[44] A co-production of the Ivory Coast, Burkina Faso, Switzerland and France, *Adanggaman* won prizes at the Amiens International Film Festival, the Marrakesh International Film Festival and the Ouagadougou Panafrican Film and Television Festival.

Filmed in the Ivory Coast using the Baule, Gouro, More and Senoufo languages, the story is set in an unspecified region of Africa in the late 17th century. It tells the story of Ossei, a young man from a noble family who rejects the marriage his father has arranged for him because he is in love with a slave girl. After a fight with his father over the marriage, he leaves the village to spend the night in the bush and returns the next morning to discover that King Adanggaman's female Amazon warriors have attacked the village. His father and lover have been killed, and his mother has been taken away as a slave. He follows the Amazons and tries to rescue his mother, but is defeated in a fight with Naka, a fierce Amazon warrior. After wounding him, Naka has an opportunity to kill or capture him, but instead she walks away.

Ossei follows the slaves to King Adanggaman's capital. There he meets an old healer named Sory who dresses his wound and helps him formulate a plan to

offer himself as a slave in exchange for his mother's freedom. King Adanggaman laughs at Ossei's plea for his mother's freedom and orders both Ossei and Sory to be enslaved. The old healer spots the Amazon warrior Naka and recognises her as his daughter who was taken away in a slave raid fifteen years earlier. He tries to speak to her, but she ignores him. That night Naka sets Ossei free and runs away with him to her home village, to try to reclaim her former identity and her lost soul. They try to live a peaceful and happy life, but the Amazon warriors catch up with them. They kill Naka and carry Ossei away, bound for a life of slavery in the New World.

King Adanggaman is pictured as both a ruthless tyrant and a buffoon. When Ossei follows the local custom to request that he be traded for his mother, the king says: 'Look around you. This world belongs to me. Mine is the only voice. Everything alive sprouts, grows, and breathes in the shadow of my protection.' When Ossei claims that his request is supported by tradition, the king shouts at him: 'Your ignorance is very persistent. I am the law here. Traditions are made by me.' The wealth that the king receives from the slave trade is clearly at the core of his arrogance and tyranny. Because of the slave trade, traditions based on a social contract are abandoned in favour of personal expressions of power. No person or tradition is safe.

Adanggaman paints a complex and nuanced portrait of the operations of the slave trade in Africa. The film shows a meeting of the king with his provincial governors. One governor reports on a border war in which the enemy was annihilated. The king responds, 'What? No women? No men? How will we populate and enrich the kingdom?' The point is that slaves were not taken solely to feed the transatlantic slave trade. Many captives were resettled to produce food and provide services for the king and the nobles. The character of Naka illustrates the use of slaves in the army. In the film she was taken away from her village at the age of seven and trained to be a bloodthirsty fighter. The Amazon soldiers of Dahomey were clearly the model for *Adanggaman*'s female warriors. Many of the Amazons in Dahomey had originally been captured in wars or slave raids and thus owed their lives and freedom to the king. In the 19th century it was reported that King Gezo of Dahomey used *only* young foreign captives as Amazons because he felt that he could count on their loyalty.

The complexities of slavery in Africa are further explored when King Adanggaman condemns Ossei and Sory to slavery. He selects Ossei to be sold to the Dutch, while Sory is sold to a local slaveholder. When Ossei asks Sory what the king does with his prisoners, Sory tells him, 'He sells the strongest for the dreaded voyage across the ocean. The weaker, who would never survive, are sold to rich locals.' There follows a scene of an auction where slaves are sold to local buyers for cows, sheep and goats.

The film also shows how the king tries to maintain a local monopoly on the slave trade. When Adanggaman learns that the enemy were killed in a certain battle, he suspects that the general has kept back some captives for sale on his own account. He says, 'Only Adanggaman captures slaves, sells them, and buys them. Only I have that power.' The film also shows how the king plays the rival European slave-trading powers against one another. One scene shows him drinking English rum, which he judges to be of poor quality, and saying that next time he will trade with the Dutch in the hope of getting better rum.

The morality of slavery and the slave trade is also explored. In the opening scenes it is clear that Ossei's village contains slaves. His clandestine romance with a slave girl is causing a local scandal because his father believes that marriage to a slave would defile his noble blood. It is Ossei's mother who defends the romance and later emerges as the major voice of opposition to slavery. When King Adanggaman gives her the slave name of Botimo, the monkey, she retorts: 'Who are you to suppress the lives and freedom of others, pretending that you have the power over life and death by selling human lives? You are the monkey. You monkey around with the whites for rum and guns. You sell your own flesh and blood. You are selling your soul. The monkey is you.' It is uncertain what she means when she accuses Adanggaman of selling his 'own flesh and blood'. The slaves were not the king's direct kin, and were most likely from outside the borders of his kingdom. The statement seems to reflect a modern nationalist or a pan-African ideal rather than the more localised consciousness of the late 17th century.

When *Adanggaman* was shown at the FESPACO Film Festival in Ouagadougou, Burkina Faso, critics complained that the film absolved whites of guilt by not having a single white character. Yet the film is historically realistic in that Africans who lived inland from the Atlantic coast usually had no direct contact with white slave traders. In the closing credits, the film makes a clear connection with the transatlantic slaving system and New World slavery. As a shot of the Atlantic Ocean fills the screen, the on-screen text reveals that King Adanggaman became drunk with rum one night and was sold into slavery by one of his aides. He was taken to America, where he became a cook in St Louis named Walter Brown. We are also told that Ossei was purchased by a wealthy American plantation owner and took the name John Stanford. The connection between King Adanggaman's pillaging and the transatlantic slave trade could not be more clearly stated. But the purpose of the film is to tell an *African* story, and it tells it well.

~

Conclusion

Of the seven slave trade films reviewed in this chapter, five of them (*Tamango*, *Sankofa*, *Ceddo*, *Cobra Verde* and *Adanggaman*) are works of fiction that use the cinematic art to examine themes that are not easily captured in footnoted historical studies. They explore how enslaved individuals cope with their situation, the corrosive effects of the slave trade on African societies, the spiritual connections between Africa and the New World, and the way slave trading corrodes the souls of the slave traders. These are issues that are not easily explored using the methods of academic historians.

In evaluating these fictional films as history, Rosenstone's concepts of 'true invention' and 'false invention' are useful tools, though they are somewhat vague and can be difficult to apply. How are we to determine when a film 'engages with the historical discourse' and when it does not? I would modify Rosenstone's categories to talk about 'authentic invention', which I define as scenes and storylines that are generally consistent with the findings of historical scholarship on the slave trade, and 'inauthentic invention', which is not.

The five fictional films all gain authenticity in different ways. *Tamango* tells the story of a totally fictitious and somewhat implausible love triangle that is set in the context of authentic depictions of slave purchasing on the African coast and the complex process of planning and carrying out a shipboard revolt. *Sankofa* uses the fantasy device of a spirit transported across time and space to address the important issue of historical connections between modern Africans and the descendants of African slaves living in the New World. *Ceddo* does not show slave ships or slave caravans, but it makes a powerful point about the corrosive effects of slavery and slave trading on African societies. *Cobra Verde* is an allegorical tale about one man's restless soul, but it presents powerful images of the operations of the slave trade at an African port. *Adanggaman* tells a tale of love lost, found and lost again in the context of a predatory African king who enriches himself through the slave trade. The parallels with the kings of Dahomey are evident, and the film powerfully illustrates the destabilising impact of the slave trade on African societies. I would classify all of these films as examples of 'authentic invention' because their individual stories are set in contexts that are consistent with the scholarly data about the operation and impact of the slave trade in Africa.

The two films based on true episodes are more problematic. *Roots* has been characterised by Alex Haley as 'faction' (a combination of fact and fiction), and *Amistad* is described in its publicity book as 'a movie that blends fiction with

true events'.[45] These films are more difficult to evaluate because even when they engage with historical discourse, there remains the question of *which* historical discourse is being engaged. Does the film engage the immediate episode, the mechanics of the slave trade, or the emotions, personal tragedies and societal breakdowns engendered by the slave trade?

As the earlier discussion of Steven Spielberg's scene of starving slaves being thrown overboard illustrates, different levels of historical discourse can sometimes be in conflict with one another. If Spielberg had depicted the *Amistad* captives as well fed, as they apparently were in this case, he risked presenting a falsely benign image of the slave trade as a whole. But by picturing the captives as starving, he lost his ability to explain the logic of this particular revolt. In a similar way, the directors of *Roots* sought to counter negative stereotypes of Africans by showing only positive images of African society, but in the process they distorted the operations of the slave trade in Africa. It can be extremely difficult for a single film – especially one based on historical events – to engage different levels of historical discourse at the same time.

The main problem with slave trade films as a genre is that there are so few of them. This situation places a huge burden on each of these films not only to tell its own story, but also to tell the larger story of the transatlantic slave trade at the same time. Thus, *Adanggaman* was criticised for not having any white characters, even though Europeans seldom ventured into the interior of Africa prior to the 19th century. *Ceddo* had two white characters – a slave trader and a Catholic priest – but it did not show a single slave ship. *Tamango* gave a detailed account of a shipboard slave revolt, but it showed little of the slave trade in Africa and nothing about the slave plantations of the New World. *Sankofa* and *Cobra Verde* showed slave castles in Africa and New World plantations, but they did not depict the middle passage. *Amistad* was set in the New World and depicted Africa and the middle passage only as brief flashbacks. The only film that tried to devote adequate attention to all segments of the slave route was *Roots*, and it is nearly ten hours long.

The solution is to produce more films about the slave trade. The most we can ask of a single film is that it should give us a small piece of the larger picture. As more slave trade films are produced, perhaps a composite image will begin to form. The complex truth about the history of the slave trade will emerge only when we have a critical mass of films on the subject.

5

'What are we?':
Proteus *and the problematising of history*

⁓

NIGEL WORDEN

Proteus[1] is set in the Cape Colony under the administration of the Dutch East India Company. In 1725 a Khoi, Claas Blank, is imprisoned on Robben Island where he meets the Dutch convict Rijkhart Jacobsz. Over the course of the following ten years an emotional and sexual relationship develops between them that is finally exposed by a fellow prisoner. The men are tried for sodomy, at the same time as the occurrence of the *sodomieten gevaar*, the persecution of male same-sex activities, in the Netherlands. Under interrogation Rijkhart confesses to committing sodomy, but Claas only admits guilt voluntarily in the final moments of the trial. Both are executed by drowning in Table Bay.

This takes place against the background of the conquest and dispossession of the indigenous Khoi and San inhabitants of the Cape. Claas has been sent to Robben Island for resisting settlers and towards the end of the film he learns that his mother has been killed by colonists who made a tobacco pouch out of one of her breasts.

At the same time a Scottish botanist Virgil Niven and his assistant Lourens visit the Cape to identify and to catalogue its flora. They set up a garden on Robben Island using prison labour, and use Claas as a local informant for the names of plants. Niven takes his specimens back to Europe and sends his material to the great Swedish botanist Linnaeus, who renames the plants and appropriates Niven's work.

Niven and Lourens have also participated in the same-sex sub-culture of Amsterdam, and Lourens is executed in the persecution of Dutch homosexuals after he returns from the Cape. When Niven's wife discovers this she leaves him. Niven is drawn to Claas and attempts to save him from execution, but Claas's voluntary confession ensures that he dies with Rijkhart.

⁓

Proteus differs markedly from the other films discussed in this collection. Released in 2003, it is a low-budget production that is striving to make its presence felt in non-mainstream cinema. It depicts a historical setting and story that will be unfamiliar to viewers. Its cast is also largely unknown, some of them untrained actors and appearing in a film for the first time.[2] *Proteus* has received mixed reviews, largely unfavourable in the North American press.[3] Yet it has also attracted considerable attention from more serious film critics as well as from historians. This is because *Proteus* raises questions about the representation of history in film in ways which consciously reject mainstream conventions.

Selecting history

Most South African historical films deal with the grand narratives of 19th-century colonial conflicts (especially with the Zulu), the Voortrekkers of Afrikaner nationalist reputation, the upheavals of the diamond and gold discoveries, and the subsequent rise and fall of apartheid.[4] *Proteus* differs from these. It is almost the first feature film to be set in the little-known time and place of the 18th-century Dutch Cape colony.[5]

Apart from the controversial founding of the colony by Jan van Riebeeck in 1652, the history of the 143 years of the Cape Colony under the rule of the Dutch East India Company (VOC) has made relatively little impact on public awareness of the South African past.[6] Yet this period laid the foundations for the later colonial conquest of the region and, some would argue, for much of South Africa's subsequent pernicious racial social structuring. From an initial small trading and refreshment station in Cape Town, settler farmers in the late 17th and 18th centuries steadily expropriated land from the indigenous Khoi and San as far north as the Orange River and eastwards beyond Graaff-Reinet. This was not always with the approval of the Company administration, which balked at the weakening of its authority over the settlers of the inland regions, but was usually forced to accept a *fait accompli*. Armed conflict, disease and loss of livestock decimated the Khoi and San, and reduced most of the survivors to the status of impoverished labourers.[7] Into this society were brought slaves from those Indian Ocean regions where the VOC had influence or control, notably Batavia (modern Jakarta), Sulawesi, Sri Lanka, the Coromandel coast of India, the Bay of Bengal and Rio de la Goa (modern Maputo). Slaves worked in settler households and farms and on the Company's public works, which included the stone quarry and lime kilns on Robben and Dassen islands.[8] Their labour was supplemented with that of European, African and Asian convicts who were convicted of crimes either

at the Cape or in the East Indies.[9] It is this harsh world that provides the setting for *Proteus*.

The directors of *Proteus* (and in particular Jack Lewis, who was formerly a South African academic historian) were well aware of recent and new historical work on the Dutch colonial Cape, and in some respects they were ahead of the arguments and approaches of historians. One of the key themes of the film, as we shall see, is the construction of colonial knowledge and the framing of the colonial subject, a topic prominent in recent British and North American work, which uses the techniques of the new cultural history.[10] Cape historians are also producing a new, but as yet only partially published, social and cultural history of the Dutch colony. This emphasises the experience and mentalité of those at the lower end of the social order, such as slaves, Khoi, San, convicts, soldiers and sailors, the ways in which they interacted and the different types of identities that they produced.[11] The film is full of reference to some of this latest historical work, including male demographic and cultural domination, links between nominally free and slave inhabitants, the harshness and brutality of life at the bottom end of the social scale, and in particular on Robben Island, the manipulation and corruption of local officials and the tensions between them and frontier farmers over their treatment of the indigenous Khoi and San.

One of the techniques which historians have recently employed is that of the micronarrative. This involves analysing a specific episode in great detail, usually one involving ordinary people who were not 'significant' in a conventional historical and political sense, in order to illuminate the kinds of social and mental processes that could exist at a particular time and place.[12] Historians of the early colonial Cape have used micronarratives to investigate otherwise hidden topics, such as the conflicts between settlers and Khoisan on the pastoral frontiers of the interior, cross-racial adultery, slave consciousness and the significance of concepts of honour and status at all levels of the social hierarchy.[13] Often such histories do not have single narratives or conclusive arguments, but present alternatives and uncertainties in which the role of the historian as the constructor of history is more evident than usual. Such material, which is richly textured and involves the unravelling of a particular episode and individuals, has inherent appeal to filmmakers.[14]

Historian Susan Newton-King has recently employed these techniques. Lewis consulted her in the course of making *Proteus*. She has used records of sodomy trials to examine questions of sexuality, gender and power in the early Cape colony. In particular, she is assessing the argument of the Dutch social historian Theo van der Meer that in 17th- and early 18th-century Holland a distinctive male same-sex identity and sub-culture emerged which bore remarkable similarities to the processes which Foucault and other historians believed only occurred

in Western Europe later in the 19th and 20th centuries.[15] Newton-King takes specific cases from the court records to investigate the extent to which this was true of the Dutch colony in the Cape.[16]

This work was of great interest to the directors of *Proteus*. Co-director John Greyson states that he has 'always been interested in history and how history has defined and redefined sexuality'.[17] But they were not only curious about a historical past. Lewis worked closely with the AIDS activist Zackie Achmat in documentary films about gay and lesbian history and culture in South Africa that hoped to demonstrate that same-sex activities and identities have always existed throughout South Africa, that they were not confined in racial or class terms, and that those involved in such activities have suffered considerable persecution and intolerance.[18] Achmat and Lewis both participated in campaigns that led to the guarantee of human rights irrespective of sexual orientation alongside race, gender and religious belief in the new Constitution of post-apartheid South Africa.[19] Yet Lewis is acutely aware that such a victory is vulnerable and that vendettas against gay and lesbian people can follow a period of tolerance, as shown both in recent events (Malaysia, Zimbabwe, Namibia, the Anglican Church) and in historical examples such as Soviet Russia in the 1920s or – as in *Proteus* – Holland in the 1730s. While, like many historical films, *Proteus* may indicate to modern audiences that we inhabit a more pleasant and tolerant world today than in the past, the line between the two is in this respect a fragile one.[20]

Lewis and Greyson's choice of a case involving same-sex desire and the oppression of those who felt and practised it was thus motivated both by historical curiosity and by present-day concerns in South Africa. Planning for the film began in 1997, when the Constitutional Court was reviewing sodomy legislation.[21] In the same year, the case of Claas and Rijkhart was used as an inspiration for a controversial art installation at the Cape Town Castle, a work that the military command based at the Castle tried to close down on the grounds that it promoted homosexuality.[22] The case had thus already been identified with present-day struggles for same-sex equality. It also had particular appeal because it involved an inter-racial relationship and because Claas was Khoi, a survivor of the process of indigenous land dispossession and genocide on the Cape's northern and eastern frontiers. In this respect, *Proteus* again makes links with recent historical work, in which the violence of frontier land settlement is highlighted and the racial categories of earlier Cape historiography (slave, Khoi, settler) are being challenged by examination of more complex and cross-racial social identities that included emotional and sexual relationships.[23] But it also points to the dilemmas facing racial conciliation in modern South Africa, with its complex history of destroyed personal relationships and the legacy of dispossession. Past and present are not separable in film any more than they are in the production of any other form of history.[24]

~

Problematising history

The opening shots of *Proteus* include several conventional, indeed stereotypical, devices to indicate that what we are about to see is an authentic representation of the past. As the titles roll, the pages of a parchment volume dated 1735 are turned by a human hand – the volume which records the court case of Claas Blank and Rijkhart Jacobszoon. This is interspersed with images of proteas opening, and a caption to inform us that in 1735 Linnaeus named the protea bush, followed by the image of a figure (later revealed to be Claas) running across a landscape of such bushes. As the title *Proteus* unfurls, we are informed that this is 'based on a true story'.

But this is not all that we see. Interspersed with these shots are others that are less conventional. After the camera has focused on the archival volume, three typists, with beehive hairstyles and seated in front of typewriters, discuss how to transcribe and translate a phrase from the volume that we have just read, a phrase that we are to learn later in the film is crucial in establishing the guilt of the protagonists, 'Ik heb hem in't gat geneukt'. Each typist produces a different version of 'geneukt', ranging from the frankly direct ('fucked … it's perfectly good old Dutch') to the more evasive ('an offence against God and nature'). Nor is this all. Before we see Claas running across the landscape of proteas, we witness him being dragged into the Cape Castle by a policeman dressed in a modern uniform who subjects him to near drowning in a tank being rapidly filled with water.

Immediately *Proteus* juxtaposes vivid realism and statements of authenticity with disruptions to such a claim. Such disruptions continue throughout the film and are the main source of the bewilderment and irritation expressed in some of the press reviews that it has received. For *Proteus* is an 'experimental' film, one whose experimentation poses interesting questions for the historical filmmaker of today.

The discussion by the court secretaries over how to translate a key phrase immediately shows that the record preserved in the archive volume is a construction which has been changed and filtered through several channels before reaching us. The archive is not a neutral body of factual knowledge, but the trace of a complex series of linguistic negotiations.

The untrustworthiness of the written record is a constant theme of the film. Claas and another prisoner on Robben Island speak in Nama and during their conversation they reveal that the names that they have given for the official records are fictitious. Claas later deliberately changes some of the plant names when he gives them to Niven. To the amusement of the viewer, subtitles show

that the names being carefully written down by the botanist are in fact swear words or terms of sexual ribaldry. He similarly elaborates on his mother's version of Khoi oral traditions. To underscore the point, a fellow Nama prisoner subsequently confronts him about the extent of his knowledge: 'Do you know the plant names?' to which Claas's reply is 'maybe'. Niven's work is in turn appropriated by Linnaeus, who again changes the names before they appear in a final published form. Historical knowledge as conveyed in the archive, *Proteus* shows us, is a construction rather than an absolute truth.

A key element in the film, prefigured in the opening shots, is the water tank in which both Claas and Rijkhart are tortured by near drowning. Or are they? Rijkhart tells Claas about the water cell torment that he had heard about when he was an orphan in Amsterdam and we then graphically see it being put to work, forcing Rijkhart to confess. But later Rijkhart tells Claas that it was all in their imagination, and in a hallucinatory shot all three protagonists (Rijkhart, Claas and Niven) are drowning in the tank before it vanishes to leave an empty space in the Castle grounds. Although this is not explained in the film (leading to bewilderment for some), this refers to the fearful but *mistaken* belief in 17th-century Amsterdam that such a drowning cell existed.[25] The power of the imagination, rather than actual events, is fleetingly shown at other moments in the film. For example, as Claas muses over his feelings for Rijkhart shortly after a confrontation between them, Rijkhart's hand appears on his shoulder before vanishing from the shot – this is the workings of Claas's imagination, not a 'true event'.

To underscore the point that the historical record is a construction of truths, half-truths and imagination, at the very end of *Proteus* a caption declares, 'Some of the things so far told the court are true and some are not true'. Several seconds pass while we absorb this before the source is revealed, 'Nelson Mandela on being sentenced to life imprisonment on Robben Island, 1964'. Such words are profoundly disturbing. Here one of the most revered voices of the late 20th century informs us that we should not believe everything we hear (and by implication everything we read in the historical record). *Proteus* confronts the issue with which many historians in a post-modern and post-structuralist era are engaging: there is no absolute historical truth, only textual representations.[26] As Lewis has stated, 'Doesn't all history have a potentially fictive element?'[27] *Proteus* is more honest than most films (and most historians) in revealing that the history we produce is a construction.

The inclusion of Mandela's words underscores another key element of the film's approach to history: the use of deliberate anachronisms. These are apparent from the first substantial scene in which 18th-century settlers drive a Land Rover. The Governor and his wife underscore their differences of opinion by turning a transistor radio on and off and the prisoners are transported to and

from Robben Island on a modern yacht (from which Claas and Rijkhart are finally pushed to their deaths). While most of the characters wear apparel appropriate to the period, the court secretaries and Witte, the Robben Island policeman, are in modern dress. Period settings such as rooms in the Castle and prisoner barracks on Robben Island are interspersed with timeless 'empty landscapes' such as Dassen Island or a vista of fynbos vegetation, but also with modern intrusions such as the Robben Island water tower and breeze-block harbour with modern Cape Town in the background.

Such 'purposeful inauthenticity' which subverts realism is unusual, but not unknown, in historical film.[28] Dave Kehr, the reviewer of the *New York Times*, was irritated by what he saw as a derivative device 'deep in debt to such masters of the New Queer Cinema as Todd Haynes ("Poison") and Derek Jarman ("Caravaggio")', and certainly there are strong echoes of Jarman's mixture of historical and contemporary images.[29] Lewis has alternatively (and only partially in jest) suggested that a low-budget film prevented the construction of elaborate period sets or the airbrushing of modern buildings and landscapes.[30]

But what Kehr has failed to realise is that the anachronisms in *Proteus* are not careless present-day intrusions but date from another specific historical period, the 1960s. The choice is deliberate. This was the heyday of apartheid in South Africa, as Mandela's words in the final shot reveal. The connections between the oppression of apartheid South Africa and the 18th-century Cape are constantly reinforced. This is particularly evident in the images of Robben Island, the archetypal apartheid prison, where warders hold barking Alsatian dogs and wear 1960s-era uniforms. Many of the images are direct references to icons of the apartheid era, such as rows of squatting prisoners in a courtyard breaking rocks, prisoner conversations at the Island quarry, or the suffocation of a prisoner under interrogation.[31] These are interspersed among scenes more appropriate to the 18th-century Island, such as whipping, fishing and collective prayers.

At one level, it might be argued that such images are ones that an international audience would expect of a film set in South Africa, albeit with a hazy sense of chronological accuracy. But there is a more fundamental point in this 'purposeful inauthenticity'. The fate of Claas and Rijkhart is thereby bound up with the kinds of oppression that apartheid represented. A deliberate political strategy in the advocacy of gay and lesbian rights in the 1990s was to identify discrimination on grounds of sexual orientation with human rights in general, and specifically with the central tenet of the struggle against apartheid, the inequity of discrimination by race. Being able to declare and live out one's sexuality was to be viewed as a human right alongside all others. *Proteus* thus not only shows that same-sex relationships existed in the 18th century and were the target of persecution, but also consciously links such oppression to the mechanisms of the apartheid state

and its officials. The point is emphasised further still by the fact that Claas and Rijkhart's relationship transcends racial as well as sexual boundaries.

There is another suggestive element in this association. Robben Island has become the heritage icon of the anti-apartheid struggle, a place of sanctity in the representation of a new nationalist history in South Africa.[32] Visitors are shown around the prison usually by an ex-prisoner who powerfully recounts his own experiences. And yet there are gaps in such accounts. One of them is sexuality. South African prisons (like prisons everywhere) are sites of same-sex activity, but this is taboo in the stories told about the political prisoners on Robben Island. *Proteus* portrays the same denial: people on the Island knew what was happening but nobody talks about it. By so doing it at least partially subverts the official account.[33]

Changing history

While *Proteus* clearly shows the instability of the historical record, the ways in which it changes that record are not accidental.[34] Some of the changes were for practical reasons. Claas and Rijkhart were actually together on Robben Island for twenty years rather than ten, and were older than the film suggests.[35] Lewis accounts for this by the problems of presenting actors who age over a long period of time, and instead depicts both characters as youthful and desirable. The confrontation of witnesses and accused and Claas's dramatic confession would not have occurred under Dutch East India Company court procedure where evidence was taken individually and the accused would have been unaware of what was said about them.[36] The film instead presents the trial in a way that visually accentuates human drama and tensions.

While these changes serve filmic needs, others are more fundamental to the directors' purpose. Most strikingly, the film gives Claas Blank an agency that is lacking in the historical record. Claas is the central figure around whom the plot and the human interest revolve. Claas is a man on the run, hounded out by the colonial conquest of his people and the prisoner of a ruthless legal system. But he is not a passive victim. In the opening scene he is able to manipulate those in power: he succeeds in avoiding capture and certain death by appealing (in English) to Niven, an appeal that he later uses to the Governor. He signs his own name on the prison register, rather than the cross which the prison governor expects. He makes himself indispensable to Niven on the Island through his knowledge of plants and oral tradition (a knowledge that he keeps to himself by deceiving Niven). When Niven reveals his sexual attraction to Claas, the latter

uses it as an attempt to obtain his freedom by working as Niven's servant in Europe. After this bid fails, Claas rejects the gift that Niven presents to all the prisoner workers, thus refusing to place himself in a position of indebtedness to Niven. Indeed it is Claas who is the Proteus figure of the film's title, the shepherd (and servant) of classical mythology who constantly changes form and who will answer questions only when he chooses.

Most strikingly, it is Claas who initiates and controls the relationship with Rijkhart. In the first scene between them, Claas surprises Rijkhart who is alone cooking meat for himself. Claas refuses the meat Rijkhart offers him, and then seizes it for himself; he calls Rijkhart a 'cannibal' and wrestles him to the ground, pulling a knife on him. Sexual tension accompanies this physical contact, accentuated by the fact that we know Claas has been told that Rijkhart is 'a faggot'. The lips of the two come close, but the moment is broken by Claas who tells Rijkhart 'You stink', and knees him in the groin before running off to leave Rijkhart writhing on the ground.

Claas dominates Rijkhart violently and physically, just as he has controlled settlers, the Governor and Niven through his linguistic abilities and his wits. In a later scene it is Claas who seduces Rijkhart, encouraging him to sit and drink with him, to 'relax', 'don't be fearful' and closing the doors to enable them to have sex. Immediately afterwards Claas publicly objects to being sent to fetch water with Rijkhart ('last time he tried to screw me') and rejects him when Rijkhart attempts to touch him. When they do have sex he takes the active role, asserting his independence from Rijkhart by fantasising about his female cousin 'with big tits' while he is doing so.

Five years later, Claas still controls the relationship. In a scene where they are together on Dassen Island, Rijkhart objects to the way in which Claas alternates between tenderness and rejection of him. It is then Claas who demonstrates a more permanent affection by his gift of a necklace, left for Rijkhart on the lime kiln. Shortly afterwards we witness them mutually kissing each other. On their return to Robben Island they are betrayed by Munster, a fellow German convict whose crude advances to Rijkhart to 'be my wifey' have been rejected. They are whipped in a scene which emphasises their mutual bonding in pain and adversity. Only after this, and shortly before their arrest, does Claas take the passive role in his sex with Rijkhart, but it is again he who initiates such a move ('I'll be the mare'). After their arrest it is Rijkhart who breaks down under torture, not Claas. And at the end Claas chooses to admit guilt to the court, thus ensuring his own death sentence. It is he who has determined what actions the court will take, in contrast to Rijkhart, who has been found guilty against his will.

None of this is evident from the archival record. In the documentation of the case, there is only a brief recorded statement by Claas in which he said that he

had 'allowed himself to be used against nature' by Rijkhart when he was drunk, confessed to the crime of sodomy and recognised that he deserved death.[37] Both Lewis and Greyson have pointed out that this is a classic example of 'how difficult it is to truly know history' since it shows the silencing of the indigenous voice in the colonial archive, although it has to be pointed out that Rijkhart gets no more space in the court record.[38] Certainly the perspective of the underdog is missing in the court archives. And it is this perspective that Lewis and Greyson seek to restore in *Proteus*. In so doing they provide a filmic equivalent of the most striking element of recent South African historiography: that of giving agency to officially silenced voices, to the racially silenced in particular. In notable contrast to many films about African history discussed in this volume, *Proteus* gives agency and individuality to its indigenous protagonist.

But this is not the only adjustment to the court record that *Proteus* makes. Rijkhart is also presented in a very different light. He is presented as the more passive partner in a relationship that is initiated and driven by Claas and the weaker figure who buckles under torture ('I lost my head', he tells Claas, 'you know I can't stand pain, I'm not a proper man'), but he is also a loyal lover and a guiltless victim of his own circumstance and sexuality who is framed by the jealous and odious Munster. However, in the court records Rijkhart shows little concern for Claas or anyone else. He claims that he was drunk when he committed sodomy with Claas, and is condemned through the evidence not only of Munster but also of the slave convict Pannaij (omitted from the film), who described how Rijkhart propositioned other prisoners.[39]

It would appear that Pannaij is cut since a slave witness who spoke of Rijkhart as a crude sexual propositioner complicates the film's image of a guiltless love couple who fall foul of a (white) convict's jealousy. And yet Lewis is right to maintain that such an interpretation gives undue authority to an archival record that is itself highly questionable. How far can the historian rely on testimonies given to a courtroom in which inequalities of power and authority were so evident? How truthful is the evidence of those seeking to save their own lives or to (possibly) curry favour with the authorities? Bribed and terrified witnesses and accused persons are typical of any courtroom. 'Some of the things so far told the court are true and some are not true.'

It is clear that *Proteus* wishes to portray a mutually affirming same-sex relationship and this is only possible by reading the court records 'against the grain'. Although Claas dominates this relationship from the start, its mutuality is portrayed as the film progresses. A turning point is Claas's gift of the necklace to Rijkhart and the subsequent jealousy of Munster that begins to threaten them. A key scene follows in which they are whipped together but refuse to confess in a defiant affirmation of their joint relationship. In the court record, it is only

Rijkhart who was whipped, and it was then that he confessed with the words 'Ik heb hem in't gat geneukt' in order to stop the punishment.[40] Most strikingly, Claas voluntarily confesses guilt in a dramatic moment at the end of the film ('Di ta go, ons het dit gedoen', which the typist translates as 'We did it'), as he smiles and looks first at Rijkhart and then in triumph at the judge as they are condemned to a joint death by drowning. On board the yacht, they look at each other and grasp hands as they are pushed overboard.

Various reasons for these actions are suggested by the film. To some they are a clear declaration of the ultimate triumph of love over adversity. Claas chooses Rijkhart – and death – over life with the aid of Niven (who has for long been attracted to Claas and defended him in court by saying that he would not be capable of comprehending a crime such as sodomy and that the counter-evidence of the convict Munster was invalid). To others the fact that Claas's confession comes after he has been sentenced to a further term of imprisonment on Robben Island may indicate a preference for death rather than a further lengthy term of forced labour. Lewis himself insisted on the insertion of a scene immediately before the trial, in which Niven informs him that his mother has been killed and presents him with the tobacco pouch which a colonist has made from her breast. 'I fought to have the breast given to him as an indication that he can't go back to the north.' There is thus no home for Claas to return to (a goal he has cherished throughout his imprisonment) but instead only a brutal and hostile colonial world in which his people are subjected to genocide.[41]

Whatever the reason, the film's reworking of the archival record is concerned to show the possibility of a mutual same-sex love relationship in the 1730s. In this it goes much further than the original case, which merely records the physical fact that Rijkhart and Claas's sexual activities were 'mutually perpetuated'.[42] This is what was of concern to the court, which only needed to prove that sodomy had occurred and was not interested in the reasons for it. But Lewis and Greyson add (through the words of the court secretaries) the surprise the court felt when they discovered that such mutuality could exist rather than the one-sided physical relationship of a kind that was relatively common between older men and youths in pre-modern Europe. For the filmmakers, the interest lies in what did not concern the court, that is, the possibilities raised by Van der Meer's argument about the existence of specifically gay identity and culture in early modern Holland.

This is evident in two ways. Firstly, *Proteus* includes scenes of an Amsterdam gay sub-culture whose participants 'would not have been out of place at the Bronx on a Friday night'.[43] This included specific language, ballads and cruising spots.[44] It is shown in a number of flashback shots as a culture in which Rijkhart, Niven and Lourens all participated (one of the few 'convenient coincidences' in *Proteus* is that Rijkhart recognised Niven from his younger days in the Amsterdam gay

scene). This is the gay world which is smashed by the persecutions of the 1730s to which Lourens directly (and Niven indirectly) falls victim.

Secondly, a key element of Van der Meer's argument is that participants in this world were beginning to develop a specifically gay self-identity. In the film, Claas and Rijkhart struggle towards that identity. When Claas first sees Rijkhart at the Robben Island quarry he is warned by his fellow Nama prisoner to avoid 'the faggot'. 'Is he a two-sexer?' asks the bewildered Claas. 'No, just a Dutch faggot', comes the reply. The distinctiveness of Rijkhart's fixed sexuality is marked from the start. The film explores how a mutual emotional relationship gradually develops between Rijkhart, who has experienced such types of relationship in Amsterdam, and Claas, whose sexuality is less clear, and who comes from a world of different sexual identities.[45] A key scene brings together this issue of same-sex identity with the film's focus on the uncertainties of classification and naming. Claas and Rijkhart are together after their joint whipping, and after Claas has shown his affection for Rijkhart. Claas is shortly to be released, earlier than Rijkhart. Rijkhart fantasises about them living together on a farm, a fantasy which Claas breaks ('they'd shoot us dead'). Rijkhart then looks for a commitment from him:

Rijkhart: Say it.

Claas: What?

R: What we have.

Cl: What have we?

R: What it is.

Cl: What is it?

R: What we are.

Cl: What are we?

R: [Ek weet nie – *not translated*] ... What's the name?

Cl: What is the name?

R: Why can't you say it?

Cl: There is no name.

That same-sex activity took place at the Cape, as in any other time or place, is not in question. The issue is rather whether the participants recognised themselves as having a same-sex identity and perceived their relationship in these terms. In this scene *Proteus* shows Rijkhart and (especially) Claas grappling towards such a novel understanding.[46] As the film shows, such a relationship would challenge both the sexual and the racial hierarchies of the Cape Colony. Lewis and Greyson are at pains to point out that they make this point in relation to the specific time and context of the Dutch Cape Colony, and that it is not as a general claim for a recognisable gay identity in Africa as a whole or over all time.[47] It does, however, make a significant statement about the flow of knowledge and identities between

metropole and colony and is in this sense an integral part of the wider theme of the construction of colonial knowledge, which is central to *Proteus*.

Another example of the way in which *Proteus* reads 'across the grain' and supplements the silences of the archival record is its explanation of the reason why Rijkhart and Claas's sexual activities were only brought to trial in 1735, although they had been tolerated by both fellow convicts and by the authorities for at least ten years (and possibly much longer) previously. The immediate explanation is given by the jealousy of Munster after Rijkhart spurns his sexual advances. *Proteus* inserts this detail into a wider comment on power relations and corruption amongst the VOC hierarchy. Witte uses Munster's evidence as a means of ousting Scholtz, the Island superintendent who had previously tolerated such activities, and for obtaining such power for himself. Here two suggestive but inconclusive clues from the historical record (Munster's evidence and the replacement of Scholtz at this time) are used to construct a plausible, but not directly substantiated, scenario. A broader context is that the Governor is prepared to listen to Witte because of the Dutch persecutions at the time, which require him to be seen to take firm action against 'sodomites'. And authority needs to be asserted to counter the potentially subversive frontier colonists who are acting against Company orders by extending their territory and making war on the Khoisan. In Greyson's words, this is a story of 'two guys who are caught in the geopolitics of the day'.[48] The filmic narrative thus supplements gaps in the historical record, just as the historian who employs micronarrative must make sense of a story by suggesting contextual and plausible causal connections that might not be explicit in the documentation.

The most explicit invention of the film is the insertion of the story of Niven. A coincidental discovery by Lewis and Greyson was that in 1735, the very year of Claas and Rijkhart's trial, Linnaeus named the Proteus flower, the present-day symbol of South Africa.[49] But in order to relate this event to the main story, they use the sub-plot of Niven and his research at the Cape. Although Niven was a real Scottish botanist who visited the Cape later in the century, *Proteus* transposes his visit to the 1730s to coincide with the case of Rijkhart and Claas. Lourens, his research assistant and sometime lover, his involvement in the Amsterdam gay sub-culture and his attraction to Claas, are completely fictional.

This sub-plot serves several important functions. At one level, it provides the convention of the romantic film, a three-way emotional tension. Niven's feelings for Claas present a threat to Rijkhart and Claas's relationship. The power and influence that he wields on the Island gives him advantages that Rijkhart cannot match, a parallel to the romantic convention of the rich anti-hero competing against the poor but lovestruck hero. A moment of emotional tension occurs when Niven offers Claas a job as his servant after his release from Robben Island,

in English (a language Rijkhart cannot understand). The courtroom confession scene, as noted above, presents the choice that Claas makes between death with Rijkhart and the life that Niven has attempted to preserve for him.

But the emotional tensions are more than devices in a love triangle. As a married man and father who participates in Amsterdam's gay sub-culture and who is attracted to Claas, Niven deepens the film's portrayal of the complexity of human sexuality, a complexity that Claas is also confronting in his relationship with Rijkhart. Through this we learn that men cannot be categorised into a binary opposition of gay–straight. The device of using a character to present a particular point of view or type of experience is common in film. It is also used in the case of Lourens, who, as a martyr of the *sodomieten gevaar*, represents the experience of many. Niven and Lourens thus add complexity and depth to the issues of sexual identity, which is central to the main story of Rijkhart and Claas.

The Niven plot also enables *Proteus* to deal with the central issue of colonial appropriation of knowledge. Niven names and categorises the plants and the people of the Cape. He draws on Claas's knowledge (sometimes deliberately falsified) for the former and on his very body for the latter, but it is this constructed knowledge that Linnaeus publishes under his own name, thus giving it the status and authority of scientific knowledge. Niven is an agent of the colonising gaze, who appropriates Claas's indigenous knowledge just as the Cape settlers are appropriating his land. Just as Claas has resisted settler territorial advance, so too he resists the imposition of colonial knowledge construction. He deliberately misinforms Niven about plant names and oral traditions and he mockingly and ironically addresses Rijkhart with the racial categorisations that Linnaeus has constructed from Niven's drawings. The Niven plot may be invented in a literal sense, but its exposure of issues of both sexual identity and colonial appropriation and indigenous resistance provides vital and authentic historical contexts.

Proteus uses symbol and verbal allusion to convey both colonial expropriation and sexual oppression. Lewis and Greyson avoided potentially stereotyped (and costly) 'burning village' scenarios, but suggest violence and horror through devices that shock the audience in less direct ways. The ruthless and callous nature of settler conquest of the Khoi is epitomised through the tobacco pouch that is made of Claas's mother's breast. That of the *sodomieten gevaar* is conveyed through Niven telling his (unsympathetic) wife that a bill for the costs of the instruments of torture and execution of Lourens was sent to the victim's mother, and by his evocation of scenes of terror and 'monstrous panic' to his uncomprehending son who has read about it in a newspaper. *Proteus* eschews attempts at naturalistic 'realism' in preference for images elaborated in the viewer's imagination.

Proteus uses visual imagery to particular effect in other ways. From its open-

ing images, it juxtaposes the natural landscape of the Cape (with its flowering protea bushes) with the harshness of life in the Castle and on Robben Island, the constructs of the imposed (and 'unnatural') colonial order whose associations with the apartheid era emphasise its brutality. There is little sense of the African continent that lies beyond the confines of the colonial settlement, although the flashbacks that Claas has when he recalls the stories told to him as a child by his mother briefly evoke a world before the intrusion of the colonists. Rather than a pristine depiction of an African landscape, *Proteus* depicts the ways in which that landscape, and its inhabitants, are being appropriated. This is where the Niven sub-plot is crucial. For it is not only the plants that Claas names and Niven collects, it is Claas himself. Claas's body is controlled, not only in the literal sense of his imprisonment and final drowning, but also by Niven, who draws him in a kaross of a kind he does not normally wear and in the classic pose of the 'noble savage', which ends up as the sub-human 'Hottentot' in Linnaeus's classificatory schema. This racial hierarchy constructed by European intellectuals is manifested in a cruder form by the convict Munster's challenge to Rijkhart on Dassen Island, 'Why do you let that filthy Hottentot touch you?'

This process of colonial appropriation of the African body is a central theme of the film. And yet we see that it is not the only way in which it is perceived. To Niven, Claas has a sensual body whose hair he strokes, to Rijkhart it is the body of the lover, while to the white convict Munster he is a 'filthy Hottentot'. Claas himself subverts Linnaeus's book by satirising its racial descriptions. Like *Proteus*'s mythological prototype, Claas can change his form to seduce, connive or submit when it suits his needs, but once he is captured in Linnaeus's book, he can no longer control the way in which his own body is represented.

Proteus is not a conventional history film or a blockbuster in the Hollywood tradition that will influence the perceptions of the past in the minds of large numbers of movie-goers. Its experimentalism means that it has acquired only a limited audience exposure. This may have ironically restricted the impact of the advocacy role for same-sex rights which its directors desired. But such experimentalism has raised other highly significant issues about the representation of the African past on film. It directly challenges the notion of a single reality. Unlike most films, but in tune with more recent trends in written histories, it *allows* for 'alternative possibilities'.[50] In this sense it may be described as an 'historian's film'. There is a central tension in this. On the one hand *Proteus* wishes to question the notion of the authority of the archive and the authenticity of the historical record. On the other it aims to establish beyond question the existence of mutual same-sex desire in the 18th-century Cape Colony. But this is a productive tension. The film forces us to face the central question of the practice of history: can we ever really know the past?

6

The public lives of historical films: the case of *Zulu* and *Zulu Dawn*

CAROLYN HAMILTON & LITHEKO MODISANE

Synopses

The film *Zulu*[1] (1964), set in 1879 in south-east Africa, opens with Zulu warriors roving across the scarred Isandlwana battlefield, which is littered with the bodies of British redcoats.[2] The Zulu victory is absolute. This opening sequence is followed by a regimental wedding dance at the Zulu royal residence, presided over by King Cetshwayo. Father and daughter Swedish missionaries, the Witts, are his guests of honour. A messenger interrupts the dance to report the Zulu victory at Isandlwana to the king, which Otto Witt translates to his daughter, Margrieta, as 'a massacre'. The Witts realise that their mission station at Rorke's Drift, which has become a field hospital for the British, is in danger of attack, and they leave hastily. An impetuous Zulu warrior grabs Margrieta but is summarily killed on Cetshwayo's orders. Returning to Rorke's Drift, an increasingly drunken and ranting Otto Witt tries to persuade the garrison to withdraw but to no avail. Henceforth Rorke's Drift becomes the tense locus of impending attack, and for the actions and thoughts of the small band of threatened Welsh and English soldiers. Much of the dialogue amongst the British officers and men concerns the pointlessness of war. The Zulu army then attacks the mission station, first strategically testing the defended position for the details of its disposition and firepower. With the help of a stampede of cattle, the small British garrison heroically defends the mission station, and wards off the attackers. With a salute and a song of tribute to the bravery of the redcoats, the powerful Zulu withdraw. The final voice-over proclaims the names of the eleven British soldiers subsequently awarded Victoria Crosses.

The film *Zulu Dawn*[3] (1980) focuses on the earlier battle of Isandlwana. It

opens to the spectacle of life at the residence of the Zulu king: energetic and exotic dance routines, the virile performance of a bull fight, and armed hand-to-hand combat culminating in the death of the defeated warrior. Scenes set in colonial Pietermaritzburg then introduce the various British officers: Lord Chelmsford, the aristocratic commander, and his staff; experienced local officers, such as Durnford and Vereker who are in charge of the corps of African volunteers; and Frances Colenso, outspoken daughter of the politically radical Bishop of Natal, who queries the rationale of the war. Back at the Zulu capital, a dignified and regal Cetshwayo receives a hostile ultimatum from Sir Bartle Frere, the British High Commissioner. The demands are that the king must demobilise his troops, and amend his laws. Cetshwayo refuses, and Frere declares war on the Zulu state. In the build-up to the war, Lord Chelmsford determines the strategy of attack and ignores advice from experienced local soldiers. Amid misunderstandings, ineptitude and confrontations in their camp, the British are defeated by the Zulu army at Isandlwana. In the closing scenes two officers of the regiment and the Natal volunteer Vereker try to save the colours. They are felled and the colours are seized by jubilant Zulu warriors. In a final dying gesture, Vereker shoots the bearer of the colours and they tumble from Zulu hands, ending up floating down the river.

Introduction

In January 1879, British forces, supported by colonial volunteers from neighbouring Natal, invaded the independent Zulu kingdom as part of an effort to incorporate the Zulu into a proposed British-dominated South African confederation. Confederation was to be a key move in opening up the region to capitalist development. The continued existence of the powerful and independent Zulu kingdom was one of its biggest stumbling blocks.

On 22 January, the Zulu army defeated the central column of the British forces at Isandlwana. A small detachment of British troops held off a later Zulu attack at the mission station at nearby Rorke's Drift. The British offensive was effectively halted. In July of the same year, the British provoked and repulsed an attack near the royal homestead of Ulundi, and claimed a resounding victory over the Zulu who largely melted from the battlefield. The Zulu king, Cetshwayo, was subsequently captured and the British undertook to leave the land and cattle holdings of individual Zulu intact if the men returned to their homesteads, which by and large they did. These events ensured the collapse of centralised Zulu power, and contributed to the social and economic transformation of South Africa. The

Anglo-Zulu War was, as historian Richard Cope put it, by any measure the biggest war fought between black and white in South Africa, the most conspicuous episode in the exertion of British imperial power. It swung the balance of power in the region against the independent black kingdoms, thereby opening the way for white supremacy.[4]

Two events of the war, the defeat of the British at Isandlwana and their defence of Rorke's Drift, are the subject of epic films relished by millions of viewers around the world, from the time of their production until the present. Both films, *Zulu* and *Zulu Dawn*, have not only enjoyed wide popular appeal, but have also attracted substantial attention from film critics, historians and military enthusiasts, particularly Anglo-Zulu War aficionados. They continue to be screened on history channels and are widely used as teaching resources. In addition to their (varied) merits as films – with *Zulu* widely acclaimed for its cinematic interest, and *Zulu Dawn* generally disparaged – both are valuable resources in at least three different respects: they provide accessible and exciting entry points into specific events of the Anglo-Zulu War of 1879; they engage issues of the nature and practice of British imperialism; and they are examples of, and draw on, interpretations of the events of 1879. In other words, they raise questions about the historiography and analysis of the war. The films have also generated considerable debate as to whether they perpetuate, or criticise, the imperial and military attitudes and values that they represent on screen.

In this chapter we first locate each film within the three overlapping national settings germane to their production and contemporary public discourses: the United Kingdom, the United States and South Africa. We look at the UK as the point of origin of the production of both films, situating *Zulu* in the context of 1960s debates about British imperialism in the era of decolonisation, and *Zulu Dawn* in the context of an ongoing critique of imperialism and active engagement with issues of class that prevailed in the UK in the 1970s. We then consider both films in relation to debates about US participation in the Korean and Vietnamese wars, and the US as prime purveyor, and prime market, of the Hollywood-type epic. Third, we look at the effects on the films of filming on location in South Africa and that country's changing discourses and practices of racial domination.

We also examine the animated public lives of the films from the time of their inception to the present, noting persistent ambivalences in their reception and interpretation by scholars and non-specialist viewing publics: hailed by some as anti-imperialist and anti-war films, and criticised by others for endorsing imperialism (*Zulu*) and racism (both films). Our essay probes these ambivalences through an examination of the films' 'messages'. It explores the way both films reinforce or disrupt existing stereotypes of Zulus or British imperial

figures. Disruptions to such stereotypes are linked to the political orientations of the filmmakers, and to trends in contemporary British and American public discourses. Continuities – realised primarily, though not exclusively, in the iconographic treatment of the Zulus – are linked to the limitations of the available historiography at the time, contemporary denial of the salience of race in leftwing politics, entrenched and shifting South African political discourses and, finally, to the cinematic pleasures of the depiction of power and epic military engagements. Thus our essay emphasises in particular the public discourses framing and flowing from the production and 'take-up' of the films.[5] And it is our contention that their historical value is closely tied to the disruptions and continuities in stereotyping we have mentioned.

Analysing and explaining all of this has provided an opportunity for us to consider afresh the nature of historical film itself, not least the complex articulation of authenticity and aestheticisation. Building on the insights of film scholar Marcia Landy, we suggest that a critical feature of historical films lies in their capacity to portray ambiguities and contradictions in historically distant settings which enable forms of engagement, by analogy, with difficult matters and ambiguities of the present.

Zulu: production context, contemporary public discourses and critical reception

Zulu, an epic film made in a distinctively 'Hollywood' register, was produced in 1964 in the United Kingdom. It was directed by Cy Endfield,[6] who also collaborated in the writing of the script, and in the mobilisation of its finances. Politically radical, Endfield was branded a communist at a Congressional hearing in 1951. He left McCarthyist America along with a number of other American film directors, and took up residence in the UK, which was considered to offer greater scope for unrestrained film authorship and the articulation of socialist ideas.[7] This group of expatriate American film directors included Stanley Kubrick and was responsible for the production of a range of films critical of US warmongering.[8] Indeed, by the 1960s the patriotic epics of bravery that began in the Second World War in the context of the morally clear-cut struggle against Nazism had given way to a slew of films exploring the contradictions and pain of war. In certain contexts these films were overlaid with an agenda critical of American imperialism. Although very much a military epic, *Zulu* is ultimately precisely such a discourse on the futility of war. In a 2002 interview, Robert Porter, the film's second unit director, reflected on the contemporary political imperatives driving

the making of the film. He explicitly recalled the filmmakers as being attuned to debates about the Cold War, and as setting out to make an anti-war film.[9]

Zulu was inspired by an article on Rorke's Drift written by the popular history writer, passionate nationalist and Communist Party member, John Prebble.[10] Prebble's other work and political activities reveal an abiding interest in the class character of the United Kingdom and in Scottish nationalism.[11] In his novels and historical works, Prebble revealed a predilection for ordinary characters through which he launched biting critiques on British imperialism, the fate of indigenous peoples and the circumstances of wars.[12] In the early 1960s, the British left was buoyed by the decolonisation of Africa, and optimistic about the newly installed post-colonial governments. Anti-imperial sentiments pepper the screenplay of *Zulu*: in the comments of a Boer, Adendorf, to the British officers – 'The Zulus are my traditional enemies, but what are you doing here?' – as much as in the engineer Lt. John Chard's admission after the battle, 'I feel ashamed. I came to build a bridge.' Hints of a critique of class in *Zulu*, centred on the characterisation of the upper class Lt. Bromhead, echoed social comment on the class system present in a number of other British films of the period.[13]

Porter emphasised a further progressive intention – the filmmakers' active attempts to avoid the negative and stereotypical portrayals of 'native' peoples typical of many preceding films. Thus, early in the film, Witt says of the Zulu: 'They are a great people.' A key element in *Zulu*'s effort to challenge stereotypes lay in the film's attention to the organisation, discipline and strategy of the Zulu army. Adendorf offers an exposition on Zulu strategy, and we are shown how the Zulu army carefully tests the strength of the post, and adjusts its tactics accordingly. A central feature of the film's attempt to create a sense of human parity between the two warring sides, and one much remarked on, was the symbolic counterbalancing of a Zulu regimental song with a stirring Welsh response. Identifying an actively progressive stance in the film, Porter attributed it to Endfield and Prebble's ideological persuasions, pointing out that *Zulu* explicitly sought to address the matter of prejudice by allowing the British officer Bromhead to articulate a racist view typical of the 1870s, referring to the Zulu as 'fuzzies' and having these kinds of remarks directly challenged on screen by a local protagonist, Adendorf: 'Don't talk about them like that. They are just the same as you and I.'

Cy Endfield solicited the financial help of the actor Stanley Baker – himself Welsh and sympathetic to Prebble's nationalist views – and a handful of small investors, to finance the film. Through this financial commitment, Baker co-produced the film and landed the role of the affable Chard.[14] The 1960s saw the rise of independent producers responding to the emergence of what was seen as increasingly youthful, anti-establishment core audiences for the film industry, and producing films critical of establishment values. 'The British Empire sym-

bolized everything that the members of the young audience were deemed to be against', notably the ideas of being officers and gentlemen, and the key idea of deference.[15] As an independent film, *Zulu* thus had the advantage of rewriting imperial history for a new audience, one that was, in Britain, increasingly worried about the iniquities of the imperial project.[16] There remained limits on the revisions that were possible, however. As Porter noted, the forceful involvement of Joe Levine's production company, and its gearing towards US audiences, ultimately resulted in the (incomplete) excision of Zulu dialogue and substantial cuts in the display of Zulu military tactics present in the original script.

Zulu, filmed not at Rorke's Drift but in the Royal Natal National Park to the south, was also affected by prevailing conditions in South Africa. Porter recalled that the South African government did not like the script and claimed that they ensured that 'no Zulu was made out to be a hero'. Plainclothes police were based on set to monitor developments and to ensure that the Zulu crew and extras did not mix with their British counterparts. Filming depended on an array of permits and permissions from Pretoria, and a 'Bantu Affairs' official mediated access to Zululand. While some of Porter's remarks, made some forty years later, may well have been shaped by subsequent reception of the film, contemporary records indicate that such controls were typical.[17]

Filming in Natal was only one of a number of elements of *Zulu* that indicate both a strenuous attempt to produce historical authenticity and considerable engagement with the contemporary South African present. Chief Mangosuthu Buthelezi, then an emerging black leader, played the part of his own maternal grandfather, King Cetshwayo. Zulu extras were recruited from the local Zulu population and tutored in their 'traditional' dance routines, primarily through the good offices of Princess Magogo (Buthelezi's mother). Extras among the British forces consisted of men of the 4th South African Infantry Battalion. But despite the fact that the South African government provided substantial assistance in the making of the film, concerns about the possible effect of the South African connection on the box office meant that the producer opted to market the film as made in East Africa.[18]

While the film's attention to the military skill of the Zulu was indeed revisionist in its representation of native peoples, ethnographic spectacle was the central iconographic strategy in the depiction of the Zulu. A massed wedding dance, featuring bare-breasted maidens, is the viewer's first interior view of Zulu society. This was in keeping with even those contemporary South African films set in the present.[19] Indeed filmmakers in parts of Africa that had been decolonised were only just beginning to explore the possibilities of new cinematographic practices able to represent African subjectivity outside of a colonial vision.[20] The Zulus in *Zulu*, however, remain an undifferentiated, ethnogracised[21] mass.

Premièring in London in 1964, on the 85th anniversary of Rorke's Drift, *Zulu* was an instant hit, although interpretations of this success were divergent.[22] They range from claims that the feelings of shame expressed by the officers resonated with a turning point felt by the British public regarding their empire[23] – a reading close to the filmmakers' intentions (as subsequently recorded) – to the opposing view that it fed nostalgia for empire.[24] It is probable that this success had much to do with *Zulu*'s focus on a British war and British protagonists played by British actors. This positive reception was not replicated, at least not initially, in the US, a result exacerbated by poor distribution of the film. Beyond questions of national appeal and distribution, two opposing interpretations by film scholars have sought to explain the film's different fortunes on either side of the Atlantic. Sheldon Hall argued that American reviewers, alert to the ongoing civil rights debate in the US, were more conscious than British ones of ethical and political issues arising from the film.[25] In contrast, Kenneth Cameron drew a distinction between British and American interests in Africa, suggesting that because of slavery in the US, Africa was inextricably linked to American fear and guilt. Cameron's thesis was that such guilt was assuaged in the plethora of US films in which Africans were rendered as inhuman savages; American fear was assuaged by their defeat. *Zulu*, by way of contrast, offered neither of these resolutions.[26]

Public controversy accompanied the release of the film in South Africa, where it was shown only to white audiences and declared 'unfit for black consumption' by the Publications Control Board, possibly because it was deemed to be an incitement to violence.[27] The sheer power accorded to the Zulu in the film was thus widely recognised as a factor affecting the reception of the film.[28] Nonetheless, white South Africans flocked to see it, with officers from the Ministry of Defence present at the première.[29]

The initial reception in all three settings inaugurated an ongoing and vigorous debate – in the media, film publications, historical journals, on the internet and elsewhere – as to whether *Zulu* was an innovative, radical critique of imperialism or a pernicious, pro-imperial misrepresentation.[30] The film is so open to ambivalent readings that historian Jeffrey Richards initially classified *Zulu* as part of the 'Cinema of Empire' – defined as films that detail the attitudes, ideals and myths of British imperialism – and more specifically situated it as part of the second cycle in such films, those that depict the passing of the British Empire, usually with some nostalgia.[31] His substantive analysis of the film was, however, thin, and he subsequently re-interpreted *Zulu* as a critique of imperial values, and 'no straightforward triumphalist paean to the British Empire'.[32]

Historians evaluated the significance of instances of historical licence. In a 1996 description of the film as 'an unabashed appeal to the remnants of imperial sentiment', Frederick Hale argued that *Zulu* had substantially misrepresented the

Swedish missionaries in unsympathetic ways further to emphasise heroic British national character.[33] Analyses of *Zulu* that ignore numerous instances in the film that critique war, imperialism and their associated values are thus persistent and led, in 1995, to Jonathon Rosenbaum (another film scholar) explicitly denouncing the prevalence of this misreading.[34]

Yet, in terms of popular reception, *Zulu* continued to be hailed by nostalgic imperialists, Anglo-Zulu War aficionados, and military enthusiasts. On the other hand, it drew criticism for its silence on the imperial and expansionist ambitions of the British. Later in *Zulu*'s public life, both academic and popular criticism focused on the absence of a Zulu point of view (why were they attacking Rorke's Drift?)[35] and its treatment of the Zulus as an undifferentiated mass.[36]

These contradictions in the interpretation of the film merit further exploration. Nonetheless, it is a striking feature of the take-up that it has generated such intensive, ongoing public debate. This is, we suggest, an achievement of the film, and a source of its aesthetic power and widely proclaimed appeal. *Zulu* stages debate, entertains ambiguities, recognises the complexities of the human situation that it portrays, marks the fault lines of the imperial project, limits satisfying emotional closure, and thus invites the critical engagement that ensued.

Zulu Dawn: production context, contemporary public discourses and critical reception

Zulu Dawn, also a typically Hollywood-style film, displays a similar mix of reinforcement and qualification of stereotypes. This is partly because Cy Endfield was picking up where he had left off a decade earlier, collaborating on the script with Anthony Storey. But *Zulu Dawn* was the product of a different era and different production circumstances. With a British director, Douglas Hickox, this belated prequel to *Zulu* focused primarily on Isandlwana, a humiliating British defeat.

By the mid-1970s social radicalism was growing in the UK, evident in much of the contemporary cultural production including *Zulu Dawn*'s strong anti-imperialist sentiments, its sharp critique of aristocratic leadership, and its sympathy with the men on the ground. That radicalism was attested to in the filmmakers' stated desire to criticise the invasion of an independent kingdom and portray the Zulu protagonists in a complimentary light.[37] *Zulu Dawn* was also made at a time when, in the aftermath of the Vietnam War, American filmmakers were again questioning American imperialism, and probing the harsh realities of war and death. Set in a different imperial context and in a distant

time, *Zulu Dawn* echoed some of the sentiments and critiques developed in *The Deer Hunter* (1978), *Coming Home* (1978), *Apocalypse Now* (1979), and *The Killing Fields* (1984). Nate Kohn, *Zulu Dawn*'s American producer, also compared American and South African racial politics, describing South Africa as 'Memphis 1955', a place of privileged whites and repressed blacks where change could not be postponed indefinitely.[38] Hickox, while making the film, equated the British invasion of Zululand with Hitler's invasion of Poland.[39]

As in *Zulu*, these progressive inclinations were undermined by a failure to accord any Zulus fully developed screen roles. *Zulu Dawn*, in sharp contrast to *Zulu*, offers a clear account of the reasons for war. But British motives are primarily questioned by liberal white protagonists, the Colensos. A Zulu point of view, with the exception of the speech by King Cetshwayo rejecting the British ultimatum, eluded the makers. Film scholar Peter Davis notes that, for all his revisionist aims, producer Nate Kohn embarked on the film with an image of Africa as 'the dark continent'.[40] Hickox, imbued with cultural relativism, also came to the project with a visual archive of an essentialised, embodied African-ness, combined with a keen sense of Zulu power:

> I see the Zulu sequences in a very definite way. There's some photography in a book by Leni Riefenstahl, called *People of Kau*, that I thought was the most spectacularly exotic, beautiful black people photography I've ever seen. I asked the second unit … to capture that feeling for me … I see a very strong resemblance between the Zulu and the Samurai, the Kurosawa-style warrior. Their language is very aggressive and they act rather like Samurai. The English were a warrior race in those days as well, and that makes the contrast so interesting. In the film, I'm trying to counterpoint the two societies, their mores and behaviour patterns.[41]

The absence of individual Zulu experiences, so tellingly identified in *Zulu*, continued to plague *Zulu Dawn*. Indeed the depiction of the Zulu as an undifferentiated but potent mass is enhanced. Hickox again:

> I see the Zulu as a sea of black, as African ants, because when you look at the map and go to Isandlwana, you look at this sand table opposite the actual battle sites and you think 'Where are the Zulus?' because you can't see them. Then you realize that the entire half of the map that you think is just black surface is 24,000 Zulus. And then you have some sense of the sheer courage of the soldiers that were facing them.[42]

Long-focus lenses were used in the battle scenes 'in order to compress the hordes of Zulus charging toward the camera. "Piling them up" in this way made them look like a swarm of ants and created an eerie effect.'[43]

While *Zulu* was released in the same year as *Dingaka*, dubbed by Peter Davis as a South African (black and white male) 'buddy' film aimed at racial reconcili-

ation,[44] and largely in tune with this message, *Zulu Dawn* coincided with an era of low-level civil war and the local context of low-budget South African war films. Made mostly in Afrikaans, these were formulaic films focusing on border conflicts with anti-apartheid insurgents[45] that featured binary opposites: blacks against whites, good against bad and so forth.[46] *Zulu Dawn* offered very different perspectives for debate. Davis suggests that rewrites in the script were likely to have been influenced by the 1976 Soweto Uprising, 'which enforced respect worldwide for the courage of black South Africans'.[47]

If the film was influenced by shifting public perceptions of, and political discourse about, South Africa internationally, it was also shaped by multiple and shifting discourses within South Africa, as well as the extent of its production in South Africa. Permission for the making of the film was solicited from Buthelezi, by this time Chief Minister of the KwaZulu homeland. Buthelezi declined to play Cetshwayo again, but insisted that Zulus play Zulus. At this time, a growing 'appetite for power' was becoming evident in homeland politics.[48] In 1975, Buthelezi was instrumental in resuscitating the Inkatha movement to bolster traditional authorities and mobilise Zulu nationalism. Filmic presentation of the Zulu victory at Isandlwana was compatible with this nascent nationalist impulse. *Zulu Dawn* was also compatible with the contemporary sentiments of certain elements of white South African society that defended apartheid through reference to the intimacy of their knowledge of South African blacks. The film's settler sub-theme, while a useful device for mounting the critique of the upper-class officers, and of imperialism, was surely palatable to the South African authorities. This sub-theme also showed that local whites had a far better grasp of the unfolding conflict than the imperial officers, and in part reversed the defeat at Isandlwana when the local Natalian Vereker shoots dead the Zulu warrior who has carried off the regimental colours. A South African film company, Samarkand Productions, invested in the film. Despite its enormous budget (US$8.5 million), *Zulu Dawn* ran into financial trouble, generating a trail of unpaid local creditors.[49] These kinds of commercial pressures also encouraged the camera to focus on the costly foreign stars at the expense of the Zulu protagonists.[50]

Zulu Dawn constitutes a vivid instance of narrative elements open to different interpretations in different national settings. It did not enjoy the same critical acclaim and box-office success of *Zulu*. Nonetheless, the *South African Film and Entertainment Weekly* noted that reviews of the film were positive and that it was among the top ten money-earners at the London box office.[51] Ongoing website reviews indicate that it continues to be watched with considerable appreciation, notably by Anglo-Zulu War enthusiasts.[52] Overall, the anti-imperial message of *Zulu Dawn* was more clearly recognised by reviewers and other commentators than that of *Zulu*.[53] In *Zulu Dawn* the causes of the war were addressed directly, as

were the stupidity and arrogance of British officers and their strategies. Although the treatment of the British was less ambiguous in *Zulu Dawn*, the treatment of the Zulus was much the same, though the strategic capacities accorded the Zulu in the earlier film were now absent. Simon Sabela, who played the part of Cetshwayo in the later film, was enraged by this: 'The Zulus win the battle but what makes me angry is that the picture portrays them as not being strategic. This is absolute nonsense because King Shaka was one of the greatest strategists ... and if you know black history well, you should know that [Cetshwayo] was also a strategist.'[54] The profound ambiguities which mark *Zulu*, and constitute the substance of its aesthetic achievement, are absent in *Zulu Dawn*, which does not manage to engage fully the complexities of the human situation that it portrays. Yet, more strongly than *Zulu*, it marks the fault lines of the imperial project and resists satisfying emotional closure. Both films, to varying degrees, avoid key traps – singularity of interpretation, the elimination of doubt, and the suppression of critical engagement – that historians most frequently rue in historical films.[55]

Film and historiography

Both films explicitly bill themselves as historical, not only in their choice of subject, but also in their positioning by the filmmakers, their pursuit of historical authenticity and their claims to verisimilitude. As such they have elicited considerable discussion about their veracity. The historical accuracy of the films is discussed on numerous Anglo-Zulu War websites, while the History Channel's screenings include discussions with historians. Many amateur commentators are animated in their discussion of the historical accuracy of these films. It is not our purpose in this essay to review matters of accuracy of historical detail meticulously; this is the main focus of much material available elsewhere.[56] We are concerned rather with the nature and extent of the public discussion about such accuracy, and with certain facts and embellishments that we identify as significant in making these enduringly successful historical films. We further examine the way in which evaluation of the historical credibility of the films has shifted over time, in response to both new developments in the historiography and to changes in historical discourse.

In broad terms the portrayal of the war on screen in 1964 and 1980 did not differ significantly from the contemporary historiography of each period. In the early 1960s, Anglo-Zulu War historiography was negligible, with the bulk of historical information located in eyewitness narratives, reminiscences, published

anecdotes, adventure tales, field reports, official accounts and campaign histories, largely cast in a colonial or imperial frame. While Chelmsford's conduct of the war had been condemned in a 1936 account,[57] the imperial agenda had largely escaped scholarly critique. Zulu writings on the war, mostly highly critical and often published in Zulu-language publications, were ignored and thereby denied historiographical status.[58] In its depiction and strong indictment of British imperialism, *Zulu Dawn* was thus slightly in advance of the available historiography of even the late 1970s. The colonial narrative antagonistic to the class position of the men who prosecuted the war, which is registered in *Zulu Dawn*, and its portrayal of disorder and incompetence within the army, were themes only fleetingly evident in extant, imperially focused historiography.[59] What *was* available in published historical research was substantial detail about British and colonial uniforms, weapons, the logistics of war, tactics, training and popular accounts of events from a British perspective.[60] This provided plenty of material for the filmmakers to draw on in their depiction of the British forces.

The Zulu War had, by the 1970s, received remarkably little attention from either the established liberal historians or the new generation of radical historians. The liberal perspective, which highlighted the way in which the war was forced on the Zulu by the British as part of a policy of confederation, dealt cursorily with the topic.[61] In part, this was because the liberal perspective was concerned primarily with the interaction of the peoples of South Africa, by then so firmly divided by apartheid. The new radical history, instead, placed issues of political economy at the heart of historical change and drew attention to African agency. While the rise of the Zulu kingdom some fifty years earlier and the civil strife in the Zulu kingdom that followed the war were both substantially reinterpreted in terms of the new approach, the war was left to the attention of military historians.

Zulu Dawn was on the editing table when in 1979 *Reality*, an independently produced South African journal of liberal and radical opinion, marked the war's centenary with a special issue that explicitly challenged the dominant tenor of celebrations. This issue emphasised the extent to which interpretations of the war continued to be bound up with the romanticisation of imperial adventure: notably ideas of British 'civilisation' triumphing over Zulu 'savagery' and (irresponsible) power. These ideas were recycled as part of the justification of apartheid.[62] Essays highlighted the greed and hypocrisy of the British manoeuvring of the Zulu kingdom into war within a larger campaign of domination that ultimately reduced an independent people to an impoverished peasantry and underpaid wage-labour force. They drew attention not only to the terrible depredations of war experienced by the Zulu, but also to the trauma felt by ordinary British soldiers and the war-as-sport attitudes of their upper-class officers. Despite this

admittedly low-profile intervention, more of a call for a new historiography than a substantial new history, the imperial narrative has continued (with only isolated exceptions) to dominate Anglo-Zulu War historiography.[63]

Reality also highlighted the way in which the (non-Zulu) literature almost entirely ignored Zulu experiences of the war. African agency, so markedly absent in the films, was equally absent in contemporary historiography. Studies focusing on precolonial African achievements had swiftly followed independence in much of Africa north of the Limpopo. Similar studies were uncommon in apartheid South Africa. Donald Morris's *Washing of the Spears*, one of the first accounts to give attention to events within the Zulu kingdom, only appeared in 1966, two years after the release of *Zulu*, as did John Omer-Cooper's celebration of precolonial Zulu achievement, *The Zulu Aftermath: A Nineteenth Century Revolution in Bantu Africa*.[64] Zulu experiences and views of the war were only seriously investigated in the course of the 1980s, with a focus on how the Zulu army operated, and an assessment of its commanders and strategies.[65]

Zulu power, so compellingly evoked in both films, if scarcely explained, only became the object of sustained historical analysis in the 1980s. Where Morris and Omer-Cooper had provided detailed political histories, and described and celebrated Zulu power, Marxist historians in the 1980s began to analyse it, highlighting the establishment of royal controls over production and reproduction, achieved through the establishment of the regimental system. Expanding ivory, cattle and (more controversially) slave trading were identified as key factors in the rise of the Zulu kingdom. Close examinations of the workings of Zulu power revealed a highly stratified polity dominated by a central elite clearly distinguished from exploited, often denigrated, subjects and tributaries located at the margins of the kingdom.[66] Zulu imperialism, some of these later studies suggested, echoed the major features of British imperialism, indeed any imperialism. Such insights into the nature of Zulu power were simply not available to the filmmakers.

In both films the underlying causes of the war are largely ignored. The Isandlwana battle scene at the beginning of *Zulu* largely serves to introduce, rather than explain, the Rorke's Drift encounter. At most, it implies a level of Zulu hostility that made war inevitable. This lack of overt explanation is underscored by the repeated enquiries of the British foot soldiers about the reasons for the war. Their 'whys', pointedly, are never answered. In contrast, in *Zulu Dawn*, the war is preceded by Cetshwayo's insistence on the independence of the Zulu state. Here the garden party debate, between British proponents of war and supporters of the Zulus, enables viewers to question the colonial officials' rationalisations of the war – Cetshwayo as a violent, murdering barbarian, the Zulu nation as having no rationale other than that of war, the Colony of Natal as being in grave

danger – and asks the viewer to wonder why the war was fought at all. The historiography of the time offered little more: as late as 1998, Jeff Guy bitingly observed that 'at the level of historical understanding the literature remains banal'.[67] The first serious, full-scale analysis of the war's origins only finally appeared in 1999 – Richard Cope's *Ploughshare of War*.[68] On most issues of substance, then, the two films were either faithful to, or in advance of, the written history of their respective times. As the historiography developed, however, the evaluation of the historical accuracy and value of the films has shifted accordingly.

Film scholar Marcia Landy argues that films that take history as their subject, foregrounding it conspicuously and self-consciously, employ it for propaganda, analysis or spectacle.[69] In both *Zulu* and *Zulu Dawn* we see all three to varying degrees: we discern anti-imperial agendas (the 'propaganda'), engagements with the meaning of war (the 'analysis'), and the utilisation of military and ethnographic spectacle. But neither film is confined to these effects. While *Zulu* and *Zulu Dawn* take war and empire as their subjects, they do not fully satisfy the characteristics of war and empire films.[70] In these genres the myths of national identity and patriotism are typically embodied in a male protagonist who overcomes some threat to the posited national order. Neither film is patriotic in that way. Both films are rather about the futility of war even as they rely on and deploy the spectacle of war. Both films call the myth of empire into question, even as they dramatise it. They are films with divided allegiances. Landy identifies this as a characteristic of the genre film, that is of films with formalised modes of narration, distinct and known circuits of exchange between producers, directors, stars and their audiences. 'The experience of a genre film is akin to the workings of common sense. The world presented to the spectator is not a totality, but a composite of different and often conflicting attitudes, a collage of beliefs. Hence, the appeal of these texts must reside in their capacity to evoke central contradictions concerning attitudes, values and behaviours.'[71]

So why, then, did the makers of our two films choose (particular events in) the Zulu War through which to accomplish the combined tasks of questioning war and critiquing imperialism while still exploiting war's cinematic potential? It is our proposition that, at least in part, the focus on Rorke's Drift and Isandlwana was connected to the possibilities that they provided for representing war and imperial domination in ambiguous ways. This possibility was enhanced by two key historical embellishments in the closing scenes of each film that are not reflected in the historical record. We suggest that these two embellishments, together with an insistent representation of Zulu power, are central devices in the staging of ambiguity and the evocation of contradiction. In *Zulu*, there is the embellishment of having the Zulu salute their foes and retreat in the face of the bravery of the redcoats at Rorke's Drift; and in *Zulu Dawn* there is the fictional

detail of the Natalian volunteer Vereker shooting dead the Zulu warrior who had seized the fallen colours that Vereker and two officers of the regiment had failed to save. In each case, the embellishment complicates the standard reading of the historical event. Rorke's Drift has typically been represented as a moment of exceptional imperial bravery; but the salute emphasises the Zulu withdrawal and ennobles the Zulu foe. Isandlwana has symbolised imperial humiliation; but the embellishment retrieves a remnant of colonial (perhaps more accurately, settler) power. The meanings and effects of these complications lie at the heart of the ambiguities that characterise both films, leavening their ongoing public appeal and their openness to public debate.

The engagements of Rorke's Drift and Isandlwana were impaled at the nerve centre of contemporary colonial anxieties about defeat and victory. Rorke's Drift was an ephemeral victory – the post could not have withstood a full, or even a further, Zulu attack – and was, in the greater scheme of things, a largely irrelevant encounter of the war. Isandlwana was an unimaginable defeat for the mighty British army. In their active take-up of these particular historical events, and in making the encounters of Rorke's Drift and Isandlwana stand for the entire war, the two films both focused on the fragility of the colonial project. In so doing, however, and we need to note this, they effaced the brutal reality of the subjugation of the Zulu.

A depiction of Zulu power was necessary to show colonial vulnerability, but a simple inversion of previous stereotypes was avoided by allowing individual bravery to prevail. Likewise, the depiction of Zulu power also permitted the filmmakers to avoid yet another stereotype, that of 'native' victims. The clear representation of Zulu power in the face of imperial might in the films and the two embellishments all work to complicate simple binaries of defender and attacker, savagery and civilisation, good and bad.

The Anglo-Zulu War lent itself to a critique of imperialism characterised by countless ambiguities precisely because it was one of only a few imperial conflicts where the colonised entered a statement of their power firmly into the historical record: the Zulu did indeed beat the marshalled British army in battle.[72] The filmmakers were presented with the challenge of how to portray that power beyond the mere testament of victory. Where the available historiography was unable to flesh out the workings of Zulu power, the available iconography had much to offer, and was used in potent but also limited ways to underwrite the two inversions of stereotype and to effect the ambiguities of interpretation.

Ethnogracised, exoticised and rendered as powerful: Zulu stereotypes on film

In the first instance, the titles *Zulu* and *Zulu Dawn* beckon viewers to stories focused on Zulus, gestures repeated, and modified over time, on many of the posters and other promotional materials.[73] The allure of the name 'Zulu' was clearly an international attraction, but while the Zulus (or perhaps more accurately Zulu power) provide a critically important backdrop, the two films are primarily about British participation and personal heroism in the war: whether this be the garrison at Rorke's Drift, nervously awaiting the Zulu, and the voice-over narration listing winners of the Victoria Cross (in *Zulu*), or the deployment of Lord Chelmsford's forces (*Zulu Dawn*). Although quibbles persist about the details of both films' depiction of the British, there is much that can be appreciated in their overall portrayals of late-Victorian modes of colonial behaviour and imperial culture that this focus allows.

But the successful exploration of the human side of war is not extended to the Zulu. The portrayal of fallibility or achievement by individual Zulus is all but absent. The characterisation of King Cetshwayo is the only exception to this effacement of Zulu agency. In *Zulu Dawn*, Cetshwayo, exotically marked by his *isicoco* (the Zulu head-ring symbolising seniority among the Zulu) and other accoutrements of royalty, stands proudly before his admiring subjects. When told of the demands and imminent attack by the British forces, he argues cogently for the independence of the Zulu state and declares his readiness to fight for this freedom. The low-angle shot unambiguously establishes him as powerful. The representation of his body, apparel and bearing gives him weight within the film's narrative. Yet his undeniable dignity is thwarted by *Zulu Dawn*'s portrayal of his darker side: the wanton manner in which he orders the killing of a defeated combatant. Overall, *Zulu Dawn* ambiguously portrays Cetshwayo as both brave and barbaric – qualities that have been consistently attributed to the Zulu. *Zulu*'s Cetshwayo is represented in similar manner: with his barbarism in this case rendered through an order to kill a young warrior simply for attempting to prevent the missionary's daughter from departing. Ultimately Cetshwayo's character remains elusive and undeveloped in both films. But at least he is given a few lines to speak for himself: in general, whites – whether Frances Colenso, local farmers or officers, people who 'know the Zulu' – speak on their behalf. And there is a sharp contrast between the dialogue-filled British camps and the (dialogue-light) mass activity of the Zulu camps.

In part, as we have seen, the absence of Zulu experience in the films reflected

contemporary absences in the historiography. Historical analyses of tensions within the Zulu military establishment, or detailed accounts of the political activities of educated Christian Zulus – who played significant roles in the politics of Zululand–Natal at the time of the war – were not available to the filmmakers. That they did not employ artistic licence to fill these gaps is significant given the filmmakers' statements that they sought to do justice to the Zulu and to portray the two sides as culturally equal.

A number of latter-day commentators suggest that this treatment of the Zulu is the result of the continued sway of deep-seated racial stereotypes. Peter Davis placed both *Zulu* and *Zulu Dawn* in a long line of 'Zuluology' films, defined as 'the white myth of the Zulu; the equation of the Zulus with the wild animals of Africa; the domestication of these creatures; the Zulus as the prototypical "African tribe"; the political uses of the Zulu image.'[74] Davis's analysis rightly and remorselessly exposes such stereotypes and racism in 20th-century films about or involving Zulus. Embedded in his analysis, however, are numerous details about differentiation and changes in those stereotypes that he makes surprisingly little of. These substantially modulate his own central thesis of a continuous and determinedly tribal 'Zuluology'.[75]

Remarkably, Davis does not address the overt assertions of Zulu power that constitute the essential backdrop to both films. While comprehensive analyses of Zulu power were not available in the contemporary historiography, the image of the Zulu as powerful had a well-established lineage in literary texts and in political discourse, which Davis does not acknowledge. The novels of Henry Rider Haggard, which more than any other source were responsible for establishing the literary image of the Zulu, presented the Zulu not simply as fearsome, but as powerful, disciplined, well organised, strategic and, notably, (often) as individuals. The historical plays and novels of black intellectuals writing in the early and mid-20th century also presented a view of the Zulu kingdom as ordered, innovative and powerful (again developing the characters of individual Zulu personalities).[76] Ideas about ordered Zulu power were not confined to literature: they were researched by successive native administrations seeking a model on which to base their own authority.[77] Well into the 20th century the head of the South African 'Native Affairs Department' continued to function as the Supreme Chief and to be so designated, while the system of administration itself retained key features of an original Natal version, ostensibly modelled on the Zulu.[78]

By the late 1930s, and following the passing of the 1936 segregationist Hertzog Native Bills, a different political discourse began to emerge in South Africa, one that configured the African inhabitants of South Africa in terms of their ethnic heritage and ultimately sequestered them in ethnically separate homelands, literally marking off sections of the map of South Africa as 'black'. By this time,

Africans were the object of an intensive ethnological project that represented them as culturally isolated, traditional, rural and as lying outside of history. It was a new political discourse filled with the kinds of racial stereotypes identified by Davis, but was also one in which the idea of the Zulu as the well-organised, autocratic model for native rule was still present.

In these respects both films are complex products of layered and shifting South African political discourses that intersected with more general international stereotypes. If the 20th-century notion of pre-industrial sub-Saharan Africa was one of jungle, darkness, primitivism and savagery, the inherited notion of the Zulu was somewhat different: it was an image of power, heroism, bravery and nobility. Nonetheless, in the making of the films, the transitions in South African political discourse to an idea of timeless, traditional yet powerful Zulus fused readily with the more generic, colonially rooted international stereotypes about Africa. Ideas about the location of Zulus in the natural realm of wildness crowded the imagination of the producer's mind when making *Zulu Dawn*. Nate Kohn confessed his attraction to a mythologised view of Africa: 'I knew nothing about Africa, and virtually nothing about Zulus … In short, if I was expecting anything, it was jungles, apes, elephants, lions and natives. I was prepared for adventure and wild fantasies filled my head.'[79] Vague stereotypes of this kind about Africa blended with the highly particular images of the Zulu forged within South African political and literary discourse, as noted above. They were underwritten by notions of authentic tradition promoted by Zulu leaders like Buthelezi, and given further visual form by the wartime graphics from the *Illustrated London News*,[80] the primary contemporary visual archive used by the filmmakers.

This blending of the images underpins the iconographic treatment of the Zulus in the two films: it paints the Zulus in a heavily militant corporeal schema, and repeats the strategy of presenting Cetshwayo's character primarily in terms of his bodily form. The Zulu are consistently imagined as warlike, strong and always regimented. In the early scenes of the films, mass dance routines inaugurate a palpable iconography of moving bodies. The perfect regimental rhythms add little to the narrative beyond entertainment but, most importantly, they do also convey visceral power that enables both films to portray ambiguity and contradiction.

In *Zulu*, the camera's voyeuristic motions in the dance sequence are paralleled by the missionary's anthropological elucidation. When his daughter queries the age differences between the warriors and their brides, Witt compares the practice to that of rich men marrying younger girls in Europe. This cross-cultural approach[81] attributes primary qualities of bravery to the Zulus and those of wealth to the Europeans. It inaugurates the film's subsuming of multiple characteristics among the Zulu into a generalised depiction of Zulus as brave and mili-

taristic: a view that underpinned Sir Bartle Frere's analysis in *Zulu Dawn*: 'Every Zulu is raised to be a warrior. Without war there would be no Zulu nation.' Thus in both films our introduction to the Zulu is anthropological and voyeuristic, echoing key features of the 'real' colonial encounter. But even these windows on cultural life are framed in a military idiom that is directly continuous with the militarised bodies in the ensuing battle scenes. In short, the main way that both films attempt to portray the Zulu, and Zulu perspectives, in a favourable light was through the depiction of Zulu power, primarily rendered iconographically. If individual Zulus are absent in the films, *en masse* 'the Zulu' loom large. In their collective bravery and militarisation, they constitute an essential validating backdrop to ambiguities at the heart of both films.

Perhaps the strongest indication of this, of how a depiction of Zulu power enables ambiguity in the films, comes from the contrast in *Zulu* between the opening and last scenes. In the former, a Zulu warrior's walk among the wreckage and corpses at Isandlwana culminates in his heroic hoisting of a Zulu shield and a British gun. In the last scene, Lt. Chard plants a Zulu shield in the ground, an ambiguous gesture. In view of the opening scene's depiction of Zulu appropriation of the symbol of British power, this might be registering – through their control of a key Zulu symbol – the inevitability of British hegemony. Another reading is, however, latent in the scene: a recognition of Zulu power and the Zulu right over the land. Thus *Zulu* concedes that the imperial project was wrong but allows for individual British honour – validated by both the Zulu salute and the awarding of the eleven Victoria Crosses. Such a tactic has been widely deployed in post-1960s cinema. It enables viewers to applaud the portrayal of individual honour in films that otherwise appear to critique war and imperialism, and are intended to persuade the viewer to reject them – even if the viewers themselves have been implicated in such practices.

The bravery and the power of the Zulu as depicted on screen not only make the effacement of the ultimate impact of the war possible, they provide an occasion for the experience of the pleasure of power not present in the films' depiction of British experiences, yet a key ingredient in the appeal of war films. That the left-leaning filmmakers and scriptwriters, with their anti-imperial orientations, did not manage to slip the harness of a profoundly racial iconography in relation to their Zulu subjects is not surprising. Paul Gilroy's work on the relationship between race, class and nation in the UK demonstrates powerfully how racial prejudice transcended the left–right political divide. Both films were made at a time when left-wing thinking showed little inclination to engage with critical questions around race. Gilroy points to the pernicious persistence of ideas about blacks as either constituting a problem or, alternatively, as perpetual victims rather than fully fledged subjects in their own right. It is Gilroy's central conten-

tion that 'racism rests on the ability to contain blacks in the present, to repress and to deny the past'.[82] In part the ethnographic strategies in the films fall victim to precisely these tendencies, notably their failure to deal with the rationale for, and the consequences of, the war for Zulus. Nonetheless, the assertion of Zulu power qualifies the idea of perpetual victim status.

―

Authenticity, invention and art in historical film

Robert Rosenstone has argued that historians believe that the key issue in relation to historical films is the matter of judging 'inventions' that are necessarily involved in any film. Rosenstone, who is alert to the extent to which all written history is as much a representation as historical film, but validates professional historians' practices of seeking evidence and presenting it in footnotes, proposes a distinction between 'true' and 'false' inventions in historical films: inventions that either engage with the discourse of history or ignore it. His approach seeks to gauge whether meaningful history occurs on screen and assumes that the purpose of the historical film is to provide a valid reflection of the past.

Our study shows that the two films were sophisticated engagements with the discourses of (professional and extra-professional) history that prevailed at the time of their making, occasionally even reaching beyond the limitations of those discourses. Both films have continued to engage, and be engaged by, (various) discourses of history. The relationship is not a fixed one. Subsequent historiographical developments – notably, extensive research into aspects of Zulu political and military history, the causes and effects of the war, and divisions and power struggles within the Zulu kingdom – have highlighted the shortcomings in the films' depiction of Zulu perspectives of the war. The discourses of history, as well as the films themselves (despite their overt appearance as static, fixed texts), have also shifted over time, partly in response to one another and partly in relation to the publics that they continuously call into being. The two key inventions, or embellishments as we have termed them, continue to elude categorisation in Rosenstone's terms. Neither obviously 'false' nor 'true', they are rather devices for the staging of ambiguity and for foregrounding contradiction, and thereby invite sustained public engagement.

Such points persuade us to enquire what other purposes lie behind the making and viewing of historical films beyond a desire to offer meaningful history or think about what really happened in the past. Marcia Landy argues that the aim of historical film is rarely the objective and accurate re-creation of the past. She goes on to make a point that is strongly borne out in our analyses of *Zulu* and

Zulu Dawn: that a film's selection of a past moment is linked to a critique of the present. 'The crux', Landy argues, 'is not to seek a correspondence with factual events but more generally to explore how the films conform to or disrupt popular discourse.'[83]

Our material allows us to extend Landy's observations and suggest that, in at least some instances, filmmakers use the peculiar device of the historical film to enable consideration of a particularly demanding issue of the present in a (sometimes distant) past setting in which the viewer has a diminished or different investment. Tim Dirks[84] notes that none of the Vietnam films made in the aftermath of the Vietnam War used the name 'Vietnam' in their titles. The historical film creates a distance from the current circumstances of the intellectual intervention that these films sought to make: the action is distant in place and time, thereby permitting a more radical critique to be made by analogy.

Just as the status of the historical film as 'not now' is central to its ability to engage difficult areas of contemporary public discourse, so too is its status as an art form – as opposed to a truth discourse in the way that written professional history positions itself – central to its effect. Historical settings are often romantic and engaging, thereby luring the viewer into discourses and debates that might otherwise be resisted. Indeed, as the film scholars have observed, the huge images on screen and the surround sound overwhelm the viewer, swamp the senses and undermine any attempts to remain aloof and distanced. Historical films thus set up an analogy between past and present at the level of feeling and emotion. For some 100 minutes the viewer lives historically the same issues that she or he lives outside the cinema.[85] The arguments about wars and imperialism are experienced palpably. The aesthetic power of the films is linked to their capacity to entertain and to explore ambiguity, and in that exploration to unsettle some of the dominant ideas of the time.

For the tactic of the historical film to work as a setting for thinking through present issues, its status as 'not fiction' is equally significant. For that reason, its claims to historical accuracy are critical to its work as public discourse by analogy. This alerts us to one of the roles of history, in whatever medium, as a way of pursuing conversations about the present and in providing a particular kind of venue and materials for debating the nature of the human condition. Historical films do this in ways that call into being huge, and varied, 'publics', who utilise that forum in different ways in different places and in different times. Where historical films transcend discrete national public spheres, either in their making or their reception, and deliver multiple messages – and this is the case with both *Zulu* and *Zulu Dawn* – initially the scripts, and later the film texts and the linked public discourses, travel along international networks of circulation, being refashioned, repackaged and re-argued as they travel.

The publics[86] that viewed these films, and were transported by them into the historical worlds they conjured, then debated these films. Our survey of those debates suggests that the participants were also debating themselves and their own present histories. The moments of abstraction in public discussion which these two historical films effected are ones that were initially only inviting to viewers who identified with the position of having an historical legacy of being imperialist, whether recently or in a more remote ancestral past. They debated their relationship to an imperial past, and by analogy considered their relationship to present acts of domination. The films did not readily invite the participation in that debate of viewers who may have a heritage or an experience as the subjects of imperialism. The pleasure in the power of the Zulus that the two films license is a moderated pleasure for those who might seek to identify directly with the Zulu, looking for personalities, heroes and a common humanity. Publics of the once colonially subaltern were thus not readily called into being by either film.

However, because the public lives of these films are not confined to the times of their making and primary reception, we note that the issues of 'the now' which the films engage shift over time. This allows us to build on Landy's observations in another way, to point out that the films have ongoing public lives, conforming to, intersecting with and disrupting public discourses in different ways and places as those lives develop. The 21st-century viewer does not approach the films from within the context of the aftermath of the Korean and Vietnam wars, although at certain moments such a viewer might well engage the Anglo-Zulu War from within the aftermath of latter-day war experiences, and might similarly benefit from the deferral to another space and time. In addition, over time, the two films reviewed here have also become embroiled in debates in the public domain that are not about war and imperialism, but rather about the representation of race. At this point in their public lives, the two films do call into being a new critical public, that of the once colonially subordinate, or those who identify with that position.

In spite of their being cast as a massed collectivity, the visual impression of the Zulus in the two films was, at the time of their making, a significant detour from the usual practice in the representation of Africans in Hollywood-style films. Both films displaced earlier patterns primarily in their treatment of the Zulu as powerful and admirable. In this, they marked a break with earlier Hollywood stereotypes of Africans but drew on a well-established element in the imaging of the Zulu, rooted both in literature and in colonial and later apartheid political discourse. The films disturbed the certitudes of empire as presented in earlier films. They intimated the historical fragilities of the colonial project.

Their critique was, however, one that initially invited the descendants of

imperialists to rethink themselves and their inheritance, and did not critically engage the experience of the colonised. In the strongly post-colonial setting of the early 21st-century, this gap has become the object of a critique about the representation of race, in terms of which the films experience new public lives as artefacts of their times. In their attempts to stage ambiguity around questions of war and imperialism, the makers of both films made the idea and image of Zulu power central to their films. It was paradoxically an idea also central to the model of South African racial domination and was itself rooted in the very colonial encounter that was the films' subject. It is the power of this paradox that continues to animate the public lives of these two historical films today.

7

Breaker Morant:
an African war through an Australian lens

RICHARD MENDELSOHN

'Pietersburg. Transvaal. South Africa. November 1901.'[1] The protracted South African War is in its third year. As explanatory titles at the start of *Breaker Morant* tell us, the 'British forces uneasily occupied most Boer territory, but had difficulty winning an outright victory because of mobile Boer guerrilla forces'. Three Australian officers – Lieutenants Harry 'Breaker' Morant, Peter Handcock and George Witton – of a counter-guerrilla unit, the Bushveldt Carbineers, are on trial before a British military court martial for the killing of Boer prisoners. Morant and Handcock are also charged with the murder of a German missionary. Their defence for the killing of the Boers: verbal orders from Lord Kitchener, the British Commander-in-Chief in South Africa, to take no prisoners, orders headquarters denies ever issuing. Through evidence led in the spartan military courtroom and through flashbacks, we see Morant's descent, under the pressures of fighting a guerrilla war and through the trauma of losing a close friend, into a moral quagmire.

After the death of his friend Captain Hunt in an abortive assault on a party of Boers holed up in a farmstead, and the subsequent discovery of his mutilated corpse, Breaker Morant sets out on a bloody trail of vengeance. Overhauling the fleeing Boers, Morant orders the summary execution of a Boer prisoner caught wearing Hunt's clothes. Later a group of six Boers who come into Morant's base to surrender under a white flag are shot on Morant's command. A German missionary, a potential witness to the killing of these prisoners, is ambushed and killed to cover up the crime.

All three of the accused are convicted for the killing of the Boer prisoners. Morant and Handcock are found not guilty of murdering the missionary, though Handcock secretly confesses to the deed. The two are executed by firing squad.

Breaker Morant is an Australian account of a minor but much ballyhooed incident in the South African War of 1899–1902: the court martial and execution of a pair of Australian volunteers, Lieutenants Harry 'Breaker' Morant and Peter Handcock, for the murder of Boer prisoners. Shot on location in South Australia[2] and released in 1980, the film, a popular and critical success,[3] was directed by Bruce Beresford, then at an early stage of a distinguished directing career. Beresford was one of the leading figures in the New Australian Cinema, the revival of the Australian film industry in the mid-1970s after decades of torpor, a film-making renaissance characterised by the production of Australian period pieces, of 'history' films set in the 19th or early 20th centuries.[4]

Made with substantial public funding from the South Australian Film Corporation, the Beresford film had a largely Australian cast,[5] the principal exception being the English television actor Edward Woodward,[6] in the title role. Given the circumstances of its production it is not surprising that the film's preoccupations are distinctly Australian: its central concerns are the uneasy relationship between Britain, the imperial metropole, and its Australian colony, and the emergence of an Australian identity separate from that of the mother country, rather than the South African past.[7] Produced in an era when Australians were reconsidering the character of an increasingly multicultural society that had begun to turn its gaze from Britain to Asia, the film depicted an earlier age when the citizens of the newly created (1901) Australian Commonwealth, self-governing but still tied to the British Empire, had started to assert a robust 'Australianness' alongside their continuing imperial loyalty. But for all of its Australian character and concerns, for all its exploitation of Africa as a vehicle essentially for exploring the Australian past, the film is nevertheless a welcome filmic introduction to an African war that, despite its historical significance and the rich historical literature it has generated,[8] has attracted scant attention from feature film directors in recent decades.[9] Through its absences as much as its actual content, this singular portrayal of the South African War raises important questions about the character of a major African conflict.

The South African War had its origins – barely alluded to in the Beresford film[10] – in the discovery of gold on the Witwatersrand in 1886 and the revolution this threatened in the balance of power in a region of strategic sensitivity to the British Empire. The consequent rise of Paul Kruger's South African Republic (a.k.a. the Transvaal) posed a challenge to British hegemony in southern Africa that culminated in a march to war in October 1899, led by imperial politicians and officials bent on preserving British supremacy on the sub-continent. Begun in a giddy mood of imperial over-confidence and an expectation that the struggle

against a supposedly inferior foe of ill-trained and ill-disciplined Boer civilians-in-arms would be over by Christmas, the war instead provoked an imperial crisis. Astonishingly, the underrated Boers inflicted a stinging and humiliating succession of defeats on the British army. In the Empire's hour of need, volunteers in their thousands rallied to the colours from both the metropole and its loyal colonies of settlement, Australia, New Zealand and Canada. Numbering some 16 600, the Australian contingent – including Morant and Handcock – would do little to distinguish itself other than earning a reputation for public rowdiness.[11]

The reinforced imperial army, under fresh and more vigorous leadership by Field Marshal Lord Roberts and his deputy, Viscount Kitchener of Khartoum, turned the tide of the war and forced its way through the Boer republics, capturing Bloemfontein, the capital of the Orange Free State, in March 1900, and Pretoria, the capital of the South African Republic, in June 1900. The British commanders in South Africa assumed, wrongly, that the war was effectively over, that with the Boer capitals occupied and their armies in desperate retreat, the enemy would surrender. Instead, the war would continue for a further two years, ending only with the Treaty of Vereeniging on 31 May 1902. The Boers who remained in the field – the *bittereinders*, literally bitter-enders – scattered through the countryside and launched a fierce guerrilla campaign to which they were particularly well-suited. The Boer commandos – Boer fighting units rather than elite warriors in the modern sense as Beresford's film misleadingly suggests – combined horsemanship and marksmanship with knowledge of the terrain. The British were hard-pressed to match the mobility and fieldcraft of their elusive die-hard opponents. To wear down Boer resistance, Lord Kitchener, successor to Lord Roberts as British commander in South Africa, resorted to extreme measures, highly controversial 'scorched earth' tactics – 'methods of barbarism' as the leader of the opposition Liberal Party in Britain branded them – calculated to clear the countryside and thus to deny the Boer guerrillas their rural sanctuaries.[12] Farms were systematically burnt, crops, herds and flocks seized or destroyed, and Boer women and children – as well as many black families – driven into grossly mismanaged 'concentration camps' where large numbers died of infectious diseases.[13] To restrict the mobility of the commandos Kitchener constructed a dense web of blockhouses, guard posts linked with barbed wire; within the enclosed spaces this created, Boer commandos were pursued by columns of British troops and were harried by mounted counter-guerrilla forces whose ranks included significant numbers of Boers who had changed sides.

The ultimate effect of these attritional tactics was gradually to erode the *bittereinders'* capacity to continue their struggle, and by May 1902, after more than a year and a half of guerrilla war, their leadership – fearful of the fate of the Boer women and children trapped in the British concentration camps and of the

mounting restiveness and hostility of the formerly subordinate black population of the ex-republics[14] – were willing to consider terms. Anxious to end what had become an agonisingly protracted, unheroic and messy conflict, the British granted generous terms which effectively restored the defeated Boers, within a relatively short period of time after the coming of peace, to political and social power in what were now British colonies.

Breaker Morant's subject matter is a marginal historical episode[15] during the drawn-out and gruelling unconventional phase of the South Africa War, a tragic series of events in the remote and rugged Spelonken district of the northern Transvaal beyond the small town of Pietersburg and far to the north of Pretoria and Johannesburg, the main centres of population, administration and industry. These events involved members of the Bushveldt Carbineers, an irregular mounted corps established by the British early in 1901. Like other similar units, the Carbineers regiment was created to counter the Boer insurgents roaming the countryside, wrecking trains and launching hit and run raids. Many – though not the majority as the Beresford film suggests – of the members of this unit were 'time-expired' Australian soldiers, skilled horsemen who had served previously in the volunteer Australian contingents recruited to fight in the earlier conventional phase of this imperial war. They had subsequently been induced to remain in South Africa after the expiry of their period of original enlistment and serve in the Bushveldt Carbineers for 7/- a day, well above the going rate in regular units and especially attractive considering the uncertain prospects of employment once back home in Australia.

In mid-1901 a detachment of the Bushveldt Carbineers, led by Lieutenant Harry 'Breaker' Morant, went on a killing spree that included the execution of an injured Boer prisoner after what barely passed for a drumhead court martial; the killing of eight Boers who had come in to surrender under a white flag; and the murder of a missionary of German descent, the Reverend Daniel Heese – not Hess as in the Beresford film – who was a potential witness to the slaying of the eight surrendered Boers. These illicit killings, ordered it seems by Lieutenant Morant, were revenge killings, provoked by the death in action of Morant's commanding officer, Captain Frederick (Simon in the film) Hunt, a close personal friend. Hunt's body had been recovered by his troops, allegedly in a badly mutilated state, after a botched attack on a group of Boer guerrillas.

Following a petition denouncing their officers by fifteen members of the Bushveldt Carbineers and a painstaking investigation conducted by a fellow Australian officer – both conveniently ignored in Beresford's film – Morant and two of his subordinate officers, Lieutenants Peter Handcock and George Witton, were brought before a court martial in Pietersburg in January 1902. Morant and Handcock were convicted – and sentenced to death – on the charges relat-

ing to the killing of the Boer prisoners but were found not guilty of murdering the 'German' missionary. Witton, a hapless lesser figure who had become entangled in Morant and Handcock's murderous escapades, was also sentenced to death. Despite a recommendation of mercy by the court martial, Handcock and Morant's death sentences were confirmed by Lord Kitchener and they were executed, without any delay, by firing squad in Pietersburg on 27 February 1902. Witton's death sentence was commuted to penal servitude for life on the grounds that he was unduly influenced by the other two, but even this was drastically curtailed after a public outcry both in Australia and South Africa. Witton was released in August 1904 after serving little more than two years of hard labour in England.

At the centre of the episode – and of the Beresford film – stands the dominating presence of Harry Harbord 'Breaker' Morant, who, wrote Lord Kitchener, had 'originated [the] crimes'.[16] Morant is a mysterious and intriguing figure of uncertain origins. He represented himself as the scion of an upper-class English family, the disgraced son of an English admiral, dispatched to Australia as a young man because of some unspecified shameful deed. It's more than possible, scholars maintain, that this was self-invention and that he was in fact Edwin Henry Murant, son of a humble English workhouse-keeper.[17] Whatever the truth about his origins – and the Beresford film subscribes to Morant's own, self-aggrandising version – he won a great reputation in the Australian bush as the breaker of wild horses, hence his nickname, and also as a balladeer, a popular rhymester, member of a school of 'bush poets' regularly published in a Sydney newspaper, *The Bulletin*. (Morant's vigorous ballads have a Kiplingesque quality, with shades of Byron, his favourite poet.) At something of an impasse in his unsettled life, Morant had volunteered like his co-accused and thousands of fellow Australians for the imperial war in South Africa. Serving in the ranks during his initial period of enlistment, he had secured a commission in the ill-fated Bushveldt Carbineers after his re-enlistment.

Edward Woodward plays Morant in the film as Morant would probably have chosen to play himself, indeed as it appears the self-inventing Morant played Morant in real life: as a dashing romantic hero, a man of two worlds, of genteel English origins but fully at home in the rugged, masculine culture of the Australian outback, a brave and honest if ruthless soldier at odds with the hypocrisy of his (British) superior officers. There is little hint in this impersonation of anything darker, more sinister or morally ambiguous.

The film builds its case for Australian victimhood[18] and imperial duplicity upon this one-sided and sanitised presentation of its central character, on a heroic and noble impersonation bound to persuade the audience of the essential justness of Morant's behaviour whatever military law and 'justice' might

otherwise decree. In so doing, Breaker Morant illustrates the centrality of character portrayal and performance in making historical arguments on film. This is equally evident in the film's casting and sympathetic characterisation of the co-accused. Bryan Brown, a 'ruggedly handsome Australian leading man',[19] plays Peter Handcock as a rough-and-ready countryman, earthy, cocky, defiant, contemptuous of (British) authority, humorous, comically ignorant, a 'larrikin' in Australian parlance. The third member of the accused trio, George Witton, played by the fresh-faced Lewis Fitz-Gerald, is portrayed in the film as a wide-eyed innocent, a sympathetic, idealistic and naïve foil to his older and more cynical co-accused.[20]

All three parts are written and played in a manner calculated to win audience – particularly Australian audience – sympathy and identification. The film's characterisations of the accused ensure a verdict of 'innocence' (or at least of justified killing) in the minds of the viewers whatever the actual outcome of the trial. Though the trio are convicted of murder, of the killing in cold blood of prisoners, the sympathetic portrayals and the script ensure that they win the moral argument.

Beresford's partisan interpretation of the case subscribes to an enduring myth that first surfaced soon after the actual events and that would persist for decades after. Three years after his release from jail George Witton published a book titled Scapegoats of the Empire: The True Story of Breaker Morant's Bushveldt Carbineers.[21] In this polemical account Witton claimed that the court martial and the preceding inquiry were a sham, comparing the proceedings of the inquiry to those of the Star Chamber and the Spanish Inquisition.[22] Witton contended that the sentences imposed by the court martial had been decided upon well before the court met: 'Morant and Handcock were sentenced to death long before the court sat to take evidence for the murder … of the said German missionary.'[23]

Witton's book laid the foundations of the Breaker Morant legend: that this English-born but Australian hero had been martyred by Perfidious Albion in the interests of imperial realpolitik, that the killing of a German missionary had provoked the fury of the German government and that Morant and Handcock had consequently been sacrificed to appease imperial Germany. The legend still flourished in the 1970s, seven decades after the execution of Morant and Handcock, at a time when there was an upwelling of national self-confidence and assertiveness. It was the subject of a bestselling romantic novel by Kit Denton, first published in 1973 in Australia, serialised on ABC radio in 1978, and then republished in a retitled form as The Breaker in 1980 to capitalise, it seems, on the success of the Beresford film.[24] The legend was also the subject of a play by Kenneth Ross titled Breaker Morant, which was first performed by the Melbourne Theatre Company in February 1978.[25] This courtroom drama exonerates both

Morant and Handcock, portraying them as sacrificial victims and the trial as a miscarriage of justice.

Bruce Beresford acknowledges a debt to the play (and to the Denton novel) but insists that his own account – largely scripted by the director himself – moves significantly beyond the stage version.[26] Beresford does not subscribe to the playwright's view that the accused were wholly innocent, instead he allows that they were guilty of the killings, including the murder of the missionary, the charge they escaped at the court martial. The issue for Beresford was not whether they were innocent or not, but how the pressures of fighting a guerrilla war had brought them to commit these ugly acts.[27] The film leaves the play well behind both in terms of content and of treatment. The film borrows a few of its lines from Ross's work as well as its basic structure, the courtroom drama. But it supplements the courtroom scenes with extensive illustrative flashbacks of the events in dispute that serve to comment on, elucidate and sometimes confirm the evidence led at the trial. Thus, for example, we actually see Captain Hunt issuing the disputed order – the very existence of which was centrally at issue in the trial – to take no prisoners, relaying this to Morant as an instruction from headquarters. 'New orders. From Kitchener', Hunt instructs Morant in the field, 'Colonel Hamilton confirmed it to me personally. No prisoners. The gentlemen's war is over.'

Exploiting the possibilities of film, the director has incorporated a range of additional scenes which broaden the film beyond the confines of the courtroom. These include sequences at Lord Kitchener's headquarters in Pretoria, where we see the Commander-in-Chief and his calculating military aide, Colonel Ian (Johnny) Hamilton,[28] conspiring to rig the trial and articulating the motives underpinning the prosecution.[29] Beresford adds two major set-pieces for dramatic effect: an action sequence in which Boer horsemen descend on the garrison in Pietersburg and hurl sticks of dynamite at the defenders, including the prisoners on trial, who blaze back at them with a machine gun; and an extended execution scene at the end of the film, where the two martyrs, Morant and Handcock, go hand-in-hand to their unjust fate at this Pietersburg Calvary. Refusing a blindfold, Breaker Morant's defiant last words are: 'Shoot straight, you bastards! Don't make a mess of it.'

Like its predecessors, the Witton book, the Denton novel and the Ross play, the Beresford film presents the trial as a miscarriage of justice, a show trial, a sham. Once again Breaker Morant and his co-accused are 'scapegoats of empire', victims of imperial policy. In the film version, as in the earlier accounts, the outcome of the trial is pre-ordained. The trial is essentially fixed by the military authorities who are determined to secure a guilty verdict. A potentially key defence witness is sent off conveniently to India; the appointed military prosecutor is clearly experienced and skilled; the defence lawyer, Major Thomas, is an Australian country

solicitor, a land conveyancer with no trial experience. He is given the barest minimum of time to prepare his defence. The president of the court martial is a caricature of the senior British officer, a Colonel Blimp-like figure, who, at least in the film, summarily dismisses most of the objections raised by defence.

In Beresford's film Lord Kitchener is fully determined from the outset on a guilty verdict. It is all a question of policy as we discover through discussions between the Commander-in-Chief and his Machiavellian military aide at headquarters in Pretoria. At a briefing for Major Bolton, the British officer charged with prosecuting the Australians, Kitchener explains the necessity of a conviction: 'I have received a telegraph message from Whitehall ... the German government has lodged a serious protest about the missionary in particular.' Colonel Hamilton adds: 'The fact is that Whitehall feels the Germans are looking for an excuse to enter the war ... on the Boer side, of course. We don't want to give them one.' 'Needless to say,' Kitchener expands, 'the Germans couldn't give a damn about the Boers. It's the diamonds and gold of South Africa they are interested in.'

Later, Hamilton is sent by Kitchener to give false testimony at the trial. When Hamilton balks, Kitchener blusters: 'Good God, Johnny, I'm not trying to prove some academic point. I'm trying to put an end to this useless war. The Boer leaders must see in this court martial a demonstration of our impartial justice. If these three Australians have to be ... sacrificed ... to help bring about a peace conference, it's a small price to pay.' Hamilton replies: 'I quite agree, sir, though I doubt the Australians share our enthusiasm.' Hamilton goes off to Pietersburg, and as the film indicates, perjures himself to secure the conviction, falsely denying conveying any instruction not to take prisoners.

Thus the film actively shows Kitchener and Colonel Hamilton conspiring to pervert justice. No room is left for doubting the Commander-in-Chief's nefarious role in the Breaker Morant affair. Similarly, the film endorses and, crucially, depicts in flashback form Breaker Morant's justifications for the killings: firstly, that he was simply following orders in executing the Boer prisoners, and secondly, provocation, the mutilation of his best friend Captain Hunt's body by the Boers. The film leaves no space for doubting that the body was indeed obscenely mutilated and that the Boers were the culprits, an assumption which is at least debatable.[30] The film presents all this with a high degree of certainty. Bruce Beresford is not Akira Kurosawa; *Breaker Morant* is not *Rashomon*. The film leaves little or no space for alternative interpretation, for uncertainty, for ambiguity. All the powers of film are used to make a watertight case for imperial culpability and to exculpate Morant and his fellow accused if not of the actual killings, of moral responsibility for these, as honest soldiers fighting in a bad cause under impossible conditions.

History inevitably is somewhat less certain. Prompted by the film,[31] Professor Arthur Davey, a historian formerly at the University of Cape Town, prepared and edited a volume of all the surviving documentation about the Breaker Morant affair.[32] Published in 1987, this added scholarly muscle to a more popular history published four years before by Kit Denton, author of the novel *The Breaker*. Titled *Closed File*, the Denton history surprisingly reverses the verdict of the earlier Denton novel.[33]

Davey and Denton demonstrate that there was no fixing of the trial and that proper procedure was followed. As Davey shows, the trial itself followed a very careful and thorough investigation by an Australian officer, Captain Frederick de Bertodano, who, significantly, is not mentioned in either Witton's account or in any of the Australian popularisations. The trial was not driven by pressure from Whitehall, or by any desire to appease the German government. (Though of German descent, Heese, the murdered missionary, was in fact a British subject by birth, and while the German government had shown an interest in the case, it had certainly not brought diplomatic pressure to bear.)[34] In pursuing the case, Kitchener was not acting on orders from London but acting on his own volition. His motive, Thomas Pakenham, the author of a best-selling account of the war, argues, was to attempt to reassert military discipline in the face of increasing lawlessness and criminal behaviour by units like the Bushveldt Carbineers.[35] There is certainly no evidence for the self-incriminating words that Beresford as script-writer puts into the mouths of Kitchener and Hamilton. And finally, there were no orders, verbal or otherwise, from headquarters to 'take no prisoners'.[36] Such orders would simply have been counter-productive in the context of the counter-guerrilla struggle.[37] The whole point of the British military effort was to persuade the *bittereinders* still on commando to surrender. Shooting prisoners would surely have had exactly the opposite effect. The South African War, unlike the later Vietnam War (which cast its shadow, as we will see, over the Australian film), was not a war of 'body counts' but of captures and surrenders.

Predictably much in *Breaker Morant* is invented. This, as Robert Rosenstone and this volume argue, is not problematic as such, for the translation of history into feature film necessitates invention. The question is really whether Beresford's inventions are 'true invention' or 'false invention', consistent with the discourse of history or fundamentally at odds with it.[38] Clearly there is much in the film that is 'true invention', that is consistent with the 'discourse of history', or at least with one version of it, the Australian legend of Breaker Morant with its one-eyed exculpation of Morant and Handcock and its indictment of the imperial authorities.

Equally there is much that is 'false invention', at odds with the 'discourse of history'. The film vastly overestimates the importance of the Breaker Morant

affair and misinterprets its significance. The killings are represented as a road-block to peace with the Boers, and as potentially providing Germany with an opportunity to enter the war. The execution of the Australians is presented as a means of smoothing the path to peace and of removing a pretext for German intervention. This is false invention, based on a fundamental misunderstanding of the international politics of the South African War and of the state of the conflict in its latter stages. Germany in 1901–02 was not itching to enter the war – anything but. And by this point the final outcome of the war, a Boer defeat, however deferred, was long since a foregone conclusion. By late 1901 the chances of foreign intervention on behalf of the Boers, which had been slight from the very start, were virtually nil.

While German public opinion, like that of much of continental Europe, rallied to the Boer cause, the 'official mind' was far more circumspect. Despite its very considerable economic interests in the Witwatersrand, Germany had conceded, already in the late 1890s, before the war, that South Africa fell squarely in Britain's sphere of interest, and that interference in the affairs of the Transvaal would not further the Reich's broader strategic interests. Throughout the war Germany maintained a studiously neutral posture – something Britain both recognised and appreciated – despite the hostile clamourings of the German press.[39]

Similarly the film greatly overestimates the significance of the Breaker Morant affair for finally ending the war. The Boer leadership in 1901–02 was preoccupied with much larger matters than this minor incident. The agonising decision of whether to continue the struggle or to at last surrender would hardly hinge – as the film misleadingly suggests – on the outcome of an obscure court martial in Pietersburg of junior officers. Contrary to the declaration by the film's cardboard Kitchener, sacrificing Breaker Morant could barely be conceived as a meaningful contribution to bringing the Boers to the negotiating table.

But while the film seriously misreads the international politics of the war, as well as its military 'politics', does it provide 'true invention' of a larger sort? Whatever its factual errors, its omissions and misdirections, its necessary altera-tions and conflations, does it give viewers a helpful sense of the war itself? How well (or badly) does *Breaker Morant* 'do' the South African War?

The war the film depicts is that of the guerrilla phase of the three-year con-flict, the phase in which the British army had resorted to 'methods of barbarism': the devastation and clearing of the countryside, farm burning, the wholesale confiscation and destruction of livestock, and the herding of civilian Boers and blacks into concentration camps. The film speaks of these brutal methods by way of courtroom argument by the defending lawyer. Justifying and relativising his clients' misdeeds, Major Thomas argues passionately 'that orders that one would consider barbarous have already been issued in this war. Before I was asked to

defend these men, I spent some months burning Boer farmhouses, destroying their crops, herding their women and children into stinking refugee camps, where thousands of them have died already from disease. Now these orders were issued, sir, and soldiers like myself and these men here had to carry them out, however damned reluctantly.'

But, crucially, while the film *speaks* of these atrocities, it fails to deploy the graphic power of film to *show* these atrocities. Instead, Thomas's talk of devastation is undercut by the film's imagery. The visuals subvert the verbiage. The film presents a pristine and idyllic (South Australian) pastoral landscape rather than the war-ravaged and desolate countryside of Kitchener's scorched earth tactics.[40] Here Boer women remain on their farms, awaiting the amorous attentions of Australian officers, rather than being herded into camps.[41] Instead of towns with overcrowded refugee encampments on their doorsteps, we see a pretty garrison town, Pietersburg, complete with a Victorian bandstand and a garrison orchestra entertaining the townsfolk, incongruously, with 'Sarie Marais', the wartime lament sung on commando to the tune of the American 'Sweet Ellie Rhee'. The historical concentration camp at Pietersburg is not part of this vision.

The film does take strong issue with the nostalgic notion that the South African War was the 'last of the gentlemen's wars',[42] a conflict somehow redeemed by chivalrous conduct on both sides, and very different from the industrialised slaughter of the coming Great War. A core argument of the film is that this was instead the first 'dirty' war of the twentieth century, a brutal and brutalising conflict which led inexorably to excesses by the combatants on both sides, misdeeds for which soldiers consequently could not be held fully morally responsible. These are the arguments used by Morant himself in the film to justify his brutal actions, including the murder of the missionary. In a secret jailyard confession to the unwitting George Witton of his co-responsibility for the killing of Reverend Hess [*sic*], Morant says:

> It's a new kind of war, George. It's a new war for a new century. I suppose this is the first time the enemy hasn't been in uniform. They're farmers. They're people from small towns. They shoot at us from houses and paddocks. Some of them are women, some of them are children. And some of them are missionaries, George.

In similar vein, Major Thomas argues in summing up the case for the defence:

> When the rules and customs of war are departed from by one side, one must expect the same sort of behaviour from the other ... Lieutenant Morant shot no prisoners before the death of Captain Hunt. He then changed a good deal and adopted the sternest possible measures against the enemy. Yet there is no evidence to suggest that Lieutenant Morant has

an intrinsically barbarous nature. On the contrary. The fact of the matter is that war changes men's natures. The barbarities of war are seldom committed by abnormal men. The tragedy of war is that these horrors are committed by normal men in abnormal situations, situations in which the ebb and flow of everyday life have departed and been replaced by a constant round of fear and anger, blood and death.

Soldiers at war are not to be judged by civilian rules as the prosecution is attempting to do, even though they commit acts which, calmly viewed afterwards, could only be seen as unchristian and brutal. If, in every war, particularly guerrilla war, all the men who committed reprisals were to be charged and tried as murderers, court martials like this one would be in permanent session. Would they not? I say that we cannot hope to judge such matters unless we ourselves have been submitted to the same pressures and the same provocations as these men whose actions are on trial.[43]

Not unexpectedly, these arguments resonated with and provoked international audiences, particularly American audiences. Here the timing of the production of the film is significant. The film was released just less than a decade after William Calley's conviction in 1971 for the My Lai massacre of innocent Vietnamese villagers in 1968. Coincidentally, *Breaker Morant* was made soon after the great Vietnam War trilogy of *Apocalypse Now* (1979), *The Deer Hunter* (1978) and *Coming Home* (1978). There is no direct evidence that Beresford was influenced by these films, but certainly *Breaker Morant* was produced in the same post-Vietnam War climate, where issues of culpability for acts of war were still highly topical.[44] The film's timing and resonances might help to explain its heated reception in the United States where it became the subject of critical controversy, much of it centred around the film's apparent justification and rationalisation of war crimes.[45] Beresford's defence of Breaker Morant was read, wrongly or rightly, as a defence of William Calley. Thus David Denby, writing in the liberal *New York* magazine, dismissed *Breaker Morant* 'as "duplicitous", "morally confused" and "possibly dishonest." '[46] On the other hand, the conservative critic Richard Grenier lauded the film (and its politics, as he interpreted them) in *Commentary*:

It burns with a white rage against societies as a whole, from military leaders and chiefs of state to (more common in our time) comfortable civilians in easy chairs, who send rough men out to serve their interests brutally, murderously (what is war?) and then – when circumstances change and in the exquisite safety and fastidiousness of their living rooms they suddenly find these rough men's actions repugnant – disown them.[47]

Memories of the recent Vietnam War might have played some part too in the enthusiastic Australian reception of *Breaker Morant*.[48] The film would have had a

special resonance for Australian audiences because of their country's unpopular participation as an American ally in the ground war in Vietnam. Local audiences would have been aware of the parallels between Australian participation as imperial subalterns in an unpopular and protracted imperial war in Africa and their participation as junior partners in an even more unpopular neo-imperial venture in Asia in the mid-20th century.

While *Breaker Morant* challenges the view of the South African War as a 'gentlemen's war', it does little to challenge the equally erroneous notion – which had its origins in British policy, often honoured only in the breach – that this was a 'white man's war', a war fought almost exclusively between white opponents, Boer and Brit, with limited participation at most by the indigenous population. In *Breaker Morant* the black participants are minor background figures, little more than bit players who serve as signifiers of place, signalling that the setting is African. There are a handful of appearances by black extras; there are no black characters as such in the film. There are black orderlies sweeping the courtroom; black servants washing the clothes of the troops; and there is a smartly attired black courtroom clerk (shades of Sol Plaatje, the pioneering South African black author and political activist, who served as interpreter and clerk in the Mafeking magistrate's court during the lengthy siege)[49] in a non-speaking part. A black informant for the Bushveldt Carbineers at the scene of the ambush, in which Captain Hunt is killed, has the only speaking part and his solitary lines are barely audible.

This neglect runs counter to the realities on the ground in the Bushveldt Carbineers' theatre of operation and of the war at large. George Witton himself refers in his *Scapegoats of the Empire* to the sizeable presence of black communities in the operational area. The northern reaches of the Transvaal were home to the larger part of the black population of the former republic. The film shot in South Australia, with black extras in short supply, conveys little sense of this human landscape. The film also omits the intriguing and important part played by black scouts in the employ of the British army in bringing Morant and his fellow officers to justice. In the collection of documents assembled by the historian Arthur Davey, Captain de Bertodano, the Australian intelligence officer chiefly responsible for the investigation of Morant and Handcock's crimes, dramatically narrates the part that 'two splendid native scouts, Hans and Kaffirland' played in the detection of the crimes. (Kaffirland, it seems, was murdered for his pains.)[50]

The film's uncritical subscription to the notion of a 'white man's war' is perhaps an accident of timing as its production came just too soon to assimilate a major shift in the interpretation of the war which coincided with its release. In 1979 Thomas Pakenham published an internationally bestselling popular history of the war which explicitly challenged the conventional wisdom. 'In all the myths

that have accumulated around the war, none has been as misleading', he wrote, 'as the idea that it was, as both sides claimed, exclusively a "white man's war."'[51] This preceded the publication in 1980, the year *Breaker Morant* was released, of a groundbreaking scholarly volume on the history of the war, edited by Peter Warwick.[52] One of the key contributions was by the editor himself, drawing upon the research for his recently completed D.Phil. thesis on 'African Societies and the South African War'.[53] 'It soon becomes evident,' Warwick wrote, 'once one begins to question seriously the popular image of the war as one confined to white participants, that black people played an indispensable part in military operations.' Warwick's pioneering work was followed by that of Bill Nasson whose study of the 'people's war' in the Cape Colony gave the quietus to any lingering notions of a 'white man's war'.[54] As the new research indicated, blacks played a key part on both sides of the conflict: perhaps 100 000 worked for the British and 10 000 for the Boers.[55] A sizeable number bore arms despite official British policy, while blacks played an indispensable part in scouting and intelligence gathering.

What of the film's representation of the other side, the Boers? While the occasional African figures in the film provide little more than local colour, the Boers are more active players in *Breaker Morant* though still largely marginal and depersonalised. Besides the hapless Boers prisoners who are executed, the only significant Boer character – and the only one individualised – is Christiaan Botha, a *hensopper* (literally a hands-upper) turned 'joiner', a Boer who had changed sides. Bearded and dressed in civilian clothes like his former comrades, this Boer collaborator is a scout and interpreter with the Bushveldt Carbineers, a weasel-like figure, despised and distrusted by his new employers. Possibly to prove his loyalty to his new masters – his motives are not explained – he is shown in the film eagerly rushing to join the reluctant firing party ordered to execute Visser, the prisoner caught wearing Captain Hunt's clothes. We see him as a perjuring witness for the prosecution at the court martial, and, finally, as a victim of an unlikely revenge killing in the streets of Pietersburg where he is gunned down by his betrayed fellow countrymen who have come to hear of his role in the execution of the Boer prisoner.

This is a stereotypical Hollywood-style presentation of the snivelling turncoat who gets his just deserts. The historic Ledeboer – the intelligence agent who was present at the 'kangaroo court' that ordered Visser's judicial murder and was consequently a key witness at the court martial – is a very different and more attractive character than the screen Botha. Described by Captain de Bertodano, the Australian investigating officer, as 'a very capable man ... who spoke the native languages as well as he did Dutch and English', he played an important and brave part in uncovering the crimes, carrying 'out his work well in spite of its difficulties'.[56]

Beyond the minor villain, Botha, there are only the sketchiest depictions of the Boers. We only see brief – and not necessarily flattering – glimpses of the Boers still on commando. The *bittereinders* wait in night-time ambush for Captain Hunt and his men; his mutilated corpse is testimony to their savagery. The Boers in turn are surprised by an avenging Morant while camping by a riverside; Visser, left behind when his comrades flee, is a wretched, cowering figure. (The historic Visser, unlike the screen version, was wounded; Beresford does not undercut audience sympathy for Morant by showing him executing a wounded man.)

The film also shows a surprise attack on Pietersburg. In the best tradition of the Hollywood Western, a line of Boer horsemen swoop early one morning on the sleeping British garrison in Pietersburg. The raid is abetted by a Boer Mata Hari, whose ardent attentions distract the solitary British guard. Morant, Handcock and Witton, released from their cells, save the day, driving off the Boers who clamber up the walls of the fort like Hollywood's Indians. Unlike in the war itself, where women's suffering became a central motif, Boer women play little meaningful part in the film; this is a 'boy's own' vision of the South African War. Beyond the Boer spy, the only Boer women with minor speaking parts are two desperate housewives, locked in comic embrace with Lieutenant Handcock while their respective husbands are away on commando and as prisoner of war.

The Boers speak a mixture of English and what the film describes in its titles as Africaan. The use of Afrikaans is inevitably a mixed success;[57] clearly native speakers of that language were hard to come by in South Australia. Whether in English or in (sometimes mangled) Afrikaans, the film does not have much to say about why they fought – or, alternatively, collaborated. Here the curious viewer would have to turn to the memoirs of a *bittereinder* like Deneys Reitz, whose classic account of the adventures of a young man at war, *Commando*,[58] remains fresh and vivid today, or to the extensive scholarly literature on the South African War, particularly the richly detailed account by the historian Fransjohan Pretorius of life on commando in which he explores why the *bittereinders* remained in the field for so many months in what seemingly was a hopeless cause.[59]

Breaker Morant gives little hint of any of this. Similarly it does not portray the extent of Boer collaboration with the British. This vexed topic – Boer collaborators were shunned after the war, while the subject of their collaboration remained, for many decades, an embarrassment best left undisturbed by historical research – was eventually explored by the historian Albert Grundlingh. Grundlingh shows that the Botha figure in the film was only one of many such collaborators.[60]

Breaker Morant's failure to pursue such intriguing issues is only partly because of the well-known limitations of feature film as a means of exploring

the past. Historical film can only carry a light 'information load'; it is constrained both by scarcity of time and by the limited attention span and historical knowledge of its audience.[61] Beyond these general constraints, shared with the genre at large, *Breaker Morant*'s historical reticence has much to do with its Australian provenance and concerns. Made by Australians for an Australian audience in the first instance, it is as much (and probably more) about Australian identity and the country's relationship with Britain as it is about an African war. This might account for the enduring popularity of the film in Australia where debate still rumbles about the episode[62] and where *Breaker Morant* is still commonly used as a teaching aid in Australian high-school history and English classes.[63] Clearly this is not only, or even primarily, because of the film's evocative representation of an unpopular imperial war in Africa fought by unsavoury means against a tenacious opponent. Instead, more likely, it is because Bruce Beresford's film has inscribed Breaker Morant so vividly – if questionably – in an Australian martyrology alongside the likes of the legendary Ned Kelly.

8

From Khartoum to Kufrah:
filmic narratives of conquest and resistance

SHAMIL JEPPIE

Khartoum[1] deals with the conflict between British imperialism and a local resistance movement in the Sudan in the 1880s. The film is structured around two leading personalities – General Charles Gordon (played by Charlton Heston) and Muhammad Ahmad, 'the Mahdi' (Laurence Olivier) – who stand for the opposing sides in the struggle between what is portrayed as a civilised and civilising British imperial venture and a proud but fanatical African Muslim movement opposed to foreign interference. Gordon is reluctantly sent on a mission to save Khartoum – and especially its European inhabitants – from the advancing fighters of the Mahdi. *Khartoum* focuses much more on Gordon as a determined man with a vision than on Ahmad, and in some ways can be viewed as an instalment of a Gordon biography on film. Even though Gordon dies in Khartoum at the hands of the Mahdists, he remains a hero because he represents certain cherished Christian Victorian values. The film is set largely in the Sudan, particularly around the capital, Khartoum, hence the title of the film. It is an unabashedly nostalgic view of the period that romanticises an aspect of the late-19th-century British imperial adventure in Africa.

Omar Mukhtar: Lion of the Desert[2] also deals with imperialism in Africa, in this case Italian expansion in the inter-war period into northern Africa, deep into the Saharan desert. Conquering Kufrah, a remote oasis settlement in the eastern Sahara, is a prime objective for the Italians. In the course of the conquest there are a series of battles between this weak but extremely violent European imperialist power and a determined local resistance movement. The story is told from the perspective of the local African Muslim resistance leader, 'Umar al-Mukhtār (Omar Mukhtar), who was already 70 years old at the time of the events covered in this film. The hero (played in the film by Anthony Quinn, the Mexican-born

American actor) is both a grey-bearded teacher at a traditional Quranic school and a superb guerrilla strategist. He is both an otherworldly, pious figure and a worldly leader of men, taking them into battle shrewdly and fearlessly. The film conveys very well the unequal military strengths and technologies of the two sides, as well as the severity of Fascist rule over the conquered population. We are shown Mukhtar's courage, persistence and brilliance as a leader and also his care for women and children even in times of war. His antagonist in the film is very different to him; the Fascist General Rodolfo Graziani (played by Oliver Reed), sent out to the colony by Il Duce himself (played by Rod Steiger) to quell the resistance and capture Mukhtar, is presented as overbearing and cruel.

~

Introduction

Both films deal with African societies that have received very little cinematic attention, from either Western or African or Arabic-speaking filmmakers. Furthermore, the films are about significant figures and events in the recent pasts of these societies, events that have been formative in the way in which the birth of the modern nation-state in Sudan and Libya is narrated. The histories of the movements depicted in the two films are by no means universally revered or respected in these countries. Both states have contested pasts, and possibly because of this contestation over the meanings of key events in their past, such events function in significant ways in what is considered as 'history'. Different groups – political parties, dissident factions and ethnic groups – in each country have distinctive versions of the past, and therefore events and historical actors function differently in each group's history. For instance, in the Sudan there are, and have always been, even among northern Arabic-speaking Muslims those who attach no significance to the Mahdist movement and are critical of it and oppose its contemporary followers.[3]

Khartoum and *Lion of the Desert* appear to be the only full-length films that deal with these events or periods in any language. As might be expected, the interpretations of these films differ from the recollections of descendants of participants, and from the academic and popular histories published in European languages and Arabic. But they should not be taken as yet another interpretation or unique type of reading of these histories, for they are in a medium very different to standard literary historical narratives.[4]

Even though the two films are set in different places and times, they can be profitably viewed together because they share a number of common themes, although their approaches are radically divergent. Two distinctive imperial-

isms in Africa are approached in contrasting ways: on the one hand Italian Fascists asserting themselves over a colony they have been struggling to pacify, on the other British imperialists rather reluctantly engaging in a new venture in Africa. Then there is the role of religion, Islam in particular, and of resistance in African history. Both movements are led by and composed of Muslims, but they are represented in rather different ways. 'The Mahdi' hailed from a strong Sufi background and through visions proclaimed himself 'the expected one' who had come to renew the faith of Muslims and herald a new era on earth.[5] Mukhtar, on the other hand, was a leader within the North African Sanusi tradition of Sufism. But we learn nothing about these Sufi traditions or their practices and rites in either film.[6] In *Khartoum* we only get brief glimpses of the social life of the Muslim communities of the Nile valley and of the Mahdi himself, and these views are stereotypical and even plainly wrong, for example the method of prayer of the Mahdists. Very early on in the film the Mahdi is shown leading his men in what resembles the canonical daily *salah* worship, but this is more a product of the filmmaker's imagination than any Islamic act of worship. Representations of Muslims in *Lion of the Desert* are more extensive and concerned to show social practice and community life in a far more positive light than in *Khartoum*. 'Umar Mukhtār is depicted favourably as a teacher at a traditional Quranic school. The film provides some sense of the hustle and bustle among various sections of his community. His preparations for prayer close to the end of the film are presented in a thoughtful and realistic fashion. *Khartoum*, on the other hand, seems not overly concerned with Muslims except either as rebels with a cause or as friends of Gordon 'our saviour', as one local leader fearing the Mahdist encroaching forces addresses him.

Both films focus on the role of the individual in history, emphasising the centrality of 'big men' in historical change: in this vision, momentous historic events are made by charismatic personalities animated by powerful ideas – religious or otherwise – and large numbers of people are swayed by such personalities. But these are not close portraits of the inner sufferings or psychological drives of these men; instead they are largely films about the military careers of their powerful leading characters. In both films there is little place for other factors such as economic interest or ecological setting, conflicts over status or material resources that could shape human action or historical process. Similarly, no attention is given to the ordinary followers in either movement, or to the regular foot-soldiers of the imperial armies. Instead the actions of Mahdi and Mukhtar on the one hand, and Gordon and Graziani on the other, are the exclusive focus of both films.

Khartoum was made by an English director under Hollywood auspices for a Western audience while *Omar Mukhtar* was filmed in Libya by a Syrian–American

director and producer, Moustapha Akkad, who some years previously had made a film about the early years of Islamic history in the Arabian Peninsula. His *Mukhtar* film, it seems, received financial backing from the Libyan government.[7] Clearly, as will be seen, the differing production circumstances influenced the perspectives taken by these films.

History versus *Khartoum*

How does the film relate to the history of the Sudan? The late-19th-century 'Sudan' was a possession, at least nominally, of Ottoman Egypt. Egypt in turn was occupied by British forces and its economy was essentially managed by a consortium of European powers. Britain had installed a puppet ruler, Khedive Tawfiq, but he was unpopular and powerless. Egypt only had nominal control over the Sudan, and Britain was the real decision-maker in Egypt and, in theory at least, over Sudan. In the 1880s an armed movement, directed by a religiously inspired figure, 'the Mahdi', had arisen in Sudan and this seriously threatened the colonial state. Both Egyptian and English interests were jeopardised by this movement.[8]

The invitation to Gordon to undertake a mission to rescue Khartoum was highly controversial both in London and Cairo. Gordon was famous for his exploits from 1860 to 1865 in China where he was active in the suppression and defeat of the Tai Ping rebellion. (On his return to England, he had been popularly nicknamed 'Chinese' Gordon.) He had also previously served in the Sudan between 1874 and 1879, ending his time there as the Governor-General. He was consequently a prime, indeed the only, candidate to undertake a mission to Sudan to secure the capital. The British government did not want to commit troops so chose instead to send Gordon despite his unpredictability and known dislike of officialdom. For all that, he was left a rather wide space in which to plan the defence of British–Egyptian interests in Sudan and to save Khartoum. His schemes began when he arrived in Egypt.[9]

Political affairs in Egypt and Sudan are central to the film, although the complexities of political relations between these two countries do not emerge very clearly. Egypt was a province (*vilayet*) of the Ottoman Empire, albeit a largely autonomous one, until British conquest in 1882 – this almost coinciding with the rise of the Mahdi in the Sudan. The Sudan was conquered by the forces of Mehmed Ali, the Governor of Egypt, in 1822. He established a dynasty in Egypt while trying to free himself and his province from Istanbul, and his descendants were the rulers of Egypt with whom the Europeans had to work. As a British-controlled territory, Egypt's dominant place in the Sudan was complicated by

its own colonial status. From the 1870s onward Egypt was increasingly unable to meet its domestic and international financial obligations, and dependence on Britain and Europe became more explicit until complete British occupation. There was a strong sense in many quarters that Britain had to act to save the Sudan, for it was, after all, an extension of the territory Britain now controlled.

One of the ideas that Gordon entertained was to hand over authority in the Sudan to Sudanese notables. Thus in Cairo he met with the infamous slaver Zubayr Pasha against whom Gordon had fought and whose son was killed by Gordon's men while suppressing slavery. Gordon saw Zubayr Pasha and other notables as future leaders of the Sudan. As part of this plan Gordon would offer the governorship of Kurdufan to the Mahdi; he, of course, would reject this as his objectives were much larger than a governorship. These intricate but unrealisable political plans – to identify a local elite to rule the Sudan under British tutelage – are only fleetingly covered in the film and may in fact be quite confusing as represented.

The film also glosses over the many factors that motivated European interest in the Sudan: a belief that there was gold and other mineral riches; that the source of the Nile lay there; that slavery should be abolished; that a future market had to be prepared for European goods; that the land had strategic importance; and that with the rise of the Mahdi there could potentially be a massive growth of anti-British and anti-European religious and nationalist sentiment in the region. The 'Urabi uprising in Cairo in 1882 – led by Colonel Ahmad 'Arabi – was a worrying sign of popular unrest that could spread and be repeated. Popular anti-colonial protest in Egypt and the same in Sudan could potentially present serious challenges to the British.

The Mahdist movement was directed against the Ottoman–Egyptian administration and its European supporters in Khartoum. Muhammad Ahmad believed the rulers to be foreigners who were untrue to their Islamic principles, and relied heavily on foreign unbelievers. He challenged the state and offered an alternative vision of a state based on his understanding of *shari'ah* (Islamic law). The sources of his authority came from his claim that he was divinely appointed. He came from within an established *sūfi* order and proclaimed himself more than a *sūfi* master with a divine calling to challenge the status quo and establish a new order. He was the *mahdi* ('expected one'), who in Islamic traditions is a renewer of the whole *ummah* (Muslim community) during times of its corruption and decline. This gave him his legitimacy.[10]

Others among the religious elite opposed him precisely on these grounds, arguing that he was an impostor, a false *mahdi*. From the time of his proclamation as *mahdi* in 1881 his movement spread rapidly and threw the established religious, social and political order into disarray. His military capacity grew, as

did his capacities to run alternative state structures. By the time Gordon came to the Sudan in 1884 the Mahdist movement was only about three years old, yet it had succeeded in a number of military encounters. The Mahdi's *ansār*, as his supports and army were called, had emerged as an organised force with distinctive dress and modes of operation. They managed to take large swathes of territory from the state in a short time and recruit leading personalities as supporters in various regions of the country. The founder died in 1885, shortly after Khartoum was taken, and after Gordon's death. The capture of Khartoum was a major achievement for the Mahdi. The movement continued to grow after its founder's death since there was a well-formed system of authority under the Mahdi. Little of this rich history is hinted at in *Khartoum*.

Khartoum as cinema

Khartoum grapples with a crisis of British imperialism. It focuses on British efforts to force back the rapid advance of Sudanese Mahdist forces of Muhammad Ahmad through the northern and central Sudan, and especially to prevent the fall of the city of Khartoum. The film places the man charged with defending the city, General Charles Gordon, at the centre of its narrative. After a long composed music score – which has touches of the Oriental – the film opens with magnificent scenes of the mighty Nile River and a voice-over telling us of the powers of the river and how it has shaped history. The suggestion is that there is something almost natural about the story that is about to unfold. Landscape and history are intertwined. This is exemplified in what immediately follows: striking scenes of the defeat of a British-led Egyptian force in the deserts of the northern Sudan by Mahdist fighters followed by a dramatic speech by the Mahdi (Laurence Olivier) himself. We are then immediately taken into the corridors of British power where we meet Prime Minister Gladstone (played by Ralph Richardson). Though initially hesitant, he ultimately supports General Gordon's mission to save Khartoum from imminent fall. Despite Gordon's efforts, graphically depicted in the film, Khartoum does eventually fall to the Mahdists. The film ends with Gordon's dramatic, and much mythologised, death at the hands of Mahdist fighters. Throughout, Gordon is the principal focus of the film, which might have been more aptly titled 'Gordon of Khartoum'. The film is overwhelmingly one-sided, presenting only the British experience in the Nile valley.

The local peoples and the Mahdists feature merely as props to the central figure of Gordon. Even though the rise of the Mahdists is the cause of Gordon's journey to Khartoum, their movement is given prominence only in relation to his

place in the region. Gordon is cast as the altruistic would-be saviour of the Sudan who in the end fails to fulfil his objective. A fictional encounter with Muhammad Ahmad is used to sketch the contending views of the Sudan and its future supposedly held by the two men. Gordon is portrayed as a true lover of the Sudan whose vision is practical and concerned with the simple welfare of the ordinary folk, while the Mahdi's vision is fanatical and apocalyptic.

Khartoum was made in 1966 and did not take its cue from the emerging Africanist historiography or growing Third World nationalisms of the age. There is only a faint suggestion in the film of African heroes and agency, values that were then increasingly being stressed in the field of African history. In some sense the Mahdi is a 'hero' in the film but, unlike Gordon, he is not a man with a complex personality. The Mahdi is left inscrutable and one-dimensional. *Khartoum* is essentially a film about British imperial power and the character of the enigmatic Englishman, Charles Gordon. It is a conservative film in many ways. The musical score is possibly influenced by Edward Elgar and is invested with imperial grandeur and pomp. The script is crafted in an English appropriate to the upper-class England of the time, but at times this is overdone. Even the Mahdi (played by Olivier) is made to speak this kind of English.

—

Khartoum as history

What of the film as 'history'? In its defence it does strive to capture some of the complexities of British politics and of Gordon's personality. It does represent the mass following of the Mahdi's movement and its military successes. In general there are numerous points of congruence between the film and published history. But inevitably it fictionalises with key inventions, including Gordon's meetings with Prime Minister Gladstone, and with the Mahdi. Gordon's offering the Mahdi a robe he had brought back from China is a fabrication. Historians might also frown upon some of the absences: very little, for example, about the vital role of the press, especially the *Pall Mall Gazette*, in shaping public opinion in Britain and in influencing Whitehall. There might also be questions about the costumes and sets. Khartoum in particular is represented as a neat Hollywood-style 'Oriental city'. In general there is far less dust and sand than one would expect from the Sahelian location of the movie. The costumes of the Mahdists are much too crisp and fresh, certainly not the dust-covered and rugged gear of an army perpetually on the march. The depiction of the Mahdi leading his men in prayer has little connection to the Islamic mode of prayer.

～

Omar Mukhtar: Lion of the Desert

Fifteen years after *Khartoum*, a film was released about a different imperial adventure in Africa. This time the camera does not focus on representatives of a powerful imperialist nation, but instead closely follows the indigenous heroes – and one figure in particular. *Omar Mukhtar: Lion of the Desert* tracks the last fighting years in the life of the resistance leader *'Umar al-Mukhtār* (Omar Mukhtar, played by Anthony Quinn). His guerrilla strategies, determination and physical abilities at the age of 70, in the context of an increasingly aggressive Italian imperialist assault, are the focus of the film. The Muhammad Ahmad and General Gordon of this movie are Mukhtar and General Rodolfo Graziani, although their moral positions are reversed. Unlike the heroic Gordon, Graziani is the evil Italian military mastermind who would bring modern mechanised warfare and a scaled-down version of 'total war' – tanks, artillery, aeroplanes, concentration camps, wire fencing, among other things – to the desert.

To provide a documentary effect the film opens with black and white newsreel footage from the period accompanied by a voice-over giving brief 'dispassionate' reportage of the story of the Italian conquest of Libya to this point. Newsreel footage recurs at other points in the movie, the purpose of which is to signal that the film is telling a 'true story' drawing on the historical record. The film is indeed about an actual and tumultuous moment in North African history. The Italian conquest of Tripolitania and Cyrenaica, two large regions in what would later become Libya, began in 1911. Italy was a weak colonial power. Unlike Britain and France, for example, it did not have a long history of overseas colonisation. It did not possess overseas colonies until it sent its ships across the Mediterranean to seize a North African province from an even weaker Ottoman state. When Italy came under Fascist rule in 1922, Benito Mussolini aimed to create a new Italy: colonial possession was part of this project to mould a great Italian nation. Its colonies (Libya and the complex case of Abyssinia) would also come to experience this assertion of Fascist Italian power. This change is represented in the film by an early scene of Mussolini scolding the governor of the colony for failing to assert full control over it. He tells his generals that 'twenty hopeless years have been wasted' by not defeating the resistance to Italian conquest. As a consequence, General Graziani (Oliver Reed) is dispatched to reassert control over the colony. Graziani confronts Omar Mukhtar, the leader of the resistance and victor over numerous Italian expeditions sent against his forces.

The Italian ambition under Graziani was to conquer territory as far into the Sahara Desert as possible, despite the huge costs involved and the absence of

any economic rationale for the possession of so much desert. It seems territory was valued simply for its own sake. Therefore capturing the thinly populated oasis settlement of Kufrah became one of Graziani's major objectives. Kufrah was important because it was the only habitable place in the heart of the Libyan desert, and would represent the furthest colonial outpost of the Italian regime. It was the last settlement in the region before entering equally harsh desert terrain claimed by Egypt to the east, and the Anglo-Egyptian Sudan to the south-east. Kufrah and its immediate region were strongly Sanusi in its Sufi practice since an important and historic Sanusi centre is to be found in this region.[11] The resistance to the Italians also had strong roots locally. Despite the vast distance between Tripoli, site of the colonial administration, and Kufrah, Graziani and his forces eventually managed to cross the immense stretches of harsh and hot desert terrain to take the settlement. Destruction and dispersion of resistance followed. In the film the Italian flag is raised over the destroyed oasis settlement, a mass grave is created, and Graziani stands proudly on the ashes of the settlement exhorting his men: 'Gentlemen, this is Kufrah!'[12]

Mukhtar, however, survived the conquest of Kufrah and so the next aim of the Italians was to capture Mukhtar. As Graziani would recognise, the old man knew the lie of the land and had not only evaded capture, but also inflicted losses on the colonial forces. As Graziani says regretfully of Mukhtar at one point, recognising that more of his forces with very advanced weaponry had been defeated and Mukhtar eludes capture yet again: 'He is good.' It took the Italians under Graziani nearly ten years to finally capture the 'lion of the desert'. In pursuing him the Italians imposed a reign of terror over the local peoples of the colony. They used tanks and aeroplanes to attack the resistance. Indeed, this would be the first use of tanks in the desert. Graziani also adopted a scorched-earth policy and constructed concentration camps to imprison men, women and children after attacks on villages, among other policies to weaken the resistance. Some of these measures taken by the Italians against their subjects are portrayed in the film. Indeed, in the opening newsreel footage there are images of the camps. It has been argued of this case of European colonialism in Africa that 'probably nowhere was the African–European confrontation as protracted, bloody and brutal as in Libya'.[13]

Our first encounter with the leading characters comes very early on in the film when Mussolini meets his generals and appoints Graziani to lead the campaign against the guerrillas in the colony. The film strives to show the brutality of Italian colonial policy and warfare in Libya, under Graziani in particular. In the context of such policies the resistance of Mukhtar and his band of fighters is even more impressive. The film ends with the capture, trial and execution of Mukhtar. With his capture there is the first opportunity for Graziani and Mukhtar to come

face to face and for the former to finally present his trophy to the Italian press and photographers. The trial that follows is a show trial and the verdict a foregone conclusion. But its staging in the film provides an opportunity to present the case for the absurdity of the Italian claim to the colony as well as the counter-arguments. By this time, however, the viewer would have been deeply persuaded of the rightness of the cause of the resistance.

The outcome of the trial is execution by hanging. This is one of many such public executions – by hanging and firing squad – we see in the film. Mukhtar's execution takes place outside one of the largest concentration camps built by the Italians. As we watch his hanging we are aware of the multitudes he led and who are imprisoned in this camp. The film connects the death of a hero and the possibilities of the struggle against colonialism through the huge numbers witnessing this event, which would close an important phase in an ongoing anti-colonial struggle.

In both *Khartoum* and *Lion of the Desert* the narrative centres on the motives and actions of two individuals. But in the latter case, the concern is to narrate an anti-colonial struggle and focus on an African hero. This distinguishes it clearly from *Khartoum*. Following the thrust of the Africanist historiography of the 1960s, the film *Lion of the Desert* spotlights African initiative. However, it does not take its cue from later developments in African and other historiographies that are less concerned with the 'big men' of history and instead attempt to write history from 'the bottom up'. In this later framing of history the story of Italian colonialism in Tripolitania and Cyrenaica would not be 'reduced' to the battle between important personalities. But in the film's defence it might be argued that when it was made, the list of films in which African resistance struggles were depicted was still relatively short and this one, therefore, should have an important place.

Mukhtar is depicted as a caring old teacher of young boys at a traditional *madrassah*. Clearly he was not born to be a warrior but circumstances forced him into this situation of taking up arms to defend his land, people and honour. As he tells a young Italian lieutenant, whom he might have had killed but instead spared: 'Tell your general it [the Italian flag] does not belong here.' While preventing the killing of this officer by one of his own men, he says: 'They are not our teachers.' This noble portrayal of the hero recurs throughout. The resistance is shown to have the moral high ground. The conquerors, on the other hand, are portrayed as ruthless and cruel.

But *Lion of the Desert* is not a simplistic portrayal of good 'resisters' against bad colonisers. A range of figures amongst the locals are represented. There are those who collaborate with the Italians and try to persuade Mukhtar not to pursue the military path. We are introduced rather briefly in the film to those

among the Sanusi who had opted not to take the path of resistance but instead chose co-operation. They seek out Mukhtar and attempt to persuade him to lay down his arms. But Mukhtar cannot be persuaded to submit even though he does not object to talks with the enemy. He meets for preliminary talks with officials of the military establishment and from Rome. On the Italian side we are shown a senior figure who arranges these talks and seems to have a line of communication to Mukhtar's people. Unlike Graziani, he is presented as sympathetic and soft-natured. Graziani simply uses him to buy time by tying Mukhtar up in talks. We are also shown one officer, Lieutenant Sandrini, who is hesitant about Italian policies, and whose life is spared by Mukhtar when the troops he was travelling with are ambushed. This sympathetic officer is ultimately murdered by Graziani. Something of the complexity of colonial occupation and resistance in this period of Libyan history is thus presented in the film.

The film focuses on military action and manoeuvres in the desert. The landscape shots are dramatic and awe-inspiring. Against this visually impressive backdrop we see the lumbering movements of heavy Italian weaponry and the more stealthy movements of the local resistance fighters. While the Italians parade in their stiff military uniforms, the local fighters are agile and comfortable, even elegant, in their white robes. Similarly, their way of life, traditions and religious practice are shown to be perfectly adapted to local conditions. Despite the attacks on their villages, they seem to move about easily; their male fighters in their traditional costumes are shown to be very able horsemen who, when they capture modern weapons from the enemy, can make effective use of these. Their faith was under attack as much as their land and they were willing and capable of fighting to preserve both. Mukhtar is a modest man of faith who knows his terrain well while the Italians are lost in more than one sense. It is only with superior modern weaponry and extreme brutality that the Italians are ultimately able to defeat the resistance and capture Mukhtar. Even at his execution in 1931, Mukhtar was a model of composure.

Lion of the Desert is a film of the post-independence and later nationalist (African and Arab) phases of African and Third World history. It captures local agency and integrity even in defeat. In the process it tends to idealise the struggle of the local peoples and their way of life. It focuses on imperialism and its violence against local peoples, and it pays some attention to internal conflicts and tensions on either side of the struggle.

<p style="text-align:center">⌒</p>

Memories of the events and personalities covered in these films are still part of the political histories of Sudan and Libya. Some of the issues the films raised

were particularly relevant at the time the films were made. In the period from the 1960s to the 1980s there were still lively debates about the impact of colonialism. The post-colonial states were grappling with important political and economic policy questions and were anxious to secure their own legitimacy. In these circumstances some sort of 'history' was always brought to bear on contemporary arguments. This is particularly the case with *Khartoum* where the descendants and supporters of the Mahdi have continued to play an important role in Sudanese national politics. In Libya, on the other hand, the Sanusi Sufi order of which 'Umar Mukhtār had been a member and leader, has lost traction. In 1950, Idriss, its leader, had become king but after the 1969 coup d'état led by Colonel Mua'mmar Qaddafi the memory of the order was given no special place in the new regime's mythology. Qaddafi's 'revolution' was against monarchy and for modernity, against an order that was pro-Western and for a non-aligned socialist order. Only much later would such episodes as the struggles captured in *Lion of the Desert* gain Qaddafi's attention and support.[14]

Both films deal with events that were part of very complex processes involving a range of political and economic forces, intricate geopolitical policies and plans, a host of personalities, and vast cultural and linguistic differences. They also offer contrasting perspectives on local peoples, their practice of Islam, and the role of imperialism – issues that this chapter has addressed. Feature films understandably struggle to bring all this complexity onto the screen, and certainly they cannot reasonably be expected to do so.

Khartoum was intended for a Western audience, and with its starry cast and story about the enigmatic Gordon, it had considerable appeal. It was both a popular and critical success. It was nominated for an Oscar in the screenplay category and for two BAFTA awards, one for Best British Actor and another for Best British Art Direction. Unsurprisingly, it was not screened after its release in the Sudan itself, except for semi-private viewings at the British Embassy.[15] *Lion of the Desert*, by contrast, was far less successful at the box-office. It did, however, earn a following in communities going through periods of political struggle themselves, such as in apartheid South Africa. It was also a hit in Libya, but not in Italy where nationalists felt it demeaned the Italian army. According to one source, 'the film is banned in Italy. Owning and showing it is a criminal offence, on the ground of "defamation of the armed forces."'[16] Clearly, celluloid with all its flaws and shortcomings can still unsettle and stir old debates about which some would rather not speak.

9

Cheap if not always cheerful:
French West Africa in the world wars in
Black and White in Colour *and* Le Camp de Thiaroye

BILL NASSON

Black and White in Colour

In 1915 a handful of comic French colonists living in a remote rural station in West Africa discover belatedly that they are at war with Germany.[1] In a patriotic frenzy, they assemble a squad of African soldiers and attack a neighbouring German post with which they had previously enjoyed friendly commercial relations. Driven back in a panic, the French regroup under more authoritarian and efficient command, and mobilise a larger African force to throw against enemy firepower. But, instead of achieving success, the French side is sucked into a little war of attrition and stalemate. Peace returns eventually and a normal colonial life resumes.

French director Jean-Jacques Annaud's credits include *Seven Years in Tibet* (for which he was banned from entering China) and a more recent World War Two film, *Enemy at the Gates* (2001). His *Noir et blancs en couleur,* which won a 1977 Oscar for Best Foreign Language Film, was shot discreetly in the Ivory Coast, one of the eight territories of the former French West Africa which became national republics in 1960, while remaining strongly pro-French through a dense web of neo-colonial links and sensibilities. At the gala première of the Annaud film in Abidjan, French officials and various embarrassed Ivorian dignitaries walked out of the performance on realising that they had come to see a sardonic spoof of French colonial policies. It was, perhaps, one of the better mean jokes in the history of historical films. *Noir et blancs en couleur* appears to have remained a source of discomfort for Ivorian authorities, although in France itself its anti-colonial critique struck a critical chord with younger audiences. Interestingly, the

film was only released in West Germany in 1987. Presumably its distributors were wary of treading on Franco-German corns.

—

Le Camp de Thiaroye

In November 1944, a contingent of French West African infantry veterans of the war in mainland Europe disembark in Senegal prior to their final repatriation.[2] Passing from more liberal metropolitan French army command to a high-handed colonial officer corps, they are crammed into bleak demobilisation barracks. Conditions in Thiaroye camp are poor, and soon there is mounting tension and conflict between aggrieved African servicemen and authorities. Anger finally boils over when the French administration refuses to pay what soldiers consider to be their rightful due as war gratuity for service and sacrifice. The soldiers rebel and seize control of the camp. A duplicitous French high command buys time by falsely promising to meet its moral obligations to the agitated African veterans, before moving in to put down the mutiny with brutal force. Thiaroye was the most bloody clash between discontented African troops and the French colonial regime in World War Two.

Hailed as the 'father of African film', the acclaimed Senegalese artist Ousmane Sembène has built a reputation on his prolific writing as well as film directing. His first film, *L'Empire Songhaï* (1963), was a documentary history of the Songhai empire, funded by the Mali government. Subsequent feature films have been stamped with his political vision, a critique of social injustice and exploitation, and a passionate commitment to the freedom and revival of oppressed African societies. During World War Two, Sembène served in Niger in a French colonial infantry unit, an autobiographical sideshow which clearly helped to feed the epic narrative of his 1987 *Le Camp de Thiaroye*. Winner of a Special Grand Prize at the 45th Venice Film Festival, its combined French and Wolof dialogue helped to ensure it a large and enthusiastic West African audience which included numerous war veterans.

In the early pages of *An Ice-Cream War*, William Boyd's memorable picaresque novel about love, lunacy and languid death in East Africa during the Great War, Temple Smith, a failed safari manager and bungling sisal farmer in British East Africa, has an exchange with his perky young sons, Glenway and Walker. On his recent June 1914 trip along the Northern Railway of German East Africa, Temple Smith had spotted more than just coffee seedlings. 'Guess what,' he reveals. 'I saw a big battleship and lots of soldiers.' Ears pricked, Glenway asks, 'Are they going to fight in a war?' Temple Smith snorts, 'Did you hear that … a war? Don't be

silly, Glenway. There isn't going to be a war. Well, at least not here in Africa.' Like his German farming friend Erich von Bishop, he cannot envisage 'there being any fighting out here'.[3] When it came to contemplating world war, it was felt that Africa would be left to its own devices.

But, as the most considerable influence on those devices was European, Africa was never likely to be left a peaceful front, whether in World War One or Two. The continent became sucked into both world wars because most of its peoples and materials were under a European imperial thumb. Mobilised for an essentially European conflict by the demands of total war, Africa's economic and human resources, strategic ports and communications arteries made it inevitable that its territories would be at war.[4] And the character of that participation was, at times, striking. British hostilities in the Great War were opened by its African soldiers, who invaded German Togoland in West Africa, while tenacious German East African *askaris* kept on campaigning through the November 1918 European armistice. When World War Two broke out in September 1939, seven of the 80 infantry divisions guarding metropolitan French borders were African, while by mid-1940 around 80 000 French West African troops were serving in France. At the time of its surrender to Germany in June 1940, colonial African soldiers comprised almost ten per cent of the French army.[5]

What this all amounted to at the French end of things – and not only there – was that the total wars of the 20th century brought the bitter and often confusing experience of war between European imperial powers to African soil, led to the enlistment of hundreds of thousands of volunteers and conscripts into their colonial African armies and exposed those forces to the experience of modern war in operational theatres distant from Africa, including the Western Front and Gallipoli, Corsica and Burma. To this broad summary could be added two further elements. In the case of French imperialism, the raising of African forces for fighting overseas was not in itself novel; for instance, Senegalese *tirailleurs* had been deployed in the Franco-Prussian War as career warriors or military professionals.[6] What was new was the intensity and scale of conscription after 1914 and 1939, and the fact that mass recruitment was no longer lubricated by racial stereotypes of favoured 'warrior' or 'martial' races. This was a major departure from established colonial preference and practice.[7] In its way, the Parisian approach to cannon fodder in the 20th century had grown altogether more liberal and enlightened.

A further consideration is historiographical. On the one hand, general histories of the world wars situate Africa quite correctly as an involuntary belligerent, a minor sideshow compared to, for example, mainland European experience of warfare. Most Africans, after all, barely felt the direct impact of these shattering conflicts.[8] On the other hand, specialist African scholarship on wartime

life emphasises that mobilisation and local campaigning was anything but a light matter to affected communities. Moreover, the multiple inflationary, ecological and other pressures of total war affected societies that would have been untouched by actual fighting.[9] Thus summarised, at the most fundamental level the two world wars were a testing time for African inhabitants of *la France d'outre-mer*, or overseas France In trying to understand the complexities of that impact, partly disruptive, partly galvanising, it is necessary to remember the overriding French imperial focus. While African colonies were clearly useful as suppliers of raw materials, food and tax levies in war, their skinny infrastructure limited their industrial effectiveness.

The real value of French territories in West and North Africa lay in a seemingly unlimited reserve of troops and labourers.[10] At the same time, and of central importance to the war films addressed in this essay, the identities and voices of France's colonial African soldiers have long been either inaudible or muffled. Certainly, metropolitan French soldiering experiences have been amply reflected in historical literature on personal testimonies of trench service by scholars such as Stéphane Audoin-Rouzeau.[11] The vociferous *prise de parole* or 'speaking out' associated with grumpy French servicemen has also been captured in numerous historical feature films, starting early with Abel Gance's *J'accuse* (1920), Leon Poirier's *Verdun: vision d'histoire* (1932), and Raymond Bernard's *Les Croix de bois* (1937). In contrast, first-hand depictions or re-creations of the war experiences of individual colonial soldiers, who were often illiterate, remain rare, although praise is due to the pioneering oral history study of Senegalese Great War veterans and observers by Joe Lunn, and to Myron Echenberg's vivid account of the experiences of the *tirailleurs senegalais* regiments of the French Colonial Army in both world wars.[12]

Other studies of the war participation of French West Africans remain rooted in French documentary archival sources, and are methodologically too cramped to be peopled with individual faces or characters, to evoke the fabric and texture of their lives, or to convey what recruits thought and said about what they were living through as they were confronting it.[13] In fact, probably the best illustration of the historiographical limitations posed by the lack of African written records on what the wars meant is the Senegalese Bakary Diallo's first-hand testimony of battle experience, published in the 1920s. *Force bonté is* the only contemporary African war memoir, aside possibly from the Algerian Mohammed Dib's autobiographical novel, *Le Métier á tisser*, which tells the story of life in the wartime Algiers of the 1940s.[14] This is the context in which to set any evaluation of the modern, cinematic ways of 'seeing' the past experiences of West Africans under belligerent French colours, represented here by Jean-Jacques Annaud's 1976 *Black and White in Colour* and Ousmane Sembène's 1987 *Le Camp de Thiaroye*.

A no less important consideration in approaching these feature films as constructions of historical 'reality' or as useful 'knowledge' of African war experience is that they are in some ways different in perspective from many popular 20th-century European war films. In the case of the Great War, to take a random early example, there is no Rudolph Valentino of the Côte d'Ivoire to have his soul redeemed through heroic death in order to return in a melodramatic vision to entreat his lover to tend her afflicted husband, a blinded veteran.[15] Nor, for the 1940s, is the war on view steeped in the literary plot tradition of vigorous adventure stories, in which *Ice Cold in Alex* and *The Cruel Sea* furnish an arena of ambition for 'male protagonists' to probe themselves 'for weakness and insufficient enterprise' in the emotionally sustaining company of comrades.[16] In visions of wartime which are sometimes surreal, sometimes grimly matter-of-fact, the promise of *Black and White in Colour* and *Le Camp de Thiaroye* is film-making that draws viewers into a colonial world jolted by the inhumanity, barbarism and madness of war. And, given the rocky nature of their African setting, a further promise is of historical stories in which a clean, happy ending is not a foregone conclusion for their audience.

In one sense, these film interpretations of war and its shadows might be seen as versions of European war dramas about hardship themes such as conscription, rationing, internment, expulsion, mutiny and trauma, suffused with their own robust moral language in which stoic or prickly black *combattants* confront their burden of inept and callous French commanders. They are, then, avowedly political films about war as a political instrument. Yet on another level, they are equally films that finger the conventional chords of cinematic entertainment narratives, through entering 'the realm of the mythical, by telling stories about universal themes, common to all cultures, about death, sacrifice, love, friendship'.[17]

Accordingly, as an invention of 'history on film', what do these productions tell us about the nature of war experience in colonial Africa? Most crucially, in tone and theme, how effectively do they present the political context of wartime conditions? Here, perhaps the first thing to say is that although *Black and White in Colour* and *Le Camp de Thiaroye* are very different kinds of films, taken together they evoke a larger and important reality about France in the world wars. The crucial test for any society waging 'total war' is how to mobilise its available human resources most effectively. Being demographically and militarily weak yet a core terrain of conflict, the French faced this test in its most acute form. Whatever the imperative of constructing a technologically sophisticated industrial war effort, France was obsessed with drafting men into the field, drawing on colonial manpower far more than other European imperial powers. Mobilised manpower, from the industrial basin of the Loire to tropical African colonies, was not just a technical or organisational enterprise. It went, as John Horne has put it,

to the imaginative 'heart' of the meaning of war, as the 'premise on which popular understanding' was founded was the universal claim 'of the *patrie* on the services of all in the hour of need'.[18] When it came to obligation to armed service under the colours, it was World War One that first turned the *impôt du sang* or blood tax from metaphor into bodily reality. Moreover, as we see in *Black and White in Colour*, the logic of French urgency over their manpower crisis was inescapable, even where the actual numbers involved were small.

Jean-Jacques Annaud's film is a World War One satire, set in a French Ivory Coast colony and involving the inhabitants of a well-drawn outpost in the rural hinterland, an isolated and dog-eared commercial and administrative settlement, where a handful of mostly scruffy and lonely French men and women maintain tenuous communications with their homeland and scratch out an existence through small commodity trade, including sex. Nearby African villages supply the dusty trading post of Fort Coulais with menial labour as well as concubines to satisfy the sexual needs of its glum and cynical military *commandant*, an NCO named Bosselet.

While exacting taxes, imposing labour demands and expropriating favoured women for its administrators was the daily bread of the rural French colonial regime, two things ensure that life at Fort Coulais will not remain humdrum. In January 1915, its half-forgotten white colonials discover that France has been at war with Germany since August 1914. Secondly, their nearest neighbour and best customer a few miles up the river is an equally remote and tiny German colonial garrison. Initially, we see French and German colonials interacting equably enough, with Fort Coulais traders rubbing their hands at their neighbours' dependence on them for supplies, and sniggering smugly at German training of their African bearers to perform drill and precision marching. The French characters have a sense of moral superiority which appears here as more subliminal than ideological. Their astute Frenchness is the justification of their rule. As one of the film's two missionary priests observes, half-reprovingly yet half-admiringly, when it came to handling African labour, the unsparing German 'works them hard'.

The quiet (and quietly exploitative) existence enjoyed by the small French circle of vulgar shopkeepers, grasping priests, energetic prostitute and lethargic sergeant is disturbed unexpectedly one day. A package arrives for the trading post's resident intellectual, Hubert Fresnoy, a stylish and self-regarding geographer. Full of Parisian panache but without a Parisian job, the socialist Fresnoy is stuck in the equatorial hell of a French African trading post, dependent on letters between Fort Coulais and the metropolis, which take months to reach their destination. The gaggle of colonists falls upon the newspapers included in Monsieur Hubert's post, from which they discover that they are several months into a

European war with Germany. As dozy but patriotic citizens of the Republic, what are they to do about their ominous German neighbours?

Egged on by Rechampot, the main storekeeper, the bumbling characters ignore Fresnoy's misgivings over commencing hostilities, declare themselves to be 'at war', and in a fit of patriotic hubris opt to attack the German garrison. What with six African soldiers to swamp the Germans' three, and the combined tactical genius of a veteran regular army sergeant, a schoolteacher and a couple of priests to manage the operation, Fort Coulais backs itself to rout the enemy. Suddenly, and comically, the knives are out. The French have themselves carried off to war, borne on litters by tramping servants, and are so assured of victory that they even arrange a sedate picnic at a safe vantage point from which to observe the action while fortifying themselves with *fromage et baguette*. Although this absurd scene is in keeping with the surreal, 'fable' quality which pervades much of this film, it also points to one obvious issue for history films. Is it the historical accuracy or the plausibility that matters? The Great War may have had its share of small-scale African skirmishes of the 'Ice-Cream War' kind, but none could possibly have served as the lounging entertainment spectacle portrayed here. Unless, of course, as a viewer one is in thrall to Joan Littlewood's *Oh, What a Lovely War* as a satirical genre. In that famous 1963 play and subsequent film, the radical British theatre director Joan Littlewood satirised the Great War, having declared that 'war is for clowns'. Mixing slapstick comedy with mordant satire, Littlewood's drama is a comic sweep through the strangeness of the war, from the sergeant-major's incomprehensible drill to the bleating of Frenchmen, walking suicidally to battle, like proverbial lambs to the slaughter. Annaud may perhaps be viewed as a very French African version of Littlewood.

Predictably, in *Black and White in Colour* the French African assault on the German position turns out badly. Not only are their enemies adept at defence and well organised, but they also have a machine gun. The disagreeable sight of their small band of peasant soldiers being cut down quickly spoils the colonists' picnic outing, and they scramble in undignified retreat to Fort Coulais. Amidst mounting panic, it is up to the rueful Bosselet to come up with a means of gaining ascendancy. The solution is the recruitment and then impressment of an ever-larger squad of African infantry to do all of the fighting and dying for the French. Here, *Black and White in Colour* provides a salutary illustration of the margin of wartime risk borne by metropolitan Frenchmen and colonial Frenchmen. Equal exposure to risk in time of war, on the Jacobin principle of popular egalitarianism, 'absolute equality in the face of military duty', was the rhetorical core of the republican political culture that had developed after 1870.[19] During World War One, exemption in France from the danger of front-line service generated intense feelings of popular resentment, and created a contemptible category of *embus-*

qués, or cowardly 'shirkers'. But, out in their remote equatorial African colony, the able-bodied Frenchmen of Fort Coulais are able to shirk without shame, guzzling picnic fare out of range while leaving all the risks to be borne by poorly prepared African irregulars.

Annaud's film is particularly sure-footed historically in its portrayal of the recruiting of African villagers to fight for the French Republic against its imperial enemy; its treatment of the rough and ready techniques of recruitment offers a thumbnail, celluloid sketch of analyses furnished by historians such as Suret-Canale, Echenberg and Lunn.[20] Here, villagers are not blind to the consequences of the initial ham-fisted run at the Germans. A trickle of severely wounded or mutilated men was hardly likely to inspire a sacrificial rush to the colours. Thus, Bosselet and his compatriots turn first to 'volunteer' inducements, offering a tin basin and a pair of boots as a welfare perk to every recruit who, upon attesting, is re-labelled with a French name. But the supply of Rechampot's basins runs out rather rapidly, and the boots fail to cut it with rural volunteers, who find them uncomfortable and end up carrying the footwear instead of marching in them. In one droll aside, a recruit concludes that the foul mood of most Europeans is because their boots are unbearably tight.

Fresnoy is central to the next part of this picture. Drawn early in the film as a rather constipated socialist, pacifist and man of science with a romantic view of a pastoral Africa, he is jolted out of his earnest philosophising by the military incompetence of his stumbling compatriots. Facing up to the mess enveloping the French effort, he turns into a kind of supreme command zealot, turning his attention to this and that, including the pressing need to boost recruitment. Under Fresnoy's beady eye, the French break bread with local chiefs and other influential African agents to secure levies of able-bodied men, either through currying favour by offering benefits, or through menaces, making peace with France dependent on compliance. *Black and White in Colour* provides sombre realism in its depiction of the manner in which the colonial administration leaned on conniving African intermediaries to do its bidding as pompous loyal chiefs make ethnic war upon vulnerable communities, launching sweeps or 'man hunts' to capture the bodies of 'savages of the savanna' to fill recruitment quotas in the face of flight or stubborn resistance.

On the other hand, Annaud's fabrication of African troops in African trenches (complete with rain, mud, misery, disease and death) is an instance of film drama conflicting with historical accuracy. Granted, the screen trench is probably a sig-nature image of any film on the Great War, and here *Black and White in Colour* is attempting to capture the essence of a combat stalemate between Western colonial adversaries. In eventually matching the effectiveness of the Germans, the French have achieved the stalemate of a war of position; reflecting tactical

deadlock, a scruffy spot of the Côte d'Ivoire has become an equatorial mirror of the *departement de la Somme*. Trench warfare was, of course, the predominant characteristic, even the substance of the greater part of the hostilities of World War One, but it is stretching things to extend it to the African bush. Still, this is just a feature film, and if one considers historical truth rather than a problem of screen plausibility, there may be something to be said for this vision. How better to portray the essence of the Great War encounter than by making its African theatre embody its essence? Africa is inextricably part of the deep reality of the Great War, as its deluded French colonials display blind faith in the glory of the all-out offensive, symbolised by Rechampot's apparent bravado in skipping over a stagnant stream that separates French and German colonial settlements, for all the world as if he were General Henri-Philippe Pétain fording the Rhine in 1917. Inevitably, rash optimism in a dashing short war of manoeuvre is snuffed out by lingering stalemate and the fog of attrition. Here, by inserting Africa into the encompassing, larger meaning of World War One, *Black and White in Colour* is exemplifying the film historian Robert Rosenstone's notion of 'true invention' in film that depicts historical events, or engages inventively with the established 'discourse of history'.[21]

Peace is reached with little fanfare and even less dignity. The white inhabitants of Fort Coulais have to bow and scrape to the commander of a relieving Anglo-Indian column who turns out to be a supercilious Indian cavalry officer, a patrician Punjabi who is incredulous at finding no one able to speak English. While the French learn that German African subjects will now fall under British jurisdiction, little else changes in 1918. Whether it is Rechampot's commerce, Fresnoy's sniffing out of the terrain, or Catholic conversion of the heathen, colonial business is resumed almost effortlessly. This was, indeed, more or less the case. 'Such was the French authorities' determination to keep firm control of their colonies', concludes Philip Dine, 'that their future was not seriously questioned.'[22]

Black and White in Colour is a film which goes beyond the framework of its single historical event to provide fascinating fodder for contemplating the varied, subtle and frequently comic ironies of European empire in Africa. Many of the resonances of the Great War are here, portrayed in a kind of microcosm. To those already noted, more could be added. The bloated and boorish Rechampot's obsessive hoarding and deceptions reflect the rampant profiteering of the commercial bourgeoisie who, for all their fervent patriotism, always had an eye on higher returns. The austere Fresnoy ditches the idealism of his socialist pacifism in favour of patriotic bonding when the going gets rough, turns into a technocratic martinet and relishes the authority and prestige of directing a more efficient Fort Coulais war effort. War brings the beguiling whiff of personal power,

liberating Fresnoy from the political impotence of his earlier egalitarianism.

The film's historical universe is also filled with the larger matter of the daily record of the African colonial past. Alongside the mostly mocking depiction of routine French racism and bigotry, there is missionary Catholicism. The commercially minded Father Simon and Father John of the Cross view the African population either as a valuable source of barter for artefacts, or as a pliable flock to be dazzled into accepting the divine Kingdom of Christ and any of its earthly purposes, such as dying for France from January 1915. Nor are the 'enlightened' attitudes of French socialism towards African society spared mockery. Fresnoy is airily dismissive of the consternation he causes his white compatriots, scandalised by his showy relationship with a decorative African mistress, and is dewy-eyed about the tranquillity and homeliness of local peasant life. For all this, though, the film makes him a credible social evolutionist of his era in venturing that the 'natives' are not far off the mark in 'meeting the honoured name of men'.

So much for the racial arrogance of the *colons*. What of African attitudes towards the exalted French? To be sure, Annaud's satire focuses squarely on the colonists, with Africans mostly background characters at the behest of either French or German power. But it does not wholly ignore a participant African voice. As a fleshy missionary rocks between parishes in a litter carried by obedient adherents, he exults in their joyful singing. Yet, being as ignorant as his compatriots of the local language, he is unaware that his bearers are sneering at his bodily odour, that of just another white man whose 'feet stink like dung', and are mocking his size. In a later scene in which Fresnoy parleys with a chief during his drive for recruits, perpetually swatting Frenchmen prompt villagers to observe that 'white men attract flies'.

These screen interludes are effective in showing the often startling physical and cultural differences between African and French groups in very isolated rural areas, and the extent to which white colonists struck Africans as extremely odd or peculiar.[23] Through the educated character of Bartelemy, an acculturated clerk who enjoys a friendly relationship with Fresnoy as his French patron, *Black and White in Colour* illustrates a further human dimension of the colonial relationship for West Africans. Ensuring compliance with the requirements of the colonial order depended on the use of competent and skilled civilian African intermediaries. The sly and often impertinent Bartelemy stands for the ideology of *assimilation*, absorption into the colonial regime that 'offered to a tiny minority of highly educated Africans the prospect of full intellectual membership in the most enlightened polity in the world, the French nation'.[24]

Historians of French African imperialism such as Jean Suret-Canale and Philip Dine have suggested that the impact of the world wars made and then broke *la France d'outre-mer*, or overseas France.[25] Fort Coulais's scrappy contri-

bution to the French war effort plays its pitiful part in re-establishing colonial security, so that in the immediate wake of 1918 the French Empire would go on to achieve its largest territorial and demographic expansion. By the 1930s, *la plus grande France* or Greater France was at its peak, the Mobile Draft Boards of its peacetime conscription system ensuring a constant supply of West African praetorians to defend the sacred soil of France. Meanwhile, Europe was slithering into its next great conflagration, one with far more injurious political consequences for its great powers. This is the context for the portrayal of the experience of African combatants in *Le Camp de Thiaroye*, a major 1980s production by the leading Senegalese writer and filmmaker, Ousmane Sembène.

The background to the events depicted in this fictionalised account of the life of demobilised and disaffected *tirailleurs senegalais* World War Two veterans in a West African transit camp is again provided by French self-delusion. Tucked in behind their rickety defensive Maginot Line between 1939 and 1940, the metropolitan General Staff believed that France would hold out with minimal losses. As in the Great War, colonial *tirailleurs* were spooned into the front lines and endured the catastrophe of 1940, facing the brunt of Berlin's Blitzkrieg and suffering heavy losses. Considerable numbers of survivors of African units were then incarcerated in German POW labour camps in terrible conditions for up to four years. Such trauma was not the only thing to have left its mark upon colonial troops. Following the June 1940 armistice and France's division into an occupied northern zone and a 'free' southern region, the partial break-up and neutralisation of the regular French Army removed most French troops from the field.[26]

Although Charles de Gaulle's Free French forces built up strength, they did so slowly and, in the phase from mid-1940 until the liberation of 1944, French West Africans comprised the main rank-and-file element of the Free French Army; from the end of 1942, their involvement in the Free French war effort became 'large-scale', spurred on by the 'rallying of the greater part of the French African territories to the Free French cause'.[27] A sense of sacrifice and of valour in cleansing France of the humiliation of defeat and the Vichy shame of collaboration became part of the *tirailleurs'* group consciousness, as did a feeling of entitlement to just reward and recognition from Gaullists, who had every reason to be grateful to black veterans for their conspicuously loyal combat contribution. 'The notion', as Echenberg suggests, 'that they had served France above and beyond the call of duty was deeply embedded in these men', as was 'a heightened consciousness of themselves as Africans united by their shared experience in suffering'.[28]

For these men, liberation brought little else but discontent from 1944 to 1945. While French soldiers were speedily paid off and discharged, thousands of West African servicemen were deposited in shabby transit camps in central and southern France, where they languished until shipping became available to repatriate

them. Inevitably, the clustering together of so many demobilised and disaffected French colonial troops triggered disturbances during the last two years of the war, and there were over a dozen serious incidents in locations including Versailles and Liverpool. But the gravest uprising by far occurred not in Europe, but at the Thiaroye barracks on the edge of Dakar, Senegal. Sembène's long and, it must be said, rather ponderous film takes its title from the name of this ill-fated transit camp for repatriated *tirailleurs*, not only from Senegal but also from elsewhere in the French West African empire. It is a pungent historical title, for in the post-war era Thiaroye came to be deeply embedded in the collective popular memory of African veterans and an older generation, which experienced social upheaval and political turbulence at the end of the war. In its way, *Le Camp de Thiaroye* could be viewed as an attempt to embalm a flaring radical moment in collective memory or as an ashen monument to African sacrifice for a tawdry colonial France which dished out ingratitude, injustice and maltreatment, instead of due recognition and fair reward.[29]

Unlike Annaud's sunlit satire about Great War absurdity in colonial Africa, Ousmane Sembène's film is powerful and politically earnest African cinema, drilling its sombre anti-colonial message into viewers through a passionate chronicle of African defiance. A fictionalised account of a notable historical episode, it opens towards the end of 1944 with a tumultuous civilian welcome at the Dakar dockyard and a ceremonial parade to mark the return of French West African *tirailleurs*, disembarking in Senegal for repatriation to local villages or to neighbouring countries of origin. Immediately, rather than encountering 'the colonial subject' as 'a stick figure in a drama written elsewhere',[30] the film offers insights into the consciousness, identities and voices of individual soldiers, and shows a dense interplay between them as distinctive characters. Some of these demobilising *tirailleurs africains* have been German POWs since the Fall of France, while others are battle-hardened veterans of draining years of adversity and sacrificial combat as members of the 1st Free French Army.

Their ranks pulse with a sense of honour, dignity and pride in their military accomplishments, and with expressions of indebtedness to the World War One martial spirit of their 'fathers' which had fortified an heroic tradition of defending the *patrie*. These weighty sentiments do come across as a little laboured at this juncture. Were they typical preoccupations or not? We may, probably, have no way of knowing, although if we follow David Killingray's reasonable argument 'that African armies of the Second World War were not necessarily very different from the armies raised in the modern industrial states',[31] then it is at least conceivable that bored returning veterans would have been equally preoccupied with the more mundane essentials of life, such as awaiting families, lovers, jobs and possessions. But, as 'filmic' African social history, this may simply be an inversion

of G.M. Trevelyan's venerable dictum on innocuous social history: the history of the people with the politics left out. What Sembène's film sets out to do is to portray the people with the politics left unequivocally in place or, at least, politics of a particular rhetorical kind.

Others on the Dakar quayside are burdened personal victims of the war, like the crazed infantryman, Pays, who has been in a German camp and has lost his speech. 'The war', in the words of a sympathetic companion, 'has destroyed him.' Another figure, Sergeant Major Diatta, had been campaigning with Free French forces until the liberation of Paris, and has left behind a white French wife and young child, a sign of easy individual acceptance and social integration into metropolitan French civilian society, which is borne out by historical literature on the experience of colonial troops on duty in France since the 1920s.[32]

Europeans in Europe were not necessarily the same breed as Europeans in Africa. In fact, in a moving illustration of the clash between the expectations of 'traditional' custom and 'modern' aspiration, it is Diatta's kinsmen and kinswomen who are put out by his having acquired a white wife. Having spoiled their anticipation of a village marriage to a favoured bride, he does not get off culturally to a good family start on his return to Dakar.

Trailing behind Diatta is a muster of veterans drawn from varied parts of French Africa, stamped by place as 'Niger', 'Congo' and the like in the shorthand language of the lower ranks. Awaiting French officers in Dakar are peeved to discover that the servicemen (with exception of the assimilated Diatta) are incapable of understanding their language 'codes', while the troops themselves share no common language, communicating in a flamboyant form of Creole or pidgin derided by the French as *petit negre* or 'little nigger'. This shared, bubbling language bonds the subjects of this film as much as the shared emotion of joy at their homecoming to what characters celebrate as a 'warm Africa' and 'the soil of Africa'. *Le Camp de Thiaroye* has a distinct tendency in various scenes to 'essentialise' Africa as a benign repository of fraternal virtues, a warm terrain enlivened by vigorously egalitarian bonhomie, with a saintly pre-colonial heart still natural and uncorrupted by a stiff-necked and oppressive Europe. Disembarkation into the romanticised folds of a cherished place is also a key moment at another social level in the unfolding historical drama: this film depicts very strikingly troops chafing on the brink of resuming civilian status, stuck behind a khaki that has an increasingly tenuous hold upon their thinking and their manner.

Their sympathetically portrayed commanding officer, Captain Raymond, hands over the infantry contingent to Major August, commander of the Dakar base and a compromised representative of the Vichy-regime neutrality of the French West African officer corps. There is, in this, a nicely instructive irony, the meaning of which does not exactly escape the *tirailleurs'* notice. They are then

marched to the Thiaroye transit barracks, termed 'better than their villages' by camp authorities. In reality, Thiaroye amounts to little more than a rough and arid POW camp, its cramped rows of huts ringed by a barbed-wire perimeter and menacing guarded watchtowers. For the shambling Pays under his macabre souvenir German SS helmet, the camp is an immediate and searing reminder of an earlier ordeal. More broadly, the authoritarian bearing of Captain Labrousse, the Thiaroye camp commander, reminds African infantrymen that they are returning home to a colonial system that has not softened in recognition of their considerable wartime sacrifices.

The provision of inedible and unacceptably short rations sparks the first clash with camp authorities, a confrontation over the customary right to meat in which the seething *tirailleurs* get their way. Their victory in obliging the army to provide meat is conveyed by nonchalant images of animal slaughter and blood-letting which flit across the screen, serving to illuminate the role of Muslim religious practice among the soldiers. Other period incidents also hold the screen. Diatta receives visiting relatives (including the village cousin chosen as his future bride), who are appalled to learn of his wartime French marriage. They have fled to Dakar from the countryside, survivors of a massacre by French forces in which Diatta's own parents died. Embittered, yet dignified, they find it incomprehensible that he could have married 'one of those' who had destroyed his home. On the beaming French paternalist side, Diatta is praised fulsomely by Raymond for his fondness for European classical music ('no longer tom-toms'), and for the acquisition of 'educated' status and 'excellent French'.

Diatta, *Le Camp de Thiaroye*'s central character, saunters into town in his US Army fatigues, for all the world not only looking but also sounding like a black American GI as he also speaks English; it was not uncommon for African soldiers to have been short of clothing by 1944 or 1945, and to have scrounged replacements from well-stocked American units.[33] Even as a black GI, Diatta is welcomed at first at a European brothel as a man with dollars. But when his breezy order for a Pernod unmasks him as a francophone 'native', Diatta is turfed out. Encountering a friendly black GI in the street, he relates a flourishing piece of *tirailleurs'* fighting folklore or African veterans' mythology: that it was their singular valour that had determined the fate of France, that charging black Africans had thrown out the Germans while terrified metropolitan French forces had folded meekly. Here, again, the film echoes beliefs that were widespread among West African veterans.

Out on the street, Diatta is again misidentified (this time, by American soldiers) and is roughed up and arrested by a US military police patrol. His enraged men retaliate by taking an American NCO hostage to secure his release and safe return to Thiaroye. For the French command, this unravelling of military disci-

pline is bad enough. But what really causes consternation is that black service-
men have kidnapped a white Allied forces soldier. With the dispute resolved by
the negotiated release of both men, a black NCO from the vindictive US street
squad makes an olive branch visit to the freed sergeant-major. He delights in
the nerve of Diatta's comrades in having collared a hapless white, and the two
indulge in a distinctly saccharine bout of transatlantic African solidarity, as an
instinctively shared chemistry of jazz and admiration for Marcus Garvey affirm
the pieties of a black brotherhood, with Mississippi clasping Senegal in a thera-
peutic embrace. On screen, this is all done with such quiet dignity that it seems
almost ungenerous to raise a question. Such scenes are surely symptomatic of
more general problems which can arise in 'historical' film. Although the impact
of Garveyism on French-dominated Africa was never more than 'faint',[34] the
film's insistent political need for noble character identification and celebration
inflates it beyond historical credibility.

Sembène's aim through a succession of these and other episodes is to re-
create a social context in which to show the intelligible world of the veterans
themselves. That world eventually explodes over French bad faith. The failure of
Dakar authorities to provide proper back pay and demobilisation gratuities raises
simmering tensions between infantrymen and brusque camp authorities to boil-
ing point. Protesting *tirailleurs* demand service pay that is rightfully their due,
and insist that the metropolitan francs that they had accumulated individually be
exchanged for local currency at a fair, and not discounted, rate.

Disregarding Raymond's view of the moral legitimacy of the claim, the short-
handed Thiaroye command refuses to meet expected levels of compensation.
Some disdainful officers see no need to compensate Africans already in posses-
sion of monies felt to be 'too much for a native', while others insist that the sol-
diers' francs must have been obtained unlawfully, or from having callously looted
the corpses of dead comrades on the battlefield. Officers are also perturbed that
insistent talk of rights is an indication of some Communist contagion or, even
more bizarrely, may be the consequence of furtive Nazi mischief-making.

With mutiny in the air, jumpy Thiaroye officials turn to supreme Dakar
military authority. The general adjusts his gold-brocaded *képi*, orders that the
pay protest be abandoned, and upholds the French refusal to pay a better rate of
exchange. He is then taken hostage by the *tirailleurs* in a grand, madcap moment
of historical verisimilitude, for in late 1944, 1 280 repatriated African veterans at
Thiaroye barracks 'refused to obey orders', and went 'so far as to take the com-
mander of the French forces in West Africa hostage'.[35] As control of Thiaroye slips
into the hands of its alienated African soldiers, the panicky general puts up a
persuasive show of capitulation and concession, offering his ultimately worthless
word 'as a general officer'. Released, he is fêted as he leaves, while the honourable

Raymond, reassured that France will indeed meet its ethical obligation to loyal Africans, congratulates Diatta on a peaceable outcome. As night falls, the camp is exultant, exploding into a raucous screen spectacle of throbbing music, flaring wood fires and communal dance. It is a last great unwitting fling, as a smouldering French colonial administration decides on severe repression.

Pays alone has fears, fuelled by cruel experience that 'an infantryman knows only two things: guns and corpses'. Early on the morning of 1 December, through the darkness he spots tanks rumbling into position to shell the camp. Flailing about in terror, his alarm is ignored by his comrades, who know him to be demented. As firing commences, Diatta's cry is 'now we fight for Africa', but there is virtually nothing with which to make a defensive stand. By dawn, the merciless assault on Thiaroye is over and the dead are disposed of. The official record of the actual incident put the African death toll at thirty-five, with a similar number seriously wounded and hundreds of others injured.[36] The general murmurs to Major August that the Senegalese colonial administration is pleased with the outcome of exemplary force at Thiaroye.

Alert to that key historical sense of the human constraints which set the bounds of what characters can do, and how well they can do it, *Le Camp de Thiaroye* ends appropriately with the misled Captain Raymond, his infantry force brutally betrayed by his superiors. Earlier in the story he had agreed to take some coffee back to Diatta's wife in Paris, and is disconcerted by the absence of his stalwart and admired NCO on the quayside. Yet, the coffee has still been brought along by Diatta's cousin. It suggests that his village kin have become reconciled to the French marriage, a disconcerting social reality of colonial intrusion on the conventions of a customary older order. In a memorable seafront image, rich in allegory, Raymond embarks for France in command of a newly recruited contingent of local *tirailleurs*. Once again, his fine standing in the eyes of his African troops gives the impression that he is at the centre of things. But, as the film sets out to show, as a liberal Frenchman in an unsentimental colonial world he is always on the margins, somewhere else. Indeed, in an earlier pivotal scene at Dakar General Headquarters, Raymond is brushed aside as a misguided innocent who cannot 'know natives or the colonies'.

Sembène's reconstruction of the tragic episode of Thiaroye can be viewed as an artistic effort to keep alive the memory of an important symbol of French African colonial opposition in the 1940s, its French and Wolof dialogue ensuring it an audience throughout former French West Africa as well as in Europe. It is also a romantic celebration of the character and spirit of its eloquent and ebullient African soldiers, whose rhetorical exchanges and theatrical gestures undercut the deadening rigidities of European military hierarchy and the colonial order.

This is a genuinely populist historical film in which the men are the message. In weighing up its value in representing the past, it is important to bear in mind that, as a feature film, it is only a part – and highly selective at that – of the Thiaroye story. Thiaroye also had more complex and ambiguous historical meanings than are explored in this narrative. Like other Senegalese army camps, it would have had its share of social animosities, ethnic particularisms and brawling.[37] Proclaiming the spiritual essence of an African unity was no guarantee of fraternity when the fists came out, as they invariably did in soldiering life. Sembène's mistiness suggests the other side of the Rosenstone comment on historical invention in film, the use of 'false invention' which ignores the question of commonsense probability in history. Reactions to Thiaroye also underlined a tricky rift in emerging African nationalist politics. Committed to collaboration with French authorities through and beyond the Vichy era, conservative Muslim leadership actually supported French repression on the grounds that unruly rural soldiers had to be brought to heel and obliged to respect all established authority, including that of the French.[38]

As entertainment, *Le Camp de Thiaroye* relies on an instantly recognisable stock of 'good' and 'bad' characters, instructing audiences to assign heroic credit and to apportion villainous blame in the style of so many classic popular film narratives.[39] With their curling lips and bilious racism, Major August and Captain Labrousse are the demons of Dakar. Captain Raymond, with his affective patron–client kind of tie with Diatta, is the golden boy of metropolitan assimilation, a decent white officer whose basic integrity is beyond question. Equally, in its portrayal of character, the film rarely loses sight of the broader dilemmas and tragic ironies which represent the sum of Raymond as an historical figure. The *tirailleurs'* captain presses the army to honour its moral obligations to its African infantry, arguing that France cannot restore itself at the expense of downtrodden black soldiers, by 'robbing' them. He also pointedly reminds former Vichy fellow officers of the special significance of the debt due to Free French Africans, men who had put their lives on the line 'in your place, gentlemen'. Sembène's historical drama constantly makes impressive connections at this level, between structure and personal action, between position and consciousness. Thus, taken in by his fellow officers in the belief that a word from a French officer cannot but be kept, Raymond plays a losing waiting game which consumes his *tirailleurs*. Similarly, distressed at hearing of the early 1940s massacre in Diatta's village, he fingers the Vichy regime's responsibility as providing extenuating circumstances. Clinging to a gossamer thread of belief in Gaullist colonial decency, Raymond is also put out by Diatta's sour conclusion that the mentalities of European colonial armies, whether French or Nazi German, represent essentially the same ruthlessness towards African subjects.

Indeed, aware for his part that the ideology of assimilation is coming nearer to choking than to feeding him, Diatta is also at pains to identify French African war veterans not as 'Frenchmen' but as 'French subjects'. Yet, even here, Sembène's vision infuses this main character with ambiguity. Dangling between France and Africa at the centre of his historical universe, a worldly and self-aware Diatta finds himself impelled to choose Africa. But, even as he is roused to revolt against the colonial order, the film invokes the personal poignancy of the situation of assimilated French Africans. Unable to completely slip the threads of an associational culture of French honour, duty and *civilisatrice*, Diatta, too, is initially deceived by the general's false promise to meet the *tirailleurs'* demands. Even as this drama charts the growth of a collective political consciousness as Africans, it records the clinging reality of 'francophone' Africanness as a miasmic form of after-life. True, Sembène's camp on the rural outskirts of Dakar is defined by the creeds, popular rhetoric and umbrella pidgin of its soldiering Africans. But, as it is the 1940s, it is defined by black Citroëns and Ray-Ban sunglasses, too.

Black and White in Colour and *Le Camp de Thiaroye* are very different types of film about African historical experience. While Annaud's production delights in showing up the wartime absurdities of French imperial hubris, its Great War Africans occupy a subordinate, sat-upon role. Sembène's characters of three decades later are awakening, aware of the rights to which they are entitled and, within colonial boundaries, pressing to go their own way. If these cinematic visions have a common constructed view of French colonial administration in Africa, it is harsh: the reward 'of assimilation through blood sacrifice may be regarded as a monstrous lie told to those Africans and Asians called upon to suffer and, all too often, to die *"pour la France"* in 1914–18 and 1939–45'.[40]

At the same time, we would do well to remember that this is not the only perspective and proportion provided by these interesting features. Annaud and Sembène both explore the ways in which race and racial differences shaped the social experience of African colonial armies. Both films offer 'social documentary' sequences that show how colonial army service funnelled African soldiers into a pool of new experiences, introducing rural conscripts and volunteers to a world of new technologies, relationships, food, clothing and disciplinary impositions shaped more by industrial habits and time than by 'the more relaxed notions of … agrarian life'.[41] Naturally, none of this is either very novel or very surprising to anyone acquainted with conventional forms of historical representation of African colonial soldiers and modern war. Still, perhaps more evocatively than anything else, it is these films that suggest that African experience of the world wars was part of the common grain of men at the bottom who endured these terrible conflagrations, for whom mere survival was the most desirable ending. For African village conscripts of the French Empire, the 'physical contours of war'

were no longer 'dictated by geography and climate, by the seasons and the hours'. Nor, ultimately, would they see 'courage ... allied to action and initiative' prevail, as in an imagined world of traditional warrior fidelity and courage. Rather, *Black and White in Colour* and *Le Camp de Thiaroye* accurately depict how the industrialisation of war in Africa 'set the individual at nought'.[42] In the Côte d'Ivoire in 1915, it is the chilling clatter of the machine gun which changes the odds. In Senegal in 1944, it is the terrifying fire of the unstoppable tank.

10

Whites in Africa: Kenya's colonists in the films Out of Africa, Nowhere in Africa and White Mischief

NIGEL PENN

Historical introduction

A legitimate African complaint about films made by non-Africans about Africa is that such films 'undermine our misery by putting us in the background, which is where we are in Western history'.[1] We should hardly expect films made about whites in Africa during the colonial period to rectify this imbalance. Indeed, we should expect quite the opposite, and our expectations would be confirmed after a viewing of the three films that are the subject of this chapter. The films are about Europeans in Kenya and, if they reflect a Eurocentric view, so much the more realistic. Rather than judging the historical veracity of the films by their sensitivity to the experience of Africans, it is more fruitful to ask whether they are accurate portrayals of the experience and sensitivities of European colonists in Kenya, and this will be the approach taken by this chapter.

The history of European settlement in Kenya began with the declaration of a British protectorate over Buganda in 1894, and a protectorate over a ten-mile coastal strip around Mombasa in 1895. The two areas were 800 miles apart and for reasons which were declared to be strategic (but which seemed, to contemporary commentators, to be beyond conjecture), it was decided to link them together by means of a railway line. The line was started in Mombasa in 1896 and reached Nairobi in 1899. By the time it was completed it had cost five and a half million pounds and was now expected to pay for itself.[2] How?

The British government decided that the territory now known as the East Africa Protectorate (its name was changed to the Kenya Colony in 1920) should be encouraged to develop its agricultural potential. Since it lacked any mineral

167

deposits this was, perhaps, the only viable economic option. The trouble was that the great majority of the country, particularly its northern regions, was a barren wilderness. The only region with agricultural potential lay around Lake Victoria and in the Kenya Highlands – an H-shaped area formed by the twin flanks of the Rift Valley and joined by a connecting belt in the centre where the Valley rose over 5 000 feet and fell within the 30 inches a year rainfall isohyet. Who was to unlock this agricultural potential?

It was, theoretically, possible to encourage the local Africans to become market-orientated, commercial farmers. But the land seemed too promising to leave to Africans, who might well take years to begin turning a profit and would, in any event, need European instruction in growing cash crops. Besides, it was felt that most of the land in question belonged to the Masai – a pastoralist society whose 'customs may be interesting to anthropologists, but [who] morally and economically ... are all bad'.[3] The Masai, conveniently, were no longer the military threat they had once been as civil war, rinderpest, pleuro-pneumonia, syphilis and smallpox had devastated their societies. The Kikuyu, an agro-pastoralist society that had contested the Mount Kenya area of the Highlands with the Masai before the arrival of the British, did not seem to the colonial mind to have better claims to much of the land than colonists themselves. In any event, Kikuyu military resistance was negligible and they were pacified by 1910.[4] There seemed little impediment to white settlement. It was estimated that there were a mere two million Africans in the East Africa Protectorate, most of them members of stateless societies. Thus it was that the first Commissioner of the EAP, Sir Charles Eliot, expressed the opinion that the Protectorate was to be 'a white man's country in which native questions would present but little interest'.[5]

The first white settlers were encouraged to take farms of approximately 640 acres freehold and to lease grazing lands of approximately 5 000 acres at a nominal cost. Though it was not quite clear initially what type of farming should be attempted, it was clear, from the outset, that African labour would be necessary. Quite what the relationship between settler and African labourer was to be was also uncertain, but the process of defining this contested relationship would be the central dynamic of Kenyan history until independence in 1963. Who were the white settlers?

The popular conception of the early Kenya pioneers is that they were 'well capitalised and influential, drawn from the upper strata of society and nostalgic for "the world of dependency and obligation which their ancestors had lost to the Industrial Revolution."'[6] One of the first to express this view was Evelyn Waugh, who visited Kenya in 1930, and decided that the settlers 'wish to transplant and perpetuate a habit of life traditional to them, which England has ceased to accommodate – the traditional life of the English squirearchy'.[7] These predominantly

English or Anglo-Irish scions of the nobility and gentry were, it seems, trying to replicate a quasi-feudal ideal, benevolently supervising the labours of the African peasantry whilst guiding them to a better appreciation of the benefits of civilisation. In keeping with their aristocratic character, the settlers came to Kenya in pursuit of good sport: hunting, shooting and fishing; sun, space, action and adventure: 'not so much to make money as to spend it in congenial occupations in a delightful land', as a type of resident tourist.[8] Kenya was a vast parkland of game affording ample opportunities for the pleasures of the hunt in a landscape of spectacular, exotic beauty. The bracing air was said to produce euphoria in white people, who were therefore not held strictly accountable for their behaviour. As Judith Thurman puts it, Kenya 'had a highly erotic atmosphere; it was a place where, with the sanction of Nature, civilized inhibitions were let go. Serial monogamy was athletically practised, and in the bars of steamers that carried settlers out to their farms or hunters to their adventures, women were accosted with the famous question, "Are you married, or do you live in Kenya?"'[9]

It may be appreciated that if all Kenya settlers were sexually dissolute and hedonistic, very little farming would have been done. It should also be noted that not all the settlers were well capitalised nor, indeed, were they aristocratic. By 1903 there were some 100 Europeans around Nairobi and many of them were in fact South Africans, both English speakers and some 'bittereinder' Afrikaners, disillusioned by post-South African War society. The South Africans, with their unique experience of farming in Africa, did a lot to influence the development of race and labour relations in the new colony, but their contribution, perhaps rightly, has never been romanticised. British farmers looked somewhat askance at their colonial brethren and the word kaburu (derived from Boer) entered the Swahili language with the meaning of 'rude' or 'coarse' attached to it.

British settlers with no inclination to farm, or lacking the necessary capital, did not find it easy to survive, as may be observed from the example of Lord Delamere, the foremost of Kenya's settlers. Delamere, described as a hot-tempered Eton dropout, arrived in Kenya as a badly mauled lion hunter in 1896 and decided that the Highlands were the promised land, the realisation of Rider Haggard's dream of a rich fertile country hidden beyond impenetrable desert and mountains.[10] He acquired about 142 000 acres of the Rift Valley on a ninety-nine-year lease for the rental of one half-penny per acre and set about trying to farm. Despite these advantages he swiftly ran through a fortune of £80 000 before developing a strain of wheat that would grow in East Africa and mastering African pastoralism. His inaugural flock of 4 000 ewes produced only six lambs that survived and, although he began to sell meat and wool by 1910, the prospect of disaster was never far away.[11]

If things were hard for Delamere, a farmer on the grand scale, they were

even worse for small farmers. A large part of the problem was that there was no compelling reason for Africans to work for Europeans, for until about 1920 Africans in the Highlands had sufficient access to their own land and had no reason to go hungry. The imposition of a hut tax, in 1902, was one incentive for Africans to earn wages. Africans would also offer labour in exchange for access to European-owned land if they deemed it to be in their interests. In time many Kikuyu became fairly successful market gardeners, growing maize and vegetables, whereas their European landlords struggled to grow coffee (which Africans were not allowed to grow for themselves) and other cash crops for the international market. By 1910 Africans were producing some 40% of the colony's total revenues in tax and import duties whilst the settlers were producing only 20%. Furthermore, products of African origin furnished some three-quarters of export earnings. This buoyant and powerful African peasant agriculture was all very well but what about the settlers' economic interests and labour requirements?[12]

The Liberal government of Britain had stipulated, in 1908, that there should be no forced labour in the British Empire, but the Kenyan settlers were increasingly feeling the need to apply extra-economic means to secure their labour supply. The one thing settlers had that appealed to Africans was land, and this resulted in a large-scale migration of 'squatters', or tenants, into the White Highlands. The hut tax was increased and a poll tax levied. These taxes were unpopular with the Africans and did not improve the settlers' position and, if anything, they stimulated the peasant economy. World War One, followed by the influenza epidemic, severely disrupted the Kenyan economy as settler males went off to fight and thousands of Africans served in the Carrier Corps in the German East Africa Campaign.[13] The recession that followed the war made it even more imperative for the settlers to secure labour supplies. In 1918 the colonial government was forced to intervene, on behalf of the settlers, to stipulate that 'squatters' (the name given to Africans who were resident on European farms) were required to provide 180 days of labour a year to the white land-owner at two-thirds of the normal salary of a contract labourer. The idea was to convince the squatters that they were servants, without the land rights that tenants might have. Since the squatters were largely self-sufficient and not reliant on their meagre wages, they were still, however, in competition with the settlers.

The Kenyan government sent directives to the chiefs, empowering them and encouraging them to order up to sixty days of labour per annum on state projects at reduced wages for the adult males under their authority. Only those men who could prove they were employed for wages for three months or more per annum were exempt from this requirement. By 1920 African males over the age of fifteen had to carry a pass (the *kipande*) bearing details of their labour history. The *kipande* was a hated law as it enabled the state to trace labour deserters and

to fine men without a pass. There were already a severe number of Masters and Servants Ordinances (1906–16) that made labour offences, such as desertion, a criminal offence and punishable by up to six months in prison.

The British government took a dim view of the coercive content of this legislation and the actions of the Kenyan authorities prompted some lively debates in parliament. The end result was the Devonshire Declaration of 1923 which stated: 'In the administration of Kenya His Majesty's Government regard themselves as exercising a trust on behalf of the African population, and they are unable to delegate or share this trust, the object of which may be defined as the protection and advancement of the native races.'[14]

This seeming reversal of Sir Charles Eliot's pronouncement that Kenya was to be a 'white man's country' drew attention to the central dilemma at the heart of the British settlement of Kenya: how could the conflicting interests of African peasant accumulators and white settler farmers be reconciled? The more the state intervened on behalf of Africans, the more it antagonised the settlers, and the more it tried to protect white farmers, the more it antagonised Africans. As it happened, by the second half of the 1920s the indirect pressure of taxation, along with the growing population pressure in African reserves and the development of a taste for consumer items amongst Africans, combined to create an adequate supply of labour without further direct state coercion.

The problem remained, however, of dealing with the expectations and demands of an economically prosperous African peasantry as well as a large population of wage earners in other branches of the economy, such as government service, the railways and clerical work. By 1929, 33.8% of Kenyan Africans were earning wages and, amongst the Kikuyu, the figure was between 50 and 75% – very high figures compared to other colonies. By 1931 there were 113 176 squatters in the White Highlands, occupying one million acres of settler land, land to which squatters felt they had earned, or inherited, rights.[15]

Settler agriculture, meanwhile, showed less spectacular returns and was largely a failure until World War Two. The white population had grown from 3 175 in 1911 to 12 529 by 1926. Whites had been granted a virtual free market in land, with secure land title, in 1915 – recognition by the state that it needed to make Kenya attractive to capital investment. It was clear by this date that large, well-capitalised farms were pioneering agricultural developments, whereas the small farmers were simply living off their African tenants. It is not hard to find reasons for the precariousness of white agriculture. In the first place, it took time and experimentation to determine what cash crops were suited to Kenya. Inefficiency and shortage of skills steepened the learning curve. Once a suitable crop such as coffee was found, it was subject to the fluctuations of the international market and the vagaries of the African climate. Land speculation often

seemed a more lucrative enterprise in these circumstances, and this did little to develop agriculture whilst speculation encouraged debt. Meanwhile the settlers were constantly competing with African peasants whose overheads were much lower and who benefited from their proximity to the local market of Nairobi and the colonial road and rail network.[16] It must also be acknowledged that some of the popular conceptions about Kenyan settlers having irrational or anachronistic social aspirations that interfered with their economic performance are well founded. No less a person than Governor Brooke-Popham pronounced in 1939 that it was wrong to regard Kenya Colony as a money-making organisation. 'It isn't. There is no reason why a settler with a good farming knowledge shouldn't make a decent living, but the main object of most people coming out here is to live in fine scenery, a good climate and among friends.'[17]

Such a view of the colony was no doubt congenial to members of the colonial administration who were themselves gentlemen drawn from the ranks of public schools and Oxbridge. It has been pointed out that from 1920 onwards the tone of the administration was elitist, authoritarian and paternalistic. It based its legitimacy on the knowledge that it was the paternalistic protector of Africans and that it was concerned with curbing the excesses of white settlers. It sought to bolster (and in some cases create) chiefly authority in the reserves and reinforce tradition, a stable social hierarchy and social harmony amongst Africans. It tried to discourage political activity and believed that Africans were quite incapable of dealing with modernity. As Sir Philip Mitchell, Governor of Kenya from 1944 to 1952, put it: 'A people helpless by themselves ... technically and educationally almost wholly incompetent for the world into which they were brought in such a sudden, even violent manner; economically totally dependent on new enterprises begun for the first time under the colonial Governments.'[18]

World War Two brought economic prosperity for both white and black in Kenya by creating an economic boom. Kenyan agricultural products helped to fuel the Allied war effort and replaced other pre-war sources of supply. The Kikuyu were well placed to fill any gaps in production that might have been caused by settlers joining the Allied forces, or taking on roles in the colonial administration. By 1950 perhaps half of the White Highlands was given over to black agriculture, mostly in the hands of the Kikuyu, who now numbered over a million, with perhaps one-third of that number living outside of the reserves. The settler farmers had strengthened their political muscle during the war because of their incorporation into the administration, and were now keen to increase their economic prosperity by decreasing the number of squatters on their land.[19] The stage was set for the three-sided contest between the Kikuyu, the settlers and the state that would culminate in the Mau Mau.

Recent historical scholarship, particularly those works that have concen-

trated on the Mau Mau, has done a lot to undermine the view that labour relations between white and black in Kenya's colonial past were always cordial. The struggles of the Kikuyu peasantry to secure economic prosperity and to define their identity, in both a rural and an urban setting, suggest that white rule was neither as feudally anachronistic nor as benign as might be supposed.[20] Titles such as 'Unhappy Valley' and 'Britain's Gulag' point to the darker side of the White Highlands.[21] We should bear in mind, however, that the relationship between farmer and squatter was not always as bad as it became after World War Two. It was a period of virtually uninterrupted, though not necessarily painless, Kikuyu economic growth. In retrospect, despite economic hardships, white settlers came to view this pre-war period as a veritable golden era in Kenya. Despite revisionist histories, it is this romantic view of Kenya that remains embedded in popular consciousness. The myth's tenacity owes a great deal of its strength to its promotion in popular books and films – of which the three films under discussion here are good examples. But it probably owes most to the fact that it was articulated, at an early stage, by a writer of genius in a work of literature. The writer in question was Karen Blixen (who wrote under the *nom de plume* of Isak Dinesen) and the work is *Out of Africa*.[22]

Out of Africa

An aristocratic Danish woman, Karen Blixen née Dinesen (Meryl Streep), travels to Kenya in 1913 in order to meet and marry her fiancé and countryman, Baron Bror Blixen (Klaus Maria Brandauer), who is starting to farm coffee at the foot of the Ngong Hills.[23] On the journey up from Mombasa she meets the white hunter Denys Finch Hatton (Robert Redford). After a brief introduction to settler society at the Muthaiga club in Nairobi, she proceeds to the farm and her new house and installs her expensive furniture and possessions. She grows accustomed to the life of the farm and, after some moments of happiness with Bror, discovers that he is a wanderer and philanderer. Soon she discovers that he has given her syphilis. With the outbreak of World War One, Bror and other settler males go off to Tanganyika to fight the Germans. Karen is left to run the farm but decides to make herself useful to the war effort by driving, with the help of African servants, some cattle to the British forces on the Tanganyika border. The adventure is successful and she meets Finch Hatton again. Back on the farm she struggles to make a success of coffee growing but in the process grows closer to the African squatters and servants. After the war Bror is away more and more often on safaris and Karen becomes closer to Finch Hatton. He takes her on one of his safaris

and they fall in love. The love affair blossoms and, as Karen develops as a writer and storyteller, Finch Hatton proves to be a lover of literature. As the business of farming gets more and more difficult and economic ruin faces Karen and her investors, her relationship with Finch Hatton is strained. Bror is an economic liability. Finch Hatton buys an aeroplane and takes Karen on a wonderful flight. It is the climax of their relationship. Shortly afterwards her financial troubles and possessive jealousy cause Finch Hatton to distance himself from her. Just as she is going through the pain of selling the farm and auctioning her possessions, preparatory to returning to Denmark, Finch Hatton dies in a plane crash. Karen's loss is complete. She returns to Denmark to write.

The opening sentence of the book *Out of Africa* – 'I had a farm in Africa, at the foot of the Ngong hills' – is one of the best-known lines in 20th-century literature. It sets the elegiac tone of the book and introduces the theme of loss, 'the psychic reference point'[24] of the narrative. *Out of Africa* is about the loss of a farm and about the loss of a lover. It is also about the loss of paradise, the para-dise here being Africa. As Robert Langbaum explains, 'It is because Africa figures as a paradise lost – both in Isak Dinesen's life and in the life of Europe – that *Out of Africa* is an authentic pastoral, perhaps the best prose pastoral of our time.'[25] Significantly, it is not the specific territory of Kenya that is mourned or celebrated as the paradise lost, but the entire continent of Africa, which Kenya is thought to represent or symbolise in its entirety.[26] This is, even today, a commonplace association in the minds of Europeans and Americans, whose image of Africa is shaped by their picture of Kenya, land of big game, wilderness and safari country par excellence. Though subsequent books, films and travel brochures may have reinforced this connection, in the beginning was *Out of Africa*.

A major theme of Blixen's work is that, in Africa, one is closer to nature, closer to the primitive and hence closer to God, fate or eternity. The lofty indifference of the elemental towards human endeavours may destroy lesser mortals or cause them to despair. Those possessing true nobility of character, however, rise above tragedy and attain a heroic stoicism in the face of disaster. Such qualities were not only to be found in the aristocratic white men of Kenya's settler society, they were also to be found in the inscrutable fatalism of the Africans and the natural dignity of wild animals. The calm majesty of Blixen's vision, the tragedy of her own life in Kenya and the beautiful serenity of her prose, exerted a powerful influence on sub-sequent writers about Kenya. The fact that *Out of Africa* was published just before World War Two (which was followed shortly afterwards in Kenya by the Mau Mau and, ultimately, independence) meant that it was viewed by post-war readers as a description of a lost world, an elegy for a generation far removed from the beastly and sordid struggles which followed. Blixen's Kenya was the ideal Kenya, the ideal Africa, and her book is the most influential book ever written about Kenya.

The purpose of this chapter, however, is not to try to support this claim by tracing the influence of *Out of Africa* on scores of later works about Kenya, but to consider its influence on some films about Kenya and, in particular, the three films under discussion here. Although it is obvious that Sydney Pollack's film *Out of Africa* is based on the book *Out of Africa*, it can be shown that both *Nowhere in Africa* and *White Mischief*, despite having books with these titles behind them,[27] are also heavily influenced by Blixen's book.

Pollack's film is in many ways a faithful and sensitive treatment of Blixen's *Out of Africa*. It is less true, however, to both Blixen's life and to Kenyan history. But then, so too was the book *Out of Africa*, which sought to convey a sense of 'Africa distilled up through six thousand feet, like the strong and refined essence of a continent'.[28] Blixen once described Africans as being often untruthful but always sincere, a judgement appropriate to her own artistic practice. Blixen's book was highly poetic and highly selective, 'the strong refined essence' of her life in Africa. The film takes similar liberties, rearranging the order of events for the sake of narrative power and dramatising others. It is, above all, beautiful, and so too is Blixen's prose. The central couple in the film, Karen Blixen (Meryl Streep) and Denys Finch Hatton (Robert Redford) are beautiful, civilised individuals. They were not, of course, in real life, Americans. Though Meryl Streep speaks throughout the film in, what must be to a non-Dane, an authentic Danish accent, Redford sounds unapologetically American, a strange attribute for the brother of the 14th Earl of Winchilsea and 9th Earl of Nottingham to have. They are surrounded by beautiful scenery, and beautiful animals, they share intimate moments in Karen Blixen's expensively furnished sitting room, and wear clothes that launched a new fashion – safari-chic. The real Finch Hatton was apparently as bald as a billiard ball, which is why he always kept his hat on (a joke he first heard at Eton) and always looked as though he dressed in a hurry.[29] Beautiful music provides the aural background to their moments together whilst no commonplace expressions ever pass their lips. The Kenyan landscape has never looked more beautiful, especially in the soaring, swooping aerial shots that accompany the film's visual climax – the flight of the lovers above the Earth in Finch Hatton's doomed Gypsy Moth. The land is verdant, vast, teeming with game, devoid of people. The beaches are crystalline white. The sea is cobalt blue. The African labourers are dark and vibrant against the rich soil that nurtures (alas, at too high an altitude) the coffee tree, loveliest of crops with its dark green foliage, red beans and white blossoms.

All this is true to the book, which contains many exquisitely observed descriptions from which all squalor and banality seem to have been distilled. The cast of characters in the film likewise corresponds to the extraordinary people who populate Karen Blixen's pages. White settler society, high born and eccentric if masculine, is almost synonymous with the membership of the Muthaiga Club.

The Club, indeed, serves as both microcosm and metaphor for Kenya Colony. Only gentlemen (and, to a lesser extent, their ladies) are socially significant enough to count as members. Only an insider who respects its rituals is licensed to indulge in high-spirited revelry and the pursuit of serial monogamy. Settler women, on the other hand, were less favourably viewed by Karen Blixen. Not only were they her sexual rivals, with whom she had to share both her husband and her lover, but they were her social and intellectual inferiors. They were, she observed, 'particularly dreadful … have appalling taste, always appearing in khaki down to the knees, with cartridge cases … they are over made-up, screech frightfully and laugh hysterically, scold their workmen like fish wives, are furious about everything in this country and all have to look like girls of 17'.[30] No woman could ever compete with the masculine charms of Baron Blixen (brilliantly played by Klaus Maria Brandauer), the courtly manners of Finch Hatton's friend Berkeley Cole, or the unfettered spirit of Finch Hatton (Robert Redford), scholar, hunter and golden-haired god.

The Africans in *Out of Africa* (the film) are also true to Karen Blixen's view of them and play the parts allotted to them – faithful retainer, noble savage or enigmatic indigene mystically attuned to Africa's primal soul – as they take their first tentative steps, under her tutelage, towards civilisation. The Africans working on the coffee plantations are shown as being happy and contented. Blixen often professed her great love of the Africans and this was not a sham. Most of her farm was given over to Chief Kinyanjui's Kikuyu and it is probable that Karen Coffee Estate would have been economically viable had she chosen to utilise their land as mixed farming land instead of concentrating her energies (or those of her under-acknowledged manager and brother) on growing coffee on one small area. As we have seen, however, the presence of African squatters on her farm was typical of Kenyan estates at that time. She also started a farm school for the Africans and attempted to treat their ailments with her scant supplies of medicine and her limited knowledge of first aid. In the end the farm fails not because of labour problems, but because of natural disasters like drought, fire and the reluctance of coffee to grow at such a high altitude.[31]

Blixen liked to contrast her own attitude to Africans with that of the British, though it is doubtful whether she was as exceptional as she thought she was – 'Most of the whites take very little interest in their natives, regarding them partly as their natural enemies; and even if one does not take a humanitarian view it must be remembered that the future of this country does depend on native labour, and it is in our own interests to take care of their children just as much as calves and foals.'[32] There is no escaping the fact that Blixen believed that people of her class needed servants, black or white if need be, and that the Africans whom she knew best – Farah and Kamante – were domestic servants.

The film portrays these men as Blixen saw them: sage, loyal and imbued with an aloof dignity. Their integrity seems to stem from their voluntary decision to serve beings they recognised as possessing noble qualities but who were, at the same time, essentially a class of superior squatters on their land. The Kikuyu proved their spiritual strength by stoically enduring and remaining whereas Blixen, when she lost everything, returned to Europe. Her loss confirmed the Africans as possessors of Africa, and enabled her to idealise them from a distance. To her credit, Karen Blixen managed to secure a place for 'her' Kikuyu in the reserves once Karen Estates were sold and transformed into a suburb of Nairobi. Significantly, however, it was not the plight of these Kikuyu in the overcrowded reserves that engaged her imaginative powers, but that happy time of harmonious though uneconomical co-existence in an irreclaimable past.

Nowhere in Africa

Jettel Redlich (Juliane Köhler) is a Jewish woman in Germany in 1938.[33] Nazi persecution is on the increase. Jettel's husband, Walter (Merab Nindze), has already gone to Kenya to escape this persecution. His letters urge Jettel to hurry away to join him, bringing their young daughter Regina (Lea Kurka) with her. The two females travel to Kenya, leaving the rest of the family behind. Walter, an ex-lawyer, is working as a farm manager at a dry and demanding cattle ranch at Rongai. It is obvious that he is not a good farmer. He has malaria and is being nursed back to health by the African cook, Owuor (Sidede Onyulo), who seems to be the real manager of the farm. When Jettel and Regina join him, life is hard. The girl takes to her new surroundings well and Owuor is very kind to her. Jettel is most dissatisfied with her circumstances and unsympathetic to her husband. They have only one friend, a kindly Jewish settler called Susskind (Matthias Habich). Marital discord is interrupted by the outbreak of World War Two when the British decide to round up German nationals in Kenya. The men are sent to an internment camp and the women and children to luxurious confinement at the Norfolk Hotel. Here Jettel surrenders to the sexual advances of a British officer. He repays Jettel's kindness by arranging employment for Walter when he, along with all the rest of the German Jews in Kenya, are released from detention. The Redlichs go to a new farm, Gibson's Farm, which has better rainfall, to supervise African agricultural labourers. Owuor joins them. Susskind too reappears. Jettel slowly learns to love Africa but remains hostile towards Walter. She is much more comfortable with Susskind, a man considerably older than her. Regina becomes more and more like an African child until she is sent off to

boarding school in Nairobi. News from Germany is bad, and before the end of the film we learn that both Jettel and Walter have lost their parents and other family members in the Holocaust. Walter joins the British army, leaving Jettel to run the farm, which she does, side by side with Africans, in conditions of poverty. When the war ends, Jettel and Walter re-establish their relationship. Jettel falls pregnant and the couple decide to return to Germany where Walter is to resume his legal career, this time as a judge judging war crimes. Leaving Kenya is sad, especially for Regina, who is now on the verge of womanhood. Like Karen Blixen, one day she will write a book about her loss, a book called *Nowhere in Africa*.

It is not too fanciful to state that the film and book *Nowhere in Africa* drew inspiration from the book and film versions of *Out of Africa*. There is, to begin with, the similarity of the title. Significantly, though the film is set in Kenya during World War Two, it is not called 'Somewhere in Kenya'. This should alert us to the fact that, after Karen Blixen, not only are Kenya and Africa seen as being synonymous, but that Kenya acts as a synecdoche for a continent that is itself a metaphor for wildness and remoteness. It is not so much a specific state as a state of mind. A further point of reference between the two works is that both are centred on a female protagonist and are authored by women. The author of the semi-autobiographical novel on which *Nowhere in Africa* is based is the German author Stephanie Zweig. The girl, Regina, in the film is modelled on her. Zweig and her Jewish family left Germany in 1938, like the Redlichs, to escape the Nazis and, like Regina, Zweig attended a boarding school in Nairobi.[34] In the case of the film *Nowhere in Africa*, the director too is female, Caroline Link. Like Blixen, Jettel was not British. Whilst Blixen was an upper-class Dane, Jettel was an haute bourgeoise German Jew. Implicit in this outsider status is the assumption that both women were likely to be more critical, more objective about the British and less complicit in the project of colonialism. The assumption, fairly overt in Blixen's writing, is that being a non-British, non-imperialist woman facilitated a closer relationship with Africans, a maternalistic relationship free from the racist, paternalistic attitudes of many British settlers.

Nowhere in Africa is not, however, primarily concerned with documenting British attitudes towards Africans so much as it is concerned with contrasting the humanity of Africans with the inhumanity of European civilisation in general. Compared to the Nazis, the British appear as a strangely benevolent, avuncular power that sends Jewish women and children to luxury hotels for internment and provides them with an abundance of free food. Yet although the British might direct this munificence towards alien women and children, it is Africa that is the real refuge and succour of the Redlich family. It is Africans who teach Jettel the healing power of humility over arrogance and who seem ready to accept the newcomers despite their difference, a far cry from the racial exclusivity advocated by

the rulers of Germany. Towards the end of the film Jettel articulates what Africa has taught her, it is 'how valuable differences are'.

The principal personification of this African spirit of humanity is the Redlichs' cook, Owuor. It is he who nurses Walter back to health using traditional medicines. It is he who helps Jettel by carrying water for her – culturally, a woman's work – despite the ridicule of his own people. It is he who lifts the young Regina into his arms to welcome her to Rongai, an action that wins her love and trust, and that he repeats at periodic intervals throughout the film. It is Owuor who teaches the Redlichs Swahili, who loyally follows them to their new farm and who, in a scene reminiscent of Farah's farewell to Karen Blixen, takes heart-breaking leave of them when they return to Germany.

Jettel did not initially warm to Owuor, or to Africa in general. On first seeing Rongai her comment was 'It's lovely, but we can't live here'. Ultimately, these words prove to be prophetic, though by the film's end Jettel wishes she could stay in Africa, and Kenya. The happiness she eventually experiences in Kenya has nothing to do with economic prosperity. Just as in *Out of Africa*, farming in Kenya is portrayed as an activity best left to African subsistence farmers because any greater commercial ambitions simply invite economic ruin at the hands of drought, disease, flood, fire, locusts or other acts of God. The Redlich family are not typical Kenyan settlers. They are not British (but neither were the Blixens), nor are they even landowners. 'I did not come here to get rich,' explains Walter to a labourer, implying that he is different to other whites. The Redlichs certainly did not come to Kenya to live in congenial surroundings among friends. They came as refugees. Their first employer, Mr Morrison, is not, by his accent or his behaviour, a gentleman, and his attitude suggests that Walter, who is certainly a very inexperienced farm manager, is practically useless. This judgement is borne out by Walter's later decision to join the British army in Kenya as soon as it is permissible to do so. It is Jettel who is the real worker on the farm, not her husband, just as it was Karen and not Bror who ran the Blixens' farm. The point seems to be that the female psyche is more in tune with the African earth. True happiness, it seems, lies in the attainment of greater personal self-awareness and an appreciation of the Africans' more sensible adaptation to their environment. Jettel is frequently portrayed as physically working the land alongside the Africans – sweaty, dusty, poor, but increasingly happy.

But Kenya/Africa is not the Redlichs' home. The film's end coincides with the end of World War Two when Walter decides to take the family back to Germany where, newly promoted to the bench, he will sit in judgment over war criminals. Quite clearly it is Europe that must be cleansed of barbarism and not Africa. Besides, as Walter says to a Scottish sergeant, he will never really fit in in Kenya because the English, kind and humane though they might be, will never really

accept him. He is not one of them. The Redlich family, like Karen Blixen, never return to Kenya. The country they leave behind (like Denys Finch Hatton) never grows old. It remains, forever, a land of lost content: vivid, colourful, extreme and primal.

Paradise lost has always been a place of sexual experience or, more correctly, a place from which one is expelled because of sexual experience. Jettel, like Karen Blixen, had an extra-marital affair. In Blixen's case she was encouraged to do so by her husband's infidelities and, possibly, by the seemingly tolerant attitude of Kenyan society, which condoned her relationship with Finch Hatton. But Blixen is unable to possess Finch Hatton. He dies and Blixen must immortalise him, if she can, in her writings in cold, grey Denmark. Jettel had no excuse to be unfaithful to her husband. *Nowhere in Africa* suggests that her dissatisfaction with Walter is related to her dissatisfaction with Africa. Once she accepts Africa, she accepts her husband and is rewarded by the gift of fertility, her pregnancy. The child, however, will not be born in Africa, just as the offspring of Adam and Eve are born out of Eden.

Nowhere in Africa is also concerned with the growing sexual awareness of the Redlichs' daughter, Regina. Indeed, a large part of the film may be viewed as a 'coming of age' film as Regina negotiates her way between European culture, represented here by her parents' home and the British-style boarding school she attends in Nairobi, and the African culture of the farm workers and her childhood playmates. It is quite obvious that the girl far prefers the seemingly carefree, bare-breasted existence of an African child in nature to the regulated, uniformed world of classrooms, dormitories and playing fields – which child would not? But just at the stage when Regina becomes a young woman (a point in the film where the child actress playing the young Regina is replaced by a teenage actress, Karoline Eckertz) and seems torn between her twin identities of European and African, she has to follow her parents to Germany, and thereby is spared the difficulty of having to make a choice. It is, it seems, impossible for even the most sympathetic Europeans to become African. Their place is in Europe. Because the Redlichs leave when they do, they will never experience the disillusionment of Mau Mau or the ambiguities of Kenyan independence.

White Mischief

World War Two has just begun.[35] The lovely Lady Diana Broughton (Greta Scacchi) leaves England to join her husband, Sir Jock Delves Broughton (Joss Ackland), in Kenya. Sir Jock is elderly but rich, a substantial landowner in the

White Highlands. As soon as Diana arrives it is clear that she has not married Sir Jock for love, but for money, and that she is looking for a more congenial sexual partner. Eyeing the local talent at the Muthaiga Club, she is very taken by Josslyn Hay, Earl of Errol (Charles Dance), and he with her. A love affair begins between them, which they do not bother to conceal, particularly since Joss belongs to the Happy Valley set, a group of friends who do not see anything wrong in cross-dressing, wife swapping and drug abuse. As the affair progresses, Sir Jock becomes more and more jealous. At the same time, his financial position deteriorates and he loses heavily at gambling. One night, after taking Diana home, Joss is shot dead by an unknown person in his (Joss') car. Sir Jock is a suspect and is tried for murder but found not guilty. Various clues, however, convince Diana that Jock did indeed kill Joss. His guilt and his wife's hatred unsettle Sir Jock and he kills himself. One of Joss's Happy Valley lovers, Countess Alice de Jantze (Sarah Miles), also kills herself out of grief at Joss's death. Diana spurns an offer of marriage from Joss's eccentric friend Gilbert Colville (John Hurt) and flees in turmoil and sorrow into the wide outdoors. She finds herself at Alice's wake, a party on the shores of a lake. The film ends as the white party-goers dance under the gaze of their black servants.

Like *Nowhere in Africa*, *White Mischief* is also set in the Kenya of World War Two. It is loosely based on James Fox's book of the same title, an account of the murder of Lord Errol in 1941. The film accepts the vision of white society first popularised by Karen Blixen – that it was eccentric and aristocratic in style – but portrays its characters (supposedly based on real historical personages) as being completely devoid of either nobility of character or educated sensibility. Without these qualities their superiority looks like affected snobbishness and their eccentricity like selfish frivolity. White society in general is portrayed as a hard drinking, cliquish set that spends most of its time partying at the Muthaiga Club, gambling at the Nairobi Racecourse, committing adultery at decadent house parties or being waited on by an array of immaculately dressed African servants. The only character who is portrayed with a degree of sympathy, at least initially, is the bankrupt cuckold Jock Broughton. Once the film establishes, however, that it was he who shot Lord Errol, Jock disintegrates morally before our eyes and indulges in some most ungentlemanly behaviour before shooting himself. Until his demise, Lord Errol glides about the scenery of club and beach house with a reptilian amorality, finding, it seems, no shortage of willing women to seduce. He and his friends swap sexual partners and indulge in cross-dressing at orgiastic parties in scenes that might as well have been set in Caligula's Rome as in the White Highlands. The luminously beautiful Diana, despite being a recent arrival from England, is no better than the rest. She eagerly betrays her husband and divests herself of her clothes as readily as she divests herself of her morals.

The rest of the cast includes a voyeur who spies on women in the bathroom, a latent homosexual gone native amongst the Masai, a white memsahib who finds her sexual satisfaction with a black houseboy and Countess Alice de Jantze, previously convicted of shooting her lover in the compartment of a Calais train. In a scene that was cut from the film when it was first screened in South Africa, De Jantze smears her vaginal secretions on Joss's corpse whilst she is viewing it at the mortuary so that 'you'll always be mine'. Seemingly, the only one to find this behaviour unacceptable is the African attendant who tries to restrain her. Following De Jantze's suicide, Diana inadvertently attends her funeral party at a cemetery on the shores of what looks like Lake Naivasha. True to form it is a bizarre event complete with jazz musicians, champagne and dancing couples. The film's last shot is of a young and innocent African waiter serving at the party, a silent witness to a depravity, one surmises, totally beyond his comprehension. We, the viewers, know that he and his people will long outlast the ephemeral and self-destructive excesses of his white masters and white mistresses, who are, in effect, dancing on their own graves.

Even if the scenes described above corresponded to actual historically recorded incidents (and the film does take considerable liberties with Fox's book), *White Mischief* seems to work too hard to scandalise its viewers, and one suspects that material is being exaggerated, distorted and even invented. Broughton, for instance, did not commit suicide on being discovered as a murderer and the case is still officially unsolved. It is true that there was a Happy Valley set that centred on Josslyn Hay (another ex-Etonian), who had established a farm at Wanjohi, a hundred miles north of Nairobi, in 1923. He had married the divorcée Lady Idina Gordon (a woman who would eventually go through six husbands but who is not, unfortunately, portrayed in the film) and it was she who did so much to promote the idea that Wanjohi, and by extension Kenya, was a den of sybarites. In Sara Wheeler's words: 'Lady Idina in particular was emblematic of the untamed female. She stalked the polo grounds like a divine but rackety temptress in a shimmering confection of plum and emerald silk slung with ropes of pearls (there were always lots of pearls).'[36] The real Josslyn Hay does not seem so far removed from the filmic version of himself. He was, according to Wheeler, 'a suave figure with foxy good looks, pale gold hair and a glimmering smile, rest[ing] on a shooting stick at the racecourse in a white silk suit, polka-dot bow tie and panama ... In the Men's Bar at Muthaiga he divided women into three categories, Droopers, Boopers and Super-boopers, although in their state of semi-permanent inebriation most of his chums fell into the first category themselves. Like many of the truly debauched, Hay himself did not smoke or take drugs, and he drank little. He liked to gamble and once air-freighted a pair of fighting cocks and a hen to Wanjohi, a project which ended when his cook inadvertently roasted the birds for dinner.'[37]

Evelyn Waugh (author of *Black Mischief*) had been a guest of the Wanjohi set in 1930 and their 'Quixotic' attempt 'to recreate Barsetshire on the equator' appealed to his sense of the absurd. As a group, however, they were not typical of the farming settlers and probably 'as representative of Kenya as beefeaters are of London'.[38] In the film only Broughton is shown to be concerned with the business of farming, and in this he fails spectacularly. At a time when most Kenyan settlers were doing well out of the war, rinderpest exterminates his cattle herds and he is forced to sell his estates in England to subsidise his ranch and gambling debts in Kenya. More successful as a pastoralist is the monosyllabic Gilbert Colville who had basically become part of the Masai (just as Lord Delamere lived with the Masai) and is a misfit amongst his own kind. The only white he can relate to is Joss, whom he has a crush on, and this emotion causes him to propose marriage to Diana, the woman Joss loved, when Joss is killed. Diana recoils in horror from the fly-blown life of squalor she is being offered. The message, once again, seems to be that Europeans can only succeed at farming in Africa by becoming African.

The only sign that Kenya is at war is that some of the settler males occasionally wear military uniforms. Apart from this sartorial detail the war makes no impression on the lives of Kenyan settlers. True, Broughton declares that he can contribute more to his country's war effort by growing food rather than fighting (with what results we have seen) but the other settlers seem to inhabit a high-altitude time capsule, far more concerned with the shifting pattern of sexual relationships than they are with their Empire's survival.

As depicted, this is not a society or an era about which it is easy to feel nostalgic. The characters are uniformly repellent and their affairs sordid and unromantic. The Kenyan landscape is not summoned to lend its grandeur to the ignoble activities of the *dramatis personae*; indeed, most of the film seems to have been shot during a drought as the vegetation is sere and dusty. Wild animals are strikingly absent and African retainers are virtually mute. *White Mischief* is, in essence, an anti-pastoral. A charitable interpretation of the film is that it deliberately sought to discredit Karen Blixen's idealised view of Kenya. A less charitable view is that *White Mischief* was an excuse to tell a tale of adultery, debauchery and murder against an exotic backdrop. Sara Wheeler's judgement of the Happy Valley set compared to the life of Karen Blixen and Denys Finch Hatton might well serve as a measure by which to compare the films *White Mischief* and *Out of Africa*. The story of the Happy Valley set is that of a group trying to escape life through sex and stimulants whereas the story of Tania (Karen's name amongst family and friends) and Denys is a story of 'transcendence through love; through living out deeply held personal values; and eventually, through art'.[39]

~

Conclusion

The three films that have been discussed are set in the historical Kenya Colony. They are about incidents and relationships that were experienced by white settlers. They are not about Africans so much as they are about European attitudes towards Africans. Likewise, they are not so much about Kenya, as about a set of European attitudes towards Africa, or the idea of Africa. It may be possible to find deep psychological origins for some of these attitudes, based on the tendency of the psyche to create oppositions between white and black, savage and civilised, nature and civilisation, or between what is taboo and what is permitted. We may also turn to the mass of material on the discursive practices of colonialist representation and consider the 'vast colonial intertext' which underlies so much of the European representations about Africa.[40] But it has not been the purpose of this chapter to explore or reveal these profound truths. Its modest aim has been to argue that Karen Blixen's book *Out of Africa* has had a profound influence on shaping historical consciousness of, and representations about, white settlers in Kenya. The work of literature, in many cases, has shaped European responses to Africa. This influence was readily acknowledged by the film *Out of Africa* and was more subtly present in the film *Nowhere in Africa*. It was also present in the anti-pastoral *White Mischief* and will no doubt continue to haunt the European imagination for as long as the Ngong Hills abide.

11

Beholding the colonial past
in Claire Denis's Chocolat

RUTH WATSON

Preface

A young woman, symbolically called 'France', visits present-day Cameroon. At first she appears to be a tourist, but as she daydreams on a trip to Douala the audience learns that she is the daughter of a colonial administrator who spent her childhood in remote northern Cameroon during the 1950s. France's reminiscences are presented as a film-long flashback which is framed by the contemporary story of her visit to southern Cameroon. Her memories centre primarily on her mother, Aimée, and the family's male servant or 'houseboy', Protée, who was her friend and also an object of Aimée's desire.

The emergency landing of an aeroplane divides the flashback narrative into two parts. The first half examines, through the eyes of a child, the controlled civility of everyday life in the colonial household. The second half introduces strangers from the aeroplane who conform to various colonial 'types': the bold adventurer and his loyal assistant, the unenlightened district officer and his nervous wife, the bigoted planter and his black mistress. These characters expose the racism of colonial society and also destabilise its façade of propriety. So too does Luc, an insensitive ex-seminarian who arrives with a gang of African labourers. He taunts Aimée about her attraction to Protée and provokes a confrontation. Aimée then makes a sexual gesture towards Protée but he emphatically rejects her and is banished from the household. This incident also causes him to sever his relationship with the child, France. The film narrative then returns to the present and we find out that France's driver, hitherto assumed to be a local, is actually African-American. The film ends with France departing from Cameroon, apparently without having visited her childhood home.

⌣

Introduction

Picture this. In a French colonial outpost in far-north Cameroon a little white girl climbs out of her bedroom window and escapes from her mid-afternoon nap. Tentatively creeping past the green shutters outside her mother's bedroom she patters to the end of her home's elegant veranda and finds her way to the servants' quarters. There her friend Protée, the family houseboy, is washing the dishes while his co-worker, the cook, leafs through his recipe book. Two women chatter and laugh as one of them sits while her hair is plaited. She sees the little girl and points at her, scolding, 'You're not in bed?' Gesturing towards her own face, she declares, 'You'll see, you'll turn black, and your father will scream!' The girl stares at her impassively and blinks in the bright sunlight. We see her discomfort as she fidgets and curls her toes inwards. But perhaps we should not over-interpret her body language. Maybe she behaves this way because she finds the concrete on which she stands too hot for her tender bare feet.

Such ambiguity is characteristic of Claire Denis's *Chocolat* (1988). One interpretation might view the scene as examining the boundary between personal intimacy and social distance in the colonial household. That is, because of her young age, the girl has not been entirely imbued with the rules of propriety that govern her parents' lives. She is thus interested in and is able to witness the intimate world of her family's servants. At the same time, she is literally located on the margins of this world and is warned that if she continues to cavort around in the hot afternoon sun she will 'turn black'. The implication is that she will then be an outsider to her own society. Another interpretation might focus on how meticulously put together the scene is. Like much of *Chocolat* it is beautiful to look at and each frame can be viewed as an aesthetic image of a colonial world. In this understanding the shadows of the harsh African sun on the white colonial girl are all-important and so is the burning concrete under her feet.

The colonial world of *Chocolat* is that of a French household in a remote area of Cameroon during the late 1950s. The film's title was apparently inspired by the 1950s French slang meaning of *être chocolat* – to be chocolate –which referred to someone who'd been had, or cheated. At the same time, it means 'chocolate' in the sense of colour, that is, a black person. In the context of the film, Denis contended, it meant 'to be black and cheated.'[1] It appears that she saw the main African character in the film, Protée, as cheated although he is not identified as 'chocolat' in the film narrative itself.

Chocolat has often been viewed as a semi-autobiographical film because it tells a story through a white female protagonist and Denis spent most of her

childhood in French colonial Africa. Her father was a colonial administrator and she moved from Paris to Cameroon in 1948 when she was two months old. The family remained in southern Cameroon following independence in 1960 but, when Denis was thirteen, she and her sister contracted polio and they returned to France with their mother.[2] Recalling this period, Denis remarked that she went reluctantly: 'I was already nostalgic for another world. Usually, when one is an adolescent, the feeling is that life is just beginning. I felt I'd already finished one life and was mourning it heavily.'[3] As we shall see, such nostalgia pervades the narrative of *Chocolat*, and it is difficult not to perceive the young adult France as the figure of Denis returning to find her former life. Apparently, her inspiration to make the film came when working as an assistant director on Wim Wenders's film *Paris, Texas*, where the stark landscapes reminded her of Africa.[4]

It is thus possible to evaluate *Chocolat* as an historical film on two levels. First, it offers a representation of the French colonial past in Africa, and second it presents a more personal historical story of Denis's early life. Denis herself, however, is somewhat unclear on the link between her childhood background and the plot of *Chocolat*. She admits that when she began writing *Chocolat* it was a very autobiographical script until she decided to add fictional elements. As she put it: 'I decided to turn my personal memory of life in West Africa into a fictional film.'[5] On another occasion she described the film as a collection of random memories rather than autobiographical in nature, and declared that she was not very interested in her own childhood. Instead she sought to explore the experience of being a foreigner, of people who 'don't know so well where they belong'.[6] Denis thus views her past as a resource rather than a reality to be documented. Nevertheless, although the characters and story of *Chocolat* are invented, an authentic historical setting (that is, the colonial period in Africa) is intrinsic to the film's meaning. In Robert Rosenstone's typology of the historical film, this is 'history as drama' and the audience is expected to see the screen as 'a transparent "window" onto a "realistic" world.'[7]

Acknowledging that *Chocolat* has a claim to being an historical film, however, does not necessitate accepting its version of the colonial past. It is simply the first step in critically engaging with how the film uses history. This is difficult at first because the aesthetic qualities of *Chocolat* usually impress audiences far more than its historical elements. For example, at the time it was released in 1988, most critics saw the visual beauty of *Chocolat* and did not view it as a commentary on the French colonial past. Roger Ebert, the first film critic to win the Pulitzer Prize, voted it 'one of the best films of the year'. 'It is a deliberately beautiful film', he wrote, 'many of the frames create breathtaking compositions.'[8] 'The movie is like sex for the eyes – it's ravishing in a way that goes straight into your blood,' declared Hal Hinson of the *Washington Post*.[9] For Desson Howe, it was 'suffused

with sunlit, sensual images ... like an odd collection of old-time photographs, it seems to hold enigmatic truths.'[10]

Despite this general lack of interest in *Chocolat* as an historical interpretation of French colonialism, it does present a viewpoint on how the French empire in Africa is remembered. This viewpoint invites the possibility of interrogating the colonial past, and some scholars have analysed it as critically post-colonial.[11] Alison Murray suggests that *Chocolat* can also be related to recent historiography on cultures of colonialism.[12] This scholarship has challenged the idea that the French empire was a monolithic coherent system based on binary distinctions between coloniser and colonised and instead interprets it as an unstable entity shot through with conflicts.[13] Murray argues that the French empire was previously presented in terms of domination and resistance. In cinema, this meant that some films supported colonial ideology while others criticised it.[14]

Yet although *Chocolat* certainly uses history, this chapter contends that its claim to *be historical* is uncertain. A similar observation is made by Murray, who compares *Chocolat* with two other recent French films (*Outremer* and *Indochine*) and suggests that they all approach memories of the colonial past as nostalgia or homesickness. By yearning for the empire as a source of exoticism or lost authenticity, she argues:

> All three films aestheticise the colonial past without giving it serious critical consideration ... Despite the attempts to pay lip service to certain aspects of colonial realities, the rich colours, sweeping landscapes, and voluptuous cinematography offer up the former French empire as feminized spectacle, a guilty pleasure for a postmodern audience. Moreover, all of these films acknowledge the fact of decolonization, yet they still seem to long for a colonial past that has no beginning (conquest), nor end (war) but merely an eternal present.[15]

Taking up Murray's argument, this chapter contends that there is a constant tension in *Chocolat* between the colonial past as aesthetic image and the colonial past as history. In some ways this is because the plot of the film is only vaguely related to a specific time period, and it does not refer to particular historical events in Cameroon. Since the film never resolves this tension between aesthetics and history, rather than constructing an historical argument about the French empire in Africa, Denis often only reifies images which 'are not the outcome of anything, nor are they the antecedents of our present; they are simply images'.[16] As a result, the historical value of *Chocolat* is diminished. Film critics admire Denis's technique which, they argue, 'teaches you to think through your eyes.'[17] Today, her filmmaking is known for its 'purely cinematic aesthetic, one in which the aspect of time floats unmoored'.[18] But for the historian such a denial of change over time is ultimately meaningless.

After briefly introducing the post-colonial setting of *Chocolat*, this chapter will examine both its versions of the colonial past – as aesthetic image and as history. Central to the past as aesthetic image is the African landscape which, as Hinson points out, is 'itself a character in the drama'.[19] Also important is the African male body, particularly as represented by the character of Protée. Following a short explanation of the historical context of *Chocolat*, the chapter goes on to analyse its historical elements. The time frame of *Chocolat* is for the most part unspecified, but it does make a link between a German colonial past and a French colonial present. Other historical elements in *Chocolat* are its depiction of the role of white women in French colonial Africa, and interracial relationships in the colonial household.

～

Chocolat in the post-colonial present

The first scene of *Chocolat* is an aesthetic image of the sort that typifies Denis's enigmatic style. We see three characters on a beach and there is no dialogue for the first four minutes; all the audience hears is the sound of the ocean. The surrounding vegetation suggests a tropical environment and a young white woman watches a black man and boy play in the sea while she rubs black sand off her white foot. Is this a metaphor for the constructed nature of racial identities and social anxieties about skin colour? Or is it simply included for the visual pleasure it gives the viewer? The context suggests the latter. It is preceded by an image of the boy which presents him as an artistic composition. A film critic described the 'visual anomie' as follows: 'A child lazes on his back in the sand, a transparent skin of seawater rising to caress, then slide away from, his rich brown flesh. Soon a grown man lies down beside him, and together their bodies form a dark continent that fills Denis' frame.'[20] Such images are colonial fantasies – they are not a re-visioning of history.[21] The interpretation of the scene as representing the 'dark continent' shows how intellectually dangerous such fantasies can be. A contrived image completely displaces the historical subject of post-colonial Africa and replaces it with a timeless aesthetic.

Next, the audience sees the young woman walking away from the beach and along the side of a road. A car passes her and stops. It turns out to be the black man and his son; they give her a lift to the nearest town, Limbé, thus instructing the audience that the location is south-west Cameroon. A car registration certificate, visible on the windscreen as she gets into the car, reveals the time period as 1987/1988. After arriving in Limbé it turns out that her bus to Douala is not leaving for an hour, so she continues her journey with the black man and his son.

Clutching an old sketchbook (her father's travel diary) she watches them play a word game which, the audience later learns, she too played as a child. The driver asks the woman's name. She replies: 'France'. 'Vive le France!' he exclaims, making a grammatical mistake that subtly identifies him as a foreigner. Observing the passing scenery through the car window, France and the audience are then drawn back into her childhood memories. The camera assumes France's gaze and the lush tropical vegetation fades into a parched landscape dotted with mud huts. The next scene shows a little girl in colonial dress surveying the savannah from the back of a pick-up truck with a tall African man. He is Protée, her family's houseboy, and driving the truck is her father, Marc Dalens, accompanied by his wife, Aimée.

The plot of *Chocolat* focuses on the relationships between three of these characters – France, Aimée and Protée. It is important to note that their names are allegorical. France, of course, symbolises the imperial metropole whose existence bridges post-colonial and colonial Cameroon. Her mother Aimée is the 'loved one', hinting at her need for romantic fulfilment amid the lonely monotony of life in the colonial household. Protée is the 'changeable one', referring to Proteus, the sea deity of Greek mythology, who could live in water and on land. Similarly, Protée occupies a dual role which sees him moving from the private home of his employers to the public quarters of the colonial household's staff. He is a servant to Aimée but, when her husband is away, he is a man who protects and performs intimate tasks for her. The houseboy thus becomes an object of Aimée's desire; he is both servant and potential lover.[22]

The colonial past as aesthetic image

This use of the flashback technique makes a connection between past and present. However, rather than exploring a dynamic historical relationship, it directly connects France's perspective in the post-colonial period with her colonial perspective as a child. Two distinct historical periods are fused into an eternal present and Denis constructs the 'timeless air of the nostalgia film'.[23] The colonial past is not historically situated by a subtitle indicating time and place; instead, the audience is left to guess where and when they might be. Precise location is only revealed when characters mention specific towns, and the particular epoch is indicated by a 'period look' of the 1950s.[24]

The African landscape is central to constructing this 'timeless air'. As Murray argues, 'visual pleasure is used to "seduce" the viewer into the love affair with the colony. Denis's landscapes are gorgeous painterly tableaux, with careful com-

positions and richly saturated colour.'[25] One can appreciate the care that went into constructing these frames, as well as their deliberate beauty. But even if it is not Denis's intention to perpetuate an aesthetic of colonial Africa, the images she presents inevitably appeal to viewers' desires for the exotic. Roger Ebert, for example, responds enthusiastically:

> Of all the places I have visited, Africa is the place where the land exudes the greatest sadness and joy. Outside the great cities, the savanna seems ageless, and in the places where man has built his outposts, he seems to huddle in the center of a limitless space … 'Chocolat' evokes this Africa better than any other film I have ever seen.[26]

Along with the child France, he suggests, the audience 'has glimpses of a vast, unknown reality reaching out in all directions from the little patch of alien French society that has been planted there'.[27] Stylistically, this is conveyed through long shots laboriously panning the sparse savannah landscape. The second scene of the colonial drama presents one such view that eventually swings around to reveal Marc and Protée urinating in the scrubland. 'Next year, I'll widen this road,' declares Marc, thus asserting his jurisdiction over the area. Throughout the film, similar images are viewed through the imperious gaze of Marc when he is on tour and performing his duty as the local *commandant*, thus further reinforcing the colonial perspective of the audience. Silence is ubiquitous in these vistas, many of which lack even a musical soundtrack. If there are any sounds, these are the noises of crickets, birds and hyenas – the wildlife of 'timeless Africa'.

Comparing *Chocolat* to *Vendredi Soir* (one of Denis's more recent films set in Paris) a film critic questioned Denis about the lack of a soundtrack in *Chocolat*. She responded that *Chocolat* had three pieces of music written for it by Abdullah Ibrahim.[28] The interviewer suggested that although both *Vendredi Soir* and *Chocolat* built a subtle tension through the plot, in *Vendredi Soir* music was so prevalent that 'it helped create the mood'. To this statement Denis responded: 'I think the urban night has nothing to do with an African night … I mean, I used Abdullah's music for the pleasure of using it – but I would also have been able to not use it at all, because … there is a specific sound of the land.'[29] The irony of Denis's assertion is that Abdullah Ibrahim's music has its historical origins in the African urban night that Denis seeks to deny. Thus not only does the music in *Chocolat* come from Cape Town, a completely different part of the continent to where the film is set, it does not fit historically with the aesthetic image of Africa that Denis seeks to create. Although she seems at ease with this incongruity, it is more difficult for historians to be.[30] In Rosenstone's terms of 'false' and 'true' invention, the choice of music evidently ignores the discourse of history.[31]

A second, related element of the aesthetic image of the colonial past in *Chocolat* is its representation of the African male body. Murphy illustratively

describes how the African landscape forms a backdrop to the African man: '*Chocolat* is all devouring space, sun-baked scrubby expanses that eat away at the substantiality of figures in the landscape ... Visually, Protée stands out, solidly inhabiting his strong, dark body, filling out his flesh with no slack.'[32] This picture of Protée as the handsome and virile sexual male set against radiant images of the African landscape is another aspect of the colonial love affair that *Chocolat* offers its viewers.[33] It connects directly with the latent sexual tension between Aimée and Protée that drives the plot of the film. Similar to the depiction of landscape, Aimée's feelings of desire for Protée are expressed 'by focusing a fetishising and eroticising look on him which is reflected by the camera'.[34]

This look is an explicit part of a scene where Aimée, France and two female companions chat while they watch the construction of an emergency runway in the elevated shade of a rocky outcrop. One of the women, Monique, senses that Aimée is not listening to her and she follows Aimée's gaze down to Protée. He walks towards the pick-up truck in the midst of the savannah. 'He's handsome,' Monique says. Aimée denies her voyeurism, but all three women, as well as little France, watch him get into the truck. Aimée's desire is present again in two scenes where she asks Protée to enter the private domain of her bedroom, once to protect her and France from a prowling hyena and another time to perform the intimate task of tying up the corset of her ball gown.

In a later scene, Protée takes a shower in the servants' quarters, which is in plain view of the main house. The sun is high; in the background is a granite slab and spiky savannah trees. In the foreground, Protée's perfect body, covered in soapy lather, is sensuously revealed. The audience is aware, before Protée, that Aimée and France are returning from a walk. Protée hears them when they reach the veranda of the house and knows that they can see him naked. With a pained expression on his face, he leans back and stifles a cry as he smashes his elbow against the wall behind him. The servants' quarters thus become a visual field, charged with sexual yearning, that the colonial woman (and implicitly the audience) can survey for their own pleasure.[35] This contrasts with the privacy that Aimée enjoys in her own bathroom. Her naked body is not shown when she takes a shower and all Protée sees is the lather draining away.

Silence is omnipresent in Aimée and Protée's relationship. What is 'spoken' between them is revealed in visual terms, through bodily movements, expressions and gestures. 'The unsaid words in *Chocolat* could fill volumes', as one critic puts it.[36] This sophisticated cinematic technique impresses many, but it has the effect of rendering Protée voiceless. The identity constructed for him is that he was 'raised by missionaries into a white colonialist culture, removed from his cultural and racial heritage and emasculated by the domestic duties he performs'.[37] Combined with the film's emphasis on his physical qualities, this depiction of

Protée as a liminal figure trapped between two cultures is simply a stereotype. Just as timeless images of the landscape displace the historical subject of colonial or post-colonial Africa, sexualised images of a silent African man suggest that colonised peoples had no agency and were utterly disempowered.

The aestheticised colonial past that Denis offers her audience has at its core a timeless view of the African landscape and a sexualised presentation of the African body. The highly contrived nature of these images diminishes their potential historical value and places them in an eternal, unchanging colonial present. With no reference to change over time, there is no space for historical interpretation or argument. Instead, the audience is compelled to yearn for the beautifully controlled and composed spectacle of colonial life that Denis constructs. This is not an engagement with the history of French colonialism in Cameroon; it is simply a nostalgic memory of it.

Chocolat in historical context

Although an aesthetic reading of the colonial past dominates *Chocolat*, it cannot be denied that memories, even stylised nostalgic ones, are intrinsically historical. To analyse these memories with reference to an actual past, however, we need some idea of time and place. Denis once said that the film was set in 1957, but this is not explicitly stated in the plot itself.[38] Its location is revealed when a group of strangers from a stranded aeroplane arrive at Marc's office.[39] The scene depicts symbols of French colonial rule, such as a French flag fluttering in the breeze, the colonial officers' uniforms and the clatter of a manual typewriter. The main feature is the District Office painted red and white, and prominently labelled 'Mindif'. As Marc informs the marooned strangers, Mindif is a small settlement thirty kilometres south-east of the larger town of Maroua. This is in the far north of Cameroon and a great distance from Limbé in the south where the opening scenes of *Chocolat* are set.

French Cameroon came into existence as a mandate granted to France by the League of Nations after the First World War, although a French administration had been in place from 1916 when the Germans were ousted by African forces under British command. Imperial interest in the area that became northern Cameroon dates back to the early 19th century, at which time several small lamidates or sub-emirates were founded as part of the Emirate of Adamawa, which was under the control of the Sokoto Caliphate.[40] The north contrasted with the coastal region where contact between Europeans and Africans began in the 16th century, and there was much less Islamic influence.[41] Adamawa was eventually

drawn into the partition of Africa, and in 1892 British, French and German delegations converged on its capital, Yola, to sign a political treaty. The French were initially successful, but combined British and German pressure forced the French government to recall their mission. This cleared the way for the Anglo-German agreement of November 1893, which placed Yola and one-quarter of the Adamawa Emirate under British jurisdiction. The remaining three-quarters, including Mindif, was declared part of German Kamerun.[42]

It was not until 1901 that Yola fell militarily to the British. The Emir fled and the Germans conquered the lamidates of Garoua and Maroua between 1901 and 1903, subsequently setting up military and administrative posts.[43] These were maintained until Germany lost its battle for the colony during the First World War. Nevertheless, this event did not mark a dramatic change in colonial administration. The German practice of ruling through the existing administrative structure was continued because the rulers of the sub-emirates were considered vital for the success of tax collection.[44] Any recalcitrant chiefs were replaced by others sympathetic to the French and a campaign was undertaken in the early 1920s to quash residual pro-German sentiment.[45]

The French empire reached its greatest extent in the inter-war years. Colonial policy became focused on *mise en valeur*, a wholesale plan to develop colonial resources to increase production and stimulate trade between France and its empire. The archetype of the new colonialist was the entrepreneur armed with designs for roads, railways and bridges, plans for schools and hospitals, and figures for imports and exports.[46] During the same period, the first significant numbers of white French women arrived in French Equatorial and West Africa. These were not settler colonies and were never expected to be, because of their reputation for disease. But by the 1920s, improvements in tropical medicine had lowered French mortality rates and the wives of administrators began to accompany their husbands.[47] The arrival of these white women heralded a realignment of cultural, racial and sexual boundaries. Social intermingling of Africans and Europeans was discouraged and the practice of white men keeping concubines, which had previously been encouraged, was condemned.[48] White women were cast in the role of implementing a redefined colonial morality in the face of challenges to French authority from burgeoning protest movements and, particularly, African claims for the full political rights of citizenship. As Alice Conklin explains, it became the duty of an overseas wife to reinforce her husband's prestige by formalising his relations with the colonised, keeping him healthy, and allowing him to produce white French offspring. She was also responsible for '"softening the crude mores" prevalent among white males deprived of French female company ... In short it was the job of woman "to create France" wherever she went.'[49]

The drive to increase colonial productivity from the 1920s onwards led to a

much greater use of forced labour in cash-crop cultivation and European private enterprises across French colonial Africa.[50] As a result, even during the 1930s depression, unprecedented quantities of palm oil, palm kernels, cocoa, peanuts, coffee, cotton and timber were exported. Foreign trade plummeted during World War Two, especially in French West Africa, which remained loyal to the Vichy regime until 1943. There was less of an economic decline in French Equatorial Africa and Cameroon, because they contributed to the Free French war effort without interruption.[51] This led to an intensification of forced labour from which French settlers, particularly coffee planters, profited handsomely.[52]

The post-war period saw the granting of new political rights and the abolition of forced labour, fuelling the hope for a new and better colonial system. African voters were given powers to elect representatives to territorial councils and to the French National Assembly. Cameroon gained the status of a United Nations Trust Territory, which stipulated that there should be 'progressive development towards self-government or independence'.[53] This potential encouraged vigorous anti-colonial activity in the southern regions of Cameroon, spearheaded by a radical nationalist party called the Union of Cameroonian Peoples (UPC) which had its origins in the trade union movement. There was much less political activism in the north, which remained locked between the dual layers of political control held by the French and the former lamidates. In May 1955, a series of violent clashes between UPC supporters and the police left 26 people dead and almost 200 injured. The UPC was banned and brutally repressed; it later responded by launching a guerrilla movement to fight for independence in December 1956.[54] Between 1957 and 1958, this conflict claimed 446 lives, while 196 people were wounded, 91 abducted and nearly 900 arrested.[55]

Manipulated by France, nationalist politics was subsequently taken over by the conservative political forces that had long opposed the anti-colonial struggle. Self-government was granted in 1957, and a year later a northern Muslim politician from Garoua, Ahmadu Ahidjo, became Prime Minister. Cameroon ultimately achieved independence under a regime headed by Ahidjo which favoured the continuation of close economic, military and political ties with France.[56]

The colonial past as history

Turning to how *Chocolat* portrays this complex colonial history, since Denis states that it is set in 1957, one would expect that the film would give some attention to the severe civil conflict that was occurring in Cameroon at that time. Yet, beyond a description of Mbanga in the south as 'a festering centre of revolt', there

is no reference to the UPC rebellion.[57] The historical reality that a north–south political schism had occurred in Cameroon after the 1955 riots, and that many observers feared its territorial unity was threatened, is completely ignored.[58] Instead, Denis focuses on the permanence of European imperial conquest by linking the French colonial present with the German colonial past.

For example, one scene shows a familiar vista of the African landscape: Marc on his horse trotting along the road, dwarfed by the immensity of the space and silence around him. He is followed by an African man on another horse, a boy pushing a fully laden donkey, as well as porters and soldiers. This is the French *commandant* on tour, claiming authority over his realm. The film then cuts to a picture of grey, wooden crosses with German names painted on them. We hear France struggling to read them out. Aimée, who is weeding the graves, corrects her pronunciation and then her daughter asks if the Germans lost the war in France too. After Aimée assures her that they did, France enquires: 'Do you think we'll be buried here?' Her mother does not reply. She freezes, then turns around and looks at her daughter incredulously.

We could interpret this as an historical argument about the ephemeral nature of European colonial rule in Cameroon. The French are present today but, just like the Germans who ruled for barely a decade, they might be dead and buried tomorrow. Yet despite such a fleeting presence, there is a chance that, on an individual level, they might end up stuck in this alien environment forever. This possibility, which seems not to have occurred to Aimée, obviously causes her great alarm. Denis thus emphasises continuity between German and French colonialism and confirms the colonial present as eternal.

Another scene in which German imperialism is obliquely present is one where Aimée evokes the history of her home. She points out a German inscription on her veranda to a visiting British colonial official and translates the phrase as 'this house is the last house on earth'. The German official who carved it, she declares, is buried in the cemetery. Her guest responds sarcastically by asking about Marc, describing him as a dreamer who 'loves this land, the people, the insects, everything'. Aimée takes no notice. Looking dreamily towards Protée, she remarks: 'They say this German official was killed by one of his "boys."' Protée is shown looking at her; he lowers his eyes and looks away. Possibly, Aimée refers to the actual murder of the German Resident of Maroua in 1903, but this seems unlikely since the perpetrator was a Fulani leader, not a houseboy.[59] The point appears to be more concerned with the inherent racial tension of the colonial relationship showing that, for all his good intentions, Marc could just as easily be killed by his houseboy. At the same time, Aimée's eroticising look towards Protée suggests that he might kill Marc out of a jealous desire for her.[60]

The complexity of relations between coloniser and colonised is again exam-

ined in a scene which reveals the network of collaboration upon which colonial rule in northern Cameroon was based. It concerns the visit of a local dignitary, Djatao, to Marc and Aimée's homestead and his encounter with Delpich, a somewhat caricatured French coffee planter. Stuck in Mindif because his flight was aborted, Delpich is delighted to see Djatao arrive in a car. Ignoring Aimée's attempt to introduce her visitor, he demands that Djatao drive him to Yaoundé and tells him to name his price. Djatao ignores Delpich and presents Aimée with a ram for her guests from the aeroplane. Delpich eventually stuffs a wad of notes in Djatao's face, declaring 'this is my last offer'. As the car begins to drive off, he clings onto the side, prompting Aimée to shout at him while he screams 'How much? Shit!' at Djatao through the window. Eventually he jumps off the vehicle and walks back to Aimée. 'Do they run things around here?' he barks. Aimée fixes a furious stare on him and says nothing. She turns to look at Protée, who has been watching the incident all the time. Gazing at him seductively and breathing deeply, she asks that he take the ram away.

Through this episode Denis reveals the dignity and generosity of Djatao, in contrast to the crude exploitative attitude of Delpich. The respect and friendship Aimée shows to Djatao disgusts Delpich and he treats the dignitary with complete contempt. For him, the proper place for all 'natives' is at his service. Yet this was simply not practicable in northern Cameroon. As far back as 1917, the *commandant* of the North Cameroon region remarked: 'It is contrary to our own interests to treat a Sultan, however humble his real situation may be in comparison with the high-sounding title, as a black houseboy.'[61] Forty years later, colonial officials needed their collaborators more than ever. But such respect was only given to Africans of a particular status; it was not given to houseboys. Thus Protée stays fixed in his servile role. At the same time, Aimée's seductive look reminds the audience of the sexual tension that characterises their relationship.

In so depicting layers of colonial hierarchy, this scene reveals a central historical theme of *Chocolat*, which is to explore interracial relationships in the colonial household. These relationships are examined on a number of levels: between Aimée and Protée as well as other servants; between Protée and France; and between the visitors from the plane and various African characters. The introduction of the strangers from the plane serves to destabilise the façade of proper colonial conduct that had hitherto been carefully maintained in the family home. This prompts what is perhaps the most important scene in *Chocolat*, when Aimée literally reaches out to Protée and thus crosses the boundary that defines her colonial relationship with him. Commenting on the theme of interracial relationships, Denis remarks that she initially wrote a script 'based on real incidents from my own African childhood'. She sought to show that French colonials and Africans led very separate social lives, but at the same time wanted to reveal

how French children became friends with the African servants. She recalled that 'incidents of sexual liaisons between African male servants and white females occurred several times and resulted in big scandals', and thus she decided to make this part of the drama.[62]

Such interest in the subject of how white women in the African colonies relate to their houseboys invites comparison with Doris Lessing's *The Grass is Singing*, a novel originally published in 1950. It appeared as a film directed by Michael Raeburn in 1980. Set in Southern Rhodesia, the central character in Lessing's novel is Mary who, like Aimée, struggles against the lonely boredom of her colonial life and feels similarly attracted to her African servant. To occupy herself and give meaning to her existence, Mary endeavours to maintain certain domestic standards which serve to distinguish her from the 'natives' and establish a degree of social distance. She thus makes a great effort to decorate her home by sewing curtains and cushion covers. When this task is complete, she begins embroidering her underwear, 'instinctively staving off idleness as something dangerous … There she sat all day, sewing and stitching, hour after hour, as if fine embroidery would save her life'.[63] For Bardolph, 'the useless needlework is a tragic pointer to the futility of her life'.[64] Later in the story, Mary's attempt to create a genteel life is shown to be inadequate when a neighbour, Charlie, notices that the home decor 'was of the material always sold to natives … so much associated with "kaffir-truck" that it shocked Charlie to see it in a white man's house'.[65] Lessing thus conveys the subtle way in which colonial society was culturally 'contaminated' by its African environment, despite the best efforts of a white wife to 'keep up appearances'.

The Grass is Singing is to some extent a more sophisticated depiction of the tensions in the colonial household than the highly dichotomised presentation of *Chocolat*. Nevertheless, the film does illuminate the part that white women played in asserting European prestige in French colonial Africa. This subject is of central interest to the extensive historiography on colonial gender relations, much of which emphasises the contradictory position of European women in the colonies and examines how they were trapped between different roles. Sometimes they were expected to act as agents of imperial domination while on other occasions they were assumed to be subordinate in a male colonial hierarchy.[66]

An example of how white women helped to sustain the regal and commanding style necessary for asserting colonial authority was the custom of dressing for dinner.[67] A remarkable historical occurrence of this is described by the widowed wife of a British official, Sylvia Leith-Ross. In 1913, while touring up the Benue River in Nigeria by steel canoe, she insisted that she and her companion had to dine formally on the edge of the sandbank every night, and also change an item of clothing: 'We had always dressed for dinner,' she declared, 'this was a rule

that could not be broken, either at home or abroad, at sea or on shore, in the Arctic Circle or on the Equator.' Explaining why this ritual was necessary, she wrote: 'When you are alone, among thousands of unknown, unpredictable people, dazed by unaccustomed sights and sounds, bemused by strange ways of life and thought, you need to remember who you are, where you come from, what your standards are.'[68] As Helen Callaway points out, in the signifying system of colonial society, the discipline of dress was closely tied up with the discipline of a moral code.[69]

After administrators' wives began to arrive in French Equatorial and West Africa from the 1920s, entertaining other Europeans became an important social ritual that defined the racial and cultural boundaries between Europeans and Africans.[70] The depiction in *Chocolat* of the visit of a British colonial official, while Marc is away on tour, draws attention to this practice. It emphasises Aimée's responsibility to entertain her guest to a sufficiently high standard and thus we hear her begging her cook, whom she has recently chastised for not cooking *la cuisine française*, to make stodgy English fare such as Yorkshire pudding. Then, while she dresses for dinner, Protée cautiously knocks at her bedroom door to warn that her guest is wearing his tuxedo. Alarmed, she rushes off to get her ball gown, which she subsequently has to ask for Protée's help in putting on. The film thus conveys the challenge of maintaining the racial boundaries of the colonial household, when such boundaries were being continually eroded by the intimacies of everyday life. After their dinner, Aimée and her guest dance, elaborately costumed and choreographed, as if at a formal ball. Just like Leith-Ross on the banks of the Benue, they represent a transplanted European high culture that is completely at odds with its African surroundings. Nonetheless, by performing the ritual of formal dining and dancing, they define a cultural boundary between themselves and the colonised and confirm a sense of their own superiority.

This careful alignment of racial barriers and cultural propriety is later destabilised by the arrival of the provocative Luc Segalen. A former Catholic priest, he enters the drama when Marc employs a group of African labourers to help build a runway for the stranded plane. Disturbed by the fact that Luc, a white man, works and takes his afternoon nap with the black labourers, Marc tells him he doesn't belong there and asks that he come to his house in Mindif. Luc complies but, much to the consternation of Aimée and Protée, he sleeps outside on the veranda and also showers in the servants' quarters. Protée confronts Luc, telling him he is in the 'boys' shower, but Luc ignores him and calls out to Aimée that 'it's the most beautiful bathroom in the world'. He thus forces Aimée and Protée to look at him naked, as they dare not look at each other. His intrusion into the limited African living space, however, is an assertion of white authority rather than a statement of racial equality. It is evident that neither Protée nor any

of the other servants would be similarly permitted to use the indoor facilities.[71]

It is Luc who provokes the final close encounter between Aimée and Protée. Eating outside with the servants, Luc taunts Protée to admit that his presence bothers him, but Protée does not answer. Aimée watches from the veranda. To her, Luc says: 'You'd like to be in my place, rubbing against Protée. Come, I'll make room for you.' Soon afterwards, Protée and Luc confront each other on the veranda. 'Fuck off! Go lick the boots of your bosses,' Luc declares. 'You're worse than the priests who raised you.' Protée reacts by picking up Luc's sleeping mat and hurling it off the veranda; the two men wrestle. Luc falls to the ground before picking up his things and leaving. Protée resumes his work of tidying up the house and begins closing the screens in the living room. Aimée sits on the floor, apparently having heard all the commotion outside. As he begins to draw the curtains she reaches out and caresses his leg while staring up at him pensively. He stops, and then moves away, before returning to tap her on the shoulder. Forcefully pulling her to her feet, he looks at her for a moment to make her 'ascend from the darkness of her immoral and impossible desires'.[72] He then walks out of the room.

For Denis, Protée's rejection of a sexual encounter with his mistress 'was the purpose of the film'.[73] Asked why she wanted the houseboy to refuse his mistress's advance she replied:

His rejection of this white woman demystifies the prevalent screen image of the black stud and exotic black, something imagined in Hollywood films like *Out of Africa*. *Chocolat* rejects images of the colonized black African as an always passive subject who bends to the white European's whims. I wanted to show that the choice lay in the black man's calloused hands instead of the woman's finely manicured sexual fantasies.[74]

Thus paradoxically, rather than a voiceless aesthetic image, Denis intends Protée as a colonial subject with agency. His role is based on Toundi, the main character in *Une Vie de boy* (Houseboy), a novel which was first published in 1956 by the Cameroonian author Ferdinand Oyono.[75] However, *Une Vie de boy* is quite a different story to *Chocolat*, because the madam of Oyono's imagination has no sexual desire for her servant. Instead, the novel focuses on the confused self-perception of Toundi and is written in the form of his diary. In the beginning, Toundi recounts how he is adopted by a Catholic priest who teaches him to read and write, and he then becomes convinced that he must imitate white men and 'live like them'.[76] His lowly status means that he cannot achieve this dream, but he still believes that even a subordinate relationship to white people gives him superiority over fellow Africans. After the priest dies and he is told to go and see the *commandant*, he declares, 'I shall be the Chief European's boy. The dog of the King is the King of dogs.'[77] Later on in the book, the wife of the *commandant*

arrives; Toundi sees her as an ideal of feminine perfection. She begins having an affair with one of her husband's colleagues.

Toundi passes messages from his mistress to her lover and, after the *commandant* discovers his wife's infidelity, he accuses the houseboy of being a go-between. The couple reconcile, but as long as Toundi remains in their household his madam cannot deny her unfaithfulness and her husband cannot forget being cuckolded. Toundi's potential for unmasking their pretensions makes them fear him as 'the eye of the witch that sees and knows'.[78] He is falsely accused of stealing, unjustly arrested and brutally beaten. Barely alive in hospital, he finally asserts his own agency and decides to flee Cameroon. This initiative occurs too late to save his life, but it confirms that he can 'discern the human truth beneath the illusory appearances that are maintained by social convention'.[79] Bjornson argues that this detached humanist perspective was typical of Oyono, who despised how the artificial social distinctions of colonialism prevented recognition of a shared humanity.[80]

Since *Une Vie de boy* is written from the perspective of the houseboy, the shifting process of self-realisation and consequent self-assertion within Toundi is quite discernible. By contrast, because Protée is most often viewed through his mistress's eyes, he generally appears to be a disempowered shell. Yet as Morgan points out, by rejecting Aimée's sexual advance Protée asserts the racial boundary that separates them, at the same time as 'reversing the power dynamics of his relationship with his white employer. Ironically, by so carefully patrolling the boundaries of who they can be to each other, Protée is dangerously crossing over into a wilful agency denied to him by his status as racial other and subordinate.'[81] This is an interesting historical point, but the aesthetic qualities of *Chocolat* generally obscure this element of Protée's character development. No wonder, then, that Denis had difficulty finding an actor for the role in Cameroon because 'the actors found the subject of the film degrading'.[82]

~

Conclusion

While the sexual tension of Protée and Aimée's relationship reaches its climax, Marc is putting France to bed. He decides to define the horizon for her, to correct her misconception that after the plane flew over her house, 'it fell behind the mountain'. Marc explains that it is a line 'where the earth touches the sky'. But, he goes on, 'the closer you get to that line, the further it moves. If you walk towards it, it moves away. It flees from you. I must also explain this to you. You see the line. You see it, but it doesn't exist.'

As the filmmaker, Denis's historical argument here seems to be that the horizon is a useful metaphor for understanding the boundaries of interracial relationships in the colonial household. This observation is convincing but, as ever, her emphasis on the colonial past as aesthetic image dominates. Shortly after he is banished from the house, Protée is framed sitting on a rock watching the sun rise over the horizon. Thus, again, the argument is enigmatic. Is it made to justify the inclusion of a beautiful scene of a silent African taking in the view of a timeless land? Or is there a more significant contention here about intimacy and distance in colonial societies?

Ultimately, the unmoored nature of time in *Chocolat* makes it very difficult to tell. When the narrative emerges out of France's daydream, the audience hears the driver of the car telling France that his name is Mungo. He explains it is a nickname that he was given when he came to Africa from the United States, his real name being William J. Park. Evidently, this is a play on the name of the Scottish adventurer Mungo Park who explored the Niger River in the 19th century. Admitting he is African-American, Mungo asks France, 'You're not disappointed? Were you looking for a real native?' She does not reply. The film thus returns to the theme of nostalgia that lies at its core. Just like the grown-up France, who returns to the exotic colonial world in search of something lost from her past, Mungo came to independent Cameroon in search of another lost authenticity, that is, his African roots. But, he admits, 'I really stayed American. They don't give a shit about guys like me here. Here, I'm nothing.' In the end, Mungo is as much an outsider in Africa as France is.

As an historical film, *Chocolat* does not claim to be 'true'. Its director emphasises that, notwithstanding her childhood background, its story of the colonial past in Cameroon is fictional. Within this story, there are historical elements that do illuminate our understanding of French colonialism in Cameroon, particularly the role of white women in defining racial and cultural boundaries and in the colonial household. Nevertheless, these elements are so often aestheticised that their historical value is diminished. As Murray explains, the problem is not that *Chocolat* gets history wrong. It is, after all, a work of fiction. The danger is rather that the film is 'presented with all the trappings of historical authenticity, as well as of a post-colonial critical stance, that might be mistaken for the real article'.[83] The overwhelming impression of the colonial past in *Chocolat* is that it was beautiful to behold. But for historians, the colonial past will always be less than beautiful and much more than a resource for artistic plundering.

12

The Battle of Algiers:
between fiction, memory and history

~

PATRICK HARRIES

Gillo Pontecorvo's 1965 film, *The Battle of Algiers*,[1] stands as a masterful combination of political statement and aesthetic innovation. The film won the Lion d'Or at Venice in 1966 and, in the US, was nominated a year later for an Oscar as Best Foreign Film. In 1969 it was again nominated for Oscars in the categories of Best Director and Best Screenplay.[2] Despite this acclaim, no distributor in France was prepared to take *The Battle of Algiers* before the censors because of its graphic portrayal of torture during the war. Two million young Frenchmen served in Algeria between 1954 and 1962, over twenty thousand died, and the intervention of the military in politics had changed the government in 1958 and brought the nation close to civil war three years later. At the end of the conflict, well over a million French settlers and Muslim loyalists were 'repatriated' to France, a country many had never seen.[3] But an older, third stream of immigration also grew markedly during and after the war as Muslim Algerians fled rural poverty to feed the economic needs of post-war France. By 1965 the Algerian population in France numbered about 600 000 and, within a decade, would grow to outnumber the country's traditional Protestant and Jewish minorities.[4]

The generation that had experienced the war in Algeria had little reason to celebrate its memory. The Algerian community in France had been caught up in a savage conflict as the followers of the old nationalist leader, Messali Hadj, and the young men in the National Liberation Front (FLN), fought a merciless battle to control metropolitan sources of funding for the armed struggle. French conscripts wanted to forget their role in a foreign, 'dirty war' and re-establish themselves at home. The repatriated *pied-noir* settlers developed a rose-tinted view of 'papa's Algeria' that would grow, with time, into a full-blown nostalgia. But it was particularly the institutions of the French state that showed little

203

interest in grappling with the less savoury aspects of the war. The honour of the French army had been sullied by accusations of torture and the imprisonment of many senior officers after the failed military coup d'état in Algiers in 1961. Moreover, many officers felt independence had betrayed their promise to protect both the *pied-noir* (settler) population and the large number of Harkis, or Muslim soldiers, who had sided with the French during the conflict. Nor were many politicians eager to recall the assurances of French suzerainty that they had offered to the *pieds-noirs* and the Harki soldiers employed by the French army.[5] Most were content to turn their backs on France's colonial past and look to a brighter European future.

The Algerian war had brought France to the edge of a civil conflict that had strong parallels with the murderous conflagration in Spain only twenty years earlier. But the Algerian war had particularly succeeded in reopening the bloody chasm that traditionally divided France into two bitter camps, both with long memories, on the political left and right. During World War Two, the Vichy government had imprisoned 135 000 opponents, interned 70 000 others and dismissed 35 000 civil servants. About 650 000 men were conscripted to work under appalling conditions in wartime Germany. Most shamefully, the Vichy administration had not only collaborated in the deportation of 76 000 French Jews; it had in many cases ordered and executed their removal to death camps in the east.

The Algerian war started barely a decade after the Vichy regime collapsed in a welter of perhaps 9 000 extra-judicial killings. The trial and imprisonment of 50 000 collaborators and the legal execution of 767 others soon followed the summary killings of 1944.[6] As World War Two ended, France was divided by the recent experience of a small, but growing, part of the population that resisted the Nazi occupation, and that of a far larger element of the population that had accommodated itself in various ways to the demands of the victorious Germans. Reconciliation in the post-war years depended on the ability of the nation to forget its fratricidal, divided past and look to the future. The Algerian war threatened to reopen these wounds and it was for this reason, amongst others, that François Truffaut and Henri Cartier-Bresson boycotted the final ceremony of the Lion d'Or in 1966 when they heard that *The Battle of Algiers* would beat Robert Bresson's *Au hasard Balthazar* into second place.

At this time French films like *Les Parapluies de Cherbourg* (1964) could treat the lives of individuals affected by the war; but if a film attempted to tackle the conflict more directly, it was inevitably banned. This was the fate of Paul Carpita's *Le Rendez-vous des quais* (1955) on the Indochina war, Claude Autan-Lara's 1958 study, *Tu ne teuras point* ('Thou Shalt Not Kill'), on a pacifist's refusal to serve in Algeria, and Jean-Luc Godard's *Le Petit Soldat* in 1960. This led most producers to practise a form of self-censorship, although Alain Resnais's 1963 *Muriel*

ou le temps d'un retour ('Muriel or the Time of Return') treated the collusion of conscripts with torture and murder in Algeria as a sub-theme. Hence it was only in 1971 that the censors finally allowed *The Battle of Algiers* to be distributed in France. This decision immediately led to boisterous demonstrations mounted outside cinemas by repatriated colonists, war veterans and right-wing political activists. At one venue a gang burst into the cinema, destroyed the film with sulphuric acid and cut up the screen on which it was shown. The film was eventually withdrawn after a bomb exploded at the premises of the company charged with its publicity. In the same year the general in command of anti-insurgency operations in Algiers during the battle for the city in 1957, Jacques Massu, joined these protests when he called torture 'a cruel necessity' and an almost natural response to any campaign of terror.[7]

Nevertheless, by this time films appeared that were distributed with some success despite their criticism of France's role in the war. These included Claude Berri's 1970 *Le Pistonné* (with Algerian-born Guy Bedos as a Good Soldier Schweik figure), René Vautier's *Avoir vingt ans dans les Aurès* ('To Be Twenty Years Old in the Aurès', 1971) on a platoon of unwilling conscripts, and Yves Boisset's 1973 *R.A.S.* ('Nothing to Report') with Philippe Leotard as the officer who wants to bring his men home alive. Within a few years the memory of the traumatic 'events' in Algeria (which the government had still to recognise as a war) had started, like the brutalities of the Vichy period or the massacre of Protestants on St Bartholomew's Eve, to slide into the unconscious of the nation. At the same time the various antagonistic groups that had engaged in the war found their distinctive, collective memories reinforced by films reflecting their particular experience of Algeria. Mohamed Lakhdar-Hamina filmed *Le Vent des Aurès* ('The Winds of Aurès'), a film about the destruction of a peasant family during the war, in 1966 in Algeria. Nine years later his *Chronique des années de braise* ('Chronicle of the Years of Fire') with Marcello Gatti, the cinematographer of *The Battle of Algiers*, recounted the final stages of colonialism and the beginnings of the revolution in Algeria. Both films won prizes at Cannes (best first film in 1967 and the Palme d'Or in 1975). A very different memory emerged a few years later when *Coup de sirocco* (1979) spoke to the repatriated colonists as mellifluously as *Honneur d'un capitaine* (1983) addressed the military. By 1981, when *The Battle of Algiers* was finally brought back to the French cinema, it no longer represented the sole cinematographic representation of the war; and it was received with general indifference.

Coming to terms with the past

In Algeria, *The Battle of Algiers* became a cult film, a part of the national patrimony that still fills cinemas today. Its strongly anti-colonial message appealed to Third World activists and left-wing habitués of small film clubs and narrow cinema circles.[8] It started to resurface in France, however, when the newspaper *Le Monde* began a campaign in June 2000 calling for the country to recognise the cruelty of the methods of war used against the Algerians and, by extension, called on the leaders of the socialist government to confront the unsavoury aspects of the country's colonial past.[9] The exposés in *Le Monde* brought the question of torture as a method of counter-insurgency back into public view. Almost a decade earlier, the historian Benjamin Stora had raised some of these issues in a groundbreaking book on the memory of the war and in a frank documentary series on television called *Années algériennes* ('Algerian Years').[10] This was followed by a major exhibition on 'France and the War in Algeria' organised by the Museum of Contemporary History in the war museum in the Invalides in Paris.[11] The fortieth anniversary marking the end of the war also served as good reason to produce soul-searching TV documentaries and, for the first time, a debate that included members of the French Algerian die-hards, the Secret Army Organisation (OAS) and Yacef Saadi, the head of the FLN operations in Algiers in 1957. But the new disclosures in *Le Monde* in June 2000 added rape and assassination to the crimes of the French army in Algeria.[12] In interviews with *Le Monde* later that month, General Massu again admitted that the army had engaged in torture during the war but, at the same time, attempted to shift blame for the practice to the politicians who 'covered, even ordered [torture and] who were perfectly aware of its existence'. Towards the end of the year he attempted to pour oil on troubled waters when he declared torture to be no longer defensible and 'something ugly'.[13]

However, the climate became explosive in May 2001 following the publication of a book containing Louisette Ighilahriz's accusations of rape and torture first raised in *Le Monde* a year earlier.[14] In the same month another French general, Paul Aussaresses, who had served as a Special Operations officer in Algeria, publicly admitted to the widespread use of torture during the war and to his personal participation in the execution of 25 men, including Larbi Ben M'Hidi, one of the nine original founders of the FLN and the leader of the movement in Algiers in 1957. 'The methods I used were always the same,' wrote the 83-year-old retired and highly-decorated general, 'beatings, electric shocks, and, in particular, water torture ... only rarely were the prisoners we had questioned during the night still alive the next morning.'[15]

A few months later the publication of the memoirs of two young conscripts, Henri Pouillot and 'Jean Martin' (a nom de plume borrowed from the actor who played the role of the French colonel in *The Battle of Algiers*), confirmed that torture had been widespread and highly organised during the war and that many 'ordinary Frenchmen', like Germans in the Second World War, had engaged in it.[16] Horrified by Aussaresses's declarations and by the banality of evil contained in these new disclosures, the army quickly brought out an illustrated book containing a defence of its own memory of the war.[17] But when Paul Aussaresses was charged in November with complicity in 'war crimes', General Maurice Schmitt stated in his defence that torture was unavoidable in the fight against terror. 'If one has to dirty one's hands or accept the killing of innocent parties,' he said at the trial, echoing Colonel Mathieu in the film, 'I must choose to dirty my hands or risk losing my soul.' He had no doubt that torture had taken place during the battle of Algiers; but it was 'only a form of legitimate defence employed by a population threatened by death'.[18]

Schmitt had led the paratroop company charged with controlling the casbah during the summer of 1957, but the account of the battle of Algiers in his book made no mention of torture and called the campaign an unqualified 'victory'.[19] At the same time, Schmitt's direct commander during that summer, Marcel Bigeard, declared himself 'sickened' by the news that Larbi Ben M'Hidi's supposed suicide had been an assassination carried out by French troops. Despite their involvement in the use of torture to suppress the insurrection in Algiers, both Schmitt and Bigeard had experienced rapid promotion in the army. Schmitt had risen to head the general staff of the French army (1987–91) and Bigeard had at one time served as Minister of Defence in the French cabinet. As the role of the army came increasingly into question, Bigeard contacted one of Larbi Ben M'Hidi's sisters and soon declared his willingness to return to Algiers if this gesture would help heal the wounds of the past.[20] By this time the *fracture coloniale*, or way of remembering the colonial experience, had re-emerged as a source of deep division within France.[21]

The Battle of Algiers soon became a part of this public debate over the effect of the colonial past on French national identity. The process to which the Germans have given the name *Vergangenheitsbewältigung*, an attempt to come to terms with the past, had begun formally in France during the Mitterand presidency. During the 1980s, as the socialists turned away from their traditional policies, they had tried to rally support by portraying themselves as the true defenders of a republic that had been hijacked by Charles de Gaulle and his followers. This required a frontal assault on the picture constructed by De Gaulle, through a series of memorials, museums, commemorations and histories, that presented France as a nation unified during World War Two in opposition to the Nazi occu-

pier. De Gaulle had fostered this myth in an attempt to create a national pride in those who had resisted the Nazis while, at the same time, hiding the full extent to which many had collaborated with the occupation. In the wake of the war in Algeria, which had rejuvenated the deeply rooted political antagonisms in French society, De Gaulle had initiated an active policy of strategic remembering and forgetting. This built a national consensus around issues such as the pride of the French in their opposition to the Nazis while, at the same time, it countered the Communist Party's attempt to portray itself as the representative of the *quinze mille fusillés*, the 15 000 victims executed by the Vichy regime and its allies. Most importantly, De Gaulle and his followers depicted themselves as the leaders of a modern, post-colonial France united by a long period of uninterrupted post-war economic growth. When this prosperity ended in the mid-1970s, and the socialists eventually came to power in 1981, François Mitterand strove to break this national consensus, which was held responsible for the long reign of De Gaulle and his followers, by reopening the divisions within the nation that were embedded in the country's history.

In this confrontation with the past, French politicians had to turn to the work of an American historian, Robert Paxton, who in 1972 and 1973 had exposed the widespread support in the country for the Vichy government.[22] But cineastes had also served to alert the public to this new, critical approach to World War Two. Marcel Ophuls had first raised the question of the extensive and venal nature of collaboration in 1969 in his documentary, based on actual footage, *The Sorrow and the Pity*; and five years later Louis Malle and Costa-Gavras had advertised the extent to which 'ordinary Frenchmen' had collaborated with the Nazis through films like *Lacombe Lucien* and *Special Section*. The publication in 1987 of Henry Rousso's soon-to-be-classic work on the history and memory of the Vichy regime coincided with the trial of Klaus Barbie, the SS officer responsible for the murder of the resistance leader Jean Moulin.[23] The sentencing of Barbie marked a new stage in this public reassessment of the past, as did the arrest of the *milicien* Paul Touvier and, later, that of the senior Vichy official, Maurice Papon.[24] In the meantime, the socialists pushed their confrontation with the past in new directions when they attempted to claim the legacy of the French Revolution at bicentenary celebrations in 1989.

One result of this heightened interest in history was the passage of the Gayssot Law of 13 July 1990 that prohibited the publication of 'revisionist' views of the Holocaust. Having succeeded in getting the state to outlaw denials of the Holocaust, intellectuals then turned to the question of the collaboration of the French state with the Nazis during World War Two. On the fiftieth anniversary of the widespread arrests of Jews in occupied France in 1942, intellectuals called on the president to issue a formal apology on behalf of the state. But it was during

the mid-1990s, as the National Archives prepared to open the records covering the war years, when the French had finally to come to terms with the terrible divisions created by the Nazi occupation, particularly the role of the national police in the expatriation of Jews to death camps in the east. The public apology pronounced by Jacques Chirac in July 1995 served to heal old wounds, and curb a growing anti-Semitism, by bringing the crimes of various organs of the French state into the national arena.[25]

The campaign waged by *Le Monde* formed part of this *Vergangenheitspolitik* and resulted in another petition, tabled in October 2000, which called on government to recognise and condemn the army's use of torture during the Algerian war. Rather than prosecute individuals, as it had in the late 1980s and early 1990s, or constitute a commission of historians that it could not control, the government opted to allow a public examination of the role of the army in Algeria, including the part played by two million conscripts. By uncovering and publicising some of the crimes of the army in Algeria, this campaign would convince the French to see Arabs as victims rather than as enemies against whom they had waged a pitiless war. By this time the Muslim population in France had grown to around five million and was besieged by many ills in the wake of the economic crisis of the mid-1970s. These included high levels of unemployment, a growing tendency for Muslims to retreat into segregated communities in impoverished peri-urban estates (or *banlieus*) and, most worryingly, a turn to an Islamic fundamentalism that contradicted the French tradition of assimilation. Vandalism, destruction of property and politically motivated football hooliganism attested to the frustrations of this marginalised community.[26] By bringing the many different and painful memories of the Algerian war into public view, politicians hoped to integrate the memories of various communities into a more pluralistic view of the nation and, in the process, bring about a growing reconciliation between hostile communities.[27] But while this campaign attempted to bring the experience of Muslim Algerians into the purview of the nation, it did little to bridge the memories separating communities and, most importantly, deflected attention from the responsibility of politicians for the conduct of the war in Algeria. Nevertheless, as part of this process *The Battle of Algiers* was shown on the TV station CineClassics on 25 September 2001 and, a few days later, was included in a 'Week-end special' on the Algerian war that included Godard's *Le Petit Soldat*.

The urgency behind the need to come to terms with the past grew suddenly and fundamentally, when Islamic militants destroyed the World Trade Centre in New York on 11 September 2001. Six months later Patrick Rotman, who had collaborated with Bertrand Tavernier on a film covering the experience in Algeria of French conscripts (*La Guerre sans nom*, 'The War Without a Name'), screened a harrowing series of documentaries on national television during prime time

viewing.[28] *L'Ennemi intime* traced the guilt for the crimes of the French army in the Algerian war to paratroopers, professionals and conscripts – to the enemy 'within' – and was soon followed by other supportive documentaries.[29] This celluloid reworking of France's memory and identity was accompanied by a rush of commemorations aimed at honouring the various antagonists in 'the events' that the National Assembly had finally come to recognise, in June 1999, as 'the Algerian war'.[30]

In 2003 the film version of *The Battle of Algiers* experienced another unexpected revival, this time on the other side of the Atlantic. As the televised scenes of terror in Iraq increasingly occupied television screens, planners in the Pentagon came to see *The Battle of Algiers* as a graphic example of how to win the battle but lose the war. On 27 August 2003 the Directorate for Special Operations and Low-Intensity Conflict, a civilian group working on issues of guerrilla war, circulated a pamphlet on 'how to win a battle against terrorism and lose the war of ideas. Children shoot soldiers at point-blank range. Women plant bombs in cafés. Soon the entire Arab population builds to a mad fervour. Sound familiar? The French have a plan. It succeeds tactically, but fails strategically. To understand why, come to a rare showing of this film.'[31]

The response of the forty officers and civilians who attended the screening is not public knowledge; but by this time their enthusiasm for the film as a means of understanding 'the war on terror' had spread to France where, on 20 October, it was shown by the channel Public Sénat. The Algerian government, the direct descendant of the National Liberation Front (FLN) that took power in 1962, had, despite the appreciation for the finer points of anti-insurgency warfare expressed by the film's new viewers, good reason to observe with approbation the growing, if unexpected, popularity of *The Battle of Algiers*. Algeria was in the eleventh year of a bloody civil war with Muslim fundamentalists and it had found new and comforting allies in the United States and France. In a clear demonstration of the warm relationship with these new friends, Yacef Saadi joined in a debate on the film after its showing on Public Sénat and, a few months later, accompanied *The Battle of Algiers* to a screening in Bethesda, Washington. Later in 2004 a newly restored copy of the film, with some small additions, was presented at the Cannes Film Festival and later shown in major cities throughout the United States. In November that year it was screened on the popular Franco-German channel, Arte, to commemorate the fiftieth anniversary of the outbreak of the war. 'A masterpiece! Surely the most harrowing political epic ever!' wrote Philip Gourevitch, the veteran of the war in Rwanda and now staffer on the *New Yorker*. J. Hoberman of *The American Prospect* commented on the film's 'astonishing immediacy' that 'anticipates the artfully raw you-are-there vérité of *Bloody Sunday* and *Black Hawk Down*'.[32] By the start of 2005 *The Battle of Algiers* had gone through some

rigorous reinventions. Let me now turn to its content before addressing the extent to which the film can be seen as both an historical document and a work of lasting aesthetic value.

⸻

The narrative outline of the film

The film starts with the shocking scene of an anonymous figure breaking under torture. Dishevelled, bent and shaking, the man divulges the hiding place of the last National Liberation Front (FLN) operative active in Algiers. It is 8 October 1957 and soldiers rush through the narrow streets of the casbah to surround the apartment in the rue Caton where Ali la Pointe hides with Hasssiba Ben Bouali and 'little Omar'. In his confined hiding place behind a false wall, Ali thinks back to the day he was arrested and taken to the Barberousse prison next to the casbah where he witnessed the guillotining of two FLN operatives by the French. This takes the viewer back to 19 June 1956 and the beginning of the struggle to control Algiers. The FLN starts to arm itself and to attack police and soldiers in the city. With some dramatic licence, Ali is portrayed on his release from prison as a petty criminal, part of the lumpenproletariat susceptible to the revolutionary ideas of the FLN.[33] He joins the FLN, receives a lesson in politics and strategy from Omar's uncle Jafaar, an FLN organiser in the casbah. He then helps clean the area of anti-social elements unwilling to accept the rule of the FLN. The old Turkish quarter, filled with narrow streets and 70 000 inhabitants living in two square kilometres, rapidly becomes a liberated zone. But as the FLN intensifies its attacks, the *pied-noir* colonists reply by setting a bomb in a safe house in the rue de Thebes in the casbah. Here the viewer is confronted by the horror of terrorism for the first time; the bodies of children and young men are extricated from the building to the accompaniment of a melancholy tune. When crowds gather in the street to demand action, Ali and Jafaar promise that the FLN will make reprisals.

Soon the casbah is surrounded by barbed wire and the army is in charge of 'maintaining order'. Searchlights play on the dark side streets flanking the casbah and the FLN start to run its ZAA (Zone Autonome d'Alger). From this area young Muslim women, dressed in the European manner, take three bombs into the city as the FLN launches its reprisals on 30 September 1956. The killings continue and a few weeks later, after the killing of Amédée Froger (the president of the Association of the Mayors of Algiers) on 28 December 1956, the Prefect of Algiers gives police powers to General Jacques Massu, commander of the 10th Division of Parachutists.[34] On 7 January (mistakenly announced as 10 June in

the film's titles) some 7 000 parachutists enter Algiers, led by the very professional Colonel Mathieu, to break a general strike fomented by the FLN. In the next scene Mathieu explains to his officers the need to apply 'police methods', i.e. torture, in order to extract the information needed to find the bombers. The colonel is a veteran of the French Resistance and has himself used 'terror' to fight the German occupiers; some of his colleagues were in Dachau and Buchenwald. But the film does not pose the question of torture as a problem and rather presents it as an integral part of the colonial situation (which it implicitly compares to that imposed by the Nazis on occupied France). This is clearly expressed by Mathieu, who sees torture as a means of acquiring information, but who also sees it as part of the system needed to keep Algeria French. 'France must stay in Algeria?' Mathieu says to reporters. 'If you answer "yes" then you must accept what that entails.' The paratroopers are portrayed as professionals who have a job to do; they respect their opponents and dislike torture, but find it the only way of preventing terrorism from developing into wider social struggles, such as strikes, that form part of 'revolutionary warfare'.

Within weeks Larbi Ben M'Hidi, the leader of the FLN in the casbah, is arrested and, much to Mathieu's chagrin, 'commits suicide'. Ben M'Hidi's 'suicide' is part of the 'system' defended by the paratroopers, for the film then cuts to gruesome scenes of the many forms of torture practised during the war. Eventually Jafaar is captured on 24 September 1957 with one of the bombers, Zohra Drif, and the film returns, two weeks later, to Ali la Pointe in his hideout in the rue Caton. After the death of Ali and his friends the film cuts to the huge demonstrations in Algiers on 11 December in favour of independence. These joyful crowd scenes bring *The Battle of Algiers* to an end.

The narrative of neo-realism

The making of *The Battle of Algiers* is shrouded in some controversy. After his arrest, Yacef Saadi was sentenced to death three times by three courts, but was reprieved by Charles de Gaulle after the coup d'état in Algiers in May 1958. He was released after the ceasefire in March 1962 and, instead of taking up a ministerial position, threw himself into the private sector where the exodus of over a million *pieds-noirs* had created business opportunities. In 1963 he went to Italy, the home of neo-realism, to find a director capable of mounting a film on the battle of Algiers. There he met Gillo Pontecorvo, who wanted to direct a film on the story of a journalist (played by Paul Newman) working for an American press agency who arrives in Algiers to cover the war. Yacef Saadi was uncomfort-

able with this perspective and told Pontecorvo that he would not be able to film in Algiers unless he focused on the 1957 battle for the city.[35] Pontecorvo, on the other hand, remembers that he, a committed communist and veteran of the anti-Fascist struggle in Italy, had wanted to make a film on colonialism. He had been to Algeria to investigate the possibility of mounting a film called 'Paras', but this project was aborted because of the producer's fears of the OAS.[36] Pontecorvo recounts that he conceived the plot of the film, adding that Saadi's original script was 'awful, with a sickeningly propagandistic intention'.[37] Saadi rejects this view and holds that the scriptwriter Franco Solinas was inspired by his account of the battle of Algiers during a six-month stay in Algiers with Pontecorvo in 1964.[38]

Although Yacef Saadi produced *The Battle of Algiers* and played himself in the film, the narrative is far from Manichaean. It is not a propaganda film glorifying one side at the cost of the other. The settlers are anonymous rather than terrifying and, in several scenes, gendarmes save young Muslims from vengeful crowds. The enemy is the system, not the individuals who constitute it. In another scene, members of the FLN are shown shooting gendarmes in the back and participating in wild, drive-by killings. Mathieu, particularly, is portrayed as an efficient, professional soldier, 'almost the hero' of the film, wrote Alistair Horne.[39] The film makes no attempt to criticise his perspective. Nor do the film's makers attempt to convince viewers of the superiority of FLN policies. Furthermore, the film does not stress the full ruthlessness of the French. If General Aussaresses's account is to be believed, the informant who led Mathieu to Ali la Pointe's hideout would have been executed rather than freed. Except that, again according to Aussaresses (and other French officers), the informant was none other than Yacef Saadi himself (who escaped execution by revealing the whereabouts of his colleague).[40] Aussaresses, however, downplays the callousness of the French when he repeats the view held by French officers that the explosive charge set in place by the paratroopers was only supposed to blow a hole in Ali's hiding place, not kill him.

Pontecorvo did not try to hide the horror accompanying terrorist bombings. Like Eisenstein, whose camera focuses on an innocent baby caught up in the massacre on the Odessa steps in *Battleship Potemkin*, Pontecorvo captures a little boy licking an ice-cream moments before an FLN bomb explodes. But while Saadi holds that he insisted on the inclusion of this scene so as to increase the realism of the film, Pontecorvo says he had to firmly oppose the Algerian government's attempts to cut this portrayal of innocence from the film.[41] In a similar scene, the indiscriminate savagery of terrorism is brought home by close-ups of colonists enjoying the sun, dancing in a nightclub, or flirting innocently just moments before a bomb destroys their peaceful world. Through a mixture of distance shots, close-ups, freeze footage and different camera angles, Pontecorvo magnified the horror caused by the bombings.

Gillo Pontecorvo went to great lengths to capture the gritty realism portrayed in the film. He had been influenced by Eisenstein as a youth and particularly by the neo-realism of Roberto Rossellini. He brought their concerns with history into his early documentaries and into his 1959 film, *Kapo*, on the experiences of a young Jewish girl in a Nazi concentration camp. By building *The Battle of Algiers* around the life of Ali la Pointe, Pontecorvo succeeded in presenting the film as a simple historical narrative. To reinforce this picture 'of what really happened' his team spent a month looking for bit players on the streets of Algiers and only four days on screen tests. Following Eisenstein's casting practices, Pontecorvo thought the faces of the actors more important than their acting talents, particularly as he used various cameras to film a scene. He eventually chose Brahim Haggiag, an illiterate peasant discovered in a market, to play Ali la Pointe. Jean Martin, as Mathieu, was the only professional actor on the set. But even he, when marching into Algiers at the head of the paratroopers, was not realistic enough, says Pontecorvo. To make him look more forceful and mean, Pontecorvo supplied the tall French actor with dark glasses and padded his shoulders with handkerchiefs.

The Battle of Algiers, unlike an earlier, famous casbah movie, *Pépé le Moko*, was filmed in the narrow, winding streets of the old Turkish quarter of Algiers.[42] Hand-held cameras were used partly because of the alleyways of the casbah, with its overhanging buildings, and partly because by sweeping the viewer into Saadi's liberated 'world apart', they added to the realism of the film. The use of Arabic and French dialogue, with English sub-titles, helped to reinforce this picture. The titles used to introduce different sequences in the film, the radio messages read out by 'objective' French and the FLN narrators, and a score that included traditional Algerian music, also contributed to the vivid sense of realism. In order to achieve the grainy reality of newsreel footage, Pontecorvo's team used a very soft black and white film, Dupont four, and were careful to break the harsh light of North Africa. They also used telephoto lenses, in much the same way as television crews, and the freeze-footage style pioneered by Eisenstein. This allowed Pontecorvo and his colleagues to focus on important historical moments in the film, such as when the three Algerian women fetch their bombs and symbolically take women into both the revolution and a less patriarchal future. Pontecorvo's team finally spent more than a month editing the film in such a way as to balance suspense and character portraits with a newsreel quality. They particularly used sound and music to infuse their images with emotion and to supply their narrative with tension. This emerges most forcefully in the opening scenes when hymnal music accompanies the betrayal of Ali la Pointe by his broken, erstwhile colleague. Martial music underlines Mathieu's position as a soldier, Algerian music accompanies the marriage ceremony led by FLN officials in the casbah,

and light, frivolous music gives meaning to the film's portrayal of the French bourgeoisie in Algiers. While the music tells the viewer how to interpret a scene, it adds excitement and charm to the narrative. 'I believe in the dictatorship of truth,' says Pontecorvo, but 'audiences do not want to pay to see the news.'[43]

Fiction and history

In some ways *The Battle of Algiers* is even a little aseptic by today's standards. The bombings are not filmed in slow motion, there are no close-ups of the victims' wounds, and melancholy music, rather than the screams of the wounded, follows the explosions. The pain inflicted by terrorism and counter-terrorism is represented as psychological rather than physical. However, despite the realism of *The Battle of Algiers*, the film is a left-wing icon that is unlikely to attract large numbers of conservative viewers. This is partly because the most human figures in the film are all Muslims, large crowds support the anti-colonial cause, and the FLN is portrayed as a brave and resolute organisation aiming to bring freedom and equality to a population discriminated against by colonists and their army of occupation. Terror is portrayed as an almost natural response to the ruthlessness of the colonists and the French army. Like Michael Collins, in the eponymous film on the armed struggle in Ireland, Larbi Ben M'Hidi states that terror is the only weapon that the colonised can use against the coloniser. 'Of course, if we had your airplanes it would be a lot easier for us,' he explains to a French journalist after his capture. 'Give me the bombers and you can have [the bombs in] the baskets.' The moral legitimacy for the use of terror in the film follows this logic as the FLN starts its campaign of urban terror after the guillotining of its two operatives on 19 June 1956. What goes unsaid in the film is that the two men had killed civilians and that the French authorities were under pressure to exact retribution, particularly because of the slaughter of 123 loyalists, including 71 Europeans, in the Philippeville area the previous summer.[44] Most authors point out that the FLN did not turn to terror in response to French atrocities, such as the execution of guerrilla fighters, or the destruction of the FLN safe house in the casbah. Instead, they call attention to the role of the Berber politician Ramdane Abane in persuading the FLN to adopt this formal strategy of warfare at its Soummam Conference in August 1956.[45]

In the film Colonel Mathieu is quick to trace the reasons for a war of terror and torture to the nature of the colonial situation. However, he makes no attempt to uncover the beneficiaries of that situation or to discern those responsible for its existence. Long-standing ministers (and future presidents) of France – such

as Valéry Giscard d'Estaing and François Mitterand – were at one time ardent supporters of French Algeria; and Jacques Chirac, Lionel Jospin, Jean-Pierre Chevènement, Jean-Marie Le Pen and others all served in the war. Despite the deep implication of many politicians in the conflict, Mathieu makes only one brief remark about their responsibility for a situation in which he is required to practise torture as a means of putting down the campaign of terror in Algiers. Yet it was the politicians who introduced the 'special powers' in 1955 and 1956 that suppressed human rights and who later gave 'police powers' to the paratroopers in Algiers. Perhaps most notably, it was the politicians who handed Algeria to the FLN through a referendum in March 1962. As Elie Kedourie has pointed out, rather than organise a democratic transfer of power to the various political groups in the country, the French handed power to the extremists who depended on violence for their leadership of the nationalist movement. According to this point of view, the failure of democracy in the country and, ultimately, the civil war that erupted in 1992, can be traced to the duplicity of the French politicians.[46]

The crowd scenes in *The Battle of Algiers* constitute one of the great strengths of the film. Because both Ali la Pointe and Larbi Ben M'Hidi die in the film, the ultimate hero of the story is the anonymous crowd that, in the tradition established by Eisenstein, is the real maker of history (along with the film's producer, Yacef Saadi). Most spectacularly, *The Battle of Algiers* portrays the FLN as leading a popular, mass uprising against the French. This is well captured after the bombing in the rue de Thebes where crowds gather in the street to demand action. Ali takes the lead and promises that the FLN will represent the people. This popular support for the movement is confirmed throughout the film whenever the crowd, pushed on by a musical theme by Ennio Morricone that seems to capture the heartbeat of the revolution, surges forward in patriotic support of the FLN. Yet few historians would today portray, as did Frantz Fanon, the independence struggle in Algeria as a popular, unified uprising.

The leaders of the FLN were impatient young men, a small minority within Messali Hadj's party who established their political position through violence and who, through force of arms, came to dominate the nationalist movement. In 1957 it was far from clear that they would carry the Muslim population with them.[47] Many loyalists served the French government while the build-up of Muslim 'Harki' military units would soon turn the war in the favour of the French. The film also says nothing about the terrible fratricidal conflicts within the Algerian nationalist movement that occurred in France even more than in Algeria, and that pitted the younger generation, represented by the FLN, against the older generation led by the veteran Messali Hadj.[48]

Equally obscured is the 'first coup d'état' within the FLN that occurred at the height of the battle for Algiers. As the FLN headed for military defeat in the city

the military districts, or *wilayas*, became more important as sites of resistance to the French. The *wilaya* leaders increasingly distanced themselves from the politicians whom they held responsible for the setback in Algiers. This led to a massacre of over 300 of Messali Hadj's followers in the small village of Mélouza in May 1957 and, two months later, caused a handful of colonels to seize control of the movement. This palace coup isolated Ramdane Abane, the 'architect of the battle of Algiers', and weakened the position of the politicians within the FLN. When the colonels finally assassinated Abane in December 1957, they symbolically brought an end to the politicians' control of the movement. For a leading historian such as Mohamed Harbi, this event placed Algeria's future in the hands of the armed wing of the movement and effectively destroyed the seeds of democracy within the FLN.[49] What is equally left unsaid in *The Battle of Algiers* is that the defeat of Abane placed the revolution more firmly in the hands of Arabic-speakers and that it gave more weight to Islam as the religion of the nation-to-be. The film also leaves out the participation of the Algerian Communist Party in the conflict and, in this way, ignores its view of Algeria as a pluralistic 'nation in formation'.[50] Through this bricolage of images, *The Battle of Algiers* portrays the FLN as what it was to become rather than what it was in 1956–57: as a nationalist movement built on Islam and Arabic. This view of the nation would quickly marginalise or exclude various groups in the country, from the Berber-speakers to the francophile élite, the secular left and, most notably, the 'European' minority. Many would argue that this view of the nation would eventually help undermine the FLN's hold on power.[51]

The film also makes a powerful contribution to the myth of a great popular uprising through some cavalier editing. This is particularly achieved by cutting from the death of Ali la Pointe in 1957 to end the film with scenes from the patriotic demonstrations in favour of independence in December 1960. A more natural conclusion would have been the coup d'état of May 1958 in Algiers (brought about, many would argue, by the transfer of police powers to the paratroopers at the start of the battle of Algiers). By excising three pivotal years in the history of the Franco-Algerian war, the film effectively hides the 'crushing defeat' suffered by the FLN in Algiers in 1957.[52] Not only did the French succeed in destroying the operative structures of the movement in Algiers; they also managed to 'turn' members of the FLN captured during conflict in the city. Under the instructions of officers like Aussaresses, these *bleus de chauffe* infiltrated one of the crucial Kabyle military districts and, by targeting the FLN's leadership, decapitated the armed struggle in this *wilaya*.

What the film also elides is that, following the battle of Algiers, only the supporters of French Algeria were able to mobilise large crowds in the capital. In November 1957, and throughout 1958, large crowds of Muslims and Europeans

fraternised behind the banner of a reformed French Algeria, particularly after the seizure of power by Charles de Gaulle and his associates in May that year.[53] It was only after De Gaulle's change of heart on the question of autonomy for Algeria in late 1959 that the FLN was able to reconstitute its support in Algiers. Perhaps most importantly, the military defeat suffered by the FLN caused its leaders to leave the country and to build a formal army in neighbouring newly indepen-dent countries. Cut off from 'the interior' by the French lines of defence along the borders of Algeria, the National Liberation Army (ALN) grew at the cost of the embattled, and increasingly isolated, guerrillas in the *wilayas*. The movement was never able to (re)gain the upper hand in the armed conflict – but it was able to establish a disciplined, well-trained army in Tunisia and Morocco. It was this military force that, supported by Saadi's units in Algiers, won the struggle for power during the two months following independence in July 1962; and it was the ALN that effectively seized power in 1965 and that has continued to govern the country to this day.

The film's depiction of Muslims and Europeans as discrete groups uni-fied by their specific interests also obscures the divisions within the *pied-noir* community. This, at the same time, hides the degree of support for a reformed French Algeria by figures such as the Algerian-born novelist Albert Camus, and the anthropologist Germaine Tillion, who sought together with Muslims like Mouloud Feraoun a 'third way' situated between the extremes supported by the violent men in both the Muslim and *pied-noir* camps.[54] Even a serving general in Algeria, Jacques de la Bollardière, participated in the general opposition to the use of torture.[55] These reformists refused to see torture through Mathieu's eyes, as an integral part of the colonial system, and instead viewed it as a problem to be rooted out and eradicated. Tillion had served briefly in the French cabinet and, when she arrived in Algiers in 1957 as part of an international team inves-tigating the concentration camps, she met secretly with Saadi on two occasions. He offered to stop attacks on French civilians if she could convince the French government to stop the executions of FLN operatives. This resulted in a unilateral attempt to halt the killing of civilians which was ignored by the French who, by this time, had gained the upper hand in the conflict.[56]

Conclusion

After the success of *The Battle of Algiers*, Casbah Films continued to sell the Algerian climate to Italian productions. Yacef Saadi claims that Dino de Laurentiis made one of the early spaghetti westerns, *Three Pistols against Caesar*, in Algeria

in 1967 with his group.[57] Although there is no formal evidence to support this, Casbah Films certainly helped produce Luchino Visconti's *The Stranger*, adapted from the novel by Albert Camus, and starring Marcello Mastroianni and Anna Karina, Bernard Blier and others, in Algiers in that year. Algeria's renown as a film site brought Constantin Costa-Gavras to film '*Z*' in the country in 1968 with a local producer (Ahmed Rachedi). This film, on the colonels' junta in Greece, won two prizes at Cannes in 1969 (Best Actor and the jury's prize) and collected two Hollywood Oscars the following year (Best Foreign Film and Best Film Editing). Gillo Pontecorvo went on to make *Queimada* ('Burn!') in 1969 with Solinas and Marlon Brando. In many ways the film picks up where *The Battle of Algiers* left off as it focuses on the history of a 'Portuguese' island in the Caribbean in the wake of a successful slave revolt. In the less successful *Ogre* (1979), Pontecorvo turned his attention to the Basque separatist movement. Franco Solinas went on to write other psycho-political thrillers such as Josef Losey's *The Assassination of Trotsky* and Costa-Gavras's *State of Siege*. Ennio Morricone became a renowned writer of cinema music to whom we owe the haunting themes to films such as *Once upon a Time in the West* and *A Fistful of Dollars*, as well as the music to Oscar-nominated films like Roland Joffe's *The Mission* and *Vatel*.

Algiers has not fared as well as the team that made Pontecorvo's film. It is no longer a symbol of freedom for young people anxious to support the liberation of oppressed peoples. Over time the FLN atrophied into a single party that brooked no opposition. Popular dissatisfaction eventually exploded into mass demonstrations in 1988 and the party eventually agreed to allow limited democratic reforms. But when Islamic fundamentalists seemed certain of winning power through the ballot box in 1992, the army formally seized control of government. The subsequent, decade-long dirty war with Islamic fundamentalists, and a devastating earthquake in May 2003, sapped the city of much of its creative energy. It remains to be seen how the soldier-politicians will invest the wealth derived from the recent hikes in the petrol price.

Republican France has still to come to terms with the diverse historical experiences and conflicting memories of its complex population. The Gayssot Law of 1990 had sought to protect the memory of the Jewish minority in the country. This legislative attempt to safeguard the memory of one community was followed ten years later by the Taubira Law of 21 May 2001 that spoke to those French citizens descended from slaves living in overseas departments (Guadeloupe, Martinique and Réunion). By treating the slave trade as a crime against humanity, this law recognised the experience of one particular element of the French community. The memory of the Armenian community in France was recognised by a law of 29 January 2001 that applied the term 'genocide' to the massacres inflicted on these people by the Turks in 1915. At the same time,

this 'collective memory of the nation' was expanded to include volunteers in the International Brigades during the Spanish Civil War, who were made eligible for state pensions, as well as the 'mutineers' executed during the First World War for refusing to fight. Special days were also set aside to commemorate the contribution of various communities in France to the wellbeing of the nation.

A more contentious issue arose on 23 February 2005 when the National Assembly in Paris passed a law dealing with repatriated colonists that included an amendment on 'the positive role' of French colonialism, particularly in North Africa, and on the duty of teachers to make these 'facts' known to their pupils. This led to voluble protests from left-wing parties in the National Assembly, while historians questioned the right of the state to legislate and enforce its own interpretation of historical events, on pain of penal sanction (five years' imprisonment or a fine of 45 000 euros). On 7 June 2005 the FLN entered the fray when it denounced the attempt of the new law 'to rub out the most odious aspects of a barbarous colonialism'. But these debates were overtaken when, in November 2005, the battle of Algiers seemed to move into the *banlieus* of France as Muslim youths burned and vandalised property and exhibited a forceful reluctance to abandon their cultural practices and beliefs and adopt those of France.

Curfews and a state of emergency eventually brought an end to the disorder. But when the National Assembly confirmed the Law of 23 February by a large majority, new voices spoke out against the state's attempt to impose an 'official history' on the nation. In Algiers the secretary-general of the FLN accused the law of 'falsifying history'. Historians were also taken aback by the passage of the law but focused their attention on an attempt to prosecute one of their number, an expert on the history of the slave trade, for his criticism of the Taubira Law.[58] In December, nineteen of France's leading historians called on the government to withdraw or amend the laws contributing to the creation of an 'official history'. The historians believed that politicians could legislate on the commemoration or celebration of past events, but that they should not fix in law how those events should be interpreted. Many politicians agreed with this view. The prime minister, Dominique de Villepin, was quick to point out that 'there is no French memory, only memories' and President Jacques Chirac reassured the nation that 'it is not for the law to write history, the writing of history is the business of historians'. But the pluralism pursued by France's political leaders was not reflected by extremists in their parties. On the left the socialists' Jacobin heritage surfaced in their talk of a 'shared national memory' and the suspicion with which they viewed 'separate memories, conflictual memories', while on the right politicians mixed the problems of the *banlieus* and immigration with criticism of the positive role of French colonialism. For the conservatives, the attack on their memory of the past quickly became a 'climate of repentance' that served as a fifth-column sup-

porting the assault on French identity launched by the Islamic *communautarisme* in the *banlieus*. In this climate the minister of the interior, Nicolas Sarkozy, asked ironically whether 'we will soon have to apologise for being French'.[59]

By 4 January 2006 the debate over the memory of France's colonial past had divided the nation to such an extent that President Chirac held it responsible for a 'crisis of identity for France' and demanded that the Law of 23 February 2005 be recalled and amended. Three months later the Algerian president raised the memory of French colonialism on the other side of the Mediterranean when he described it as a 'genocide against the Algerian people'.[60] The French foreign minister then pointed out that France's colonial experience had provided his government with two Muslim ministers of Algerian extraction and that the health system in Algeria was insufficiently developed to serve the president (at that moment undergoing tests in a French hospital).

In these conflicts over the past, Pontecorvo's *The Battle of Algiers* stands as an icon of memory for the left. As I write, Constantin Costa-Gavras is producing another film in Algeria, with the help of Salem Brahimi, based on Francis Zamponi's 1999 novel *Mon Colonel*. Due for distribution in January 2007, the eponymous film is directed by Laurent Herbiet, Alain Resnais's old assistant. It recounts the story of a young lieutenant who volunteers in 1957 to serve in Algeria where he quickly falls under the spell of his colonel and is ensnared in the colonial system of justice. Like some of Mathieu's colleagues in *The Battle of Algiers*, the colonel is a charismatic former Buchenwald deportee who draws the young man into the system of torture and execution. When the lieutenant eventually rebels against the system and rejects it, he mysteriously 'disappears'. The story picks up in 1995 when his father searches for the colonel – who is found dead in his apartment a few days later.

Like 'Z', the film combines the intrigue of a detective mystery with that of a political thriller. Although it does not focus on the war as a struggle for freedom, it raises many of the issues first treated in *The Battle of Algiers*, most notably the unacceptable aspects of counter-insurgency warfare. Through its character study of a man fighting for justice, *Mon Colonel* aims to seek out those responsible for the particularly vicious system of state violence that existed in colonial Algeria. Forty years ago *The Battle of Algiers* created a cinematographic genre that reinforced the memory of victimhood through which communities constitute themselves on the margins of society. In a situation aggravated by the absence of the state, profound socio-economic problems and a growing anti-Semitism that feeds off the Palestinian conflict, restrictions on immigration from Algeria and the 'war on terror', these communities turn against each other. Laurent Herbiet states that *Mon Colonel* will not deflect attention from the real perpetrators of human rights abuses. The guilt of the political class and its allies is 'overwhelm-

ing' says Herbiet, who regards his colonel as little more than a means of enforcing a system put in place by state officials. Thus while *The Battle of Algiers* created an Arabo-Islamic community for which justice came in the form of the victory of the national liberation struggle, *Mon Colonel* seeks justice in the prosecution of the political leaders responsible for the conduct of the war. Finally, while *The Battle of Algiers* tends to reinforce the politics of group memory, *Mon Colonel* might serve to reconcile hostile communities by drawing attention to the role of the state and its officials. Only time will tell.

13

Raoul Peck's Lumumba: history or hagiography?

DAVID MOORE

C eci une histoire vrai – 'this is a true story' – is what viewers read a few min-utes into Raoul Peck's *Lumumba*,[1] in the bold authority that only print wields on film. Peck's claim is mostly accurate: the 'docu-drama' traces the rise and grisly fall of Patrice Lumumba (Eriq Ebouaney), the most short-lived and arguably most famous prime minister in Africa, with remarkable veracity. This truth needs little varnishing to be exciting enough for a feature-styled film, a combination of political thriller and 'Africa in the Cold War' history lesson with the Democratic Republic of Congo (DRC) at its centre. With a careful blend of narrative prescience and archival accuracy, *Lumumba* encompasses the six months of Lumumba's post-independence political life – and the few years before that, as he struggled for Congo's independence and his rise to power – skating on quite firm historical and film-making ice. Yet Peck's focus on Lumumba as an individual hero, rather than the meeting point of the socio-economic and politi-cal forces conditioning his existence and elimination, threatens to turn the film into the portrait of a saint rather than a complex political figure. In the process, the inevitable flaws the historian uncovers in the ethereal figure become magni-fied. When he crashes down to earth the causes in which he was embedded and for which he spoke can too easily become discredited as well, and the foundations of progressive historical construction must begin again. However, the opening of the space represented by this film – and shared with a number of similar cul-tural productions – indicates a wide re-thinking of Lumumba and his country's history. After a brief synopsis and historical contextualisation of *Lumumba* this chapter will discuss these themes and issues in depth.

David Moore

Synopsis

Lumumba is the political biography of a postal clerk and, later, beer salesman who in 1960 became prime minister of one of the biggest and most resource-endowed countries in Africa when its colonial master, Belgium, decided precipitately but ungenerously to untie its strings. The film begins and ends with variations on two scenes: in one, a severely tortured Lumumba is driven to his death while his voice utters philosophical projections about his role in and the future of Africa, he and two comrades are shot in the night-time woods by a firing squad, and Belgian soldiers chop, saw, dissolve and burn his corpse; in the other, hundreds of richly sated souls lull around a luscious feast at which, we discover at the end, Lumumba's usurper cynically proclaims a national holiday in Lumumba's name. Thus from the very beginning we know that there will be no surprises: we are watching the truth; we will not be shocked. However, the pace of events and Lumumba's magnetism when times are propitious make the audience live with the hopes of the present, forgetting his eventual fate.

The charismatic Patrice Lumumba is almost immediately transported from his humble beginnings to the heady days of pre-independence political jockeying, and just as quickly from rally-rousing induced imprisonment, to the Brussels Roundtable and the hammering out of the 'nation's' new constitution in early 1960. Seemingly faster, albeit more obscurely given the manoeuvring and the coalition-building necessitated by the Congo's many parties, he is nominated to the DRC's prime ministership by the new president, Joseph Kasa Vubu (Maka Kotto) after Lumumba's Mouvement National Congolais (MNC), the only really nationally oriented party amidst a panoply of particularistic ones, wins a plurality in the 15 June 1960 elections. However, quicker still, Lumumba's robust nationalism and thirst for social justice earns him the enmity of a host of local power contenders and world players: Moïse Tshombe (Pascal N'Zonzi) and the cold-blooded Godefroid Munongo (Dieudonné Kabongo), the two Katangese politicians who later, in co-operation with the Belgian government and mining corporations, try to secede their extraordinarily mineral-rich province, and later still preside over Lumumba's assassination; King Baudouin of Belgium, angered by Lumumba's passionate and unscheduled speech at the inauguration of independence on 30 June 1960 in response to the King's platitudes about the glories of Belgium's civilising mission and his warnings against too much reform; the American diplomats and spies who fear his dalliance with the Union of Soviet Socialist Republics (USSR) and the development of a Cuba in Africa; and Joseph Désiré Mobutu (Alex Descas), once his best friend and comrade, who when he

gains leadership of the armed forces becomes his enemy and the dictator in his wake.

After only two months, during which soldiers revolt over the continuation of Belgian control over the ranks and their lack of pay and promotion, Katanga secedes, Lumumba's and Mobutu's soldiers massacre hundreds of people in Kasai, and the USSR is asked to contribute planes and soldiers because the United Nations refused to allow its peace-keepers to bring Katanga back to the Congolese fold, Kasa Vubu removes Lumumba from his post. Days after that, Lumumba is placed under house arrest by his fair-weather friend Mobutu, who then carries out a 'peaceful revolution' – or coup – to ensure Lumumba does not return to power by the parliamentary road. In November, the ex-prime minister attempts escape to Stanleyville, his home town and the base for his diminishing support, but is foiled when he refuses to allow his wife and child to be beaten by Mobutu's troops while he canoes across the river to his freedom. By 17 January 1961 his enemies agree to fly Lumumba from his grimy jail to Katanga, where Tshombe, Munongo, and a coterie of Belgians torture and kill him and his two comrades.

As his body parts burn in an oil drum, he speaks from beyond the grave. 'History will have its say one day,' we hear. 'It won't be a history written in Brussels, Paris or Washington. It will be ours, the history of a new Africa.' As a match lights, we hear the film's last words: 'And on that day ...' Flames erupt from the barrel of acid that has been decomposing Lumumba's body. We are to imagine the revolutionary impact inspired by a truly African history. The two young and glowering soldiers who in the previous scene refuse to clap for Mobutu Sesé Seko Kuku Ngbendu Wa Za Banga (the all powerful warrior who goes from conquest to conquest, leaving fire in his wake) are, we suppose, the bearers of this new history.

———

Historical context

As Peck promised, the film is 'true'. There is little in this synopsis that history books do not confirm, aside from a collapsing of one demonstration into another and a few other 'historical inventions' that Rosenstone notes cinematically constrained narratives create.[2] As did seventeen other African countries, the Congo gained its independence in 1960. Belgium, however, being a late (and particularly brutal and hypocritical)[3] starter at the colonial game did not foresee this eventuality in decent time. It trained fewer candidates to be ruling or administrative cadres than did the other colonial powers, resulting in fewer *évolués* – including Lumumba – than its peers. However, its pace of mineral extraction and agri-

cultural commercialisation created an urbanised and partially proletarianised population rapidly,[4] and when some of the demonstrations and riots illustrated in *Lumumba* erupted, the Belgians decided to pull out as quickly as possible – hoping to retain economic and administrative control while pliant politicians enjoyed big cars and the other perquisites of power.

Lumumba was not as tractable as expected. His commitment to national unity rather than tribally based political structures and their federalist constitutional arrangements, and his Pan-African ideology, were worrisome to the colonialists who wanted independence to be just a 'word'. His assertion that the resources of his country would be used for the benefit of the Congolese sounded suspiciously like socialism, too. The Americans – the neo-colonialists hoping to gain strategic minerals from countries like the Congo (the uranium that bombed Hiroshima was from the DRC) and to keep them away from their Cold War enemy, the USSR – hoped to be able to spread their notion of democracy a little more enthusiastically than the jaded Europeans but were willing to dispense with it for their greater good.[5] Lumumba was a threat to all of these 'Western' interests, and seemed a bit unstable and impolite to boot; whether or not the imperialists were behind everything going wrong in the Congo (as Lumumba seemed to think) they were behind enough of it to make anyone suspicious. No Western power involved in Lumumba's Congo hesitated to let his local enemies – well contextualised in the film's discussion of ethnicity and regionalism – eliminate him, and indeed encouraged them heartily.

Thus the film is 'true'. Inasmuch as an extraordinary degree of the Congo's fate revolved around the solitary figure of Lumumba, and it is 'individuals' on which films focus best,[6] it is difficult to fault Peck for focusing so intently on the man of the moment. Indeed, the fact that Mobutu would prove to be one individual powerful enough to nearly destroy the whole country over the next thirty-five years also justifies zooming in on these two characters. Lumumba's mistaken appointment of Mobutu as head of the armed forces and his Shakespearian betrayal are confronted directly. *Lumumba* foreshadows Mobutu's corruption and collusion, which lasted until he was ousted in 1997 by an ostensible 'Lumumbaist', Laurent-Désiré Kabila with the help of Rwandan and Ugandan soldiers.[7] The young soldiers in the national holiday scene symbolise this – but the film, finished in 2000, could not predict what many observers say could only have been organised by the same people who erased Lumumba from history. Exactly forty years after Lumumba's murder, Kabila was assassinated by one of his bodyguards. His son Joseph rules in a manner more suited to 'good governance' dictums and economic management, yet the country is still best described as 'war-torn', even with elections due in mid-2006.[8]

Peck's closing states clearly that he hopes *Lumumba* will have an effect on

Africa's history: that although at present there is little evidence of Lumumba's prophecy coming true, films like this might hasten such eventualities. The film must be judged in this light. It is this chapter's contention that although the film is an important intervention in this process of making history, and individuals such as Lumumba invent history almost as much as they are invented by its conditions, unfortunately Peck focuses so much on Lumumba himself that the project of making history a *collective* endeavour is compromised. Hagiography, rather than history, does not a revolutionary cinema make.

Lumumba's focus on and sanctification of Patrice Lumumba tends to hide deep social and political forces structuring the agency of all political actors. As Rosenstone argues, it *is* possible to 'avoid the glorification of the individual' in a film: by not doing so, Peck has avoided the difficulties of what Rosenstone calls 'non-bourgeois modes of representation'.[9] To further complicate matters, Peck neglects important facets of Lumumba's biography, thus compromising even his individualised notion of the 'truth'. Because his film places so much weight on one man, if it misrepresents *any* aspect of Lumumba's life the film as a whole is in danger of collapsing. Saints, like giants, have a long way to fall. It does not take much, however, to start the tumble. Then they fall very quickly, and when they hit the ground the impact is very hard. A careful study of the bizarre world of the social and political contradictions surrounding him, however, would erase, or at least contextualise, the desire to create a complete hero and to craft his hagiography.

Two films, two ways of telling the truth

Lumumba is Peck's second film about the man with this name. The first is the experimentally styled *Lumumba: Death of the Prophet*.[10] It begins by challenging received notions of 'telling the truth' cinematically, as if in direct dialogue with Rosenstone's discussion.[11] *Death of the Prophet* is full of talking-head interviews with Lumumba's comrades, enemies and his daughter. Most contest the notion that either the news media or history can be free of bias. Our distrust of the notion of objectivity is compounded when Peck prefaces many controversial 'facts' with the phrase 'my mother told me ...', thus suggesting that history is reconstructed by significant others telling stories and weaving mythologies. When we learn that the newsreel footage of Mobutu's soldiers grabbing the captured Lumumba in the back of a pick-up truck cost £3 000 a minute, and that Peck did not film in the DRC because he discovered its secret service was 'very interested' in his project, the difficulties involved in producing history on

film are displayed. Viewers gain insight into the social and historical context of the film when we see 8 mm film memories of Peck's petty bourgeois childhood in the DRC's capital city, Leopoldville. There, his mother was secretary to many mayors and his father was a Haitian professor of agricultural sciences, brought over by the French in order to build some 'capacity' in an educational system ill-prepared for independence. When Peck suggests that he gained interest in Lumumba when his mother brought home a photograph of this Christ-like presence at an ominous press conference in her office, viewers are inducted into the inspiration of such works. Furthermore, the oddly pervasive presence of Belgian streets and passers-by, paralleled by ostentatious dinner parties counterpoised with the narrative of Lumumba's untimely and unthinkably cruel assassination, reminds us of the colonial complicity contextualising the politics of Lumumba's quick rise to, and quicker fall from, power. *Death of a Prophet* challenges notions of documentary truth at every turn: it contests the construction of history in a way Rosenstone would condone.

Lumumba's differences go beyond the fact that it is a 'docu-drama' with actors recreating their historical counterparts, resonant of both Shakespeare and Hollywood, instead of 'retired anarchists' reflecting on the surrealist qualities of political life in the Congo around 1960. The significant distinction is in the way the films contend with the 'truth'. *Death of the Prophet* challenges its genre's very foundations. Yet *Lumumba* claims it is 'a true story', challenging Rosenstone's warning about the confines of the narrative and the pitfalls of romantic – or tragic – cinematic constructions:[12] there are no self-conscious warnings about the tenuous nature of political history on film. 'Take it or leave it,' *Lumumba* says, and lots of lines lifted from archival records make the point that its 'data' rival any historian's. To be sure, *Lumumba*'s broad historical sweep can be faulted very little, and, almost as important for Rosenstone, its ideological slant is consistently progressive: *Lumumba*'s facts and interpretations are very close to the 'overall data and *meanings* of what we already know of the past' – if 'we' are broadly left-wing critics of colonial and neo-colonial actions on the periphery of the global capitalist system, sympathising with those trying to reverse their negative effects and to accentuate their good ones.[13]

Yet to claim the film is the 'truth' is impossible – especially when many truths are ignored in its singular pursuit. Of course, all of this is more difficult in Africa than it was in Rosenstone's Eisensteinian alternative: revolutionary Russia, where the 'group' – the revolutionary working class – could be presented as a progressive protagonist. In the DRC in 1960, the very nature of the social structure and the political process placed extraordinary power in the hands of the individual on its fragile pinnacle. Simultaneously, however, the pressures pulling at this power were so delicate that even if Lumumba *had* been a saint worthy of biblical por-

trayals, the 'right moves' were extremely elusive and the wrong groups too ready to move into the vacuums occasioned by the slightest of mistakes. Thus it is very important to analyse – and portray cinematically, if possible – the social forces constraining individual action in such situations. This chapter will attempt this, as well as discussing *Lumumba* in the context of the global cultural representations that have arisen in the wake of the DRC's consistent crisis.

Embezzling history: the man=masses myth

Lumumba bears a close relationship to Ludo de Witte's book *The Assassination of Lumumba*, the most thorough investigation of Lumumba's death to date. Indeed, Peck and de Witte have discussed the events represented in the film.[14] Perusing other history books also indicates affinity between *Lumumba* and 'the facts' professional historians – even those with a different ideological perspective from Peck – represent.[15] What could a sympathetic political historian find wrong with such a film? The key is in Peck's attempts to make Lumumba a complete hero, assuming that whatever Lumumba said and did was an automatic reflection of what everybody in the Congo really wanted. This has left Peck and his film open to criticism by anyone pursuing the historical texts on the DRC diligently, as well as those attempting to add class analysis to the picture. In this post-nationalist and post-modern age, 1960s tropes are inadequate to the task of reconstructing history and rebuilding Africa. This is not to say that nationalism and modernism should be thrown out with the dirty bathwater of their many failed projects, but to suggest that if filmmakers and other constructors of cultural artefacts do not add more nuance and context to their subjects, their audiences will respond with cynicism. The nationalist tendency to construct big heroes who are at one with the undifferentiated 'masses' will not wash anymore. *Lumumba* lets us down on that score.

Lumumba is definitely the hero in the film of his name. To make a myth of him, however, the audience must believe that if only the hero had lived, the Congo would be a much better place today. The audience does not get to know enough about Lumumba to know if this might be the case. It can easily find out, however, if the film slips in its efforts to tell us the truths of Lumumba as an *individual*, as well as his struggles in the context of a history setting whose conditions he did not choose. If films fail to tell all the truths, they do not take us beyond the cynical assertion that in the real world there are no heroes, but there are always people wanting to make them. Precisely because *Lumumba* focuses so much on an individual, its truth must take us to the intimate surfaces of the large

historical forces and the predictions of politicians and philosopher-kings – to the nitty-gritty of its 'hero's' life. *Lumumba* fails – ever so slightly – on that count, and so compromises the big picture too. It almost self-consciously falls short of admitting any fault in its hero. Thus, in addition to not countering the tendencies within 'Africanist' history to celebrate its mythmakers uncritically while blaming outside forces for the unhappy fate of its subject matter, it overly simplifies both the individual and the context.

Lumumba replicates the 'pan-Africanist' truth. The man was a hero undiminished by his death. Indeed, his assassination propelled him into a nationalist and pan-Third Worldist sainthood, as this bloody truth exemplified the nefarious machinations of the imperialists and their comprador lackeys in Katanga and beyond. As a restrained British analyst wrote only a few years after Lumumba's assassination, after his death 'the details of [his] character and actions had been forgotten and … he had been accepted purely and simply as the symbol of the African nationalist struggle … he was depicted by one half of the world as an inspired statesman leading his people against all odds.'[16]

Replete with nationalism – sovereignty's sacred texts – this image is fleshed out by the discourse of social justice and anti-imperialism. The heroism is contextualised well too, with the nuances of the Congo's ethnic contradictions and local power struggles merging intricately with the politics of the Cold War. Yet posing these epic truths as the only ones worth knowing is not enough – even within the bounds of a Shakespearian tragedy so self-conscious, the viewer begins to think the screen, not just the world, is a stage. Yet the small truths – including Lumumba's complex nature – affect the big ones, including the role of the United Nations in the crisis centring on the Congo and its new leader, because the film accepts Lumumba's 'word' as final. The film's own truth, then, is compromised by these lacunae. The devil is in the detail, and saints have very little in their way. The troubling specificities must be encountered, otherwise the portrayal of the hero becomes little more than propaganda.

The pervasive myth of African nationalism merges one political man and the masses. That it is hard to shake off in the Congo is illustrated not only by *Lumumba*, but also by the otherwise brilliant and detailed book *The Assassination of Lumumba*. De Witte too easily asserts that 'each time Lumumba spoke, it was basically the masses speaking'. He also implies that if another self-proclaimed Lumumbaist – Laurent-Désiré Kabila – had had his way, an 'authentically nationalist programme' would have been on the cards.[17]

Assuredly, as Guy Tillim's photography illustrates, the crowds lined up to salute Kabila as he marched across the border from Rwanda into Goma suggest that man and mass appeared to merge again in the DRC with his arrival.[18] But what to make of the thousands who came to Mobutu's beck and call, the worst

manifestation of that fusion? Michel Thierry's *Mobutu: King of Zaire*[19] – essential viewing, to be seen immediately after Peck's *Lumumba* – allows one to see just how perilous a too quick assertion of the man=masses equation is. Thierry shows thousands of 'masses' in awe of their leader, more so than those opposing his dictatorship or even looting following its demise. If the masses are presumed to be at one with their leader, it is just too easy for the leader to justify his every move as 'popular', as did Mobutu. How could such a being ever be accused of dictatorship?

When considering Lumumba's short career the question becomes: how could Mobutu's masses be the same as his? Mobutu did not have almost supernatural powers enabling him to pull the wool over their eyes. Nor did he simply dominate and terrorise them into fear. It is unlikely, too, that the masses all changed their minds in favour of the next leader – after Mobutu so cynically declared himself at one with the man he helped kill, by proclaiming a national holiday in his name. One must look beyond the myth that one leader – any leader – can speak for the masses, assimilating their 'collective consciousness' like sponges soak up water. For one thing, when one man – even a hero – is made synonymous with 'the masses', both lose complexity as well as freedom. As Jean-Paul Sartre – a Lumumba admirer as well as a fan of freedom – noted, individuals and 'the masses' are in a 'constant state of self-transformation and self-production' as one's self (either the leader or any individual within the 'mass') plays 'an active part within the masses as a conscious collection of individuals who make history': this is not a one-to-one relationship but a fusion of dialectical interactions.[20] The crude perspective also posits masses without classes (or tribes, genders or generations), and their leaders do not have problems – or 'pasts' – because they are at one with a perfectly righteous mass. However, the Congolese masses, just as in any heterogeneous social formation struggling to emerge within the bosom of a fragile 'nation-state', were and are replete with divisions and fissures. It should not be surprising if its leaders have problems and convoluted histories.

Lumumba only hints at a past every part-time historian knows about Lumumba. When Lumumba receives his visa allowing travel to Ghana, where he will meet the pan-African scions Kwame Nkrumah and Frantz Fanon, the sweating Belgian official says: 'You have a police record. And you hope to travel?' Lumumba answers: 'Yes.' That is it. The audience may wonder what record Lumumba had, but the official only alludes to connections in high places allowing Lumumba to travel. The scene stops there, with some doubt placed on Lumumba's radical credentials due to the possibility of friends in high colonial places. The amateur historian, however, will wonder why Lumumba's famous embezzlement case is left unsaid. The more accomplished student might wonder, too, why Lumumba receives permission to travel for the first time. In fact, he

had visited Belgium for a month in 1955 on a government tour, after meeting King Baudouin on the latter's Congolese trip.[21] Lumumba was already an *évolué* (before indicated in the film) and vice-president of the Belgian Liberal Party's Congolese branch, as well as the secretary-general of a non-Belgian union for civil servants. After meeting the King and visiting the metropole, he wrote a tract attempting an ideology for a Belgian–Congolese 'community,' with suffrage for literate Congolese. Therein he wrote: 'I believe that it would be possible, in the relatively near future, to grant political rights to the Congolese élite and to the Belgians of the Congo ... there would be no question of granting those rights to people who were unfit for them, to dull-witted illiterates; that would be to put dangerous weapons in the hands of children.'[22]

On his return he was arrested for embezzling some funds – 126,000 Belgian francs or about US$2 500[23] – from the post office, in which he worked as an accountant (not a mere clerk, as most biographies, and the film, assert; he had also lectured at an agricultural college). Nationalist accounts say Lumumba's motivation was 'political'.[24] Dayal, whose version seems most detailed – and who will return to this story – writes that Lumumba admitted to the theft, beginning to repay it before the police caught him.[25]

Why did Peck choose to ignore this story? He instead began the film when Lumumba arrives in Leopoldville from Stanleyville (now Kisangani), starting to sell beer and politics. Perhaps a few minutes of his first, less radical, career as a liberal and an embezzler (or, more kindly, an unauthorised borrower) would have detracted from the myth. However, a brief excursion into the story, and his first forays into the world of ideological prognostication, might have indicated the uncertainties of the novice philosopher-king during Africa's nationalist 'awakening'. It is doubtful that these blemishes would have cast shadows clouding the celluloid myth. Lumumba spent twelve months in prison for this misdemeanour: this seems a lengthy and 'political' sentence. Perhaps he was beaten there as in the film, where he was imprisoned for clearly political reasons, and from whence he was released for the very political reason of his invitation to the 'roundtable' in Brussels, garnered by the protests of his colleagues there negotiating independence. In any case, such an experience would be a formative one for a thirty-year-old man, worthy of inclusion in a 'true' film. Some of his frailty would have been exposed, and he could have been portrayed as a man who 'grew' with this experience.[26] The man who wrote *Is the Congo, That Land of the Future, under Threat?*,[27] would be young and unsure, on the verge of discovering nationalism, but still rooted in the ideologies of gradual assimilation.

Yet half a decade later, even at his most radical, Lumumba could not transcend his class belonging. As Sartre puts it, even Lumumba's nationalism – at the time the most advanced in the country – was marred by a too recent history of

'universalisation'. The MNC's 'composition … soon revealed its nature: it was universalist beyond ethnic groups and frontiers because its active members were people who had been universalised; in short, it was the movement of the *évolués*'.[28] Lumumba's dream of a huge party embracing everyone was still-born; in Sartre's poignant words, 'No one was to blame: it could not be any other way. The MNC was the Congolese petty bourgeoisie in the process of discovering its class ideology.'[29] Yet even Sartre was too optimistic at this point: it was not long after the MNC's birth in 1959 when an MNC faction split off its edges in Lumumba's home area. The petty bourgeoisie about to inherit the whole of the Congo from the colonialists was far from nationalist; indeed, it was closer to the venality indicated by Lumumba's embezzlement, and it was too eagerly following the lines of ethnicity and region to create a national project.[30]

The point is not that Lumumba's brush with the law tarnished him forever (although it may have left deep scars) but that this incident indicates the temptations of his class. The point *is* that he transcended the embezzlement mode of class accumulation and other forms of corruption. It is also that he believed the rest of his class – and all of the Congo's 'patriotic elements' – could be persuaded by his reasonable logic to pursue his more rigorous path. If Sartre was correct to say Lumumba was 'clear-sighted and blind at the same time', the less philosophical Hoskyns was also right suggesting this broad yet too focused vision of national unity went over the heads of his class peers. He did not even see them, and most of them failed to see his vision. Thus he was seen increasingly as a 'one-man show' by both 'national' and 'tribal' leaders.[31] He was, as Sartre puts it, a 'Jacobin universalist' remaining too much within his class even as he turned away from it. The 'masses' were rebelling against their new rulers – Lumumba's class – and the new rulers were turning against Lumumba as they pursued their own fiefdoms (some of them very feudal: Munongo, Tshombe's wicked henchman portrayed so precisely in the film, was the son and brother of chiefs, and wanted nothing so much as a restoration of these modes of 'traditional', but colonially mediated, power.)[32] Yet for Sartre, Lumumba did not make clear enough alliances with the subaltern classes, either: many rebelled against him too.[33]

We are returned to the problem of the man=masses myth. As Sartre continues, Lumumba 'looked upon himself as a guide, believing himself to be classless, and refusing, in his centralising zeal, to take differences of economic origin any more seriously than tribal divisions: the single Party would break down these and other barriers, and reconcile all interests.'[34] Would this have led to some sort of socialism, thus validating many of his opposition's – and certainly the West's – accusations of 'communism'? Sartre hoped yes, but feared no. Only

> the most astute of the parliamentarians and ministers … feared … his
> Jacobinism would end in socialism by virtue of his unitary humanism.

The important thing ... was that he placed his class in power and then set about governing against it. Could it have been any different? No: during the last days of colonisation, the proletariat did not do a single thing that would have made these petty bourgeois accept it as a valid interlocutor.[35]

How might Raoul Peck have portrayed such issues? Margarethe von Trotta's biographical film of Rosa Luxemburg illustrates such serious theoretical discussions at dinner parties and ballroom dances, inside newspaper offices, during general strikes and in prison letters.[36] Aside from Thomas Kanza and Maurice Mpolo – the first a voice of moderation and the latter, assassinated along with Lumumba, a spur to more radical action – there is not much strategic and ideological debate among Lumumba's stalwarts in *Lumumba*. This may well be, of course, because he did not have many unfaltering allies. The story of Mobutu, his Judas, is more to the point, as are the angry encounters with his enemies Tshombe and Munongo in Leopoldville's bars and dance-floors, and the stilted exchanges with the shifty Kasa Vubu. How could Peck have exposed these complex debates? He might have projected ghostly images of Sartre and Frantz Fanon in conversations, exposing the politicians' and soldiers' class roots with socio-political clarity and debating the merits of violence and non-violence.[37] Such scenes could have followed from the meeting with Fanon at the famous 1958 pan-African meeting in Accra, perhaps continuing with Fanon and Sartre discussing Lumumba. The importance of the Congo for the emerging 'Third World' – and the Western left's role in it – could have been thus indicated.

Another instance of Peck's avoidance tactics might also have been addressed in such a fashion. It is related to the pride of a man who once wrote that those he thought were no better than 'children' did not deserve the rights of political participation. In August 1960, just weeks before Kasa Vubu stripped Lumumba of his prime ministership, Hoskyns reports that Lumumba banned any associations formed without government approval, as well as 'any journal publishing material liable to bring the Government into disrepect'.[38] By the middle of the month – just as he decided to wage war against the secessionist Katanga and Kasai, bringing in the Soviet-supplied trucks and planes and thus the knife-edge politics of the Cold War – a state of emergency was declared. Lumumba also called an All-Africa conference at this time to garner support for his battles, but given his absence from Leopoldville (he had gone to Stanleyville to gather support for his war against Tshombe and Kalonji) and the fact that foreign photographers taking pictures of crowds with anti-Lumumba banners had their cameras seized,[39] that succour was hard to gain. Without exposing these issues to debate, viewers and students are deprived of the chance to consider the merits of the rights to freedom of association and expression when a régime is on its last legs, or even under attack.[40]

Viewers only learn of the war Lumumba started against the breakaway province of Katanga in the scene where Lumumba and Mobutu part. While Lumumba's daughter amuses the photographer taking pictures of the prime minister for hanging in government offices (as in Peck's mother's office in *Death of the Prophet*), Lumumba harangues Mobutu for massacring over 200 people at a Kasai mission. The audience is unsure about the nature of this war, and the actual culpability of Mobutu for the act Lumumba is portrayed as saying will lead to United Nations' accusations of genocide. Hoskyns tells us about the slaughter, which was hardly all of Mobutu's doing: sending troops to battle with no food supplies is hardly conducive to soldiers acting with 'honour',[41] and Lumumba bears some blame for that.[42] But in this scene, Mobutu takes the responsibility and reproach, while Lumumba – coming close to accusing Mobutu of allowing the killings to take place in order to discredit Lumumba – is the one who ends the friendship. Almost contextless, we are subject to the most Shakespearian moment in *Lumumba*: after his dressing-down Mobutu departs in a very angry and resentful mood. Thenceforth we see him sneaking to meetings with the equally devious American ambassador, Clare Timberlake (who, we are told elsewhere, liked to call the young prime minister 'Lumumbavitch', emphasising his supposedly Soviet leanings.)[43] It is not long until Mobutu carries out his coup – a 'peaceful revolution', he claimed, ostensibly to bring the warring Kasa Vubu and Lumumba back together again. Was the parting really so sudden?

Death of the Prophet handles this differently. In it, Peck interviews the Polish-born Frenchman Serge Michel, on loan from the Algerian Front for National Liberation as a press attaché to Lumumba, giving the 'Western' powers reason to believe the Congolese prime minister had 'communist advisors'.[44] Michel offers a perfect scene to a filmmaker pursuing a more nuanced – and chaotic – portrayal of Lumumba's and Mobutu's conflict:

Mobutu was with us until the end. He spent his days with us. He ate with us, but mostly he drank ... One evening Mobutu was late for the evening meal ... He was moaning; he'd already drunk a lot ... Lumumba was seated ... with two or three others, working. It was nearly midnight. Mobutu gets up and says he's going and Lumumba tells him to go to bed. So he leaves, then returns straight away ... 'I need some champagne. I'm going to celebrate.' Lumumba says: 'You're annoying us. It's in the kitchen, serve yourself.' He takes a magnum of champagne. Three-quarters of an hour later, he returns with some soldiers and says, completely drunk: 'I arrest you in the name of the people'. Lumumba stands up, takes him by the shoulders, turning him around and says: 'Go to bed.' And he did. This was the first failed coup attempt. This is to show you just what point these people had reached.

Michel also wrote of Lumumba's and his colleagues' state of mind at this conjuncture.[45] According to Michel, Lumumba was able to continue to function amidst such pressure 'partly by his own fantastic energy ... and partly by his almost mystical belief in himself and the role he was destined to play in the Congo'. His office was 'in complete confusion with newspapers, documents, files and letters piling up'. All sorts of people, some he hardly knew, arrived at all times 'to talk, drink, and propose wild schemes; very few came to work and when Lumumba wanted something typed he often had to do it himself'. Lumumba's group had no good intelligence: they could not tell who were informers, secret police or even party members. Thus they became paranoid. Lumumba was 'highly nervous', found it 'difficult to concentrate or consider any subject in detail', and many thought he was using drugs. In *Lumumba* there is one scene, just after Mobutu's 'peaceful revolution', with empty champagne bottles beside Lumumba's typewriter; we know he was tired because he tells his daughter so, and we learn there may have been suspicions about him smoking hemp because his wife teasingly tells him this is why the servants say he can do with so little sleep. As for the 'almost mystical belief in himself and the role he was destined to play in the Congo', viewers do see him tell his wife to look after the children well when he is gone, and hear the letters he composed to be read after his death. The film offers us slightly sanitised visions of a man who appeared to know he would die, but also would say: 'the Congo made me, I shall make the Congo'. Thus the man=masses equation arises again. To follow the consequences of the elision, one must attempt to see how the 'one-man show' affected the efforts of international actors and institutions, as well as its cultural representations, at the time of – and after – his rise and fall.

The art and the politics of man, masses and international institutions
The relationship of the Congo to the aspects of cultural production concerning critical moments in global history is uncanny.[46] From Joseph Conrad's *Heart of Darkness* at the turn of the 19th century to Barbara Kingsolver's bizarre but best-selling *The Poisonwood Bible* just a year short of a century later,[47] the Congo has figured large in cultural representations of Africa's crucial transformations. Conrad's multi-layered novel – considered by some to be racist but by others to indict colonialism and imperialism[48] – was written as the colonial moment and the *belle époque* of global capitalism were reaching their heights.[49] The Congo was at the heart of these upheavals, during which, as Polanyi put it, the peoples in the periphery could not protect themselves against the 'ravaging international trade and imperialism' destroying 'precapitalist communities of kinship, neighbourhood, profession and creed ... all forms of indigenous, organic society'.[50] It was also at the centre of E.D. Morel's precursor of Amnesty International-like

human rights organisations: his campaign to eradicate King Leopold's horrendous crimes gained wide global support and shamed Britain's parliament into commissioning a report leading to Leopold abdicating his personal fiefdom to the Congolese state.[51] As the 20th century came to a close and 'globalisation' reached new heights, creating particularly brutal contradictions in Africa's heart once again, novelists, filmmakers and popular historians chose to concentrate on events of a century ago and the moment when the Cold War met the birth of the 'Third World'.[52] Adam Hochschild's enormously successful and influential revisiting of Leopold's travesty of the 'civilising mission'[53] appeared in 1998, as did Kingsolver's magical post-modernist creation. Ronan Bennett's sizzling social-realist portrayal of the Lumumba moment was published just the year before that.[54] Peck's *Lumumba* is in good company.[55]

Yet unlike these other artefacts portraying the Congo's insertion at the centre of the world's storms, when addressing the *realpolitik* of international relations Peck's film seems glib. The links between the mining companies, the United States, Belgium and especially the United Nations are all too tight in the film to be completely convincing. More precisely, the links are assumed rather than demonstrated, and since the only personality encountered in any depth is Lumumba, we do not gain an understanding of other global actors' motivations. We see little of the interactions between Lumumba and the representatives of these various international forces: with the Belgian ambassador, self-righteous indignation; with Timberlake, contemptuous dismissal; with the United Nations (never dignified with a personal envoy to the film), a verbal waving of the hand as the USA's lackey, worth no more than a couple of lines of dialogue. These mini-scenes just might be Peck's way of saying that Lumumba was too impatient for his own good, but it is Lumumba's self-righteousness in the face of imperial onslaught that leaves its mark. Perhaps, just as Sartre said Lumumba forgot about the real class nature of the ruling group in which he was embedded, he also ignored the characteristics and contradictions of the *global* class that he had just joined. To be sure, as many observers say, he was 'not a communist', but he did misread the nature of the Cold War. He did not foresee the consequences of a plea for assistance from the Soviet Union.[56]

Most obvious by its near absence is the film's dismissal of the United Nations.[57] If indeed Lumumba and Dag Hammarskjöld, the Secretary-General of the UN, hit it off as badly as observers say, and this led to the latter allowing Lumumba to meander to his death so easily, then the film missed a golden opportunity to illustrate how personality clashes of such a high order can have terrible consequences. If the issues were to be understood in terms of how the Republican foreign policy-making network in the United States manipulated the United Nations and just about every other actor involved to clear Lumumba

from the scene before a more 'Third World'-friendly John F. Kennedy took the fruits of the election he was about to win, then the film has failed us on that count too.[58] No matter, it seems clear that the United Nations and its Secretary-General's attempts to be 'neutralist' involved more contradictions than the film allows. In the scenes, for example, in which Lumumba, Mpolo and Okito are arrested during their escape attempt and their disembarking in Katanga, we see no United Nations troops. But Ghanaian UN troops wanted to stop the arrest by Mobutu's soldiers, and there was a UN contingent at the 'non-Katanga' section of the airport able to observe the landing on the day of Lumumba's death. Conor Cruise O'Brien's dramatisation shows how the contradictions of such moments could be illustrated. *Murderous Angels* has the theatrical equivalent of Dayal, the Indian head of the UN Mission, call Hammarskjöld and ask permission for the UN troops to intervene at Lumumba's arrest to save him from certain death. That permission is denied in reality and in the play. O'Brien puts the blame squarely at Hammarskjöld's feet.[59] O'Brien neither plays to the personality clash thesis, nor does he posit Hammarskjöld as the USA's puppet. Rather, his play situates both Lumumba and Hammarskjöld as caught between the two huge abstractions of 'freedom' and 'peace', only one of which could win in the Congo of the Cold War, and either of which meant the lost lives of a few people in various stations of life. Peck, however, does not consider views other than Lumumba's: a fuller array of characters would have helped to flesh out imperialism's skeletal bones.

Even a look at a representative of the most evil of empire builders might have helped viewers understand the heights of the ideological stakes around Lumumba. Assertions of cynical manipulation alone gain no insights into the motivations of quiet Americans all over the place. Ronan Bennett's *The Catastrophist* – a novel with almost as much reality on the side of its fiction as *Lumumba's* 'true story' – gives readers a closely drawn picture of the CIA man on the spot, 'Mark Stipes'. Bennett's amalgam of such sometimes rather noisy Americans presents his ideological justification for turning against Lumumba as the novel's protagonist, James Gillespie, questions him. Gillespie has spent the night being tortured by Mobutu's henchmen with Stipes's full knowledge: they are still in the prison, beside the brutally battered corpse of a mutual acquaintance.[60] Stipes is asked what he is doing in the Congo.

'I'm trying to make this country a safe place.'

'Safe for who?'

'People like you.'

'Leave me out of it.'

'You always want to be left out of things, Gillespie,' he says scornfully, 'but you're involved in this. I don't mean just because you have connections with the people we're looking for. You're involved the same way we're all

involved. People like you don't like the dirty games people like me play, but you benefit every time we play and win. You won't admit it, you'd probably deny it even to yourself, but you want me to win, because if I lose, then so do you. You lose everything. All your privileges. Writing, publishing, journalism – to mention only the things of particular interest to you – they're only possible in a certain context, and my job is to make sure that context continues to exist.' ...

'What am I doing here in this country? I am making sure that the biggest and richest country in central Africa – one with huge strategic importance – doesn't fall into the hands of the people who want to destroy our context.'[61]

Thus is portrayed the ideological zeal of the people who brought Lumumba down: this is something bigger than the Cold War for power and territory; it is for the 'context' to pursue the freedom novelists and journalists – and all for whom they write, and academics teach – enjoy in liberal democratic societies.[62] In their minds, at least, it is more than filling the tanks of American SUVs, and grabbing the uranium for the bombs to guard them. Unless people such as Stipes are suffering from ideological illusions, it is about a tenuous balance between untrammelled and fettered power.[63] Such fervour, if brought to colour in *Lumumba*'s not insignificant shades between black and white, would not likely dampen the viewers' support for the film's hero or, more importantly, confuse the issues on which Peck was focusing. At the very least, delving into such other perspectives would have encouraged even more debate on the issues the film raises so very well. The questions of the morality of Western (or imperialist) 'intervention' in the name of 'democracy' in the sovereign affairs of 'developing' nation-states, especially democratically constructed ones (as Lumumba's Congo, although shaky, was) are still burning today, long after the wane of the 'Soviet threat' that justified American and Western European imperial acts[64] – not least in the Democratic Republic of Congo, still suffering in the wake of Lumumba's tragic death.

Lumumba must be heralded for its uncompromising examination of the execution of such interventions at their crudest, even though its hero worship threatens to make a saint out of a very human politician. Lumumba was made angelic only by the inhumanity of those believing they needed him out of the way, and who had the power to carry that ill-considered thought to reality. It does not take much to add on a few human foibles to a man many make a hero. At the end of the day, that *Lumumba* serves to create the public space for more people to make the historical and political examinations necessary to turn *all* powerholders into fallible humans speaks well for a film that is in all other respects a powerful addition to its genre.

14

Flame *and the historiography of armed struggle in Zimbabwe*

⁓

TERESA BARNES

Our Country of Zimbabwe
That's where we were born
Our Fathers and our Mothers
That's where they come from
We love Zimbabwe
With all her riches
Arise Zimbabwe

Zimbabwe
We love Zimbabwe
We love Freedom
We love our Country
Her day has now come

… Give us wisdom in Zimbabwe
War
We want war in Zimbabwe
Give us mysterious powers
Her day has now come.[1]

A brief synopsis of *Flame*

Rhodesia, 1975.[2] Two rural girls, best friends, Florence and Nyasha, decide to leave their village and cross the border into Mozambique, to join the liberation struggle: armed forces fighting for majority rule in Rhodesia. The immediate impetus for their decision is the arrest, by the Rhodesian forces, of

Florence's father who was falsely accused of supporting the struggle by the local shopkeeper. Florence and Nyasha walk eastward day and night through the bush until they cross a river that marks the boundary with Mozambique (recently liberated after its own armed struggle against the Portuguese). They are found and taken in by the ZANLA[3] forces. In the ZANLA camp, they choose war aliases – *Chimurenga*[4] names: Florence becomes Comrade Flame; Nyasha becomes Comrade Liberty. Flame, who has always had an eye for handsome young men, is courted by Comrade Danger, a guerrilla leader. The young women adjust to the difficult life in the camp. One night Flame is raped by a guerrilla officer, Comrade Che. He later apologises to her and she forgives him. They have a child, but the baby and Che are killed in an air raid. Meanwhile, Nyasha has been training herself to type and to work in the media section of the struggle. After Che and the baby are killed, Flame transforms into a grim, uncompromising battalion leader. On one foray she returns to her village and burns down the store of the man who betrayed her father, but she lets the collaborator himself live. The end of the war finds Flame advancing through Rhodesian territory with the troops in her command. After the war she links up with Comrade Danger and returns to a rural life of peasant womanhood. Only Danger's gradual degeneration into drunkenness pushes her to the city to find her old friend Nyasha and ask for her assistance. Nyasha has a smart office job and is shocked to see her old friend on her doorstep after 15 years. Nyasha initially does not respond but the two old friends are eventually reunited. Florence finds a programme for rural women that holds some possibilities. The last scene of the film is a reunion of old comrades from the struggle days, sharing beer in a small flat, singing the good old songs of struggle and watching the annual Independence Day celebrations on TV. 'Aren't we heroes?' Florence pensively, and then laughingly, asks Nyasha.

Rhodesia: 1890 – Zimbabwe: 1980

The land between the Limpopo and Zambezi rivers, a central north-east by south-west spine of a high plateau sloping down to the rivers, was peopled by settled agriculturalists and some city-builders (in earlier epochs) for many centuries before colonialists arrived at the end of the 19th century. By the 19th century, however, the era of great building and large settlements had long passed, and the Shona and Ndebele peoples lived lives of cattle-raising, subsistence agriculture and trade, both forced and voluntary. A handful of missionaries joined this mix in the mid-19th century, foreshadowing the great invasions of white settlers that came from the south in the 1890s.

Seeking wealth equivalent to that found in the fabulous gold fields of the Witwatersrand in South Africa, these settlers, mercenaries and their servants indiscriminately claimed local land and labour. The settlers named the land Rhodesia, in honour of the arch-imperialist and their inspiration, Cecil John Rhodes. But they found only scattered gold deposits and land which was mainly drought-prone with a few scattered excellent agricultural areas. These areas were quickly allocated to white farmers, miners and commercial syndicates, while Africans were forcibly dispossessed and forced into less agriculturally suitable 'reserves.' The Shona and Ndebele rose up in tandem against these settlers between 1896 and 1897 in the first Chimurenga, but were soundly defeated. The 20th century saw the settlers' swift imposition of British colonial laws, institutions and material extractions on a defeated people. The settlers hoped to carve a 'white man's country' out of the 'bush'; but despite a host of preferential policies, their economic hopes and dreams really only came true during and after World War Two, when Britain badly needed the crops (tobacco) and minerals (chrome) that only her remaining colonies could provide. From that point until the civil war or liberation struggle began to bite in the 1970s, the majority of the white population of Rhodesia enjoyed a lifestyle practically second to none: material ease and a plentiful supply of servants under the warm African sun.[5]

The settlers set up a state founded on and dedicated to the perpetuation of racial discrimination in all walks of life. Health care and education for the African majority were next to non-existent. By the 1960s, the social and political organisations of the majority of the population had tried and discarded the politics of petition and negotiation in an effort to gain civil and economic rights in the land of their birth. They resorted to armed struggle again with the second Chimurenga beginning in 1967. The struggle ended with a British-brokered peace settlement in 1979, and the first democratic national elections in 1980.

The conduct of the armies of liberation – the guerrilla forces – in relation to women in their ranks, as well as to other social groups in war-time Rhodesia – is the subject of the film *Flame* and of this chapter.

~

Flame's genesis and reception

Flame, released in 1996, was the sixth large-scale film made in Zimbabwe after Independence. The new nation had had an interesting but distinctly uneven experience with filmmaking. The government bankrolled an awful Hollywood production of *King Solomon's Mines* in 1985. The film was a flop and the government lost millions of its investment. Other films shot in Zimbabwe included *Cry*

Freedom and A Dry White Season (about apartheid South Africa – see the chapter in this volume by Bickford-Smith), Consequences, Jit, and an alternative film, Neria, in 1991.

Flame was produced by Ingrid Sinclair, Simon Bright and Joel Phiri, all of whom have subsequently remained active in film production.[6] The cast consists of Zimbabwean actors; for some it was their first time in front of the camera.[7] Flame was funded by the European Union, a French development fund, as well as the Rotterdam Film Festival. Sinclair, the film's director, is a white Briton who was a Zimbabwean resident at the time of the film's genesis. Her motivation in making the film was to give a voice and presence to the voiceless:

I want to make FLAME because the stories of these women have never been told. It's a tribute to their bravery, and also a reminder of how strong they really are. They must use their strength to push themselves forward. No government and no society is going to give them what they want. They must take it for themselves. And behind their stories lies a universal theme that women everywhere recognise – the fight for independence, and then the isolation and disregard and suppression that follows. It's time to show African women in a universal light. They're shown as victims, courageously struggling, imbued with wisdom of the earth. Born to die as slaves of circumstance. In other words, different from women in developed countries. I want to go beyond difference to show similarities: their loves and hopes, their failings, their stubbornness, their vanity, even their cruelty – women as full human beings with every nuance and shade of emotion.[8]

Flame was widely released on the international film-festival circuit in 1996 and 1997 and won a number of prizes. Its controversial treatment by the Zimbabwean authorities before its release (rushes were seized after complaints from the War Veterans' Association but were handed back to the director after a week) ironically served mainly to give the film international notoriety and publicity. It was thus described on the California Newsreel website as 'perhaps the most controversial film ever made in Africa'.[9] It was selected for the Directors' Fortnight at Cannes in 1996; one reviewer noted, 'the applause for this film was the loudest at Cannes'.[10] It won awards at festivals in Zimbabwe, South Africa, Tunisia, France, Italy and the United States, including the Nestor Almendros Prize at The Human Rights Watch International Film Festival in New York in 1997. Flame was shown commercially in Zimbabwe and was quite successful, 'breaking box office records' for a local film.[11]

Flame is a realistic drama, visually low-key and without grand Hollywood flourishes; its straightforward style and pace gradually reveal a difficult story with surprising subtlety. The film's retelling of the nationalist canon – as paraphrased

in the song lyrics at the beginning of this chapter – constantly evokes history. The opening sequence of the film is a series of historical photographs – icons of Zimbabwean history: Cecil John Rhodes; a pioneer ox-wagon struggling across a flooded river; the female spirit medium Mbuya Nehanda captured in 1897; a banner proclaiming 'Advance Rhodesia' adorning one of the colony's first trains; and many decades later, a guerrilla in the bush reaching out a helping hand to a child with a delighted and admiring peasant standing by. From the photographs, the action then segues into Florence looking over her own collection of photographs. The message is clear: the anti-Rhodesian, anti-colonial struggle was undoubtedly legitimate – and the story which will follow in the film receives its authenticity from the history of that struggle.

But *Flame* is not merely a simplistic retelling of the familiar narrative of nationalist struggle in Africa. It is a deceptively complex production: firmly situated in a strong nationalist perspective on the Zimbabwean liberation struggle, it simultaneously challenges the core tenets of that same narrative. *Flame* was one of the first productions, academic or otherwise, to do so. In Rosenstone's terms, there is really no reason to differentiate between *Flame* as a film and as a piece of conventional historiography.[12] It is, as will be shown in this chapter, firmly situated in a developing narrative of the armed struggle in Zimbabwe, as were many other more conventional productions, which were also based on oral history research. It has had a huge impact on public consciousness and women's studies in Africa; as such it deserves to be taken as seriously as any other historical production.

The controversy generated by *Flame*'s bold attack on the idiom of the benevolent guerrilla has ensured that the film lives on as an historical artefact in itself – sometimes inaccurately described as a victim of censorship. For example, a discussion of the treatment of women combatants during South Africa's liberation struggle in the ANC camps incorrectly states:

We have not attempted to research the male gendered constructions developed within the liberation armies and the methods used to ensure conformity and compliance … When issues of sexual abuse surface … they are often censored. The issue of censorship also came up in Zimbabwe where *Flame*, a film that highlights abuse of women guerrillas, was censored.[13]

Armed and legitimate: narrative and counter-narrative

In the 1970s and 1980s, the Rhodesians portrayed members of the armies it was fighting as mindless, destructive, greedy 'terrorists'. The following quotation dis-

plays the easy contempt of the vast majority of white Rhodesians for the African population and the guerrillas.

> We soon became familiar with the ZANLA terrorist system of infiltrating and subverting an area. Political commissars accompanied by a small group would move through a tribal area calling the people to meetings where they would explain they were sons of Zimbabwe, who had volunteered to fight against the evil system of Government imposed upon the indigenous African people by the European, supported by puppets in the form of African government servants, soldiers, policemen and so on ... It was the old and easy call for revolution. The attractive call to the unsophisticated and poor have-nots to grab and make over to their use the property and possessions of the haves. The call to re-distribute wealth ... to take it from those who would increase it, as in the biblical parable of the talents ... and hand it to those who would do no more than consume it ... in the same rapacious manner as a donkey eating carrots.[14]

The post-1980 historiography of independent Zimbabwe rushed to set this record straight. Combatants were 'comrades', '*vakomana* – the boys' or 'guerrillas' – not terrorists.

In considering the context of the development of new war narratives for independent Zimbabwe, it should be remembered that this was an issue with many supra-national overtones. Southern Africa in the late 1970s and early 1980s was, among other things, a Cold War battleground. Portraying the liberation fighters as legitimate combatants was simultaneously an act of defiance against the local settler/colonial powers – such as Rhodesia and metropolitan Portugal – and the powerful backers of colonial rule: the United States, Britain, France. Thus, the overwhelming emphasis in the first wave of studies of the Zimbabwean liberation war – and others – was to provide convincing arguments for the violence and disruption of wars of liberation on the African continent and for the correctness of the decisions taken across the continent to wage armed struggle. This argument hinged powerfully on the portrayal of liberation fighters as morally superior to the settler/colonial forces against whom they fought. If 'just war' was superior to 'unjust war', then the prosecutors of just war had themselves by definition to be superior to their adversaries.

Another contextual element of the Zimbabwean liberation struggle, and an aspect of civilian–guerrilla relations that needs to be mentioned, was the differing levels of prior politicisation of rural populations and the correspondingly different methods of political mobilisation adopted by the two guerrilla armies. The first nationalist organisation in Southern Rhodesia, the Zimbabwe African People's Union (ZAPU), developed in the early 1960s as a nationalist organisation with party members and organised branches, especially in the southern,

western and central parts of the country. When the Zimbabwe African National Union (ZANU) was formed following a split from ZAPU in 1963, its leaders – most of whom hailed from the north and east of the country – went into exile without any pre-existing rural structures behind them. According to Alexander, McGregor and Ranger, when ZIPRA[15] combatants 'returned' to Rhodesia to fight, they had the advantage of being able to make contact with substantial networks of the 'old ZAPU' party members who were already well versed in the arguments for nationalist struggle.[16] ZANLA, on the other hand, operated in regions of the country where this advantage did not exist, or at least not to the same extent. They were therefore obliged to develop techniques designed to provide a rationale for the peasantry to support and take considerable risks for the guerrillas. They developed all-night political meetings, called *pungwes*, for immediate political teaching and mobilisation. It is important to mention these differences between the liberation armies because although *Flame* portrays a ZANLA-type narrative, there were other histories and experiences in the Zimbabwean liberation struggle that should not be overlooked.

There have been two markers of social legitimacy in post-Independence Zimbabwean historiography. The first is the degree to which guerrillas worked harmoniously with the rural population of Zimbabwe: did they behave courteously and helpfully? The second is the kind of treatment received by women who were members of the guerrilla forces: was it equal, and non-abusive? On all of these counts, the mainstream historiography delivers a resounding 'yes'. The guerrillas, according to the nationalist narrative, were welcomed, protected and supported by rural people. Secondly, women were treated appropriately during the war. The rest of this section will examine the development of these two historical arguments, so that we can see *Flame* in this context.

The first major historical study of the liberation war, written by David Martin and Phyllis Johnson, although focusing mainly on struggle leaders and political history, took practically for granted that the guerrillas 'enjoyed a [high] level of support amongst the villagers at a time when Rhodesian politicians were claiming support for them had ceased.'[17] Julie Frederickse's *None but Ourselves*, also published soon after Independence and widely read in Zimbabwe, went into considerable detail about atrocities committed by the Rhodesian forces but included nothing about any alleged guerrilla excesses. Rather, it simply quotes an issue of *Zimbabwe News*, published by ZANU in exile in 1978:

> The three main rules of discipline and nine points of attention are as follows:
> 1. Obey all orders in all your actions.
> 2. Do not take a single needle or piece of thread from the masses.
> 3. Turn in everything captured.

The nine points of attention:
1. Speak politely.
2. Pay fairly for what you buy.
3. Return everything you borrow.
4. Pay for everything you damage.
5. Do not hit or swear at people.
6. Do not damage crops.
7. Do not take liberty with men.
8. Do not take liberty with women.
9. Do not ill-treat captives.[18]

Terence Ranger's *Peasant Consciousness and Guerrilla War in Zimbabwe*, published in 1985, represents the war, fought almost exclusively in the rural areas, as a high stage in peasant consciousness. There was a seamless transition from 'rural peasant radicalism' to active support for the struggle and for the guerrillas. The only discussion of guerrilla violence against indigenous targets is situated in his discussion of class-based violence, i.e. guerrillas acting against petty bourgeois elements in the rural areas such as shopkeepers and mill owners. Ranger portrays the guerrillas and the rural population as practically one and the same. There is no other suggestion of any acts by guerrillas that could erode their legitimacy or their status as liberators.

The central premise of *Guns and Rain* by David Lan, published in 1985, is the close connection which developed between spirit mediums, the guerrillas and the people, and how ZANLA guerrillas both symbolically and physically put on the mantle of the cause of the ancestors: regaining the lands lost in the 1896–97 Chimurenga. This narrative is so powerfully written that it completely overshadows what in hindsight seem to be clear examples of guerrilla violence against civilians. For example, in a description of the hardships faced by villagers who fled into the bush with their children from war-torn villages:

> The parents began to cry and we [young people who had pledged to support the guerrillas] said: you must be brave like we are. The parents asked for food. We said: Do you think we grow anything while we are in the bush? They [the guerrillas] took bamboo shoots and gave them to the children. One woman complained: Do you call that food? And the comrade said: Woman, do you want to stay alive? And she kept quiet. Then she began to speak softly. She said: We people, we are now wild animals. Our children are now wild animals. Do you think we shall ever go back home and grow crops? And she began to cry again.[19]

Information like this was only seen in the mid-1980s as a small aberrant island that could be safely ignored in an ocean of nationalist heroism. The extent to which Zimbabwean historiography of the 1980s created a monolithic narrative,[20]

inter alia of the guerrilla as 'servant of the people', cannot be overemphasised. Even Andre Astrow's widely read 1983 critique of the class politics of the liberation struggle maintained the narrative of the alliance between radical peasants and guerrillas, who enjoyed 'considerable support' from the rural population.[21] A much smaller, but influential, literature developed in the mid-1980s of the wartime reminiscences of white Rhodesian soldiers. Ironically, whether in tones of regret for wartime atrocities or for the lost Rhodesian 'ideal,' these books perpetuated a new discourse of soldier misconduct during the war as a matter exclusively relating to the Rhodesian forces.[22]

It is important to note that by the late 1990s, Zimbabwean nationalist historiography had developed a minority of narratives of anti-colonial struggle that acknowledged and examined rural conflicts in a less triumphalist light. Ngwabi Bhebe, for example, wrote in 1999 of the experiences of rural Christian missions during the war:

> The ambiguous nature of the colonial system of exploitation ... tended to produce a few men and women in the rural communities who stood up or even sought means to collaborate with the enemy forces in defence of what they thought were useful things such as bridges, dip-tanks, grinding mills, clinics, etc. Such people would find themselves branded collaborators or sell-outs and be killed. Mission institutions suffered greatly in all these ambiguous situations. But of course all this suffering which people and their institutions had to bear only served to indicate the complex and painful nature of destroying an entrenched colonial system.[23]

Parallel to the general growth, solidification and even institutionalisation of the nationalist narrative,[24] by the early 1990s a tenacious literature was also growing that asserted the robust existence of gendered dimensions of Zimbabwean history. These books and articles began an important tradition of reviewing the ways that mainstream historiography had ignored sources related to women and gender issues, and brought neglected histories and voices to the fore.[25]

What of women and the war?

The primary nationalist narrative of women fighters in the struggle was that they participated equally with men, fought alongside them and that the war experience was an important example of gender equality, which was then carried on to the reform of aspects of society in independent Zimbabwe.[26] For example, Joyce Kazembe quotes the Zimbabwean Ministry of Community Development and Women's Affairs in 1985:

... little has been documented about the role played by women in the course of the protracted struggle for independence. The fault lies at the feet of Zimbabwean women themselves. And yet the national liberation struggle marked a major breakthrough for the liberation of women in this country. 'Women fought side by side with men on an equal footing, demonstrating that they were indeed a force to reckon with, and thus destroying the age-old myth that a woman's place is in the kitchen.'

Kazembe concludes, 'One cannot find a better justification for demanding equality on the part of women in Zimbabwe.'[27] An example of a later book in this spirit is Irene Staunton's oral history, *Mothers of the Revolution*, published in 1990. This extended the argument of women fighters deserving to be considered full citizens to include rural women. Although the latter may have 'stayed behind', they made many sacrifices as civilians, and therefore also deserved national credit and recognition.

These women, the mothers, were both victims and actors. Throughout the war, over and over again, they fed and protected the freedom fighters and they risked their lives to do so. This they know and it is a fact of which they are proud ... They regarded the *vakomana* as their children, everybody's children, with needs which they as women, as mothers, had a responsibility to meet.[28]

Mothers is not simply one long paean of praise for the struggle and the guerrillas, however. Without glossing over the most painful moments, it focuses on the suffering, decisions and actions of rural women in wartime. There is, for example, in one of the stories a long description of the role of young unmarried women, *chimbwidos*, who served the guerrillas, with food and sometimes with sex.[29] This is the first description of this practice in the historiography. Nonetheless, these critical scenes and voices are somehow contained by, and do not negate, the overall undoubted legitimacy of the nationalist narrative in *Mothers*. In interview after interview, the wives, daughters and mothers of the revolution assert that their sacrifices, made in the service of ending systemic racial oppression in their country, were valid and worthwhile.

In 1991, however, the tide began to turn with the publication of Richard Werbner's *Tears of the Dead*. An oral history with an original methodology, *Tears of the Dead* brought the subject of the state war waged against the population of Matabeleland – now known as the *gukurahundi* – in the mid-1980s to public and critical attention. Ostensibly searching for dissident ZIPRA troops, the Zimbabwe national army committed scores of atrocities against the rural people of Matabeleland, who had survived 'Smith's war' only to become the targets of 'Mugabe's war'. *Tears of the Dead* presented a theme that was to be taken up again by Alexander, McGregor and Ranger: the long continuities of violence

and resilience in rural Zimbabwe. A woman in *Tears of the Dead* speaks her mind:

> [During the liberation war, in Mashonaland] I cooked for the boys of the country [the guerrillas]. Sometimes, while you were still cooking, they would run for it, and the soldiers would come and beat you. You wouldn't know where the boys had gone to, but after they had gone you would have to stay alone, facing the soldiers. We feared Smith's soldiers and we feared the boys. Smith's soldiers would come and say, "do this". The boys would come and beat you, saying, "What are you doing that for?" [Baka Jesi laughed at the absurdity of the contradiction.] Ah, it was just heavy.[30]

Disarmed, forgotten, discredited – but then resurrected

In the homes, schools and workplaces of independent Zimbabwe, a backlash against the ex-combatants of the two liberation armies reared its head by the mid-1980s.[31] Although it seemed to be generally agreed that by being willing to make the ultimate sacrifice, the ex-combatants had liberated Zimbabwe for the benefit of all, their social association with a dangerous, bloody and, ironically, rebellious past saw many sink into chronic unemployment and poverty as mainstream Zimbabwean society turned its back on them. Especially for women, being an ex-combatant became something to hide rather than something to celebrate. 'Prostitute' was (and remains) the catch-all category for women who challenge social norms, and ex-combatant women – shooting, killing and wearing trousers – par excellence could be categorised in this way in the post-1980 Zimbabwean social imaginary. Thus, just as the post-war official and rhetorical reverence for the liberation struggle and its heroes began to solidify, so many of those heroes found themselves excluded from the fruits of liberation.[32]

Following on this exclusion of ex-combatants after the early 1980s, the political scientist Norma Kriger cracked the monolithic nationalist narrative wide open with a journal article in 1988 and a book in 1992.[33] Kriger's work, much more than Werbner's, was focused on using the idea of guerrilla coercion to bring the whole nationalist dynamic under the spotlight. Based on oral history interviews in the guerrillas' operational areas, she argued that the issue of coercion of peasant support by guerrillas was a widespread but hitherto completely ignored historical phenomenon. Her sources told her that guerrillas accused, beat and sometimes killed innocent people, demanded that food and sexual relations be provided by rural women, and forced people to stay up at *pungwes*. Kriger also

argued that from a class perspective, the guerrilla leadership was a rapacious elite bent on using the ordinary guerrilla as cannon fodder in a quest to suck national power firmly into their grasp. Thus misconduct, if not criminality, was not only a matter of personal excesses by guerrillas, but a symptom of a wider and deeper malaise in the body of the liberation struggle itself. Kriger's analysis leads to the conclusion that this malaise permanently soured relations between fighters of the liberation war and the vast majority of the Zimbabwean public.[34]

This, then, was the historiographical moment of the production of *Flame*.

~

Flame and the nationalist narrative

As noted at the beginning of this chapter, *Flame* holds a complex stance in relation to the master narrative of Zimbabwean nationalism. The film never challenges the narrative in racial terms. The story of 'the whites – maBhunu – who took our land' and who must be 'sent back to where they came from' is unchallenged throughout. The opening song of the film, 'Nyika yedu ya baba, Zimbabwe' (Land of our fathers, Zimbabwe), says it all. The political legitimacy of the struggle is not questioned.

Flame, however, does not just evoke Zimbabwean history and historical imagery. It challenges the historiography – albeit, as noted above, from within. *Flame*'s claim to fame, its central moment, and the reason it was so controversial, is its head-on collision with the previously monolithic narrative of the benevolent male guerrilla. As brief a scene as it is, when Flame is raped by Che you can almost hear thirty-odd years of mainstream nationalist historiography crashing to the floor.

The film confronts the accepted canon of Zimbabwean history on the issue of the treatment of women guerrillas by their male counterparts. When Flame is raped by Che, the film soundtrack is filled with sounds of her futile struggle. When challenged by Nyasha/Liberty upon leaving his tent in the morning, Flame bitterly asks her suspicious friend, 'Do you think I enjoyed it?' Liberty – who had been slapped by another officer when she refused his advances – urges Flame to fight back. But Flame declines to lay charges against Che; in the voice-over, Liberty muses that 'Something had broken inside her.'

This filmic portrayal of rape directly contradicted the nationalist narrative in two ways: first, of gender equality in the war and, second, of the benevolent character of relations between male guerrillas and the Zimbabwean people in general. The rape scene was the source of huge controversy and the reason that the War Veterans' Association tried to stop the distribution of the film. They

asserted that it was inaccurate and pornographic (even though there is no nudity in the scene).

The idea of oppression of women fighters by men is not sustained throughout the film; it is confined to the one rape scene. In addition, it is sugar-coated a few cinematic minutes later when Comrade Che calls Flame back into his tent – but this time he apologises to her for his behaviour, blaming it on his loneliness. He then tells her – twice – that she can go. But Flame chooses instead to walk further into his tent and sit down beside him on the very bed on which he had raped her. Later she goes on to bear his child and they develop a fond relationship. When there is an air raid on the camp by the Rhodesian air force, Che tries to run to Flame and the baby. Che and the baby, named Hondo (War), are killed in the attack. Flame is devastated by their loss. Later, remembering Che, she describes him as 'a good friend'.

This invocation of love and romance, and the sanitisation of rape and of violent gender relations in the bush, engage Zimbabwean historiography at several levels. First of all, the logic of the 'classic nationalist' narrative is that since women acted like men during the struggle, they were entitled to be treated like men after the struggle. For example, a Legal Age of Majority Act, which nullified the colonial-era designation of women as legal minors, was passed in 1982. A Ministry of Women's Affairs was also established, which was meant to eradicate discrimination against women by promoting a range of community development programmes. But *Flame* suggests, through the rape scene, that women combatants were, in fact, not always treated like men during the struggle. And in the film, after Independence, Flame becomes Florence once again. She returns to her role as a rural woman almost meekly – hoeing, bearing children, teaching them and carrying wood on her head. This is the life she leads for 15 years, until Danger's civilian drunkenness forces her to go to town and find her old friend Nyasha and ask for her help. Flame/Florence's vulnerability is the crucial factor that makes her different from a man – both physically weaker (able to be raped) and psychologically stronger (able to go to the big city to find assistance). The underlying message is that women are different to men – challenging the 'women are equal' message – but the film takes pains to make it clear that while women may be different, they are not inferior.

Flame also subtly challenges feminist historiography. Flame only becomes filled with true zeal to go back into Zimbabwe from the Mozambican camp to fight the Rhodesians when she receives news from a new recruit arriving from her village that her father, who had been arrested by the Rhodesians just before she decided to leave her village, was in fact killed by them. Thus she only directly takes up arms and shoots to kill in defence of her own personal patriarchy. This concept engages, in a roundabout way, the early feminist historiography of colonial and post-colonial Zimbabwe, which tried to delineate a history of women

and suggest a kind of proto-consciousness of their oppression by men.[35] In word and deed, Flame defends her father's memory – even though he was the same kind of drunken lout as her husband turned out to be.

Flame is one of several direct contemporary re-examinations of the experiences of women civilians and combatants during the war. It seems that when asked, women ex-combatants did not tell stories of how fulfilled they had been by the equal treatment given during the war. Rather, they said:

> … far from transforming gender roles, the war further entrenched male dominance. During the liberation struggle, women continued to perform tasks long associated with their gender. They cooked, washed clothing, and performed sexual services for the male guerrillas. However, the fulfilment of these tasks was now trumpeted as their patriotic duty … Relatively few women served as guerrilla fighters. With the exception of a limited number who were connected to powerful men, women were generally excluded from positions of power and authority. Most disturbing, internal ZANLA documents and ex-combatant interviews reveal that sexual abuse of women by male guerrillas was rampant.[36]

Josephine Nhongo-Simbanegavi's book, *For Better or Worse? Women and ZANLA in Zimbabwe's Liberation Struggle*, published in 2000, and Tanya Lyons's *Guns and Guerrilla Girls: Women in the Zimbabwean Liberation Struggle* (2004), both take as their central task the dismantling of the old nationalist claim for gender equality in the war.[37] Lyons's book includes an entire chapter with useful perspectives on *Flame*, especially its reception in Zimbabwe at the time of its release. Their conclusions are similar: that the claims of gender equality in the camps and in the struggle in general were extremely inaccurate. Both argue that wartime gender inequities were continued into post-war gender inequities. This is clearly a perspective portrayed in the film, as girl Florence becomes victim Flame becomes revenging daughter Flame becomes mother Flame becomes commander Flame becomes quiet rural peasant woman Florence back on her knees to her male in-laws – just like her mother.

Perhaps the most harrowing tales of the abuse of women – which go into much more detail than *Flame* – are contained in a 2000 publication by the civil society group, Zimbabwe Women Writers. *Women of Resilience*, while also respectful and supportive of the necessity for anti-colonial struggle, pulls absolutely no punches when reporting the verbatim testimony of women who were guerrillas and *chimbwidos*. One woman, who was in Grade 8 in 1976 when the war came to her rural village, would come home during school holidays and be forced to perform oral sex with one guerrilla after another, night after night. It was oral sex because there was a prohibition on penetrative sex during the course of the struggle. Her memories of that time are extremely painful.

There are many women like myself that have had the idea of sex [as pun-
ishment] and some have cancelled it right out [of] their lives. I also think I
have nothing to tell my children when they grow up. I have nothing to tell
them ... about sex. I think I am not right, because I am not the best person
to do that, because as a child I was already sucking a man's [body]; I was
being sucked myself; all these things [were on] my body, and I am not the
best person to discuss sex with my children. It has done a lot of harm...

When asked 'What does liberation mean?' she replied,

Okay, liberating us from the white government, politically, but there is
more damage than good that came with that. [Maybe people] need to
know all this because the truth has never been said. Nobody wants to talk
about the truth. Everyone wants to pretend they [the guerrillas] were very
good. Oh, they sang songs, they taught us politics, they did this. Nobody
wants to look at the other side. But here are lives – like my own – damaged
lives, that will never be repaired, because of the trauma.[38]

Flame and historical production

Flame achieves a difficult balancing act. It avoids the glaring insinuation of
Kriger's work: if the struggle was fought by such a bunch of thugs, what kind of
struggle, ultimately, was it? *Flame* never questions the overall nationalist impera-
tive and reinforces its truth throughout. It is a tribute to the director and the
actors that these contradictions end up sitting quietly side by side: the slap of
Liberty and the rape of Flame are central but are ultimately submerged in the
triumphant re-emergence of independent Zimbabwe, even though the women
themselves wryly observe at the end of the film that they don't lead liberated or
independent lives after liberation and Independence.

It is worth noting in production terms that all of these accounts of the lib-
eration struggle rely on and base their claims for legitimacy on the practice of
oral history. Ingrid Sinclair,[39] Norma Kriger, Irene Staunton, Josephine Nhongo-
Simbanegavi and Tanya Lyons base their ultimate claim to truth on the fact that
they 'interviewed women ex-combatants themselves'. Thus memory and the
spoken word are held to be more accurate than, or at least an equally potent
counterweight to, the largely de-personalised and overarching nationalist grand
narrative. Each author, in turn, reassures us that the subaltern is in fact speaking
to the audience through the mediating vehicle of their work. It is worth noting
that to date there has not been a full-length piece of fiction or non-fiction by a
Zimbabwean woman ex-combatant published by an international publisher. In

Zimbabwe, the only exceptions to this rule are two books of poems written by Freedom Nyamubaya,[40] and the Zimbabwe Women Writers collection, *Women of Resilience*.

~

Conclusion and postscript

Flame succeeds as a film through its evocation of the wonderful, subtle colours and textures of the Zimbabwean countryside, its use of authentic *a capella* music, and the freshness of its acting team. In intriguing ways it simultaneously supports and contradicts the central tenets of substantial parts of Zimbabwean historiography. Zimbabwe itself moves on. As of this writing, the previous relatively harmonious relationship between the post-colonial project and the goal of national democratisation has soured bitterly.[41] An important aspect of the rise of demagoguery and violence on the part of the ruling party since 2000 has been a new role for history: to glorify, rather than critically examine, the roles of the victors in the liberation struggle.[42]

Among many other changes in Zimbabwe in the new millennium are the enormous changes in the social status and popular representation of guerrillas. From selfless servants of the masses with vast historical legitimacy but without much official recognition (as shown at the end of *Flame*), twenty years later they became a kind of caricature: not so selfless, without much legitimacy, but at least for a time with a great deal more official recognition. First, the state began searching for allies in the context of a growing political challenge from opposition parties, ex-guerrillas were given state pensions.[43] Secondly, they were officially supported in undertaking forcible and violent land invasions of white-owned farms after 2000. This enabled a media reincarnation of ex-guerrillas as thugs, leading perhaps inevitably to popular and scholarly questions about traditions and continuities of guerrilla violence against civilians.[44]

Thus, Zimbabwe's ex-guerrillas continue to travel a long and twisted road between victor, victim and villain. Historians interested in the complex shifts and interplay in Zimbabwean historiography, nationalism and politics since 1980 might do well to view *Flame* with this question in mind: how deeply did the suggestion that women combatants were badly treated during wartime (as minimally but controversially portrayed in *Flame*) pierce the armour of mainstream nationalism in Zimbabwe?

15

Picturing apartheid: with a particular focus on 'Hollywood' histories of the 1970s

VIVIAN BICKFORD-SMITH

South Africa, renowned both far and wide
For politics and little else beside.[1]

R oy Campbell wrote these lines in the 1920s. They are an even more appropri-
ate description of the country in the 1980s. By then, South African politics
had graduated from being merely an international news story to featuring in
an impressively wide range of global cultural forms: be they documentaries,
novels, plays, popular songs, music videos, T-shirts featuring political slogans or
portraits, satirical television programmes and feature films. Indeed the fact that
Afrikaners were picked to be the villainous opponents of Mel Gibson and Danny
Glover in *Lethal Weapon 2* (1989) was a sure indication of the worldwide fame,
or infamy, now achieved by South African politics.[2]

The Hollywood release of two history films in this period also reflected such
infamy. *Cry Freedom* (1987)[3] and *A Dry White Season* (1989)[4] were not necessarily
'the best' (though that term begs definition) representations of apartheid South
Africa. But they were filmic histories of serious intent because they engaged
with 'the issues, ideas' and 'data' surrounding South Africa in the mid-1970s, the
period they were attempting to portray.[5] If only to this extent, they were little
different from contemporary written histories; and both films and books gener-
alised, synthesised and used metaphors while establishing their arguments.

Cry Freedom and *A Dry White Season* arguably deserve serious analysis by the
historical academy, and are the films that form the major focus of this chapter,
because they were (and still are) among the most influential representations of
apartheid South Africa. They were distributed by major Hollywood studios and

thereby gained relatively substantial audiences, whether in the cinema or through subsequent video or DVD rentals and sales. They also make logical objects of comparative scholarly analysis because their stories are both set in the mid-1970s and deal with similar issues and events.

Yet in the two most extensive and influential critiques thus far – by Peter Davis and Rob Nixon – the 'history' in *Cry Freedom* and *A Dry White Season* has been largely ignored. Instead, both authors have given far greater attention to denouncing the Hollywood narrative strategies of both films: notably the fact that they use a white male protagonist and his second-fiddle black 'buddy' to investigate the 'third world problem' of apartheid South Africa. In the process both films are said, *inter alia*, to have neglected black South African perspectives, contained unrealistic (or undeveloped) arguments about how change could be achieved, and to have distorted the true nature of the liberation struggle. Such a hostile and partly unfair verdict has probably contributed to the fact that the 'history' in both representations has received only summary examination.[6]

This chapter aims to redress this lacuna. The first section provides historical and filmic background. It intertwines a brief history of apartheid with some analysis of 'state of the nation' films – films set in the (changing) present, which reported on the nature of South Africa – that preceded our two 'history films', thereby providing context and demonstrating that filmic representations of apartheid (like any topic) are shaped by the ideological perspectives of the period (as well as the people and place) that produced them. The second section contains an analysis of the historical arguments and information in *Cry Freedom* and *A Dry White Season*. A short conclusion attempts to assess the impact of these filmic histories.

Apartheid and feature film
representations before the 1980s

By the time that *Cry Freedom* was released in 1987, apartheid had been official government policy for almost forty years and had undergone numerous, often highly significant, changes. Filmic representations of apartheid are therefore often attempting to capture different moments and were produced in different contexts. Significant economic and demographic change, for example, interplayed with both major and minor changes in the ways in which a complex range of apartheid laws were drawn up, enforced or resisted over these decades.

When the (Afrikaner) National Party introduced apartheid in 1948, part of what it was doing was merely extending and more rigidly enforcing existing

policies and practices of racial segregation and discrimination. Many of these had been initiated by British colonial governments or Boer republics in the 19th century, then maintained or expanded under Union of South Africa (white) governments from 1910. But this segregation was not yet comprehensive: some residential areas or facilities, for instance, remained 'open', and many male 'mixed race' South Africans still had the vote in the Cape.

Apartheid largely and ruthlessly destroyed such 'anomalies'. The Population Registration Act of 1950 crucially required (for the first time) the registration of a person's 'race', officially dividing the population into four groups: 'White' or 'European', 'Coloured' ('mixed race'), 'Asian' and 'Native' (or, slightly later, 'Bantu'). South Africans were forced to register as a member of one of these groups whether they wanted to or not. This categorisation paved the way for a plethora of further laws aimed at achieving comprehensive cradle-to-grave segregation: whether in schools, the workplace, residential areas or social amenities.

All this was happening at a time when governments in much of the world beyond southern Africa were gradually retreating (albeit often reluctantly and under pressure) from colonialism or legalised racial discrimination. Until the early 1960s, there was reason to believe that some reform might still be possible in South Africa. For instance, the National Party had only come to power with a minority of white votes in 1948. There was an expectation among many opponents that they could be defeated in the next general election (of 1953), and apartheid therefore remained in place. The early 1950s witnessed mass protests not only by (predominantly, but not exclusively, black) political parties (including the ANC) and civic organisations, but also by the Torch Commando, an organisation of some 50 000 white ex-servicemen. Such parties and protests remained legal.

These circumstances begin to explain the most famous filmic depiction of apartheid South Africa in the 1950s. Directed by Zoltan Korda, and starring Canada Lee (Rev. Kumalo) and the youthful Sidney Poitier (Rev. Msimangu), *Cry, the Beloved Country* (1952) was adapted for the screen by Alan Paton from his novel of the same name. Both film and novel depict and denounce the nature of living conditions in black townships, suggest that black South Africans go to the cities primarily because of rural poverty and that they (in the persons of members of the Kumalo family) are morally and physically imperilled by doing so. Life in the countryside, however difficult, is ultimately more suitable for Africans than evil urban life, and specifically evil Johannesburg life.

To that extent, *Cry, the Beloved Country* is not sharply at odds with legislation – like the 'pass laws' – that had controlled African 'influx' to the cities both before and after 1948. Equally encouraging to the National Party at a time of considerable political protest, the African nationalist in the film (John Kumalo, the Rev. Kumalo's brother) is portrayed as morally lax and untrustworthy; he

bears extremely unfavourable comparison with the deferential black Christian protagonists. Yet the film also provides ideological succour to opponents of apartheid: most obviously in its assertion of the need to recognise and uphold common (Christian) human dignity, and in its condemnation of white racism. The film is silent about what might be the best political dispensation for South Africa at a time when the difference between National Party rule and that of its predecessors was yet to be more sharply demonstrated, and the word apartheid is never mentioned. However, *Cry, the Beloved Country* does argue that whites (personified in the farmer James Jarvis) should abandon racism and (a little vague here) improve the lot of black South Africans. The implication was that it was not yet too late for them to do so.

This obviously did not happen, and instead the 1950s witnessed increasingly more confident, energetic and ruthless attempts by the National Party to attain apartheid ideals. Amendments to the pass laws – most notably the requirement to have photos in passes, the need to have been continuously employed for ten years to get residency rights in 'white' towns, and the extension of pass laws to women – led to an unprecedented number of pass raids, arrests and deportations (to the reserves). In response, both major black nationalist organisations – the African National Congress and the newly formed Pan Africanist Congress – were organising mass protests against passes by the end of the decade.

This is the context in which Lionel Rogosin (maker of *On the Bowery*) and black South African writers for *Drum* magazine collaborated to make *Come Back Africa* (1959), unfortunately little known in comparison to Korda's film. Like *Cry, the Beloved Country*, it highlighted the poverty, violence and desperation facing rural migrants to the townships and (more stridently) condemned white racism. However *Come Back Africa* went further by demonstrating that life was made infinitely worse for Africans by the existence of the pass laws, and the brutal officials who administered them. But unlike its predecessor, the argument of *Come Back Africa* was that black urbanisation was not necessarily without hope, and that it was inevitable and permanent. Suggesting alternative possibilities, much of the film is devoted to showcasing (in both documentary and workshopped dramatic styles) elements of the vibrant popular culture that characterised Johannesburg in the late 1950s. In several shebeen scenes the *Drum* writers feature as themselves: a sophisticated and articulate urban intelligentsia overtly critical of how black leadership was portrayed – as either overly deferential or morally dubious – in *Cry, the Beloved Country*. Both literally and figuratively, they demonstrate that black South Africans are capable of representing themselves and gaining their own demands. To this extent at least, and reflecting the growing urgency in the still-legal mass politics of the time, *Come Back Africa* contained an implicit optimism that change might be imminent.

But such hope was dramatically ended by the massacre of pass protesters at Sharpeville and the subsequent declaration of a state of emergency in 1960. Within a week the government banned the two black nationalist parties, the ANC and the PAC, imprisoned numerous political leaders on Robben Island, and moved significantly closer to establishing a police state with concomitant powers of indefinite detention. 'Suicides' of political detainees in police custody soon followed. A combination of political repression and economic growth meant that National Party rule was secured and extended, with some homelands even granted 'independence' in the late 1970s. A new onslaught was launched on 'illegal' black South Africans in the cities, and particularly on those in informal settlements – notably Crossroads, near Cape Town.[7]

But from about 1973, a reawakening of active internal opposition in South Africa coincided with – and was in part propelled by – economic depression sparked off by rising fuel and falling gold prices. Led first by a reinvigorated (illegal) trade union movement, it was given considerable ideological coherence and efficacy by Black Consciousness (BC), championed most notably by Steve Biko and organisations that he helped establish, such as the South African Students Organisation (SASO) and Black People's Convention (BPC). This development was an important factor, if far from the only one as we shall see, in fuelling a spirit of resistance among teachers and students that led to confrontation with the police on 16 June 1976 – the Soweto Uprising – and the onset of almost continual low-level civil war until the end of apartheid. The Soweto Uprising is featured in both *Cry Freedom* and *A Dry White Season*.[8]

It was in this immediately pre-Soweto context that Hollywood (in the form of United Artists) made its first stab at depicting 1970s apartheid South Africa. Conceived primarily as an 'adventure film', *The Wilby Conspiracy* (1975) was neither particularly concerned with the historical record, nor imbued with the 'realist' style attempted by 1980s depictions. Nonetheless it covered at least some of the same themes and established many of the same narrative ingredients as *Cry Freedom* and *A Dry White Season*.

The Wilby Conspiracy told the tale of recently released Robben Island prisoner Shack Twala (Sidney Poitier), loosely based on Nelson Mandela. Twala wants to smuggle diamonds into Botswana to buy guns for his organisation named, significantly, the Black Congress, the head of whom is known as Wilby. Twala is helped in his efforts by naïve British tourist Jim Keogh (Michael Caine), who is the boyfriend of Twala's lawyer. We soon learn that Twala's release has been arranged by Major Horn, the Machiavellian Afrikaner security policeman, who wants Twala to lead him to Wilby. The final scene shows Horn turning up at the Botswana rendezvous between the two and seizing Wilby. But just as Horn's helicopter is taking off, Twala and Black Congress supporters grab hold of it and

force it to land. When Horn says that he will one day return to capture Wilby, Keogh shoots him.

Despite its many absurdities, *The Wilby Conspiracy* did refer to a number of political developments within the country since the 1950s, many of which are included in the history films of the 1980s: the establishment of Robben Island, off Cape Town, as a modern political prison; the existence of brutal security police, of detention without trial, and of the possibility of torture or death in detention; and a positive acknowledgement of black resistance – with the title of Wilby's organisation obviously a play on the names of real organisations – and legitimate counter-violence. Such inclusions, and the manner in which they were depicted, told of increasingly negative perceptions of apartheid South Africa in the West, influenced not only by Sharpeville and its aftermath, but also by the accelerated pace of decolonisation in Africa and civil rights achievements in the United States.[9] Such negative perceptions helped fuel support for international pressure against apartheid, whether in the form of cultural and sporting boycotts or economic sanctions.

The Wilby Conspiracy also deployed a narrative structure and ideological argument very similar to our two films of the late 1980s. Most notably this mini-genre, as Davis pointed out, features a male 'buddy' friendship between a black political insider and an initially naïve white outsider. But in contrast to *Cry, the Beloved Country*, the black political insider is now likeable, his cause worthy of support – and Sidney Poitier brings all the authority of his Rev. Msimangu character, as well as his civil rights roles, to his depiction of Shack Twala. All three films also include the gradual education of the white outsider into the evils of apartheid and the security police; a speech by an Afrikaner nationalist supposedly giving his/her side of the story; and scenes that legitimise counter-violence.

There was a thirteen-year gap between *The Wilby Conspiracy* and *Cry Freedom*, the next major feature film to take on apartheid. Part of the reason for this hiatus may have been *The Wilby Conspiracy*'s discouraging lack of success at the box office.[10] But potential feature filmmakers may also have felt unable or unwilling to compete with actuality footage flowing from South Africa from June 1976 onwards that was shown extensively in television news and documentary broadcasts throughout the world: particularly of young black South Africans – often schoolchildren in uniform – battling police armed with long whips and guns.[11] As Harriet Gavshon has put it, this was 'a reality ... often so brutal and alive' that many were tempted to 'package and market it directly on to film'.[12] And the capturing of such footage was made easier in the late 1970s by improvements in video technology, a technology that was now no longer embargoed by the South African government because of its belated introduction of television in 1975.[13]

Thus from 1976 up to the South African government's declaration of a

national state of emergency in 1986, the struggle against apartheid (for foreign-ers) appeared to be an increasingly accessible story in geographic (conflict was taking place in major cities), technological and explanatory terms: it was a story that could be told simply as black versus white (whether in terms of morality or melanin). The details of the brutal murder of Steve Biko in police detention in 1977 – which were revealed at the subsequent inquest, even if the court did not find against the police – served to confirm this opinion. The tragedy and iniquity of Biko's death was kept before an international audience over the next few years through a variety of means: by a stage play, a docu-drama of the play (broadcast in Britain and the United States), two books by Donald Woods, a song by Peter Gabriel (the British ex-Genesis rock singer) and, in 1985, a music video (and accompanying CD/tape and book) by Artists United Against Apartheid called [*Don't Play*] *Sun City*.[14] All of these helped publicise the existence of atrocities in South Africa not easily captured by news journalists on the ground: torture and deaths in police custody and the plight of political prisoners more generally, thousands of whom (by the mid-1980s) had been detained without trial.

The *Sun City* video helped promote the evolution of a liberal ideological understanding and iconography of apartheid that was widespread in the West by the late 1980s. Stock footage in the video consisted of both South African and American material. The former was pre-eminently of police brutality, demon-strations, funerals and idle (and implicitly wealthy) whites by swimming pools, but also included a photographic image of Biko, as well as old pre-prison film footage of Mandela. The American footage was of Martin Luther King and other iconic images of the civil rights movement. South African and American mate-rial was inter-cut, effectively equating the struggles in both countries. It was pre-sumably in part because of this approach, as well as its stellar array of rock and rap stars, that *Sun City* became one of the few 'political' videos to get relatively extensive airing on the usually (overtly) apolitical MTV.[15]

History in *Cry Freedom* and *A Dry White Season*

Such imagery and understanding of the nature of apartheid motivated and informed the representation of 1970s South Africa in *Cry Freedom* and *A Dry White Season*. The directors of both films – Richard Attenborough and Euzhan Palcy respectively – were, like the makers of the video, overtly wishing to intervene on the side of the anti-apartheid struggle. Sir (later Lord) Richard Attenborough was already an internationally renowned figure in the British film industry as an actor, director and producer. The critical acclaim and financial

success of his multi-Oscar-winning (including Best Picture and Best Director) *Gandhi* (1982) helped him to persuade 'Hollywood' – in the form of Marble Arch Productions and Universal Pictures – to finance *Cry Freedom*. Universal also accepted responsibility for distribution, ensuring extensive international release. However, beyond any commercial considerations, Attenborough was undoubtedly sincere in emphasising his own political motivation in making the film: 'My objective was straightforward – to ensure that having seen the movie, nobody will be able to remain indifferent to the situation in South Africa, and to encourage them to stand up and say, "This is intolerable."'[16] The choice of *Cry Freedom* as a title evoked memories of *Cry, the Beloved Country* (the novel and film), and announced a similar liberal, anti-racist stance, one that Attenborough had already demonstrated in *Gandhi*.

Euzhan Palcy was considerably less well-known. But she had received critical praise for *Sugar Cane Alley* (1983), her study of black cane growers in 1930s Martinique (her birthplace), and this enabled her to attract the support of several production companies – most notably, perhaps, Star Pictures II (producers of *Rain Man*) – in making *Dry White Season*, with MGM as distributors. Palcy thereby became Hollywood's first black woman director. Like Attenborough, she was forthright about her political intentions: 'As a black film-maker, my first responsibility was to make a film about the situation in South Africa'.[17]

An added incentive to such intervention came with the South African government's declaration of a national state of emergency in 1986. This imposed extended and stringent controls on media reporting, expressly forbidding coverage of police actions against demonstrators. Making feature films was, therefore, a means of continuing to 'show' such apartheid brutality. The fact that American production companies now gave their support to such projects doubtlessly reflects a calculation that it was both politically and economically less risky to do so: public opinion in the West was now largely opposed to apartheid, and most governments had imposed various forms of economic sanctions – the United States had belatedly done so in the form of the Comprehensive Anti-Apartheid Act (1986).[18]

It is not clear why Attenborough and Palcy chose to engage with the (antiapartheid movement) present through 'history' films, rather than through 'state of the nation' reports. Taking the former option, however, meant that their films were less likely to be overtaken by events and could thereby (in theory) achieve a longer shelf-life. Setting a film in the mid-1970s also had the advantage of avoiding the arguably more complex and morally murkier politics of the mid-1980s. This later period saw the South African government attempt to retain white political supremacy by increasing the power of the security forces to suppress resistance and eliminate opponents (through officially sanctioned hit squads) while simultaneously reforming, and even repealing, key elements of apartheid.

The latter included the gradual dismantling of 'petty' apartheid (segregation of social amenities and institutions); the establishment of local governments in African townships (1982); giving coloureds and Asians political representation in a tri-cameral parliament (1983); and, most significantly, ending the pass laws and thereby control over African urbanisation (1986). Equally, a 'darker side' of the struggle had been revealed by the mid-1980s. This was, the ANC argued, a response to greater state brutality. Nonetheless, ANC bombs killed a number of civilians in city centres, while in townships many alleged collaborators and police informers were killed by young 'comrades', some using the notorious 'necklacing' method infamously condoned by Winnie Mandela.[19]

Cry Freedom and *A Dry White Season* were different categories of history film. The former was avowedly a 'true story' about 'real' people and events, while the latter featured fictional characters in a 'real' 1970s setting. *Cry Freedom* was set in the years 1975 to 1977. Opening with a police raid on an 'illegal' Cape Town squatter camp (Crossroads) in 1975, the film then proceeds to tell the 'true' story of the 'friendship that shook the world' which developed between Black Consciousness Movement (BCM) leader Steve Biko (played by Denzel Washington) and newspaper editor Donald Woods (Kevin Kline).[20] When we first meet him, Woods is a white liberal who believes that BC activists are purveyors of a racist black separatism and should therefore be condemned just as much as whites who support apartheid. These views change after Woods is persuaded to meet and debate the true meaning of BC with Biko and his comrades. Woods is simultaneously impressed by the BCM's black community projects, and (through Biko's tutelage) learns something of the reality of black township life. His (Woods's) conversion to more radical participation in 'the struggle' comes after he discovers the brutal nature of the regime: in the aftermath of a police raid on a BC community project (and the subsequent inaction of the Minister of Justice) and, more especially, the deaths in detention of a BC staff member of the *Daily Dispatch*, then of Biko himself, and finally the harassment of his own family by the security police. The final section of the film portrays Woods (disguised as a priest) making a dramatic escape from South Africa so that he can publish a book that will tell the world the truth about apartheid, Biko's death and the just nature of the BC struggle. Towards the end of the film there are flashbacks both to Biko and the Soweto Uprising. The last shot consists of a lengthy list of activists who have died in police detention – accompanied by the official (and, for the viewer, unbelievable) cause of their deaths – superimposed over the South African landscape that Woods is flying over en route to exile.

A Dry White Season was based on the novel of the same name by Afrikaner author André Brink, published in 1979.[21] Both novel and film feature fictional characters against the backdrop of the Soweto Uprising. Like *Cry Freedom*, *A Dry*

White Season also tells the story of a white male protagonist awakening to the horrors of apartheid: in particular through the deaths in detention of Jonathan (his gardener's son), Gordon (his gardener), and then Emily (Gordon's wife). But instead of an English South African liberal, this male is Ben du Toit (Donald Sutherland), a scion of Afrikaner nationalism and (to reinforce the point) a Springbok rugby player who, in joining the struggle, betrays his *volk* and deceives even members of his immediate family. Like Woods, he has a black tutor – the taxi-driver Stanley (Zakes Mokae) – to teach him the truth about conditions in the townships and what it entails to be a black South African. The film ends with Du Toit attempting to expose security police atrocities but dying at the hands of one of them (Captain Stoltz), who in turn is killed by Stanley. Yet the affidavits revealing security police brutality, which Du Toit has helped to collect, survive and serve their purpose.

As is largely evident, the two films deal with many of the same historiographically well-established elements of 1970s apartheid South Africa that appeared in *The Wilby Conspiracy*. What they add is a renewed focus – similar to the two filmic portrayals of South Africa in the 1950s – on desperate conditions in black townships, now dramatically contrasted with wealth in white suburbs. What is new, yet evocative for audiences of recent actuality footage and, for some, of the *Sun City* video, is police beating and the shooting of township dwellers.

Attenborough and Palcy make similar general arguments about South Africa in the 1970s to those of *The Wilby Conspiracy*: that the police (and particularly the security police) were brutal; that apartheid was an evil system; that the anti-apartheid 'struggle' was righteous and that viewers of the films should support it. The conclusion that audiences were clearly intended to reach was not – *pace* Rob Nixon – simply that 'the political solution to apartheid' lay in the wide-scale emulation of these men's (Biko/Woods; Du Toit/Stanley) 'struggle to build a personal relationship that triumphs over racism and suspicion'.[22] Certainly both Attenborough and Palcy imply that building such relationships might help, and arguably they did: there was much-reported 'buddy-bonding' between chief negotiators Cyril Ramaphosa (ANC) and Roelf Meyer (NP) that seemingly aided negotiations in the early 1990s.[23] But the plots, indeed the very existence, of both films argue more obviously that disseminating knowledge of the evils of apartheid could help bring about change through international pressure. And both films go further by appearing to justify violence involved in the struggle, thereby, perhaps, making more explicable in the minds of their audiences the 'darker' deeds of the 1980s: whether through particular sequencing of events – Stoltz kills Du Toit before Stanley (understandably) exacts revenge; Biko is assaulted by security policemen before (understandably) retaliating – or their overall portrayals of apartheid inhumanities.[24]

Yet despite the overall similarities, Euzhan Palcy's depiction of apartheid is harsher than Attenborough's. Beyond both films' reconstruction of 16 June, *A Dry White Season* contains a more graphic portrayal of state violence than *Cry Freedom's* sanitised rendering of Biko's death. We are shown, for instance, the welts made by police batons on Jonathan's buttocks. And we witness Stoltz, played by German actor Jürgen Prochnow as a stereotypical steely-eyed screen Nazi, torturing blood-covered (and clearly innocent) Gordon, as well as murdering Du Toit. We are also shown the marks of torture on another detainee's body at Gordon's inquest. The cross-examination and outcome of this inquest – in which the magistrate holds no one responsible for Gordon's death, despite all the evidence of security police culpability – is a clear denouncement of the South African justice system absent from *Cry Freedom*. It verifies (at length) an earlier statement by liberal lawyer Ian McKenzie (Marlon Brando) that 'Justice and the law are but distant cousins; here in South Africa they are not on speaking terms at all'. In addition *A Dry White Season* shows us, through the persons of most of Du Toit's family and teaching colleagues, that white racism is not confined to state functionaries; a conclusion that could be drawn from *Cry Freedom*. Generally, black South Africans are (more convincingly) shown as far angrier than those portrayed in Attenborough's film. In particular, Stanley is shown drunkenly swearing at the Du Toits as well as exacting revenge on Stoltz.

The harsher tone in *A Dry White Season* is largely explained by its different production circumstances. By 1989 (the year in which *Lethal Weapon 2* also depicted Afrikaners as villains), there was even greater support for the anti-apartheid cause. Palcy had visited South Africa, was personally 'enraged' by what she found, and avowedly wished to portray black South Africans as capable of (justifiably violent) agency, rather than as mere victims. Seeing herself as 'a black filmmaker', Palcy was attempting to rectify what she saw as a problem with earlier accounts of apartheid including *Cry Freedom*.[25] She was implicitly rectifying the latter's sanitised version of Biko's death and omission of the inquest by showing us the torture of a fictional detainee – Gordon – and a subsequent inquest that had tragic farcical similarities to Biko's.

Attenborough clearly knew, and could have made more of, the ghastly details of Biko's brutal murder, though what he does show is true to court transcripts.[26] He could also have (usefully?) sacrificed much or most of the Woods escape saga in favour of reconstructing incidents from the inquest. Other differences of tone might be ascribed to the fact that he and Palcy were making different kinds of history films. Attenborough, relating a 'true story' about the past, may well have felt somewhat constrained by the historical record, in particular the written and oral evidence about the 'real people' (many of whom were still alive) and 'real events' he was depicting. He might well have felt that it was particularly impor-

tant to deviate as little as possible from this evidence because his 'history' film was an overt engagement with the politics of the present, and any 'inaccuracy' of detail could be seized on by supporters of apartheid, not least by the South African government.

Palcy, and her script-writer Colin Welland (*Chariots of Fire*), enjoyed the greater licence of dealing with fictional people and (mostly) fictional events. They could alter Brink's novel to allow Stanley to punish Stoltz; Attenborough could less easily invent an avenging assassin of Biko's killers. What Attenborough could do was play around with the filmic ordering of events: he shows us Biko's death (1977) before (through flashback) a reconstruction of the Soweto Uprising (1976). Some insufficiently alert viewers might gain the impression that Soweto was partly a response to Biko's murder.

How true, then, was Attenborough to the 'historical record' in his depiction of historical figures (particularly Steve Biko) and historical events? Answering this question in part requires reminding ourselves that this 'record' itself consists in large part of opinion about people, reports of speech and events, and is never an unmediated vision of the past. Attenborough, and his screenplay writer John Briley, based the *Cry Freedom* depiction of Biko, Woods and other historical figures and events very closely on Woods's two books, the autobiographical *Asking for Trouble* and *Biko*.[27] Both books contained Woods's opinions of Biko, as well as the former's accounts of what transpired or was spoken between them, of what happened to Biko, and of South African politics and society more generally. But *Biko* also contained verbatim replications (and summaries) of Biko's writings and words: from Biko's column ('I Write What I Like') in the SASO journal, and from transcripts of evidence Biko gave at the trial of members of the BPC and SASO.[28]

Much of the dialogue spoken by Washington in *Cry Freedom* is taken almost verbatim from these sources and uses words recorded as being Biko's. Alterations, when they occur, would appear to be minor. Thus Washington-as-Biko's words are very close to those of the real Biko at the BPC–SASO trial, allowing us insight into Biko's sharp intelligence and wit – not least on the questions of racial terminology and 'confrontation' – even under such circumstances.[29] Sometimes the real Biko's recorded words – on growing up in the townships or on black pride – are given to Washington to deliver 'on location': while he accompanies Woods to a township, or at an illegal mass meeting in a football stadium.[30] Dialogue in other scenes draws on Woods's account of conversations with Biko, notably words exchanged at their first meeting.[31]

Davis has argued that *Cry Freedom* distorts Biko's philosophy by making him, misleadingly, 'unthreatening to whites': by giving him an overall 'love thy white neighbour message' and by emphasising the friendship with Woods. This (meta-

phorically) fails to free him (and, by extension, all blacks) from dependence on whites when the central tenet of Black Consciousness was 'Black man, you're on your own'.[32] Biko certainly used this slogan, and wrote extensively about white liberal paternalism limiting the efficacy of the struggle by restraining black radicalism and self-sufficiency.[33] This is touched on in *Cry Freedom* when, for instance, Biko tells Woods that white liberals – with all the advantages of the white world – were not 'best qualified to tell blacks how to react to apartheid'. However, the real Biko also believed that the white liberal had a role to play: to 'address the white world not blacks' and 'to apply himself with absolute dedication to educating his white brothers'.[34] This was surely – at least in part – what Woods and Attenborough were doing. Yet, for Davis, they 'betrayed' the BCM by choosing to tell the story of Biko's philosophy and death as part of their indictments: white liberals 'must fight for their own freedom and not that of the blacks with whom they can hardly claim identification'.[35]

It was indeed BC philosophy for black South Africans to lead the struggle; but the idea of an entirely separate white initiative was more rhetorical flourish than pragmatic action. Biko – and other BC activists – built friendships (some far deeper than the Biko–Woods relationship) and worked with white liberals. They accepted financial aid from this source – even from Helen Suzman, a white member of parliament and thereby part of the 'system'.[36] The Zanempilo Community Health Centre (featured in *Cry Freedom*) had been established with German financial assistance and run (after initial reluctance) with funding from the South African Council of Churches; the Njwaxa Home Industry (also shown in *Cry Freedom*, but incorrectly located in a King William's Town church) was established by a white priest; and a white Catholic lay sister – Anne Hope – 'had used Paulo Freire's methods to help SASO develop a sound methodology for its conscientisation programme. She trained eight of the top leaders, who later trained us.'[37] It was Biko who had wanted Ramphele to arrange a 'collaborative relationship' with Woods, and who had wanted the *Daily Dispatch* to give greater coverage to the BCM. This led to the newspaper employing a BC journalist.[38]

The point is that individuals and ideologies in the 'real world' usually involve ambiguities or contradictions that party loyalists, film screenplay writers or ideologically purist film analysts alike might prefer to skate over or avoid completely. Davis and Nixon both play down the extent of Biko's and the BCM's collaboration with the 'white world'. Arguably, so does *Cry Freedom*, by seeming to suggest that the Woods friendship was the extent of that relationship. However, Davis and Nixon are perhaps on firmer ground in asserting that *Cry Freedom* replaces the 'radical political discourse' of BCM with 'the more palatable liberal discourse of moral decency and human rights'.[39] The township visit sequence does mention, albeit briefly, Biko's opinion that integration could not be on white liberal

terms: Biko tells Woods that 'I'm not going to be what you want me to be', integration had to be on black terms, a matter of whites being invited to an 'African table'; and Biko had used this exact metaphor in his writing.[40] Yet the film plays down his belief in a socialist or 'black communalist' future for the country – it is only implied by Biko's wry comment on Woods's Mercedes, again drawn from the latter's recollections.[41] The film entirely omits Biko's call for sanctions. Also absent are Biko's views on differences between Africans and whites: 'oneness of community', 'love of song and rhythm', 'desire to share', and ease of communication were 'inherent in African people' – in contrast to the 'highly impersonal world in which whitey lives', a world of 'slaves to the machine'.[42]

Cry Freedom perhaps more accurately conveys Biko's more equivocal views on violence. It has him saying, at the soccer stadium, that whites can 'have conflict if they like'; but shortly afterwards, during the trial sequence, that 'we seek to avoid violence' and that 'we are now in confrontation but I see no violence'. The problem here is that when Biko was entrusting his views on violence to the historical record – in court, to journalists or publicly to his own followers – he was understandably careful. He was unlikely to come out with unequivocal support for armed struggle, and thereby condemn himself to immediate, long-term imprisonment. Yet Biko did appear to believe in the continued efficacy of whatever non-violent strategies were possible, and of making full use of what was left in the way of legal recourse.[43] *Cry Freedom* does not, however, include in Biko's dialogue the few moments in which – even on the record – he went further: for instance, his statement that there were many people who had 'despaired of the efficacy of non-violence as a method ... [who] are of the view that the present National Government can only be unseated by people operating a military wing'.[44] *Cry Freedom* does imply, though, that Biko supported counter-violence when 'the white minority compelled such a reaction' by showing his retaliation to the security policeman Hattingh's assault – an incident Biko had reported to Woods.[45]

But what about Biko the man? Mamphela Ramphele persuasively criticised *Cry Freedom*'s Biko for perpetuating 'the lie of Steve as a Gandhi-type person respectably married to a dedicated wife who shared his life and political commitment'.[46] In doing so, the film followed in a long filmic and written tradition of biographical hagiography. For Biko, this already included the two Woods books and a memoir by Biko's friend Father Aelred Stubbs.[47] Attenborough, director of the pre-eminently hagiographic *Gandhi* as well as a 'dutiful' and 'conventional movie biography' of Churchill in *Young Winston* (1972), was unlikely to deviate from this position;[48] the more so having sought the blessing of Biko's wife Ntsiki (and the ANC) in making the film. He establishes *Cry Freedom*'s position as soon as we meet Steve: a point-of-view shot from Woods's perspective containing a

lighting effect that serves to create a halo around the still-properly-to-be revealed Biko, conferring instant canonisation.[49] The film only hints at Biko's propensity for partying and womanising in two short scenes: when Ntsiki Biko leads Woods to this meeting – fondly describing the accompanying child as 'just a little rascal like his father and even more trouble' – and when Biko (watched by Woods) dances in a shebeen. *Cry Freedom* never reveals that Ramphele was Biko's lover, or that she was pregnant with his child when he died.[50] *Cry Freedom*, like *Young Winston*, fails to give us 'the human being behind the historical façade'.[51]

Attenborough's Woods is equally cautious and one-dimensional, unsurprisingly given that both Donald and Wendy Woods were 'technical advisors' on the film: someone (with perfect wife and family) for (largely white) audiences to identify with when learning about Biko and BC in the first part of the film, and through whom they can experience adventure in the second. Certainly the film 'truly invents' – while compressing, simplifying, sometimes embellishing, often containing minor alterations – much of what Woods tells us about himself, and how his relationship with Biko gave him an understanding of BC and drew him into the struggle. These portray events including and beyond those involving Biko: the informal circumstances of the meeting with Jimmy Kruger; Kruger's callous comments on Biko's death; his (Woods's) banning; the attacks on his home and child; and his escape disguised as a Catholic priest. But details that might confuse or appear politically contradictory are removed. We do not learn that Woods was still patron of the local police rugby team while befriending Biko, or that even when banned he (Woods) went on visiting golf and bridge clubs. Equally we are not told that Woods first addressed Ramphele in fluent Xhosa – he was brought up in the Transkei, as *Cry Freedom* later reveals – perhaps because this would have made white Westerners less able to identify with him; it certainly avoided the need for subtitles. Together with the fact that we are not told of Woods's many dealings with government ministers prior to the Kruger meeting, Attenborough's Woods is made to seem more of a politically naïve outsider than he actually was, more like (supposedly) the audience.[52]

There remains the matter of *Cry Freedom*'s portrayal of events where neither Biko nor Woods was present, notably Attenborough's spectacular set-pieces: his opening depiction of a police raid on Crossroads in 1975 and, near the end of the film, his reconstruction of events on 16 June 1976. The Crossroads sequence, praised by both Davis and Nixon for its evocation of apartheid's 'random brutality', is another example of 'true invention'.[53] Crossroads had come into existence in February 1975 as a government 'transit camp', a place where several thousand Africans – with and without passes – who had previously been scattered across the Cape were concentrated prior to possible removal. Police raids in search of those without passes duly began in March and continued throughout the year.

These, and raids elsewhere in Cape Town, led to some 24 000 prosecutions by the end of December. The future of the entire settlement remained uncertain. But thanks to the determination of (especially women) residents as well as white liberal (and international) support – not mentioned in the film – Crossroads survived. Given this survival, the shots showing shacks being bulldozed might be seen, misleadingly, as informing viewers that Crossroads was all but destroyed, and some shacks were indeed bulldozed. But if the impression is given that entire settlements were destroyed, this still might be justified as filmic metaphor: two other shantytowns, Modderdam and Unibel, suffered this fate in 1977.[54]

Cry Freedom deals with the Soweto Uprising in two sequences. In a telephone conversation, Woods informs Biko that schoolchildren are on strike because they refuse to study in Afrikaans and be trained merely to be 'servants in the system'. Biko replies that once people's minds have been changed, 'things will never be the same'. The subsequent reconstruction is confined to the first major clash between schoolchildren and police on 16 June, and includes students with clenched fists – the black power salute – and placards such as 'Afrikaans is the Oppressors language'. This sequence, like the Crossroads shots, draws on iconography of the struggle best known in the West: white police attacking unarmed blacks with bullets and whips. Attenborough also recreates – through similar framing, dress and arrangement of actors – Sam Nzima's photograph of the dying 13-year-old Hector Pieterson being carried away by one of his comrades. Attenborough recreates this image – as famously iconic of apartheid atrocities as Nick Ut's photograph of nine-year-old Phan Thi Kim Phuc (naked and burnt by napalm bombing) was of those in Vietnam – because it was an internationally well-known part of the historical record that lent authenticity to his representation.

Attenborough's main explanation of 16 June was the influence of the BCM: all the children appear to be using the black power salute and, as Woods tells Steve, 'the name Biko has been uttered here and there'. Biko's reply – 'Change the way people think and things will never be the same' – implies that BC inculcated a greater, and enduring, will to resist among black South Africans, signified by placards in the crowd such as 'Boers Out' and 'Defy Unjust Laws'. In highlighting BC influence, Attenborough's account was in keeping with the Cillié Commission, the government inquiry into the uprising. This blamed BCM 'agitators', which in turn justified banning numerous BC organisations and detaining leaders like Steve Biko.[55] Much subsequent historiography allowed that BC played a role, albeit as one of many causes. Historiography is often more cautious, though, on BC's precise influence on the organisations that organised the Soweto protests: the South African Students' Movement and Soweto Students' Representative Council. That the Afrikaans question was an immediate causal factor, albeit linked to a wider crisis in 'Bantu' education, is not disputed.[56]

This brings us back to the history in *A Dry White Season* and, to begin with, its more complex depiction of the causes and initial stages of the Soweto Uprising. Palcy argues that generational change and challenge was crucial. In contrast to *Cry Freedom*, *A Dry White Season* makes no overt mention of Biko or BC, mirroring Brink's novel, but does show school students using the black power salute, implying this influence. What is more explicitly shown is generational conflict: a scene of young people haranguing their elders at a municipal beer hall. Here Palcy asserts that young black South Africans were fighting for their freedom, that they criticised their fathers' drinking because it led to inactivity, and that drinking in such places 'buys bullets that kill your children'. This adds a dimension missing from *Cry Freedom*, and is in keeping with most contemporary accounts and academic analyses.[57] We are not told that children were often concerned simply with stopping their fathers wasting family income or that non-government sources of alcohol – shebeens and bottle-stores – were attacked by them, as well as municipal beer halls.[58]

In a subsequent sequence, featuring Gordon insisting that Jonathan continue to attend school, the latter and his friend argue that (unlike their parents) they will no longer tolerate inferior education meant to train them for menial labour, an education now made worse by having to study in Afrikaans. We are then shown the clash on 16 June, with students bearing placards decrying education in Afrikaans. After the shootings, Ben du Toit is shown reading an account of events in *The World* newspaper, with the Nzima photograph featuring prominently – helping to educate him as it should the audience – and, as for *Cry Freedom*, authenticating this filmic history. Much of the rest of the film focuses on the theme of security police atrocities aimed at rooting out 'agitators', suggesting that such acts drew even the previously apathetic, ignorant or would-be peaceful into the struggle: in the words of Ben du Toit near the end of the film, 'No-one will be free until all can be free', a message unlikely to be lost on the film's audience.

A Dry White Season, wishing perhaps to stress black defiance – yet softer on the police here than *Cry Freedom* – has a police officer with a megaphone clearly warning the students to disperse before firing teargas: they momentarily stop to listen before breaking into 'Nkosi Sikelel' iAfrika'. *Cry Freedom*, keeping closer to most reports, has a police officer (without megaphone) giving a warning that can only possibly be heard by the front row of marchers: to emphasise the point, Attenborough cuts to a shot from the back of the marchers in which what is happening at the front is far distant.[59] However, both films convincingly convey the point made by witnesses to the Cillié Commission that police presence and 'over-reaction', here and on many subsequent occasions, led to children being callously shot even when fleeing. Stanley's comment that conflict was spreading to 'all the townships' was a slight exaggeration; but at least it was a means by which *A Dry*

White Season correctly informs us that conflict was not confined to Soweto, and that it became widespread throughout most South African urban areas.

Both filmic depictions of the causes and events of 16 June have much in common with written accounts: they vary in the amount of information they convey, give different emphases to particular causal factors and, thereby, implicitly argue with one another. Given that portraying the Soweto Uprising is only a small part of their overall representation of South Africa in the mid-1970s, it is not fair to compare their (considerably more limited) details to a monograph on the topic. Nevertheless they predictably display many of the weaknesses of filmic history. They supply little in the way of statistical information: there are no numbers given for children killed or wounded in 1976 – one estimate was that, country-wide, this was 575 and 2 389 respectively by the end of the year – let alone for the precise ages, geographical residency or gender breakdown of the casualties.[60] Conveying such statistics might be difficult to do within the narrative conventions of Hollywood history; and the ends of both films have already been used to supply information in textual form. Equally they are weak on context. They say nothing about many underlying processes that made a revolt of some kind by town dwellers likely by 1976, with or without BC or the introduction of Afrikaans as a medium of instruction. These included economic recession, growing unemployment, a housing crisis, the increasing burden of supporting urban 'administration boards', and the strains on Bantu education of burgeoning student numbers.[61]

But they also contain many of the strengths of filmic history. They explain the significance of the (not-so-distant) past to the 'present': *Cry Freedom* by closing with a long list of those killed in detention up to March 1987; *A Dry White Season* by closing with text that read in part: '1989: The South African government continues to ban, imprison, torture and murder the men, women and children who oppose apartheid'. Both films provide narratives that humanise the past and emphasise the possibility of individual human agency, unlike most academic takes on South Africa in the 1970s and 1980s. We get multi-dimensional worlds which combine, for instance, politics with elements of popular culture rather than placing these into separate chapters.

The information that both films provide is often different to written history, and conveyed in the multi-media language of cinema. In a frame or two Western audiences are given a good sense of the appearance of unfamiliar places: the shanties of Crossroads, township housing (contrasted with wealthy white suburbia), or the interior of a beer hall in Soweto – even if all of these are 'true inventions', locations or sets in Zimbabwe (where the films were shot). The influence of BC on at least some Crossroads inhabitants is proposed in *Cry Freedom* by a poster of Biko on a shanty window; *A Dry White Season*'s sense that the Soweto Uprising

was, for many, a fight for complete freedom (not just a protest about education) is reinforced by *mise-en-scène*: a prominent placard among the marchers that reads 'The Whole System Stinks'. Films employ metaphors. By showing Afrikaner boys playing rugby, Johan scoring a dazzling try and making Ben du Toit an ex-star of the game (wearing a Springbok blazer when he first visits the security police), Palcy departs from the Brink novel: neither Ben nor Johan was any good at the game.[62] In doing so, she suggests a link between rugby, the construction of Afrikaner masculinity and Afrikaner nationalism – a supposition argued by a collection of academic essays in the 1990s.[63] After Du Toit's political conversion, neither rugby nor the blazer is shown again. And acting can convey historical meaning: the upright stance, exuding confidence, of Du Toit's first encounter is in stark contrast to Stanley and Gordon's bowing and scraping when visiting a police station – mock deference that Biko memorably described: 'In the privacy of his toilet his [a black man's] face twists in silent condemnation of white society but brightens up in sheepish obedience as he comes out hurrying in response to his master's impatient call.'[64]

Both filmmakers adapt their written sources – and in Attenborough's case the historical record – to provide additional historical information and argument. Thus Palcy has a boy in Du Toit's class reciting canons of Afrikaner history – the 'Great Trek' away from British oppression (in the Cape Colony) and wars against African 'tribes' – to say that learning this history played a part in constructing Afrikaner identity. Similarly, Attenborough has Kruger address Woods on Afrikaner history – not mentioned in the latter's account of the meeting – to make the point that history was used as part of Afrikaner nationalism's self-justification: not only the Trek, but also Afrikaner confinement in British concentration camps (during the South African War). In addition, Kruger asserts that 'we didn't colonise' South Africa, 'we built it'; so 'why should we give it away?' Here Attenborough – through Woods – uses the counter-argument that Africans helped build the country, and had to work for Afrikaners because they had taken their land. Palcy gives Susan, Du Toit's wife, dialogue in the same vein as Kruger, but adding the further self-justification that the rest of Africa was in 'a mess' and 'we have to survive'.

Both films make arguments about the origins and rationale of apartheid: that it was a result of Afrikaner victory over Africans, their (Afrikaners') desire to be free from British oppression, and their construction of a historical narrative that justified Afrikaner nationalist domination. Neither film reveals that it was British armies that decisively defeated African chieftaincies; nor do they say anything about the significant British/English-speaking contributions to the rise of segregation. As such, and in solely blaming Afrikaners for apartheid, they are in keeping with much liberal English-language historiography up to the

1960s. They are at odds with neo-Marxist 'radical' historiography of the 1970s and 1980s that largely blamed the destruction of African polities, the creation of reserves, the pass laws and the rise of systematic segregation and apartheid on the needs of (initially largely British/British colonial) capitalism.[65] Yet Palcy's argument – through Susan – that Afrikaner security was an issue is supported by a major recent history of Afrikaners that sees apartheid as 'The Making of a Radical Survival Plan'.[66]

Both films, again in predictable Hollywood history style, offer us history as a Manichaean struggle between good and evil. Altering the historical record or original novel is part of achieving this duality. Attenborough was prepared not only to gloss over Biko's weaknesses of the flesh, but also to make the security police smash up home industries in Leopold Street – which in fact housed BCM offices – making their actions more heinous for audiences. Palcy's Du Toit is morally purer than Brink's: she keeps his relationship with a female journalist platonic. She also adds servants to the Du Toit household, explicitly not there in the novel, thereby maintaining the stereotype of white South African households.[67]

Equally, neither film attempts to give a nuanced depiction of black South Africans. Instead they remain stereotypically poor, innocent victims. The only apparent deviation is Stanley, but we understand that he is driven by white evil – the killing of Jonathan, Gordon, Emily and Ben – to (momentary) drunkenness and, ultimately, violent revenge. The reconstructions of events on 16 June omit, for instance, the stabbing and setting alight of police dogs (not calculated to appeal to animal-loving Western audiences), or the beating to death of two white township officials. Nor do we see later developments, for example students burning down schools and medical clinics.[68] Perhaps Stanley's actions are a sufficient metaphor for such rage, but quite clearly both Palcy and Attenborough are unwilling to confuse their audience either by moving beyond moral dualities or by overloading their viewers with additional (complicating) information. Thus we gain no insight into the motives of thousands of Africans (black policemen, homeland leaders, township officials) who helped make apartheid work, nor into the position of South Africans – 'coloureds' or 'Asians' – somewhere between the 'black' and 'white' worlds.

Both films employed the well-worn device of a white male protagonist to make, in Nixon's words, 'obscure, squalid, tedious, and threatening "Third World" politics' seem 'adventurous' and 'manageable' to Westerners.[69] In other words, Nixon (and others) criticised the films for using whites to relate black experience, and for giving the latter insufficient attention. The *Washington Post's* Rita Kempley demurred: 'that's a little like whipping Paul Simon for introducing Ladysmith Black Mambazo to American audiences. In both cases, the ends

justify the means.'[70] Whether or not one agrees, both films clearly argue that we should accept black South African views ahead of those of whites, including those of white liberals. White protagonists – Woods and Du Toit – are portrayed as innocents; they have to be taught the true nature of apartheid, black experience and the struggle by Biko and Stanley. Black roles may be smaller, but black characters rather than white ones possess the authoritative voice on apartheid, and continually get the better of whites – whether white heroes or villains – in verbal exchanges.[71] In addition, Palcy (much more than Attenborough) uses parallel editing to switch between 'white' and 'black' worlds, to give the viewer somewhat less sense of following only the white protagonists' story.

Yet there remains a déjà vu similarity in the two films' perspectives. Filmic history, like historiography, can be enriched by different points of view (literally and figuratively) on the same topic. The challenge, if not the problem, for filmmakers wishing to depart from Hollywood formula is how to gain or retain audiences; though marketing and distribution are important, they are not the sole factors. *Mapantsula* (1988) was a South African 'state-of-the nation' film praised for foregrounding black experience, not least by featuring a black South African protagonist. With genuine South African settings, a South African cast and use of indigenous languages, the film related the gradual political awakening of a 'mapantsula' or thief. It was critically acclaimed for its powerful (anti-apartheid) message, its well-rounded central character, because it gave insights into black women's experiences and, in general, for its 'authenticity' (compared to our two Hollywood takes). Yet its screenings were largely confined to film festivals, occasional appearances at arts cinemas and, in time, late-night television airings.[72]

A World Apart (1988) was also critically acclaimed, winning the Grand Jury Prize at Cannes. This was another 1980s history film, one that featured women protagonists based on South African Communist Party activist Ruth First and her daughter Shawn Slovo (who wrote the screenplay), focusing on how First's political activities and detention affected Shawn. It possibly fared better than *Mapantsula* in box-office terms partly because its protagonists were white. But both *A World Apart* and *Mapantsula* may have failed to gain a substantial audience by not including other ingredients of Hollywood history success: sufficient 'spectacle' or adequately evil villains. *Cry Freedom* and *A Dry White Season* scored somewhat more highly in this respect, and perhaps consequently at the box office. This may have been in part because they deal with the more spectacularly violent and villainous mid-1970s, rather than 1963 – the year in which *A World Apart* was set.

Conclusion

What, then, has been the popular impact and critical reception of *Cry Freedom* and *A Dry White Season*? Gaining a sizeable audience was crucial if the main purpose of the films – beyond money-making – was to popularise an anti-apartheid message. Each undoubtedly reached more people than any individual written history of South Africa. One viewer was even moved to assert, in 2001, that '*Cry Freedom* helped in no small way to end apartheid'.[73] But, more soberly, Peter Davis judged that 'the public's response to the anti-apartheid films was disappointing, deflating Hollywood's interest' and that 'they came too late to do much more than throw some more soil on the coffin [of apartheid]'.[74]

Monetary takings give some indication of how many (paying) viewers the films attracted. They were certainly disappointing. *Cry Freedom* cost around $21 million to make yet achieved receipts of only $6 million, a fraction of Attenborough's *Gandhi* (more than $50 million), with *A Dry White Season* receiving (just) under $4 million.[75] Still, the very making of an anti-apartheid film by the director of the multi-Oscared *Gandhi*, as well as Attenborough's visit to South Africa in 1984 to visit (and receive the blessings of) Ntsiki Biko and Winnie Mandela, received worldwide publicity. Also helpful (ironically) was the South African Broadcasting Company's dubbing of Sir Richard as a dangerous subversive, and the South African government's banning of the film on the day of its South African release (29 July 1988).[76] And further publicity for both films was gleaned by casting of international (i.e. North American) stars such as Kevin Kline, Donald Sutherland, Susan Sarandon, Denzel Washington and Marlon Brando (his first film appearance in almost a decade). The last two both received Oscar nominations for Best Actor in a Supporting Role.

But the fact that neither film won a major international award reflects the lukewarm critical response. While reviewers generally applauded the intentions of both films, and many (especially in Europe) were enthusiastic, *Cry Freedom* in particular attracted negative comments: for being 'overly long'; for descending in its second half into a predictable 'adventure story' (of Woods's escape); and for failing to give sufficient screen-time to the more interesting of its two main characters, Biko.

All of these points may help explain why Attenborough's film failed to gain a greater audience than it did, despite Hollywood's considerable financial investment. But another possibility, and one that could account for the relative failure of all the late-1980s takes on apartheid, was that lack of audience interest was partly 'issue fatigue'. After more than a decade of extensive, ongoing news and

documentary coverage of apartheid, perhaps only the politically committed were likely to venture into the cinema to see more.

Yet we have argued that when the history in *Cry Freedom* and *A Dry White Season* is subject to closer scrutiny, much is either very close to the historical record or 'true invention'.[77] Certainly there are many elements of typical 'Hollywood history' in their narrative strategy and structure, in their sanitising and simplifications.[78] However, historical representation is marked at least on occasion in both films by skill and power, as even Nixon and Davis concede.[79] And there is a surprisingly high historical 'information load' in both films. As such they remain useful, empathetically engaging, visions of the 1970s South African past, whether as points of entry or for comparative purposes with other filmic or written offerings.

16

Hotel Rwanda: *too much heroism, too little history – or horror?*

MOHAMED ADHIKARI

Introduction

Hotel Rwanda[1] is based on the true story of Paul Rusesabagina (Don Cheadle), house manager at the luxurious Hotel des Milles Collines in Kigali, who used his position and influence to save the lives of 1 268 victims[2] who had sought refuge at the hotel during the Rwandan genocide. In what many will rank as the most horrifying episode in African history, an estimated 800 000 people, mainly Tutsis, were massacred by their Hutu countrymen in little more than three months between early April and mid-July 1994. Most victims were hacked to death with machetes, spiked clubs or farming implements. A further half a million people died as a result of disease, famine and military action, while over two million Hutus fled to neighbouring countries for fear of reprisals when a Tutsi-dominated government was installed by the invading Rwandan Patriotic Front (RPF), which took control of the country in July 1994.[3] These casualty figures are enormous if one takes into account that the population of Rwanda was in the region of seven million at the start of the genocide and that Tutsis formed about fifteen per cent or just over one million of this total.[4]

A unique and disturbing feature of the Rwandan genocide was widespread popular participation in the killing. While over 120 000 suspects were jailed by the RPF government by the end of the decade, many more participated directly in the killing. Some estimates range as high as a million.[5] An even greater number were accessories to the crime for betraying the whereabouts of victims, urging on the killers and performing auxiliary tasks. A large part of the Hutu population was complicit by regarding the killing as necessary, turning a blind eye to it, or failing to help victims.

At the start of the film Rusesabagina is depicted as a suave, stylish man who, through a combination of deference, flattery and canny bribery consciously stores up favours with the rich and powerful and, through his charm and resourcefulness, manages to keep the hotel's clientele happy. Paul, a member of the majority Hutu group, is married to Tatiana (Sophie Okonedo), a Tutsi, which puts them and their three children in grave danger once the slaughter begins. Left in charge of the hotel by the evacuating European management, Paul has little option but to allow more and more people fleeing the killing frenzy to cram into the Milles Collines, which is owned by Sabena Airlines. Mainly interested at first in saving his own family, Rusesabagina takes responsibility for all the refugees at the Milles Collines when it becomes clear that intervention by the United Nations (UN) is aimed solely at evacuating foreign nationals. An uncaring and racist West was turning its back on the Rwandan crisis. In a series of daring escapades the inspirational Rusesabagina cajoles, bribes, outsmarts and confronts a variety of military officers and militia commanders in a desperate bid to prevent the Milles Collines refugees, including his family, from being killed as the madness of the genocide envelops Rwanda. Through a combination of luck, resourcefulness and quick-witted responses in situations of extreme danger, Rusesabagina manages to keep the death squads at bay. Surviving several narrow escapes, the Milles Collines refugees barely succeed in holding out until the advancing rebel army allows them to flee to safety behind RPF lines in a convoy of trucks made available by the sympathetic UN Colonel Oliver (Nick Nolte). Through much of the film Paul and Tatiana try desperately to find their nieces, two young children lost in the maelstrom of violence when separated from their parents, who, it later transpires, have been killed. At the end of the film the Rusesabaginas are miraculously reunited with the children in a refugee camp while on their way to Tanzania.

An opportunity missed?

Hotel Rwanda makes little more than a cursory attempt to explain why the genocide happened or to sketch the political and historical context in which it unfolded. The film instead focuses on the intense drama around Rusesabagina's heroic attempts to save his charges. The choice of a strong dramatic centre clearly did not preclude Terry George from providing sufficient background to make the slaughter credible. This disembodiment of Rusesabagina's story from the complexity of its context is the central weakness of *Hotel Rwanda*.

Most obviously, better historical and political contextualisation would have made the genocide much more intelligible, and Rusesabagina's story more mean-

ingful to viewers. Simply replacing some of the superfluous and repetitive scenes, especially those involving a tearful and frightened Tatiana, with ones clarifying some of the complexities of the Rwandan situation would have gone a long way toward achieving these objectives. Appropriate contextualisation would also have helped to strengthen the flaccid plot line, and greatly improved the coherence of the film. More importantly, because it was the first feature-length offering with mass appeal to deal with the genocide in Rwanda – about which, it needs to be said, there is widespread public interest but a good degree of ignorance – it would not be unfair to regard the film as having a duty to inform, perhaps even to educate, viewers to a greater extent than it does. *Hotel Rwanda* is, after all, not a film people are likely to want to see purely for entertainment. On the contrary, *Hotel Rwanda*'s simplistic approach to the genocide is more likely to perpetuate rather than dispel stereotypes of Africa as a place of senseless violence and tribal animosities. The absence of a well-founded explanation of the genocide is bound to result in many viewers falling back on shop-worn, racist conventions of Western attitudes toward Africa. Indeed, the film inadvertently reinforces such mystification. When Dube (Desmond Dube) asks Rusesabagina how such cruelty could be possible, Paul simply replies, 'Hatred ... insanity', as if the mass killing defies logical explanation.

Terry George's overall approach may be summed up as one that evaded the key issues at stake in the Rwandan genocide. These would include why the genocide occurred, why there was such widespread popular participation and how one explains the ferociousness of the violence that was perpetrated.[6] As one reviewer commented: 'One of the ways filmmakers have traditionally tried to make unpleasant scenarios more palatable to audiences is by changing the focus from the awfulness of events to individual acts of bravery, from the complicity of the many to the heroism of the few. *Hotel Rwanda* saw the opportunity to take this path and did not hesitate.'[7]

Many viewers will have been enticed into seeing the film in the expectation of gaining insight into one of the most heinous crimes of the recent past. Instead viewers come away with little real insight but a formulaic story about the triumph of the human spirit in which the focus is diverted from the dire human cost of the carnage and disturbing questions it raises to the noble actions of a single hero. In celebrating the relatively minor triumph of Rusesabagina's extraordinary courage, *Hotel Rwanda* promotes a simplistic morality of good conquering evil and has very little of substance to offer by way of elucidating why the greater evil of the Rwandan genocide was possible in the first instance.

This is not in the least to criticise *Hotel Rwanda* for focusing on an individual, for individual experiences can indeed be a most effective vehicle for illuminating broader social, even global, experiences and truths. The trick in doing this success-

fully is to bring into a simultaneous frame of reference localised detail and broader social structures and experience. *Hotel Rwanda* fails to do this through a lack of proper contextualisation of its subject matter and by choosing to focus on a set of experiences that were atypical of the Rwandan genocide. Rusesabagina may well have succeeded in saving all of the refugees at the Milles Collines, but nearly eighty per cent of the internal Tutsi population succumbed in the genocide. A large proportion of those who survived were physically maimed, many died in the aftermath, and all were very deeply scarred emotionally and had little option but to continue a fraught existence as a small minority amongst a hostile majority.

These criticisms are also not in the least to argue that the film is not justified in reinforcing the optimistic message that the actions of individuals of conscience can make a big difference, even in the face of overwhelming odds and the most abominable evils imaginable. After all, like its most obvious parallel, *Schindler's List*, *Hotel Rwanda* is based on a true story and Rusesabagina deserves to be lauded for his bravery, integrity and altruism. But to communicate this message as ineptly as *Hotel Rwanda* does, represents a missed opportunity to disseminate a cogent understanding of the Rwandan genocide to an expectant world-wide audience, the greater part of which has had little opportunity for grappling with the meaning of this atrocity through the popular media. This is all the more the case, since the release of the film during the tenth anniversary of the genocide generated added popular interest.

These criticisms are made in full recognition that there are limits to what can be packed into two hours of viewing, to the demands that can be made on the attention span of popular audiences and the commercial imperatives that inevitably weigh on a film of this sort. *Hotel Rwanda* could, however, have done a far better job, given the constraints of the medium and the opportunities offered by the Rusesabagina story, of informing a receptive audience about the Rwandan holocaust and of raising consciousness about the scourge of genocide. The feature film is an extremely powerful medium and the Rwandan genocide a potentially explosive issue but *Hotel Rwanda* comes nowhere close to fully exploiting their potential. This is a pity given the filmmakers' good intentions and the urgency surrounding issues of genocide and state-sponsored mass murder.

The particular challenge of the Rwandan genocide

In the case of the Rwandan genocide one is faced not merely with the task of explaining how and why the genocide occurred but, crucially, also with accounting for large-scale popular participation in the killing. In his insightful study,

When Victims Become Killers, Mahmood Mamdani thus stresses that 'My *main* objective in writing this book is to make the popular agency in the Rwandan genocide thinkable'.[8] The particular challenge of the Rwandan genocide is to provide an understanding of how and why the hatred of one social group for another, both of whom had lived together for centuries, inter-married extensively and shared an identical culture, grew to the extent that hundreds of thousands of members from one group could in a three-month rampage kill over 800 000 compatriots. Most of the slaughter was conducted in face-to-face encounters involving acts of unspeakable cruelty and in many cases the victims were the colleagues, neighbours, friends, even family, of the perpetrators.[9]

Hotel Rwanda provides no real answer to this question and offers little more than two short pieces of discourse that are meant to furnish historical background and political context to its plot. The first is a voice-over from an RTLM[10] radio broadcast, presented against a black screen at the very start of the film, which summarises Hutu extremist attitudes toward the Tutsi:

> When people ask me, good listeners, why do I hate all the Tutsi, I say, 'Read our history.' The Tutsi were collaborators for the Belgian colonists. They stole our Hutu land, they whipped us. Now they have come back, these Tutsi rebels. They are cockroaches. They are murderers. Rwanda is our Hutu land. We are the majority. They are a minority of traitors and invaders. We will squash their infestation. We will wipe out the RPF rebels. This is RTLM Hutu Powa Radio.

This is supplemented by a two-minute bar-room scene early on in the film in which a Rwandan journalist explains the difference between Hutu and Tutsi to a Western counterpart, Jack Dalglish (Joaquin Phoenix):

> According to the Belgian colonists the Tutsi are taller, are more elegant. It was the Belgians that created the divisions ... They picked people – those with thinner noses, lighter skin. They used to measure the width of people's noses. The Belgians used the Tutsis to run the country. Then when they left, they gave the power to the Hutus and of course the Hutus took revenge on the elite Tutsis for years of repression.

After questioning two patrons at the bar about their identities – one of whom turns out to be Hutu, the other Tutsi – an incredulous Dalglish comes to the conclusion that 'They could be twins'.

This elucidation of Hutu–Tutsi differences is grossly simplistic and misleading, and is blatantly untrue in some respects. The suggestion that Hutu and Tutsi identities are the arbitrary creations of Belgian colonialism is clearly untenable. Also, the insinuation that Hutu and Tutsi are physically indistinguishable from each other is disingenuous. While some people classified Hutu conform to the Tutsi physical stereotype, some Tutsi 'look Hutu' and a good proportion

of people fall somewhere between the two racialised ideals, there clearly is also substantive correlation between social identity and outward appearance.[11] The best that can be said of the film's depiction of the Hutu–Tutsi distinction is that it embodies the idea that identities are socially constructed. Overall, the explanation of Hutu–Tutsi conflict provided by *Hotel Rwanda* does not make the genocide remotely credible.

Some comparison with another 2004 release on the Rwandan genocide, *Sometimes in April*, written and directed by Raoul Peck, is instructive as this film is more successful in contextualising the genocide and elucidating some of the complexities of the Rwandan situation.[12] This film is set in two periods, alternating between the unfolding of events during the genocide and the ongoing struggle in 2004 of protagonists to come to terms with their experiences of a decade earlier. At the centre of *Sometimes in April* is the relationship between Augustin Muganza (Idris Elba), a captain in the Rwandan army in 1994, and Honorè (Oris Erhuero), his brother, a Hutu extremist and broadcaster at RTLM. Because Augustin is married to Jeanne (Carole Karemera), a Tutsi, with whom he has three children, he is targeted by the genocidaires. Trapped in their house at the outbreak of violence in early April 1994, Augustin opts to entrust his wife and two sons to the care of his brother, who reluctantly agrees to drive them to the Milles Collines where they hope to find refuge. This was the last time Augustin was to see his family as he himself gets caught up in a desperate struggle to survive. In 2004 Augustin is living with Martine (Pamela Nomvete), a teacher who cared for his daughter after she was mortally wounded in a massacre at her boarding school. Augustin sets out to meet Honorè, who is standing trial at the International Criminal Tribunal for Rwanda (ICTR), in the hope of finding out what had happened to his wife and sons so that he might find some closure.

During the first thirty minutes, *Sometimes in April* provides historical and political context far more effectively than *Hotel Rwanda* by using a variety of devices including old newsreel footage, voice-overs, radio broadcasts, television interviews, snatches of conversation as well as Augustin responding to one of his sons asking 'Why do they call us cockroaches?' and 'What are we, Hutu or Tutsi?' An opening scroll provides an overview of Rwandan history much more cogently than *Hotel Rwanda*'s voice-over and bar-room scene taken together. That *Sometimes in April* weaves together the diverse experiences of half a dozen characters during the genocide gives the film richness and a representivity that *Hotel Rwanda* lacks. In addition, the 2004 storyline allows for the exploration of issues relating to justice, reconciliation and other difficulties involved in adjusting to a precarious post-genocidal existence. Compared to glimpses one is given of the multiple quandaries facing Rwandan society and the haunting sadness that pervades *Sometimes in April*, *Hotel Rwanda*'s calculated skirting of such issues

and its cheerful ending appear shallow. Although Peck's depiction of the genocide is by no means above criticism, it makes for much more meaningful viewing than *Hotel Rwanda* and it manages to do so without sacrificing the human and love-interest elements that help to hold the attention of viewers and draw them into identifying emotionally with the characters. Suffice it to say that George's snipe that Rwandans preferred *Hotel Rwanda* because 'Peck had spent too much time focussing on politics rather than the human side of the story' is unjustified.[13] That *Sometimes in April* offers so much more in a film only eighteen minutes longer than *Hotel Rwanda* is testimony both to the skill with which the former is crafted and to the amount of flab the latter carries.

Mamdani eloquently warns against ahistorical approaches of the sort deployed in *Hotel Rwanda*: atrocity cannot be its own explanation. Violence cannot be allowed to speak for itself, for violence is not its own meaning. To be made thinkable it needs to be *historicized*.'[14] This is not to suggest that the cause of the Rwandan genocide lies in ancestral hatreds or age-old tribal antagonisms as is often suggested in the Western media. On the contrary, the manipulation of social identities by politicians and political parties for their own purposes and short-term gain in the post-independence period was central to inflaming Hutu–Tutsi animosities. The film also hides from the viewer the intensifying struggle through the early 1990s for political power between factions of the ruling Hutu elite that precipitated the resort to genocide amongst extremists. Most immediately, the conflict could not have escalated into genocide of such scale and efficiency without meticulous planning of the mass murder as well as a determined and systematic execution of such plans using both the state bureaucracy and the armed forces. The Hutu–Tutsi cleavage and its intensification into blind hatred, however, have a longer history than *Hotel Rwanda* would have us believe. It predates the Belgian colonial presence even though Rwanda's colonial experience was integral to making genocide possible.

The historical and political context

A key observation of Mamdani's study is that colonialism was the crucible in which the pre-colonial identities of Hutu and Tutsi were recast and mythologised in ways that would later contribute directly to the genocide.[15] *Hotel Rwanda*'s claim that 'the Belgians created the divisions' smacks of a 'merrie Africa' view of the pre-colonial past. Indeed, that assertion is patently false, for when Germany first asserted imperial authority over this colony in the mid-1890s,[16] the greater part of present-day Rwanda was under the control of a centuries-old monarchical

state[17] fairly rigidly stratified into a ruling Tutsi elite, who almost exclusively prac-tised pastoralism, and Hutu commoners, who were mainly agriculturalists.[18]

In pre-colonial Rwandan society Hutu and Tutsi were neither ethnic nor racial identities. Firstly, there had been a thorough acculturation between the two groups by the time of colonisation. Over several generations Hutu and Tutsi inter-married extensively, came to share the same language, Kinyarwanda, as well as the same social customs and religion. Secondly, it was possible through the practice of *kwiihutura* (shedding Hutuness) for a small number of the most successful Hutus to become Tutsi, and for a fall in social status from Tutsi to Hutu (*gucupira*).[19] Also, Hutus were not completely excluded from power.[20] The distinction between Hutu and Tutsi was thus not rigidly defined by birth but was in essence a political one – about who exercised power and who was subject. Given this flexibility the Tutsi state was able to survive for over four centuries with surprisingly little conflict between Hutu and Tutsi.[21]

While neither *Hotel Rwanda* nor *Sometimes in April* mentions it, German colonialism was important in racialising Hutu and Tutsi identities and promoting inter-group conflict. The Germans' lack of interest in the colony and its resort to indirect rule meant that Tutsi structures of domination and state authority, the monarchy and the state bureaucracy, remained intact. Thus although the Rwandan state had lost its independence, the Tutsi elite actually became more powerful, using German backing to extend its control beyond the reach of the pre-colonial state and to exact higher tribute payments and labour service. These demands fell particularly heavily on the Hutu peasantry creating intense resent-ment. Indirect rule meant that, to ordinary Hutu peasants, their lives were not dominated by German colonial masters but by an increasingly oppressive local Tutsi elite.

Very importantly, under German rule the colonial establishment resorted to the Hamitic myth to explain the nature of the society it encountered in Rwanda and to justify the colonial order it instituted. Both German colonial administra-tors and missionaries saw Tutsi political dominance, as well as their typically tall, thin stature, as evidence of Tutsi racial superiority and that they were of Hamitic origin, while the Hutu were classified as Bantu and racially inferior.[22] The Tutsis were thus seen as natural allies for governing this colony and were taken up by the colonial state as collaborators to rule, administer and exploit in its name. The Hamitic hypothesis is important because it constructed Tutsis as an alien, conquering race, not even African, as opposed to Hutus, who were charac-terised as indigenous, the sons and daughters of the soil. This idea of the Tutsi as racially distinct foreigners, as invaders, was later taken up by Hutu nationalism and helped to sharpen the hatred and inform the fear and distrust felt toward Tutsi.

Belgian colonial rule[23] was significantly more oppressive and exploitative than that of the Germans. The brunt of this exploitation was borne by the Hutu peasantry.[24] The demands of the colonial government for forced labour for the building of roads and railway lines, the clearing of bush, the planting of trees for reforestation and the growing of export crops, were passed on by Belgian administrators to Tutsi chiefs, who then used their discretionary powers to enforce these measures. With unfettered control over the Hutu peasantry under Belgian rule, the Tutsi elite became rapacious, increasing both tribute payments and demands for labour service.[25] Hutu who failed to comply with the demands of Tutsi chiefs were severely beaten or were denied access to land, a sanction that spelt disaster for any peasant. This intensified exploitation impoverished the Hutu peasants and left them vulnerable to famine during years of poor harvests.[26] The effect of colonial rule was to harden patron–client relationships of the pre-colonial era into ones of out-and-out exploitation.

Besides solidifying the identities of Hutu and Tutsi into caste-like racial categories, colonial rule removed the flexibility and safety valves that had blunted social conflict in the pre-colonial Rwandan state. Firstly, the Belgians removed all Hutus from the state bureaucracy, making it entirely Tutsi.[27] Tutsis were also given special treatment in the education system in that they were placed in a separate stream and taught a superior curriculum in French as opposed to Kiswahili for Hutus. This was meant to ensure that only Tutsis would be qualified to occupy positions in the state bureaucracy, that Tutsis would retain dominance over Hutu and that values and beliefs appropriate to Belgian colonial interests would be inculcated into their surrogates.[28] Very importantly, the Belgian administration took the ultimate step in institutionalising the Hutu–Tutsi divide when it conducted a census in 1933. In the process all colonial subjects were classified as Hutu, Tutsi or Twa, and were required to carry passes that identified them as such. No longer could wealthy Hutu become Tutsi or disgraced Tutsi become Hutu. These identities now became permanent, absolute and inscribed in identity documents.[29] As is apparent in *Hotel Rwanda*, identity documents played an important part in killers identifying victims during the genocide.

The prospect in the late 1950s of Rwanda receiving independence[30] initiated an intense contest between Hutu and Tutsi over how and when decolonisation would occur because any degree of democratisation would either erode or overturn Tutsi political dominance. Tutsi hardliners demanded an immediate transfer of power to existing state structures while Hutu nationalists clamoured for further political reform to allow for Hutu majority rule. In this charged atmosphere of Tutsis claiming control of the state through right of conquest and Hutu nationalism painting the Tutsis as alien invaders that had enslaved the Hutu and stolen their land, a minor disturbance in central Rwanda in November

1959 escalated into a peasant revolt that soon spread to the rest of the country and became known as the Rwandan Revolution. Between one hundred and two hundred Tutsi were killed in the resulting pogroms, a number of Tutsi chiefs were forced to resign and perhaps as many as 150 000 fled to neighbouring countries.[31] Unable to quell the unrest, the Belgian authorities ousted Tutsis from positions of power and replaced them with Hutus.

As a result of the revolution, Rwanda gained independence on 1 July 1962 under a Hutu-dominated government led by Gregoire Kayibanda. The Kayibanda regime was autocratic, corrupt and fiercely anti-Tutsi. Possibly as many as 2 000 Tutsis were killed in a reign of terror in the months after independence. When exiled Tutsis launched a failed invasion of Rwanda in 1963, the Kayibanda government instigated the massacre of between 10 000 and 14 000 Tutsi living within the country. This set an ominous precedent of making the internal Tutsi population scapegoats for the actions of Tutsi exiles, of civilians participating in the killing and the property of victims being distributed amongst perpetrators. Further massacres of Tutsi occurred in 1967 and 1972–73, the latter in retaliation for the genocidal massacre of 200 000 Hutus by the Tutsi-dominated government of Burundi. Calm was restored to Rwanda when the minister of defence, General Juvénal Habyarimana, took advantage of the chaos to stage a coup d'état in July 1973.

The Habyarimana regime, though even more autocratic and corrupt than that of Kayibanda, was one of relative calm during the 1970s and 1980s, partly because the price of its main export crop, coffee, remained stable at relatively high levels and partly because Habyarimana took a softened stance toward the Tutsi. He allowed Tutsi participation in the government and administration in terms of a rough quota of ten per cent and tried to change the dominant Hutu nationalist discourse from seeing Tutsis as a race of alien invaders, to one that presented them as an indigenous ethnic group that was part of the Rwandan nation. The attempt to ameliorate attitudes toward the internal Tutsi population was negated by the failure to address the danger posed by exiled Tutsis. This neglect was in retrospect the key failure of the Habyarimana regime, for it was the actions of the exiles that was to trigger the civil war and the crisis that would lead to genocide.

Hotel Rwanda also provides little insight into the more immediate socio-political circumstances that contributed to genocide. There is no indication of the severe economic crisis into which the society was thrown when the international market price of coffee, from which Rwanda gained over half its foreign exchange earnings, plummeted in the latter half of 1989.[32] The resultant insecurity and hardship were important ingredients in the making of the genocide. Hard on the heels of the economic crisis came one of even greater proportions

when, in October 1990, an RPF invasion from Uganda plunged Rwanda into civil war. The small, ill-equipped Rwandan army was unable to counter the guerrilla tactics of the battle-hardened, well-disciplined RPF fighting force backed by the Museveni government of Uganda.[33] Throughout the early 1990s Rwanda was in the grip of civil war, which went badly for the Rwandan army and Habyarimana. Put under severe pressure by the RPF invasion, the economic crisis and a dramatic rise in military spending, Habyarimana was forced by his foreign backers, especially President Mitterand of France, to agree to a process of internal political reform and to negotiate a settlement with the RPF. By the latter half of 1993 these talks held at Arusha, Tanzania, yielded a ceasefire as well as an agreement to form a power-sharing transitional government with the RPF.

Demanding loyalty to the Hutu nation above all else in this time of unprecedented crisis, Hutu extremists, many of whom were to be found in the ruling party, the army and upper levels of the state bureaucracy, regarded Habyarimana's reforms as a betrayal and were determined to derail the Arusha agreement. In this extreme atmosphere of economic collapse, effective defeat in civil war, heightened racialised hatred, recurrent political assassination, periodic massacre of Tutsis[34] and a disintegration of social order, the Hutu extremist leadership resorted to genocide as a final solution to the problems facing the Hutu nation. The carefully planned genocide, which included the training of Interahamwe[35] death squads and the circulation of hit lists weeks in advance, was set in motion by the assassination of Habyarimana on 6 April 1994 when the aeroplane in which he was travelling was shot down over Kigali airport. A coup d'état by Hutu extremists followed and killings started within the hour. With 'a well organized civil service, a small, tightly controlled land area, a disciplined and orderly population, reasonably good communications and coherent ideology (of Hutu Powa), the lethal potential' of the Rwandan situation was realised during the next three months.[36]

Themes, motifs, devices

Some aspects of the early 1990s crisis are reflected in the early parts of *Hotel Rwanda* in that the society is presented as dysfunctional with palpable social tensions and a serious degree of political instability. Soldiers are a common sight on the streets of Kigali, an unruly Hutu Powa rally underscores the naked aggression felt toward Tutsis, and radio broadcasts spew forth virulent anti-Tutsi propaganda. That Paul is forced to source hotel supplies from a business run by an Interahamwe leader, George Rutaganda (Hakeem Kae-Kazim), is indicative

of endemic corruption as well as the economic woes of the country. Not only are ordinary commodities such as whisky, beer, rice and beans in critically short supply, but their sale is monopolised by a small group of people who are either part of, or connected to, the political elite. While a sense of disorder and a climate of fear in the society are communicated to viewers within the first few minutes, *Hotel Rwanda* comes nowhere close to evoking the profound sense of crisis or the degree of social chaos that prevailed in Rwanda on the eve of the genocide. Though chilling, episodes such as the spilling of a crate of imported machetes in Rutaganda's warehouse and the arrest of one of Rusesabagina's Tutsi neighbours do not convey much about the deep feeling of desperation that prevailed throughout Rwanda.[37] Popular participation in the genocide needs to be understood in the context of the acute, prolonged crisis that gripped Rwanda throughout the early 1990s. It was in particular the fear of a return of Tutsi domination that helped mobilise the masses to the cause of Hutu extremism.

While *Sometimes in April* similarly fails to provide a realistic sense of the popular experience of these exigencies, partly because its protagonists are middle class, its opening scenes are much more explicit about the orchestration of an impending mass slaughter. Whereas what one sees in *Hotel Rwanda* could be typical of any one of a dozen tin-pot regimes across the globe, *Sometimes in April* shows the training and indoctrination of Interahamwe, the distribution of weapons to them, as well as the circulation of hit lists. There is little doubt about the intended use of the crates of machetes imported from China by the military.

Hotel Rwanda has a decided tendency to understate the horrors of the Rwandan genocide and even to romanticise aspects of the story it tells. This is mostly due to a box-office strategy that seeks to make the genocide more tolerable to a mass audience, partly a result of trying to communicate an optimistic message about the ultimate triumph of human benevolence, and partly a product of the decision to focus on a case that is unrepresentative of the Rwandan catastrophe. The penchant for romanticism is nowhere more marked than in the clumsy wrapping up of the story at the end of the film. The improbable saving of the UN convoy from an Interahamwe mob through a fortuitous RPF ambush is inept, and the subsequent depiction of an all too orderly refugee camp with its all too ample medical facilities is a good example of the film's tendency to underplay the wretchedness of the Rwandan situation. Most conspicuously, however, the film succumbs to a cloying sentimentality with its conventional Hollywood ending.[38] *Sometimes in April* appropriately avoids any such neat resolution. Martine's heated question to Augustin 'How are we going to move forward?' is left unanswered.

Hotel Rwanda's sunny dénouement strikes a false note also because it actively encourages uninformed viewers to conclude that with the RPF about to capture

Kigali, the genocide will soon come to an end and Rwanda will settle down to an edgy calm.[39] This was far from the case, for not only did substantial killing continue within Rwanda itself for some time, but the regional repercussions of the genocide were to result in devastation for large parts of the eastern Democratic Republic of the Congo (DRC) and ongoing civil strife in Burundi through the latter half of the 1990s. *Hotel Rwanda* shows the mass exodus of refugees but is silent about its consequences – of chaotic, squalid camps in which death and disease were rampant, and of genocidaires regrouping, gaining effective control of these camps and sowing further mayhem and violence in the region. Seen within a global perspective, the upbeat ending of *Hotel Rwanda* is also hardly justified because the spectre of genocide is still very much abroad as the nearly contemporary Bosnian massacres and the subsequent mass exterminations of East Timor and Darfur demonstrate.

It should thus not come as any surprise that *Hotel Rwanda* quite deliberately avoids depicting the full horror of the violence perpetrated during the Rwandan genocide. In an interview in Johannesburg to promote the film, Terry George answered critics of his evasion of graphic violence by making clear that 'there was no way I was going to shoot a bloodfest film with people being hacked to death with machetes … I set out to create a political entertainment story rather than a pornographic depiction of the terror and violence.'[40] Thus the only actual killing one sees is a short, indistinct sequence of people being hacked by machete, filmed at a distance and replayed on a tiny television screen by members of the news crew stationed at the Milles Collines. For the rest, the slaughter is presented indirectly. For example, a few corpses are strewn about the front gardens of houses and Rusesabagina's blood-spattered son serves as evidence of the murder of one of his neighbours. The high point of horror in the film occurs when Paul and Gregoire (Tony Kgoroge) encounter the victims of a massacre after being deliberately sent along the 'river road' by George Rutaganda. Driving along, their van suddenly seems to hit an exceptionally bumpy and deeply rutted stretch. Thinking that they had strayed from the road, Paul gets out of the vehicle only to fall onto mutilated bodies that had been left lying in their path. Their grotesque poses and terrified facial expressions are depicted through the softening effect of pre-dawn darkness and swirling fog. The camera then pans upwards to reveal corpses carpeting the outstretched thoroughfare in the gathering light.

An obvious response to Terry George's defence is that confronting the reality of the awful violence that transpired in Rwanda does not have to be 'pornographic' or require a resort to tactics of the 'bloodfest' genre. Depicting mass violence in ways that do not diminish its reality for the viewer, yet do not denigrate victims or trivialise the pain of survivors, is one of the core challenges that filmmakers of genocide face. Such films will always raise vexing questions about

the ethics of creating entertainment out of mass murder, of appropriate ways of commercialising atrocity, and of how to engage viewers with visual representations of unspeakable cruelty without desensitising or alienating them. Finding a balance between these sorts of tensions lies at the heart of the making of feature films about genocide.[41] The specific circumstances of the Rwandan genocide demand a degree of engagement with human depravity and mass violence that is lacking in *Hotel Rwanda*. Terry George gets the balance wrong. There is too much heroism and too little horror in *Hotel Rwanda*, too much romanticism and too little reality.

Though it too is restrained in its depiction of violence, *Sometimes in April* rises to these challenges more successfully. Violence is not only much more prevalent and more graphic in this film, but one sees a greater variety of it, from individual killings such as the shooting of Augustin's friend Xavier (Fraser James), through the gang rape and subsequent suicide of Jeanne, to the massacre in which his daughter Anne-Marie succumbed. Much of the actual killing, though, such as the shooting of Augustin's sons and the execution of ten Belgian soldiers guarding the prime minister, is kept off-screen and machete killings are not shown. Some aspects of the violence are presented through oral testimony before the ICTR and *gacaca* courts,[42] and grosser forms are not referenced at all.[43] The high point of horror for most people in this film is likely to occur when Augustin encounters Martine and a helper removing the rotting corpses of her students from the dormitory where they had been massacred weeks earlier. Though inevitably a pale reflection of reality, *Sometimes in April* gives viewers considerably better insight into the ferocious violence of the Rwandan cataclysm.

Hotel Rwanda portrays in some detail two real-life, leading perpetrators of the genocide, namely General Augustin Bizimungu (Fana Mokoena) and George Rutaganda. Together they embody much of the pathology of Rwandan society as it is rendered in the film. Rutaganda, affable yet menacing, is the more interesting and rounded character, though Bizimungu plays a more prominent role in the film. As the first vice-president of the Interahamwe,[44] Rutaganda was not only an influential Hutu Powa leader, but also one of the inner-circle of planners of the genocide, as the crate of spilt machetes is meant to indicate. When Paul arrives before dawn to fetch supplies from Rutaganda's warehouse, it is apparent that the premises are being used to rape and torture Tutsi women before they are killed. Rutaganda drives up soon afterwards with a contingent of his followers, apparently fresh from a massacre – the butchered bodies of which Rusesabagina would encounter on his way back to the Milles Collines. Rutaganda makes no attempt to hide the nature of his activities, emphatically telling Paul that 'Soon all the Tutsis will be dead'. In response to Paul's horrified 'You do not honestly believe that you can kill them all?', Rutaganda matter-of-factly responds, 'And why not? We're

halfway there already.' In a parting shot he threatens the Milles Collines refugees: 'It is time to butcher that fat cow of yours for the meat.' Rutaganda represents the coldly calculating fanaticism that went into the making of the genocide.[45]

General Bizimungu, chief of staff of the army and a regular at the Milles Collines bar, is depicted as a hard-drinking, easily corruptible and highly gullible figure. In the film, especially in the latter stages, the bribes are too small and Bizimungu far too easily manipulated by Rusesabagina for him to be a credible character. From the way he is portrayed it would appear that it was the intention of the scriptwriters to make the point that some of the leading perpetrators of the genocide were venal fools. In an interview Terry George, however, claims that with the Bizimungu character, 'I wanted a level of complexity to it so that you understood there were different degrees of involvement or avoidance of the genocide. Clearly, he's a guy who had his doubts but, through his own corruption and his position, was forced into participating.'[46] If this was his intention it is ineptly executed.[47] By comparison, Sometimes in April's depiction of a brash, menacing Colonel Théoneste Bagosora, the key figure in co-ordinating and executing the genocide, is far more plausible.

An aspect of the genocide that is fairly thoroughly explored in Hotel Rwanda is the use of radio in the perpetration of the genocide. Rwanda being a society in which few people read newspapers and fewer still could afford television sets, but where radio ownership was widespread, the airwaves were the most effective medium of mass communication. Radio was an important channel for the dissemination of information by planners of the genocide, whether for more generalised intentions such as stoking hatred of Tutsis, or for very specific purposes such as summoning bulldozer drivers for the digging of mass graves. Indeed, prior to the genocide Hutu extremists distributed cheap radios free of charge, especially in outlying areas.

The motif of the radio broadcast is used throughout Hotel Rwanda, whether it is Rusesabagina picking up anti-Tutsi propaganda while driving, the hotel staff tuning in to keep abreast of developments, or genocidaires using it to incite the Hutu population. The film includes the most notorious of the refrains used by RTLM broadcasters, 'The graves are not yet full, who will help us fill them?' as well as the signal for the killing to start, 'We must cut the tall trees!' Hotel Rwanda on occasion uses radio broadcasts to give viewers information about the Rwandan situation, such as to inform the audience early on that a peace deal between the Rwandan government and the RPF is on the verge of being implemented and to reference that about half a million people had been killed by the time the first convoy of trucks is about to leave the hotel. Radio broadcasts are even used to drive the plot forward as when the Interahamwe use the radio to organise an ambush of that same UN convoy. Radio plays an even more prominent role in

Sometimes in April. Not only are radio broadcasts and voice-overs used more frequently, but one of the central characters, Honorè, is a broadcaster. He is forced to face the awful consequences of the hatred he has helped to incite when his nephews are executed before his very eyes at a military roadblock. His anguished plea of 'They are ours [i.e. Hutu]' goes unheeded. Later that night he has to wade through a corpse-filled ditch to retrieve his unconscious sister-in-law.

A major theme in *Hotel Rwanda*, one that is relatively well accomplished, is the failure of the international community to act, even when it became apparent that the escalating massacres were not the product of a spontaneous, popular uprising, but a planned extermination of the internal Tutsi population. It seems clear that playing on Western guilt about Rwanda is part of the film's commercial agenda. It is no coincidence that one of the main images used to market the film is of Rusesabagina and the rest of the Milles Collines refugees, nuns foregrounded, standing in the rain in front of the hotel as the intervention force and foreign nationals are about to leave, deserting the Rwandans in their hour of greatest need. The tagline used to promote the film was 'When the world closed its eyes, he opened his arms'.

When the violence erupted, foreign governments were mainly interested in evacuating their citizens and cared little about the fate of Rwandan victims. A shameful aspect of the Rwandan genocide is that a little more than two weeks after the start of the massacres, the United Nations Security Council (UNSC) passed Resolution 912 to reduce the troop strength of the United Nations Assistance Mission to Rwanda (UNAMIR) from 2 500 to a mere 270 despite repeated pleas by UNAMIR commander Roméo Dallaire to have reinforcements sent out and to be allowed to conduct arms seizures.[48] Member nations of the UNSC, especially the United States, feared being caught up in an intractable and costly conflict, as had happened with US intervention in Somalia the previous year. The UNSC decision to reduce its troop presence to a token force signalled to the genocidaires that the international community would not intervene and that they would have a free hand in exterminating the Tutsi. Kofi Annan, who headed the UN Peacekeeping Department at the time, correctly judged it to be less a lack of information than a lack of political will that stood in the way of an effective response by the international community.[49]

Some of this travesty is mirrored in *Hotel Rwanda*. Early on, Colonel Oliver, loosely based on Dallaire,[50] is made to state the UN's position in a television interview: 'We are here as peace-keepers not as peace-makers. My orders are not to intervene.' The determination of the West to avert its gaze even when it knew that a full-scale genocide was in progress is disclosed in the scene where the refugees listen to a radio broadcast in which the hapless Christine Shelly, US State Department spokesperson, tries to defend the use of the term 'acts of geno-

cide' as opposed to 'genocide' itself to describe what was happening in Rwanda. The Clinton administration resorted to these semantics because to admit that genocide was in progress in Rwanda would have obliged it as a signatory to the United Nations Convention on Genocide (UNCG) to act to stop the killing. That Paul within a matter of minutes is able to get Mr Tillens, the president of Sabena, to apply international pressure to avert their imminent slaughter when all the hotel's occupants are ordered out of the building by a belligerent Rwandan army lieutenant is meant to indicate how easily international pressure could have been applied to halt the killing and how little effort on the part of Western powers was needed to stop the genocide.[51] Though highly critical of the UN, the filmmakers are sympathetic toward the hamstrung Dallaire. Oliver is thus depicted as willing to intervene aggressively to stop the killing, but is frustrated by a lack of resources and a mandate that leaves him with little leeway to act. Nearly overwhelmed by a situation over which he has almost no control, Oliver nevertheless strives to do all he can to save Rwandan lives, not least those of the Milles Collines refugees.

Given the inertia of the international community, it was left to the invading RPF to put an end to the genocide. Spurred on by evidence of widespread mass slayings, the RPF captured Kigali on 4 July 1994 and mopped up the remnants of Hutu resistance within the next two weeks. *Hotel Rwanda* is thus favourably disposed toward the RPF. Not only does the RPF magnanimously negotiate a deal with the Rwandan army through Colonel Oliver to allow the Milles Collines refugees to escape to safety behind their advancing line, but RPF soldiers are also shown as saving their convoy when an Interahamwe mob closes in on it as it is about to cross over into RPF-held territory. This one-sided portrayal of the RPF is somewhat naïve, for although it put a stop to the genocide,[52] the RPF was complicit in the violence in a range of ways. The RPF invasion was a key element in the potent mix that resulted in genocide, it perpetrated a good deal of violence during the civil war, RPF soldiers carried out revenge killings of tens of thousands of people during and after the genocide,[53] and in April 1995 RPF soldiers were responsible for the death of perhaps 5 000 people in the notorious Kibeho camp massacre.[54] *Sometimes in April* is more balanced in its appraisal of the RPF, depicting both a revenge killing by its soldiers and the succour that others offer survivors hiding in a swamp.

Throughout the first half of *Hotel Rwanda* Rusesabagina is confident that the UN or an international intervention force will soon put an end to the killing. Paul tries to comfort an anxious Dube with the misplaced triteness that the extremists' 'time is soon over'. He also dismisses his brother-in-law Thomas's warning of impending mayhem on the presumption that the current violence will be curbed because 'the UN is here now' and 'the world press is watching'. In a later encounter Paul tries to reassure Dalglish that he was glad that their camera

crew had managed to film graphic footage of a machete massacre near the hotel because it would spur foreign intervention. The jaded Dalglish, however, does not share Paul's optimism. In a well-delivered line he explains that when Westerners 'see this footage they'll say "Oh my God that's horrible!" and they'd go on eating their dinners'. When the hoped-for international intervention force does arrive and it becomes clear that it was there only to evacuate foreign nationals, who in any event were not in immediate danger, Colonel Oliver expresses his anger by throwing a tantrum in which he slams his UN beret onto the ground at the feet of the intervention force's commander. A dispirited Oliver soon after vents his disgust at Western racism toward Africa. 'Paul, you should spit in my face … We [the West] think you're dirt, Paul … You're black, you're not even a nigger. You're an African … They're not going to stay, Paul. They're not going to stop the slaughter.' Later Mr Tillens points to Rwanda's lack of strategic significance to the West. 'They are cowards, Paul. Rwanda is not worth a single [UN] vote to any of them … The French, the British, the Americans.' More to the point is Colonel Bagosora's response in *Sometimes in April* to State Department official Prudence Bushnell's threat of US intervention. 'We have no oil here, we have no dams, we have nothing you need in Rwanda. Why would you come?'

It is ironic that this theme, which is probably the strongest element of *Hotel Rwanda*, is the weakest of *Sometimes in April*. The frequent cut-aways to discussions amongst Washington bureaucrats and Bushnell's futile attempts to persuade the US government to intervene are repetitious, belaboured and detract from the immediacy of the main story. The point about Western indifference was brilliantly made on the ground in Rwanda with the melée that ensues when UN troops evacuate expatriates from the Saint-Exupéry French school and when Xavier pleads with an intervention force officer at a roadblock to be allowed to follow their convoy to the Milles Collines in Augustin's car. The official's curt 'I am sorry, I have orders' seals his fate.

Interwoven with this theme of the international community betraying the people of Rwanda is that of the growth of Rusesabagina into an altruistic hero. The self-assured Rusesabagina that we see at the start of the film essentially acts from selfish motives, revelling in his success and the acceptance he wins from whites. He consciously cultivates those with power and influence for his own and his family's benefit. Thus when his neighbour Victor is arrested early on in the film and Tatiana implores him to use his high-level connections to intervene, Paul declines saying that he is storing up favours for when he or his family needs it. 'Family is all that matters,' he says. Paul is also reluctant to shelter neighbours at his house or to take on additional refugees at the Milles Collines. Throughout the first half of the film one sees evidence of Paul becoming more humane as the situation he faces becomes progressively more desperate. The turning point,

however, comes when it is apparent that the intervention force is aimed solely at rescuing foreigners. Western indifference to Rwandans' plight comes as an epiphany for Paul. He confides to Tatiana, 'I am a fool. They [whites] told me I was one of them and ... I swallowed it. And they handed me their shit.' The realisation that 'There will be no rescue ... We can only rescue ourselves' has a galvanising effect on Paul. He takes full charge of the situation, devoting himself and all the resources at his disposal to saving the lives of those who continue to crowd into the Milles Collines. An inspired initiative is to use the hotel's functioning telephone line to launch a highly successful campaign in which the Milles Collines refugees persuade international contacts to lobby foreign governments on their behalf. Paul's advice that 'We must shame them into sending help' underscores the film's message about Western indifference. Rusesabagina's maturing into a heroic figure is complete when he demonstrates that he is prepared to sacrifice his life for the refugees he has taken under his wing. Thus when the opportunity arises for the Rusesabaginas to leave for Tanzania in a UN-escorted convoy, Paul tricks the rest of his family into leaving without him. He calls out to a near-hysterical Tatiana trapped in the back of a departing truck, 'I cannot leave these people to die.'

Sometimes in April has a very different sort of protagonist – 'hero' is not an appropriate description. Rusesabagina and Muganza share obvious traits in that they are both middle-class Hutu men married to Tutsi women, which places both of them above the racial hatred that consumes their society. Their young children help to add suspense and tragedy. But unlike Paul, Augustin is not morally detached from the violence. As a captain in the Rwandan army, and one charged with providing Interahamwe with military training, although he has serious misgivings, he is complicit in the violence that destroys his family. And unlike Paul he is unable to avert disaster at the last minute. He is forced into decisions that ultimately send both his family and Xavier to their deaths. His life is messier, hardly heroic, and more realistic.

The glorification of Rusesabagina as having almost singlehandedly saved the refugees leaves little room for Tutsi voices to be heard. However much one might admire the figure of Rusesabagina in the film, and however honourable his actions in real life, one is compelled to ask to what extent he deserves being elevated to this heroic status. There is evidence to suggest that *Hotel Rwanda* considerably exaggerates Paul's role in the whole affair. Although the film on occasion indicates that wealthier Tutsi refugees tended to congregate at the Milles Collines, it fails to mention that one of the reasons this refugee community enjoyed relative immunity from death squads is that several Hutu Powa leaders deposited Tutsi loved ones – wives, lovers, family, friends – at the hotel. In an interview with journalist Philip Gourevitch, the real-life Rusesabagina recalled

how a prominent cleric and notorious militia sympathiser, Father Wenceslas Munyeshyaka who was attached to the Catholic cathedral of Saint-Famille a few hundred yards from the hotel, left his mother there with the words, 'Paul, I bring you my cockroach.'[55] Alison des Forges also claims that because they were a highly visible group whose safety was monitored by foreigners, the Milles Collines refugees received a measure of protection from high-ranking military officers, Bizimungu included, who were wary of attracting undue international censure.[56] Roméo Dallaire further claims that it was UN personnel rather than Rusesabagina who played key roles in saving the Milles Collines refugees. In an interview in January 2005 Dallaire explained why Rusesabagina did not merit a mention in the 550-page memoir of his experiences in Rwanda. 'It seems the filmmakers downplayed the eight UN observers who protected people in the hotel. They did a lot of the saving. The manager was there, and I was aware of him, but that's it. I remember he was helpful.'[57]

The distinctly South African flavour of the film detracts from its authenticity. Over three-quarters of *Hotel Rwanda* was shot in South Africa. Terry George cites the logistical difficulties of shooting in Rwanda as the main reason for this. One suspects a contributing reason is that a good deal of South African capital went into the making of the film, the South African Industrial Development Corporation being a major financial backer. The majority of the secondary characters are played by South Africans and the extras are also mainly South African. To anyone who has some familiarity with Rwanda, or with the streets of Johannesburg's larger black townships where much of the film was shot, too much of the backdrop to the action rings false. The frequent use of South African names, rather than ones that are typically Rwandan, is sloppy in the extreme. *Sometimes in April*, on the other hand, was shot entirely in Rwanda, which gives it a powerful sense of place. The film also makes extensive use of Rwandan actors, extras and crew. Although fictional, the film is based on copious research, especially eyewitness accounts. Peck describes it as 'an original story based on a million true stories'.[58]

Both films make extensive use of what Robert Rosenstone refers to as true invention to recreate the past, but they do so in very different ways. *Hotel Rwanda*, being based on a true story, recounts many actual events with real characters, often with a high degree of accuracy. While this chapter has identified diverse examples of false invention in this film, the main way in which it distorts historical truth is through omission, most notably by failing to place its story within an appropriate historical and socio-political context, and by considerably underplaying the violence and woe of the Rwandan situation. Although the story and characters of *Sometimes in April* are fictional, many of its scenes are based on eyewitness accounts and are filmed in the actual locations where they took place.

Not only is Peck's film far better contextualised, but it at times also has a strong documentary feel to it. Voice-overs, newsreel footage, television interviews, radio broadcasts and sub-titles inject factual information about the genocide that allows one to situate the evolving fictional story within the unfolding of real events. Thus although *Hotel Rwanda* is based on a true story, *Sometimes in April* represents a more authentic and, in many senses, a more accurate portrayal of the Rwandan genocide.

Conclusion

In the final analysis, *Hotel Rwanda* is a film of uneven quality. The film has won widespread critical and popular acclaim.[59] Audiences seemed to like the mixture of suspenseful drama and tender love story set within the framework of an inspirational account of ordinary humanity triumphing over the most abhorrent of evils. Film critics generally agree that Cheadle gives a performance deserving of his Oscar nomination and praise Okonedo, Nolte and Phoenix as well. It is also rare for a film primarily about Africans and with an African hero with agency to receive popular endorsement from Western audiences.

While it is moving, even potent, the film is seriously flawed in parts. Terry George limits his ability to exploit his medium and undermines the efficacy of his message by being too restrained in depicting the horror of the Rwandan genocide. The attempt at an uplifting ending is ham-fisted, if not open to censure for the questionable messages it conveys. Terry George's treatment of Rusesabagina's story deprives it of much of its power to provoke or enlighten. *Hotel Rwanda* is lacking in both complexity and the potential to raise disturbing questions about its subject matter. In this and almost every other respect, *Sometimes in April* comes out ahead.

Whatever its faults, the movie did reach a mass audience, kindling international interest in an atrocity about which relatively little was known. Amnesty International has tried to leverage the heightened public awareness about genocide created by *Hotel Rwanda* to promote education around the subject, and to lobby for intervention in Darfur. This is an indication that the film had a meaningful impact.[60] Films such as *Hotel Rwanda* may be said to play a role, however small, in helping an irresolute international community grope its way to a more effective response to the scourge of genocide. The more energetic response to the Darfur crisis indicates that there is a lingering sense of shame about Western inaction in Rwanda.

17

Looking the beast in the (fictional) eye: The Truth and Reconciliation Commission on film

~

DAVID PHILIPS

Having looked the beast of the past in the eye, having asked and received forgiveness and having made amends, let us shut the door on the past – not in order to forget it but in order not to allow it to imprison us.[1]

This chapter examines three feature films that deal with the South African Truth and Reconciliation Commission (TRC), and how it tried to handle issues of truth and reconciliation, human rights violations and the granting of amnesties, arising from the end of the apartheid regime in 1994. All three films were released in 2004: *In My Country*,[2] *Red Dust*,[3] and *Forgiveness*.[4]

The films

In My Country (based on Antjie Krog's book *Country of My Skull*)[5] is centred on Anna Malan (Juliette Binoche), an Afrikaner reporting on the TRC for the South African Broadcasting Corporation (SABC), who works closely with a black colleague Dumi Mkhalipi (Menzi 'Ngubs' Ngubane). In reporting on the Commission, she forms a relationship with an African-American reporter for the *Washington Post*, Langston Whitfield (Samuel L. Jackson), who is initially suspicious of the TRC, and hostile towards her as a white Afrikaner and presumed racist. But he is won over to a belief in the virtues of amnesty, forgiveness, reconciliation – and the African idea of *ubuntu*[6] – by his experience of attending TRC hearings (a number of which are depicted in the film), and his interviews

with Colonel de Jager (Brendan Gleeson), a notorious ex-security police killer. He and Anna Malan grow close and (though both married to others) have sex. Together they uncover a security police torture farm[7] – in which, it emerges, Anna's younger brother was involved; his exposure leads to his suicide. The film ends with the end of the TRC hearings; Dumi Mkhalipi is brutally shot dead by some of his former comrades for having been an *impimpi* (informer); Whitfield returns home; Anna Malan stages a form of personal reconciliation with her husband.

Red Dust (based on a novel by Gillian Slovo)[8] tells the story of one specific amnesty application heard by the TRC's Amnesty Committee over a few days in c. 2000, in the fictional small Karoo town of Smitsrivier. To Smitsrivier for the hearing come: Dirk Hendricks (Jamie Bartlett), a former security policeman serving 18 years in prison for the murder of a prisoner in custody; Alex Mpondo (Chiwetel Ejiofor), rising young ANC MP, who was interrogated and tortured by Hendricks back in 1986; and Sarah Barcant (Hilary Swank) – from the town originally, but who left after being arrested at the age of 16 for having an intimate relationship with a young African man, and now a successful lawyer in New York. Hendricks seeks amnesty for having tortured Mpondo; Mpondo, psychologically scarred by his torture, knows that what emerges from the hearing might damage his political career, but wants to find out what happened to Steve Sizela, an activist who was detained at the same time but who then disappeared. In the hearing, Hendricks establishes an initial psychological advantage over Mpondo, but is subsequently forced onto the defensive, and has to admit that the torture of Mpondo, and the torture and killing of Steve Sizela, took place on a nearby torture farm where, it emerges, the missing Steve is buried. Exhumation of the body shows that the man responsible for Steve's death is Piet Muller (Ian Roberts), a former security police captain now running a security firm in Smitsrivier. He has been a sinister presence throughout the film and tried to prevent Hendricks from revealing his involvement. Mpondo withdraws his opposition to amnesty for Hendricks, to whom it is immediately granted; Muller is arrested and charged with the murder of Steve Sizela, for which he immediately applies for amnesty.

Forgiveness takes place after the end of the TRC. Former security policeman Tertius Coetzee (Arnold Vosloo) comes to the (real) Western Cape fishing village of Paternoster and makes contact with Father Dalton (Jeremy Crutchley), who takes him to the house of Hendrik Grootboom (Zane Meas), a coloured fisherman, and his wife Magda (Denise Newman). Coetzee killed their eldest child Daniel, was granted amnesty by the TRC and now wants to apologise to Daniel's parents and ask for their forgiveness. Their daughter Sannie (Quanita Adams) and younger son Ernest (Christo Davids) are hostile towards him. Sannie phones Llewellyn (Elton Landrew), a coloured former comrade of Daniel's who

now lives in Johannesburg. He tells her to keep Coetzee there long enough for him and two other former comrades – black Zuko (Hugh Masebenza) and white Luke (Lionel Newton) – to make the long trip to Paternoster. Sannie persuades Coetzee to come back the next day, and persuades her parents to receive him. Ernest is notably hostile to this idea as he doesn't know Sannie's ulterior motive. Coetzee returns to a tense and uncomfortable atmosphere. To keep him there, Sannie gets Coetzee to tell them about his interrogation, torture and killing of Daniel on a security police torture farm near Cape Town. As Coetzee describes torturing Daniel, Ernest moves behind him and suddenly smashes the teapot down on his head, causing him to bleed profusely; Father Dalton rushes Coetzee to the hospital. Sannie tells Ernest about the three ex-comrades coming to kill Coetzee and Ernest now helps her to keep him there longer. Meanwhile the three ex-comrades, on their way to Paternoster, fight amongst themselves over who betrayed Daniel to the police. They go to the remote spot where Luke hid the AK-47 rifles and ammunition and retrieve them, still in working order. Coetzee returns to the Grootbooms, for the third time, and invites the family to dinner at the town's hotel, where they dine in style and relax somewhat. After dinner Sannie, now feeling friendlier towards Coetzee, warns him that the ex-comrades are coming, and tells him to get out while there is time. Coetzee tells her that one of those three betrayed Daniel, but does not leave. The next morning, Coetzee, the Grootbooms and Father Dalton go out to Daniel's grave, and are there when the three ex-comrades arrive. It becomes clear that Zuko was the informer, and he shoots Coetzee with an AK-47, killing him. The three then drive off at high speed. The final scene shows the Grootboom family apparently reconciled among themselves: Hendrik takes Ernest fishing with him; Magda, a virtual invalid since Daniel's death, is back outside and planting flowers; and Sannie leaves Paternoster on the bus – presumably for good.

The Truth and Reconciliation Commission (TRC)

Apartheid was the official policy of the South African government from 1948 to 1994. Well before it finally ended, it had become a target of international condemnation and had been declared to be a crime against humanity. In its final decade, in particular, the major trading nations of the world imposed international economic sanctions against the government of South Africa. Apartheid enacted the most complete code of racial legislation since the Nazi Nuremberg Laws and was responsible, *inter alia*, for destroying black communities under the Group Areas Act and for forcibly relocating 3.5 million black rural dwellers

under the 'Bantustan' legislation. To protect itself, the South African state gave its security forces licence to shoot, arrest, detain without trial, torture and kill those who challenged its rule – from the Sharpeville massacre of March 1960, through the suppression of the Soweto Students' Uprising in 1976, to the atrocities committed under States of Emergency in attempts to suppress the township revolt of the 1980s.

When apartheid was finally ended by a negotiated new constitution and the first democratic elections in South Africa, the new government passed legislation to set up a Truth and Reconciliation Commission (TRC),[9] to investigate and record the gross human rights violations of the apartheid period. In the last quarter of the 20th century, truth commissions became an important new institution of transitional justice – the intermediate stage for countries making the transition from authoritarian to free and democratic regimes. The South African TRC was the most significant and successful of the 21 such bodies set up in Latin America and Africa in that period. It was the largest, best resourced and most thorough of the truth commissions; it was the only one that offered conditional amnesty for perpetrators of atrocities, provided that they applied individually for each human rights violation and made full disclosure of their acts. It was extensively reported on by both national and international media.[10]

The new government was bound, to some extent, by the negotiated settlement, which committed it to deal with the conflict and crimes of the apartheid regime on the basis of 'a need for understanding but not for vengeance, a need for reparation but not for retaliation, a need for *ubuntu* but not for victimisation. In order to advance such reconciliation and reconstruction, amnesty shall be granted in respect of acts, omissions and offences associated with political objectives and committed in the course of the conflicts of the past.'[11]

Since 1945, two basic models have evolved in international law for dealing with transitional justice. First, the 'Nuremberg model' – used in the Nuremberg and Tokyo tribunals in 1945 to try the leaders of Nazi Germany and Japan, and only used twice since in international tribunals set up by the Security Council to deal with the former Yugoslavia (1993) and Rwanda (1995). The second is the 'Latin American model' of the truth commission. South Africa opted for the 'Latin American model'; its legislation committed the TRC both to finding and recording the truth about atrocities, and to promoting 'reconciliation' among the various ethnic communities of the 'new South Africa'. The Promotion of National Unity and Reconciliation Act set up a TRC with 17 commissioners with a brief to achieve four major objectives. First, to establish as complete a picture as possible of 'gross violations of human rights' in the period between March 1960 and May 1994. Second, to grant amnesty to individual perpetrators of such offences who applied and could show that: the offence was committed in the period between

March 1960 and May 1994; it was associated with a political objective; and the perpetrator satisfied the committee that he had made full disclosure about it. Third, to establish the fate of the victims of such offences, to restore their dignity by giving them or their families the opportunity to tell their story, and to recommend measures of reparation for victims or their dependants. Finally, to compile a report of the TRC's activities, with recommendations of measures to prevent future violations of human rights.

The TRC held hearings (normally in public), and had the power to subpoena witnesses and compel them to answer questions or produce materials. It worked through three committees: one that dealt with human rights violations; another for the granting of amnesty; and a third that focused on the reparation and rehabilitation of victims. The public hearings of the Human Rights Violations Committee (HRVC), at which victims[12] told their stories, recorded and publicised through media reports the nature of many of the atrocities committed. Together with evidence from perpetrators who made full disclosure to the Amnesty Committee (AC), this enabled many family members to find some form of emotional closure where their loved ones had simply 'disappeared'. The AC was the most formally legal – staffed by lawyers and chaired by a judge – and the most practically powerful of the committees. If it found that an applicant satisfied the requirements, it was required to grant him (almost all the perpetrators who went to the AC were male) amnesty for that act; he then acquired full immunity against both criminal prosecution and civil litigation. The Reparations Committee was much less prominent than these two committees, and the reparations issue – both individually for victims or their families and symbolically for affected communities – was poorly handled by the TRC, and by the South African government thereafter.[13]

The TRC began its public hearings in April 1996, and published its five-volume report in October 1998. The AC, however, continued hearing applications well into 2001 and it was not until 2003 that the South African government belatedly announced the financial reparations that it would pay to victims (considerably less than those recommended by the TRC), and the TRC issued the final, sixth and seventh, volumes of its report. The HRVC took about 22 000 statements from victims, and about 2 000 of those gave public testimony at HRVC hearings. The AC received 7 127 amnesty applications[14] – most of them from people already serving prison sentences. The great majority of these applications (more than 5 000) were refused without a hearing, usually because the offences had no political objective. Of those that went to a public AC hearing, only 1 167 were granted amnesty by the AC.

The TRC on film: courtrooms, accuracy,
inaccuracy, true and false inventions

The TRC was a major landmark in the history of post-apartheid South Africa and it has been widely reported upon and analysed as a case study of considerable significance for Africa, for other former colonial possessions of European powers, for formerly authoritarian regimes, and for countries trying to deal with problems of racial and ethnic discrimination.[15] During its lifetime between April 1996 and October 1998, it attracted a great deal of media coverage, both national and international. The hearings where victims testified to the HRVC about atrocities committed against them or their loved ones, and where perpetrators hoping for amnesty testified to the AC, were open to the public and were generally filmed by television cameras. As a result, much footage was shot of the hearings themselves, to be shown (every week, while the Commission was in session) to South African viewers on the SABC; or to be shown (less frequently) on news or current affairs programmes internationally.[16]

Not surprisingly, it also attracted documentary-makers who recorded the TRC and its investigations, both its public hearings and its interviews with victims, perpetrators and other involved parties. The best-known of such documentaries are the American *Long Night's Journey into Day*,[17] and the South African *Between Joyce and Remembrance*.[18] *Long Night's Journey* deals with four case studies from the TRC: Amy Biehl, the American Fulbright student murdered by PAC-supporting youths in Gugulethu in 1993; the abduction and murder by security policemen of the 'Cradock Four', the leaders of the UDF in the Eastern Cape town of Cradock, in 1985; the placing of a bomb, which killed three young white women, in Magoo's Bar in Durban by Robert McBride, as an operative of Umkhonto weSizwe; and the entrapment and killing by security police of the 'Gugulethu Seven', seven black youths who believed that they were joining Umkhonto weSizwe, in 1986.[19] By using footage shot in the relevant HRVC and AC hearings, the directors conveyed a very good sense of the workings and content of the TRC hearings.[20] By combining these with interviews with those victims and perpetrators who were willing to talk to them, they were also able to pursue larger and more ambitious themes of reconciliation and forgiveness.

Between Joyce and Remembrance focuses on just one case – the disappearance in 1982 of black student activist Siphiwo Mtimkhulu. It was eventually shown, via the TRC, that he was abducted, murdered and his body disposed of by the security police. By concentrating on the long and painful efforts of Joyce Mtimkhulu, Siphiwo's mother, to get the truth publicly revealed and acknowl-

edged, and on the security policeman Gideon Nieuwoudt who belatedly sought amnesty for that crime and disclosed what he had done, director Mark Kaplan was able to use this one case to say a great deal about the anti-apartheid struggle in the 1980s, the brutalities of the security police, and the role of the TRC in trying to discover the truth about people who 'disappeared' by granting amnesty in return for full disclosure about offences deemed 'political'. The last part of the film also raises interesting, and possibly disturbing, questions about the TRC's ideas on reconciliation and forgiveness.[21]

The three feature films discussed in this chapter were all made a little later than the documentaries. All three place the TRC within a fictional setting in order to raise and attempt to resolve related issues of truth, reconciliation and forgiveness. Robert Rosenstone, in discussing how fictional feature films handle historical issues,[22] has pointed out that 'all films will include fictional people or invented elements of character ... We must recognize that film will always include images that are at once invented and true; true in that they symbolize, condense, or summarize larger amounts of data; true in that they impart an overall meaning of the past that can be verified, documented, or reasonably argued.' Rosenstone goes on to distinguish between what he calls 'false invention' (that 'ignores the discourse of history') and 'true invention' (that 'is an invention of something that could well have happened ... the invention of a truth').[23] This is a useful distinction which we can try to utilise in analysing these three films.

In My Country, though a fictional feature film, is the closest of the three to the documentary form as it is based on *Country of My Skull*, Antjie Krog's highly successful book about her experience of reporting on the TRC for the SABC. Antjie Krog was a well-known Afrikaans poet and writer before she reported on the TRC, and grew up in an Afrikaner family on a farm near Kroonstad in the Orange Free State.[24] Krog is something of a renegade Afrikaner who scandalised her small rural community by writing sexually daring poems while at school, and subsequently taking the opposite side to most of her family and supporting the anti-apartheid cause. *Country of My Skull* is a wonderfully evocative and sensitive book; Krog uses various imaginative techniques to re-create in words the atmosphere in both the HRVC hearings in which victims testified about what was done to their loved ones, and the AC hearings in which perpetrators gave evidence about what they had done (and memorably, in the case of police torturer Captain Jeffrey Benzien, who actually demonstrated to the committee how he had used the wet bag method of torture on detainees).

Krog also writes powerfully about the psychological impact on her, and on other reporters and members of the Commission, of having to listen and respond to such material for sustained periods of time. In particular, she reflects on the irony of her being an Afrikaner reporting so many dreadful things done by fel-

low Afrikaners in the name of the Afrikaner *volk* and their government.[25] The dedication of the book reads: 'For every victim who had an Afrikaner surname on her lips'; and she notes, of the early HRVC hearings, that 'Afrikaner surnames like Barnard, Nieuwoudt, Van Zyl, Van Wyk, peel off victims' lips'. Her comments before the first AC hearings on which she reported re-live her love-hate relationship with her fellow Afrikaners who were responsible for the evils of apartheid. Her phone calls for information from the army and police generals who were about to testify produced nothing:

> I'm told to get lost in the *ons-is-nog-steeds-baas-al-dink-jy-nie-so-nie* tone [The we-are-still-the-boss-even-if-you-don't-think-so tone.] … The military squad marches into the venue in Cape Town for Operation Shut Up and Deny. And one has actually forgotten how they look: the clipped little moustaches, *snorretjies*; the shifty eyes; the arrogant circumnavigation of questions. When General Deon Mortimer opens his mouth, a chill runs down my spine. I have forgotten the worst: the brutal Afrikaner accent and the unflinching tone.[26]

Country of My Skull also contains interludes dealing with Krog's relationship with her family – her parents and two brothers, and her husband and children – in between reporting on the TRC; this aspect of her life is given considerably more attention in her subsequent book, *A Change of Tongue*.

As a book about the TRC, and the experience of reporting it, *Country of My Skull* is a wonderful success. Can such a book, reporting many hearings over more than two years, be successfully turned into a feature film? Scriptwriter Ann Peacock and director John Boorman thought that it could be done. Krog had nothing to do with the screenplay once she had granted the film rights, and had reservations about how well it could work as a feature film: 'My own feeling was that it was not possible to make a film out of my book. It has no story unless you tell the story of the commission itself and then you need to make a documentary.'[27]

The film, given the title *In My Country*, tries to use its Krog-figure, Anna Malan, to hold together the story, which includes a number of hearings of what are meant to be both the HRVC and AC (though this distinction is not made at all clear in the film). It would always have been difficult to translate Krog's book successfully onto the screen as fiction rather than as a documentary but, given that initial premise, Peacock and Boorman aggravated the problem by making some poor decisions. The black American Langston Whitfield was invented for the film for the love interest, and to act as the outsider to whom the background of South Africa, the TRC, *ubuntu*, etc. would have to be explained by locals – in order to educate the ill-informed American audience at whom the film is aimed.[28] The latter purpose is understandable and is not unhistorical. However, as is often the

case in historical films that want to convey a lot of background information to their audiences as quickly as possible, it is done badly. It tends to impart to sections of the film a wordy didactic tone – as if the audience is being fed a quick history lesson on South Africa, slightly sugar-coated by the fictional treatment.

Film-makers have long known that legal trials and courtroom settings make for good drama on screen. The TRC's committee hearings, while not conventional trials, included enough inherent drama in their revelations about abductions, torture and killings (especially those of the AC, which included cross-examination), to make them good material for dramatic set-pieces.[29] Both *In My Country* and *Red Dust* capitalise on this fairly effectively – though this advantage tends to dissipate in the former as the film progresses. The scenes of the early TRC hearings supply human drama and interest in *In My Country*; the film offers five such hearings, recognisably drawn from actual TRC cases in different parts of the country. However, as the film progresses, this becomes a growing problem. For one thing, the film blurs the real-life distinction between HRVC hearings at which victims testified (but were not cross-examined or otherwise put under pressure) about what had been done to them or their loved ones, and AC hearings, at which perpetrators testified, and were cross-examined (sometimes rigorously), about the offences they had committed. The film's scenes show what are essentially HRVC hearings, but perpetrators are also present at them and are called on to comment – a piece of 'false invention' that is inaccurate and only serves to muddle the actual functioning and achievements of the TRC and its committees. More seriously, by trying to cover five different hearings involving very different people and situations in various parts of the country, the film loses dramatic focus, and makes it difficult for the viewer to keep track of all the people and cases. Towards the end of the film, two incidents (the first dead body exhumed at the torture farm and the shooting of Dumi Mkhalipi for informing on his comrade) refer back by name to the first two cases raised at the very first hearing – but the connections are not well made and the viewer would have had to be concentrating very well to notice these points. The film would have worked much better by focusing on fewer cases, preferably just one or two, in greater depth.

Red Dust works much better in this respect, both as a film and as a portrayal of the TRC in action, by focusing the story on just one amnesty application. The film is able to use that one case to develop the individual characters involved, whom the viewer is able to get to know, and its context within the town. It can then effectively build up the tension involved in the questions of whether or not Alex Mpondo cracked under torture and informed on his comrade, and who was responsible for Steve Sizela's death and disappearance. The AC hearing of Hendricks's application for the torture of Mpondo works as a piece of 'true

invention'; it accurately reproduces the setting, workings and atmosphere of an AC hearing, and effectively handles the drama to be derived from the interaction between the perpetrator, the 'victim' (even though he explicitly rejects that label), his counsel, the presiding panel, and the vocal audience of locals.

In My Country also contains some inaccuracies (as opposed to inventions) that were avoidable, and therefore likely to annoy South Africans who will easily spot them. One such inaccuracy suggests a certain cavalier attitude towards South Africa's major black ethnic groups on the part of the film-makers. A key scene takes place in the Free State, where the Malan family have their farm. Their faithful servant Anderson (who was born on the farm) goes to the TRC to report his harassment by the police, who broke everything in his house and destroyed his trees. He prefaces his testimony by reciting his generations of forebears, going back to King Thembu, punctuating each generation by thumping his stick on the floor. This recital is taken straight from Krog:

> King Thembu begat Bomoyi,
> And Bomoyi begat Ceduma
>
> …
>
> and Gangeliswe begat Dalindyebo,
> and Dalindyebo begat Jongiliswe,
> and Jongiliswe begat Sabata,
> and Sabata begat Buyelakaya,
> and this is where I begin.[30]

But Krog records this as being recited in an actual hearing, punctuated by thumps of his stick on the floor, by Chief Anderson Joyi, a Xhosa chief in the Transkei; anyone with any familiarity with Xhosa history or the Thembu royal house (which includes Nelson Mandela) will recognise the names. In the film, however, Anderson, being born on the Free State farm, is (as Krog records of the servants on the farm) from the BaSotho people – this royal Xhosa lineage can have no connection with him. He would also speak SeSotho not isiXhosa, as the film suggests when it has him supporting his views on *ubuntu* by quoting Tutu's favourite Xhosa proverb: *Ubuntu ungamntu ngobanye abantu* ('People are people through other people').[31] Apparently this error did not worry Peacock or Boorman, but it is as accurate as endowing an Irishman with an English royal lineage, or a Frenchman with a German one. It is an avoidable inaccuracy – getting it wrong serves no necessary purpose for the story.

Another avoidable inaccuracy comes in Colonel de Jager's application for amnesty. The film depicts the decision on his application being pronounced in a conventional courtroom by a judge, rather than by the Amnesty Committee, as was in fact done. The judge announces that De Jager's application for amnesty has satisfied the criteria of disclosure and political motive, but fails on the issue

of proportionality, and he will therefore be prosecuted on 63 counts of murder. This is misleading in a number of ways. Central to the amnesty process was the principle that there should be no blanket amnesty; perpetrators had to apply separately for each offence. Eugene de Kock, the model for De Jager, was prosecuted in 1994, shortly after the first democratic election and well before the TRC was set up. The trial was a long and complex one and eventually, in August 1996, he was convicted on 89 charges, including six of murder and two of attempted murder. In October 1996, he was sentenced to serve two life sentences plus 212 years. From prison, he applied for amnesty for all these offences naming police generals and government ministers who had given him his orders, and was granted amnesty for almost all of his offences. He was refused in only five cases where the AC panel found that there was no clear political objective in the killing or, in one set of murders, where they held that 'the killing of the deceased was wholly disproportionate to any objective which applicants might have pursued'.[32] The film could, without impairing the dramatic role played by De Jager in the film, have got this part of the amnesty procedure right.

In contrast, *Red Dust* does get the procedure of the AC hearings right by focusing on only one amnesty hearing. It is able to use this focus on this hearing in one place not only to achieve artistic unity and a tight narrative and build-up of tension, but also to capture the somewhat claustrophobic atmosphere of a small Karoo town under apartheid (and post-apartheid). It was filmed in Graaff-Reinet, which makes a splendid Smitsrivier – both the gracious old white town and the poverty-stricken black township. The (continuing) racial and ideological divisions of the town are visually conveyed, both by the contrast between the white town and the black township, and by showing the opening of the hearing accompanied by placard-bearing black comrades doing the *toyi-toyi* with white Afrikaners praying for Dirk Hendricks under the guidance of a *dominee*.[33]

Forgiveness benefits similarly, both dramatically and in terms of the authenticity of its invention, from focusing on just one place and on a few characters that we are able to get to know quite well. Here all the action takes place after the end of the TRC, and is influenced by the AC's decision to grant amnesty to former security policeman Coetzee for the murder of Daniel Grootboom. One of the strengths of the film is its creation of a powerful atmosphere in Paternoster, shown – like Smitsrivier – to be a small, parochial, rather claustrophobic community, where the effects of Daniel's murder still resonate many years later. It also sensitively explores the internal strains in the Grootboom family and the unresolved tensions stemming from Daniel's death. Not least of the reasons for this is its sense of authenticity – both in its location in Paternoster, and in the fact that (unlike the other two films) all the actors are South African.

The nationality of the leading actors in each film is of some relevance to the

question of how well they work in conveying a sense of authenticity. Both *Red Dust* and *In My Country*, as international films seeking international money, felt the need to offer potential backers some well-known international names. This works less well in *In My Country*, where three of the four main actors are non-South African; only Menzi Ngubane, playing Dumi Mkhalipi, is South African. Samuel L. Jackson is appropriate for the black American, but this is not true of the two leading actors playing white South Africans. Juliette Binoche, good actress though she is, struggles, as Anna Malan, to play a convincing Afrikaner. John Boorman did consider casting Charlize Theron – who is not only South African but also an Afrikaner – but decided against it.[34] The result is a central character who is far from convincing. Even more unfortunate was Boorman's decision to cast the Irish actor Brendan Gleeson as Colonel de Jager; Gleeson plays him as a loud blusterer, which fails to make him the truly dangerous and fearful figure which the film requires him to be. Director Boorman claims[35] that there were no South African actors who could have played the role – but *Red Dust* shows this to be untrue. South African actors Jamie Bartlett as Dirk Hendricks, and Ian Roberts as Piet Muller, both convey a sense of the sinister quiet menace and ruthless violence of the South African security police in their prime far more effectively. In *Red Dust*, one can accept Hilary Swank as Sarah Barcant, since Sarah is supposed to have spent most of the last 14 years in New York. Less acceptable, however, is the Nigerian-British Chiwetel Ejiofor as Alex Mpondo. In *Cry Freedom* (1987), Steve Biko had to be played by Denzel Washington, and even in 2004 it seems that a British director was still not prepared to take the chance of casting a black South African to play a leading black South African role.

Only *Forgiveness* has the full courage of its convictions in using an entirely South African cast for its South African characters. Even here, one might raise a small quibble. The Grootboom family speak Afrikaans to each other (with English subtitles), which is authentic and what one would expect of a coloured family called Grootboom. Yet, when they speak to Coetzee, an Afrikaner, they always do so in English, which makes little sense. One might explain it in the early scenes as a courtesy to Father Dalton, who is English-speaking; yet even in the hotel dinner scene, when Father Dalton is not present, they still speak English. One can only conclude that the makers of the film felt that it would sell better internationally with most of its dialogue in English, rather than Afrikaans. Perhaps this underestimates the sophistication and willingness of a modern international audience to experience languages other than English. The recent South African film *Yesterday*[36] has dialogue entirely in isiZulu, with English subtitles, and has secured international showings. But *Forgiveness* certainly benefits from the South African cast in establishing the authentic feel of the film and its characters.

A final niggle of dissatisfaction in relation to the casting of characters comes from the portrayal, in *In My Country*, of the chairperson of the TRC, Reverend Mzondo (Owen Sejake). The real chairperson was Desmond Tutu, the charismatic former Archbishop and Nobel Peace Prize winner. Tutu is almost as famous internationally as Mandela and, more than anyone else, he embodied the TRC, for both national and international audiences, and became a familiar figure – a small, unashamedly emotional man with an irrepressibly impish sense of humour. Many observers of the TRC, including Krog, have criticised aspects of the way Tutu ran the TRC; but they have also noted that it is impossible to envisage the TRC succeeding as it did without Tutu at its helm.[37] Tutu showed his emotions in hearings, crying at some of the testimony. He also showed his sense of fun on occasion and burst out into some excited paeans of praise to 'the rainbow people of God' (often rendered as the 'rainbow nation') of the new South Africa.[38] One would not expect the film to offer a simple copy or parody of him, but it still jars to have Reverend Mzondo portrayed, as he is here, as a large, sombre, almost lugubrious man, who barely shows any emotion, never laughs or smiles, and could not be imagined as doing or saying the things that we associate with Tutu in the TRC. TRC hearings without a Tutu figure in charge seem a bit like *Hamlet* without the Prince of Denmark.

Security policemen

All three films feature security policemen who killed and tortured people under apartheid and then applied to the TRC for amnesty. All show some characteristics of actual policemen who went to the Amnesty Committee, but they differ considerably in the pictures they present. Colonel de Jager, in *In My Country*, is clearly based on Colonel Eugene de Kock, nicknamed 'Prime Evil' and perhaps the most notorious of all the security police killers.[39] Unfortunately, Brendan Gleeson, who plays De Jager, seems to think that in order to convey how dangerous a man De Jager is, it is necessary for him to shout and swear and bluster a good deal. The real De Kock was fairly quiet in demeanour – but no less deadly in his actions for that.

Jamie Bartlett's performance in *Red Dust* as security policeman Dirk Hendricks is a much subtler and better picture of such a man. Initially, he is quiet and trying to reveal as little as possible of what he did, but the AC hearing compels him to reveal more. In the course of it, he admits to having tortured Alex Mpondo and other prisoners using the 'wet bag' torture method, and explains its features to the AC panel. In this aspect, he resembles Captain Jeffrey Benzien who, in his

actual AC hearing, admitted to having used the wet bag on his victims, and even demonstrated its use to the television cameras. Benzien was confronted by one of his victims, Tony Yengeni, a rising young ANC MP, but by reminding him of how the torture led him to betray some of his comrades, Benzien was able to disconcert Yengeni and re-establish some sort of temporary psychological supremacy over him. Benzien also claimed to suffer from post-traumatic stress disorder as a result of his torture activities.[40] These events are closely echoed in the early part of Hendricks's AC hearing in the film: he similarly confronts his former victim, now a rising ANC MP, and initially puts him at a psychological disadvantage. Similarly, Hendricks, when confronted with his actions, claims to suffer from post-traumatic stress disorder. Hendricks and his former superior Piet Muller (who is a menacing presence throughout the film until he is exposed and prosecuted at the end) suggest very effectively just how powerful and dangerous the security police were under apartheid, especially in small country towns such as these.

Tertius Coetzee, former security policeman in *Forgiveness*, is also endowed with some characteristics of real security police who applied for amnesty. He bears the surname of Captain Dirk Coetzee, first commander of the death squad base Vlakplaas. Just as Dirk Coetzee arranged the murder of Griffiths Mxenge to look like a robbery and burned his car,[41] so Tertius Coetzee did the same in his killing of Daniel Grootboom. Like Jeffrey Benzien, he suffers from headaches and psychological discomfort as a result of his killings and tortures, and he is shown frequently having to take aspirin and pills and put drops in his eyes. Where Benzien used the 'wet bag' torture method, he used a wet towel to make detainees feel that they were choking or drowning. And, most notably, the scene where Ernest crashes the teapot on his skull invokes Gideon Nieuwoudt of the Port Elizabeth Special Branch. Nieuwoudt abducted and killed student activist Siphiwo Mtimkhulu and was granted amnesty for it. He subsequently went to see Siphiwo's parents to apologise and ask for their forgiveness, and while he was pleading for it, Siphiwo's teenage son hit him over the head with a heavy vase, fracturing his skull – a moment memorably caught on film in Mark Kaplan's documentary *Between Joyce and Remembrance*.[42] Nieuwoudt also revealed (in the amnesty hearing into Steve Biko's death in detention, in which he had a hand) that he had flogged Biko with a hosepipe.[43] Coetzee, in *Forgiveness*, admits to having beaten Daniel with a hosepipe, and is shown in one scene apparently hitting himself with a hosepipe. Psychologically, he is portrayed quite differently from the security police in the other two films – he has none of the blustering ranting of Colonel de Jager, or the quiet menace of Hendricks and Muller. His is a surprisingly sympathetic portrayal of an ex-policeman who seems personally haunted by what he has done and genuinely wants to make amends in some way.

At the end of the film there is even a suggestion that instead of leaving safely when he can, he fatally chooses to stay in Paternoster knowing that Daniel's ex-comrades will kill him.

—

Place, community and the TRC
in post-apartheid South Africa

Red Dust and *Forgiveness* share a strong feel of place and community (largely lacking from *In My Country*); both are also suitably realistic about the achievements of the TRC and post-apartheid 'new South Africa' where some important things have changed but many things have not. In *Red Dust*, the AC is shown as achieving something real – extracting the truth about the killing of Steve Sizela from Dirk Hendricks, and exhuming Steve's body, which leads to Piet Muller being charged with the murder. The film does not pretend that the TRC will solve all the problems of racial hatred and the desire for revenge for the myriad killings and humiliations of the apartheid era – even for little Smitsrivier, let alone for the larger community of South Africa. The opening scenes, memorably, show the procession of TRC vehicles entering the town to set up the hearing; the final shot shows them leaving the town again, suggesting what some critics of the TRC have said about its hearings in small communities, that it 'came into town like a travelling circus, and then left after a few days, and we never heard from them again.'[44] Certainly, post-apartheid Smitsrivier seems almost as divided as it was at the height of apartheid; the whites still hold the wealth, and are now defensive and bitter; the blacks (except for Alex Mpondo, who has prospered by leaving and becoming an ANC MP) still live in poverty, the youth still angry and aggressive, and some of them resenting Mpondo's success. The film shows that the potential for conflict (demonstrated in the form of a riot by black youths in the middle of the town on the night of the first day's hearing) is as great as ever. It is a tribute to the power and authenticity of the film that it makes the viewer feel the potential for conflict, and yet also that the amnesty hearing – and more broadly, the whole TRC process – has still achieved something real and substantial.

Forgiveness achieves something similar, even though it is structured very differently. Its strong core lies in its depiction of the Grootboom family within the Paternoster community. It conveys well the sense of a small, inward-looking community, still divided by colour, class and socio-economic status. Formal apartheid may be gone from South Africa, but its effects will continue in most areas for a long time. In a telling detail, the Grootboom house has no telephone due to their relative poverty, and Sannie has to make special trips to a coin-

operated phone box some distance from their house to make her important phone calls to the ex-comrades whose arrival is anxiously awaited. In this small community, everyone knows everyone else's business – Hendrik's workmates immediately know that he has been visited by 'a white man' and Hendrik can only avoid telling the full story of Daniel and Coetzee by letting them think that the ex-policeman is considering buying real estate in Paternoster. This is a plausible explanation, tapping into two post-apartheid themes: the economic difficulties of the fishing industry, providing an incentive for fishermen to sell up and leave, and the progressive 'gentrification' of places like Paternoster on the sea and close enough to Cape Town to provide good bases for weekend and holiday homes. Hendrik and Magda Grootboom are portrayed as a self-consciously respectable coloured couple, concerned with how the community views them. When they killed Daniel, the police burned his car to make it look like a hijacking. The Grootbooms – embarrassed to admit to the community that their son was a 'terrorist' – maintained this fiction, and did not testify to the TRC. Hendrik blames himself for Daniel's death because he provided the money for Daniel to become a student in Cape Town and to buy a car. Magda has also blamed him – until now. Within the family, Ernest resents the fact that Daniel was the favourite son who could do no wrong. After his death, Magda took to her bed and has shown little interest in her younger son who will never be able to compete with Daniel. Sannie, too, resents this cult of the perfect Daniel.

These tensions, outlined in early scenes, culminate in the dinner at the hotel, which nicely brings together a number of the themes. When Coetzee invites them to the dinner, Hendrik's immediate response is: 'Mr Coetzee, hotels are not a place for people like us [i.e. a coloured fishing family].' To which Sannie responds, for the younger generation: 'Apartheid is long gone, Pa. It's a very nice offer, Mr Coetzee.' At the hotel, where the Grootbooms are somewhat overwhelmed by the unaccustomed luxury, the family fall into mutual recriminations about their tensions, but those tensions are largely resolved by being submerged within a larger theme of the need for forgiveness. Ernest initially accuses Coetzee of trying to 'buy forgiveness', but Magda suggests that Coetzee's attempt to apologise and seek forgiveness has somehow led to the welcome return of the fish, which Hendrik has just caught in abundance. Sannie says, 'God brought the fish back' but her mother rebukes her: 'And if you believe in God, then you must also believe in forgiveness.' Later in the meal, Magda says to Sannie and Ernest, 'You children must forgive us', and suggests that all of them – not just Coetzee – need to ask forgiveness from Daniel at his grave.

Reconciliation, *ubuntu*, forgiveness ...

This last point raises what must be a major theme in discussion of a commission whose title contained the word 'reconciliation' – issues of reconciliation, *ubuntu*, forgiveness, which were broadly included within the mandate of the TRC.[45] How well are these addressed and handled in these films?

The issue is explicitly raised by the title of *Forgiveness*; is it meant to be taken seriously or ironically? The film ends with the former security policeman Coetzee being shot by one of Daniel's ex-comrades, the one who betrayed him. On the face of it, hardly an embodiment of reconciliation, let alone forgiveness. And yet, the scene at Daniel's grave, before Zuko shoots Coetzee, suggests forgiveness in a wider sense: Daniel's parents appear to have forgiven Coetzee for killing their son and, as a result, have shed a great psychological burden and feel better within themselves. Magda leaves her bed and ventures outside into the sun and Hendrik goes back to his fishing with renewed confidence; even Ernest, joining his father in the fishing, seems to have become reconciled with his family and the death of his older brother. Sannie also seems to have forgiven Coetzee; she regrets inviting the comrades there to kill him, and urges him to escape. Perhaps the film deliberately ends on a note of ambiguity. Certainly, the picture it conveys of post-TRC South Africa is far removed from that of a simple, happy, reconciled 'rainbow nation'. It suggests that communities such as Paternoster, and the wider South African population, still have a long way to go to reach full reconciliation.

Red Dust similarly suggests that Smitsrivier is still very much a community divided into black and white, and that the wounds of apartheid are far from healed. It is suitably realistic about the achievements of the TRC and the 'new South Africa'. Hendricks's disclosure of what he did to Alex Mpondo, and solving the mystery of what happened to Steve Sizela, are shown as important achievements of the Amnesty Committee, but the film does not try to pretend that this will somehow resolve the huge economic and social problems facing post-apartheid South Africa.

The issue of reconciliation does bring out one area of weakness in *Red Dust*, a potential weakness in all films dealing with actual historical events, that of preaching a message to its viewers. The conscience of the film (and of the novel on which it is based) is represented by the old white liberal lawyer, Ben Hoffman (Marius Weyers). In the conflicts of the 1980s, he represented Alex Mpondo and Steve Sizela, and in 2000 – with his poor health preventing him from still practising – he is responsible for bringing his protégée Sarah Barcant back to the town, and trying to get her to take up where he left off. A few of the scenes between

Ben and Sarah take on a rather stilted didactic tone, in which he tells her what seems to be the film's larger message about the TRC. After the first day of the hearings, he tells a sceptical Sarah that South Africa is coming apart and the TRC 'is helping to hold it together. It seeks forgiveness, not retaliation.' At the end of the film, when Sarah is about to leave, he urges her to come back for Muller's amnesty hearing, and, more broadly, for the new South Africa: 'It's not about putting bad guys away; it's about putting communities together. We've just got a small window of opportunity to open up the past before all these memories get set in stone.'

He agrees that this will not bring back the dead Steve Sizela, nor remove Alex's psychological scars – or even Sarah's; but neither would punishing the perpetrators restore these losses, and 'escaping to New York' is not the way for Sarah to deal with her still unresolved anger toward Smitsrivier and South Africa. This explicit message in the film jars for the viewer and sticks out awkwardly; it is a false note from the director, as if the audience cannot be trusted to form its own conclusions about the TRC and the larger issues it raises. The message of reconciliation is delivered better and more subtly at the end of the film when Alex Mpondo apologises to Steve Sizela's parents, who have blamed him for their son's disappearance. Steve's mother is responsive, and his father, a stern headmaster, allows Alex just a tiny hint of a smile, suggesting that he has forgiven him and has reconciled himself to the death of his son.

In My Country places a lot of emphasis on its message of *ubuntu*, forgiveness and reconciliation. For this purpose, it makes much use of Langston Whitfield, the black American outsider and observer, who has to be educated in the ways of South Africans, black South Africans in particular. The film is structured to show the successive hearings of the TRC as progressively informing and enlightening Whitfield about these issues. He starts as someone suspicious of the TRC and what it is meant to do, hostile to Anna as a white Afrikaner and presumed racist, opposed to the idea of amnesty for the white security policemen who committed atrocities, and sceptical about the notion of reconciliation emerging from these proceedings. The film shows the sceptical outsider being gradually won over to become a believer in the virtues of amnesty, forgiveness, reconciliation – and, in particular, in the African idea of *ubuntu*, which is invoked and explained numerous times.[46] Whitfield is led to this position through some key events: attending a number of TRC hearings at which the African victims display an almost saintly degree of forgiveness, and both preach and practise the virtues of *ubuntu*; his interviews, as a reporter, with Colonel de Jager; and his developing relationship with Anna, culminating in a sexual relationship.

The film hammers the theme that the 'African way of justice' is that of *ubuntu* and forgiveness almost to the point of tedium, and that whatever whites and

sceptical outsiders may think of this, it comes naturally to all Africans. Anna's family's faithful farm servant, Anderson, is shown going to a TRC hearing to denounce the police who persecuted him (where he begins by reciting his genealogy, punctuated by banging his stick on the floor), in order that he might then forgive them. After the hearing he lectures Whitfield, somewhat self-righteously, on the African virtues of *ubuntu* and forgiveness, and presents him with the stick. In an improbably melodramatic scene soon after this, which leads to De Jager's revelation of the existence of the torture farm (based on Vlakplaas), an angry Whitfield grabs De Jager by the throat with murderous intent but then lets him go, saying: 'I would love to kill you, but you know what's saving you – an old black man with a stick'.

Both of these scenes are, in Rosenstonian terms, 'false invention'. Anderson's appearance at the hearing – as pointed out earlier – involved the scriptwriter clumsily trying to impose an actual Xhosa recital of chiefly descent onto an invented appearance by a BaSotho farm worker, and his rather smug lecture to Whitfield afterwards does not ring true. The De Jager scene is even less historically plausible. Not only would Colonel de Jager (shown as obsessed with his personal security) never allow a black reporter to get close enough to kill him, but the discovery by Whitfield and Anna of the torture farm (following De Jager's revelation about it) is even less plausible. That discovery invokes a common Hollywood convention in which the intrepid investigative reporters uncover the truth which the police and authorities have been unable to find. In fact, the existence and activities of Vlakplaas, which was a base for police death squads and a place for torturing detainees, were revealed well before the TRC began. Journalist Jacques Pauw revealed information about Vlakplaas which was told to him by former security policeman Dirk Coetzee in late 1989. Max du Preez published the information in his *Vrye Weekblad* newspaper despite heavy government pressure to prevent these revelations. Details about Vlakplaas and its operations were corroborated and amplified by the report of the Goldstone Commission chaired by Justice Richard Goldstone in 1992.[47] During the life of the TRC, disclosures by some security policemen seeking amnesty added to the information about Vlakplaas, but although TRC investigators made some discoveries and exhumed some bodies of people the police had killed and then secretly buried, there were no dramatic discoveries by reporters as portrayed in *Red Dust*. In this respect, *Red Dust* comes much closer to the historical truth in revealing the existence of a nearby torture farm on which the missing body is buried, during the course of Hendricks's cross-examination.

A further problem with the way in which *In My Country* handles its message of *ubuntu* presents itself when, at the end of the film, Dumi Mkhalipi is hauled out of Whitfield's car and shot dead by some of his former comrades for having

been an *impimpi* who informed on a comrade to the police. It is certainly true that in the course of the anti-apartheid struggle, some activists buckled under police torture and interrogation and revealed the names of their comrades. All three films incorporate such incidents and the possibility of surviving comrades seeking revenge for the betrayal. In *Forgiveness*, Daniel's three comrades fight amongst themselves about who betrayed Daniel to the police. At the climax of the film, Coetzee reveals that Zuko was the informer, coerced by the police who held his brother in custody and broke his spine while torturing him. In *Red Dust*, Hendricks states that Alex Mpondo informed on Steve Sizela, and the Smitsrivier comrades threaten to 'necklace' Mpondo for this betrayal.[48]

But only in *In My Country* does such an issue raise serious inconsistencies that threaten to undermine the main message of the film. For most of the film, we are shown Africans in obedience to the spirit of *ubuntu* living together in the new South Africa, and forgiving white policemen for the most dreadful atrocities and declaring revenge on them to be un-African. Yet, apparently this only applies to nasty white policemen; when it comes to black informers the spirit of revenge is as strong in Africans as it is in anyone else, and Dumi Mkhalipi is callously shot and left to die. The film overwhelmingly endorses Desmond Tutu's view that South Africans (and black South Africans in particular) are naturally given to *ubuntu* and forgiveness, and have no wish for revenge. Tutu did make some excited outbursts to this effect, while chairing HRVC hearings – such as the one below directed at a white victim testifying the day after the committee had heard from black victims. In both cases, what Tutu admired was their spirit of reconciliation and forgiveness for the perpetrators of the atrocities against them:

> I just want to say, we are, I think, a fantastic country. We have some quite extraordinary people, yesterday, I had spoken about how proud I was to be black in seeing the kind of spirit that people showed in adversity, and now we're seeing another example, and I think it just augurs so wonderfully well for our country. We thank you for the spirit that you are showing and pray that those who hear you, who see you, will say, 'Hey, we do have an incredible country with quite extraordinary people of all races.'[49]

Tutu frequently referred to these and some other cases to suggest that such a spirit of reconciliation and forgiveness in the victims who came to the TRC, both black and white, was the norm, and showed that South Africans collectively constituted 'the rainbow people of God'.[50] But when Tutu did this, we could say that he was indulging in 'selective rainbow people-ism'. The TRC did have heart-warming examples of people who suffered dreadful atrocities but were still willing to forgive their perpetrators and reconcile with them, but it also showed many examples of South Africans – black and white – who committed dreadful acts of cruelty and murder, and were caught up in violent spirals of

revenge killings. These include the white security policemen (such as Eugene de Kock, Dirk Coetzee, Gideon Nieuwoudt, Jeffrey Benzien and Jack Cronjé) who killed and tortured people, and black *askaris*[51] (such as Joe Mamasela or Almond Butana Nofemela) who killed for the police. However, it would also include black supporters of the ANC and Inkatha Freedom Party (IFP) who killed thousands of their fellow township dwellers in a vicious spiral of killing, retaliation and counter-retaliation in townships such as Kathorus.[52] In one incident, killing a nine-month-old baby was justified with the chilling Zulu proverb 'A snake gives birth to another snake',[53] and black comrades 'necklaced' other blacks suspected of being informers.[54] There are no signs here of an inherent black South African inclination towards *ubuntu*.

It was naïve of Tutu to claim that Africans were different from (and better than) other people in this respect because they were motivated by *ubuntu* and therefore above ordinary feelings of revenge. It was similarly naïve for Justice Albie Sachs, of the Constitutional Court, in his judgment in that court's first case on the constitutionality of the death penalty, to claim that because of *ubuntu*, capital punishment had never been part of traditional African society. Richard Wilson, in his book on the TRC, rightly ridiculed this claim:

> To see African law ... as completely excluding violent revenge is an act of willful romantic naiveté on the part of Sachs. Courts administered by Africans have often applied the death penalty for certain categories of persons (informers, witches and, in the 1990s, car hijackers) in numerous and successive historical contexts. The South African papers constantly report such cases of 'rough justice'.[55]

The claims made for the special African virtues of *ubuntu* in *In My Country* were already straining credulity in the first three-quarters of the film. But when the film added, at the end, the shooting of Dumi Mkhalipi as revenge for his having informed, it made nonsense of its own argument. If *ubuntu* really does motivate Africans to forgive racist white police killers and torturers, why then doesn't it operate similarly for black activists who were coerced into betraying their comrades? Not surprisingly, John Boorman revealed[56] that he cut the shooting of Dumi from the film a number of times, but then reinserted it. Reinserting it gives the film a dramatic and unexpected climax, but at the price of destroying the consistency and credulity of the film's central argument.

In My Country also tries to approach the reconciliation issue on a personal basis through the sexual relationship between Anna Malan and Langston Whitfield. Antjie Krog did have an affair while covering the TRC. In her book she mentions this, and her scene of reconciliation and forgiveness with her husband, rather briefly and obliquely. The film makes much of the fact that the affair here is with a black man, mentioning that, under apartheid, it would have been a pun-

ishable offence under the Immorality Act. It tries to use the relationship of Malan and Whitfield to symbolise some major themes: it is literally a case of black and white coming together in love and intimacy and, since both of them are married, it also denotes personal betrayal and the need to admit the truth and seek reconciliation and forgiveness from the injured spouse. Malan's mother confesses an earlier affair of her own to her daughter and tells her that being dishonest has a bad effect, and it is time to reveal the truth. This motivates Malan to tell her husband the truth and ask for forgiveness, allowing the husband to make ironic reference to the TRC and her asking for 'amnesty'.[57] But are the personal infidelities, confessions and requests for forgiveness of South Africans (let alone of an American who flew in briefly to report on the TRC) really relevant to or appropriate symbols for the South African national pursuit of truth and reconciliation? The TRC was an exercise in transitional justice in which a society emerging from a long period of authoritarian government tried to deal with its effects by confronting some aspects of that traumatic past. Is it appropriate – even in a feature film – to reduce that exercise to one of personal psychology? Michael Ignatieff, in some trenchant remarks about truth commissions, has suggested that it is not appropriate to think of this issue in individual psychological terms:

> What does it mean for a nation to come to terms with its past? Do nations, like individuals, have psyches? Can a nation's past make a people ill as we know repressed memories sometimes make individuals ill? Conversely, can a nation or contending parts of it be reconciled to their past, as individuals can, by replacing myth with fact and lies with truth?
>
> Repentance, if it ever occurs, is an individual matter. It is too much to expect an institutional order to engage in collective repentance. All that a truth commission can achieve is to reduce the number of lies that can be circulated unchallenged in public discourse.[58]

Adultery between the leading man and woman, and requests for forgiveness from the spouse, are standard film clichés; to reduce it to this cliché risks trivialising the film's larger message about the TRC and reconciliation.

Visually and aurally, *In My Country* and *Red Dust* make some good use of South African material. *In My Country* features stunning shots of the beauties of the Drakensberg (somewhat inappropriately, since no TRC activity actually took place against that backdrop), and *Red Dust* uses the location of Graaff-Reinet very effectively. And both feature, on their soundtracks, the Xhosa hymn *Senzeni na* (What have we done?) – in the case of *In My Country*, virtually throughout the film. It was, in fact, sung at TRC hearings. Antjie Krog noted the following at the very first HRVC hearings during the testimony of the widows of the abducted and murdered 'Cradock Four':

When the hearing resumed, Tutu started to sing: '*Senzeni na, senzeni na* ... What have we done? What have we done? Our only sin is the colour of our skin.' I was at a meeting once where ANC leaders rejected this song because it perpetuates the idea of being a helpless victim. But when it was sung this morning, I cried with such a sense of loss and despair I could hardly breathe ...[59]

The haunting words and music certainly help to evoke something of the emotion of the hearings for the viewer.

Finally, how effective are these three feature films in conveying to the uninformed viewer something of the historical reality of the TRC and its achievement? A viewer seeking an introduction to the TRC would be best advised to start with a documentary film such as *Long Night's Journey into Day* or perhaps *Between Joyce and Remembrance*. If looking to have their introduction leavened by a fictional story, then *Red Dust* provides the best approach to the drama of the amnesty process in the context of a small community. *Forgiveness* offers a good sense of the working out of issues of reconciliation and forgiveness, within family and community, in the post-TRC environment. *In My Country*, perhaps the most ambitious of these three films in its attempt to put Antjie Krog's book on the screen and convey the sense of a number of hearings, is also the least successful. Despite some good sections and moments, too many of its crucial parts involve 'false invention', and it fails to hold together dramatically as a truly effective film on this important piece of South African history.

Endnotes

Introduction

1. See in particular Paul Smith (ed.), *The Historian and Film* (Cambridge: Cambridge University Press, 1976).

2. See Antony Aldgate, *Cinema and History: British Newsreels and the Spanish Civil War* (London: Scolar Press, 1979).

3. See Jeffrey Richard, *Visions of Yesterday* (London: Purnell, 1973) as an early example of the historian's mining of fiction film as a source for popular beliefs and myths.

4. For a later example of this approach, with its focus on historical film's accuracy or otherwise, see Mark C. Carnes, *Past Imperfect: History According to the Movies* (London: Cassell, 1996).

5. The contributions to this pathbreaking forum in the *American Historical Review*, 93, 5 (1988) were John E. O'Connor, 'History in Images/Images in History: Reflections on the Importance of Film and Television Study for an Understanding of the Past', pp. 1200–1209; Robert A. Rosenstone, 'History in Images/History in Words: Reflections on the Possibility of Really Putting History onto Film', pp. 1173–1185; Robert B. Toplin, 'The Filmmaker as Historian', pp. 1210–1227; Hayden White, 'Historiography and Historiophoty', pp. 1193–1199.

6. Robert A. Rosenstone, *Visions of the Past: The Challenge of Film to Our Idea of History* (Cambridge, Mass.: Harvard University Press, 1995), p. 19.

7. Hayden White, 'Historiography and Historiophoty', p. 1193.

8. Rosenstone, *Visions of the Past*, p. 72.

9. Cited in Vivian Bickford-Smith and Richard Mendelsohn, 'Film and History Studies in South Africa Revisited: Representing the African Past on Screen', *South African Historical Journal*, 48 (May 2003), p. 5. For the fullest and most recent account of Rosenstone's views, see *History on Film/Film on History* (Harlow: Pearson Longman, 2006).

10. See Robert B. Toplin, *History by Hollywood: The Use and Abuse of the American Past* (Urbana: University of Illinois Press, 1996); *Reel History: In Defense of Hollywood* (Lawrence, Kansas: University Press of Kansas, 2002). See also the edited collection by Robert B. Toplin, *Oliver Stone's USA: Film, History and Controversy* (Lawrence, Kansas: University Press of Kansas, 2000) in which the controversial filmmaker disavows 'the mantle of "cinematic historian."'

11. Toplin, *Reel History*, p. 1.

12. For British studies, see, for example, Jeffrey Richard, *Films and British National Identity: From Dickens to Dads' Army* (Manchester: Manchester University Press, 1997) and Claire Monk & Amy Sargeant (eds.), *British Historical Cinema: The History, Heritage and Costume Film* (London: Routledge, 2002).

13. For African film in general, see Manthia Diawara's *African Cinema: Politics and Culture* (Bloomington: Indiana University Press, 1992), an 'insider's account' of the history of African cinema and its contemporary status at the end of the 1980s, and Nwachukwu Frank Ukadike's *Black African Cinema* (Berkeley: University of California Press, 1994), a comprehensive study of filmmaking in both anglophone and francophone Africa from the colonial period to the present, focusing largely on developments since independence. See also Nwachukwu Frank Ukadike, *Questioning African Cinema: Conversations with Filmmakers* (Minneapolis: University

of Minnesota Press, 2002). Sharon A. Russell's *Guide to African Cinema* (Westport: Greenwood Press, 1998) is a valuable reference guide to African filmmakers and to African films, including some discussed in this volume: *Battle of Algiers, Emitai, Ceddo, Keïta, Yeelen,* and *Camp de Thiaroye*. Regional studies include studies of South African cinema, a region which is particularly well represented in the scholarly literature. See, for example, Keyan Tomaselli, *The Cinema of Apartheid: Race and Class in South African Film* (London: Radix, 1989); Johan Blignaut & Martin Botha (eds.), *Movies Moguls Mavericks: South African Cinema 1979–1991* (Cape Town: Showdata, 1992); Isabel Balseiro & Ntongela Masilela (eds.), *To Change Reels: Film and Culture in South Africa* (Detroit: Wayne State University, 2003).

14. For an early contribution, by a popular writer, see Kenneth M. Cameron, *Africa on Film: Beyond Black and White* (New York: Continuum, 1994). Particularly recommended is Peter Davis's pioneering venture into South African 'film and history', *In Darkest Hollywood: Exploring the Jungles of Cinema's South Africa* (Athens, Ohio: Ohio University Press, 1996).

15. A selection of the conference papers was published in a special section of the *South African Historical Journal* (vol. 48) in May 2003, co-edited by the editors of this volume. Unlike this book, the selected contributions, with a couple of exceptions, focused mainly on film as evidence rather than on film as a means of historical representation. For a full listing of the papers presented at this pioneering conference, plus the text of many of these, see the conference website, www.uct.ac.za/conferences/filmhistorynow.

16. For the published version of this paper, see Mbye Cham, 'Film and History in Africa: A Critical Survey of Current Trends and Tendencies', in Françoise Pfaff (ed.), *Focus on African Films* (Bloomington: Indiana University Press, 2004), pp. 48–68.

17. Josef Gugler, *African Film: Re-imagining a Continent* (Bloomington, Indiana: Indiana University Press, 2003).

18. Rosenstone, *History on Film/Film on History*, especially chapters 3 and 4 and *Visions of the Past*, especially chapter 8. For an extended account of the defining characteristics of Hollywood history, see also Toplin, *Reel History*, pp. 8–57.

19. Rosenstone, *Visions of the Past*, p. 9 includes Sembène in a list of filmmakers 'whose major work centers on historical questions'. On pp. 178–180, Rosenstone expands on his reasons for this inclusion in exploring Sembène's innovativeness and desire 'to dramatize history and to teach it so as not to let others teach it to us'.

20. Natalie Zemon Davis, *Slaves on Screen: Film and Historical Vision* (Cambridge, Mass.: Harvard University Press, 2000), p. 70, cited in Rosenstone, *History on Film*, p. 26.

21. For other analyses that are revealing about this stereotype of Africa, see William Beinart, 'The Renaturing of African Animals: Film and Literature in the 1950s and 1960s', in *Kronos: Journal of Cape History* (November 2001), pp. 201–226 and Lauren van Vuuren, 'The Great Dance: Myth, History and Identity in Documentary Film Representations of the Bushmen, 1925–2000' (Ph.D. thesis, University of Cape Town, 2006).

22. Marcia Landy, *British Genres: Cinema and Society, 1930–1960* (Princeton: Princeton University Press, 1991).

Chapter 1

1. *Wend Kuuni:* Gaston Kaboré, 1982, Burkina Faso, 75 mins, Moore. *Buud Yam:* Gaston Kaboré, 1996, Burkina Faso, 97 mins, Moore. Mbye Cham, 'Official History, Popular Memory: Reconfiguration of the African Past in the Films of Ousmane Sembène', in Samba Gadjo (ed.), *Ousmane Sembène: Dialogues with Critics and Writers* (Amherst: University of Massachusetts Press, 1993), also provides a list of early historical films made in West Africa.

2. David Herlihy, 'Am I a Camera? Other Reflections on Film and History', *American Historical Review*, 93, 5 (1988), p. 1191.

3. Robert Brent Toplin, 'The Filmmaker as Historian', *American Historical Review*, 93, 5 (1988), p. 1223.

4. Manthia Diawara, *African Cinema: Politics and Culture* (Bloomington, Indiana: Indiana University Press, 1992), p. 160.

5. Françoise Pfaff, 'Gaston G. Kaboré', in Françoise Pfaff (ed.), *Twenty-five Black African Filmmakers: A Critical Study, with Filmography and Bio-bibliography* (New York: Greenwood Press, 1988), p. 177.

6. Michael T. Martin, 'Interview. "I am a Storyteller, Drawing Water from the Well of my Culture": Gaston Kaboré, Griot of African Cinema', *Research in African Literatures*, 33, 4 (2002), p. 163.

7. Henry Barth, *Travels and Discoveries in North and Central Africa*, vol. 4 (London: Longman, Brown, Green, Longmans & Roberts, 1858), p. 290.

8. For an overview, see Diawara, *African Cinema*. Also Claire Andrade-Watkins, 'France's Bureau of Cinema – Financial and Technical Assistance 1961–1977: Operations and Implications for African Cinema', in Imruh Bakari & Mbye Cham (eds.), *African Experiences of Cinema* (London: British Film Institute, 1996).

9. Mamadou Diouf, 'History and Actuality in Ousmane Sembène's *Ceddo* and Djibril Diop Mambety's *Hyenas*', in Bakari & Cham, *African Experiences of Cinema*.

10. For detailed analysis of *Emitai* and Sembène's *Ceddo*, see chapter 3 in this volume by Robert Baum.

11. Victor Bachy, 'Un Film à caractère historique: si les cavaliers ... Un interview de Mahamane Bakabe', in Centre d'Etudes sur la Communication en Afrique (CESCA) (ed.), *Camera nigra: le discours du film africain* (Brussels: OCIC, 1984), pp. 93–100.

12. We should add to this little survey a film released the same year as *Wend Kuuni*, Christian Richard's *Le Courage des autres*. Richard was a Frenchman who taught for several years in the film institute in Ouagadougou (INAFEC). His film, sponsored by the government of Upper Volta (Burkina Faso) and produced with local crew and technicians, tells the story of a fictional uprising in a convoy of recently enslaved people driven to a distant port. It is told at a slow pace, with beautiful images and sound, and almost no dialogue. The film was not admitted to the FESPACO competition because its director was not African (see Victor Bachy, *La Haute-Volta et le cinéma*, 2nd ed. (Brussels: OCIC, 1983), pp. 41–43). This film, in limbo between being African and European, has not been screened very often and it is not clear how much influence it exercised on other Burkinabe and African directors. Its theme is not one of those Gaston Kaboré admits in his presentation of history.

13. The major works for Moose political history are: Elliott P. Skinner, *The Mossi of the Upper Volta: The Political Development of a Sudanese People* (Stanford: Stanford University Press, 1964); J.D. Fage, 'Reflections on the Early History of the Mosi-Dagomba Group of States', in J. Vansina, R. Mauny & L.V. Thomas (eds.), *The Historian in Tropical Africa* (London: Oxford University Press, 1964); Michel Izard, *Introduction à l'histoire des royaumes mossi* (Paris: Centre National de la Recherche Scientifique, 1970); Michel Izard, *Le Yatenga précolonial: un ancien royaume du Burkina Faso* (Paris: Karthala, 1985); Michel Izard, *Gens du pouvoir, gens de la terre: les institutions politiques de l'ancien royaume du Yatenga (Bassin de la Volta Blanche)* (Cambridge: Cambridge University Press, 1985); Michel Izard, *L'Odyssé du pouvoir: un royaume africain: état, société, destin individuel* (Paris: Editions de l'Ecole des Hautes Etudes en Sciences Sociales, 1992); Michel Izard, *Moogo. L'Émergence d'un espace étatique ouest-africain au xvie siècle: étude d'anthropologie historique* (Paris: Karthala, 2003); Junzo Kawada, *Genèse et évolution du système politique des Mosi méridionaux (Haute Volta)* (Tokyo: Institute for the Study of Languages and Cultures of Asia and Africa, 1979); Junzo Kawada, *Textes historiques oraux des Mosi méridionaux (Burkina Faso)* (Tokyo: Institute for the Study of Languages and

Cultures of Asia and Africa, 1985). A large colonial historical and ethnographic literature is critically incorporated in the works of these authors.

14. Bachy, *La Haute-Volta*, p. 35.
15. Martin, 'Interview', pp. 164–165.
16. Martin, 'Interview', p. 166
17. Nwachukwu F. Ukadike, 'Gaston G. Kaboré (Burkina Faso)', in N.F. Ukadike (ed.), *Questioning African Cinema: Conversations with Filmmakers* (Minneapolis: University of Minnesota Press, 2002), p. 111.
18. Pfaff, 'Gaston G. Kaboré', p. 174.
19. For the phenomenally profitable video film industry of Nigeria, sharply contrasting with the art-house cinema tradition of francophone Africa, see Françoise Balogun, 'Booming Videoeconomy: The Case of Nigeria', in F. Pfaff (ed.), *Focus on African Films* (Bloomington: Indiana University Press, 2004).
20. ATM and FESPACO (L'Association des Trois Mondes and Le Festival Panafricain du Cinéma et de la Télévision de Ouagadougou), *Les Cinémas d'Afrique: dictionnaire* (Paris: Karthala, 2000), pp. 248–250; Bachy, *La Haute-Volta*, pp. 35–36; Pfaff, 'Gaston G. Kaboré', p. 174.
21. Josef Gugler, *African Film: Re-imagining a Continent* (Oxford: James Currey, 2003), p. 31.
22. René Prédal, 'Babatou, les Trois Conseils', *CinémAction*, 17 (1982), pp. 97–105.
23. Olivier Barlet, *African Cinemas: Decolonizing the Gaze* (London: Zed, 2000), p. 89.
24. Férid Boughedir, 'African Cinema and Ideology: Tendencies and Evolution', in June Givanni (ed.), *Symbolic Narratives/African Cinema: Audiences, Theory and the Moving Image* (London: British Film Institute, 2000), p. 119.
25. Françoise Pfaff, 'Africa from Within: The Films of Gaston Kaboré and Idrissa Ouédraogo as Anthropological Sources', *Society for Visual Anthropology Review*, 6, 1 (1990), p. 237.
26. Clyde Taylor, 'Searching for the Postmodern in African Cinema', in Givanni, *Symbolic Narratives/African Cinema*, p. 140.
27. Françoise Pfaff, 'Impact de la co-production sur les composantes socioculturelles de cinéma d'Afrique francophone', in *Cinémas et liberté: contribution au theme du FESPACO 93* (Paris: Présence Africaine), pp. 43–48; Boughedir, 'African Cinema and Ideology'; Taylor, 'Searching for the Postmodern in African Cinema'.
28. Martin, 'Interview', pp. 165, 167, 169.
29. In a presentation at the University of Illinois, April 2005.

Chapter 2

1. *Keïta!*: Dani Kouyaté, 1994, Burkina Faso, 94 mins, Jula and French.
2. *Yeelen*: Souleymane Cissé, 1987, Mali, 105 mins, Bambara.
3. This despite the distributor's placement of it in the 13th-century era of Sunjata (see DVD cover), for which there is absolutely no reference in the film.
4. For more on this issue, see chapter 1 by Mahir Saul in this volume.
5. Orthography is a constant issue here not only for the usual reasons of late and inconsistent efforts at standardisation but also because of French spellings (Ouagadougou, Sundiata/Soundyata, Dioula,/Dyula) vs. English ones (Wagadugu, Sunjata, Juula/Jula).
6. This issue is, again, better pursued in the chapter by Mahir Saul.
7. In this role he inspired the Cape Town theatre director Mark Fleischman to mount his own version of 'Sunjata' (Mark Fleischman, personal communication).
8. e.g. Samba Diop, *African Francophone Cinema* (New Orleans: University Press of the South, 2004), pp. 36–37.
9. Josef Gugler, 'Keïta! 1995: Transmitting the *Sundjata* to the Next Generation' in Josef Gugler,

African Film: Re-imagining a Continent (Oxford: James Currey, 2003), pp. 41–42. (This article is otherwise one of the best published analyses of this film that I have found.)

10. D.T. Niane, *Sundiata: An Epic of Old Mali* (London: Longman, 1965), p. vii.

11. Jan Jansen, 'An Ethnography of the Epic of Sunjata in Kela', in Ralph A. Austen (ed.), *In Search of Sunjata: The Mande Epic as History, Literature and Performance* (Bloomington: Indiana University Press, 1999), pp. 297–312. 'Traditional' *griots* are also presented more as court mouthpieces than repositories of 'tradition' in Dani Kouyate's next feature film, *Sia: The Myth of the Python* (2001) as well as such earlier works as Ousmane Sembène's *Ceddo* (1977) and Cheikh Oumar Sissoko's *Guimba the Tyrant* (1997). For the changing role of *griot* patronage, see Clemens Zobel, 'Clients or Critics? Politics, Griots and Gender in Postcolonial Mali', *Mande Studies*, 4 (2002), pp. 45–64.

12. Dani Kouyate's *Sia* is based upon the Wagadu legend but here again he links the empire of this story to Mali by naming its ruler (also played by his own father) Kaya Maghan Cissé.

13. Stephan Bulman, 'Sunjata as Written Literature: The Role of the Literary Mediator in the Dissemination of the Sunjata Epic' in Austen, *Sunjata*, pp. 231–251.

14. Gugler (p. 39, n. 9) thus appears misguided, and not even entirely historically accurate, in pointing out that cowry shell divination and the types of cloth depicted in these portions of the film are out of place for the 13th century.

15. Denise Bouche, 'Autrefois, notre pays s'appelait la Gaule ... Remarques sur l'adaptation de l'enseignement au Sénégal de 1817 à 1960', *Cahiers d'Études africaines*, 29 (1968), pp. 110–122. (The title of this article closely echoes the original phrasing of the teacher's question in *Keïta!*: 'Comment s'appelaient autrefois les habitants de la France?')

16. Bulman, 'Sunjata as Written Literature', pp. 240–241.

17. Marcel Guilhem, *Précis d'histoire de l'Ouest Africain* (Paris: Ligel, 1961), pp. 30–37. (I thank Mahir Saul for calling my attention to this text.)

18. Jean-Louis Triaud, 'Haut-Sénégal-Niger, un modèle "positiviste"? De la coutume à l'histoire: Maurice Delafosse et l'invention de l'histoire africaine', in Jean-Loup Amselle (ed.), *Maurice Delafosse entre orientalisme et ethnographie: l'itinéraire d'un africaniste (1870–1926)* (Paris: Maisonneuve et Larose, 1998).

19. *La Genese (Genesis)* is the title of a 1999 Mande film by Cheick Oumar Sissoko, but its subject matter is the affairs of the biblical patriarch Jacob.

20. Walter van Beek & Jan Jansen, 'La Mission Griaule à Kangaba (Mali)', *Cahiers d'Etudes Africaines*, 40 (2000), pp. 363–376.

21. Another well-regarded film that makes this assertion under a similar title is Kwaw Ansah's *Heritage ... Africa* (Ghana, 1988); here James Aggrey, a key protégé and instrument of British adapted education, is presented as a suppressed nationalist hero.

22. Suzanne H. MacRae, 'Yeelen: A Political Fable of the Komo Blacksmith/Sorcerers', *Research in African Literatures*, 26, 3 (Fall, 1995), pp. 57–66 cites Cissé's earlier films and interviews to argue that the critique is directed against the then current Mali dictatorial regime of Moussa Traoré.

23. There is also some confusion caused by changes in the man pursuing Nianankoro between his father, Soma, and a second uncle, Baafing. This is the result of the death, during filming, of the actor originally playing Soma, Ismaila Sarr. Cissé was apparently very close to Sarr, having used him in earlier films and as an intermediary to learn about the Komo ceremony prior to shooting *Yeelen*. He thus changed the script to retain the one scene that Sarr had completed; see Manthia Diawara, 'Souleymane Cissé's Light on Africa', *Black Film Review*, 4, 4 (1988), p. 14.

24. Joseph Campbell, *The Hero with a Thousand Faces* (New York: Pantheon, 1949).

25. Nwachukwu Frank Ukadike, *Questioning African Cinema: Conversations with Filmmakers* (Minneapolis: University of Minnesota Press, 2002), p. 23.

26. Dominique Zahan, *Sociétés d'initiation Bambara: le N'domo, le Korè* (Paris: Mouton, 1960).

27. Patrick R. McNaughton, *Secret Sculptures of Komo: Art and Power in Bamana (Bambara) Initiation Associations* (Philadelphia: Institute for the Study of Human Issues, 1979).

28. Marcel Griaule, *Dieu d'eau: entretions avec Ogotemmêli* (Paris: Editions du Chêne, 1948); the French original and English translation of this work are both still in print.

29. Criticism of the Griaule school has become a minor industry within Mande studies (q.v. below) but for a good outside discussion see James Clifford, 'Power and Dialogue in Ethnography: Marcel Griaule's Initiation' in James Clifford, *The Predicament of Culture: Twentieth-century Ethnography, Literature, and Art* (Cambridge, Mass.: Harvard University Press, 1988), pp. 55–91.

30. For an account of Cissé's transition from these earlier films to *Yeelen*, see Férid Boughedir, 'African Cinema and Ideology: Tendencies and Evolution', in June Givanni (ed.), *Symbolic Narratives/African Cinema: Audiences, Theory and the Moving Image* (London: British Film Institute, 2000), pp. 109–121. (The relevant passages are discussed in the chapter by Mahir Saul in this volume.)

31. Ukadike, *Questioning African Cinema*, p. 22.

32. Diawara, 'Light on Africa', p. 15.

33. Patrick McNaughton, 'Comments on "Secrets and Lies"', *Mande Studies*, 2 (2000), p. 178; this entire volume of *Mande Studies* consists of essays on 'Secrets and Lies' edited by Jan Jansen and Molly Roth; most of the authors (including McNaughton) explicitly disavow the Griaule school.

34. For my own experience with a schoolteacher in Kangaba who accepted the validity of Dieterlen's creation myth precisely because it was unfamiliar, probably of Dogon inspiration, and thus revelatory of 'true' pre-Islamic Mande culture, see Ralph A. Austen, 'The Problem of the Mande Creation Myth' (unpublished); this is also an issue in my current work on the very eminent writer Amadou Hampâté Bâ.

Chapter 3

1. *Ceddo*: Ousmane Sembène, 1976, Senegal, 120 mins, Wolof and French.

2. *Emitai*: Ousmane Sembène, 1971, Senegal, 103 mins, Wolof and French.

3. Mbye Cham, 'Official History, Popular Memory: Reconfiguration of the African Past in the Films of Ousmane Sembène', in S. Gadjigo, R. Faulkingham, T. Cassirer, & R. Sander (eds.), *Ousmane Sembène: Dialogues with Critics and Writers* (Amherst: University of Massachusetts Press, 1993), pp. 25–26.

4. Amar Samb, 'L'Islam: la religion indigène du Sénégal' (Dakar: Institut Fondamental d'Afrique Noire, 1973).

5. Ousmane Sembène, *Les Bouts de bois de Dieu* (Paris: Le Livre Contemporain, 1960), translated into English by Francis Price as *God's Bits of Wood* (Garden City, NY: Anchor Books, 1970). The English translation included an introduction by the Ghanaian historian Adu Boahen, who set the book in the context of modern West African history.

6. I am thinking of characters like Fa Keita and his wife, Niakoro, parents of the labour organiser Bakayoko, and Ramatoulaye, a powerful older woman, living in the African quarter of Dakar. See Robert M. Baum, '*Emitai, Allah*, and *God's Bits of Wood*: Sembène Ousmane and the Question of Religion and Resistance', paper presented at the American Academy of Religion Annual Meeting, San Francisco, November 1992.

7. D. Iyam, 'The Silent Revolutionaries: Ousmane Sembène's *Emitai, Xala*, and *Ceddo*', in *African Studies Review*, 29, 4 (1986), p. 85.

8. Robert Rosenstone notes a similar attraction of film for the academic historian. See his 'History in Images/History in Words: Reflections on the Possibility of Really Putting History onto Film', *American Historical Review*, 93, 5 (1988), p. 1174.

9. Interview with Ousmane Sembène, Dakar, Senegal, 1978, cited in Françoise Pfaff, 'The Uniqueness of Ousmane Sembène's Cinema', in Gadjigo et al., *Ousmane Sembène*, p. 13.
10. Rosenstone, 'History in Images', p. 1181.
11. *Le Monde*, 14 August 1979.
12. Samb, 'L'Islam'; Vincent Monteil, *L'Islam noir* (Paris: Seuil, 1971), p. 59 and passim. Views to the contrary can be found in Martin Klein, *Islam and Imperialism in Senegal: Sine-Saloum, 1847–1914* (Stanford: Stanford University Press, 1968).
13. Cham, 'Official History', p. 26.
14. Donal Cruise O'Brien, *Saints and Politicians: Essays in the Organisation of a Senegalese Peasant Society* (Cambridge: Cambridge University Press, 1975), pp. 19–35.
15. Interview by Robert M. Baum with Ousmane Sembène, Dakar, 1977.
16. My critique of the historicity of *Emitai* is based on over four years of field research in the area, beginning in 1974 and continuing until the summer of 2005. This is supplemented by work in the Senegalese and French Colonial archives. See Robert M. Baum, 'Alinesitoué: A Woman Prophet in West Africa', in N. Falk & R. Gross (eds.), *Unspoken Worlds: Women's Religious Lives* (Belmont, CA: Wadsworth/Thomson Learning, 2001); Robert M. Baum, 'Crimes of the Dream World: French Trials of Diola Witches in Colonial Senegal', *International Journal of African Historical Studies*, 37, 2 (2004).
17. R.J. Raack, quoted in Rosenstone, 'History in Images', p. 1176.
18. Robert Baum, *Shrines of the Slave Trade: Diola Religion and Society in Precolonial Senegambia* (New York: Oxford University Press, 1999), p. 91.
19. Baum, 'Alinesitoué', passim.
20. Baum, 'Alinesitoué', passim
21. Rosenstone, 'History in Images', p. 1174.
22. Rosenstone, 'History in Images', pp. 1176, 1179.

Chapter 4

1. This paragraph is based on the following BBC reports: 'Conference Split on Slavery Issue,' 5.9.2001, and 'Racism Conference Declaration,' 9.9.2001.
2. For slave trade statistics, see D. Eltis, S.D. Behrendt, D. Richardson & H.S. Klien, *The Trans-Atlantic Slave Trade: A Database on CD-ROM* (Cambridge: Cambridge University Press, 1999); D. Eltis, 'The Volume and Structure of the Transatlantic Slave Trade: A Reassessment', *William and Mary Quarterly*, 63 (2001), pp. 17–46.
3. K.O. Dike, *Trade and Politics in the Niger Delta* (Oxford: Clarendon Press, 1956); I.A. Akinjogbin, *Dahomey and Its Neighbours, 1708–1818* (Cambridge: Cambridge University Press, 1967); K.Y. Daaku, *Trade and Politics on the Gold Coast, 1600–1720* (Oxford: Clarendon Press, 1970); W. Rodney, *A History of the Upper Guinea Coast, 1545–1800* (Oxford: Clarendon Press, 1970).
4. P. Lovejoy, *Transformations in Slavery: A History of Slavery in Africa* (Cambridge: Cambridge University Press, 2000), pp. 318–354.
5. I wish to thank Christopher Miller, who kindly shared with me a draft of chapter 14, 'African Silences', of his book manuscript entitled *The French Atlantic Triangle: Literature and Culture of the Slave Trade*.
6. *Roots*: Alex Haley, 1977, USA, 573 mins, English.
7. *Tamango*: John Berry, 1958, France, Italy, 98 mins, English.
8. *Amistad*: Steven Spielberg, 1997, USA, 152 mins, English, Mende, Spanish.
9. *Sankofa*: Haile Gerima, 1993, Ghana, Burkina Faso, Germany, USA, UK, 125 mins, English.
10. *Ceddo*: Ousmane Sembène, 1977, Senegal, 120 mins, French, Wolof.
11. *Cobra Verde*: Werner Herzog, 1987, Germany, Ghana, 111 mins, German.

12. *Adanggaman*: Roger Gnoan M'Bala, 2000, Ivory Coast, Burkina Faso, France, Switzerland, 90 mins, French, Bambara.

13. R.A. Rosenstone, *Visions of the Past: The Challenge of Film to Our Idea of History* (Cambridge, Mass.: Harvard University Press, 1993), pp. 72–76.

14. O. Barlet, 'Une Réflexion sur le pouvoir: entretien avec Roger Gnoan M'Bala', *Africultures*, 20 (September 1999), p. 41. I owe this reference to Christopher Miller.

15. *Cobra Verde*, director's commentary on the DVD.

16. J.R. Jeffrey, '*Amistad* (1977): Steven Spielberg's "true story"', *Historical Journal of Film, Radio, and Television*, 21 (2001), pp. 77–96.

17. P. Merimée, *Prosper Merimée: romans et nouvelles*, introduction and notes by M. Parturier (Paris: Gallimard, 1967), vol. 1, pp. 481–483.

18. On the gun-slave cycle, see J. Thornton, *Africa and Africans in the Making of the Atlantic World, 1400–1800* (Cambridge: Cambridge University Press, 1998), pp. 112–125.

19. D. Richardson, 'Shipboard Revolts, African Authority, and the Transatlantic Slave Trade', in S.A. Diouf (ed.), *Fighting the Slave Trade* (Athens, Ohio: Ohio University Press, 2004), pp. 199–218.

20. D.R. Wright, 'Uprooting Kunta Kinte: On the Perils of Relying on Encyclopedic Informants', *History in Africa*, 8 (1981), pp. 205–217.

21. 'DVD Review: *Roots* (1977) (Anniversary Edition)', www.reel.com.

22. D.R. Wright, *The World and a Very Small Place in Africa* (Armonk, NY: M.E. Sharpe, 1997), pp. 105–122.

23. J. Barber, *A History of the Amistad Captives* (New Haven, Conn.: Hitchock and Stafford Printers, 1840), p. 9.

24. *Amistad: 'Give Us Free': A Celebration of the Film by Steven Spielberg* (New York: Newmarket Press, 1998), p. 20.

25. *Newsweek*, 8 December 1997, p. 65.

26. Barber, *History of the Amistad Captives*, p. 19.

27. *New York Commercial Advertiser*, 10 January 1840; Barber, *History of the Amistad Captives*, p. 19.

28. Letter from Kale, writing on behalf of the *Amistad* captives, to John Quincy Adams, 4 January 1841, New Haven Colony Historical Society, New Haven, Connecticut.

29. A. Bresnick, 'Telling Everyone's Story: "Give Us, Us Free": *Amistad* and the Hollywood Fantasy of Abolitionism', *Times Literary Supplement*, 20 February 1998, p. 18.

30. A. Abraham, 'Fact, Fiction, and the Making of *Amistad*', *Film and History CD-ROM Annual*, 1999.

31. Quoted in Abraham, 'Making of *Amistad*'.

32. R. Harms, *The Diligent: A Voyage through the Worlds of the Slave Trade* (New York: Basic Books, 2002), pp. 139–140.

33. One film that I was not able to include is *Le Courage des autres*. Produced in Burkina Faso in 1982, it is accessible only at the Cinématheque Afrique in Paris. This film is discussed in Miller, *French Atlantic Triangle*, chapter 14.

34. U. Gregor, 'Interview with Ousmane Sembene', *Framework*, 4, 7/8 (1978), p. 36.

35. M. Diouf, 'History and Actuality in Ousmane Sembene's *Ceddo* and Djibril Diop Mambety's *Hyenas*', in I. Bakari & M.B. Cham (eds.), *African Experiences of Cinema* (London: BFI Publishing, 1996), p. 243. I owe this reference to Christopher Miller.

36. Diouf, 'History and Actuality'.

37. 'Rencontre avec Ousmane Sembene,' *Nations Nouvelles* (1976), p. 28.

38. On the *ceddo* as slave soldiers, see J.F. Searing, *West African Slavery and Atlantic Commerce: The Senegal River Valley, 1700–1860* (Cambridge: Cambridge University Press, 1993).

39. 'Rencontre avec Ousmane Sembene', p. 28.
40. On female soldiers, see S.B. Alpern, *Amazons of Black Sparta: The Women Warriors of Dahomey* (London: Hurst, 1998); E.G. Bay, *Wives of the Leopard: Gender, Politics, and Culture in the Kingdom of Dahomey* (Charlottesville: University of Virginia Press, 1998), pp. 198–213.
41. R. Law, *Ouidah: The Social History of an African Slaving Port, 1727–1892* (Athens, Ohio: Ohio University Press, 2004), pp. 165–172; J.M. Turner, 'Les Bresiliens: The Impact of Former Brazilian Slaves upon Dahomey' (Ph.D. thesis, Boston University, 1975), pp. 88–98.
42. J.A. Skertchly, *Dahomey As It Is* (London: Chapman and Hall, 1874).
43. *Cobra Verde*, director's commentary on the DVD.
44. Barlet, 'Réflexion sur le pouvoir', p. 41.
45. *Amistad: 'Give Us Free'*, p. 17.

Chapter 5

1. *Proteus*: John Greyson and Jack Lewis, 2003, Canada, South Africa, 100 mins, Afrikaans, English and Nama.
2. *Proteus* is a joint Canadian-South African production with a budget of R5 million, of which 80% was raised in Canada. It was shot in Cape Town over only 18 days on Pal-D Beta (Kaizaad Kotwal, 'An interview with John Greyson', www.thefilmjournal.com).The cast includes some established Canadian actors such as Shaun Smyth (Niven). Neil Sandilands (Rijkhart) was known in South Africa as a television soap actor but Rouxnet Brown (Claas) was a newcomer.
3. For a range of such examples, see www.rottentomatoes.com (accessed 5 February 2005). In particular, Mary Brennan, 'Big Important Themes Imprisoned in Tangled Mess', *Seattle Times*, 5 November 2004, and Dave Kehr, 'On an Island Where Sex and Death Loom', *New York Times*, 30 July 2004.
4. See chapters 6 and 15 in this volume on *Zulu Dawn* and *Zulu* and on apartheid films.
5. Almost, since *Slavery of Love* (John Badenhorst, Three Worlds Film and Afrikan Connection Productions, 1998) depicted slave life in the VOC Cape. Like *Proteus* it had a very low budget and minimal exposure. Unlike *Proteus*, it provided a conventionally 'realist' reconstruction of a historical period.
6. For controversies surrounding 1652 and its significance, see Leslie Witz, *Apartheid's Festival* (Cape Town: David Philip, 2003).
7. For accounts of this process see especially Richard Elphick, *Khoikhoi and the Founding of White South Africa* (Johannesburg: Ravan Press, 1985); Nigel Penn, 'Land, Labour and Livestock in the Western Cape during the Eighteenth Century' in Wilmot James & Mary Simons (eds.), *The Angry Divide: Social and Economic History of the Western Cape* (Cape Town: David Philip, 1989) and Susan Newton-King, *Masters and Servants on the Cape Eastern Frontier, 1760–1803* (Cambridge: Cambridge University Press, 1999).
8. On Cape slavery see especially Nigel Worden, *Slavery in Dutch South Africa* (Cambridge: Cambridge University Press, 1985); Robert Shell, *Children of Bondage: A Social History of the Slave Society at the Cape of Good Hope, 1652–1838* (Johannesburg: Witwatersrand University Press, 1994).
9. Research on the *bandieten* is only just beginning. See especially J. Armstrong, 'The Chinese at the Cape in the Dutch East India Company Period, 1652–1795', *Slave Route Project Conference*, Robben Island, 24–26 October 1997; K. Ward, 'The Bounds of Bondage: Forced Migration between the Netherlands East Indies and the Cape of Good Hope in the Eighteenth Century' (Ph.D., University of Michigan, 2001).
10. Inspired by the debates over Edward Said's *Orientalism* (London, 1978). A huge literature now exists, of which recent examples are Kathleen Wilson (ed.), *A New Imperial History: Culture, Identity and Modernity in Britain, 1660–1840* (Cambridge: Cambridge University Press, 2004);

Martin Daunton & Rick Halpern (eds.), *Empire and Others: British Encounters with Indigenous Peoples, 1600–1850* (Philadelphia: University of Pennsylvania Press, 1999).

11. For example, Robert Ross, *Status and Respectability in the Cape Colony, 1750–1870: A Tragedy of Manners* (Cambridge: Cambridge University Press, 1999). Such work on the Dutch period at the Cape is the focus of an academic research group jointly based in the history departments of the University of Cape Town and the University of the Western Cape.

12. Edward Muir, 'Microhistory or *Microstoria*' in D.R. Wolf, *Global Encyclopedia of Historical Writing*, vol. 2 (New York and London: Garland Publishers, 1998), pp. 615–617; Giovanni Levi, 'On Microhistory' in P. Burke (ed.), *New Perspectives on Historical Writing* (Cambridge: Polity Press, 1991), pp. 93–113.

13. For example, Nigel Penn, *Rogues, Rebels and Runaways* (Cape Town: David Philip, 1999); Yvette Abrahams, 'Was Eva Raped?: An Exercise in Speculative History', *Kronos*, 23 (1996) pp. 3–21; Nigel Penn, 'The Wife, the Farmer and the Farmer's Slaves: Adultery and Murder on a Frontier Farm in the Early Eighteenth Century Cape', *Kronos*, 28 (2002), pp. 1–20; Susan Newton-King, 'For the Love of Adam: Two Sodomy Trials at the Cape of Good Hope', *Kronos*, 28 (2002), pp. 21–42; Nigel Worden, 'Forging a Reputation: Artisan Honour and the Cape Town Blacksmith Strike of 1752', *Kronos*, 28 (2002), pp. 43–65; John Mason, 'Hendrik Albertus and his Ex-slave Mey: A Drama in Three Acts', *Journal of African History*, 31 (1990), pp. 423–445.

14. Perhaps the best known example being N.Z. Davis, *The Return of Martin Guerre* (Cambridge, Mass.: Harvard University Press, 1983), the film of which received large audiences both in France and in North America (*Le Retour de Martin Guerre/The Return of Martin Guerre*, 1982/3, Martin Vigne, 111 mins.).

15. Theo van der Meer, *Sodoms zaad in Nederland: het ontstaan van homoseksualiteit in de vroegmoderne tijd* (Nijmegen: SUN, 1995); Michel Foucault, *Histoire de la sexualité: la volunté de savoir* (Paris: Gallimard, 1976).

16. This is a question that Newton-King had not yet resolved in publication, and in this sense *Proteus* pre-empted the writing of historians.

17. Kotwal, 'An interview with John Greyson', www.thefilmjournal.com.

18. Historical (as opposed to sociological) writing about same-sex identity and activity in South Africa is extremely limited and Newton-King's work is pioneering for the early colonial Cape. There is some work on migrant mineworkers, notably Dunbar Moodie, 'Migrancy and Male Sexuality on the South African Gold Mines', *Journal of Southern African Studies*, 14 (1988), pp. 228–256. The collection of source materials by the Gay and Lesbian Archive at the University of the Witwatersrand gives hope for future work in this direction.

19. The South African constitution was ratified in 1996 after an extended period of consultation and debate that was linked to human rights legislation. Following a sustained campaign by anti-apartheid activists who supported gay, lesbian and trans-sexual rights, discrimination on the grounds of sexual orientation was included in the same clause as that which made discrimination on the grounds of race, gender and religious belief unconstitutional. However, gay sodomy was only made lawful in 1998, while rights of same-sex couples to equality in terms of inheritance, taxation, insurance and marriage gradually proceeded through the courts in subsequent years, not always successfully. Hence Lewis's concern about vulnerability, despite the constitutional link with anti-racism, the lynchpin of the post-apartheid era. See Michael Lambert, 'South Africa' in George Haggerty (ed.), *Gay Histories and Cultures* (New York and London: Garland, 2000), pp. 834–836.

20. R. Rosenstone, *Visions of the Past: The Challenge of Film to Our Idea of History* (Cambridge, Mass.: Harvard University Press, 1995), p. 56.

21. Jack Lewis, 'Slaves to Love', *Weekly Mail and Guardian*, 12–18 March 2004, Friday supplement, p. 1.

22. Annie Coombes, *History after Apartheid: Visual Culture and Public Memory in a Democratic South Africa* (Johannesburg: Witwatersrand University Press, 2004), p. 264. The installation by Clive van den Berg was part of the *Faultlines* exhibition.

23. See notes 5 and 6 above for examples of such work.

24. It could be argued that the shift of the work of historians of the Dutch Cape from issues of racial oppression and resistance in the 1980s (particularly evident in work on Cape slavery) to a more nuanced recent approach reflects not only a response to international historiographical trends but also changes in the political environment in which they work.

25. Simon Schama, *The Embarrassment of Riches: An Interpretation of Dutch Culture in the Golden Age* (Berkeley: University of California Press, 1987), pp. 15–24. This is a further example of the ways in which *Proteus* draws on recent historical work. It also makes an ironic connection with the actual fate of the protagonists who are drowned in Table Bay.

26. Willie Thompson, *Postmodernism and History* (London: Palgrave, 2004); Keith Jenkins, *Refiguring History: New Thoughts on an Old Discipline* (London: Routledge, 2003). For an alternative, but not unsympathetic, viewpoint see Richard Evans, *In Defence of History* (London: Granta Books, 1997).

27. Jack Lewis, discussion with HST 322 class, University of Cape Town, 17 March 2004.

28. On historical films that deliberately subvert realism, see Robert Rosenstone, 'History in Images/History in Words', *American Historical Review*, 93, 5 (1988), p. 1183.

29. Kehr, 'On an Island Where Sex and Death Loom'.

30. Jack Lewis, 17 March 2004.

31. The iconic image of stonebreaking in the prison courtyard appears in Nelson Mandela's *Long Walk to Freedom* (London: Abacus, 1994), while that of suffocation using a wet bag was re-enacted at the TRC hearings and widely broadcast on public television.

32. Coombes, *History after Apartheid*, pp. 54–115.

33. I am indebted to Harriet Deacon for this observation. A comparison could here be made to *Flame*, a film that directly confronts the official African nationalist narrative (see chapter 14 in this volume by Teresa Barnes).

34. I owe much of the following section to a stimulating discussion between a group of specialist historians of the VOC Dutch Cape and Jack Lewis on 23 September 2004. The group included me, Susan Newton-King, Antonia Malan, Gerald Groenewald, Harriet Deacon, Candy Malherbe and Sandra Burman.

35. I am grateful to Gerald Groenewald for this point. The film dates Claas's sentencing to Robben Island to 1725, although he was in fact sent there in 1715. Rijkhart had been sentenced in Batavia to 25 years on the Island in 1713 and was only two years from the end of his sentence when he was executed for sodomy. He was by then 40 years old while Claas was about 36; Cape Archives, CJ 3188; CJ 339, f.228.

36. Nigel Worden & Gerald Groenewald (eds.), *Trials of Slavery: Selected Documents Concerning Slaves from the Criminal Records of the Council of Justice at the Cape of Good Hope, 1705–1794* (Cape Town: Van Riebeeck Society, 2nd series, no. 36, 2005), pp. xxiii-xxvii.

37. Cape Archives, Council of Justice records (CJ) 339, ff.228–229.

38. Kotwal, 'Interview with John Greyson'; Jack Lewis, 23 September 2004. The testimonies of Rijkhart and of Claas are each four pages long (CJ 339, ff.226–227 and 228–229).

39. CJ 339, f.226 and ff.237–238.

40. CJ 339, f.221v.

41. Jack Lewis, 23 September 2004.

42. One of the original titles proposed for the film was 'Mutually Perpetuated', Jack Lewis, 23 September 2004.

43. Jack Lewis, 23 September 2004. The Bronx is a gay night club in Cape Town. An 'in-joke'

for Cape Town viewers is that the cruising spot was filmed at the site of Cape Town's now prestigious Victoria and Alfred Waterfront, invoking one of the more hidden aspects of the history of this dockland area.

44. Originally there was more footage of this, including ballads taken from Van de Meer's work, but this was cut in the final edit; Jack Lewis, 23 September 2004.

45. Lewis describes these differences as those of an Enlightenment and pre-Enlightenment perception of sexuality, 23 September 2004. Historians know very little about pre-colonial Khoi or San concepts of sexuality.

46. Van der Meer informed Lewis that it could not be assumed that such identities and ideas had spread to the Dutch colonies (Jack Lewis, 23 September 2004) and this uncertainty is reflected in the film. More recent evidence is now coming to light in the Cape archival records that shows that it had spread, and that the authorities were well aware of this. For example, Eijsch in the case of Francois Eduard van Duijnkerke, sailor, Cape Archives, CJ 335, ff.56–63, paragraph 48.

47. Jack Lewis, 17 March 2004.

48. Kotwal, 'Interview with John Greyson'.

49. Lewis, 'Slaves to Love', p. 1.

50. Rosenstone, *Visions of the Past*, p. 57.

Chapter 6

1. *Zulu*: Cy Endfield, 1963, UK, 138 mins, English, Zulu.

2. We are grateful to participants in the February 2005 workshop held in preparation for this book, our colleagues and guest participants in the Constitution of Public Intellectual Life Project, as well as J. Maingard, for valuable comments on our material and arguments. Our thanks to Trevor Moses of the National Film, Video and Sound Archives for ongoing research support.

3. *Zulu Dawn*: Douglas Hickox, 1980, USA, South Africa, Netherlands, 113 mins, English.

4. R. Cope, *Ploughshare of War: The Origins of the Anglo-Zulu War of 1879* (Pietermaritzburg: University of Natal Press, 1999), p. 10.

5. We use the term 'take-up' to refer to the myriad ways in which the films, aspects of the films or issues raised by or in reaction to the films are relayed, discussed, researched or analysed. The term thus refers to a much wider range of effects that flow from the film than those entailed in the concept of reception, a term also employed in this essay.

6. Earlier films by Endfield include *Gentleman Joe Palooka* (1946), *The Sound of Fury* (1951), which engaged lynching and intolerance, and *Tarzan's Savage Fury* (released in 1952).

7. B. Neve, *Films and Politics in America: A Social Tradition* (London: Routledge, 1992), p. 175. See also D. Thomson, *A Biographical Dictionary of Film*, 3rd ed. (New York: Alfred A. Knopf, 1994), pp. 225–226. Although Katz's encyclopedia contains certain factual errors, it is also helpful. See E. Katz, *Macmillan International Film Encyclopedia* (London: Harper Collins Publishers, 1994), p. 420; J.S. Cook, *World Socialist Website*: www.wsws.org.

8. See, for example, *Dr Strangelove* (1964), Stanley Kubrick's allegory of Cold War America; *Paths of Glory* (1957), Stanley Kubrick on the insanity and absurdity of war; *Bridge over the River Kwai* (1957), David Lean on the madness of war; *Pork Chop Hill* (1959), Lewis Milestone on the Korean War; *The Manchurian Candidate* (1962), John Frakenheimer on the Korean War.

9. Interview conducted by film scholar Sheldon Hall with second unit director, Robert Porter, 2002 Paramount Home Entertainment DVD release of *Zulu*.

10. '40 years of *Zulu*', by Dave Barry, Research Officer, National Screen and Sound Archives of Wales, screenandsound.llgc.org.uk.

11. James, *World Socialist Website*: www.wsws.org. Our thanks to Jon Hyslop for the pointer to Prebble's socialist orientation and writings.

12. *Culloden* (1963), one of his famed works, also made into a film for television, was as much about a colonial war – in 18th-century Scotland – as the film *Zulu*.

13. See the discussion of this in P. Clarke, *Hope and Glory, Britain 1900–1990*, Penguin History of Britain (London: Penguin, 1996), p. 275; and S. Ward (ed.), *British Culture and the End of Empire* (Manchester: Manchester University Press, 2001). See the Introduction and the essay by J. Richards in the same volume, 'Imperial Heroes for a Post-imperial Age: Films and the End of Empire', pp. 128–144.

14. Chad R., www.mrqe.com.

15. Richards, 'Imperial Heroes', p. 135.

16. Ward, *British Culture*, Introduction.

17. See K.M. Cameron, *Africa on Film: Beyond Black and White* (New York: Continuum, 1994), especially pp. 197–198.

18. *South African Film and Television Weekly*, 1, 8 (21 November 1963), p. 1.

19. See for example Jamie Uys's South African film *Dingaka* (made in the same year as *Zulu*, also starring Stanley Baker, and also produced by Joe Levine). P. Davis, *In Darkest Hollywood: Exploring the Jungles of Cinema's South Africa* (Johannesburg: Ravan Press, 1996), p. 62; DVD Porter interview. The film, which tracked its African characters' entry into the city, missed an opportunity for introducing the modern African subject and energetically exploited ethnographic spectacle: 'witchdoctors, body-parts, muti, familiars, tribal dancing, fur and skin costumes' (Davis, *In Darkest Hollywood*, p. 61; Cameron, *Africa on Film*, pp. 124–125, 155), a visual and ethnographic archive that even *Zulu*, despite the radical political tendencies of its scriptwriters, was unable to escape.

20. J. Givanni (ed.), *Symbolic Narratives/African Cinema: Audiences, Theory and the Moving Image* (London: British Film Institute, 2000), p. 83. See also J. Gugler. *African Film: Re-imagining a Continent* (Bloomington: Indiana University Press, 2003), p. 4.

21. We use the term 'ethnogracised' in the manner deployed by Edwin Wilmsen (following J. Clammer) in *Land Filled with Flies* (Chicago: University of Chicago Press, 1989), p. xii, to describe the process by which the so-called Bushmen of the Kalahari were lifted out of history and made anthropological, becoming the object of an intensive ethnographic project that determinedly positioned them as cultural isolates, unaffected by cultural contacts or change over time.

22. S. Hall, 'Monkey Feathers: Defending *Zulu* (1964)', in C. Monk & A. Sargeant (eds.), *British Historical Cinema* (London: Routledge, 2002), pp. 110–128.

23. Keyan Tomaselli, AMP Review (www.und.ac.za).

24. Hall argues that it is precisely the success of *Zulu* in Britain that has led hostile critics to identify an ideological role for the film in its own time comparable with that of Rorke's Drift itself for the Victorians. See Hall, 'Monkey Feathers', p. 113.

25. Hall, 'Monkey Feathers'.

26. Cameron, *Africa on Film*, conclusion.

27. See, for example, *South African Film and Television Weekly*, 2, 53 (31 Dec 1964).

28. On the debate around the politics of *Zulu* see C. Sharrett, '*Zulu*, or the Limits of Liberalism', *Cineaste*, 25, 4 (2000), pp. 28–33, and responses and Sharrett's reply in *Cineaste*, 26, 2 (2001), pp. 59–61.

29. *South African Film and Television Weekly*, 2, 52 (24 December 1964).

30. See, for example, epinions.com, notably reviews by Jedi Kermit (5 July 2001) and Mrs Norman Maine (29 April 2001).

31. J. Richards, *Visions of Yesterday* (London: Routledge, 1973), pp. 2, 6, 59–61.

32. Richards, 'Imperial Heroes', p. 138

33. F. Hale, 'The Defeat of History in the Film *Zulu*', *Military History Journal*, 10, 4 (1996), pp. 145–151; these quotes, see p. 145.

34. J. Rosenbaum, *Placing Movies: The Practice of Film Criticism* (Berkeley: University of California Press, 1995), pp. 281–282.

35. See epinions.com, especially Jason Gilbraith, 5 June 2000; also see Bill Mauzey, 23 March 2000; David Wragg, 29 July 2000.

36. Cameron, *Africa on Film,* p. 141.

37. Davis, *In Darkest Hollywood*, p. 164 citing Nate Kohn, 'Glancing off a Postmodern Wall: A Visit to the Making of *Zulu Dawn*', 1991. For contemporary comments see 'Filming *Zulu Dawn*', *American Cinematographer* (February 1979).

38. See Davis, *In Darkest Hollywood*, p. 162.

39. 'Filming *Zulu Dawn*'.

40. Davis, *In Darkest Hollywood*, p. 162.

41. 'Filming *Zulu Dawn*'.

42. 'Filming *Zulu Dawn*'.

43. 'Filming *Zulu Dawn*', picture caption based on explanation by director of photography, Ousama Rawi.

44. Davis, *In Darkest Hollywood*, pp. 60–122.

45. Among them were *Kaptein Caprivi* (1972), *Ses Soldate* (1975), and *Game for Vultures* (1979).

46. K. Tomaselli, *Cinema of Apartheid* (Sandton: Random Century, 1989), p. 135.

47. Davis, *In Darkest Hollywood*, p. 164.

48. G. Maré & G. Hamilton, *An Appetite for Power: Buthelezi's Inkatha and South Africa* (Johannesburg: Ravan Press, 1987).

49. P. Cowie (ed.), *International Film Guide* (London: The Tantivy Press, 1981), p. 276.

50. Davis, *In Darkest Hollywood*, p. 165.

51. *South African Film and Entertainment Weekly* (January 1980), p. 2.

52. See review by Alan Critchley, Rorkesdriftvc.com, accessed 9 February 2005, undated posting.

53. See for example, epinions.com, George Chabot, 5 February 2004, updated 6 May 2004; J. Paul Holt, 25 August 2001; Macresarf, 22 December 1999, updated 19 October 2003; Donkrider, 15 January 2000, updated 7 October 2002.

54. Interview, *The Star*, 22 January 1981.

55. See the various contributions to the *American Historical Review*, Forum, 93, 5 (1988).

56. Readers of this essay who are interested in pursuing the detailed discussions about the historical accuracy of the films will find the topic fully covered in various postings, by professional and amateur historians, on the site Rorkesdriftvc.com, under the menu items 'The Film "Zulu"' and 'The Film "Zulu Dawn"', as well as on the topics of the two films on H-Net Discussion Networks. Also see the essay by Hale cited previously.

57. W.H. Clements, *The Glamour and Tragedy of the Zulu War* (London: The Bodley Head, 1936).

58. This point is developed in H. Mokoena, 'Magema Magwaza Fuze: A Discursive Biography' (Ph.D. thesis, University of Cape Town, 2006).

59. Our discussion of Anglo-Zulu War historiography relies heavily on John Laband's review discussion, 'Anglo-Zulu War Studies: Where to from Here?', *Journal of the Anglo-Zulu War Historical Society*, 12 (December 2002), pp. 44–47.

60. See for example, D. Featherstone, *Weapons and Equipment of the Victorian Soldier* (New York: Arms and Armour Press, 1978); C. Wilkinson-Latham, *Uniforms and Weapons of the Zulu War* (London: B.T. Batsford, 1978); J. Mathews, 'Lord Chelmsford and the Problems of Transport and Supply during the Anglo-Zulu War of 1879' (MA thesis, University of Natal, 1979).

61. See, for instance, Monica Wilson & Leonard Thompson (eds.), *The Oxford History of South Africa*, vol. 2 (Oxford: Oxford University Press, 1971).

62. *Reality*, January 1979.
63. See Jeff Guy, 'Battling with Banality', *Journal of Natal and Zulu History*, 18 (1998), pp. 156–193. This article offers a valuable discussion of the persistence of the imperial historical tradition into the present.
64. D. Morris, *Washing of the Spears* (London: Jonathan Cape, 1966); J.D. Omer-Cooper, *The Zulu Aftermath: A Nineteenth Century Revolution in Bantu Africa* (London: Longmans, Green, 1966).
65. R. Egerton. *Like Lions They Fought: The Zulu War and the Last Black Empire in South Africa* (New York: Free Press, 1988); J. Laband, *Kingdom in Crisis: The Zulu Response to the British Invasion of 1879* (Pietermaritzburg: University of Natal Press, 1992); I. Knight, *The Anatomy of the Zulu Army from Shaka to Cetshwayo* (London: Greenhill Books, 1995).
66. The pioneering work in this area was undertaken by Jeff Guy in the 1970s, followed by the detailed studies of C.A. Hamilton & J.B. Wright. See, for example, their 'The Making of the *AmaLala*: Ethnicity, Ideology and Relations of Subordination in a Precolonial Context', *South African Historical Journal*, 22 (1990), pp. 3–23.
67. Guy, 'Battling with Banality', p. 172.
68. John Laband's meticulously researched *Rope of Sand: The Rise and Fall of the Zulu Kingdom in the Nineteenth Century* (Johannesburg: Jonathan Ball, 1995), while comprehensive in its coverage, offers what is essentially a detailed narrative of the run-up to the war rather than sustained analysis of the origins of the war, of the kind found in the later text by Cope.
69. M. Landy, *British Genres: Cinema and Society: 1930–1960* (Princeton: Princeton University Press, 1991), p. 53.
70. Landy, *British Genres*, p. 97.
71. Landy, *British Genres*, p. 484.
72. *Khartoum*, the subject of chapter 8 in this volume by Shamil Jeppie.
73. The changes evident in the promotional materials and in the packaging of the two films, over time, provide a perspective on how distributors alter the framing of the films in response to perceived changes in how the films are received. See, for example, www.michaelcaine.org.
74. Davis, *In Darkest Hollywood*, p. 124.
75. Davis's discussions of the various films show, for example, substantial characterisation of individual Zulus in films (although mostly as, in his terms, 'faithful servants') before 1938, and much less thereafter. His work also shows that in film terms while most interest centred on Zulus in tribal mode, urban depictions of modern Zulu lives were not wholly absent.
76. See for example J. Dube, *Insila kaShaka* (Mariannhill, 1930) and the many works of H.I.E. and R.R. Dhlomo.
77. C. Hamilton, *Terrific Majesty: The Powers of Shaka Zulu and the Limits of Invention* (Cambridge, Mass.: Harvard University Press, 1998), chapter 3.
78. S. Dubow, *Racial Segregation and the Origins of Apartheid in South Africa, 1919–1936* (London: Macmillan, 1989).
79. Kohn quoted in Davis, *Darkest Hollywood*, p. 162.
80. DVD, Porter interview.
81. Witt's qualification of Zulu practices in culturally relativist terms is mirrored in *Zulu Dawn* when Frere presents the war as an effort to curtail the barbarity of Cetshwayo, claiming that he massacred 20 000 of his own people to make himself king, to which the Bishop counters that the Tudors and the French did no less.
82. P. Gilroy, *There Ain't No Black in the Union Jack* (London: Hutchinson, 1987), p. 12.
83. Landy, *British Genres*, p. 55.
84. T. Dirks, 'War and Anti-War Films 1996–2005', www.filmsite.org.
85. R. Rosenstone, 'History in Images/History in Words: Reflections on the Possibility of Really Putting History onto Film', *American Historical Review*, 93, 5 (1988), p. 1177.

86. In invoking the concept of 'publics' here, we do not mean to suggest that all viewers engage in discourse about the films, but that an arena of public discourse emerges around the films. The debating publics may even include individuals who have never seen the films but who have read reviews of films, or engaged in dinner-time conversation with friends who viewed the films, as well as critics and scholars who comment on the films. See M. Warner, *Publics and Counterpublics* (New York: Zone Books, 2002).

Chapter 7

1. *Breaker Morant*: Bruce Beresford, 1980, Australia, 107 mins, English.
2. The producers chose the historic copper-mining town of Burra in South Australia for the Pietersburg scenes. Countryside locations were found that 'resembled the South African veldt'. The ornate interiors of Lord Kitchener's headquarters in Pretoria were shot at the Loreto Convent in Marryatville and at the Sacred Heart College in Somerton Park, the imposing exteriors of Kitchener's headquarters at Rostrevor College in Rostrevor, South Australia (information from *The Internet Movie Database*).
3. The film was shot for an estimated $AUS650 000. It grossed a modest $7 142 857 in the American market – a respectable tally for a foreign film on an historical topic wholly unfamiliar to American audiences – and $AUS4 735 000 at home, at the time an Australian box-office record (information from *The Internet Movie Database*). Beresford is self-deprecating about the reception of what was his breakthrough film: Breaker Morant 'never made a cracker, you know. It's amazing when you think I was super-hot on the basis of a film nobody saw. It was a good movie but it was a flop in the US. It had bad reviews, and the only reason I got all the offers was because they ran it for a long time on the plane between New York and LA. It was the in-flight movie. All the executives saw it.' (Interview with Jennifer Byrne in bulletin.ninemsn.com.au.) Contrary to Beresford's coy disclaimer, the Americans critics were by no means universally hostile. See Peter Coleman, *Bruce Beresford: Instincts of the Heart* (Pymble, New South Wales: Angus and Robertson, 1992), pp. 87–88 for the glowing reviews in the *New York Times*, the *Saturday Review* and *Commentary*.
4. The chief examples of these Australian historical films are Peter Weir's landmark *Picnic at Hanging Rock* (1975); his much-acclaimed *Gallipoli* (1981); Bruce Beresford's *The Getting of Wisdom* (1977); Fred Schepisi's *The Chant of Jimmie Blacksmith* (1978); and Gillian Armstrong's *My Brilliant Career* (1979).
5. Besides the actors in the key Australian parts – Bryan Brown as the hot-tempered and defiant Peter Handcock, Lewis Fitz-Gerald as the naïve George Witton and Jack Thompson as the bluff Major Thomas, the defence attorney – Australians play the pukka English roles of Lord Kitchener, his aide Colonel Ian (Johnny) Hamilton, and Colonel Denny, the pompous and blimpish president of the court martial. An Australian, Russell Kiefel, fills the one significant Boer-speaking role, Christiaan Botha, a collaborator with the British. Jack Thompson won the best supporting actor award at the Cannes Film Festival for his role. See *The Internet Movie Database* (www.imdb.com) for casting information.
6. Woodward, best known at this time for his performance in a popular British TV series as Callan, a special agent with a licence to kill, was not the first choice for the title role. Improbably, the American actor Rod Steiger – Napoleon in *Waterloo* (1971) and Benito Mussolini in *Omar Mukhtar: Lion of the Desert* (1981) – was originally considered for the part; later the Australian actor Terry Donovan (father of the more famous Jason). Donovan was subsequently relegated to the supporting role of Morant's friend Captain Simon Hunt, whose death triggers Morant's campaign of vengeance. Woodward was chosen instead because it was thought desirable to cast an 'international star' in the title role (information from *The Internet Movie Database*).

7. The rich Australian critical literature on the film has largely concentrated on Australian concerns rather than on the quality of the film's representation of the South African War. See, for example, Roslyn Jolly, '"Frontier Behaviour" and Imperial Power in *Breaker Morant*', *Journal of Commonwealth Literature*, 32, 2 (1997), pp. 125–139; Lorraine Mortimer, 'The Soldier, the Shearer and the Mad Man: Horizons of Community in Some Australian Films', *Literature/Film Quarterly*, 21, 2 (1993), pp. 139–156; Thelma Ragas, '*Breaker Morant*: Patterns of Heroism', *Cinema Papers*, 36 (1982), pp. 48–53. See also Susan Gardner, 'From Murderer to Martyr: The Legend of "Breaker" Morant', *Critical Arts Monograph*, 1 (July 1981), pp. 2–29.

8. Recommended general texts include Thomas Pakenham's popular *The Boer War* (London: Weidenfeld and Nicolson, 1979); Bill Nasson's fine synthesis, *The South African War 1899–1902* (London: Arnold, 1999); and Denis Judd and Keith Surridge's *The Boer War* (London: John Murray, 2002), which has a few pages devoted to the Breaker Morant affair. The centenary of the war generated a wave of re-appraisals, including Greg Cuthbertson, Albert Grundlingh & Mary-Lynn Suttie (eds.), *Writing a Wider War: Rethinking Gender, Race and Identity in the South African War 1899–1902* (Athens, Ohio: Ohio University Press, 2002).

9. While the South African War has been neglected by feature film directors, it has been the subject of numerous documentaries, including *Scorched Earth* (2001), a lengthy documentary, based on extensive interviewing of historians and others, and screened on both British and South African television. The war has also featured in a couple of television series: *Arende* (1988, 1991), a South African production in Afrikaans that dealt with the experience of Boer prisoners of war, and the BBC's *Rhodes* (1996), a mini-series on the exploits of the great empire builder.

10. Titles at the start of the film supply scant historical context: 'The Boer War (1899–1902) was fought between countries of the British Empire and the Boer (mostly Dutch) population of South Africa. The issues were complex, but basically the Boers wished to retain their independence from England.' The mineral wealth of the region is mentioned in passing in a conversation at Lord Kitchener's headquarters.

11. For comprehensive coverage of Australian participation in the South African War and of the Breaker Morant affair, see Craig Wilcox, *Australia's Boer War: The War in South Africa 1899–1902* (Melbourne: Oxford University Press, 2002). This supersedes L.M. Field's *The Forgotten War: Australian Involvement in the South African Conflict of 1899–1902* (Melbourne: Melbourne University Press, 1979).

12. For this controversial policy, see S.B. Spies, *Methods of Barbarism? Roberts and Kitchener and Civilians in the Boer Republics January 1900–May 1902* (Cape Town: Human and Rousseau, 1977).

13. For the tragic fate of Boer women and children, and African refugees in these camps, see Fransjohan Pretorius (ed.), *Scorched Earth* (Cape Town: Human and Rousseau, 2001).

14. For this restiveness, see Jeremy Krikler, *Revolution from Above, Rebellion from Below: The Agrarian Transvaal at the Turn of the Century* (Oxford: Oxford University Press, 1993) and Peter Warwick, *Black People and the South African War 1899–1902* (Cambridge: Cambridge University Press, 1983).

15. For the best accounts of the Breaker Morant affair, see Wilcox, *Australia's Boer War*, ch. 14 and Arthur Davey (ed.), *Breaker Morant and the Bushveldt Carbineers* (Cape Town: Van Riebeeck Society, 1987).

16. Quoted in Judd & Surridge, *The Boer War*, p. 231.

17. See Davey, *Breaker Morant*, p. 11. Kirsten McKenzie, writing of an earlier period in *Scandal in the Colonies: Sydney and Cape Town, 1820–1850* (Melbourne: Melbourne University Press, 2004), p. 1, notes 'that the ability to transcend past origins and masquerade in new identities was especially common to antipodean lands founded as penal colonies'.

18. Peter Weir's *Gallipoli,* released the year after *Breaker Morant,* is similarly concerned with Australian martyrdom in a bad imperial cause.
19. Leonard Maltin's *Movie Encyclopedia,* quoted in the *Internet Movie Database* entry on Bryan Brown.
20. Here Beresford is also possibly drawing on the character types that populate the classic combat film genre.
21. George Witton, *Scapegoats of the Empire: The True Story of Breaker Morant's Bushveldt Carbineers* (Melbourne: D.W. Paterson, 1907, reprint 1982). Captain Frederick de Bertodano, the investigating officer in the Breaker Morant case, described Witton's account years later as 'mostly a garbled and untrue version of the facts'. See Davey, *Breaker Morant,* p. 53.
22. Davey, *Breaker Morant,* p. 24.
23. Davey, *Breaker Morant,* p. 24.
24. Kit Denton, *The Breaker* (London: Angus and Robertson, 1980). The 1980 paperback edition has a defiant portrait of Edward Woodward as Breaker Morant on the cover and includes a selection of the Breaker's poetry.
25. Kenneth Ross, *Breaker Morant: A Play in Two Acts* (Melbourne: Edward Arnold, 1979).
26. See Coleman, *Bruce Beresford,* pp. 18, 80–81.
27. Coleman, *Bruce Beresford,* p. 80.
28. The historic Colonel Hubert Hamilton, Kitchener's military secretary, is renamed (accidentally?) Ian Hamilton in the film. The latter, also serving in South Africa during the war, would have been familiar to Australian audiences as the commanding general during the Gallipoli fiasco in the First World War.
29. Here Beresford takes his lead from Ross's play, which cuts from the courtroom to Kitchener's headquarters.
30. The film depicts Morant's horrified response as he views the mutilated body of his friend. This is the turning point for Morant that sets aside his previous reservations about the killing of prisoners and places him on a path of vengeance. The historian Arthur Davey (*Breaker Morant,* p. xliii) records that Hunt's body had already been buried by the time Morant arrived and that Morant learnt from witnesses that 'his neck had been broken, his face stamped upon with hobnailed boots and that his legs had been slashed with a knife'. Davey allows that the injuries are consistent with 'the savage character of close combat' (p. xliv) but he also raises the possibility of the removal of body parts for ritual purposes by black tribesmen (pp. xliv–xlv).
31. Information from Elizabeth Davey.
32. Davey, *Breaker Morant.*
33. Kit Denton, *Closed File: The True Story behind the Execution of Breaker Morant and Peter Handcock* (Adelaide: Rigby, 1983).
34. See Davey, *Breaker Morant,* ch. 2: 'The Missionary Factor and Germany'.
35. Thomas Pakenham, 'A New Game, the Old Rules', *Times Literary Supplement,* 7 November 1980, p. 1258.
36. The cover of the 2001 DVD version of *Breaker Morant* leaves no doubt about the disputed order. It reads in strident capitals: 'THEY WERE ORDERED TO "TAKE NO PRISONERS."'
37. See Davey, *Breaker Morant,* p. xxxiv.
38. Robert A. Rosenstone, *Visions of the Past: The Challenge of Film to Our Idea of History* (Cambridge, Mass.: Harvard University Press, 1995), p. 72.
39. For the gap between German public opinion and official policy, see Ulrich van den Heyden, *Diplomasie en politiek: Die pers, die Boererepubliek en Duitsland tydens die Anglo-Boereoorlog* (Pretoria: Protea Boekhuis, 2000) and Martin Kröger, 'Imperial Germany and the Boer War', in Keith Wilson (ed.), *The International Impact of the Boer War* (New York: Palgrave, 2001).
40. In defence of the filmmakers it might be argued that the setting for the Breaker Morant saga

is the remote Spelonken area, far removed from the Free State and Highveld epicentres of the scorched earth regime.

41. Peter Handcock's alibi for the day on which he shot the missionary is provided by two Boer women he dallied with that afternoon.

42. For the description of the South African War by the noted military historian Major-General J.F.C. Fuller in these flattering but misleading terms, and an historical rebuttal, see Judd & Surridge, *The Boer War*, ch. 16.

43. Coleman, *Bruce Beresford*, pp. 85–86 quotes this speech with minor inaccuracies.

44. Australia itself had participated in the Vietnam War as an American ally. Beresford's apparent views – as expressed in *Breaker Morant* – on guerrilla war and its impact on the behaviour of soldiers could well have been shaped by the surrounding controversy.

45. For the critical controversy, see Coleman, *Bruce Beresford*, pp. 87–88. Despite the negative comment, the screenplay was nominated for an Oscar.

46. Quoted in Coleman, *Bruce Beresford*, p. 87.

47. Quoted in Coleman, *Bruce Beresford*, p. 88.

48. *Breaker Morant* swept the Australian Film Institute awards in 1980.

49. For Sol Plaatje's wartime experience, see John. L. Comaroff (ed.), *The Boer War Diary of Sol T. Plaatje* (London: Macmillan, 1973). For Plaatje's career, see Brian Willan, *Sol Plaatje: A Biography* (Johannesburg: Ravan Press, 1984).

50. Davey, *Breaker Morant*, pp. 56–57.

51. Pakenham, *Boer War*, p. 547.

52. Peter Warwick (ed.), *The South African War: The Anglo-Boer War 1899–1902* (Harlow, Essex: Longman, 1980). The title of this book finesses the debate around the naming of the war by using both of the principal contending appellations. It gives primacy though to the South African War, the preferred title for those who, like the editor himself, would argue that the war encompassed more than Boer and Brit.

53. Peter Warwick, 'African Societies and the South African War, 1899–1902' (D.Phil. thesis, University of York, 1978). See his subsequent book, *Black People and the South African War 1899–1902*.

54. Bill Nasson, *Abraham Esau's War: A Black South African in the Cape, 1899–1902* (Cambridge: Cambridge University Press, 1991). See also Bill Nasson, *Uyadela Wen'osulapho: Black Participation in the Anglo-Boer War* (Randburg: Ravan Press, 1999).

55. Warwick, *The South African War*, p. 196.

56. Quoted in Davey, *Breaker Morant*, p. 59.

57. The film credits an 'Africaan Language Adviser'. Some of the Afrikaans lines added to the soundtrack are clearly authentic.

58. Deneys Reitz, *Commando: A Boer Journal of the Boer War* (London: Faber, 1968).

59. Fransjohan Pretorius, *Life on Commando during the Anglo-Boer War 1899–1902* (Cape Town: Human and Rousseau, 1999), ch. 11.

60. Albert Grundlingh, *Die 'Hendsoppers' en 'Joiners': die rasionaal en verskynsel van veraad*, 2nd ed. (Pretoria: Protea Boekhuis, 1999). See also his chapter, 'Collaborators in Boer Society' in Warwick, *The South African War*.

61. See the forum on 'Film and History' in the *American Historical Review*, 93, 5 (December 1988), pp. 1173–1227.

62. For recent debate about the Breaker Morant affair in Australia, see Nick Bleszynski, *Shoot Straight You Bastards! The Truth behind the Killing of 'Breaker' Morant* (Milsons Point, NSW: Random House, 2002).

63. *Wikipedia*, 'Breaker' Morant (film) entry. (Find at en.wikipedia.org.)

Chapter 8

1. *Khartoum*: Basil Dearden, 1966, UK, 137 mins, English.
2. *Omar Mukhtar: Lion of the Desert*: Moustapha Akkad, 1981, Libya/USA, 173 mins, English.
3. See for example Abdel Salam Sidahmed, *Politics and Islam in Contemporary Sudan* (Richmond: Curzon, 1997), Gabriel Warburg, *Islam, Sectarianism and Politics in Sudan since the Mahdiyya* (London: Hurst, 2003), and Hassan Ahmad Ibrahim, 'The Role of Sayyid 'Abd al-Rahman al-Mahdi in the Sudanese National Movement 1908–1956', in Mahasin Abdelgadir Hag al-Safi (ed.), *The Nationalist Movement in the Sudan* (Khartoum: Institute of African and Asian Studies, 1989).
4. Such histories are widely available either as single-volume works or as parts of general histories. This is especially so in the case of 'the Mahdi', which has an extensive historiography. See, for example, P.M. Holt, *The Mahdist State in the Sudan 1881–1898: A Study of Its Origins, Development and Overthrow* (Oxford: Clarendon Press, 1958).
5. On the history of the 'Mahdi' idea in Islamic theology see W. Madelung's entry 'al-mahdi' in *Encyclopedia of Islam*, CD-ROM edition (Leiden: Brill). Madelung writes that 'The term mahdi as such does not occur in the Quran; but the name is clearly derived from the Arabic root h-d-y commonly used in the meaning of divine guidance. As an honorific epithet without messianic significance, the term was employed from the beginning of Islam.'
6. For studies on Sufism see Martin Lings, *What Is Sufism?* (London: George Allen and Unwin, 1975); Annemarie Schimmel, *Mystical Dimensions of Islam* (Chapel Hill: University of North Carolina Press, 1975). The following biographies of leading 19th- and 20th-century Sufis in Africa are also useful: Martin Lings, *A Sufi Saint of the Twentieth Century: Shaikh Ahmad al-Alawi, His Spiritual Heritage and Legacy*, 2nd ed. (London: George Allen and Unwin, 1971); Louis Brenner, *West African Sufi: The Religious Heritage and Spiritual Search of Cerno Bokar Saalif Taal* (London: C. Hurst, 1984); and R.S. O'Fahey, *Enigmatic Saint: Ahmad ibn Idris and the Idrisi Tradition* (London: Hurst, 1990). A useful overview work is B.G. Martin, *Muslim Brotherhoods in Nineteenth Century Africa* (Cambridge: Cambridge University Press, 1976).
7. See details in entry for film on the *Internet Movie Database* (www.imdb.com).
8. On the Ottoman-Egyptian Sudan see Richard Hill, *Egypt in the Sudan* (London: Oxford University Press, 1958).
9. Soon after his death 'Gordon memorials were being unveiled and Gordon Boys' Clubs were being opened. During the decade after his death, over twenty-five books, and a far greater number of pamphlets and articles, were written to his glory.' Denis Judd, 'Gordon of Khartoum: The Making of an Imperial Martyr', *History Today* (January 1985), pp. 19–25. See also Douglas Johnson, 'The Death of Gordon: A Victorian Myth', *Journal of Imperial and Commonwealth History*, 10, 3 (1982), pp. 285–310.
10. On these aspects of the movement see Holt, *Mahdist State*.
11. On the Sanusi, see E. Evans-Pritchard's classic *The Sanusi of Cyranaeica* (Oxford: Oxford University Press, 1948).
12. For a good compilation of Italian studies on the Italians in Libya and the role of Mukhtar's resistance in particular, see Enzo Santarelli et al., *Omar al-Mukhtar: The Italian Reconquest of Libya*, transl. John Gilbert (London: Darf Publishers, 1986).
13. A. Adu Boahen (ed.), *General History of Africa*, vol. 7, South African abridged edition (Cape Town: New Africa Books, 2003), p. 49.
14. See Jonathan Bearman, *Qadhafi's Libya* (London: Zed Books, 1986).
15. Oral information from Prof. Sean O'Fahey, Cape Town, August 2005.
16. See entry for film in the Internet Movie Data Base (www.imdb.com).

Chapter 9

1. *Black and White in Colour (Noir et blancs en couleur)*: Jean-Jacques Annaud, 1976, Ivory Coast, France, West Germany, Switzerland, 92 mins, French.

2. *Le Camp de Thiaroye*: Ousmane Sembène, 1987, Algeria, Senegal, Tunisia, 153 mins, French, Wolof.

3. William Boyd, *An Ice-Cream War* (Harmondsworth: Penguin, 1983), pp. 32, 47.

4. David Killingray, 'The War in Africa', in Hew Strachan (ed.), *The Oxford Illustrated History of the First World War* (Oxford: Oxford University Press, 1998), p. 92.

5. David Killingray, 'If I Fight for Them, Maybe Then I Can Go Back to the Village: African Soldiers in the Mediterranean and European Campaigns, 1939–45', in Paul Addison & Angus Calder (eds.), *Time to Kill: The Soldier's Experience of War in the West 1939–1945* (London: Pimlico, 1997), p. 95.

6. Bernard Waites, 'Peoples of the Underdeveloped World', in Hugh Cecil & Peter H. Liddle (eds.), *Facing Armageddon: The First World War Experienced* (London: Leo Cooper, 1996), p. 603.

7. Myron Echenberg, *Colonial Conscripts: The Tirailleurs Senegalais in French West Africa, 1857–1960* (London: James Currey, 1960), pp. 25–26; John Lamphear, 'Sub-Saharan African Warfare', in Jeremy Black (ed.), *War in the Modern World since 1815* (London: Routledge, 2003), p. 182.

8. See, for example, J.M. Winter, *The Experience of World War I* (London: Macmillan, 1988); R.A.C. Parker, *Struggle for Survival: The History of the Second World War* (Oxford: Oxford University Press, 1989). Also Killingray, 'War in Africa', p. 92.

9. Jean Suret-Canale, *French Colonialism in Tropical Africa, 1900–1945* (London: Hurst, 1971), p. 139; Killingray, 'War in Africa', pp. 100–101.

10. C.M. Andrew & A.S. Kanya-Forstner, 'France, Africa, and the First World War', *Journal of African History*, 19, 1 (1978), pp. 14–15; Philip Dine, 'The French Empire', in John Bourne, Peter Liddle & Ian Whitehead (eds.), *The Great World War 1914–45*, vol. 2 (London: Harper Collins, 2001), p. 277.

11. Stephane Audoin-Rouzeau, *Men at War: Trench Journalism and National Sentiment in France 1914–1918* (Oxford: Berg, 1992); 'The French Soldier in the Trenches' in Cecil & Liddle, *Facing Armageddon*, pp. 221–229.

12. Joe Lunn, *Memoirs of the Maelstrom: A Senegalese Oral History of the First World War* (London: James Currey, 1999); Echenberg, *Colonial Conscripts*.

13. See, for example, Marc Michel, *L'Appel á l'Afrique: contributions et reactions a l'effort de guerre en A.O.F. 1914–1919* (Paris: Publications de la Sorbonne, 1982).

14. Bakary Diallo, *Force bonté* (Paris: Rieder, 1926); Mohamed Dib, *Le Metier á tisser* (Paris: Seuil, 1957).

15. In Rex Ingram's romantic epic about suffering and noble redemption in the 1914–18 war, *The Four Horsemen of the Apocalypse* (1920).

16. Sue Harper, 'Popular Film, Popular Memory: The Case of the Second World War', in Martin Evans & Ken Lunn (eds.), *War and Memory in the Twentieth Century* (Oxford: Berg, 1997), p. 173.

17. Jay Winter, *Sites of Memory, Sites of Mourning: The Great War in European Cultural History* (Cambridge: Cambridge University Press, 1995), p. 138.

18. For the Great War, see John Horne. '*L'Impôt du sang*: Republican Rhetoric and Industrial Warfare in France, 1914–18', *Social History*, 14, 2 (1989), p. 201.

19. Horne, '*L'Impôt du sang*', p. 205.

20. Suret-Canale, *French Colonialism*, pp. 134–143; Echenberg, *Colonial Conscripts*, pp. 25–30; Lunn, *Memoirs*, pp. 33–58.

21. Robert Rosenstone, *Visions of the Past: The Challenge of Film to Our Idea of History* (Cambridge, Mass.: Harvard University Press, 1998), p. 72.

22. Dine, 'French Empire', p. 283.

23. For which, see Lunn, *Memoirs*, pp. 24–27.

24. Echenberg, *Colonial Conscripts*, p. 3.

25. Suret-Canale, *French Colonialism*, p. 129; Dine, 'French Empire', p. 276.

26. Echenberg, *Colonial Conscripts*, p. 88; Dine, 'French Empire', p. 283.

27. Dine, 'French Empire', pp. 284–285.

28. Echenberg, *Colonial Conscripts*, p. 103.

29. Echenberg, *Colonial Conscripts*, p. 170; Lunn, *Memoirs*, p. 230.

30. Frederick Cooper, *Decolonization and African Society: The Labour Question in French and British Africa* (Cambridge: Cambridge University Press, 1996), p. 9.

31. Killingray, 'African Soldiers', p. 103.

32. See, for example, Echenberg, *Colonial Conscripts*, p. 91.

33. Echenberg, *Colonial Conscripts*, p. 99.

34. Suret-Canale, *French Colonialism*, p. 452.

35. Dine, 'French Empire', p. 286.

36. Echenberg, *Colonial Conscripts*, p. 101.

37. See, for instance, Lunn, *Memoirs*, p. 98.

38. Echenberg, *Colonial Conscripts*, pp. 101–102.

39. For the American expression of this individual realm in history, see Robert Brent Toplin, *History by Hollywood: The Use and Abuse of the American Past* (Chicago: University of Illinois Press, 1996).

40. Dine, 'French Empire', p. 287.

41. Killingray, 'African Soldiers', p. 37.

42. Hew Strachan, 'The Soldier's Experience of Two World Wars: Some Historiographical Comparisons', in Addison & Calder, *Time to Kill*, p. 378.

Chapter 10

1. Ethiopian filmmaker Haile Gerima, quoted by Françoise Pfaff in 'Introduction', Francois Pfaff (ed.), *Focus on African Films* (Bloomington: Indiana University Press, 2004), p. 1.

2. The best account of the railway's construction is Charles Miller, *The Lunatic Express* (London: History Book Club, 1971).

3. The words of Sir Charles Eliot in 1903 quoted by D.A. Low, 'British Rule, 1895–1912', in Vincent Harlow & E.M. Chilver (eds.), *History of East Africa*, vol. 2 (Oxford: Oxford University Press, 1965), p. 35.

4. For the conquest and early colonisation of Kenya see Bruce Berman & John Lonsdale, *Unhappy Valley: Conflict in Kenya and Africa.* Book One: *State and Class* (London: James Currey, 1992).

5. Quoted by C.C. Wrigley, 'Kenya: The Pattern of Economic Life 1902–45', in Harlow & Chilver, *History of East Africa*, vol. 2, p. 213.

6. Judith Thurman, *Isak Dinesen: The Life of Karen Blixen* (Harmondsworth: Penguin, 1984), p. 149. Thurman is quoting Neal Acheson, 'Longing for Darkness', *New York Review of Books*, 18 September 1975.

7. Evelyn Waugh, *Remote People* (1931), quoted in Sara Wheeler, *Too Close to the Sun: The Life and Times of Denys Finch Hatton* (London: Jonathan Cape, 2006), p. 173.

8. James Fox, *White Mischief* (Harmondsworth: Penguin, 1982), p. x.

9. Thurman, p. 147.

10. Elsbeth Huxley, *White Man's Country: Lord Delamere and the Making of Kenya*, 2 vols. (London: Chatto and Windus, 1935).

11. Wheeler, *Too Close to the Sun*, pp. 55–58.

12. A good account of the relationship between the state, settlers and Africans in colonial Kenya

is Bruce Berman, *Control and Crisis in Colonial Kenya: The Dialectic of Domination* (London: James Currey, 1990).

13. See Charles Miller, *Battle for the Bundu: The First World War in East Africa* (London: Macdonald, 1974). Some 163 000 Africans from Kenya served in the war as carriers; 47 000 died in war service, mainly as a result of disease, and 120 000 Kikuyu died from famine and influenza. See John Middleton, 'Kenya: Administration and Changes in African Life, 1912–1945', in Harlow and Chilver, *History of East Africa*, vol. 2, p. 353.

14. Berman, *Control and Crisis*, p. 200.

15. Berman & Lonsdale, *Unhappy Valley*, Book One, p. 109.

16. Berman & Lonsdale, *Unhappy Valley*, Book One, parts 2 and 3.

17. Berman, *Control and Crisis*, p. 135.

18. For Mitchell see Berman, *Control and Crisis*, pp. 282–292 and David W. Throup, *Economic and Social Origins of Mau Mau* (London: James Currey, 1987), ch. 3.

19. Berman, *Control and Crisis*, ch. 6.

20. There is a vast literature on this topic. Apart from Berman & Lonsdale, *Unhappy Valley*, Books One and Two, we may note Throup's *Economic and Social Origins of Mau Mau*, Frank Furedi, *The Mau Mau War in Perspective* (London: James Currey, 1989) and Tabitha Kanogo, *Squatters and the Roots of the Mau Mau* (London: James Currey, 1987).

21. See Caroline Elkins, *Imperial Reckoning: The Untold Story of Britain's Gulag in Kenya* (New York: Henry Holt, 2005) and David Anderson, *Histories of the Hanged: The Dirty War in Kenya and the End of Empire* (New York: Norton, 2005).

22. *Out of Africa* was first published by Putnam in 1938. The edition I have used is Karen Blixen, *Out of Africa* (London: Century Publishing, 1985).

23. *Out of Africa*: Sydney Pollack, 1985, USA, 161 mins, English.

24. Thurman, *Isak Dinesen*, p. 327.

25. Robert Langbaum, *The Gayety of Vision: Isak Dinesen's Art* (New York: Random House, 1965), p. 119, quoted in Thurman, *Isak Dinesen*, p. 327.

26. This point is reiterated by Binyavanga Wainaina in his article 'How to Write about Africa', *Granta*, 92 (2005). He writes, ironically, on p. 92, 'In your text always treat Africa as if it were one country. It is hot and dusty with rolling grasslands and huge herds of animals and tall thin people who are starving.'

27. *Nowhere in Africa* is based on the book *Nowhere in Africa (Nirgendwo in Afrika)* by the German author Stefanie Zweig (2001). *White Mischief* was written by James Fox (1982).

28. Blixen, *Out of Africa*, p. 11.

29. Points made by Wheeler in her biography of Finch Hatton.

30. Frans Lasson (ed.), *Isak Dinesen: Letters from Africa 1914–1931* (Chicago: University of Chicago Press, 1981), p. 10.

31. Details about Karen Blixen's farming activities are taken from Judith Thurman's outstanding biography.

32. Judith Thurman, *Isak Dinesen*, p. 73.

33. *Nowhere in Africa*: Caroline Link, 2002, Germany, 142 mins, German, English, Swahili.

34. Zweig also wrote another semi-autobiographical novel about Kenya called *A Mouth Full of Earth (Ein Mund voll Erde)* in 1980 that describes an infatuation with a Kikuyu boy.

35. *White Mischief*: Michael Radford, 1987, UK, Kenya, 107 mins, English.

36. Wheeler, *Too Close to the Sun*, p. 173.

37. Wheeler, *Too Close to the Sun*, p. 173.

38. Wheeler, *Too Close to the Sun*, p. 173.

39. Wheeler, *Too Close to the Sun*, pp. 173–174.

40. Robert Stam & Louise Spence, 'Colonialism, Racism and Representation: An Introduction',

in Joanne Hollows, Peter Hutchings & Mark Jancovich (eds.), *The Film Studies Reader* (London: Arnold, 2000), p. 316.

Chapter 11

I am grateful for comments on an earlier draft of this chapter from the editors, as well as Wayne Dooling and Helen Verran.

1. Diana Sandars, 'CTEQ Annotations: Chocolat', *Senses of Cinema*, 17 (November–December 2001): www.sensesofcinema.com. *Chocolat*: Claire Denis, 1988, France, West Germany, Cameroon, 105 mins, French.

2. Mark A. Reid, 'Colonial Observations: Interview with Claire Denis', *Jump Cut*, 40 (1996), p. 68.

3. Chris Darke, 'Desire Is Violence' [Interview with Claire Denis], *Sight and Sound*, 10 (July 2000), p. 17.

4. Martine Beugnet, *Claire Denis* (Manchester: Manchester University Press, 2004), p. 42.

5. Reid, 'Colonial Observations', p. 68.

6. 'Claire Denis interviewed by Jonathan Romney', *The Guardian*, 28 June 2000: film.guardian. co.uk.

7. Robert Rosenstone, 'The Historical Film: Looking at the Past in a Postliterate Age', in *Visions of the Past: The Challenge of Film to Our Idea of History* (Cambridge, Mass.: Harvard University Press 1995), p. 53.

8. Roger Ebert, 'Chocolat', *Chicago Sun-Times*, 12 May 1989.

9. Hal Hinson, 'Chocolat', *Washington Post*, 14 April 1989.

10. Desson Howe, 'Chocolat', *Washington Post*, 14 April 1989.

11. See Frank Leinen, 'The Discovery of Otherness: Claire Denis' Film *Chocolat* (1988) and the Presentation of the Limits of an Intercultural Hermeneutics' in Guido Rings & Rikki Morgan-Tamosunas (eds.), *European Cinema: Inside Out. Images of the Self and Other in Postcolonial European Film* (Heidelberg: Anglistische Forschungen, 2003), pp. 45–61; Stuart Hall, 'European Cinema on the Verge of a Nervous Breakdown', in Duncan Petrie (ed.), *Screening Europe: Image and Identity in Contemporary European Cinema* (London: British Film Institute, 1992), pp. 45–53; and Fiona A. Villella, 'Postcolonial Cinema: *Chocolat*', *Senses of Cinema* 1 (December 1999); www.sensesofcinema.com.

12. Murray cites Frederick Cooper & Ann Laura Stoler (eds.), *Tensions of Empire: Colonial Cultures in a Bourgeois World* (Berkeley: University of California Press, 1997). A comparison between *Chocolat* and historiography on colonial gender relations (pioneered by Stoler, among others) is discussed later in this chapter.

13. Alison Murray, 'Teaching Colonial History Through Film', *French Historical Studies*, 25 (Winter 2002), p. 45.

14. Alison Murray, 'Women, Nostalgia, Memory: *Chocolat*, *Outremer*, and *Indochine*', *Research in African Literatures*, 33 (Summer 2002), p. 235.

15. Murray, 'Women, Nostalgia, Memory', p. 241.

16. Murray, 'Women, Nostalgia, Memory'.

17. Hinson, 'Chocolat'.

18. Damon Smith, 'L'Intrus: An Interview with Claire Denis', *Senses of Cinema*, 35 (April–June 2005); www.sensesofcinema.com.

19. Hinson, 'Chocolat'.

20. Kathleen Murphy, 'The Colour of Home', *Film Comment*, 28 (September–October 1992), p. 62.

21. Murray, 'Women, Nostalgia, Memory', p. 238.

22. Leinen, 'The Discovery of Otherness, p. 50.

23. Murray, 'Women, Nostalgia, Memory', p. 240.

24. The phrase 'period look' is from Rosenstone, 'The Historical Film', p. 60.

25. Murray, 'Women, Nostalgia, Memory', p. 240.

26. Ebert, 'Chocolat'.

27. Ebert, 'Chocolat'.

28. Known as 'Dollar Brand' before his conversion to Islam, Abdullah Ibrahim is a famous pianist who pioneered South African township jazz in the 1950s and 1960s.

29. Jamie Stuart, 'Claire Denis': www.movienavigator.org.

30. To be fair, after Denis met the musicians 'Les Têtes Brulées' when she was in Cameroon filming *Chocolat*, she wanted them to be in the ending of the film. However, difficulties over copyright made it impossible. Her next film, titled *Man No Run*, was a documentary about this group touring in France for the first time. See 'Claire Denis interviewed by Jonathan Romney', *The Guardian*, 28 June 2000.

31. Rosenstone, 'The Historical Film', p. 72.

32. Murphy, 'The Colour of Home', p. 62.

33. Celine Philibert, 'From Betrayal to Inclusion: The Work of the White Woman's Gaze in Claire Denis's *Chocolat*' in Samina Najimi & Rajini Srikanth (eds.), *White Women in Racialised Spaces: Imaginative Transformation and Ethical Action in Literature* (New York: State University of New York Press, 2002), p. 212.

34. Leinen, 'The Discovery of Otherness, p. 54.

35. Hilary Neroni, 'Lost in Fields of Interracial Desire: Claire Denis' *Chocolat* (1988)', *Kinoeye: New Perspectives on European Film*, 3 (June 2003); www.kinoeye.org.

36. Robert Davis, 'Claire Denis: Intruding Beauty', *Paste Magazine* 13 (2004); www.pastemagazine.com.

37. Sandars, 'CTEQ Annotations: Chocolat'.

38. Reid, 'Colonial Observations', p. 68.

39. The phrase 'period look' is from Rosenstone, 'The Historical Film', p. 60.

40. Martin Njeuma, 'The Lamidates of Northern Cameroon, 1800–1894', in Martin Njeuma (ed.), *Introduction to the History of Cameroon: Nineteenth and Twentieth Centuries* (New York: St. Martin's Press, 1989), p. 7.

41. Ralph A. Austen & Jonathan Derrick, *Middlemen of the Cameroons Rivers: The Duala and Their Hinterland, c.1600–c.1960* (Cambridge: Cambridge University Press, 1999).

42. Njeuma, 'The Lamidates of Northern Cameroon', p. 25.

43. Njeuma, 'The Lamidates of Northern Cameroon', p. 26.

44. Daniel Abwa, 'The French Administrative System in the Lamidate of Ngaoundere, 1915–1945', in Njeuma, *Introduction to the History of Cameroon*, p. 141.

45. Robert Aldrich, *Greater France: A History of French Overseas Expansion* (London: Macmillan Press, 1996), p. 49.

46. Aldrich, *Greater France*, p. 115.

47. Alice L. Conklin, 'Redefining "Frenchness": Citizenship, Race Regeneration, and Imperial Motherhood in France and West Africa, 1914–40', in Julia Clancy-Smith & Frances Gouda (eds.), *Domesticating the Empire: Race, Gender, and Family Life in French and Dutch Colonialism* (London: University Press of Virginia, 1998), p. 69.

48. Owen White, *Children of the French Empire: Miscegenation and Colonial Society in French West Africa, 1895–1960* (Oxford: Oxford University Press, 1999), p. 27.

49. Conklin, 'Redefining "Frenchness"', p. 81.

50. Alice L. Conklin, 'Civilization through Coercion: Human *Mise en Valeur* in the 1920s', in *A Mission to Civilize: The Republican Idea of Empire in France and West Africa, 1895–1930* (Stanford: Stanford University Press, 1997), pp. 212–245.

51. Patrick Manning, *Francophone Sub-Saharan Africa, 1880–1995*, 2nd ed. (Cambridge: Cambridge University Press, 1998), p. 114.

52. Richard A. Joseph, *Radical Nationalism in Cameroun: Social Origins of the UPC Rebellion* (Oxford: Clarendon Press, 1977), p. 51.

53. Victor T. LeVine, *The Cameroons from Mandate to Independence* (Berkeley: University of California Press, 1964), p. 139.

54. For a detailed study of events leading up to the UPC rebellion, see Joseph, *Radical Nationalism in Cameroun.*

55. LeVine, *The Cameroons*, p. 170.

56. Joseph, *Radical Nationalism in Cameroun*, p. 343.

57. After clashes between police and UPC demonstrators in Mbanga on 22 May 1955, violence spread to other towns, including the large urban centres of Douala and Yaounde. Joseph, *Radical Nationalism in Cameroun*, pp. 265–269.

58. Joseph, *Radical Nationalism in Cameroun*, p. 325.

59. Victor Julius Ngoh, *History of Cameroon since 1800* (Limbé: Presbook, 1996), p. 78.

60. Leinen, 'The Discovery of Otherness', p. 54.

61. Abwa, 'The French Administrative System', p. 141.

62. Reid, 'Colonial Observations', p. 68.

63. Doris Lessing, *The Grass Is Singing* (London: Flamingo, 1994 [1950]), p. 62.

64. Jacqueline Bardolph, 'Woman and the World of Things: A Reading of *The Grass Is Singing*', in Eve Bertelsen (ed.), *Doris Lessing* (Johannesburg: McGraw-Hill, 1985), p. 122.

65. Lessing, *The Grass Is Singing*, p. 176.

66. Ann Laura Stoler, *Carnal Knowledge and Imperial Power: Race and the Intimate in Colonial Rule* (Berkeley: University of California Press, 2002), p. 41. See also Margaret Strobel, *European Women and the Second British Empire* (Bloomington: Indiana University Press, 1991); Napur Chaudhuri & Margaret Strobel, *Western Women and Imperialism: Complicity and Resistance* (Bloomington: Indiana University Press, 1992); Anne McClintock, *Imperial Leather: Race, Gender and Sexuality in the Colonial Context* (London: Routledge, 1995); Claire Midgley, *Gender and Imperialism* (Manchester: Manchester University Press, 1998); Ruth Roach Peirson & Napur Chaudhuri, *Nation, Empire, Colony: Historicizing Empire and Race* (Bloomington: Indiana University Press, 1998); Philippa Levine, *Gender and Empire* (Oxford: Oxford University Press, 2004). Much of this literature focuses on the British Empire. For a study on the French Empire, see Clancy-Smith & Gouda, *Domesticating the Empire.*

67. Margaret Strobel, 'Gender and Race in the Nineteenth- and Twentieth-Century British Empire', in Renate Bridenthal, Claudia Koonz & Susan Stuard (eds.), *Becoming Visible: Women in European History*, 2nd ed. (Boston: Houghton Mifflin, 1987), p. 380.

68. Sylvia Leith-Ross, 'Stepping Stones: Memoirs of Colonial Nigeria, 1907–1960', quoted in Helen Callaway, *Gender, Culture and Empire: European Women in Colonial Nigeria* (Chicago: University of Illinois Press, 1987), p. 72.

69. Callaway, *Gender, Culture and Empire*, p. 73.

70. Conklin, 'Redefining "Frenchness"', p. 70.

71. Janice Morgan, 'The Spatial Politics of Racial and Cultural Identity in Claire Denis' *Chocolat*', *Quarterly Review of Film and Video*, 20 (2003), p. 150.

72. Villella, 'Postcolonial Cinema: *Chocolat*'.

73. Duncan Petrie, 'The Film-Makers Panel', in Petrie, *Screening Europe*, p. 67.

74. Reid, 'Colonial Observations', p. 68.

75. Reid, 'Colonial Observations'.

76. Ferdinand Oyono, *Houseboy*, trans. John Reed (Oxford: Heinemann, 1990 [1966]), p. 13.

77. Oyono, *Houseboy*, p. 20.

78. Oyono, *Houseboy*, p. 100.

79. Richard Bjornson, *The African Quest for Freedom and Identity: Cameroonian Writing and the National Experience* (Bloomington: Indiana University Press, 1991), p. 73.
80. Bjornson, *The African Quest*, p. 87.
81. Morgan, 'Spatial Politics', p. 150.
82. Aimé Ancian, 'Claire Denis: An Interview', *Senses of Cinema*, 23 (November–December 2002); www.sensesofcinema.com.
83. Murray, 'Women, Nostalgia, Memory', p. 241.

Chapter 12

1. *The Battle of Algiers*: Gillo Pontecorvo, 1965, Algeria, Italy, 117 mins, French, Arabic.
2. It is sometimes claimed that the film won the Critics' Prize at Cannes in 1966. I can find no evidence of this.
3. R. Delpard, *L'Histoire des pieds-noirs: 1830–1962* (Neuilly-sur-Seine: M. Lafon, 2001); Michèle Baussant, *Pieds-noirs: mémoires d'exiles* (Paris: Stock, 2002).
4. Benjamin Stora. 'Algériens, des bras pour la France', *Le Monde*, 23 February 1997.
5. Most notably Charles de Gaulle, François Mitterand and Valéry Giscard d'Estaing.
6. Henry Rousso, 'L'Epuration en France: une histoire inachevée', *Vingtième Siècle* 33 (1992); Rousso, 'Une justice impossible: l'épuration et la politique antijuive de Vichy', *Annales*, 3 (May–June 1993); Rousso, 'Did the Purge Achieve Its Goals?', in R. J. Goslan (ed.), *Memory, the Holocaust and French Justice* (Dartmouth, NH: University Press of New England, 1996); Klaus-Dietmar Henke & Hans Woller (eds.), *Politische Säuberung in Europa: Die Abrechnung mit Faschismus und Kollaboration nach dem Zweiten Weltkrieg* (Munich: DTV, 1991).
7. J. Massu, *La Vraie Bataille d'Alger* (Paris: Plon, 1971; Monaco: Editions du Rocher, c. 1997).
8. See the showing of *The Battle of Algiers* by the 21st International Film Festival of Hong Kong in 1997 to mark the transfer of the territory to Chinese rule. The film had been banned by the British administration and was screened, along with four others, as a statement on cinematographic freedoms. *Le Monde*, 23 April 1997.
9. See *Le Monde*, 20 June, 9 November 2000. Several of these exposés were republished in *Le Monde*, Dossiers et Documents no. 302, 'Torture et mémoire française'.
10. Benjamin Stora, *La Gangrene et l'oubli: la mémoire et la guerre d'Algérie* (Paris: 1991; La Découverte, new ed., 1998).
11. Mike Mason, 'Batailles pour la mémoire', *Journal of African History*, 35 (1994).
12. 'Viols: un si long silence', *Nouvel Observateur*, 8 February 2002; Raphaële Branche, 'Des viols pendant la guerre d'Algérie', *Vingtième Siècle*, 75 (2002).
13. *Le Monde*, 21 June, 23 November 2000
14. Louisette Ighilahriz, *Algérienne: récit recueilli par Anne Nivat* (Paris: Calmann-Lévy, 2001).
15. Aussaresses, *The Battle of the Casbah: Terrorism and Counter-terrorism in Algeria, 1955–1957* (New York: Enigma Books, 2002), pp. 126–128. Originally published as *Services spéciaux, Algérie 1955–57* (Paris: Perrin, 2001).
16. Henri Pouillot, *La Villa Susini: tortures en Algérie. Un Appelé parle: juin 1961–mars 1962* (Paris: Tirésias, 2001); Jean Martin, *Algérie 1956: pacifier, tuer: lettre d'un soldat* (Paris: Editions Syllepse, 2001). See also Bernard Mancier, *Plongé dans les ténèbres: un appelé dans la guerre d'Algérie* (Paris: Éditions de l'Atelier, 2002). These new revelations echoed a similar debate around the participation of 'ordinary Germans' in the Holocaust. Daniel Goldhagen, *Hitler's Willing Executioners: Ordinary Germans and the Holocaust* (New York: Knopf, 1996), Hans-Ulrich Wehler, 'Wie ein Stachel im Fleisch', *Die Zeit*, 24 May 1996, and more broadly, Michael Schneider, *Die 'Goldhagen-Debatte': Ein Historikerstreit in der Mediengesellschaft* (1997) and Geoff Eley, *The 'Goldhagen Effect': History, Memory, Nazism – Facing the German Past* (Ann Arbor: University of Michigan Press, 2000).

17. Michel de Jaeghere et al., *Le Livre blanc de l'armée française en Algérie* (Paris: Contretemps, 2002).

18. *L'Humanité*, 14 May 2004.

19. Général Maurice Schmitt, *Alger – été 1957: une victoire sur le terrorisme* (Paris: L'Harmattan, 2002).

20. *Le Monde*, 29 March 2002.

21. Pascale Blanchard, Nicolas Bancel & Sandrine Lemaire (eds.), *La Fracture coloniale: la société française au prisme de l'héritage colonial* (Paris: La Découverte, 2005).

22. Robert Paxton, *Vichy France: Old Guard and New Order: 1940–1944* (London: Knopf, 1972). This was translated the following year with the less confrontational title of *La France de Vichy: 1940–1944* (Paris: Editions du Seuil, 1973).

23. Henry Rousso's *Le Syndrome de Vichy: de 1944 à nos jours* (Paris: Editions du Seuil, 1987) was translated into English by Arthur Goldhammer as *The Vichy Syndrome: History and Memory in France since 1944* (Cambridge, Mass.: Harvard University Press, 1991).

24. cf. Jean-Paul Jean & Denis Salas (eds.), *Barbie, Touvier, Papon: des procès pour la mémoire* (Paris: Autrement, 2002).

25. This episode is well covered by Henry Rousso & Eric Conan, *Vichy: un passé qui ne passe pas* (Paris: Gallimard, 1996).

26. Dounia Bouzar, *L'Islam des banlieus: les prédicateurs musulmans: nouveaux travailleurs sociaux?* (Paris: Syros, 2001).

27. There is a growing literature on *Vergangenheitsbewältigung* in France – and on the moral dilemma associated with 'coming to terms with the past'. On Algeria specifically, cf. Raphaëlle Branche, *La Guerre d'Algérie: une passé apaisée?* (Paris: Seuil, 2005); Benjamin Stora, *Le Livre, mémoire de l'histoire: réflections sur le livre et la guerre d'Algérie* (Paris: Le Préau des Collines, 2005); Mohammed Harbi & Benjamin Stora (eds.), *La Guerre d'Algérie 1954–2004: la fin de l'amnésie* (Paris: R. Laffont, 2004); Anny Dayan Rosenman & Lucette Valensi (eds.), *La Guerre d'Algérie dans la mémoire et l'imaginaire* (Paris: Bouchène, 2004); Guy Pervillé, *Pour une histoire de la guerre d'Algérie* (Paris: Picard, 2002), ch. 6; Richard L. Derderian, 'Algeria as a *lieu de mémoire*: Ethnic Minority Memory and National Identity in Contemporary France', *Radical History Review*, 83, (Spring 2002); Valerie Rosoux, *Les Usages de la mémoire dans les relations internationalles: le recours au passé dans la politique étrangère de la France à l'égard de l'Allemagne et de l'Algérie de 1962 à nos jours* (Brussels: Bruylant, 2001); Dietmar Hüser, 'Vergangenheitspolitik und Erinnerungskulturen in Frankreich: von zersplitterten Gedenken an den Algerienkrieg seit 1962', *Frankreich-Jahrbuch*, 13 (2000). Much of this work draws on Stora's *La Gangrene et l'oubli*.

28. Patrick Rotman & Bertrand Tavernier, *La Guerre sans nom: les appelés d'Algerie: 1954–1962* (Paris: Seuil, 1992) accompanied the film.

29. Shown at primetime on FR2 in March 2002, Rotman's three films took 3 hours 20 minutes to screen. In a book completed a few months later, Rotman characterised the TV series as an attempt 'to dive into the black holes of memory'. Rotman, *L'Ennemi intime* (Paris: Seuil, 1992), p. 7. See also Jean-Charles Deniau's documentary on the torturers, 'Paroles de tortionnaires' (2002) and André Gazut's 'Pacification en Algérie' (2003).

30. Jacques Chirac had first used this term in a speech in September 1996. On 17 October 2001 the mayor of Paris inaugurated a plaque on the Saint-Michel bridge 'in memory of the numerous Algerians killed during the bloody repression of the peaceful demonstration of 17 October 1961'. On 5 December 2002 Jacques Chirac unveiled a monument on the Quai Branly to French soldiers and 'auxiliaries' killed during the wars in defence of the colonial empire in North Africa, particularly Algeria.

31. Cited in *New York Times*, 7 September 2003.

32. See this and other critics on the film's website at rialtopictures.com/battle.html.

33. Ali la Pointe was in fact in prison for two years for resisting arrest when the war broke out in November 1954. He was converted to the FLN's cause in the Barberousse prison. See Alistair Horne, *A Savage War of Peace: Algeria 1954–1962* (London: Macmillan, 1977), p. 187.

34. Alistair Horne thought Ali la Pointe responsible for the killing of Froger. See Horne, *A Savage War of Peace*, p.187. But Yacef Saadi claims that the forerunners of the Secret Army Organisation (OAS) were responsible for the killing, as well as various other contemporary atrocities. Their ultimate aim, holds Saadi, was to provoke the French army to seize power – which it did (successfully) in May 1958 and (unsuccessfully) in April 1961. Saadi, 'Qui a tué Amédée Froger?' *Le Nouvel Observateur*, 9 (1992), Collection dossiers. La Guerre d'Algérie: 30 ans après.

35. *Le Monde*, 13 May 2004.

36. Jean Roy, 'La Bataille d'Alger apprend à faire du cinema', *L'Humanité* (22 May 2004).

37. Irene Binardi, 'The Making of the Battle of Algiers', *Cineaste*, 25, 2 (2000), p.15, cited by Donald Reid, 'Re-viewing *The Battle of Algiers* with Germaine Tillion', *History Workshop Journal*, 60 (2005), p. 98.

38. Yacef Saadi, *Souvenirs de la bataille d'Alger, décembre 1956–septembre 1962* (Paris: R. Julliard, 1962).

39. Horne, *A Savage War of Peace*, p. 17; Hugh Roberts, 'The Image of the French Army in the Cinematic Representation of the Algerian War: The Revolutionary Politics of *The Battle of Algiers*' in Roberts (ed.), *The Algerian War and the French Army, 1954–62* (London: Palgrave Macmillan, 2002).

40. A charge that has even been raised in heated discussions in Algeria, cf. *Le Monde*, 13 May 2004. Captain Paul-Alain Leger recounts the capture of Yacef Saadi in his account of the war, *Aux carrefours de la guerre* (Paris: A. Michel, 1983).

41. *Le Monde*, 13 May 2004; *L'Humanité*, 22 May 2004.

42. Directed by Julien Duvivier in 1937, and starring Jean Gabin, *Pépé le Moko* recounts the story of a Parisian gangster who hides in the casbah for two years in an attempt to evade the police. See Michael G. Vann, 'The Colonial Casbah on the Silver Screen: Using *Pépé le Moko* and *The Battle of Algiers* to Teach Colonialism, Race, and Globalisation in French History', *Radical History Review*, 83 (2002).

43. *L'Humanité*, 22 May 2004. Joan Mellen provides a particularly good account of the techniques used in the film in her book-length *Filmguide to the Battle of Algiers* (Bloomington: Indiana University Press, 1973).

44. Horne, *Savage War of Peace*, p. 183.

45. Authors like Horne and Pervillé agree that the Philippeville killings provoked the French into reprisals that created the beginnings of a divide, a 'moat of blood', that would become unbridgeable. Pervillé, *Pour une histoire*, pp. 148–149; Horne, *Savage War of Peace*, pp. 118–124, 132–135. Mohammed Harbi and Annie Rey-Goldzeiguer trace the roots of terror back to the Sétif massacres and reprisals of May 1945. Harbi, 'Des usages du passé: l'affaire Abbane', in Rosenman & Valensi, *La Guerre d'Algérie*, pp. 27–30; Rey-Goldzeiguer, *Aux origines de la guerre d'Algérie, 1940–1945* (Paris: La Découverte, 2001), p. 361. A younger generation points out that torture and terror had been integral elements of French colonialism in Algeria since the conquest of the territory. Raphaëlle Branche, *La Torture et l'armée pendant la guerre d'Algérie, 1954–1962* (Paris: Gallimard, 2001); Sylvie Thénault, *Une Drôle de justice: les magistrates dans la guerre d'Algérie* (Paris: La Découverte, 2001); Thénault & Branche, 'L'Impossible Procès de la torture', in Marc-Olivier Baruch & V. Duchet (eds.), *Justice, Politique et République* (Paris: CNRS, 2003).

46. Elie Kedourie made this point in a review critical of Alistair Horne's analysis of Algerian

nationalism in *A Savage War of Peace*. Kedourie, 'The Wretched of Algeria', *Times Literary Supplement*, 10 July 1992. See also his review of the first edition, 'The Retreat from Algiers', *Times Literary Supplement*, 21 April 1978, reprinted in his *Islam in the Modern World* (New York: Holt, Rinehart and Winston, 1980)

47. cf. Mohammed Harbi, *Une Vie debout: mémoires politiques* I: *1945–1962* (Paris: La Découverte, 2001).

48. Stora, *La Gangrène et l'oubli*, pp. 227–230; Mohammed Harbi, *Le F.L.N. Mirage et realité: des origins à la prise de pouvoir (1945–1962)* (Paris: Jeune Afrique, 1985), ch. 6. On the fate of the Harki units, Jean-Jacques Jordi & Mohand Hamoumou, *Les Harkis: une mémoire enfouie* (Paris: Autrement, 1999).

49. Harbi, 'Des usages du passée', p. 27; Harbi, *Une Vie debout*.

50. In November 1956 a party militant of European descent was arrested and executed for attempting to bomb the Algiers gasworks. A maquis run by members of the PCA was also quickly rooted out by the French. Historians sympathetic to the communist perspective stress the close ties between the PCA and FLN. Horne suggests that the FLN was responsible for the elimination of the communists as an independent force in Algeria. Compare Horne, *Savage War of Peace*, pp. 137–38 with Jacques de Bonis, 'A la recherche du dernier quart d'heure', in Henri Alleg (ed.), *La Guerre d'Algérie* (Paris: Temps Actuel, 1981), vol. 2, pp. 364–368; Jean-Luc Einaudi, *Pour l'exemple: l'affaire Fernand Iveton: enquête* (Paris: Harmattan, 1986), pp. 102–110.

51. A lively debate arose around these issues when Ben Bella denounced Ramdane Abane's Soummam conference as an attempt to deviate the revolution from its Arabo-Islamic principles. His outburst on *El Djazira*'s 'Temoins du siècle' (3 November 2002) provoked impassioned responses from secularists and Berber nationalists alike, cf. the Algiers newspaper *Liberté*, 5 November, 26 and 28–29 December 2002. For another founding ancestor of the FLN, Aït Ahmed (in *Quotidien d'Oran*, 10 November 2002), Soummam was a pact that respected political pluralism, rather than a populist consensus, within the movement. In the same debate Benjamin Stora drew a parallel between Abane's attempts to bring together the representatives of the very different tendencies within Algerian nationalism with those of Jean Moulin, who tried to unite the French resistance during World War Two. *El Watan*, 26 November 2002.

52. Mohammed Harbi calls the battle for Algiers a 'crushing defeat' and 'a tragedy' for the FLN. Harbi, *Le F.L.N.*, pp. 197–199.

53. Guy Pervillé, 'Une Capitale convoitée', in Jean-Jacques Jordi & Guy Pervillé (eds.), *Alger 1940–1962: une ville en guerre* (Paris: Autrement, 1999), pp. 146–148.

54. On this 'third way' between the FLN and the OAS, see Germaine Tillion (ed.), *A la recherché du vrai et du juste* (Paris: Seuil, 2001); Alain-Gérard Slama, 'L'Indépendance de l'Algérie était-elle inevitable?', *La Guerre d'Algérie* (Les Collections de l'Histoire, H.S. no.15), March 2002.

55. Jacques de la Bollardière, *Bataille d'Alger, bataille de l'homme* (Paris: Desclée, 1972; new ed., Saint-Denis: Bouchène, 2003).

56. Reid, 'Re-viewing *The Battle of Algiers*', *History Workshop Journal*, 60 (2005), p. 108.

57. Garry Crowdus, 'Terrorism and Torture in the Battle of Algiers: An Interview with Saadi Yacef', *Cineaste*, 29, 3 (Summer 2004), pp.30–37. This is supported by Cinematografo in Italy although IMDB gives the producer as Carmine Bolgna.

58. Olivier Pétré-Grenouilleau. See his prize-winning *Traites négrières, essai d'histoire globale* (Paris: Gallimard, 2004). The charges were later withdrawn.

59. The debate was closely reported in *Le Monde*, cf. 1, 8–10 December 2005; 5, 21 January, 27 April 2006.

60. *Le Monde*, 11, 15, 20 March 2006.

Endnotes

Chapter 13

1. *Lumumba*: Raoul Peck, 2000, Belgium, France, Germany, 115 mins, French, Lingala.
2. Robert Rosenstone, *Visions of the Past: The Challenge of Film to Our Idea of History* (Cambridge, Mass.: Harvard University Press, 1995), pp. 67–68; Kenneth Kyle, 'Film Review Article: Lumumba', *International Affairs*, 78, 3 (July 2002), p. 596, notices that the demonstration after which Lumumba was imprisoned is wrongly dated.
3. Adam Hochschild, *King Leopold's Ghost: A Story of Greed, Terror and Heroism in Colonial Africa* (Boston: Houghton Mifflin, 1998).
4. J.Ph. Peemans, 'Capital Accumulation and State Policy: The Case of Congo', in Peter Duggan & Lewis Gann (eds.), *Colonialism in Africa*, vol. 4 (Cambridge: Cambridge University Press, 1974).
5. *The Quiet American*, directed by Phillip Noyce in 2001, based on Graham Greene's novel of the same name (London: Heinemann, 1955), is excellent on this issue.
6. Rosenstone, *Visions*, p. 57.
7. Michela Wrong, *In the Footsteps of Mr. Kurtz: Living on the Brink of Disaster in the Congo* (London: Fourth Estate, 2000), p. 3.
8. See David Moore, 'War in the D.R.C.', *New Agenda*, 14 (2004), pp. 90–92 and 'From Leopold to King Kabila: The Congo Is Being Carved Up and Everyone Wants a Piece ... Again', *Arena*, 52 (April 2001), pp. 36–39.
9. Rosenstone, *Visions*, p. 30.
10. *Lumumba* was made in 1999, while *Lumumba: The Death of the Prophet* was produced in 1991.
11. Rosenstone, *Visions*, pp. 37–44.
12. Rosenstone, *Visions*, pp. 29–30.
13. Rosenstone, *Visions*, pp. 72, 79.
14. Ludo de Witte, *The Assassination of Lumumba*, transl. Ann Wright and Renée Fendy (London: Verso, 1999); Lucy Komisar, 'Carlucci Can't Hide His Role in "Lumumba"', *Pacific News Service*, 14 February 2002, http://pacificnews.org.
15. e.g., Kyle, 'Film Review'; Catherine Hoskyns, *The Congo since Independence: January 1960 to December 1961* (London: Oxford University Press, 1965); Thomas Kanza, *Conflict in the Congo: The Rise and Fall of Lumumba* (Harmondsworth: Penguin, 1972) [Makena Diop played Kanza in the film, Lumumba's UN representative, and a moderating influence]; Rayeshwar Dayal, *Mission for Hammarskjöld: The Congo Crisis* (London: Oxford University Press, 1976); Conor Cruise O'Brien, *To Katanga and Back: A U.N. Case History* (London: Hutchinson, 1962).
16. Hoskyns, *The Congo*, pp. 318, 470. She adds: 'and by the other as a dangerous maniac who was ready to drag his country into civil war and chaos to satisfy his own ambition'.
17. De Witte, *The Assassination*, pp. 176, xxiv. Cf. Ernesto 'Che' Guevara, who wrote after he and other Cubans tried to assist the 'revolutionary struggle' in the Congo in early 1965 that guerrilla leader Kabila 'has not shown ... any of [the] qualities ... of revolutionary seriousness, an ideology that can guide action, a spirit of sacrifice that accompanies one's actions ... essential ... [to] carry a revolution forward'. *The African Dream: The Diaries of the Revolutionary War in the Congo*, transl. Patrick Camiller (London: Harvill, 1999), p. 244.
18. Guy Tillim, *Leopold and Mobutu* (Trézélan: Filigranes, 2004); and PhotoZA, www.photoza.co.za.
19. Thierry Michel, *Mobutu, King of Zaire: An African Tragedy* (Belgium and France: Les Films de la Passerelle, 1999).
20. Robert J.C. Young, 'Preface: Sartre the "African Philosopher"', in Jean-Paul Sartre, *Colonialism and Neocolonialism*, transl. Azzedine Haddour, Steve Brewer & Terry McWilliams (London: Routledge, 1964, 2001), p. x.
21. Kanza, *Conflict*, p. 28.

22. Quoted in David Caute, *Fanon* (London: Fontana, 1970) p. 62, from Patrice Lumumba, *Congo My Country*, transl. G. Heath (London: Pall Mall, 1962), p. 32.

23. The American figure is a *Time* magazine estimate quoted by Dr Lynne Waldron, who reported in the Congo in 1960: www.dlynnwaldron.com; the Belgian figure comes from David Akerman, *BBC Correspondent*, 21 October 2000, news.bbc.co.uk.

24. Kanza writes judiciously that 'the Belgian and colonial press seized upon the incident as a way of discrediting him', foreseeing his 'rise to popularity and power' and trying to prevent it. The political claim is made by a website called Africa Within in 'Who Killed Lumumba?', www. africawithin.com. This document is heavily indebted to the BBC documentary noted above, without acknowledgement.

25. Dayal, *Mission for Hammarskjöld*, pp. 290–291.

26. Peck also ignores Lumumba's four wives. His family life is portrayed as 'nuclear' and 'Western'. Would this truth have portrayed Lumumba negatively to a Western audience sympathetic to 'Third World' causes, including 'politically correct' feminists? See De Witte, *The Assassination*, p. 60.

27. Jean-Paul Sartre, 'The Political Thought of Patrice Lumumba', in Sartre, *Colonialism*, p. 158, notes that the booklet's thought 'is not that of the young but mature man who founded the MNC'.

28. Sartre, 'The Political Thought', p. 172.

29. Sartre, 'The Political Thought', p. 172.

30. Sartre later points to the petty bourgeoisie's tendencies to compromise with the new imperialism: he sees even a limited nationalism among them as the product of a long struggle, which would have to be led by someone like Lumumba in alliance with workers and peasants. Sartre, 'The Political Thought', pp. 183–184, 189.

31. Hoskyns, *The Congo*, p. 29.

32. O'Brien, *To Katanga*, p. 84; Hoskyns, *The Congo*, p. 26.

33. As De Witte notes, this may not be quite the case. By 27 November 1960, the time of Lumumba's attempt to escape to Stanleyville, troops loyal to him, organised by Antoine Gizenga, his former deputy prime minister and a more overt socialist than Lumumba, were gathering strength. By January, De Witte claims support for Lumumba was growing; this was why the Belgians demanded his move to Katanga and his sure death. For Sartre these troops were mobilised on an ethnic base, while for De Witte they were nationalists. De Witte, *The Assassination*, pp. 52, 60–63; Sartre, 'The Political Thought', p. 179.

34. Sartre, 'The Political Thought', p. 176.

35. Sartre, 'The Political Thought', p. 176.

36. *Rosa Luxemburg*: Margarethe von Trotta, 1986, West Germany, German.

37. Sartre, 'The Political Thought', p. 157.

38. Hoskyns, *The Congo*, p. 189.

39. David Macey, *Frantz Fanon: A Biography* (New York: Picador, 2000), p. 434.

40. The film does not discuss this conference. Indeed it pays scant attention to the difficulties Lumumba faced in his efforts to mobilise international support, relegating them to one scene. For an example of a committed anti-colonialist debating with an 'Africanist' hero, see C.L.R. James, *Nkrumah and the Ghana Revolution* (London: Allison and Busby, 1977).

41. To borrow a notion from Michael Ignatieff's rather näive *The Warrior's Honour: Ethnic War and the Modern Consciousness* (Toronto: Penguin, 1998).

42. Lumumba decided to invade Katanga after the United Nations said it could not offer troops to help him defeat Tshombe's 'government'. He utilised Russian planes and trucks, earning the enmity of the capitalist West, as well as Belgium. The massacre was related to Baluba and Luala 'flare-ups', which, as O'Brien notes, occurred in close relation to the needs of Katangan

politicians or European mining companies. As he puts it in a phrase useful to students of ethnicity and imperialism, 'perhaps it is one of the age-old customs of these tribes to fight each other when there is a Republican Administration in Washington and live in peace when the Democrats are in'; O'Brien, *To Katanga*, p. 238. The film refers to ethnic issues directly only once, in the cynical words of a Belgian at the Brussels Roundtable meetings, about the impossibility of Congolese 'nationhood' when so many 'tribes' were at each other's throats. In the next scene, in a different room, Lumumba asks the Congolese whether they will support his unitary version of the constitution or Kasa Vubu's federalist one. Sartre notes the irony that finally the centralist Lumumba tries to escape to his ethnic heartland, Stanleyville, but Sartre fails to note that Stanleyville was where an ideological ally, Antoine Gizenga, was more or less in control. Sartre, *The Political Thought*, p. 180.

43. David Akerman, *BBC Correspondent*, 2000.

44. Hoskyns, *The Congo*, pp. 188–189, says Michel was a Marxist but not sympathetic to the Soviet Union. In *Prophet* he is called an anarchist. Dayal, *Mission*, p. 87 notes that Michel – 'a leftist of doubtful vintage' – was sent away along with other foreign advisers by Lumumba after Kasa Vubu dismissed him on 5 September 1960. Another adviser, Jean van Lierde (called a 'pacifist' in *Prophet*), claims in Akerman's BBC documentary to have advised Lumumba to read the riposte to King Baudouin's Independence Day speech, which is understandably made a key part of both films although neither mentions Van Lierde's role. There were also advisers from African countries, e.g. Andrée Blouin, Lumumba's *chef de protocol*, loaned by Sekou Touré of Guinea. *Lumumba*'s credits thank Michel with a bracketed exclamation mark, but otherwise the film does not illustrate the European advisers. *Prophet* does. One wonders why Peck changed.

45. Hoskyns, *The Congo*, p. 188, from Michel's 1962 *Uhuru Lumumba*. Larry Devlin, CIA station agent and Mobutu adviser at the time, confirms in *Mobutu: King of Zaire* the latter's fondness for the bottle and takes credit for taking it away.

46. The train of thought is from my 'From Conrad to Kabila: The Congo and "Our" Consciousness', *Review of African Political Economy*, 82 (December 1999), pp. 529–533.

47. Barbara Kingsolver, *The Poisonwood Bible* (New York: Harper Collins, 1998).

48. See Edward Said, *Culture and Imperialism* (London: Vintage, 1993), pp. 25–28, 91.

49. Beverly Silver & Giovanni Arrighi, 'Polanyi's "Double Movement": The *Belles Epoques* of British and US Hegemony Compared', *Politics and Society*, 31, 2 (April 2003), pp. 325–355.

50. Silver & Arrighi, 'Polanyi's "Double Movement"', p. 328, quoting Karl Polanyi, *The Great Transformation: The Political and Economic Origins of Our Time* (Boston: Beacon, 1957), pp. 182–183, 207–208. Also Michael Burawoy, 'For a Sociological Marxism: The Complementary Convergence of Antonio Gramsci and Karl Polanyi', *Politics and Society*, 31, 2 (April 2003), p. 219.

51. Roger Casement, "The Congo Report (1903)"', in Barbara Harlow & Mia Carter (eds.), *Imperialism and Orientalism: A Documentary Sourcebook* (Malden: Blackwell, 1998), pp. 320–322.

52. See Kanza, *Conflict in the Congo*, 1972; O'Brien, *To Katanga*, 1962; Michel, *Uhuru*, 1962. O'Brien later wrote a play about the events around Lumumba's assassination: *Murderous Angels: A Political Tragedy in Black and White* (London: Hutchinson, 1968).

53. Hochschild, *King Leopold's Ghost*.

54. Ronan Bennett, *The Catastrophist* (London: Review, 1998). Michel Thierry's documentary film *Mobutu: King of Zaire*, also produced in the same time period, was more contemporary than the work of his peers.

55. See Tessa Morris-Suzuki, *The Past Within Us: Media, Memory, History* (London: Verso, 2005), on how the 'popular' media – including film – change historical perception.

56. The scene after which Munongo refuses Lumumba permission to land in Elisabethville has Kasa Vubu proposing to call the USSR for help, with Lumumba refusing, only to raise the idea again. I have seen no sources confirming this. Hoskyns, *The Congo*, p. 189, guesses that the Guineans in Leopoldville suggested the idea. Dayal, *Mission*, p. 61, reports Lumumba hiring an American entrepreneur to 'develop' huge swathes of the country. UN advisers cautioned against this, so he cancelled. This decidedly un-communist economic management is prescient: Laurent-Désiré Kabila signed shady deals with American mining entrepreneurs as he marched across the Congo in 1996 and 1997: see David Moore, 'The Political Economy of the DRC Conflict', in Sagaren Naidoo (ed.), *The War Economy in the Democratic Republic of the Congo*, IGD Occasional Paper No. 37 (Johannesburg: Institute for Global Dialogue, September 2003), pp. 16–39.

57. Kenneth Kyle makes the same point in 'Film Review', p. 596, without elaboration.

58. A conspiracy theorist would see the American Andrew Cordier's placement in Leopoldville as a temporary UN chief of operations, pending Indian diplomat Rayeshwar Dayal's arrival, as part of a plan to pre-empt Kennedy's inauguration. Cordier gave over five million francs to Mobutu to pay the troops, ensuring their loyalty just as Kasa Vubu, probably in consultation with Cordier, removed Lumumba from the prime ministership. Cordier declared the radio station closed to politicians in the name of peace and order but allowed Kasa Vubu to use one across the river in Brazzaville. Cordier also closed the airports but allowed Kasa Vubu's choice as prime minister to fly to Leopoldville. The more 'neutralist' Dayal arrived too late to stop such interventions. In *Lumumba*, American ambassador Timberlake is seen wooing Mobutu, assuring him of support from either Eisenhower or Kennedy.

59. O'Brien, *Murderous Angels*, p. 118, and his appendix, pp. 200–204. O'Brien, clearly sympathetic to Lumumba, arrived in Katanga shortly after Lumumba's death. He soon took precipitate and forceful action to annul Katanga's secession, and thus may have inadvertently played a role in Hammarskjöld's death by plane crash if one believes that Tshombe or Munongo arranged the crash of Hammarskjöld's plane as he flew to Ndola to meet them. O'Brien resigned his post. See David Gibbs, 'The United Nations, International Peacekeeping and the Question of "Impartiality": Revisiting the Congo Operation of 1960', *Journal of Modern African Studies*, 38, 3 (September 2000), pp. 359–382.

60. Bennett himself has been in prison twice, incorrectly accused of activities for the Irish Republican Army.

61. Bennett, *The Catastrophist*, pp. 270–271.

62. Ludo de Witte's *The Assassination of Lumumba* and Michela Wrong's interviews with Larry Devlin in *In the Footsteps* suggest that the CIA did not actually assassinate Lumumba (Devlin claims to have thrown away the poisoned toothpaste). The CIA seems to have lost some of its initial passion for the task, delegating it to the Belgians with Tshombe and Munongo. However, it played a very large role in the 'pre-planning' of the murder, as the film shows correctly (so much so that Frank Carlucci, the American second secretary who said in the 'send the Jew to Satan' scene that the USA does not interfere in other nations' sovereignty, forced Home Box Office to remove the utterance of his name from the film: see Komisar, 'Carlucci Can't Hide'). As Stephen Weissman put it, the CIA must take 'significant responsibility' for the assassination although it 'may not have exercised robotic control'. Later authorising $500 000 to the people who were behind the killing surely indicates support for it, too. Stephen Weissman, 'Opening the Secret Files on Lumumba's Murder', *Washington Post*, 21 July 2002.

63. Bennett's subsequent novel, *Havoc in the Third Year* (London: Bloomsbury, 2004), based in medieval England, raises the question of power and its justification with the words of a town master whose power is slipping: 'I have no ambition for anything other than the good

government of the town and the reformation of its people. Those who allege otherwise forge pretexts for faction and sedition.'

64. An ultimately unsatisfactory attempt to deal with these issues is Micheal Ignatieff's *The Lesser Evil: Political Ethics in an Age of Terror* (Edinburgh: Edinburgh University Press, 2005).

Chapter 14

1. Michael Raeburn, *Black Fire! Narratives from Zimbabwean Guerrillas* (Harare: Zimbabwe Publishing House, 1981), p. 179.
2. *Flame*: Ingrid Sinclair, 1996, Zimbabwe, 88 mins, English.
3. The acronym of the Zimbabwe National Liberation Army, the armed force of the Zimbabwe African National Union (ZANU), the second political party cum guerrilla organisation to be formed in the country.
4. 'Chimurenga' is the name for armed struggle in one of Zimbabwe's indigenous languages, Shona.
5. For other views on racial privilege in Rhodesia, and portraits of the class tensions within white society (although written from opposite ends of the political spectrum), see Doris Lessing, *The Grass Is Singing* (London: Heinemann, 1950) and Alexandra Fuller, *Don't Let's Go to the Dogs Tonight* (New York: Random House, 2003).
6. One of the screenwriters was Tsitsi Dangaremba, whose novel *Nervous Conditions* (New York: Seal Press, 1989) was the first published in English by a Zimbabwean woman.
7. www.zimmedia.com/flame.
8. Ingrid Sinclair, quoted on the Zimmedia website www.zimmedia.com/flame.
9. www.newsreel.org.
10. Review in *The Guardian* (UK) quoted on www.newsreel.org.
11. Tanya Lyons, *Guns and Guerrilla Girls: Women in the Zimbabwean Liberation Struggle* (Trenton, NJ: Africa World Press, 2004), p. 270.
12. Robert Rosenstone, *Visions of the Past: The Challenge of Film to Our Idea of History* (Cambridge, Mass.: Harvard University Press, 1995).
13. Beth Goldblatt & Sheila Meintjes, 'South African Women Demand the Truth,' in Meredeth Turshen & Clothilde Twagiramariya (eds.), *What Women Do in Wartime: Gender and Conflict in Africa* (London: Zed Press, 1998), p. 50.
14. Ron Reid-Daly, *Selous Scouts Top Secret War* (Alberton: Galago, 1983), p. 125.
15. Zimbabwe People's Revolutionary Army, the armed wing of ZAPU.
16. Jocelyn Alexander, JoAnn McGregor & Terence Ranger, *Violence and Memory: One Hundred Years in the 'Dark Forests' of Matabeleland* (Portsmouth: Heinemann, 2000), pp. 139–179. See also Jeremy Brickhill, 'Daring to Storm the Heavens: The Military Strategy of ZAPU, 1976–1979', in N. Bhebe & T. Ranger (eds.), *Soldiers in Zimbabwe's Liberation War*, vol. 1 (Harare: University of Zimbabwe Press, 1995).
17. David Martin & Phyllis Johnson, *The Struggle for Zimbabwe* (Harare: Zimbabwe Publishing House, 1981).
18. Julie Frederickse, *None but Ourselves: Masses vs. Media in the Making of Zimbabwe* (Harare: Zimbabwe Publishing House, 1982), p. 213. See also Raeburn, *Black Fire!*
19. David Lan, *Guns and Rain: Guerrillas and Spirit Mediums in Zimbabwe* (Harare: Zimbabwe Publishing House, 1985), p. 132.
20. Luise White's book *The Assassination of Herbert Chitepo: Texts and Politics in Zimbabwe* (Bloomington: Indiana University Press, 2003) portrays what was at stake for many parties in achieving legitimacy in post-Independence Zimbabwe. White's argument – that the many competing confessions to Chitepo's 1975 murder illustrate this contestation – is convincing.

Chitepo was the first black person in then Rhodesia to qualify as a lawyer, and in exile he became the chairman of ZANU's 'war council'.

21. Andre Astrow, *Zimbabwe: A Revolution That Lost Its Way?* (London: Zed Press, 1983), p. 80.

22. For the best example of the former, see Bruce Moore-King, *White Man Black War* (Harare: Baobab Books, 1988) and the more recent book by Dan Wylie, *Dead Leaves: Two Years in the Rhodesian War* (Pietermaritzburg: University of Natal Press, 2002). An example of the latter genre is Peter Stiff, *See You in November* (Alberton: Galago, 2002).

23. Ngwabi Bhebe, *The ZAPU and ZANU Guerrilla Warfare and the Evangelical Lutheran Church in Zimbabwe* (Gweru: Mambo Press, 1999), pp. 98–99.

24. See Teresa Barnes, 'Reconciliation, Ethnicity and School History in Zimbabwe, 1980–2002', in Brian Raftopoulos & Tyrone Savage (eds.), *Zimbabwe: Injustice and Political Reconciliation* (Cape Town: Institute for Justice and Reconciliation, 2005).

25. See Elizabeth Schmidt, *Peasants, Traders and Wives: Shona Women in the History of Zimbabwe 1870–1939* (Portsmouth: Heinemann, 1992); Teresa Barnes & Everjoice Win, *To Live a Better Life: An Oral History of Women in the City of Harare, 1930–70* (Harare: Baobab Books, 1992); Diana Jeater, *Marriage, Perversion and Power: The Construction of Moral Discourse in Southern Rhodesia 1894–1930* (Oxford: Clarendon Press, 1993); Teresa Barnes, *We Women Worked So Hard: Gender, Labor and Social Reproduction in Colonial Harare, Zimbabwe, 1930–56* (Portsmouth: Heinemann, 1999).

26. See, for example, 'Nyasha and Rose: Four Years of Armed Struggle in Zimbabwe', in M. Davies (ed.), *Third World, Second Sex* (London: Zed Press, 1983).

27. Joyce Kazembe, 'The Women Issue', in Ibbo Mandaza (ed.), *Zimbabwe: The Political Economy of Transition, 1980–1986* (Harare: Jongwe Press, 1987), p. 386.

28. Irene Staunton, *Mothers of the Revolution* (Harare: Baobab Books, 1990), p. xi.

29. It should be noted that the language in which these practices are described is very matter-of-fact, not vivid or sensationalist. See *Mothers*, p. 49.

30. Richard Werbner, *Tears of the Dead: The Social Biography of an African Family* (Harare: Baobab Books, 1992), p. 183.

31. Paul Themba Nyathi, 'Reintegration of Ex-combatants into Zimbabwean Society: A Lost Opportunity', in Raftopoulos & Savage, *Zimbabwe*.

32. Teresa Barnes, 'The Heroes' Struggle: Life after the Liberation War for Four Ex-combatants in Zimbabwe', and Norma Kriger, 'The Politics of Creating National Heroes: The Search for Political Legitimacy and National Identity', in Ranger & Bhebe, *Soldiers in Zimbabwe's Liberation War*.

33. Norma Kriger, 'The Zimbabwean War of Liberation: Struggles within the Struggle,' *Journal of Southern African Studies*, 14, 2 (1988); Kriger, *Zimbabwe's Guerrilla War: Peasant Voices* (Cambridge: Cambridge University Press, 1992).

34. If the trend of re-examining contentious aspects of the liberation war continues, one might expect there soon to be a historiographical re-examination of 'sell-outs' – collaborators and people who informed on the guerrillas to the Rhodesians. This would in turn blunt Kriger's portrayal of a largely innocent rural population preyed upon by the liberation forces.

35. See footnote 24 above.

36. Elizabeth Schmidt, 'A Damning Expose of the Unhappy Marriage of Zimbabwean Women and ZANLA,' *International Journal of African Historical Studies*, 34, 2 (2001).

37. Josephine Nhongo-Simbanegavi, *For Better or Worse? Women and ZANLA in Zimbabwe's Liberation Struggle* (Harare: Weaver Press, 2000); Lyons, *Guns and Guerrilla Girls*.

38. Zimbabwe Women Writers, *Women of Resilience: The Voices of Women Ex-combatants* (Harare: Zimbabwe Women Writers, 2000), pp. 181–182.

39. According to Lyons, Sinclair was engaged in oral history research with women ex-combatants 'over a seven year period' before the production of *Flame*. Lyons, *Guns and Guerrilla Girls*, p. 257.

40. Freedom Nyamubaya, *On the Road Again: Poems during and after the National Liberation of Zimbabwe* (Harare: Zimbabwe Publishing House, 1986); *Dusk of Dawn* (Harare: Zimbabwe Publishing House, 1995).

41. See Brian Raftopoulos, 'The State in Crisis: Authoritarian Nationalism, Selective Citizenship and Distortions of Democracy in Zimbabwe', in Amanda Hammar, Brian Raftopoulos & Stig Jensen (eds.), *Zimbabwe's Unfinished Business: Rethinking Land, State and Nation in the Context of Crisis* (Harare: Weaver Press, 2003), p. 217; see also Patrick Bond & J. Manyanya, *Zimbabwe's Plunge: Exhausted Nationalism, Neo-Liberalism and the Search for Social Justice* (Harare: Weaver Press, 2004).

42. See Terence Ranger, 'Nationalist Historiography, Patriotic History and the History of the Nation: The Struggle over the Past in Zimbabwe', *Journal of Southern African Studies*, 30, 2 (2004).

43. Lyons, *Guerrilla Girls*, p. 271.

44. Norma Kriger, *Guerrilla Veterans in Post-war Zimbabwe: Symbolic and Violent Politics, 1980–1987* (Cambridge: Cambridge University Press, 2003). A woman ex-combatant friend told me in 2005, while watching a Zimbabwean music video production on television which glorified the land invasions, 'We didn't [just] fight for the land. We fought for freedom.' This crucial point about the difference between the means and the ends of the liberation struggle has been largely lost in the discourse of the land invasions, both nationally and internationally.

Chapter 15

1. Roy Campbell, *The Wayzgoose* (London: Jonathan Cape, 1928).

2. Among the more popular were, for instance: Peter Gabriel's hit song *Biko* and Jerry Dammers's *Free Nelson Mandela*; music videos for the likes of Artists United Against Apartheid's *Sun City* and Paul Simon's and Ladysmith Black Mambazo's *Homeless* (from the immensely popular *Graceland* album); feature films such as *Cry Freedom* (1987), *A World Apart* (1987), *A Dry White Season* (1989) and *Lethal Weapon 2* (1989); and the Mandela Birthday Concert of 1988, staged in London but beamed all over the world.

3. *Cry Freedom*: Richard Attenborough, 1987, UK, 148 mins, English.

4. *A Dry White Season*: Euzhan Palcy, 1989, USA, 102 mins, English.

5. Robert Rosenstone, *Visions of the Past: The Challenge of Film to Our Idea of History* (Cambridge, Mass.: Harvard University Press, 1995), p. 72.

6. Peter Davis, *In Darkest Hollywood* (Johannesburg: Ravan Press, 1996), which remains the seminal overview exploration of 20th-century feature film portrayals of South Africa; Rob Nixon, 'Cry White Season: Anti-Apartheid Heroism and the American Screen', in Rob Nixon, *Homelands, Harlem and Hollywood* (New York: Routledge, 1994). For an extended critical discussion of the Davis–Nixon arguments, and counter-argument, that nonetheless also still gives relatively short shrift to the actual history in the two films see Vivian Bickford-Smith, 'Reviewing Hollywood's Apartheid: *Cry Freedom* (1987) and *A Dry White Season* (1989)', *South African Historical Journal*, 48 (May 2003), pp. 23–34. I would like to thank Robert Rosenstone for suggesting that I now write about the history in these two films.

7. K. Kiewet & K. Weichel, *Inside Crossroads* (Johannesburg: McGraw-Hill, 1981), p. 51, cited in Josette Cole, *Crossroads: The Politics of Reform and Repression 1976–86* (Johannesburg: Ravan Press, 1987), p. 21.

8. Tom Lodge, *Black Politics in South Africa since 1945* (Johannesburg: Ravan Press, 1983), pp. 321–362.

9. H. Smith, 'Apartheid, Sharpeville and "Impartiality": The Reporting of South Africa on BBC Television, 1948–1961', *Historical Journal of Film, Radio and Television*, 13, 3 (1993), pp. 251–299.

10. Davis, *In Darkest Hollywood*, p. 80.

11. This is part of the argument used to explain the gap in Hollywood representations of the Vietnam War between *The Green Berets* in 1968 and the spate of major films in the late 1970s: see e.g. Gilbert Adair, *Hollywood's Vietnam* (Oxford: Heinemann, 1989).

12. Harriet Gavshon, '"Bearing Witness": Ten Years Towards an Opposition Film Movement in South Africa', *Radical History Review*, 47, 7 (1990), pp. 331–345.

13. Gavshon, '"Bearing Witness".'

14. Sun City was a casino and leisure resort. Because it was located in the 'independent' homeland of Bophuthatswana, a number of international artists had performed there because this, supposedly, was not South Africa, and thus not subject to the cultural boycott. The *Sun City* music video was therefore aimed at closing this 'loophole' while further publicising apartheid brutality.

15. Vivian Bickford-Smith, 'Screening Saints and Sinners: The Construction of Filmic and Video Images of Black and White South Africans in Western Popular Culture during the Late Apartheid Era', *Kronos: Journal of Cape History*, 27 (November 2001), pp. 183–200.

16. *New York Times*, 1 November 1987.

17. An interview in *South Africa Now* (1989), cited in Davis, *In Darkest Hollywood*, p. 109.

18. T.R.H. Davenport, *South Africa: A Modern History* (London: Macmillan, 1991), p. 463.

19. See, for instance, Luli Callinicos, *Oliver Tambo* (Cape Town: David Philip, 2004), pp. 555–571. Necklacing involved putting a tyre doused with petrol around the neck of a victim and setting it on fire: Winnie Mandela was quoted as saying in April 1986: 'Together, hand in hand, with our boxes of matches and our necklaces we shall liberate this country', see p. 565.

20. The quotation is from the cover of the video release.

21. André Brink, *A Dry White Season* (London: W.H. Allen, 1979).

22. Nixon, 'Cry White Season', p. 84. Davis, *In Darkest Hollywood*, p. 103 also argues that the Biko–Woods friendship 'becomes a paradigm for a new South Africa'.

23. Allister Sparks, *Tomorrow Is Another Country: The Inside Story of South Africa's Negotiated Revolution* (Cape Town: Struik, 1994), pp. 15–20, 179–180, also mentions the friendship between Winnie Mandela and her lawyer Piet de Waal that supposedly paved the way for secret negotiations in the mid-1980s.

24. Contrary to my argument, Nixon in 'Cry White Season', pp. 79–81 seems to be suggesting that both films conformed to the position of liberal South African and American politicians who were against the use of violence in the 'struggle'.

25. Davis, *In Darkest Hollywood*, p. 111.

26. They are recorded at length in one of the books that informed *Cry Freedom*, Donald Woods, *Biko* (New York: Henry Holt, 1978), pp. 226–376.

27. Donald Woods, *Biko* and *Asking for Trouble* (New York: Atheneum, 1981). See John Briley's novel, *Cry Freedom* (London: Penguin, 1987), which was published in tandem with the release of the film and is based on the screenplay and acknowledges the two Woods books.

28. Steve Biko, *I Write What I Like* (New York: Harper and Row, 1978), 'edited with a Personal Memoir by Aelred Stubbs'. In *Biko*, p. 111, Woods refers to Stubbs's memoir.

29. Compare the film dialogue here with e.g. Woods, *Biko*, pp. 147, 192, 201; Biko, *I Write What I Like*, p. 37.

30. Biko, *I Write What I Like*, pp. 69, 75, 104, 109.

31. Woods, *Biko*, pp. 61–65.

32. Davis, *In Darkest Hollywood*, p. 103. Nixon makes much the same point in 'Cry White Season',

p. 84. In fact these words were not originally Biko's but became a central message of SASO and were quoted as such by Biko: *I Write What I Like*, p. 91. See Woods, *Biko*, pp. 37–39 to read the Pityana article in which these words first appeared.

33. See for example Biko, *I Write What I Like*, pp. 19–26, 63–66.
34. Biko, *I Write What I Like*, pp. 25, 65; Woods, quoting from an article by Biko, *Biko*, p. 58.
35. Woods quoting from an article by Biko, *Biko*, p. 59.
36. Woods, *Biko*, pp. 92, 218.
37. Mamphela Ramphele, *A Life* (Cape Town: David Philip, 1995), pp. 65, 97–98, 101.
38. Ramphele, *A Life*, p. 99; Woods, *Biko*, p. 64.
39. Nixon, 'Cry White Season', p. 83.
40. Biko, *I Write What I Like*, p. 69.
41. Biko, *I Write What I Like*, pp. 63, 139, 141, 143, 149. Woods, *Biko*, p. 122; the comment on the Mercedes is on p. 64.
42. Biko, *I Write What I Like*, pp. 30, 41–46.
43. Woods, *Biko*, p. 108; Biko, *I Write What I Like*, pp. 133–134, 143, 148.
44. Woods, *Biko*, pp. 114, 122–123. Biko, *I Write What I Like*, pp. 143, 148.
45. Woods, *Biko*, pp. viii–ix.
46. Ramphele, *A Life*, p. 136. Attenborough had of course made a highly successful biopic of Gandhi, released in 1982.
47. Aelred Stubbs's personal memoir of Biko, 'Martyr of Hope' at the end of Biko, *I Write What I Like*, e.g. pp. 154–216.
48. Roger Ebert, *Chicago Sun-Times*, 14 December 1972.
49. Bickford-Smith, 'Screening Saints and Sinners', pp. 192–194 gives a detailed analysis of the sequence.
50. Ramphele, *A Life*, pp. 105, 136–137; Stubbs is almost as coy as Attenborough, see 'Martyr of Hope', pp. 172–173.
51. Ebert, *Chicago Sun-Times*, 14 December 1972.
52. Ramphele, *A Life*, p. 100; Woods, *Asking for Trouble*, pp. 199, 236–237, 274, 295–296, 326–328.
53. Davis, *In Darkest Hollywood*, p. 104; Nixon, 'Cry White Season', p. 82.
54. Cole, *Crossroads*; Vivian Bickford-Smith, Elizabeth van Heyningen & Nigel Worden, *Cape Town in the Twentieth Century* (Cape Town: David Philip, 1999), pp. 182–185.
55. John Kane-Berman, *Soweto: Black Revolt, White Reaction* (Johannesburg: Ravan Press, 1978), especially pp. 103–108.
56. See for instance: Lodge, *Black Politics*, pp. 228–236; J. Leatt, T. Kneifel & K. Nurnberger, *Contending Ideologies in South Africa* (Cape Town: David Philip, 1986); Nigel Worden, *The Making of Modern South Africa* (Oxford: Blackwell, 1994), pp. 119–120; Davenport, *Modern History*, pp. 389–394.
57. Kane-Berman, *Soweto*, p. 19.
58. Kane-Berman, *Soweto*, pp. 19–20; William Beinart, *Twentieth Century South Africa* (Oxford: Oxford University Press, 1994), pp. 220–221.
59. Kane-Berman, *Soweto*, p. 1.
60. Lodge, *Black Politics*, p. 330. Kane-Berman's *Soweto* is packed with statistical detail.
61. Davenport, *Modern History*, pp. 389–390; Worden, *Modern South Africa*, pp. 118–120.
62. Brink, *A Dry White Season*, pp. 16, 66.
63. Albert Grundlingh, André Odendaal & Burridge Spies, *Beyond the Tryline: Rugby and South African Society* (Johannesburg: Ravan Press, 1995).
64. Biko, *I Write What I Like*, p. 28
65. Harrison M. Wright, *The Burden of the Present: Liberal–Radical Controversy over Southern African History* (Cape Town: David Philip, 1977); Christopher Saunders, *The Making of the*

South African Past: Major Historians on Race and Class (Cape Town: David Philip, 1988).

66. Hermann Giliomee, *The Afrikaners* (Cape Town: Tafelberg, 2003), especially pp. xviii, 447–486.

67. Brink, *A Dry White Season*, p. 153.

68. Kane-Berman, *Soweto*, pp. 1–10.

69. Nixon, 'Cry White Season', p. 83.

70. www.rottentomatoes.com and www.imdb.com for critical responses and awards (and nominations); Rita Kempley, *Washington Post*, 6 November 1987.

71. Bickford-Smith, 'Reviewing Hollywood's Apartheid', deals with this point at considerable length.

72. Davis, *In Darkest Hollywood*, pp. 116–122; Nixon, 'Cry White Season', pp. 90–94; www. imdb.com. Government censorship predictably ensured that the film, with cuts, had only a very limited release inside South Africa itself. On uncut general release in 1992, its political moment passed, *Mapantsula* failed to make much impact: recorded takings were just over R100 000 (under $20 000).

73. Brian Koller of Epinions.com, cited on www.imdb.com.

74. Davis, *In Darkest Hollywood*, p. 112.

75. www.imdb.com.

76. Davis, *In Darkest Hollywood*, pp. 100–102, 108.

77. Rosenstone, *Visions of the Past*, pp. 72–76.

78. Rosenstone, *Visions of the Past*, pp. 54–61.

79. Both thought that the two films provided powerful reconstructions of police brutality, for instance, in the raid on Crossroads in *Cry Freedom*, or the reconstruction of the Soweto Uprising in both films.

Chapter 16

1. *Hotel Rwanda*: Terry George, 2004, USA, UK, Italy, South Africa, 122 mins, English, French.

2. This is the number given by *Hotel Rwanda* itself. This chapter was completed before the author had the opportunity to read Paul Rusesabagina's recently released *An Ordinary Man: An Autobiography* (New York: Viking, 2006).

3. The latter figure does not take into account internally displaced persons of whom there were already at least a million on the eve of the genocide as a result of the civil war. The estimate of 800 000 slaughtered during the genocide, of whom about 50 000 were Hutu, is a conservative figure. Some put the number at a million or more.

4. In pre-genocidal Rwanda, the Hutu formed roughly 85% of the population, the Tutsi 15% and the Twa 1%. The Twa were a forest-dwelling, hunter-gatherer people generally accepted as the aboriginal inhabitants of the region.

5. For a summary of various estimates of how many Hutu may have participated in the killing see N. Eltringham (ed.), *Accounting for Horror: Post-Genocide Debates in Rwanda* (London: Pluto Press, 2004), p. 69. Estimating the number of participants is difficult in the Rwandan case because there were often several killers per victim and killers commonly operated in groups.

6. The racially motivated inactivity of the West, which George foregrounds in this film, is an issue of secondary significance in my estimation.

7. K. Turan, 'Hero in the Midst of Ethnic Slaughter', *Cape Times*, 10 June 2005, syndicated from the *Los Angeles Times*.

8. M. Mamdani, *When Victims Become Killers: Colonialism, Nativism, and the Genocide in Rwanda* (Princeton: Princeton University Press, 2001), p. 8. Emphasis in the original.

9. Mamdani also points out that few of the perpetrators had killed before, many of the leaders were highly educated professionals whose training militated against such abuses – clerics,

doctors, judges – and much of the killing took place at sites of sanctuary – churches, hospitals, schools. See Mamdani, *When Victims Become Killers*, p. 7.

10. Radio et Television Libres des Milles Collines, an extremist Hutu radio station funded by Hutu extremists within Habyarimana's inner circle, started broadcasting from July 1993 onwards. It disseminated virulent anti-Tutsi propaganda and urged on the killers during the genocide.

11. This is of course not to suggest that the essentialised reifications and racial caricatures of Hutu and Tutsi that have actuated Rwandan politics for the past century exist in reality.

12. *Sometimes in April* is a made-for-cable HBO production aired a few months after *Hotel Rwanda* was released. It is estimated that over 35 million people viewed the film during March and April 2005. For confirmation see www.heritagekonpa.com.

13. *Sunday Times Magazine*, 5 June 2005. Except for the sections dealing with the American response to the Rwandan crisis, there is little that is overtly political in *Sometimes in April*. Peck's activist stance does, however, lay him open to the charge of didacticism. See Joy Press, 'Shadow of Guilt' on www.villagevoice.com/screens as well as Jon Jost, 'Senses of Cinema' on www.sensesofcinema.com/contents.

14. Mamdani, *When Victims Become Killers*, p. 229. Emphasis in the original.

15. Because pre-colonial Rwandan society was pre-literate, many aspects of its history are hazy, and because competing interpretations of its past have been pressed into service for political ends, much of it is highly contested. The following synopsis, which draws heavily on Mamdani, is offered with due caution.

16. Germany claimed Rwanda as colony in the mid-1880s but only posted colonial administrators a decade later.

17. A Tutsi-dominated state emerged in east-central Rwanda from the early 16th century onwards and had developed into a highly centralised monarchy by the middle of the 18th century. The *mwami* (king), considered to be of divine origin, was in control of a standing army and ruled through an elaborate bureaucracy of mainly Tutsi chiefs. The Tutsi aristocracy maintained control through a feudal-like arrangement of clientship known as *ubuhake*. In this arrangement of mutual obligation the patron would provide the client with cattle and access to land in return for loyalty, tribute payments and labour service (*ubureetwa*). Nearly all patrons were Tutsis and clients could either be Hutu or poorer Tutsi. Only Hutu were subject to labour service, underscoring their subservient status. Not all Tutsi were wealthy and not all Hutu were poor though high status and political power were firmly associated with the Tutsi.

18. The archaeological record indicates that about three thousand years ago migrating Bantu-speaking people, probably from west-central Africa, settled in the area of fertile highlands that today comprises Rwanda and Burundi. Their descendants would later form the basis of the Hutu grouping. Hutu identity is clearly not primordial but most likely emerged amongst subject people in response to Tutsi state formation. About six centuries ago they were joined by pastoralists who had most probably come from present-day south-eastern Ethiopia and Somalia. These people and their descendants came to form the basis of the Tutsi grouping. The new migrants were not only culturally distinct from the Hutu, but were also physically different, being tall and slender with thin, elongated features which were an adaptation to the hot, dry climate from which they emanated. Some scholars would add that their tall stature was also partly due to a protein-rich diet of milk and meat. The evidence points to the pastoralist Tutsi and Hutu cultivators living together peacefully in the earlier period of contact. In Kinyarwanda the word Tutsi means 'rich in cattle' while Hutu means 'subject' or 'servant'. The correlation between identity and economic activity was far from absolute. There were many poorer, even cattleless, Tutsi and some richer cattle-owning Hutu in pre-colonial Rwanda.

19. A Hutu family that had gained significant wealth and managed to marry Tutsi women could over a period of a few generations become Tutsi. This co-opting of successful Hutu was

crucially important for shoring up minority Tutsi control by preventing the emergence of a Hutu counter-elite.

20. At the lower levels of the bureaucracy it was not unusual to find Hutu chiefs and there were even a few in the upper levels of the provincial administration. In its more mature form the pre-colonial Rwandan state consisted of several provinces each of which was administered by three chiefs – one who oversaw issues relating to agriculture, another one who was in charge of cattle and grazing, and a third responsible for military matters, especially recruitment for the army. While the latter two positions were always filled by Tutsis, the former was sometimes occupied by a Hutu.

21. Much of the serious conflict was between rival Tutsi clans vying for power. For conflict between Hutu and Tutsi in the pre-colonial period see J. Vansina, *Antecedents to Modern Rwanda: The Nyinginyi Kingdom* (Madison: University of Wisconsin Press, 2004).

22. Europeans used the Hamitic theory to explain away evidence of social or technological advancement in African societies by attributing these achievements to the influence of ancient Hamitic peoples who were supposed to have migrated into sub-Saharan Africa from Egypt or Ethiopia. Though dark-skinned, the Hamites were taken to be Caucasoid and therefore racially superior. They were deemed to have spread elements of their civilisation, be it metallurgy, building styles, state formation or irrigation methods, to the inferior Bantu peoples as they migrated through Africa, eventually becoming corrupted and absorbed by them. The Tutsis, generally being physically different to Hutus and of somewhat lighter skin tone, were held up as examples of descendants of these racially superior Hamites.

23. With the outbreak of World War One, Belgian troops occupied Ruanda-Urundi, which in 1923 became a mandated territory of the League of Nations administered by Belgium.

24. While the Belgians continued to rely on the Rwandan monarchy and its Tutsi bureaucracy to collect taxes, recruit forced labour and maintain social order, they ruled more directly through their own administrators, not hesitating to curb the powers of the *mwami* and his bureaucracy.

25. Labour service typically increased by more than 50% from 1 in 5 days to 2 in 6. Tutsi chiefs required, amongst other things, that Hutu work in their fields, build houses for them, collect firewood, fetch water or act as nightwatchmen.

26. Some Tutsi chiefs were even able to confiscate the possessions or part of their Hutu clients' crops with impunity. Conditions deteriorated to the extent that tens of thousands of Hutu fled to Uganda in the 1920s, preferring to work on plantations there than face the exploitation of Tutsi chiefs back home.

27. To streamline the administration, the Belgians replaced the regional three-chief system with a single Tutsi chief. These changes reduced the Hutu peasantry's channels of appeal and the chance of playing one chief off against another.

28. Hutus were not entirely excluded from education but a much smaller proportion received any schooling. The only professional outlet for better-educated Hutu boys was to train to become priests, which explains why the church network became such an important conduit for Hutu nationalism and why so many clerics collaborated with the genocidaires.

29. In the case of mixed marriages, wives and children followed the designation of the father. Although there was some arbitrariness in the classification of people and a degree of manipulation of the system, people were on the whole classified in terms of their general acceptance within the society.

30. From the late 1940s the United Nations forced the Belgian administration to curb human rights abuses and implement political reform in Rwanda.

31. Gangs of Hutu, venting frustrations pent up over decades of oppression, moved through the countryside attacking Tutsis, especially wealthier Tutsis, or those in authority, forcing them to flee, and burning their houses.

32. Foreign income from coffee exports dropped to one-fifth of its 1980s level within four years. The currency was severely weakened, state revenues fell drastically and peasants growing coffee faced destitution.

33. Exiled Rwandan Tutsis formed a significant proportion of Museveni's rebel fighting force and played a major role in his overthrow of the Obote government in the mid-1980s. Unable to meet their aspirations of citizenship because of growing Ugandan resentment of exiles, Museveni tried to rid himself of a potentially dangerous problem by supporting their armed repatriation to Rwanda.

34. The main massacres were of an estimated three hundred Tutsis at Gisenyi in October 1990, of at least a thousand across the north and north-west provinces in January 1991, of several hundred in Bugesera in February and March 1992, and a further three hundred in north-west Rwanda in January 1993.

35. Interahamwe, Kinyarwanda for 'those who attack together', was the youth militia attached to the ruling MRND party.

36. G. Prunier, *The Rwanda Crisis: History of a Genocide* (London: C. Hurst, 1998), p. 238.

37. Gill Courtemanche's novel *A Sunday at the Pool in Kigali* (New York: Vintage Books, 2003) provides good insight into the state of pre-genocidal Rwanda. It is particularly relevant because it draws extensively on Courtemanche's personal experiences – he characterises the volume as 'a chronicle and eye-witness report' in which 'the characters all existed in reality' – and because much of it is set at the Milles Collines.

38. The film conveniently neglects to inform viewers that Rusesabagina lost more than fifteen members of his extended family including his mother-in-law, one of her daughters-in-law and six grandchildren. See, for example, www.wweek.com/editorial and *Sunday Times Magazine*, 5 June 2005.

39. The first item on the endscroll intimates as much.

40. George interviewed by Molele, *Sunday Times Magazine*, 5 June 2005. In the interview recorded on the *Hotel Rwanda* DVD itself, George reveals that this was part of his box-office strategy, 'I did not want anyone to feel that they should avoid this film because it was gory and it would be distasteful to watch.'

41. See K. Onstad, 'Filming the Unfilmable: The Challenge of the Genocide Movie', retrieved from www.cbc.ca/arts/film/genocide.

42. *Gacaca* courts are a new form of community justice based on the traditional system of conflict resolution. Started in March 2001, they are meant to expedite the punishment of transgressors and promote communal healing.

43. Here one thinks, amongst other things, of babies being stuffed down long-drop toilet pits, children having their heads smashed against rocks, pregnant women being disembowelled, and the notorious Burundian torture in which a body part a day is amputated until the victim dies of loss of blood after about a week.

44. Rutaganda was also a member of the MRND's central committee. P. Gourevitch, *We Wish to Inform You That Tomorrow We Will Be Killed with Our Families* (London: Picador, 1998), p. 130; A. des Forges, *Leave None to Tell the Story: Genocide in Rwanda* (New York: Human Rights Watch, 1999), pp. 69, 199.

45. Arrested in Lusaka in 1995, Rutaganda was sentenced to life imprisonment by the ICTR in 1999 for his part in the genocide.

46. M. Lee, 'Terry George: The Interview', retrieved from movies.radiofree.com/interviews.

47. For a description of the real-life Bizimungu, see R. Dallaire, *Shake Hands with the Devil: The Failure of Humanity in Rwanda* (New York: Carroll and Graf, 2003), pp. 292–293, 315–316. In real life it appears that Bizimungu could not have cared less about being held responsible for the killings. In response to Deputy Assistant Secretary of State Prudence Bushnell's warning

that President Clinton would hold him accountable for the killings, Bizimungu in 'perfectly charming French' responded, 'Oh, how nice that your president is thinking of me.' See S. Power, *A Problem from Hell: America and the Age of Genocide* (New York: Perennial, 2003), p. 370. *Sometimes in April* conflates Bagosora with Bizimungu and has the former uttering these words to Bushnell. The endscroll informs viewers that Bizimungu was captured in Angola in 2002 and is facing charges at the ICTR in Arusha, Tanzania. See L. Melvern, *Conspiracy to Murder: The Rwandan Genocide* (London: Verso, 2004), p. 253.

48. Yet six days later the UNCG passed a resolution to send 6 500 extra troops to Bosnia. A. Klinghoffer, *The International Dimension of Genocide in Rwanda* (New York: New York University Press, 1998), p. 49.

49. In January 1994 Dallaire warned UN headquarters that genocide of the Tutsis was being planned and the following month he informed his superiors that target lists and weapons for this purpose were being distributed. For studies on the international response to the Rwandan crisis, see L. Melvern, *A People Betrayed: The Role of the West in Rwanda's Genocide* (London: Zed Books, 2000); M. Barnett, *Eyewiness to a Genocide: The United Nations and Rwanda* (Ithaca: Cornell University Press, 2002); Power, *A Problem from Hell*, ch. 10; as well as the above-mentioned works by Klinghoffer and Dallaire.

50. There would have been an uncanny resemblance had a moustache been added to Nolte's face.

51. Alison des Forges's description of this incident indicates that the film version is substantially accurate. See A. des Forges, *Leave None to Tell the Story*, pp. 633–634.

52. For an analysis of the implications of this simplistic view and the ways in which the RPF-dominated government has exploited it, see J. Pottier, *Re-imagining Rwanda: Conflict, Survival and Disinformation in the Late Twentieth Century* (Cambridge: Cambridge University Press, 2002).

53. See Eltringham, *Accounting for Horror*, pp. 103–111 for a discussion of the subject. See also Dallaire, *Shake Hands with the Devil*, p. 515 for the accusation that Paul Kagame, for strategic reasons, did not move as swiftly as he could have to end the genocide.

54. Kibeho was the last of the camps of internally displaced persons to be dismantled. Panicky because the camp housed a large number of hard-core Interahamwe militia, RPF soldiers fired indiscriminately into the crowd when a stampede occurred. For accounts of the Kibeho massacre see Pottier, *Re-imagining Rwanda*, pp. 76–81, 160–170 and Gourevitch, *We Wish to Inform You*, pp. 185–208.

55. Gourevitch, *We Wish to Inform You*, pp. 140–141. Saint-Famille is where Jeanne Muganza ends up and eventually dies.

56. See A. des Forges, *Leave None to Tell the Story*, pp. 633–634.

57. B. Johnson, 'Q&A with Romeo Dallaire', retrieved from www.macleans.ca/culture/films. I thank Huseyin Akturk for drawing my attention to this website.

58. www.hbo.com/films.

59. The film won the People's Choice Award at the Toronto Film Festival, the AFI Audience Award and the Broadcast Film Critics Association Award for best picture, amongst others. For a list of awards and nominations see www.imdb.com. See also www.rottentomatoes.com.

60. See www.amnestyusa.org. I thank Basha Rubin for drawing my attention to this website.

Chapter 17

1. Truth and Reconciliation Commission, *Truth and Reconciliation Commission of South Africa Report*, 5 vols. (Cape Town, 1998) (hereafter, *TRC Report*), vol. 1, ch. 1, 'Foreword by Chairperson the Most Revd. D.M. Tutu Archbishop Emeritus', para. 91. This passage is quoted (as written text) at the end of two of the three films discussed in this chapter: *Red Dust* and *Forgiveness*.

2. *In My Country*: John Boorman, 2004, UK, Ireland, South Africa, 100 mins, English, Afrikaans.
3. *Red Dust*: Tom Hooper, 2004, UK, South Africa, 110 mins, English.
4. *Forgiveness*: Ian Gabriel, 2004, South Africa, English, Afrikaans.
5. Antjie Krog, *Country of My Skull: Guilt, Sorrow, and the Limits of Forgiveness in the New South Africa* (New York: Times Books, 1999).
6. *Ubuntu* is a word in the Nguni languages of South Africa (which include Xhosa and Zulu), not easy to translate. It has been rendered as 'humaneness', 'social justice and fairness', 'humanity', 'the quality of being human', 'personhood'; perhaps the most generally accepted meaning is 'a feeling of common humanity', implying both rights and duties for the individual member of a group. Its meaning and potential importance in the new South Africa were discussed by various judges of the new Constitutional Court in their first case, on the constitutionality of the death penalty: *S v Makwanyane* 1995 (3) SA 391 (CC). A number of the judges made use of it in their judgments, as an indigenous South African value militating against both crude revenge and the death penalty. Archbishop Desmond Tutu, Chairperson of the TRC, popularised the term by quoting the Xhosa proverb *Ubuntu ungamntu ngobanye abantu* (People are people through other people).
7. This is based on the real Vlakplaas, a farm near Pretoria that the security police turned into a base for death squads under the command, at one time, of Eugene de Kock (the real-life model for Colonel de Jager in the film). All three of the films make reference to the security police's use of such farms as convenient places to torture and interrogate suspects, and – in *In My Country* and *Red Dust* – to bury the bodies of detainees who were killed in the course of torture in detention.
8. Gillian Slovo, *Red Dust* (London: Virago Press, 2000). Gillian Slovo is the daughter of liberation struggle activists Joe Slovo and Ruth First (who was killed in 1982 by a letter bomb sent by the security police). See Gillian Slovo, *Every Secret Thing: My Family, My Country* (Boston: Little, Brown, 1997). Gillian Slovo testified to the TRC's Amnesty Committee in 1998 in the application for amnesty by Craig Williamson, who sent the fatal letterbomb that killed her mother, and she observed and reported on this and other aspects of the TRC.
9. By passing the Promotion of National Unity and Reconciliation Act (1995).
10. For a basic account of the TRC and its procedures and achievements, see Martin Meredith, *Coming to Terms: South Africa's Search for Truth* (New York: Public Affairs, 1999). There are accounts of it written by its chairperson, Archbishop Tutu, see Desmond Tutu, *No Future Without Forgiveness* (London: Random House, 1999), and by its deputy chairperson Alex Boraine, see Alex Boraine, *A Country Unmasked: Inside South Africa's Truth and Reconciliation Commission* (Oxford: Oxford University Press, 2000), a fuller, more substantial and analytical account. Antjie Krog's *Country of My Skull* reports, in a very accessible way, many of the public hearings on both human rights violations and amnesty.
11. 'Postamble' to Constitution of the Republic of South Africa, Act 200 of 1993. For *ubuntu*, see note 6 above.
12. The TRC used the term 'victim' in a broad generic sense, to cover both actual victims of gross violations of human rights and also, where the actual victim was dead as was often the case, the loved ones (parents, spouses, siblings, close friends) who testified about what had happened to them. In this chapter, it will normally be used in this generic sense. This use of 'victim' caused controversy among some activists, who felt that it suggested passive sufferers rather than active resisters of apartheid. *Red Dust* shows Alex Mpondo at the Amnesty Committee hearing deliberately removing the sign 'victim' from in front of him, and refusing to allow himself to be referred to as 'the victim', on this basis.
13. The Reparations and Rehabilitation Committee made 'victim findings' for about 22 000 people, and recommended (*TRC Report*, vol. 5, ch. 5, 'Reparation and Rehabilitation Policy',

paras. 69–77) that they should each receive annual payments, over a six-year period, of R18 000–R21 000 a year (based on the 1997 median household income). However, this was no more than a recommendation – to an ANC-dominated government, which had shown itself to be alienated from the TRC by the time the report was presented in October 1998. For more than four years thereafter, the government did nothing about these recommendations; finally, in 2003, it announced that it would pay reparations to those with 'victim' status – but only a once-for-all lump sum of R30 000 per victim. This decision has been strongly attacked by the Victim Support Group, Khulumani, and by NGOs such as the Centre for the Study of Violence and Reconciliation and the Institute for Justice and Reconciliation.

14. Because perpetrators had to apply separately for amnesty for each offence, one individual perpetrator could generate numerous amnesty applications.

15. See Robert I. Rotberg & D. Thompson (eds.), *Truth v Justice: The Morality of Truth Commissions* (Princeton: Princeton University Press, 2000); A. Barahona de Brito, C. Gonzalez-Enriquez & P. Aguilar (eds.), *The Politics of Memory: Transitional Justice in Democratizing Societies* (Oxford: Oxford University Press, 2001). Countries that have recently followed, wholly or partially, the model of the South African TRC in setting up truth commissions include Peru, Sierra Leone and East Timor. Other countries in which the TRC has been cited as a possible model for dealing with their problems include Northern Ireland, Burma, the former Yugoslavia, Nigeria, Israel/Palestine, Australia and Canada.

16. An example of the latter would be the Australian Broadcasting Corporation (ABC) current affairs programme *Lateline* on 11 August 1998, which offered a 35-minute programme on the TRC (then nearing the end of its life) under the title *Trading in Truth*. The first half of this comprised footage from the TRC hearings, including some showing former security policeman Jeffrey Benzien demonstrating on camera how he tortured detainees using the 'wet bag' method. The second half of the programme was a panel discussion, involving Yasmin Sooka (one of the 17 Commissioners), Nkosinathi Biko (son of the murdered Steve Biko), and Graeme Simpson (director of the Centre for the Study of Violence and Reconciliation), moderated, from Australia, by the presenter. A video recording of it is available in the library of the University of Melbourne.

17. Directors Frances Reid and Deborah Hoffmann: Iris Films (USA), 2000.

18. Director and producer Mark J. Kaplan: Grey Matter Media (South Africa), 2003.

19. Gugulethu is one of the four African townships in Cape Town. The ANC (African National Congress) was the main African nationalist organisation under apartheid. In 1994 it formed the government of post-apartheid South Africa and was responsible for setting up the TRC. Umkhonto weSizwe (MK) was the armed wing of the ANC. The PAC (Pan Africanist Congress) broke away from the ANC in 1959, and was its main rival as an African nationalist organisation. In 1993, while the negotiations that ultimately ended apartheid were in progress, the PAC was espousing an anti-white slogan 'One Settler, One Bullet', which was supposed to have influenced the youths who killed Amy Biehl. Both the ANC and PAC were legally banned from 1960 to 1990; the UDF (United Democratic Front) was the main legal opposition body (linked with the banned ANC) from 1983 to 1990.

20. The director of *Red Dust* admits, in his DVD commentary, that he derived his ideas for the AC hearings in the film from watching *Long Night's Journey*.

21. The film includes a scene in which Siphiwo's killer, Gideon Nieuwoudt, apologised to his parents and asked for their forgiveness; while he was doing so, Siphiwo's son hit him over the head with a heavy vase, fracturing his skull. It challenges the viewer to consider the adequacy of the TRC's ideas about reconciliation versus familiy members' wishes for some form of retribution or punishment.

22. Robert A. Rosenstone, 'The Historical Film: Looking at the Past in a Postliterate Age', in his

Visions of the Past: The Challenge of Film to Our Idea of History (Cambridge, Mass.: Harvard University Press, 1995), pp. 45–79.

23. Rosenstone, 'The Historical Film', pp 68, 71–74.

24. In *Country of My Skull*, Krog offers some autobiographical information from which one can gather that she belonged to a fairly conventional National Party-supporting Afrikaner family. Her mother wrote a lament for 'this great man' Dr Verwoerd when he was assassinated in 1966. Her subsequent book *A Change of Tongue* (Johannesburg: Random House, 2003) contained considerably more information about her family – especially her mother, an Afrikaans writer and poet who wrote under the name Dot Serfontein – and her own upbringing and education in Kroonstad.

25. As exemplified by one of the notorious security policemen who applied for amnesty, Captain Dirk Coetzee, the first commander of Vlakplaas, the security police death-squad base. Coetzee offered the AC an apologia for how he had developed into a killer and death-squad commander, saying that his beliefs were shaped by his family being 'typical Afrikaner conservative National Party members', by his religious upbringing in the Dutch Reformed Church, and by his membership of the Voortrekker Youth Movement (the Afrikaner equivalent of the Boy Scouts). He went on to say: 'I was born into this environment, grew up in this environment, where we were made to believe that we were God's own people. We were the last southern Christian tip on the southern tip of Africa, that we were threatened with a communist revolutionary onslaught from the north, which if it was ever to succeed would plunge the southern tip of Africa into chaos.' Dirk Coetzee (Case No. 0063/96), AC hearing, Durban, 5 Nov. 1996. Killing of Griffiths Mxenge (part 1) at www.doj.gov.za/trc.

26. Krog, *Country of My Skull*, pp. 59, 75.

27. Barry Ronge, 'Hollywood in Her Skull' (quoting Antjie Krog), *Sunday Times*, 26 June 2005, *Lifestyle*, p. 14.

28. This is made very clear on the DVD of the film in the interviews with John Boorman, Ann Peacock and the producers, and in John Boorman's commentary going through the film.

29. In a comment on the AC hearing for the security police involved in abducting and killing the 'Cradock Four', George Bizos (a famous Greek-South African advocate, who represented many anti-apartheid activists and their families) remarks that the hearings have elements of the classical Greek dramas and their ideas of catharsis (*Long Night's Journey into Day*).

30. Krog, *Country of My Skull*, pp. 181–182.

31. Post-1994 South Africa has 11 official languages, nine of them African. The film recognises this, in a brief scene after the first TRC hearing, showing the black reporters phoning in their copy to different radio stations in different African languages.

32. TRC Amnesty Decisions (Case No. AC/99/0345), Cape Town 10 December 1999: Eugene Alexander de Kock (AM0066/96) at www.doj.gov.za/trc.

33. The toyi-toyi was the dance, accompanied by singing and chanting, with which young black comrades used to taunt the security forces during the 1980s. A *dominee* is a minister of the Dutch Reformed Church.

34. *In My Country* DVD, Boorman's commentary.

35. *In My Country* DVD, Boorman's commentary.

36. Director Darrell Roodt, producer Anant Singh, 2004

37. Krog, *Country of My Skull*, ch. 15, pp. 201–202: 'The process is unthinkable without Tutu. Impossible. Whatever role others might play, it is Tutu who is the compass. He guides us in several ways, the most important of which is language. It is he who finds language for what is happening. … A Dutch television director once asked me who Tutu's friends on the commission are. I couldn't think of anyone. There is co-operation and respect, but there is also some irritation: that Tutu from the beginning unambiguously mantled the commission

in Christian language, that he finds it difficult to move from the strong hierarchy of the church to the democracy of the commission, that he is so popular with whites, that he so often mentions black people's wonderful ability to forgive. Those wrestling out their own agendas call Tutu the fool, the court jester, the ultimate cover-up artist.'

38. *TRC Report*, vol. 1, ch. 1, Foreword by Tutu, para. 93. Also Tutu, *No Future Without Forgiveness*, p. 77.

39. On Eugene de Kock, see Eugene de Kock (as told to Jeremy Gordin), *A Long Night's Damage: Working for the Apartheid State* (Johannesburg: Contra Press, 1998); Jacques Pauw, *In the Heart of the Whore: The Story of Apartheid's Death Squads* (Halfway House: Southern Book Publishers, 1991); Jacques Pauw, *Into the Heart of Darkness: Confessions of Apartheid's Assassins* (Johannesburg: Jonathan Ball Publishers, 1997); Pumla Gobodo-Madikizela, *A Human Being Died That Night: A South African Story of Forgiveness* (Boston: Houghton Mifflin, 2003). There is also a documentary film about De Kock by Jacques Pauw, originally made for television: *Prime Evil* (SABC, South Africa, 1996).

40. Krog, *Country of My Skull*, pp. 93–99.

41. Dirk Coetzee (Case No. 0063/96), AC hearing, Durban, 5 Nov 1996, killing of Griffiths Mxenge (part 1) at: www.doj.gov.za/trc.

42. See note 17.

43. Gideon Nieuwoudt (Case No. 3920/96), AC hearing, Cape Town, 30 March 1998, killing of Steve Biko at: www.doj.gov.za/trc.

44. Author's interview with Tlhoki Mofokeng, Khulumani Support Group, Johannesburg, 1 August 2003. Charles Villa-Vicencio, who was Director of Research for the TRC, stated that it was a frequent victim criticism of the TRC that it was a 'visiting circus' – but felt that this was an unfair criticism (Author's interview, Institute for Justice & Reconciliation, Cape Town, 3 November 2003). Hugo van der Merwe, in *The South African Truth Commission and Community Reconciliation: A Case Study of Duduza* (Johannesburg: CSVR, 1998) reported the anger of victims from the township of Duduza at the fact that the TRC's Duduza hearing lasted for one day only.

45. The statute that created the TRC – the Promotion of National Unity and Reconciliation Act (1995) – did specifically mention *ubuntu* and did enjoin the Commission to pursue 'reconciliation'. It did not, however, require the perpetrators to show contrition in order to be granted amnesty, nor demand of victims that they show forgiveness towards perpetrators. It contains no mention of 'forgiveness'. This did not stop the Chairperson of the TRC, Archbishop Tutu, from making it clear that he and, more broadly, the Commission expected victims to show forgiveness towards perpetrators who confessed their deeds and showed signs of remorse. Tutu entitled his book about his TRC experience *No Future Without Forgiveness*.

46. On *ubuntu*, see note 6.

47. See Pauw, *Heart of the Whore* and *Heart of Darkness*; Max du Preez, *Pale Native: Memories of a Renegade Reporter* (Cape Town: Zebra Press, 2003).

48. 'Necklacing' was a form of popular punishment used by the 'comrades' in the 1980s against suspected informers or police spies. It involved putting a rubber tyre filled with petrol around the neck of the suspected person, setting it alight and watching the person burn to death.

49. HRVC hearings, East London, 16 April 1996 (Beth Savage) at www.doj.gov.za/trc.

50. See note 36.

51. *Askari* was the name used by the security police for guerrillas of the ANC or PAC whom they captured and 'turned', to make them killers for the police.

52. Kathorus is an East Rand complex of three adjacent townships – Katlehong, Thokoza and Vosloorus – in which 2 000 to 3 000 people were killed in fighting between the ANC and IFP between August 1990 and April 1994. The ANC supporters applied to the TRC for amnesty

for the killings, and were mostly granted it. See TRC: Amnesty Decisions, AC/99/0243, 'Background to the Political Conflict' at www.doj.gov.za/trc.

53. This was said by Victor Mthembu, IFP member, applying for amnesty for his part in the Boipatong massacre in 1992, in which 42 residents in Boipatong township, thought to be ANC supporters, were killed. He was granted amnesty. See Graeme Simpson, '"A Snake Gives Birth to a Snake": Politics and Crime in the Transition to Democracy in South Africa', in Bill Dixon & Elrena van der Spuy (eds.), *Justice Gained? Crime and Crime Control in South Africa's Transition* (Cape Town: UCT Press, 2004), pp. 1–28.

54. For 'necklacing', see note 45.

55. Richard Wilson, *The Politics of Truth and Reconciliation in South Africa* (New York: Cambridge University Press, 2001), pp. 10–11.

56. *In My Country* DVD, Boorman's commentary,

57. The DVD shows, via deleted scenes and Boorman's commentary, that the original script even had Whitfield returning to USA and patching up his failing relationship with his wife and son by invoking the TRC, forgiveness and *ubuntu*. Sensibly, these were cut from the film as released.

58. Michael Ignatieff, 'Overview: Articles of Faith', *Index on Censorship*, 5 (1996), pp. 110–122.

59. Krog, *Country of My Skull*, p. 57.

Index

Index

Index